the art of medieval spain
a.d. 500–1200

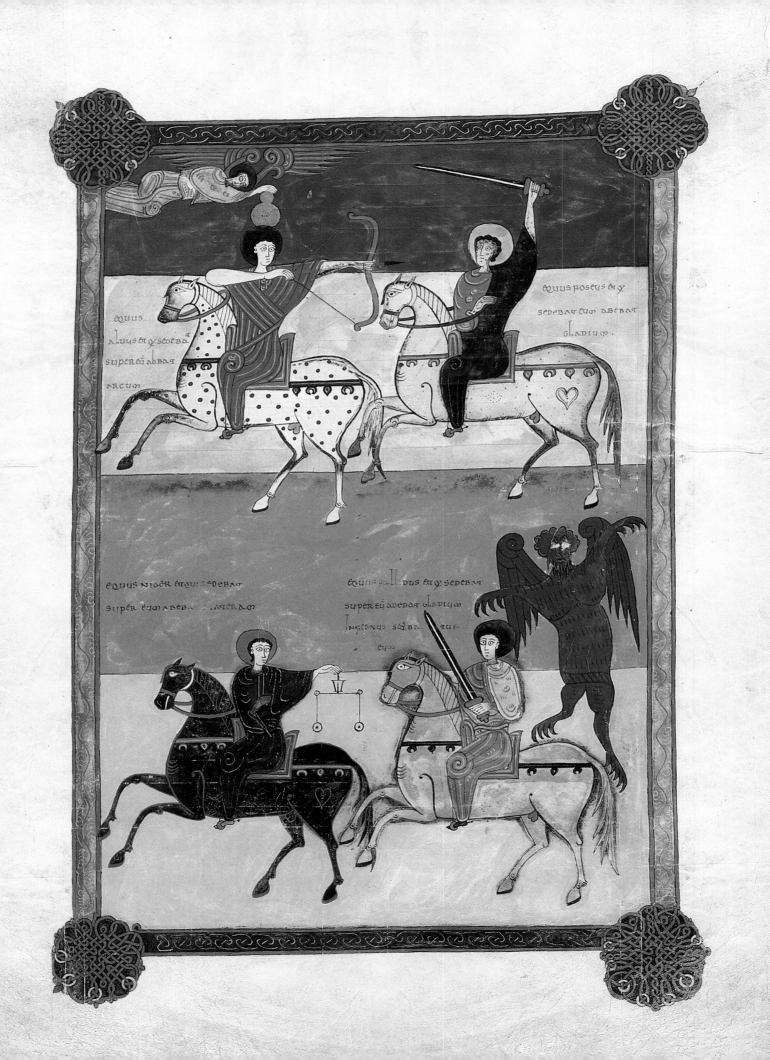

the art of medieval spain
a.d. 500–1200

THE METROPOLITAN MUSEUM OF ART, NEW YORK

Distributed by Harry N. Abrams, Inc., New York

This publication is issued in conjunction with the exhibition *The Art of Medieval Spain, A.D. 500–1200*, held at The Metropolitan Museum of Art, New York, from November 18, 1993, to March 13, 1994.

The exhibition was organized by The Metropolitan Museum of Art, New York.

The exhibition is made possible in part by the National Endowment for the Humanities, the National Endowment for the Arts, the David H. Koch Charitable Foundation, and the William Randolph Hearst Foundation.

Transportation assistance has been provided by Iberia Airlines of Spain.

Published by The Metropolitan Museum of Art, New York

John P. O'Neill, Editor in Chief
Kathleen Howard, Senior Editor, and Ann M. Lucke, Editor, assisted by Cynthia Clark,
Carol Fuerstein, Ruth Kozodoy, and Ellen Shultz
Bruce Campbell, Designer
Gwen Roginsky, Production Manager, assisted by Jay Reingold

Many photographs taken in Spain for this catalogue were commissioned by The Metropolitan Museum of Art from Bruce White, New York. Objects in the Metropolitan's collections were photographed by Oi-Cheong Lee, Joseph Coscia, Jr., and Bruce Schwarz of The Photograph Studio, The Metropolitan Museum of Art. For a complete list of photograph credits, see p. 357.

Set in Galliard and Libra by U.S. Lithograph, typographers, New York
Printed on Albamatte 135 gsm
Separations by Professional Graphics, Rockford, Illinois
Printed by Julio Soto Impresor, S.A., Madrid
Bound by Encuadernación Ramos, S.A., Madrid

Translations from Spanish by Margaret Sayers Peden (essays and entries by Serafín Moralejo and Gisela Ripoll López) and by Edith Grossman (cat. 92).
Translations from German by Russell Stockman (essays and entries by Achim Arbeiter, Peter K. Klein, and Sabine Noack-Haley and entries by Tilo Ulbert).

Maps by Wilhelmina Reyinga-Amrhein

Jacket/Cover Illustrations
Front: *Noli me tangere* (Touch me not). This ivory plaque depicts an event following the Resurrection: Christ appears to Mary Magdalene (left), whom he bids not to touch him (John 20:14–20) (cat. 115c, detail). Photo: Joseph Coscia, Jr., The Photograph Studio, The Metropolitan Museum of Art
Back: Chalice of Urraca (cat. 118). Photo: Bruce White, New York

CIP information appears on p. 358.

FRONTISPIECE: Illustration from the Beatus of Fernando and Sancha, A.D. 1047 (cat. 143; fol. 135r).
Opening of the First Seal: The Four Horsemen. Biblioteca Nacional, Madrid
And I saw . . . a white horse, and its rider had a bow; and a crown was given to him, and he went out conquering and to conquer. . . . And out came another horse, bright red; its rider was permitted to take peace from the earth so that men should slay one another; and he was given a great sword. . . . And I saw . . . a black horse, and its rider had a balance in his hand. . . . And I saw . . . a pale horse, and its rider's name was Death, and Hades followed him; and they were given power over a fourth of the earth, to kill with sword and with famine and with pestilence and by wild beasts of the earth.
(Apocalypse 6:2–8)

contents

minister of culture's statement

From a cultural perspective 1993 has undoubtedly emerged as the year of Medieval Spain. The current celebration of the year of Saint James in Santiago de Compostela is the result of the important collaboration between civil and ecclesiastical institutions, and coordination among the autonomous regional governments.

These special collaborations have brought about the development of a detailed program for the protection of the Camino de Santiago, and the organization of exhibitions at several locations along the Camino dedicated to the pilgrimage, the art, and the daily and religious life of the medieval era. These exhibitions and programs advance the body of knowledge concerning one of the periods in our history that has made a major contribution to our cultural identity.

The exhibition, *The Art of Medieval Spain, A.D. 500–1200,* at The Metropolitan Museum of Art in New York illuminates our medieval artistic and cultural history for an audience beyond Spanish borders. This careful and exceptional exploration by distinguished specialists honors the historic roots of our patrimony and brings them to the attention of a broader public. Through the considerable effort of a number of scholars and professionals, a selection of precious objects was chosen for inclusion in the exhibition. The participation of religious institutions, private collectors, and museums has been broad and generous and has resulted from an understanding of the special importance of this project. We are sure that these considerable efforts will be rewarded with the same success that The Metropolitan Museum of Art has enjoyed with other exhibitions of Spanish art that it has organized in the past decade.

Carmen Alborch Bataller
Minister of Culture

Director's foreword

Over the last several years the Metropolitan Museum has enjoyed a close and fruitful special relationship with the Spanish Cultural Ministry and with the main artistic, historic, and religious institutions of Spain. As a result of these ties we were able to mount monographic exhibitions of the great Spanish painters Zurbarán (1987), Velázquez (1989), Goya (1989), and Ribera (1992). In 1992, in a departure from these explorations of the works of a single master, the Metropolitan presented *Al-Andalus: The Art of Islamic Spain*, which examined the brilliant Islamic culture that was such a major force in the Iberian Peninsula from 711 until 1492. Now, with *The Art of Medieval Spain, A.D. 500–1200*, we complete our survey of this turbulent and fascinating period. While the earlier exhibition concentrated on the legacy of Spanish Islam, the present show brings to the fore the Visigothic invasion that transformed Roman Spain and the flowering of Christian art that culminated in the splendors of the Romanesque. These two exhibitions, which encompass a most creative and formative era, set forth the foundations of Spain as we know it today and are thus an appropriate culmination to date of the distinguished series of ventures on which we and our Spanish colleagues have collaborated.

The wealth of material in this exhibition has been divided into four main areas: Visigothic art, Islamic art, Asturian and Mozarabic art, and Romanesque art, including that of the Camino de Santiago, the great pilgrimage road. The chronological framework is expanded by emphasis on certain dominant themes, such as the importance of patronage, the widespread appropriation of forms and motifs from other European and Mediterranean traditions, and the impact of religious reform and the pilgrimage to Santiago de Compostela. Special weight has been given to the internationalism so characteristic of medieval Spanish art; indeed a number of works in the show have their artistic origins outside the Iberian Peninsula.

Among the glories of this exhibition, which covers both courtly and ecclesiastical art, is the collection of manuscripts of the Beatus Commentary. Vibrant leaves from several Beatus manuscripts join those recently acquired by the Metropolitan. Also of exceptional interest are three illuminated Bibles, most rare and precious works. Medieval graphic art in a far larger format is seen in a singular display of Spanish wall paintings. Such sculptural works as ivory plaques, stone capitals, and devotional figures show the remarkable achievement in Spain over seven centuries.

The catalogue includes a number of important works that were deemed too fragile to travel to New York and thus offers an even fuller view of the art of medieval Spain than does the exhibition itself. The scholarly essays and texts explore the broad panorama of medieval Spain, placing its art in local, regional, and international contexts.

This exhibition was organized at The Metropolitan Museum of Art by Charles T. Little, Curator, Department of Medieval Art, in collaboration with John W. Williams of the University of Pittsburgh, Jerrilynn D. Dodds of the City University of New York, and Serafín Moralejo, now of Harvard University and formerly of the Universidad de Santiago. Mahrukh Tarapor, Associate Director for Exhibitions, played an invaluable role in the exhibition's overall organization and coordination, especially in Spain. For their commitment, enthusiasm, and professionalism, our profound thanks.

We are deeply indebted to our Spanish colleagues, most especially those cited by Mahrukh Tarapor in her acknowledgments. An exhibition of this size and complexity depends completely on the generosity of many lenders—in this instance churches, monasteries, museums, and private collectors. Their magnanimity has found glorious expression in the Metropolitan's galleries. Finally I thank Plácido Arango for his warm interest in the success of this project.

It is a pleasure to recognize the financial support of the National Endowment for the Humanities, the National Endowment for the Arts, the David H. Koch Charitable Foundation, and the William Randolph Hearst Foundation. Transportation assistance has been provided by Iberia Airlines of Spain.

Philippe de Montebello
Director
The Metropolitan Museum of Art

acknowledgments

The thanks one owes, institutionally as well as personally, for the successful completion of any large international exhibition is always a complex business. When one works in another country for long periods of time, the complexity is compounded, because one is grateful for so much—the munificence of lenders; the hospitality of friends and of strangers who often grow into friends; the office services that are unexpectedly and generously put at one's disposal in moments of crisis; the counsel, the guidance, the introductions, the practical assistance, without which one's efforts would surely be doomed from the start. And, in an exhibition such as *The Art of Medieval Spain, A.D. 500–1200*, there is the further and all-encompassing debt a museum owes to a country and its people for the privilege of exploring a most critical and formative period of its national identity and being trusted to do it well.

The Metropolitan Museum acknowledges with warm gratitude the essential and generous support given to this exhibition, particularly in its final stages, by Carmen Alborch, Minister of Culture, Spain. It also gives me pleasure to extend personal thanks to the following individuals in Spain: José María Luzón Nogué, Director General of Fine Arts and Archives, Ministry of Culture; Felipe Garín Llombart, Director, Prado Museum; Manuel Gómez de Pablos González, President, Patrimonio Nacional; Duke of San Carlos; Duke of Huéscar; María Antonia Fernández Felgueroso, Secretary of the Interior,

Principado de Asturias; the Most Reverend Gabino Díaz Merchan, Archbishop of Oviedo; María Cruz Morales Saro and Francisco Javier Fernández Conde, who were the co-organizers of *Orígenes: Arte y Cultura en Asturias, Siglos VII–XV* in Oviedo; the Most Reverend Juan Martí Alanis, Bishop of La Seu d'Urgell; the Reverend Josep Amiell Solé, Parroco, Iglesia de San Miguel, Vielha; and the Right Reverend Juan Manuel Núñez, Padre Guardián, Monasterio de Santa María la Real, Nájera.

Here at the Metropolitan, a special acknowledgment is due Martha Deese, Senior Assistant for Exhibitions, and Sian Wetherill, Assistant for Exhibitions, for the dedicated efficiency with which they tracked the exhibition's administrative details and so eased my task.

As is invariably the case in any of the Metropolitan's undertakings in Spain, we are grateful to Santiago Saavedra, Ediciones El Viso, Madrid, who has been the Museum's partner in the publication of several distinguished catalogues but whose assistance has always extended beyond this sphere. To him and to Lola Gómez de Aranda in his office, we offer our heartfelt thanks.

Finally, Plácido Arango has, as always, helped in ways both tangible and intangible. It is a privilege to record here our appreciation of his efforts as Metropolitan trustee and as special friend.

Mahrukh Tarapor
Associate Director for Exhibitions
The Metropolitan Museum of Art

The making of *The Art of Medieval Spain, A.D. 500–1200* was dependent on the vision, collaboration, and cooperation of many individuals. I am greatly indebted to the authors whose scholarship informs this catalogue. Many colleagues in Europe and the United States have given counsel, information, and encouragement throughout this enterprise: Mariano del Amo y de la Hera, Achim Arbeiter, François Avril, Janet Backhouse, Xavier Barral i Altet, Eulalia Bosch, Susan Boyd, Leonard E. Boyle, O.P., Marian Campbell, Juan Carlos Elorza Guinea, Alain Erlande-Brandenburg, Javier Fernández Conde, Danielle Gaborit-Chopin, Francisco Godoy Delgado, Sigrid Goldiner, Carmen Gómez-Moreno, Luis Grau Lobo, Marilyn Jenkins, Marta Kryshanowskaja, Vivian Mann, Joaquín Manzanares Rodriguez, Denis Milhau, Stephen Morley, Sa-

bine Noack-Haley, Cristina Partearroyo, Ann Poulet, Manuel Sánchez Mariana, Susan Strickler, Ian Wardropper, Paul Williamson, Bernardo Velado Graña, Gary Vikan, William Voeckle, Eric Zafran, and Juan Zozaya. Angela Franco Mata graciously gave valuable advice and support. David and Sonia Simon lent their broad knowledge of Spain to the exhibition, and I am especially grateful for their guidance.

I thank Cardinal Angel Suquía Goicoechea, President of the Conferencia Episcopal Española, and Monsignor Damián Iguacén, President of the Comisión Episcopal para el Patrimonio Cultural, for their support of this exhibition. The Metropolitan is particularly grateful to the many religious institutions that have lent us treasures which have spiritual and artistic significance. Antonio Viñayo, Abbot-Prior of the Real Colegiata

of San Isidoro, León, deserves special recognition for his generosity and assistance.

I would like to express my warm gratitude to my colleagues at the Metropolitan Museum. Among those who gave special assistance are: Michael C. Batista, Exhibition Designer; Edmund P. Dandridge, Associate Conservator, Department of Objects Conservation; Martha Deese, Senior Assistant for Exhibitions; Sophia Geronimus, Graphic Designer; Linda Komaroff, Associate Museum Educator; Margaret Lawson, Associate Conservator, Department of Paper Conservation; Kent Lydecker, Associate Director for Education; Michele D. Marincola, Assistant Conservator, The Cloisters, Department of Objects Conservation; Nancy McLaughlin, Development Officer for Government and Foundation Giving; Herbert M. Moskowitz, Registrar; Christopher Noey, Coordinating Producer, Department of Education; Constance Norkin, Graphic Design Assistant; Franz J. Schmidt, Manager for Special Projects, Buildings Department; Mary Shepard, Museum Educator, The Cloisters; Jack Soultanian, Jr., Conservator, Department of Objects Conservation; Linda M. Sylling, Assistant Manager for Operations; Monique van Dorp, Assistant Administrator, Robert Lehman Collection; Daniel Walker, Curator in Charge, Department of Islamic Art; Sian Wetherill, Assistant for Exhibitions; and Mary Grace Whalen, Associate Museum Librarian, Department of Education. Members of the Museum's Department of Medieval Art gave thoughtful suggestions throughout; the constant encouragement and wise counsel of William D. Wixom, the chairman of the department, is acknowledged with profound pleasure.

The importance of the scholarly team of John W. Williams, Jerrilynn D. Dodds, and Serafín Moralejo cannot be overestimated; their study of Spain has been a lifelong passion, whose fruits are evident in the exhibition and the catalogue. My sincere thanks for their generous discourse and enlightening vision. Esther Morales, Research Assistant, Department of Medieval Art, was a cheerful mainstay, helping in all aspects of this project. Martha Easton, Intern, Department of Medieval Art, and Karl F. Schuler, Fellow, Department of Medieval Art, aided in the final stages. Stephen J. Ziff has my gratitude for his early support of the exhibition proposal.

The catalogue benefited greatly from the careful skill of Kathleen Howard, Senior Editor, and Ann M. Lucke, Editor, and of Gwen Roginsky, Chief Production Manager, and Jay Reingold, Production Associate; the handsome design is the work of Bruce Campbell. John P. O'Neill, Editor in Chief, supervised and shaped the publication. Finally I would like to thank Mahrukh Tarapor, Associate Director for Exhibitions, for her tireless efforts on behalf of the exhibition and Philippe de Montebello, the Metropolitan's Director, for his enthusiastic endorsement and encouragement of the project from the start.

Charles T. Little
Curator, Department of Medieval Art
The Metropolitan Museum of Art

works in the catalogue: institutions and collections

UNITED STATES

Private Collection

Baltimore
Walters Art Gallery

Boston
The Museum of Fine Arts

Bryn Athyn, Pennsylvania
Glencairn Museum, Academy of the New Church

Cambridge, Massachusetts
Fogg Art Museum, Harvard University Art Museums

Chicago
The Art Institute of Chicago

Detroit
The Detroit Institute of Arts

New York
Ariadne Galleries, Inc.
The Metropolitan Museum of Art
The Pierpont Morgan Library
Shelby White and Leon Levy

Providence, Rhode Island
Private Collection

Washington, D.C.
Dumbarton Oaks

Worcester, Massachusetts
Worcester Art Museum

FOREIGN (excluding Spain)

BELGIUM
Liège
Musée d'Art Religieux et d'Art Mosan

GREAT BRITAIN
London
The British Library
Victoria and Albert Museum

Manchester
John Rylands University Library of Manchester

FRANCE
Paris
Bibliothèque Nationale
Musée du Louvre
Musée National de Moyen Âge, Thermes de Cluny

Provins
Church of Saint-Quiriace

Toulouse
Musée des Augustins

ITALY
La Cava dei Tirreni (Salerno)
Biblioteca della Badia

KUWAIT
Kuwait City
Al-Sabah Collection, Dar al-Athar al-Islamiyyah

MOROCCO
Rabat
Bibliothèque Générale

PORTUGAL
Braga
Cathedral Treasury
Museu Don Diogo de Sousa

Coimbra
Museu Nacional de Machado de Castro

RUSSIA
Saint Petersburg
State Hermitage Museum

SWITZERLAND
Private Collection

VATICAN CITY
Biblioteca Apostolica Vaticana

SPAIN
Astorga
Museo de la Catedral

Ávila
Museo Provincial de Ávila

Badajoz
Museo Arqueológico Provincial

Barcelona
Museu Frederic Marès
Museu Nacional d'Art de Catalunya

Burgos
Monastery of Santo Domingo de Silos
Museo de Burgos
Patrimonio Nacional, Monasterio de Santa María la Real de
　　las Huelgas

Córdoba
Museo Arqueológico Provincial

Cudillero
Church of El Pito

Escalada
Monastery of San Miguel de Escalada

El Escorial
Patrimonio Nacional, Biblioteca de El Escorial

Girona
Museu de la Catedral de Girona

Granada
Museo Nacional de Arte Hispano-Musulmán

Hornija
Church of San Román de Hornija

Jaca
Benedictine Monastery of Santa Cruz
Cathedral Archive
Church of Santiago and Santo Domingo

Játiva
Museo del Almudín

León
Museo de León
Real Colegiata de San Isidoro

Lleida
Fundació Publica, Institut d'Estudis Ilerdencs

Loarre
Church of San Esteban

Madrid
Biblioteca Nacional

Instituto de Valencia de Don Juan
Museo Arqueológico Nacional
Museo del Prado

Málaga
Museo Arqueológico Provincial

Mérida
Museo Nacional de Arte Romano

Nájera
Church of Santa María la Real

Oviedo
Masaveu Collection
Museo Arqueológico Provincial
Oviedo Cathedral

Palencia
Museo Arqueológico Provincial

Palma de Mallorca
Museo de Mallorca

Pamplona
Museo de Navarra

Peralada
Museo del Castillo de Peralada

Quintanilla de las Viñas
Church of Santa María

Salamanca
Old Cathedral

Salas
Biblioteca Municipal, Palacio Valdés Salas

San Cebrián de Mazote
Church of San Cebrián de Mazote

San Millán de la Cogolla
Monasterio de Yuso

Santiago de Compostela
Biblioteca Universitaria de Santiago de Compostela
Museo de la Catedral

Toledo
Museo de Santa Cruz
Museo Taller del Moro
Toledo Cathedral

Vic
Museu Arqueologic-Artistic Episcopal

contributors to the catalogue

AA Achim Arbeiter, Responsable del Área Paleocristiana y Altomedieval del Instituto Arqueológico Alemán de Madrid (Deutsches Archäologisches Institut, Madrid)

BDB Barbara Drake Boehm, Associate Curator, Department of Medieval Art, The Metropolitan Museum of Art

KRB Katherine Reynolds Brown, Senior Research Associate, Department of Medieval Art, The Metropolitan Museum of Art

SC Stefano Carboni, Assistant Curator, Department of Islamic Art, The Metropolitan Museum of Art

JDD Jerrilynn D. Dodds, Professor of Art and Architecture, City College, City University of New York, and Special Consultant to The Metropolitan Museum of Art

JAH Julie A. Harris, Adjunct Professor, Department of Art History, Northwestern University, Evanston, Illinois

MJ Marilyn Jenkins, Curator, Department of Islamic Art, The Metropolitan Museum of Art

PKK Peter K. Klein, Professor, Kunstgeschichtliches Institut der Philipps-Universität, Marburg

CTL Charles T. Little, Curator, Department of Medieval Art, The Metropolitan Museum of Art

JM Janice Mann, Assistant Professor, Department of Art and Art History, Wayne State University, Detroit, Michigan

SM Serafín Moralejo, Zobel de Ayala Professor of Spanish Art, Department of Fine Arts, Harvard University, Cambridge, Massachusetts

EMM Esther M. Morales, Research Assistant, Department of Medieval Art, The Metropolitan Museum of Art

SNH Sabine Noack-Haley, Becaria del Instituto Arqueológico Alemán de Madrid (Deutsches Archäologisches Institut, Madrid)

 Bernard F. Reilly, Professor, Department of History, Villanova University, Villanova, Pennsylvania

GRL Gisela Ripoll López, Profesor titular de Arqueología del Departamento de Prehistoria, Historia Antigua y Arqueología de la Universidad de Barcelona

KFS Karl F. Schuler, Fellow, Department of Medieval Art, The Metropolitan Museum of Art

MBS Mary B. Shepard, Museum Educator, The Cloisters, The Metropolitan Museum of Art

DLS David L. Simon, Ellerton M. Jetté Professor of Art, Colby College, Waterville, Maine

SCS Sonia C. Simon, Associate Professor of Art, Colby College, Waterville, Maine

MS Marie Swietochowski, Associate Curator, Department of Islamic Art, The Metropolitan Museum of Art

TU Tilo Ulbert, Director, Deutsches Archäologisches Institut, Damascus

EVA Elizabeth Valdez del Alamo, Assistant Professor, Department of Fine Arts, Montclair State College, Upper Montclair, New Jersey

DW Daniel Walker, Curator in Charge, Department of Islamic Art, The Metropolitan Museum of Art

 Otto Karl Werckmeister, Distinguished Professor in Art History, Department of Art History, Northwestern University, Evanston, Illinois

JWW John W. Williams, Professor of Fine Arts, University of Pittsburgh, Pennsylvania, and Special Consultant to The Metropolitan Museum of Art

JZ Juan Zozaya, Subdirector, Museo Arqueológico Nacional, Madrid

note to the reader

Terms and place names are cited as they appear in *Webster's Third New International Dictionary*, 1986, and *Webster's New Geographical Dictionary*, 1984. The exception to this practice is the treatment of Catalonian place names; the name of the region is given as Catalonia (the standard English form), but all place names within Catalonia are given in Catalan.

Transliterations from Arabic script follow the system most widely used in English-language periodicals such as the *International Journal of Middle East Studies*.

Abbreviated references are used in the notes and literature citations. For full listings, see the Bibliography, p. 330.

Entries are signed with the author's initials. For full names and affiliations, see Contributors to the Catalogue, p. xiii.

Measurements cited represent the maximum height (h.), width (w.), depth (d.), or diameter (diam.). Height precedes width; width precedes depth.

introduction

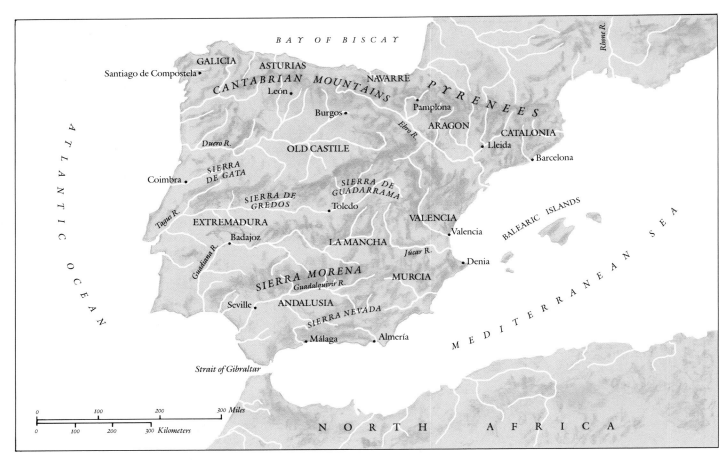

Topographical map of the Iberian Peninsula

medieval spain, a.d. 500–1200

BERNARD F. REILLY

Spain is a land of mountains and high plains. The greater part of the peninsula is a vast interior tableland more than one thousand feet above sea level. Four major mountain ranges—the Cantabrian-Pyrenees, the Sierra de Guadarrama, the Sierra Morena, and the Sierra Nevada—run east and west and divide the interior into five distinct regions whose intercourse with one another has historically been limited by the difficult terrain. The peninsula's topography fostered a social and cultural diversity that endures even today.

The major areas of population have always been in the basins of the five great rivers that drain the peninsula and long furnished the easiest means of transportation and communication. Averaging more than five hundred miles long, these are the Duero, the Tagus, the Guadiana, and the Guadalquivir, all of which rise deep in the interior and flow west into the Atlantic, and the Ebro which flows southeast from the mountains of Asturias into the Mediterranean. The Duero and the Tagus drop down steeply from the central plateau and so are not navigable far from the coast itself, an important circumstance in the somewhat independent development of Portugal.

In historic times and as late as 1200 the population of Spain has been sparse relative to its landmass. At roughly five million by the latter date it was one-third that of France and half that of Italy. Human settlement in Spain began in Paleolithic times, but the peninsula was not integrated into a single social or economic entity until the Roman period. Then, beginning with the Second Punic War (218–201 B.C.), an indigenous population with partial overlays of Celts, Carthaginians, and Greeks was organized and standardized by new Roman masters. The complete pacification of the Iberian peoples took some two hundred years, but thereafter Roman imperial domination endured over four centuries.

The Romans eventually divided the peninsula, largely along geographical features, into five provinces and built a network of roads which bound them to the Mediterranean world. Iberian wheat, olive oil, copper, and iron moved easily by sea throughout the Roman economic sphere. The gradual development of a civilization based on the Roman model is evident in those monuments that still exist. Mérida in the south has its amphitheater, Segovia in the center its aqueduct, and La Coruña in the extreme northwest its Roman lighthouse. All subsequent inhabitants of Spain have been marked by its classical past.

Under the Romans a patchwork of agricultural villas was laid down in the great river valleys. From this colonial world Seneca and Martial, Trajan and Hadrian, and a host of lesser figures went forth to a cosmopolitan destiny in Rome. Native languages were gradually supplanted by Latin which would in turn evolve into Castilian and Catalan, Galician and Portuguese. During the later imperial period Christianity followed Roman rule. By the third century Iberia had its first Christian martyrs and in the more settled fourth century was holding its initial church councils. Only in the extreme north, behind the Cantabrian Mountains along the Bay of Biscay, was there still a tribal world of Asturians, Cantabrians, and Basques, almost untouched by Roman roads, Latin, and Christianity.

The Visigothic Kingdom

The Roman Empire in the West collapsed in the fifth century A.D. From 409 groups of German invaders—Alans, Suevi, Vandals, and Visigoths—gradually made their way into Spain from the north. The Pyrenees are a formidable barrier between France and Spain; the passes at Roncesvalles and Somport are, however, less than one thousand feet in altitude, and at the Mediterranean coast there is a passage that is close to sea level. Of these new invaders only the Suevi and the Visigoths established stable kingdoms; the Suevi, however, were conquered by the latter in 585. For most purposes by the sixth century a Visigothic Spain had superseded a Roman one.

This new Germanic realm succeeded the Roman provincial world and continued its decline. The total number of German invaders is estimated not to have exceeded one-half million, and they were eventually absorbed in the native population of about four million, whose language and religion they would adopt. The peninsula's economic life was not substantially modified by the Visigoths except that old Roman villas became smaller and were increasingly fortified as the fabric of law and government shredded. Cities such as Cádiz and Tarragona shrank to a third of their former area and population. The imperial trade that had sustained them was contracting sharply everywhere in the Roman West. Though troubled by frequent revolt and general disorder, Visigothic rule endured until the Islamic conquest of 711. Under it Spain continued to be influenced by classical survivals. The Visigothic nobility intermarried with the late Roman provincial nobility.

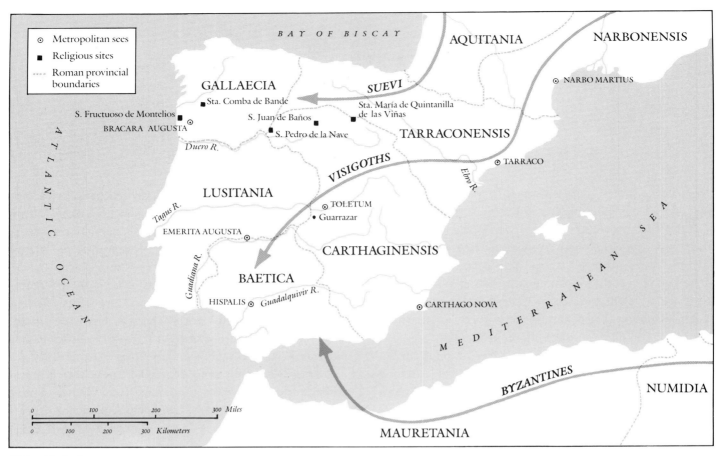

Visigothic Spain

Kings, such as Chindaswinth (r. 642–53) and Receswinth (r. 653–72), completed the amalgamation of Germanic and Roman law into a single code for their subjects, the future *Liber judiciorum* of the Christian Iberian world. From the time of King Recared (r. 586–601) a series of great councils of the Christian church, many held at Toledo, became the central legislature of the realm. The greatest churchman, scholar, and politician of his day, Isidore of Seville (bishop 600–636), was a man of letters and of action, after the classical ideal, who had previously served as a diplomat at the court of the Roman emperors in Constantinople.

Indeed the Roman, or more precisely Byzantine, province of Africa was but seven miles away across the Strait of Gibraltar. Under the Visigoths commerce with Africa continued in a reduced degree. Cultural and artistic changes moved along the trade routes they had earlier. Peninsular monasticism had North African roots. In addition, from the mid-sixth century until Swintila (r. 621–31) expelled them, the Byzantines established the province of Spania on the southern Iberian coast which, at its greatest extent, reached from Cartagena on the Mediterranean to Cádiz on the Atlantic. In its late, Byzantine form classical influence thus remained pervasive.

Nevertheless, Visigothic Spain was no more a mere cultural province of Byzantium than it was a political extension of that empire. The Visigothic kings and nobles were fundamentally war chiefs rather than civil magistrates on the order of Roman emperors and counts. They were largely illiterate, and high culture was the preserve of a new professional class of monks and bishops. For that reason, the cultural genius of this new Spain was primarily expressed in liturgical and ecclesiastical creations. A distinctive Christian liturgy, usually called "Mozarabic" because those who employed it were subject to Islamic rule, was embodied in manuscripts of collections of liturgical readings and of the Old and New Testaments. Bishop Isidore contributed his *Etymologiae,* the earliest medieval encyclopedia. The legislation of national councils was collected into a single manuscript called the *Hispania.* Fructuosus of Braga (d. 665) and Isidore both composed monastic rules.

The Visigoths ruled a society that failed to reverse the decline that had begun in late classical times. Like the Romans they could not subdue the tribal societies of the Cantabrian and Pyrenean north; in fact, those peoples expanded their predominance around the edges of the northern meseta. Additionally, the Visigothic kingdom itself often seemed about to break up into a collection of local chiefdoms, and those semi-autonomous powers in turn found it increasingly difficult to make their authority good in the countryside about them. Then, in 711–20, this autonomous culture came to an end with the Umayyad conquest of Spain by an army of Arabs and North African Berbers led by Tariq and Musa ibn Nusayr. The way

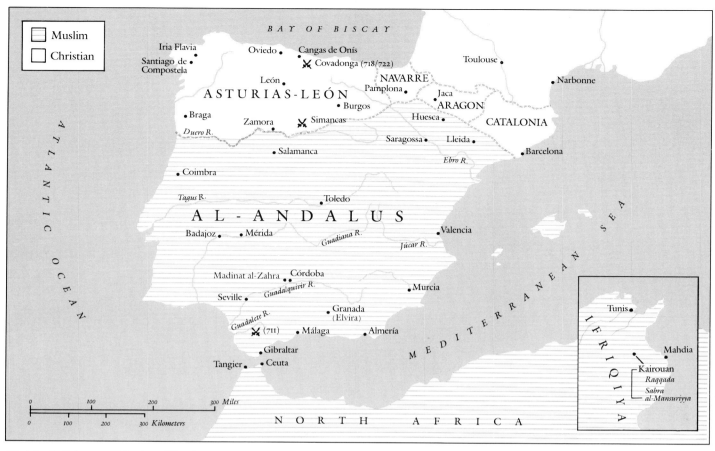

Córdoba Caliphate and Northern Kingdoms, A.D. 711–1031

Legend:
- ▨ Muslim
- ☐ Christian

for this brilliant achievement had been prepared in 698 by the Umayyad conquest of Carthage, the capital of the Byzantine province of North Africa, and the more or less simultaneous reduction of the power of the independent Berber peoples on that province's fringes.

Spain and the World of Islam

For the next three centuries, until the collapse of the caliphate at Córdoba in 1009, the dominant culture of Spain was Islamic. For the first fifty years the peninsula was a province of the Islamic empire, centered on Damascus in Syria, that stretched to the borders of India. But the arrival and ascent to power in Spain of 'Abd al-Rahman I (r. 756–88), survivor of the deposed Umayyad caliphs of Damascus, made the peninsula politically independent of his old rivals, the new Abbasid caliphs at Baghdad. Still, it was incorporated in the thriving Mediterranean economy of the Islamic world. Pious Hispanic Muslims made pilgrimages to Mecca and Medina and studied with the imams of Alexandria, Damascus, and Baghdad. The community of culture survived the demise of political unity.

Islamic Spain, or al-Andalus, was a complex society. The armies that overran the peninsula at the outset of the eighth century are thought to have numbered no more than fifty thousand men, after casualties perhaps 1 percent of the region's population of roughly four million. Islam allows multiple wives and these would have been taken from among the conquered; the wives and the children of these marriages would have become Muslims. It therefore seems reasonable to assume that the Muslim population would have quintupled from natural increase in the first generation. Allowing for a similar increase from conversion by those attracted by Islam's teaching and its successes, the number of Muslims in Spain may have been about four hundred thousand, or 10 percent of the population, by the end of the century. The number of Muslims probably increased more slowly during the caliphate at Córdoba, and it is likely that adherents to Islam never constituted a majority of the Iberian population. Even so, their political, religious, economic, and social predominance largely set the tone for Iberian life for some three hundred years and, to a more limited extent, for another two hundred and fifty years after that. They ended the long decline of peninsular society that had been endemic since the latter days of Roman control. In great part this reversal was accomplished through a reorganization of agriculture, for farming was the essential economic activity and the frame of life for at least 90 percent of the population. At the same time Islam revived the pan-Mediterranean economy, which had faltered so badly in late Roman times, and the inclusion of Islamic Spain in its orbit was a tonic for town life and internal trade. Finally the restoration

of a vigorous central government guaranteed the necessary minimum of peace essential to the recovery of both agriculture and trade.

Especially notable was the Islamic improvement and extension of irrigation, practiced since Roman times. The peninsula is on the whole a dry world with an average annual rainfall of about twenty inches. In classical times irrigation depended exclusively on gravity, which limited its use to particular areas. The Arabs introduced Middle Eastern innovations such as the noria (waterwheel) and *saqiya* (geared pot-chain) to raise water to greater heights and the *qanat* (underground canal) to distribute it. This technology greatly increased the area that could be cultivated and allowed, in many places, the utilization of the dry Mediterranean summer season to produce a second crop (in Roman times the summer had been a dead season for farming).

These changes were complemented by the introduction of new crops. A strain of "dry" wheat was better able to withstand the rigors of the climate and could be stored for long periods. Sorghum, originally an African crop, produced a cereal grain, and its cane was used for animal fodder and for thatched roofs. Other new food crops were rice, sugarcane, eggplant, spinach, watermelon, sweet oranges, limes, lemons, dates, and figs. Crops needing little water such as olives and grapes were cultivated over much larger areas than in classical times. Iberian wheat, olive oil, timber, and ores, in addition to dates, figs, and raisins, moved again in a trade world that reached not only to North Africa but also to distant Egypt and Syria.

The prosperity of al-Andalus also rested on its manufactures. The introduction of the cotton plant yielded much raw material for cloth, and the cultivation of flax for linen was greatly increased. The production of silk and the making of paper had begun before 1200. Toledo produced fine steel for weapons and tools, Córdoba became famous for leather goods and crystal wares, and Saragossa for linens. These products did travel to the peninsula's less-developed north and to the Near East, but the bulk of trade was with the North African coast, itself undergoing rapid development. Caravan routes across the Sahara brought ivory, slaves, and gold to the southern shore of the Mediterranean where they were exchanged for the more sophisticated Iberian wares.

The growing wealth of Spain was reflected in the restoration of gold coinage under the caliphs of Córdoba and in their maintenance of a fleet to protect their trade and coasts and a sizable army of slaves and mercenaries. But above all it was evident by 1000 in the revival and growth of cities such as Córdoba whose population had swelled to ninety thousand, Seville to fifty-two thousand, and Saragossa and Toledo to something like twenty-five thousand each. Al-Andalus was a world whose political, economic, and social life, unlike that of Visigothic or even late Roman Spain, was directed from and focused in its cities. At their capital, Córdoba, the Iberian caliphs entertained ambassadors from Tunisia, Egypt, Baghdad, from the emperor at Byzantium, and from the northern emperors at Aachen and Saxony.

The high culture of this world had Arabic for its vehicle, and until about 1000 it remained largely based on and subordinate to the Islamic civilization of the Near East. This basically religious civilization was founded in the study of the Koran and the traditions, or *hadith*, that supplemented the sacred book and a Malikite school of law that applied it. All of these were derived from the Near East. The mosques and the caliphal court were the centers of a learning whose religious core was increasingly surrounded by ancillary disciplines such as the study of Arabic grammar and of Greek mathematics, astronomy, medicine, and philosophy. The ancient Greek texts were known in Arabic translations made at Damascus in the eighth century and Baghdad in the ninth and tenth centuries. Greek science was supplemented by Persian astronomy and Hindu mathematics, again by way of translations made at Baghdad. All of these works were accompanied by commentaries, expositions, and corrections written by Muslim scholars in the East.

Alongside this erudite literature was the world of traditional Arabic poetry whose themes celebrated war, the hunt, nature, wine, and love. Both were practiced and developed by men of religion, professional men, and courtiers alike. At court they became a kind of playing field on which all contended for the royal favor. Outstanding profundity, versatility, or even cleverness could lead to substantial gifts, preferment to high office, and sometimes to great riches. These intellectual games first took place at the caliphal court and later in such great palaces as the Madinat al-Zahra' of the caliph 'Abd al-Rahman III (r. 912–61) and the Madinat al-Zahira of al-Mansur (r. 978–1002). Mature scholars did not scorn to participate, and even caliphs tried their hand at poetic composition. One of the latter, al-Hakam II (r. 961–76), was reputed to have assembled a library of some four hundred thousand volumes.

The mosque was the other center of learning for the dominant culture. That at Córdoba was constructed under 'Abd al-Rahman I (r. 756–88) and enlarged under 'Abd al-Rahman II (r. 822–52). Finally al-Hakam II modified it in the mid-tenth century to produce the structure that dazzles today's visitor. The Islamic use of stone, of tile, of columns and arches, and of ivory and gold tracery, under the influence of a different religious inspiration, resulted in buildings whose roots were in the Byzantine and Islamic Near East and which were without precedent in Spain.

Two subcultures—those of the *dhimmi*, or non-Muslim subject peoples, Christian and Jew—coexisted with the Islamic civilization in al-Andalus. Since Islam recognized the authenticity of the prior revelations of Judaism and Christianity, each was accorded legal existence under its own religious laws and leaders so long as the privileged position of the Muslim community was respected and special taxes paid. The Christians who lived under Islamic rule were called Mozarabs (from Ara-

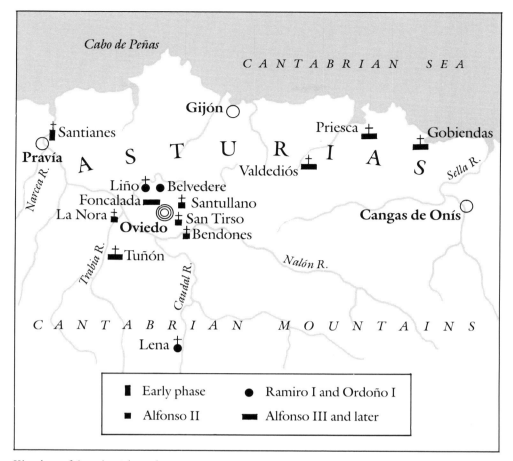

Kingdom of Asturias, 8th–10th century

bic *Musta rib,* "would-be Arab") because of their adoption of Islamic dress and customs. They were poorer and more rural than their Muslim neighbors and probably constituted the majority of the population of al-Andalus to the end of the caliphate. They retained their Latin Visigothic culture, especially in their liturgy and in their ecclesiastical architecture, both of which evolved from a Visigothic mode into a Mozarabic style. The centers of their learning were the bishop's church and the monastery. There Mozarabic divines and scholars continued to employ Latin in the creation of liturgical manuscripts and of copies of the works of the church fathers and of the classical Latin authors. They also utilized it for that continuous stream of learned commentaries upon these traditional materials that sustained their independent intellectual life. They produced as well a narrow range of original works of a generally religious nature. Their language had an influence among the Muslims who adopted some of the rhythms of their songs in Arabic poetry.

The Jews were a much smaller community, perhaps twenty-five thousand in the eighth century growing to perhaps sixty thousand by 1000. They were more affluent, urban, and educated than the Mozarabs. With family ties to the Near East and to northern Europe they moved through the Mediterranean world as merchants and sometimes as diplomats. Iberian caliphs employed them as physicians, administrators, and tax collectors, since the most educated Jews were fluent in vulgar Latin and in Arabic as well as Hebrew. Although the synagogue was the locus of their learned tradition, the caliphal court was open to them to some degree. The two cultures interpenetrated, and Jewish scholars wrote in Arabic and borrowed Arabic verse forms for Hebrew secular poetry. They participated with their Muslim counterparts in the study, discussion, and dissemination of classical and Near Eastern science and philosophy. The development of Arabic and Hebrew grammar as disciplines, in particular, went hand in hand.

The Christian Hegemony in Northern Spain

Al-Andalus was never coterminous with the Iberian Peninsula. As early as 719 the Christian leader Pelayo had defeated a small Muslim force at Covadonga in the Cantabrian Mountains and maintained his independence. Shortly thereafter a major revolt of the Berbers against their peninsular Arab masters led to a general Muslim withdrawal from Asturias, Galicia, and the Duero plains. The small Asturian kingdom gradually expanded into this area over the next three centuries, making its chief city at León from the time of Ordoño II (r. 910–25).

For the first century of its existence we know almost nothing about this realm sprung surprisingly from among the tribal peoples of the Cantabrians, never fully conquered by Roman,

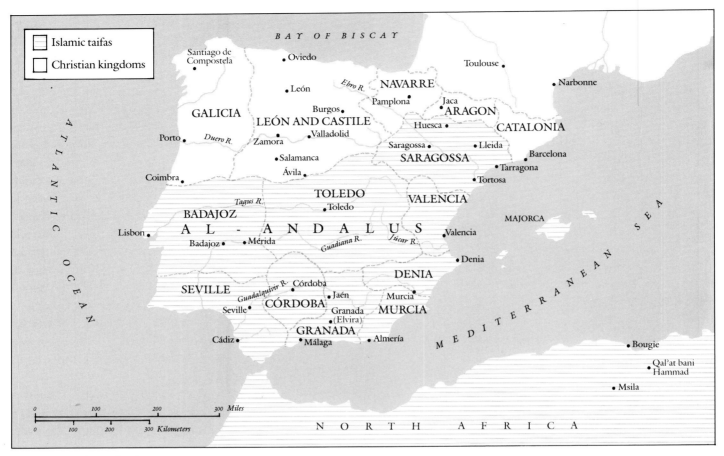

Taifas and Northern Kingdoms, A.D. 1063–65

Visigoth, or Muslim. When we begin to get a history in their own words about two centuries after Pelayo, they were already long Christian, used the Latin language, and had adopted Visigothic liturgical books and episcopal and monastic organization. They had a Christian apostolic shrine of Saint James the Great of considerable importance at Santiago de Compostela in Galicia. Perhaps most surprising of all, at least their clerical authors had begun to portray them as the political successors and heirs in the Iberian Peninsula of the Visigoths, whose inveterate opponents they had been before the appearance of the Muslims in the peninsula.

In 732 the ill-calculated incursions of Islam in the south of France had been repulsed at Poitiers by the rising Carolingian power. The Carolingians later reclaimed the Midi and Provence and under Charlemagne (r. 768–814) and Louis the Pious (r. 814–40) struck into Spain itself, wresting Girona, Barcelona, and briefly Pamplona from the Muslims. With Carolingian protection and patronage the native populations of the Pyrenean valleys gradually asserted their independence of Muslim and Frank alike within their diminutive territories. Out of these circumstances the Catalan counties and Aragon and Navarre were born. The Basque peoples to the west along the Bay of Biscay long remained stubbornly pagan and untrammeled, as Charlemagne discovered in his defeat at Roncesvalles.

During the great days of the caliphate at Córdoba, these poor and backward Christian realms maintained themselves with difficulty. After 1009, however, the caliphate disintegrated into a multitude of Islamic successor kingdoms, called *taifas*. The eastern *taifas* were Saragossa, Lleida, Tarragona, Valencia, and Murcia; in the center the great *taifas* of Toledo and Badajoz held sway; and in the south were those of Seville and Granada. Taking advantage of the weakening Islamic power, the northern Christians began the long series of advances to the south, traditionally called the Reconquista, or Reconquest.

The kingdom of Navarre took the lead under Sancho el Mayor (r. 1000–1035). Its glory was brief, however, and Navarre subsequently remained the smallest of the Iberian kingdoms, pinned against the Pyrenees by its larger Christian neighbors. Instead the old western kingdom of León, successor to that of Asturias, predominated under Sancho's son Ferdinand I (r. 1037–65) and grandson Alfonso VI (r. 1065–1109). These two kings forced the *taifas* to pay them substantial annual tributes in gold, called *parias*. Alfonso VI conquered the *taifa* of Toledo in 1085, thus bringing under the sway of León the whole of the Tagus basin of the central plain and the southern half of the Duero basin as well. The immense Christian realm that Alfonso created in the center of Spain overshadowed all the Islamic and Christian kingdoms and would thereafter largely control the political destinies of the peninsula.

The spectacular success of Alfonso invited an Islamic riposte. After the fall of Toledo the surviving *taifas* of al-Andalus appealed for help to the Murabit, a reformist and fundamentalist Islamic sect that had been constructing an empire among the Berber peoples in present-day Morocco and western Algeria during the two decades before 1085. Under their leader, Yusuf ibn Tashufin (d. 1106), the Murabit intervened and in 1086 scored a major victory over Alfonso VI at Zalaca, just north of Badajoz. Subsequently they themselves began to annex the Islamic *taifas,* beginning with Granada in 1099. Seville and Badajoz followed in quick succession. After the death of Rodrigo Díaz de Vivar (r. 1094–99), known as the Cid, the Murabit overran the *taifa* of Valencia which he had briefly converted into an independent principality. In 1110 they took the *taifa* of Saragossa in the northeast. Though they failed to reclaim Toledo, the Murabit restored a rough political equilibrium between Christian and Muslim in the peninsula. However, Islamic al-Andalus had been reduced to a series of provinces of a North African Berber empire. This dependence was rarely escaped over the next century and a half.

To the north, after the death of Alfonso VI in 1109, the kingdom of León was thrown into crisis by the succession of his daughter Urraca (r. 1109–26). These unsettled circumstances allowed the gradual evolution of the county of Portugal into an independent kingdom under his grandson Afonso I Enriques (r. 1128–85). During the same period a strong king of Aragon, Alfonso I (r. 1104–34), wrested the territories of the old *taifa* of Saragossa from the Murabit and thereby turned tiny Aragon into a Christian power second only to León.

The succession crisis in León ended with the accession of Urraca's son Alfonso VII (r. 1126–57), and that kingdom reasserted its predominance in Spain. In 1135 Alfonso had himself crowned *imperator* (emperor) in his royal city of León. Although the other Christian kingdoms of the peninsula admitted his suzerainty, he soon had to recognize the practical independence of Portugal and of Navarre. In addition, when Alfonso I of Aragon was killed without a direct heir in a battle with the Murabit in 1134, the emperor of León was unable to prevent the annexation by marriage of the now-swollen territories of Aragon by Ramón Berenguer IV (r. 1131–62) of Barcelona. This dynastic merger of the Catalan counties of the extreme northeast with an Aragon dominating the middle basin of the Ebro made the resulting kingdom of Aragon-Catalonia more than ever the premier rival to León among the Christian principalities of Spain.

The twelfth century also saw the decay of Murabit power in North Africa and in al-Andalus. In Africa the Muwahhid, another reformist and fundamentalist Islamic sect, arose in a rival Berber tribe. They attacked the Murabit as heretics, corrupted by the luxury and laxity of Islamic life in al-Andalus. By 1144 the newcomers were on the eve of complete success in North Africa. Algeria was falling into their hands, Morocco was soon to follow. North of the strait much of Islamic al-Andalus rose in revolt against all control by the now-detested and barbarian North African Berbers, whether Murabit or Muwahhid.

This conflict among the Muslims worked to the advantage of the Christian powers of Spain. Western Europe was then being summoned to a Second Crusade in the Near East, and Pope Eugene III was persuaded to declare Spain a permissible area of crusade. In 1146 Alfonso VII took the lead, forcing Córdoba to recognize his suzerainty and capturing Baeza and Ubeda in eastern Andalusia. In 1147, with the aid of contingents from Navarre, Aragon-Catalonia, and Montpellier and a fleet from Genoa, he took Almería, the major Mediterranean seaport of al-Andalus. That same year his cousin Afonso I Enriques of Portugal took Santarém on the lower Tagus and, with the help of a crusading fleet of Germans, Flemings, and English, captured Lisbon with its great Atlantic harbor. In 1148 Ramón Berenguer IV successfully attacked the port of Tarragona at the mouth of the Ebro with the aid of the Genoese fleet, with some elements of the crusading fleet that had come round from Lisbon and with other forces drawn from Montpellier and Toulouse. In 1149 Ramón also captured the formidable Islamic center of Lleida.

In Portugal the Muslims were driven south of the Tagus, in Aragon the entire lower basin of the Ebro was overrun, and in the center León appropriated the whole of the upper reaches of the Guadiana and Guadalquivir basins and the Mediterranean coast about Almería. But the new Muwahhid power in North Africa followed the path the Murabit had taken before them. In 1146 they sent a small army across the strait to hold the west of Andalusia while they busied themselves with overpowering Tunisia. That done, in 1156 they committed major forces to the peninsula, driving Alfonso VII out of Almería in 1157 and clearing the upper reaches of the Guadiana and the Guadalquivir of his forces.

As a result they restored an equilibrium between Islamic and Christian powers in Spain for the next fifty years. During that time al-Andalus gradually again became part of an African empire. Though the Muwahhid realm in the peninsula was never as extensive as that of the Murabit, by 1203 it reached from southern Portugal through Valencia to the Balearic Islands. In the center Alfonso VII had been forced back into the valley of the Tagus, and at his death in 1157 he divided his kingdom into a western one of León and an eastern one of Castile. These two kingdoms maintained a defensive posture for the next fifty years until the decisive Christian victory over the Muwahhid at Las Navas de Tolosa in 1212.

Land of Three Religions

This sway of battle back and forth failed to impede one of the richest cultural flowerings in Iberian history. Reduced largely to provincial status, al-Andalus conquered its conquerors. Its advanced agricultural practices flowed southward, enriching northwestern Africa, and its trade with that area increased.

The distinctive architecture of palace and mosque achieved in al-Andalus and a wide variety of more minor arts came to grace cities such as Marrakech, Fez, and Tlemcen. The literature and learning of Islamic Spain now enriched the court of a Murabit emir or a Muwahhid caliph. The cultural tutelage of the peninsula by North Africa, typical of the late Roman and Visigothic eras, was then exactly reversed.

Although the political history of the *taifa* kingdoms in the peninsula was a long train of disasters, their cultural development was brilliant. Nor was this luster noticeably diminished under the Murabit, although it began to fade during the Muwahhid period. In Arabic poetry *The Ring of the Dove* by Ibn Hazm (994–1064) is unsurpassed. In *Alive, Son of Awake* Ibn Tufayl (1105–1185) combined religious reflection with social observation in the most charming fashion. But certainly the outstanding figure by any reckoning was Ibn Rushd (1126–1198) of Córdoba, the polymath whose works on philosophy, religion, medicine, and astronomy were received in the medieval Christian West under his Latinized name of Averroës. At home Ibn Rushd's attempt to use the concepts and method of Aristotelian philosophy as a vehicle for the intellectual development of the religion of the Koran aroused the opposition of the Malikite judges, and he was exiled to Morocco by the Muwahhid caliph Abu Yusuf (r. 1184–99).

Despite sporadic persecution which gradually worsened, the Jewish community of al-Andalus participated fully in this cultural flowering. Solomon ben Judah ibn Gabirol (d. 1070), a Jewish theologian of Saragossa, composed love poetry of a high order in both Arabic and Hebrew and used Arabic lyrics in hymns for the synagogue itself. In his *Guide for the Perplexed* Moses Maimonides (1135–1204) of Córdoba attempted to develop an Aristotelian form of Judaism in the fashion of Ibn Rushd; like him, he died in exile, in Saladin's Egypt in Moses' case. Jewish thinkers, such as Judah Halevi (d. 1150) of Toledo, increasingly opposed an accommodation between Judaism and Islam or Christianity; synthesizing minds such as Maimonides' were less and less welcome. The cultural and scientific collaboration of Muslim and Jew suffered especially from the contraction of Islamic Spain, by which the Jews of Toledo, Saragossa, and Lisbon suddenly found themselves in a Christian world. Moreover, increasing numbers of Jews moved north into Christian territories in response to growing harshness of treatment or persecution by Islamic factions.

There they were in the midst of a society that was undergoing extraordinary transformation. While al-Andalus was contracting in area and population, the north was expanding. Probably from almost the outset of the Umayyad conquest itself, some Mozarabs had become refugees, leaving al-Andalus for the more congenial religious and social surroundings in the Christian north. This northward movement was particularly evident in the plain north of the Duero where it helped make León the greatest of the northern kingdoms. Its effects are visible in ecclesiastical architecture, where the older Visi-

gothic or Asturian style gave way to the newer Mozarabic style of, among many examples, San Miguel de Escalada near León and Santiago de Peñalba near Ponferrada in the Bierzo. The Mozarabic flavor is also evident in the manuscripts and their illuminations that the refugees brought with them; these texts —the works of the Latin church fathers, the Mass books of the Mozarabic liturgy, and the codices of the *Liber judiciorum* and the *Hispania*—gave intellectual substance to the rude north. At the same time the Mozarabs brought the improved agricultural practices of al-Andalus and so laid a basis for the rapid geographical and demographic expansion of northern Spain.

But by the middle of the eleventh century the Christian north was also feeling the impact of changes that were transforming the European West beyond the Pyrenees. Most immediately influential were the emergence of the Burgundian monastery of Cluny as the center of a new Benedictine order and the restructuring of the secular Christian church around the Roman papacy. Ferdinand I of León was a patron of the new Cluny, and his successors continued and extended the relationship. His son Alfonso VI, four of whose six wives were of French extraction, collaborated with the growing papal influence, even presiding over the substitution of the Roman liturgy for the indigenous Mozarabic one in his domains. At the same time in Catalonia, where a strong French influence had endured since Carolingian times, growing sea trade linked the area to maritime Italy. At the end of the eleventh century Genoese and Pisan fleets were operating sporadically off the Catalonian coast.

This growing network of political, economic, and religious ties was further expanded by the dramatic increase in popularity of the pilgrimage to Santiago de Compostela. Kings, prelates, knights, merchants, artisans, and ne'er-do-wells, Frenchmen, Germans, Englishmen, and Italians, they came into the peninsula in the thousands and then the tens of thousands. The first two archbishops of the reconquered primatial see of Toledo were French monks; Valencia had a French bishop in 1100, and Braga one in 1096, and Lisbon an English one in 1147.

More important because of their enduring institutional presence were the string of subordinate monasteries that Cluny established across the north from Catalonia to Galicia in the eleventh century. In the next century monasteries were founded by the crusading orders of Templars and Hospitallers as they sought a base, in Spain as elsewhere in Europe, for their operations in the Levant. The Cistercians, the monastic order of Cîteaux, added another strand to these webs slightly later in the twelfth century.

These transitions were evident in the replacement of the Mozarabic style of church building and art by the new Romanesque style. By 1076 this reached to the building of the new cathedral at Santiago de Compostela. Styles of church sculpture and of manuscript illumination were altered as well. In the area of high culture the triumph of the new Europeanizing tendency seemed almost complete, restricting the influence

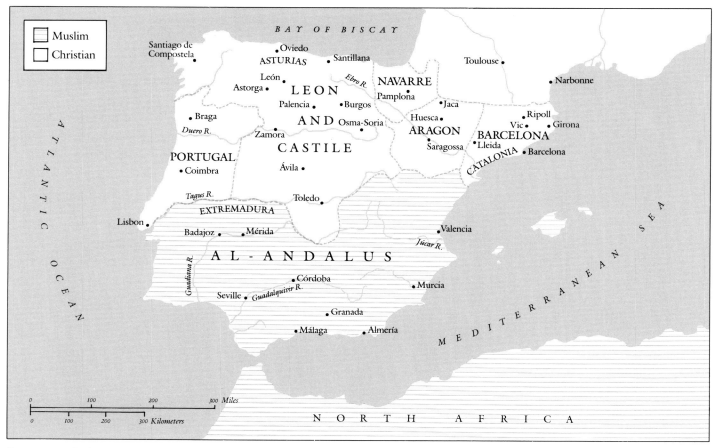

Romanesque Spain

of the Islamic south to the realms of the vocabularies of the emerging vernaculars, to agricultural practices, to commercial usages, and to some of the minor arts such as weaving and decorative carving of small pieces.

Yet while Christian Spain was being drawn increasingly into the orbit of western Europe, the older habit of collaboration with the Islamic south had one more remarkable flowering. The intellectual richness of the peninsula was to attract western scholars from beyond the Pyrenees. During the twelfth century and into the early thirteenth, they came to Toledo above all, to Barcelona, and to Tudela and other places to study and to translate the works of the ancient classical world from Arabic into Latin. Most of the philosophy of Aristotle, the medical and astronomical works of Galen and Ptolemy, and the geometry of Euclid found their way into the blossoming cathedral schools and universities through the work of such men as Gerard of Cremona, Plato of Tivoli, and Adelard of Bath. At mid-century even the Koran itself, along with brief

accounts of Muhammad's life and doctrine, was translated under the patronage of Abbot Peter the Venerable of Cluny. Such translators drew on the linguistic abilities of the Muslim and Jewish scholars of the peninsula and also appropriated the works of Averroës and Maimonides, not to mention the new mathematics of Islam and its Hindu notation, henceforth to be styled "Arabic" numerals.

Virtually all of the intellectual sophistication of al-Andalus was thus made available to western Europe at the very moment when that complex of communities responsible for it was verging on dissolution. The new and more "European" Christian Spain would continue to incorporate Islamic and Jewish communities and elements but in different proportions and inevitably with less distinctive contributions. The older heritage would survive but now the newer fashions, styles, and ideas blended into it more often came from France and Italy than from al-Andalus and the Near East.

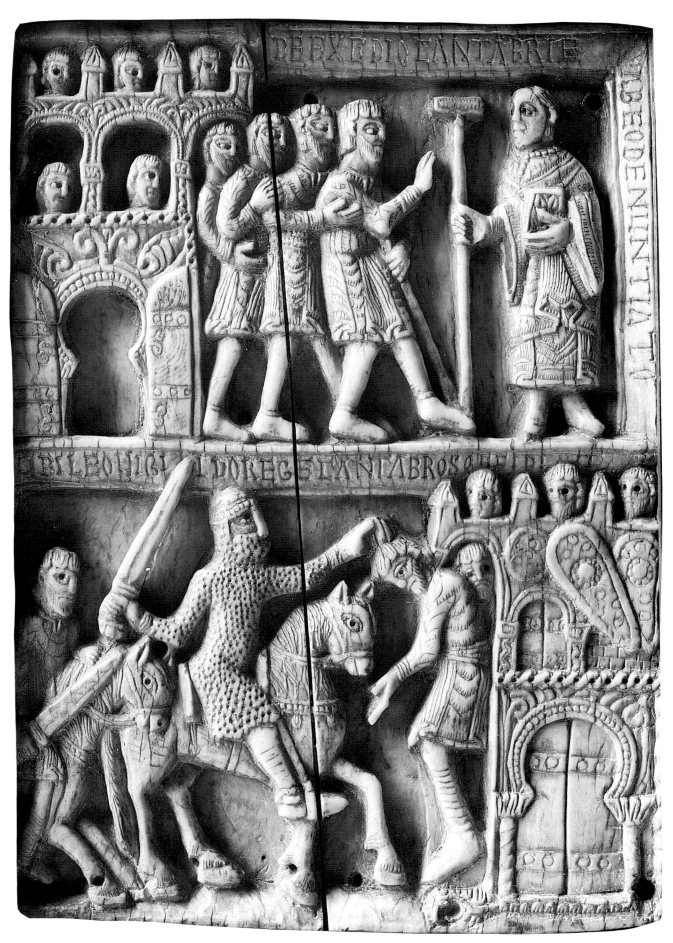

Ivory plaque from the reliquary of Saint Aemilian (cat. 125). San Millán de la Cogolla (Logroño). The lower register depicts Leovigild's campaign against the Suevi. Photo: Photo Zodiaque

orientations: christian spain and the art of its neighbors

JOHN W. WILLIAMS

he Visigoths, the Germanic people who presided over a distinctive artistic culture in Spain, began to take control of the Iberian Peninsula in the mid-fifth century. This was one of the movements that signaled the final collapse of the Roman Empire in the West. As part of that empire, Spain had shared in the artistic ecumenism of the Mediterranean littoral during Rome's hegemony. The buildings and the sculpture and mosaics which adorned Iberian urban centers and villas were scarcely distinguishable in vocabulary and technique from those elsewhere in the empire. With the introduction of Christianity Rome's cultural dominance may have lost momentum, but the capital still provided the material trappings of the cult in the peninsula in its initial stages. Fourth-century sarcophagi are among the earliest witnesses to the peninsula's conversion to the new faith. Those from the first half of the century were imported, usually from Rome. By the end of the century, however, the empire's collapse was marked by major changes in the production of sarcophagi and in the models used. The carving was taken over by local workshops; the models for both style and iconography still originated outside the peninsula, but in centers in North Africa and the Christian East rather than Rome.[1] This reorientation, compounded by the culture imported with the Muslim conquest in 711, meant that the peninsula's artistic language would for centuries be dominated by an oriental character absent from that of its European neighbors. Although there were sporadic contacts with Rome in the late sixth and seventh century, Rome was not the galvanizing center of authority it would be in later centuries even after the conversion in Recared's time (589) to orthodoxy from Arianism, the version of Christianity the Visigoths brought with them from the East. Symptomatic of Rome's marginal role was the fact that two years passed before Pope Gregory the Great learned of this momentous event. The shift away from Roman models and the use of local workshops are seen in the Alcaudete sarcophagus (cat. 2), with its oriental iconographies, and the sarcophagus of Ithacius (cat. 1), an eclectic mixture of late antique patterns associated with the East.

With the fall of Rome, Constantinople became the model for display of political power. Such emulation made no sense, of course, until a Spanish state of sufficient unity and stability had been created. Political unity was achieved under Leovigild (r. 569–86), who had the military strength and will to control the center of the peninsula and to subdue the Suevi of the northwest. The latter campaign was commemorated centuries later in one of the ivory plaques illustrating the life of the sixth-century hermit Saint Aemilian. Leovigild's son and successor, Recared (r. 586–601), provided a crucial stabilizing force when he made orthodox non-Arian Christianity the faith of the leadership of the state, a change allowing the church to be a full partner in the pull toward social cohesion.

Elements were borrowed from the monumental and ceremonial language of the Roman-Byzantine Empire to express the kingdom's identity and authority. Thus in 578 Leovigild founded a city, Recópolis, naming it after his son Recared. Of greater import were Athanagild's choice of Toledo (554) as his principal residence and the city's conversion into *urbs regia*, the royal city, a stage for the pomp and rituals which symbolized supreme authority and were modeled after the ceremonial language of Constantinople.[2] Signs of royal power of the kind associated with Roman and Byzantine emperors multiplied.[3] Unlike his predecessors, who, as Isidore of Seville remarked in his *History of the Goths*, were content to sit and dress in the manner of their subjects, Leovigild sat on a throne in ceremonial robes.[4] In another break with the past Leovigild minted coins that did not merely replicate Roman and Byzantine types but carried his own name and those of his sons. Eventually the ceremony of accession to the throne included anointing.[5]

The Visigothic metalwork which survives from before the seventh century consists of fibulae and other articles of personal adornment or use (cat. 14–22). The literature of the Muslims, the conquerors of the Visigothic kingdom, is filled, however, with references to immense treasures of luxury items said to have been encountered by the invaders; among the works described is a golden, pearl-bedecked "Tablets of Moses" which some have sought to trace to the treasure taken to Rome by the emperor Titus after the sack of Jerusalem in 70.[6] Some of these accounts are legendary; for example, the conquerors are said to have found in the "Mansion of the Monarchs" in

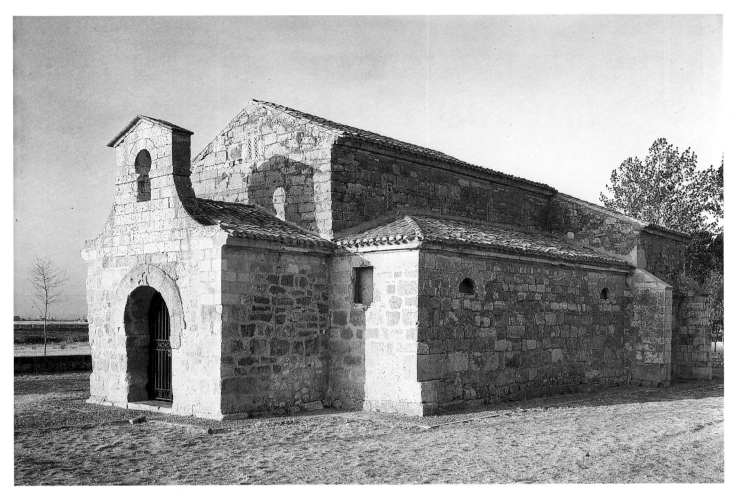

San Juan de Baños (Palencia). Photo: Archivo Fotográfico Oronoz

Toledo twenty-four crowns of gold, one for each of the Visigothic rulers. The reality of Visigothic goldwork was revealed by the discovery of a hoard presumably hidden at the time of the invasion near the capital at Guarrazar (cat. 12). This treasure confirms that the Visigothic rulers shared the Roman imperial custom of offering votive crowns and crosses to favored sanctuaries. Iconographically and technically these works belong to a late antique imperial tradition.

Visigothic Toledo was greatly changed by its service as an important Islamic subcapital for nearly four hundred years and by the erosion of centuries of development after its recovery by Christian forces in 1085. The structures of Visigothic Toledo must be experienced principally through literary allusions to buildings;[7] sculpture can be appreciated from the considerable number of fragments in the walls of buildings subsequently erected.[8] Mérida provides better evidence of Visigothic carving. This Estremaduran city had been the capital of the Roman province of Lusitania, and it remained a wealthy urban center under the Visigoths. Indeed there is reason to think that at least in the sixth century Mérida was a more important artistic center than Toledo. The pier from Mérida (cat. 4) offers striking evidence of the high level of its art in the latter

part of the sixth century, a prosperous period which is well recorded in *The Lives of the Fathers of Mérida,* written in the 630s.[9] Building and rebuilding, processions and a rich ceremonial life are the backdrop of the *Lives.* Mérida's commerce with the eastern Mediterranean and its resulting wealth allowed such developments. The cult of Saint Eulalia, an early local martyr, formed a centerpiece, and its focus, the martyrial basilica dedicated to Eulalia, was rebuilt by Bishop Fidelis (about 560–about 570). Like his predecessor, Paul, Fidelis was a Greek. He had arrived in Mérida as a youthful crew member of a Byzantine trading vessel. Although the Byzantine origin of these two bishops is in itself no direct explanation for artistic orientation, the Byzantine East offers the best counterparts for the design and decoration for the pillars found in Mérida and for the chancel screens and other reliefs (cat. 3) associated with Mérida. It is in fact the art of the areas outside the coastal region actually occupied by the Byzantines from 554 to 624 that most clearly signals a link with the Byzantine world.

The Byzantine or Eastern models often cited in explanation of the shape of Visigothic architecture are less easily discovered. The only counterpart in the western Christian world of the carefully aligned, mortarless ashlar masonry that distinguishes

a group of late Visigothic churches[10] is the mausoleum of Theodoric in Ravenna, whose builders seem to have included masons from Syria. The salient development in the evolution of Hispanic architecture after the sixth century was the abandonment of the basilican form in favor of buildings with boxed-in spatial cells that did not need columnar supports. This change also occurred in the Byzantine world, but it happened earlier in the peninsula.[11] It must be kept in mind, however, that knowledge of Visigothic building is based on provincial churches and is therefore not representative. No churches or church plans have survived from the great southern metropolitan centers of Baetica, the most Romanized province of the peninsula, or from the capital, Toledo. The remaining group of cruciform churches, which tends to shape our idea of Visigothic architecture, may offer a distorted view. Two extant churches with direct royal sponsorship—the basilica at Recópolis, the city founded by Leovigild, and San Juan de Baños, erected by kings Chindaswinth and Receswinth in 651 in the region of the royal villa of Gérticos[12]—employ a basilican scheme, and recent excavations of the church of Santa Eulalia in Mérida indicate a basilican plan with rounded apses.[13] The high quality of the art of an important city of the civilized southern zone is seen in the chancel screen of the cathedral of San Vicente, whose site was appropriated for the Great Mosque of Córdoba, and in the numerous Visigothic capitals used in the mosque (cat. 8). Works from major urban centers were remarkable for their technical sophistication. Although peninsular monuments employ a distinctive dialect, the artistic language of the Visigothic church furniture was invented in the eastern Christian, Byzantine world.

Although the artistic culture of North Africa is too poorly preserved to be certain, Eastern elements in peninsular art may have often been channeled through Africa (as the style and iconography of sarcophagi had previously been). A small group of early Spanish churches employs a special arrangement of basilical space that suggests contacts with North Africa. In these the apse with the altar is faced by a second apse at the opposite end of the nave.[14] Double apses of this sort are seen in surviving North African basilicas.

Intercourse with Africa was, of course, easy. Some seventy monks led by Abbot Donatus fled the dangers of Africa sometime in the 560s and established a monastery at Servitanum, a site probably near Valencia on the eastern side of the peninsula. The account of this migration, written by the Toledan bishop Ildefonsus (d. 667), notes that they carried with them a substantial library.[15] Almost no manuscript illuminations from the Visigothic period remain. However, Isidore of Seville had verses and portraits of authors painted on his library's walls to guide the reader through his collection; this practice testifies to the collection's diversity and to an association of imagery and book.[16] Bibles had the place of honor. The existence of richly illuminated Bibles in Visigothic Spain is indirectly confirmed by the Bible of La Cava dei Tirreni (cat. 75). In

La Cava Bible (cat. 75). Opening of the Book of Job. Biblioteca della Badia, La Cava dei Tirreni. Photo: John W. Williams

addition the Bible of San Isidoro de León (cat. 108), whose lengthy series of Old Testament scenes are valuable witnesses to the early history of Bible illustration, must have been based on a Visigothic exemplar of the fifth or sixth century.

The evangelist symbols on a seventh-century capital from Córdoba (cat. 8) also imply the existence of book illumination, for examples of this iconography are found principally in manuscripts.

The capital is virtually the only example of Visigothic figurative sculpture from the south, and the erasure of the faces is the more to be regretted because it prevents comparison of countenances with those in the reliefs of Christ (cat. 7) and of an apostle from Quintanilla de las Viñas. Although the reliefs of the Córdoba capital and of Quintanilla de las Viñas share the tendency, in comparison to the art of the antique world, to flatten masses and to simplify designs, the Quintanilla reliefs have advanced much further in this direction. The Quintanilla reliefs are also remarkable in their distribution of figural sculpture over architectonic settings, a characteristic also seen in the apostles and biblical episodes on the capitals and bases of the seventh-century church of San Pedro de la Nave. Healing miracles, scenes inspired by an early Christian ivory book cover or diptych, are carved in relief on a pier in the

Capital showing Daniel in the Lions' Den. San Pedro de la Nave (Zamora). Photo: Archivo Fotográfico Oronoz

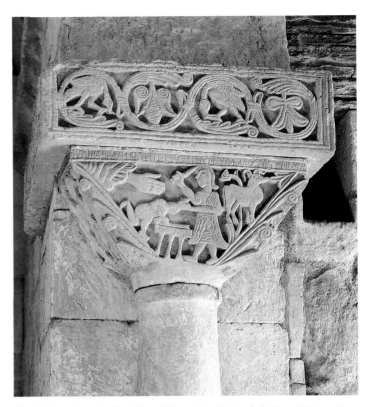

Capital showing the Sacrifice of Isaac. San Pedro de la Nave (Zamora). Photo: Archivo Fotográfico Oronoz

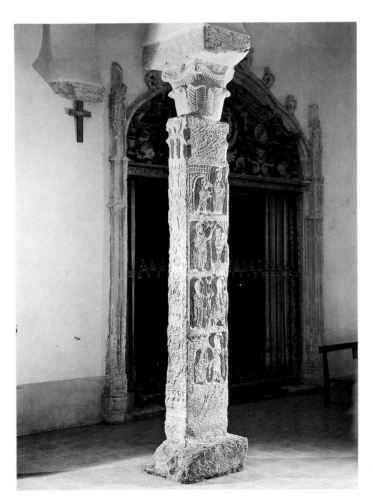

Visigothic pier with scenes from the life of Christ. San Salvador, Toledo. Photo: Archivo Fotográfico Oronoz

Visigothic church of San Salvador in Toledo. All these examples reveal a tendency to introduce figural sculpture to areas not devoted to it at this time in other parts of the western Christian world. Earlier scholarship, seeking to place such a proliferation of architectonic sculpture in the Romanesque period, found it difficult to accept a Visigothic date for the churches of Quintanilla and San Pedro de la Nave.

Iconoclasm was implied in canon thirty-six of the Council of Granada (Elvira) at the beginning of the fourth century—"There should be no paintings, so that which is adored and reverenced may not be painted on the walls."[17] The innovative use of imagery at Quintanilla and San Pedro de la Nave indicates that the stricture had been directed against pagan practices or had, for whatever reason, expired.

The almost complete ignorance of the art of Isidore's Seville and the other metropolitan centers of southern Spain is not due just to the passage of time, but to the occupation after 711 of most of the peninsula by peoples of the Islamic faith. Even if propaganda and literary convention shaped the statement in the *Mozarabic Chronicle of 754* that the invading armies "ruined beautiful cities, burning them with fire,"[18] evidence of the occupiers' destruction is provided by the early Christian sarcophagi from the northern and southern zones of the peninsula. Those surviving in the north are more numerous and have been continuously on view; those of the south, except for fragments, were turned up in modern excavations.[19] To be sure, the positive consequences of the occupation were legion. For the next three centuries the Islamic

capital of Córdoba sustained one of the most brilliant artistic cultures of medieval Europe.[20]

The fugitives who found sanctuary in the narrow free zone behind the Cantabrian Mountains settled in the area of the peninsula least touched by the Mediterranean culture of the Roman Empire.[21] The first seventy-five years of the eighth century must have been a time of recuperation, but with the reign of Silo (774–83) it is possible to speak from material remains as well as literature of a capital and a royally sponsored if not palatine church of Santianes at Pravia, near the ancient Roman provincial capital of Flavionavia, not far from the Cantabrian coast. One of those present when Silo's widow took her conventual vows after the king's death was Beatus of Liébana, the abbot of the Asturian monastery of Saint Martin. His greatest contemporary fame came from his championing of orthodoxy in that debate over the nature of the Godhead known as adoptionism. A decade earlier, however, he had compiled his Commentary on the Apocalypse. He employed the writings of the Fathers of the Church for his treatise. Jerome, Augustine, Gregory, and Isidore contributed but the model for his text's shape and content and for its embellishment with some seventy illustrations was a copy of the fourth-century Commentary on the Apocalypse by Tyconius, a North African writer

much admired by Augustine (this work may have been among the books brought in the sixth century by the North African monks mentioned above).[22] From the rich library behind Beatus's work, it seems likely he was himself a refugee who had managed to bring north a considerable collection of books from some cosmopolitan center now dominated by the invader. The Beatus Commentary inspired dozens of medieval copies which make up one of the most brilliant chapters in the history of manuscript art (cats. 79–81, 143, 145, 147, 153, 154).

It would be only natural that the cultural legacy of Visigothic Spain would have been the foundation for the reduced kingdom of Christian Spain. It is therefore surprising that surviving Asturian monuments, relatively numerous, seem by their formal character to deny a connection with the Visigothic past. Both their masonry—rows of small roughly carved stones joined by mortar and superficially covered by plaster—and their use of brick rather than stone for the archivolts of arches, a technique favoring the round arch, differ sharply from the ashlar masonry and horseshoe arches of standard Visigothic style. Further, the church plan favored in the Asturian era, basilican with a tripartite block of squared apses, contrasts with the cruciform plan typically identified with the Visigothic kingdom. Discussions of the failure of Asturian art to follow

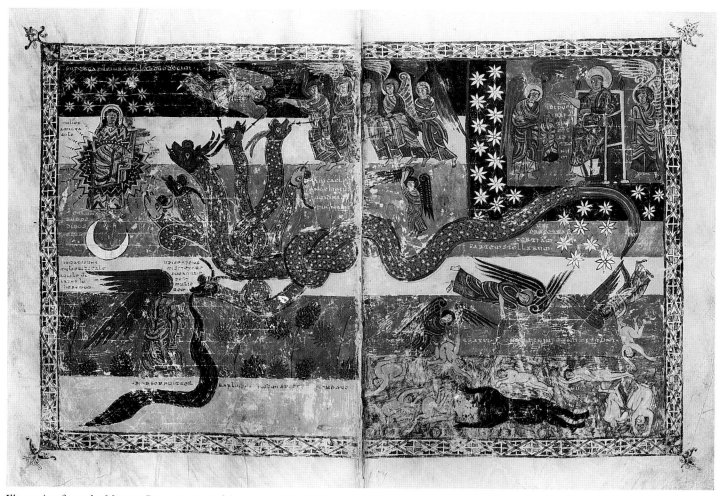

Illustration from the Morgan Beatus (cat. 78; fols. 152v–153). Left: Woman Clothed in the Sun with the Dragon; right: Satan and the Damned. The Pierpont Morgan Library, New York

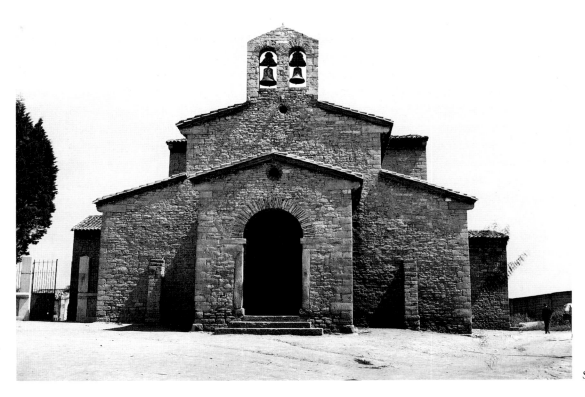

Santullano, Oviedo. Photo: MAS

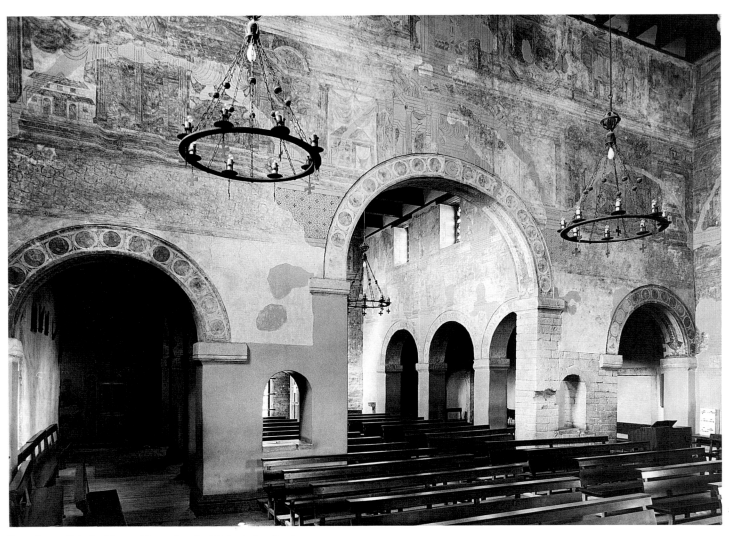

Santullano, Oviedo. Photo: Deutsches Archäologisches Institut

the increasingly uniform style of the final Visigothic century have not produced a consensus. Without traces of a prior local tradition that determined a path distinct from that followed farther south, we are left with an explanation centered on extrapeninsular forces or with one based on the assumption that Visigothic style has been too narrowly perceived.

The influence commonly cited by those who argue for extrapeninsular models is that of the Carolingian kingdom north of the Pyrenees. This estimation has recently been presented in a forceful and refined argument that recognizes a strong residue of Hispanic custom and holds that Carolingian borrowings were selective and not the result of the arrival of Frankish masons and a wholesale transplant of an alien style.[23] Certain it is that Charlemagne and his advisers had a continuing interest in Spain after their unsuccessful campaign against Saragossa. Adoptionism, the aberrant Hispanic view of the Godhead, issued from Toledo in the last two decades of the ninth century and sparked the opposition of a series of Carolingian councils. Evidence of other kinds links the Asturian and Carolingian worlds. Spoils taken from Muslims were dispatched north by Alfonso II (r. 791–842), the ruler who established the Asturian capital at Oviedo in the last decade of the eighth century. In his biography of Charlemagne, Einhard termed Alfonso "the [Carolingian] king's own man." Alfonso's suburban palatine basilica of San Julián de los Prados, popularly known as Santullano—with its soaring unencumbered transept and a set of murals which, if found in a church within Charlemagne's realm, would be the paradigmatic image of what is meant by the "Carolingian Renaissance"—is at the heart of the discussion of Carolingian influence on Alfonso's capital. Santullano's sources remain an open question.

The argument that Asturian art developed in its own way out of Visigothic traditions seems to be confirmed by an Asturian chronicle which states that when Alfonso II built a palace, churches, baths, and other buildings at Oviedo, he had "adorned them with arches and marble columns, of gold and silver, and as in the royal palace decorated them with various pictures." Moreover, "he thoroughly restored in Oviedo, in church and palace alike, all of the ceremony of the Goths, as it had been in Toledo."[24] Alfonso II did indeed, as we know from the surviving paintings in Santullano, decorate his buildings with frescoes. The chronicle, however, confirms less than it seems, for it was written in 881, in the reign of Alfonso III (866–910), and perhaps imposes a later rationale on the previous era.[25] Whether or not there was a set of frescoes resembling those of Santullano in a church or palace in Toledo, the Santullano focus on the cross accords well with the emphasis given the cross in Toledan ceremony before the conquest.[26] Following an elaborate liturgy staged in the basilica of Saints Peter and Paul, the troops of the Visigothic kings, like their imperial counterparts in the East, went into battle behind a golden reliquary cross that was their standard (this may conceivably have been the cross reliquary that Gregory the Great

sent to Recared upon learning of the conversion of the Goths from Arianism to orthodoxy in 589).[27] Devotion to the cross continued in the north after the Islamic invasion. In 737 Fáfila dedicated the first documented Asturian church to the holy cross, and Alfonso II and his successors commissioned a series of large gold crosses. The first of these was the Cross of the Angels (cat. 72) whose arms tapered inward to a medallion, a formula that has its best analogue in the eighth-century North Italian Cross of Desiderius in Brescia, a work probably based upon a Byzantine prototype. The Cross of the Angels was depicted in the frontispieces of many tenth-century manuscripts.

If we cannot finally confirm the sources of the paintings of Santullano, capitals within the church's sanctuary are actual Visigothic spolia. Their translation was intended in all likelihood to reinforce the sense of legitimate succession.[28] In its format and ornament the La Cava Bible (cat. 75) also represents a reprise of past formulas that must have been found in a Visigothic model. With its technical brilliance and archaic formal language, the La Cava Bible is in a sense a counterpart to the frescoes of Santullano. There is nothing in the rest of Asturian art to suggest such a survival of the formal language of the early Christian world.

It is hard then to imagine that in the era of Alfonso II Toledo would not be a natural model, if not the only one, for a new Christian capital in a peninsula whose original center had been conquered.[29] The cults chosen by Alfonso for the royal city had strong Visigothic, more especially Toledan, connections. Saint Leocadia, whose relics were installed in the palatine chapel (Cámara Santa) attached to the palace, was the patroness of Visigothic Toledo. Her basilica, built in 618 under Cixila, had been the site of four Toledan councils, the assemblies that effectively acted as the legislature of the kingdom. Similarly the titular saints of Santullano, the Egyptian Julian and Basilisa, were the objects of a Toledan cult celebrated with a hymn composed, appropriately enough, by the learned bishop Julian of Toledo (d. 690). Alfonso also erected a church to Saint Tirsus in front of his cathedral. The account of Tirsus's life had been an inspiration for the greatest of all of the Visigothic cult figures, Saint Eulalia of Mérida.[30]

About 800 only one city rivaled Toledo as a model for an Asturian capital: Constantinople, the great city that had vivified Toledo's earlier effort to register as a true capital. Julian and Tirsus, saints important to the Visigothic church, were eastern martyrs with important shrines in Constantinople. When Alfonso II installed twelve altars dedicated to the twelve apostles in his new cathedral, he must have been inspired by the church of the Holy Apostles that Constantine erected as his cemetery church in his new capital at Constantinople. An annex to Alfonso's cathedral, the church of Saint Mary, served as the king's and his successors' pantheon. The Santullano frescoes are evocative of late antique schemes of decoration in such eastern sites as Salonika and Damascus, the chance survivors of what must have been a widespread phenomenon in court

settings, and therefore may be another effort to employ an "imperial" language.[31]

The original imperial capital of Rome, as well as such successors as Ravenna and Pavia, offered even more accessible associations and a conduit for Constantinopolitan models. The dedication of the cathedral of Oviedo to Christ the Savior (San Salvador) evokes the Lateran basilica, the cathedral of Rome founded by Constantine. It was in the Roman Constantinian basilicas of Saint Peter and of Saint Paul that the transept was born and reached its apogee. The "innovative" stucco window screens of Santullano have their counterpart in the earlier Roman churches of Santa Sabina and Santa Prassede, and the "new" idea of imposing blind arcades on apsidal walls in Spain had a long history in Italy at such sites as Ravenna.

In the early ninth century Charlemagne himself also looked south to the imperial capitals as his own palatine complex at Aachen took shape. Aachen was not a capital in the same sense as Oviedo, which combined a permanent royal residence and a see.[32] With the passage of time, however, Charlemagne assumed for medieval culture the roles of ideal ruler, warrior, and, after 1165, saint. Merely by being his chosen seat, Aachen came to have extraordinary importance in historical consciousness. It would be anachronistic to assume such a vision of Aachen had been formulated in Alfonso's own era.

Oviedo yielded its role as capital to León as military successes shifted the center of gravity of Asturias farther south. As legends heroicized Charlemagne, Alfonso II was made to share, even in Oviedo itself, responsibility with the Frankish ruler for the status of his capital. Thus when Pelayo of Oviedo (bishop 1098–1129) composed the acts of a fictitious ninth-century church council in order to justify his claim for metropolitan status, he made Charlemagne responsible for its convocation and stated that Charlemagne's counselor Bishop Theodulf of Orléans had presided over it.[33] The ultimate attempt to exalt Charlemagne at the expense of Alfonso occurred about the same time in a widely circulated fictional account, purportedly written by Bishop Turpin of Reims. In this telling Charlemagne, alerted in a dream by the apostle himself, finds the tomb of Saint James at Compostela and begins the spectacularly successful tradition of international pilgrimage to the shrine there. In fact it was in Alfonso II's realm and in his reign that James's tomb was discovered, and it was Alfonso who built its first shrine. The discovery was surely an event calculated to further the cause of Asturian authority vis-à-vis the ancient ecclesiastical capital of Toledo and the Roman hierarchy and the Carolingians. It is difficult to divorce this strategy from Alfonso's court. Alfonso would have known Beatus, whose Commentary on the Apocalypse spread the news that Saint James had evangelized Spain.

As it had been in previous centuries, the cultural orientation of the peninsula was essentially Mediterranean as Asturian art took shape. When this distinctive chapter in Spanish art closed, a fundamental alteration had taken place. The architecture of Alfonso III had begun to include elements, such as stepped crenellations and the *alfiz* (rectangular enframement of arches), seen earlier on buildings in the Islamic capital of Córdoba. However, the cultural maturity of the Germanic, Frankish, and Anglo-Saxon kingdoms eventually imposed a vertical axis of orientation over the horizontal Mediterranean axis bequeathed by the ancient world. Asturian art of the latter part of the ninth century and the early tenth already signals this shift. The Caja de las Agatas (cat. 71) of the Cámara Santa, a gift to the cathedral from Alfonso's son and his wife, proudly displays on its crest an enamel plaque from the north. For his great Cross of Victory Alfonso III abandoned the formula established exactly a century earlier by Alfonso II in his Cross of the Angels (cat. 72). The latter's tapering arms and central disk had been imitated in 874 by Alfonso III himself for the cross, now lost, he gave to the shrine of Saint James at Compostela. However, the Cross of Victory has straight arms terminating in lobes, a design paralleled by an East Frankish work of the second quarter of the ninth century, the Cross of Ardennes in Nuremberg.[34] The vine-scroll pattern on its back has been compared to rinceau patterns produced by the scriptorium of Tours.

Connections with Tours had momentous consequences for the art of the book in León in the tenth century. In 906 Alfonso III had corresponded with the great abbey of Tours about purchasing an "imperial crown" in its possession. Whether then or earlier or later, illuminated manuscripts from the monastic writing shops of Tours found their way to the peninsula. Such examples revolutionized the peninsular concept of the illustrated book. This change was most apparent in the revised format that favored framed full-page pictures (rather than unframed column-wide pictures) in copies of Beatus's Commentary on the Apocalypse.[35] The first extant example of this new style was the copy of the Commentary made toward the middle of the tenth century for the monastery of San Miguel de Escalada (cat. 78). At the same time the tradition of small initials employing an ancient vocabulary of vine scrolls, fish, and birds gave way to initials that could be as tall as a page (cat. 84) and that used interlace patterns invented earlier in the Carolingian schools of the north.

In the illumination of these tenth-century manuscripts, the Carolingian Frankish world had its greatest impact on Spanish art, despite the span of more than a century between the creation of the Carolingian models and of their peninsular offspring. In spite of the catalytic effect of northern Christian book traditions, the Spanish manuscripts of the tenth century and the monastic churches for which they were produced represent Spanish art at one of its most creative and independent moments.

In recognition of details reflecting the Islamic art and architecture of al-Andalus, the art of the tenth century is customarily termed "Mozarabic," thus attributing the new style to the Mozarabs, those Christians raised in territories under Islamic

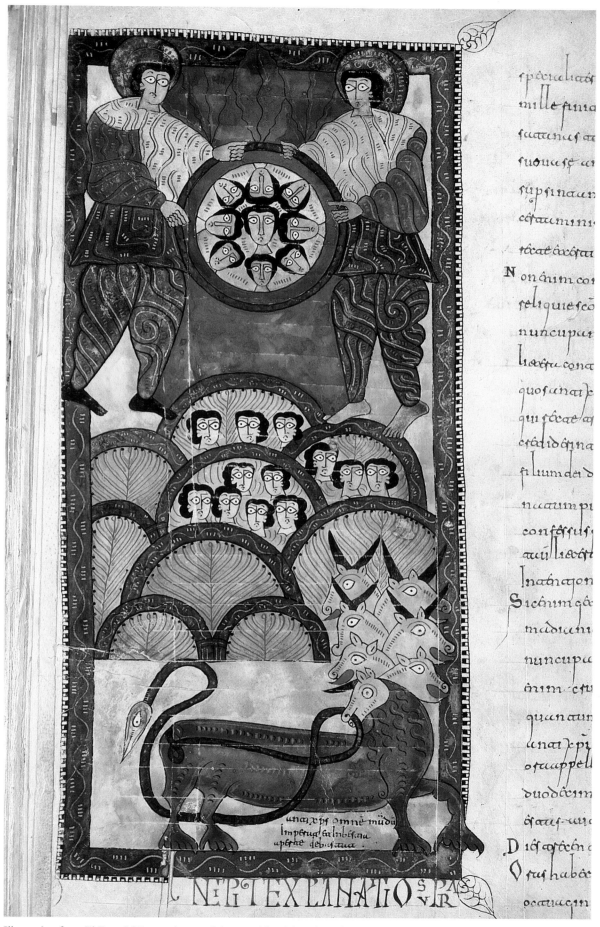

Illustration from El Escorial Beatus (cat. 81; fol. 108v). The Adoration of the Seven-Headed Beast. Patrimonio Nacional, Biblioteca del Monasterio de San Lorenzo el Real de El Escorial. Photo: John W. Williams

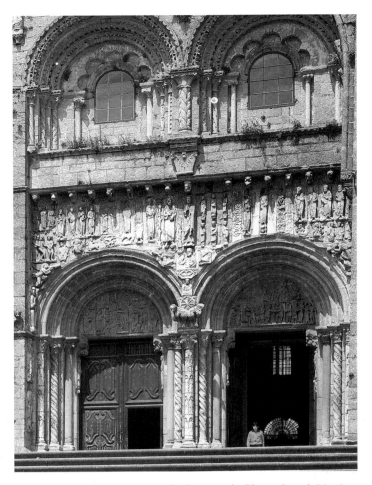

Puerta de las Platerías, Santiago de Compostela. Photo: Joseph Martin

international character of the Romanesque style that emerged in the peninsula was fundamental to it. Although the use of the term "international" for a time when nationhood had a different definition is problematic, the recognition that styles, techniques, and artists traveled beyond boundaries that are now accepted as national is not.

The Italian sources drawn on in Catalonia determined that its monuments would differ from those of the peninsular kingdoms farther west. Italian rather than Touronian inspiration fed the scriptorium of Ripoll and made possible the most densely illustrated Bibles surviving from the first millennium (cat. 157). Catalonia also produced a distinctive, precocious school of Romanesque architecture based ultimately on Italian antecedents. The Italian contribution to Spanish Romanesque art would continue in the twelfth century in the work of the Cabestany Master (cat. 161b).

Contacts with the Frankish world accelerated from the opening of the eleventh century under Sancho III of Aragon-Navarre (r. 1000–1035). Artistically, however, the significance of this European orientation became clear only under the rule of his son Ferdinand, who inherited from his father the county, later the kingdom, of Castile. Ferdinand's marriage in 1032 to Sancha, heir to the Leonese throne, allowed him to raise himself above his fellow monarchs politically and artistically (see my essay "León and the Beginnings of the Spanish Romanesque" in this volume). Under the Leonese rulers the isolation encour-

domination. Since, with the exception of a Bible illuminated in the region of Seville (cat. 85), the works called "Mozarabic" were actually produced in centers in the Christian north, the label can be misleading. Nevertheless elements taken from the architectural, ornamental, and even iconographic vocabulary of Andalusia are present in northern buildings and in those manuscripts that exhibited the widest borrowings from Carolingian models (cat. 80). These Islamic features allow the Mozarabic school to claim its place among the other well-defined pre-Romanesque European regional schools (see O. K. Werckmeister's essay in this volume). From about 1000 to 1150 Islamic models became less important. Influences from the north, however, became increasingly significant, and the time lag between Frankish invention and Spanish adaptation narrowed until about 1100 it was difficult to establish priorities among styles and motifs appearing on both sides of the Pyrenees.

The eleventh century ended Spain's artistic independence. The prosperity that was general throughout Europe inspired new works, and an expanding network of contacts through trade and pilgrimage led to an exchange of artistic ideas on a scale unmatched since the collapse of the Roman Empire. The

Fresco depicting Saints Cosmas and Damian. Lower church, San Juan de la Peña (Huesca). Photo: Foto Peñarroya

aged by the Islamic occupation and by geography was ended. Thousands of European visitors came to the vigorously promoted shrine of Saint James at Compostela. The ascendancy of the Gallic political and religious culture and position was acknowledged in Spain. A succession of Burgundian queens reigned in the Leonese court, and the new monastic church of Cluny, second in size only to Saint Peter's in Rome, was conceived and carried out in anticipation of and receipt of Islamic gold shipped north by admiring Leonese rulers. Cluny itself would not directly shape the new Romanesque style, but that style was definitely linked to Gallic inspiration. At times, however, as with the Diurnal of 1055 ordered by Queen Sancha of León (cat. 144), the Spanish works seem to be in the vanguard of the developing Romanesque style.

No Gallic area exercised a more significant influence on Spanish Romanesque art than Languedoc and especially its city Toulouse (cat. 86). Sculptors who had worked at Toulouse's great pilgrimage church, Saint-Sernin, moved to Santiago, and Spanish adaptations of the Saint-Sernin style in sculpture (cat. 89) and other media began to appear at many newly prosperous sites across the north of Spain in the first quarter of the twelfth century. But Toulouse style had to share almost full partnership with a particularly inventive school that developed first in the kingdom of León at Sahagún and Frómista (cats. 90 and 107) and underwent further development in such diverse sites as Jaca in Aragon (cat. 88) and Santiago de Compostela in Galicia (cat. 92). The peninsular talent for exploiting the new Romanesque style may be measured by the great church erected from about 1100 at Santiago by Bishop Diego Gelmírez. It was conceived almost exclusively along Gallic lines and employed, among others, sculptors from Toulouse and Conques, but only with the development of Gothic architecture in the mid-twelfth century would there be in France such a recognition of the potential of architectural sculpture.

As the Romanesque style evolved in the twelfth century, the near monopoly of the Toulousan-Fromistan currents, in monumental sculpture at least, ended. As more and more sites came to enjoy that combination of prosperity and ambition which fosters monuments, styles proliferated. Toulousan influence was not, however, exhausted. A generation later, after the middle of the twelfth century, the Gilabertus who signed figures in the cloister of the cathedral of Saint-Étienne de Toulouse went to Catalonia and carried out the magnificent enthroned Virgin with Christ Child that was part of the cloister program at the cathedral of Solsona.[36] As the late Romanesque stylistic language was being developed, no single Gallic area played as important a role as Languedoc had earlier. Rather, developments in central and northern France and later England helped fashion the final mature phases of Iberian Romanesque sculpture and painting.

Despite the shifting geography of influences, a unifying theme can be perceived: the assimilation of the successive

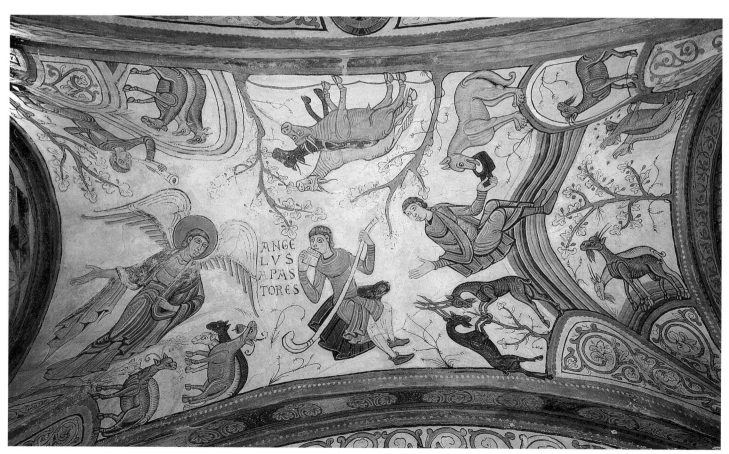

Fresco depicting an angel announcing the birth of Christ to the shepherds in the fields. Pantheon of the Kings, San Isidoro, León.
Photo: Joseph Martin

byzantinizing styles. An actual Byzantine ivory plaque had been used in Aragon in the eleventh century in a new Christian context (cat. 128), and a Byzantine cross, now lost, had arrived at Sahagún in 1101 as a gift from the Byzantine emperor Basil.[37] However, this final eastern orientation, unlike the one which marked the art of the Visigothic period, did not draw directly on Byzantine models; the East had instead an indirect impact through the adaptations of Byzantine formulas in centers north of the peninsula. As early as about 1100 a Romanesque style that depended on formal patterns originating in the painting of the Christian East appeared in the frescoes of the lower church of San Juan de la Peña. This particular byzantinizing style was introduced at Cluny at about the same time. Indeed the very painter who worked in that Burgundian monastery seems to have been responsible for works at San Juan de la Peña—a small repayment for the great church that Spanish gold had made possible at Cluny.[38] Other Spanish versions of byzantinizing styles originating in central France were carried out about the same time by local painters, notably in the illustrations of a Beatus Commentary at San Millán de la Cogolla (Real Academia de la Historia, Madrid, cod. 33) and in frescoes at Bagües, now in the Museo Diocesano, Jaca.[39] The three Spanish sites just mentioned are in Aragon, but the same central French pictorial style left its impact, although in a less marked manner, in León in the early twelfth-century frescoes of the Pantheon of the Kings at San Isidoro.

In the second half of the twelfth century later byzantinizing styles were imported from France and from the British Isles. The enamels of the tomb of Saint Dominic at the Castilian monastery of Silos exhibit such a fidelity to the particular byzantinizing stylistic current identified with the Plantagenets as to make the decision about the nationality of their authors a complicated one. A highly distinctive style, but one equally indebted at its inception to Byzantine conventions, appeared about the same time in the Beatus Commentary (cat. 153) produced at another Castilian monastery, San Pedro de Cardeña. This manner was native to England and had been used in manuscripts written for Winchester several years earlier. The same English background, although a somewhat later one, must also be accepted for the painter of the monumental fresco cycle that decorated the chapter house of the convent of Sigena (cat. 104). Whether the Cardeña painter was English or merely the importer of a British style is open to question; the Sigena painter, like the Cluny master at San Juan de la Peña, surely was an immigrant.

Byzantinizing formulas for the structure of figure style were used in media other than enamels and painting. The so-called Winchester style, noted in the Beatus Commentary of Cardeña, had a sculptural counterpart on the facade of the Leonese church of Santiago de Carrión de los Condes. A more fundamental dependence on byzantinizing formulas characterized the final blossoming of Romanesque sculpture in Aragon and Navarre. At Estella, Saragossa, and Tudela the basic vocabu-

San Juan de Duero (Soria). Photo: Photo Zodiaque

lary resembled the softened byzantinizing formulas that in France are identified with the opening phases of the Gothic style in the Île de France.

The reliance on northern Gallic centers also characterized the developments on the western side of the peninsula. At Ávila, one of the new cities that marked the growth attendant on the Reconquest, the church of San Vicente depended on an architectural vocabulary which originated in Burgundy, as did the great pilgrimage church begun a century earlier in Santiago de Compostela.[40] Like the late twelfth-century cathedral of Salamanca, that of Zamora included towers and other elements of a type first elaborated in central France. At the same time Zamora incorporated arcades articulated by a series of lobes, a prominent part of the ornamental vocabulary of Islamic architecture. A whole school of Romanesque architecture—termed Mudejar from the idea that it represents the work of Muslim builders under contract to Christians—arose in the latter part of the twelfth century in Sahagún, Toledo, and other sites in response to this taste for the oriental. Perhaps its most dramatic statement was near Soria in Castile in the arcades of interlaced arches of the monastery of San Juan de Duero. Both the so-called Mudejar churches and the arcades of San Juan de Duero drew on peninsular sources. While there were isolated cases of Islamic motifs in the fabric of Spanish Romanesque churches and in painting, the inclusion

of an Islamic vocabulary as an integral part of Romanesque style first occurred in France. Spain's widespread incorporation of Islamic motifs seemed to wait upon the sanction provided by the art of its northern neighbors. Even then in the Islamic sphere, where the peninsula had recourse to an unlimited source of inspiration, artistic orientation remained essentially with the north-south, non-Mediterranean alignment set at the turn of the millennium.

NOTES

1. Schlunk 1972; Blázquez 1969.
2. For Toledo as a capital, see Ewig 1963, pp. 31–36; Brühl 1967, pp. 201–2.
3. For the Visigoths and political imagery possibly reflective of Byzantine and Roman imperial models, see Herrin 1987, pp. 224–27; McCormick 1986, pp. 297–310; Stroheker 1965, pp. 207–45; Claude 1971, pp. 61–67; Teillet 1984, pp. 441–46.
4. "[Leovigild] was the first to sit on a throne in royal robes: before him kings and commoners dressed and sat in the same manner." See Rodríguez Alonso 1975, p. 258.
5. In employing this rite, however, far from imitating the Byzantine imperial practice, the Spanish rulers anticipated it by centuries. On the Visigothic phenomenon of anointing, see Collins 1977.
6. For the Muslim descriptions, see Sánchez-Albornoz 1986, pp. 63–66. For the alleged link between Visigothic treasure and Jerusalem, see Claude 1973, pp. 8–9.
7. Puertas 1975, pp. 29–36.
8. Zamorano 1974; Storch 1986; Schlunk 1970a.
9. Garvin 1946.
10. Hauschild 1972; with new discoveries the number of churches discussed here (nine) has almost doubled. See Arbeiter 1990, p. 406 n. 43.
11. For an explanation, see Dodds 1990, pp. 14ff.
12. Gil 1978, pp. 86–92.
13. See Buero 1987; Caballero and Mateos 1991.
14. Ulbert 1978a.
15. Codoñer 1972, pp. 50–51, 120–24. On this and other connections with North Africa, see Fontaine 1983, pp. 854ff.
16. Pérez de Urbel 1940, pp. 75–81; Beeson 1913, pp. 157–63.
17. "Picturas in ecclesia esse non debere, ne quod colitur et adoratur, in parietibus depingatur" (Vives 1963, p. 8).
18. Wolf 1990, p. 132.
19. Schlunk 1972, pp. 189–90.
20. New York 1992a.
21. For the sparse Christian remains surviving from the preinvasion period in Asturias and Galicia, see Schlunk 1970b.
22. Williams 1993, vol. 1.
23. Dodds 1990, pp. 34–46.
24. "Omnesque has Domini domos cum arcis atque columnis marmoreis auro argentoque diligenter ornauit, simulque cum regiis palatiis picturis diuersis decorauit; omnemque Gotorum ordinem, sicuti Toleto fuerat, tam in eclesia quam palatio in Ouetao cuncta statuit." From the Chronicle of Albelda (Gil Fernández, Moralejo, and Ruíz 1985, p. 174 [trans. pp. 248–49]); Bonnaz 1987, p. 24.
25. For the argument that the Visigothic orientation was institutionalized as early as the eighth century, see Bonnaz 1976.
26. McCormick 1986, pp. 297ff.
27. For this cross, see Frolow 1961, vol. 1, p. 194, no. 599.
28. Noack 1986b.
29. What seems to be an apparent Asturian shift in the typical church plan from the Visigothic cruciform formula to a triapsidal rectangular block may be a less significant index of change than it seems. The plans of the major churches of Toledo are not known. It is notable, however, that the churches built by the Christians of Toledo after the Reconquest employed plans comparable to those of the Asturian churches, at least as they are presented in Pavón 1973, pp. 62ff., fig. 11. The possibility that an earlier local tradition was being followed deserves consideration. A sixth-century example of a church plan with comparable square apsidal chapels in central Spain is recorded in the excavated plan of the church of Bobalá-Seros (Schlunk and Hauschild 1978, pp. 163–65, ill. 95).
30. For the cults, see García Rodríguez 1966. For an appreciation of these saints as part of a Visigothic restoration, see Yarza 1979, p. 45.
31. For an emphasis on the Eastern imperial origin of Santullano's program, see Schlunk 1980a, vol. 2, pp. 142–44; Schlunk 1977.
32. For Aachen as a "capital," see Falkenstein 1991, esp. pp. 275ff.
33. Barrau-Dihigo 1921, pp. 91–106; Mansilla 1955.
34. Schlunk 1985, pp. 28ff. For the Cross of Ardennes (Germanisches Nationalmuseum, Nuremberg), see Lasko 1972, pp. 38–39.
35. Williams 1987.
36. Moralejo 1988a.
37. It was described in the *Anónimo de Sahagún* as "not small, made of the wood on which Christ was crucified, and of very pure gold and adorned with precious stones and gems." A gift to Alfonso VI of León, it was placed on the altar of Sahagún. See Ubieto 1987, pp. 17–18.
38. Williams 1988, p. 98.
39. Al-Hamdani 1974, pp. 169–94.
40. See Ward 1992; Stratford 1992; D'Emilio 1992a.

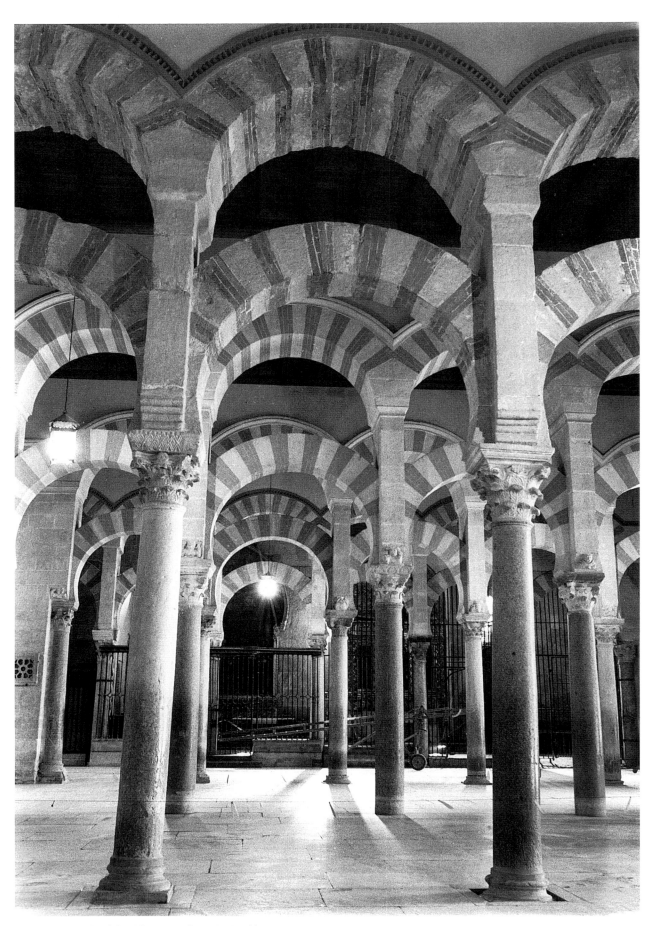

Great Mosque, Córdoba. Photo: Jerrilynn D. Dodds

islam, christianity, and the problem of religious art

JERRILYNN D. DODDS

In the Middle Ages Latin Christian writers dedicated substantial literary energy to constructing bipolar oppositions between themselves and the Muslims with whom they shared the peninsula and on whom they projected an image of cosmic alienation generated by reference to Christian dogma. The Latin Chronicle of the Kings of Castile stated: "On our side, Christ, God and Man. On the Moors', the faithless and damned apostate, Muhammad. What more is there to say?"[1] Such a sentiment was not uncommon; most medieval Spanish Latin chronicles treating the intercourse of Muslims and Christians structured relationships between these two religious groups in a similar way. The kaleidoscopic political, religious, and ethnic relations between Arabs, Berbers, Muwallads, Mozarabs, Basques, and Latin Christians (from Asturias, Castile, Navarre, Aragon, Galicia, León, Portugal, and Catalonia) were transmuted into a comfortingly reductive myth that linked Christian morality with the politics of the northern kingdoms' conquest of the peninsula. Thus Muhammad is not just an infidel, but a damned apostate, subject to Christian judgment, an assessment that not only polarizes Muslims but also draws them into the net of Christian control.

Contemporary scholarship concerning the Spanish Middle Ages is still marked by this opposition. Scholars of the medieval Iberian Peninsula study, write, and teach as representatives of a culture defined by the religion of the group that produced it. Thus scholars are defined as experts in Islamic art of the Iberian Peninsula or as experts in Christian medieval art. There is considerable interest in the "interchange" between artistic traditions that are viewed as discrete; such study, however, demands "interchange" between scholars whose fields of study are often as self-contained in the scholarly, social, and economic worlds of universities and museums as are medieval representations of "Christians" and "Moors." But, although religious difference was often galvanized by political difference in the Middle Ages, religious ideology did not control all aspects of cultural interaction, attitude, and production in Spain. In accepting a tidy, polarized representation of Spanish Christians, we miss the complex interrelations and tensions that make the arts of this period rich and original. The purpose of this essay is to mine visual representations of the early medieval era on the Iberian Peninsula, not only for expressions of the polarized model but also for evidence of different ways of viewing the complex interrelations between the peninsula's diverse inhabitants.

It is often said that the early medieval period in Spain was marked by little artistic interchange between Christians and Muslims as artists and patrons. Typically the period is contrasted with the late twelfth century and after, which witnessed the flourishing of the Mudejar culture, a tradition that exhibited a high degree of interdependence between arts conventionally associated with Spanish Islamic or Christian patronage and production. The early Middle Ages are seen instead as a time when political might eclipsed the possibility of strong artistic interchange. It is assumed that the superior political and cultural power of the Umayyads in al-Andalus precluded an interest in appropriating any product of the politically and economically weaker Spanish Christians. Christians in turn are thought to have submitted passively to invasive attacks of "influence" from Umayyad and then French artistic sources, a cultural permeability which is presumably the result of their less powerful political and economic position.

The word "influence" is perhaps too often used to characterize the relationships between artistic traditions in medieval Spain. Because it suggests exertion or action by a donor or originator, "influence" implies that a group which is creating a new art, and searching for models outside its own tradition, receives artistic stimulus passively. Of course, the opposite is true. Looking outside one's own tradition, one's artistic circle, is a highly creative and courageous act. And the movements of artistic forms across the frontier between various Spanish-Islamic and Spanish-Christian traditions—penetrating the social and cultural barriers of different religions, ideologies, and political goals—are more complex and more interesting than the reductive notion of "influence" would suggest.

In early medieval Spain religious, linguistic, and ethnic groups sought to create fictional pictures, visual identities that helped simplify the complex, protean fabric of multicultural life. So, when the Visigoths began their rule of a large Hispano-Roman

population on the Iberian Peninsula, these new, minority patrons reached far afield for grandiose symbols of sovereignty and religion and were responsible for objects such as the crown of Receswinth (cat. 12a). In less official arts, however, creative tensions resulted from the confrontation, on a more prosaic level, of Germanic and late Roman decorative traditions. Thus at San Pedro de la Nave classical rinceau forms intertwine with the schematized figures and geometric ornament more typical of Visigothic metalwork. When speaking about cultural interaction, there is always a coexistence of an official cultural attitude and the kind of contact that grows from more habitual social interaction.

For the Umayyads, the Muslims who ruled in the multicultural capital of Córdoba from the eighth to the eleventh century, the construction of a mosque in 785 was linked to the formation of an identity.[2] It meant the creation of a building that would set their faith apart from that of the important Christian and Jewish populations whom they ruled. The Umayyads used the hypostyle plan and a brightly colored, intricate, and abstract ornamentation that made careful reference to Islamic models, while consciously avoiding confusion with Christian or Roman religious buildings. But this exclusion of Christian reference did not keep Umayyad patrons and their craftsmen from using native traditions and indigenous architectural morphemes: thus the horseshoe arch, construction techniques, and basic ornamental vocabulary are the same late antique forms from which the architecture of the Visigothic period developed. Their reuse carried no other meanings than necessity and the Muslims' desire to be integrated into the life and culture of the rich frontier peninsula they had appropriated.

The issue of official culture and shared culture is especially crucial in discussing the Mozarabs, or Christians who lived in lands controlled by Spanish Muslims. Scholarship for some time reflected the assumption that because Mozarabs were po-

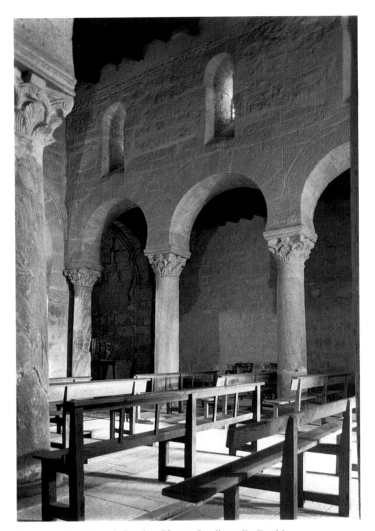

San Juan de Baños (Palencia). Photo: Jerrilynn D. Dodds

litically and economically subject to Muslims, their art must also represent a kind of passive accretion of Islamic style. But we now know that the Mozarabs' reactions to Umayyad art, and their uses of art to express their political and social dilemma, were much more complex and sophisticated.

The first buildings constructed by Mozarabs who immigrated north from Córdoba to the Christian kingdom of León are deeply conservative and reveal little that might be associated with the Islamic architecture of the Umayyads of Córdoba. Churches like San Miguel de Escalada recall the Visigothic period, when Christians ruled the entire peninsula.[3] The horseshoe-arched arcade and the partitioning of space at Escalada reflect entrenched traditions in Spanish building, which existed long before the Umayyads took control of al-Andalus.

For these immigrant Mozarabic churchmen, building in the north was an opportunity to create an image for a culture which they felt was threatened by the fashion for and sophistication of the Umayyad culture of al-Andalus. Consider the often-quoted complaint of the Mozarab Alvarus (d. about 861) of Córdoba, who lamented the assimilation of Cordoban Christians:

Decorative carving from San Pedro de la Nave (Zamora). Photo: Photo Zodiaque

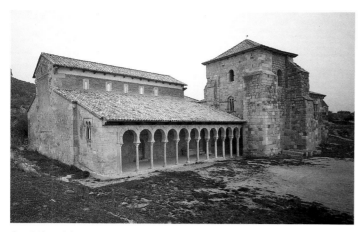

San Miguel de Escalada (León). Photo: Bruce White

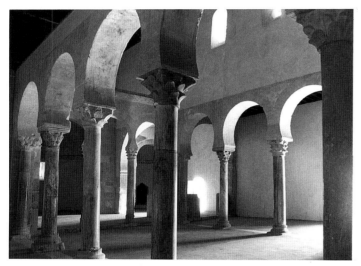

San Miguel de Escalada (León). Photo: Jerrilynn D. Dodds

The Christians love to read the poems and romances of the Arabs; they study the Arab theologians and philosophers, not to refute them but to form a correct and elegant Arabic. Where is the layman who now reads the Latin commentaries on the Holy Scriptures, or who studies the Gospels, prophets or apostles? Alas! all talented young Christians read and study with enthusiasm the Arab books; they gather immense libraries at great expense; they despise the Christian literature as unworthy of attention. They have forgotten their own language. For every one who can write a letter in Latin to a friend, there are a thousand who can express themselves in Arabic with elegance, and write better poems in that language than the Arabs themselves.[4]

This complaint may perhaps help us to understand why contemporaries of Alvar became voluntary martyrs, dramatizing the plight of the Mozarabs and providing them with a powerful rhetorical platform for a religious culture they feared was becoming obsolete. Under such unpropitious conditions the act of making a Latin Christian culture can be seen as a politi-

cal one.[5] Even building became politicized for the Mozarabs, all the more because construction of Christian churches was highly restricted under Islamic rule.[6] Indeed the tenacious, conservative style of the Mozarabic patrons of Escalada can be seen as more than a yearning glance backward; it can be regarded as a resistance to a rich and attractive Umayyad culture —one they feared would overwhelm and consume their own.

A much-studied page of the Morgan Beatus manuscript helps us see how northern Christians received and understood the idea of a Spanish Islamic art and characterized it as different from their own. There are a number of lively conventions for representing architecture in the Beatus manuscripts, but most are part of traditions in which illuminators repeat and embroider conventions that characterize buildings conceptually and iconographically. But in at least two pages of the Morgan Beatus, the artist Maius uses architecture to convey very specific meanings. In the page depicting the Feast of Belshazzar from the Old Testament Book of Daniel, Belshazzar and his court recline around a table, while Daniel points to a disembodied hand, inditing the "writing on the wall" that warns of the fall

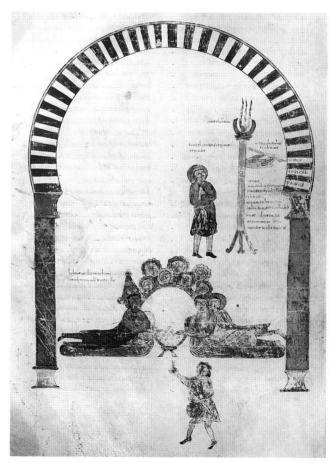

Illustration from the Morgan Beatus (cat. 78; fol. 202v). The Feast of Belshazzar. The Pierpont Morgan Library, New York

of Belshazzar's impious kingdom. The wall is represented by a distinctive horseshoe arch with alternating red and white voussoirs; this has been shown to be a direct reference to the Great Mosque of Córdoba, the building that most represented Umayyad hegemony on the Iberian Peninsula. Maius thus transformed a well-known biblical story into a contemporary morality play, in which the Muslims of al-Andalus are likened to the ungodly Belshazzar, and their demise is predicted.[7]

It is fascinating that Maius was able to make this political point through a representation of architecture: he and his audience understood that polychrome masonry distinguished this horseshoe arch—from all the others in the manuscript—as Islamic. Thus he was able to use widely understood assumptions to dissociate an "Islamic architecture" clearly from that with which he identified as a Christian. Architecture became a carrier of ideological meaning, a way of expressing difference from another group.

Painting and architecture could also express the tension between an official rejection of Islam and the shared cultural values that grew from the proximity of Muslim and Christian. Another page from the Morgan Beatus depicts the destruction of Babylon. The doomed city is represented by a single elegant house consumed by translucent flames but still encrusted with objects and ornament: floral patterns, geometric

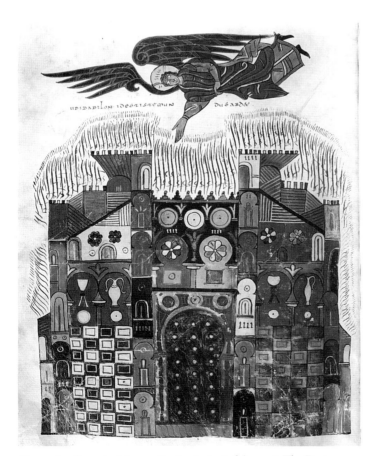

Illustration from the Morgan Beatus (cat. 78; fol. 202v). The Destruction of Babylon. The Pierpont Morgan Library, New York

motifs, and precious vases and boxes identify Babylon with a Spanish Islamic palace. Though this image of Babylon looks nothing like any particular house, the artist's energetic and original scattering of an unorthodox variety of nonrepresentational motifs on the facade distinguishes this city from others depicted in the manuscript. It conflates the Christian idea of the complex ornamentation of much of the aniconic decoration of Spanish Umayyad architecture and the costly objects found in Umayyad palaces. Here the Umayyad setting is associated with the doomed civilization of Babylon; once again, the Spanish Umayyads become "other" to Christians, one of the powers that will be destroyed in the final reckoning. But there is also in this image an acknowledgment of the opulence and attractiveness of Spanish Islamic art, an appreciation evident in later church building in the north. At San Miguel de Celanova northern churchmen built a chapel that reflects not only admiration for the power and complexity of the doorways of the Great Mosque of Córdoba but also shared formal values. Because the patrons of San Miguel were monks who did not feel their cultural identity was in peril in the northern Christian kingdoms, their attentiveness to Umayyad form—even their capacity to identify with it—could find full play in this tiny oratory.[8] And this phenomenon was not limited to monastic buildings. There is evidence that a church exhibiting similar formal values was constructed by King Ramiro II of León adjacent to his palace in the heart of the capital.[9]

It is useful to remember that while Christians were voicing antagonism toward Muslims as representatives of an opposing political power, they could still admire and feel comfortable with the material and literary culture of al-Andalus. This stance can be discerned in the precious objects featured so prominently on the facade in the Babylon miniature. Indeed those works had a prestige and value for Christians that often transcended whatever religious and ideological associations their manufacture might have inspired. They can be seen as expressing shared artistic values that form a subconscious part of the artistic dialogue between Christians and Muslims in early medieval Spain.

It is not surprising that small costly objects became the focus, both of one kind of representation of Islam, and of a value scale shared by those who lived under both Islamic and Christian rule. The Umayyads of al-Andalus used precious boxes of ivory and silver to create an image of themselves as a refined and prosperous elite on the western frontier of Islam. The very act of commissioning an object in so rare and costly a material as ivory was in itself a powerful gesture. The Umayyad period is distinguished in particular by the production of a number of solid ivory objects, most of which were gifts exchanged within the royal family.[10] Boxes carved in royal workshops, such as the al-Mughira casket and the box made for the Umayyad official Ziyad (cat. 39), are laden with figural imagery that unmistakably spells out the owner's power and sophistication. The depiction of rulers and aristocrats seated on thrones or elephants

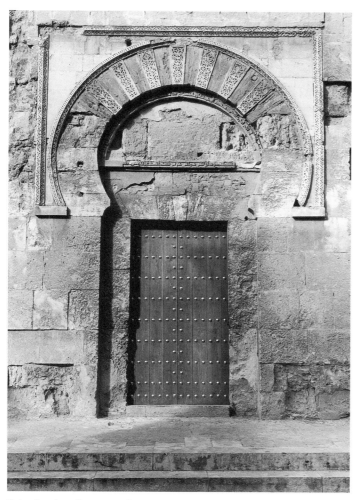

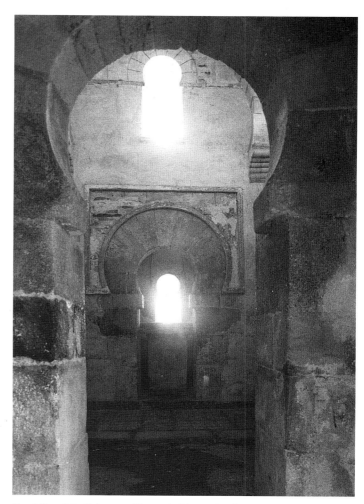

Saint Stephen Doorway, Great Mosque, Córdoba. Photo: Raghubir Singh

San Miguel de Celanova (Orense). Photo: Jerrilynn D. Dodds

in garden settings—fragile arabesques of minutely drilled vine scrolls—intertwines the notions of might and cultivation in a way unique to Spain in western Europe. And this message was not lost on the Christian north.

While princely patrons set the artistic standard in al-Andalus, ecclesiastical, monastic, and secular patrons in northern Spain dedicated their resources to the embellishment of the church. Paradoxically the best evidence of the northern Christians' deep admiration for Spanish Islamic material culture can be found in church treasuries, which are replete with objects manufactured in al-Andalus, including ivory, silver, and bronze boxes, and silk textiles. Indeed a great deal of what survives of the courtly arts of al-Andalus was preserved in northern church treasuries. So while church chronicles posited a deep alienation between Christian and Muslim populations, church treasuries reveal admiration for and understanding of Islamic artistic culture.

A pyxis in the Braga cathedral treasury (cat. 73c) dates from the end of the Umayyad caliphate, where precious ivories were traditional courtly gifts. Its decoration is structured around a horseshoe-arched arcade that creates a kind of palace setting intertwined with arabesques and animals tucked into vine scrolls.

The fecund garden, harvesting servants, animals, and architectural arcade all allude both to a pleasurable and refined courtly context and to the power that such an environment conceals.

But what was this object's meaning for the Christian churchmen who received it in the early eleventh century? An inventory of the cathedral of Braga suggests it served as a reliquary, a use that was not unusual for fine boxes of Islamic manufacture once they made their way to the northern Christian kingdoms. Alternatively this box may have held a tiny chalice and paten (cats. 73a, 73b) which are housed in the same treasury; these pieces of northern manufacture can nestle together inside the Islamic pyxis. The chalice and paten were the gift of Don Mendo Gonçalves and his wife, Dona Toda, important members of an old and distinguished Portuguese family. They recall, in gilded silver relief, many of the decorative themes and formal preoccupations of the Braga pyxis: in all three objects birds and animals folded into vine scrolls and wandering tendrils create a complex surface pattern. And one might even wonder if the keyhole arches punched into the chalice stem echo the horseshoe arches that wreathe the body of the pyxis. It is not at all certain, however, that the artist of the chalice and paten appropriated from the Braga pyxis: the silver pieces

would have to have been made very soon after the pyxis to have reflected its designs directly.[11] But the formal concerns common to these objects—one from Islamic Spain and the other two from Christian Spain—point to a wide base of shared artistic values and complex interrelations which are worth exploring. On one hand, such intricate and elegant elaboration of vine scrolls had a long history in pre-Islamic Spain, in both luxury arts and monumental contexts. In fact, the luxury arts of Muslim and Christian patrons shared a common foundation in the arts of the late Roman Mediterranean, in particular in those vegetal themes whose repeated motifs create complex surfaces with subtle variations, which express a tension between abstraction and naturalism. On the other hand, admiration for the way Islamic tradition had drawn those forms into an elegant style with potent implications led northerners to regard Umayyad luxury arts as worthy models for an opulent and authoritative art. Such an unvoiced tension between parallel development and interchange between traditions can even be found in reliefs from Escalada (cat. 77), which are deeply Visigothic in character but also reflect Umayyad developments of late Roman decorative themes.[12]

How did this duality resonate in a society that characterized Islamic religion and culture as the eternal other—the earthly military enemy and the spiritual foe of the kingdom of Christ? On what level were these complex interrelations understood by the patron of the chalice and paten, Don Mendo Gonçalves, whose father had died in battle defending Santiago de Compostela from the forces of al-Mansur—the Cordoban dictator who, in turn, was the father of ʿAbd al-Malik, the man who commissioned the Braga pyxis?

Wills and gifts of deed from the eleventh century document this passage of objects from Umayyad court to northern church treasury and the subsequent transformation of their meanings. In León an entire collection of Islamic boxes can be found in the treasury of San Isidoro (cats. 46, 47), and among the items enumerated in the extraordinary charter of 1063 were a number of textiles designated specifically as Islamic in manufacture.[13] That the Islamic origin of the textiles is mentioned is significant: indeed most of the boxes carry Arabic inscriptions, and in many of the most prized textiles Koranic inscriptions are displayed quite boldly.[14] The new Christian owners of these luxury goods did not shrink from recognizing their obvious derivation, a fact that signals their association of transcendent craft with al-Andalus. It appears that, for many northern Christians, the sumptuous quality of the material culture of al-Andalus supersedes any undermining political and religious associations with Islam. Thus Islamic objects came to galvanize the religious and hegemonic aspirations of callow Christian rulers and churchmen in a way no object of local manufacture could. This reading was further complicated by the status of many of these works as spoils of war.

The Braga pyxis probably came to the cathedral treasury as a gift from a northern noble who received it as tribute or booty. It was no doubt consigned to the cathedral in thanks for God's help in military endeavors which were increasingly sanctified by the church. But remunerative battles were not always pious in intent. The extraordinary silver casket of Hisham II (cat. 38a), for instance, probably came to the cathedral treasury of Girona in 1010, when Catalan mercenaries fought in Córdoba for Wadih, the Muslim governor of La Marca Superior. The contract for military services declared that all booty would belong to the mercenaries, and so it was probably their donation that brought the casket to the Girona Cathedral.[15] Now these spoils were captured by noble Christians—Count Ramón Borrel III of Barcelona and his brother Count Armengol of Urgel—but their battle against Muslims in Córdoba can hardly be seen as a holy war. Their contract with a Muslim governor reminds us that the political reality of alliances reveals an interdependence between Christians and Muslims far more complex and interwoven than polemicists would have us believe. The rather compromised nature of the exploit did not, however, taint the object's identity as a work of enormous monetary value or as a symbol of conquest. Once it had taken its place in the Girona cathedral treasury, Hisham II's casket surely became a symbol of Christian victory over Islam. Its ostentation and the elegance of its craft were mustered to serve the force that had appropriated it, overcome it. Its power and sophistication accrued to the church, which domesticated it within the sanctified enclosure of the treasury. The casket of Hisham II thus passed from a world in which Christians and Muslims were politically and culturally interdependent into a church treasury where it was transformed into a visual expression of the myth of bipolar opposition between Christians and Muslims. It thus served an ideological position most sympathetic to church authority in this protean land.

The victory of the faith and its appropriation of what is most precious of al-Andalus is particularly poignant in the case of two reliquaries. The first is a beautiful casket of ʿAbd al-Malik converted into a reliquary at the monastery of Leyre. The second is a tiny heart-shaped silver niello box manufactured by *taifa* craftsmen, used as a reliquary in the treasury of San Isidoro in León (cat. 46). These recognizably Islamic objects held the relics of Nunila and Alodia at Leyre and Pelagius at León—Mozarabic martyrs killed by Umayyad rulers in Córdoba for blaspheming the name of the prophet. The glorification of these martyrs in boxes that exemplify Islamic craft is possible only within a matrix of meanings that defines the appropriation of a caliphal or *taifa* object as a victory over the religious and hegemonic force of Islam.

But this stance also masked admiration for as well as openness to Umayyad and *taifa* material culture. It has been suggested that the heart-shaped box that held the relic of Saint Pelagius was crafted for a Christian market.[16] The taste for *taifa* boxes was probably widespread, and they may have been integrated into the secular domestic setting of privileged classes in the kingdom of León.

Thus we find a reverence for Spanish Islamic material culture that supersedes the language of display, the posturing of appropriation. And though the stance of the church and Christians toward the numerous Islamic realms seems to harden in the eleventh and twelfth centuries, traces of the acceptance of the arts associated with them can still be discerned. Under Ferdinand I in the second half of the eleventh century, appropriated objects of Islamic manufacture were joined in the San Isidoro treasury by sumptuous liturgical arts that had become increasingly Germanic in character. The ivory-and-gold reliquary of Saint Pelagius (cat. 109) and the gilt-silver reliquary shrine of Saint Isidore (cat. 110) were both executed in styles and techniques that show a steady gaze toward the north and that were intended, as Williams has demonstrated, to reinforce the treasury's imperial character.[17] And yet within the recesses of these same reliquaries the walls were lined with fine Islamic textiles. These silks do not seem to function as spolia, which depend to some extent on display for their message of victory and domination. Rather, their seclusion within these opulent caskets, which have a vigorous exterior imagery, suggests that a tension exists between the language of the textiles and that of the new luxury arts. These textiles were the finest material in which holy Christian relics could be wrapped, but they were also examples of an art whose discourse of power and opulence had to be circumscribed, controlled.

This ideological distancing of Islamic material culture was contemporary with a growing cultural policy that began in the Christian kingdoms in the late eleventh century.[18] Under Ferdinand's son Alfonso VI, the traditional Hispanic rite was suppressed in favor of the standard Roman liturgy. Four of Alfonso's wives were of French blood, and both father and son were passionate patrons of the Burgundian monastery of Cluny and used that relationship to help them restructure the Spanish church and papal relations. There was, in these two generations, a conscious policy of associating the aspirations of Christian Spain with those of northern Europe; this included suppressing the aspects of the Spanish Christian identity, like the indigenous liturgy, which marked the cultural individuality and insularity of the Spanish Christians and which set them apart from those Christian lands whose experience was unmediated by intercultural tensions.

The artistic arm of this policy supported the introduction of the Romanesque style in Spain. It appears first in architecture—as early as the reign of Ferdinand's father, Sancho the Great of Navarre, the man who forged the first links with the Christian north—and then in manuscripts, luxury arts, and boldly figural wall painting and sculpture, which were introduced by Ferdinand, Alfonso, and their families in León.[19]

Like the change in liturgies, the adoption of a new artistic style was marked by a turning away from traditional practice. Horseshoe-arched architecture—whether associated with Visigothic or Spanish Islamic prototypes—never again appeared in any significant way in the northern kingdoms. There were also buildings of Asturian type in the north, but now a Romanesque architectural idiom—with ashlar construction, semicircular arches, and barrel vaults—and vigorous figural arts almost subsumed the northern architectural and ornamental modes that had flourished in parallel to Islamic crafts. A more insular indigenous culture was suppressed in favor of a liturgical and artistic expression associated with unchallenged Christian hegemony in northern Europe.

It is characteristic of Spanish Romanesque sculpture that original and complex iconographies at times make direct reference to the Christian kingdoms' struggle with al-Andalus to the south. Predictably these do not refer to their actual specific rivals—there were a number of different political and ethnic groups among the Muslims with whom northern Christian monarchs fought in the eleventh and twelfth centuries, groups with widely divergent ideological positions toward the Christians and the peninsula. Rather they characterize all Muslims as a single mythic and reductive "other." The best example is the Portal of the Lamb at San Isidoro in León,

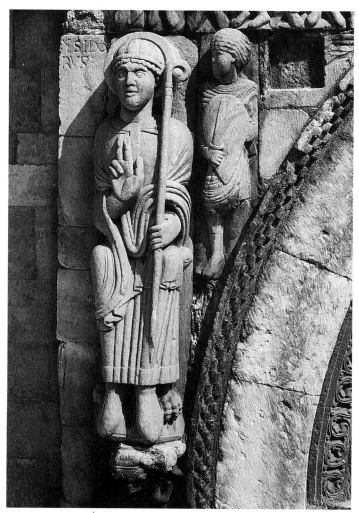

Saint Isidore. South aisle portal, San Isidoro, León. Photo: Photo Zodiaque

which was shown by Williams to place Muslims in an iconography of "reconquest" generated by the Leonese church's political cosmology.[20] Williams also demonstrated that on the same portal Isidore himself was drawn into this militarized discourse. He is shown in conjunction with a warrior, a reference to the aid he lent—according to a then quite current account—to Alfonso VII in his successful campaign against Andalusia.[21]

The adoption of Romanesque arts in the northern Spanish kingdoms had many programmatic meanings which have been widely explored by scholars; but on one level it must also have constituted not only a resistance to Spanish cultural insularity but also an exteriorization of those aspects of Spanish Christian culture which were intertwined with the arts of Islam through common sources, shared experience, or admiration. Thus in the Romanesque period appreciation of the arts of Islamic Spain was controlled. When it could not be encased in a context that exteriorized Islam through the themes of victory and domination, it was often found in the margins: in the lining of reliquaries or in the column capitals—but not the monumental reliefs—of Santo Domingo de Silos.

Perhaps the largest and most important of the reliquaries of San Isidoro was the Arca Santa (cat. 124), which held a group of important relics, including several thought to be from apostolic times. The gilded silver front presents a Christ in Majesty in a mandorla held by angels, whose bodies strain, forearms bulging, from their effort. They are flanked by two registers of apostles who gesticulate with dignified vigor from beneath arcades. The figures are quite plastic and give the vision a monumental immediacy. So it seems all the more anomalous that the entire ensemble is enclosed within a wide, pseudo-Kufic inscription. This inscription was copied at least in part from an Islamic object by an artist who did not understand Arabic[22] but who wanted to link the object and the notion of Islamic manufacture. A number of individual letters or groups of let-

ters are legible but the inscription also contains sequences of forms unrecognizable even within the most abstracted and ornamented of Kufic calligraphic traditions. Because it has the marginal, enframing position it would have on a Spanish Islamic box, it gives the impression of an enormous silver box of Umayyad manufacture, from whose core emerges a vision of Christian revelation.

The tension between the wide band of calligraphy in bas relief and the vibrant Christ it encloses is arresting. On one hand, there is high regard for Islamic manufacture, and the inscription gives the Arca the status and meaning of spolia: booty implying dominance and victory over the authors of the subjugated style. The formal contrast between the band and the front panel serves to counterpose them—to remind us of their divergence, of the opposition that results in such victories. The presence of Islam—not as a long-standing or integrated part of peninsular life but as an unholy other—gives new meaning to Christian observance in the north and a new force and immediacy to apocalyptic images.

The notion that the sacredness and power of the Arca and its owners might be augmented by an allusion to Islam is suggested by legends surrounding its arrival in Oviedo. By the beginning of the twelfth century, it was recorded that the Arca Santa had been built by disciples of the apostles themselves in the Holy Land, then brought to Spain, and subsequently to Oviedo to escape the Muslims' conquest of the peninsula.[23] The Arca origin is fit into a reading of history that rehearses the basic facts of Muslim and Christian military opposition: a recounting that smothers all memory of shared culture with the sterile image of righteous opposition. The constant presence of such an other—in legend and in art—justifies the militant posture of the church and sanctifies the militant actions of its members. The inscription reminds us of the exalted mission of the Christian kingdom, while the powerful image of

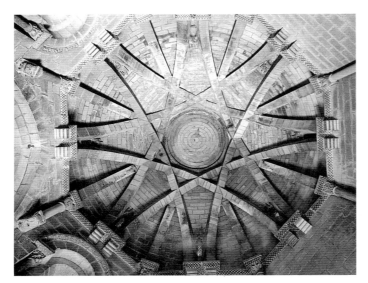

Dome, Santo Sepulcro, Torres del Río (Navarra). Photo: Hirmer Fotoarchiv

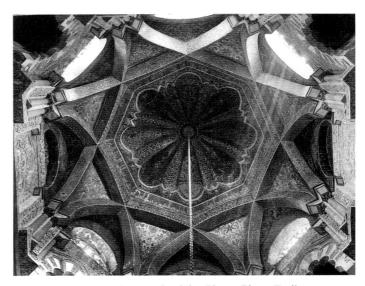

Mihrab dome, Great Mosque, Córdoba. Photo: Photo Zodiaque

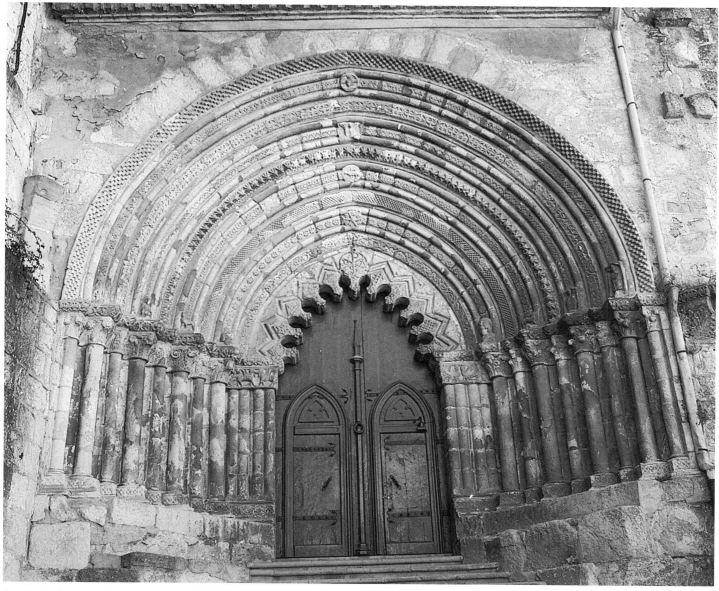

San Pedro de la Rua, Estella (Navarra). Photo: Jerrilynn D. Dodds

Christ calls up the extraordinary authority behind this sanctified endeavor.

Both the church and the kingdom are given a sharper, more forceful identity by virtue of the existence of their enemy, all the more so because that enemy is not Christian. This heightening of self-awareness may be one reason why Spanish Islamic forms occur in contexts closely associated with pilgrimage and Crusade. The Templars' church at Torres del Río, on the pilgrimage route to Santiago de Compostela, is one of many centrally planned churches throughout Europe which act as small replicas of the Church of the Holy Sepulcher in Jerusalem. They are reminders of the raison d'être of the military orders and of the holy sites to be freed from Islamic domination through the Crusades. It is fascinating then that the dome of Torres del Río is an austere ashlar copy of a tenth-century Umayyad dome in the Great Mosque of Córdoba. This one gesture links the Muslims with whom Spaniards had interacted

for centuries with the great enemy of the church in the Holy Land. It is a gesture that must surely relate to the act of Pope Eugene III, who granted Crusader indulgences to those participating in the conquest of Tortosa. His declaration that the struggle against Muslims on the Iberian Peninsula might be seen as a Crusade was recognized more than once, as knights from northern Europe aided in the Spanish Christians' appropriation of the peninsula. Some of those stayed and added another thread to the fabric of artistic form and intercultural ideology. The intervention of the French has been suggested in particular on the pilgrimage roads. The pilgrimage to Santiago de Compostela grew enormously in the eleventh and twelfth centuries, promoted by the church and rulers of the northern kingdoms and the papacy and by the Cluniacs, who had substantial hegemonic and economic interests in northern Iberia. It should not be a surprise that Islam made an appearance on the road as well.

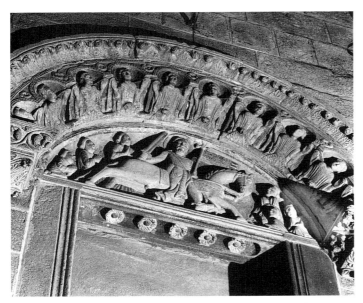

Santiago Matamoros (Saint James as Moor-Slayer). Santiago de Compostela. Photo: Photo Zodiaque

and to have aided the Spanish Christian monarchs in their task of cultural tidying—of folding all the Muslims of their experience into one reductive image.

Certainly among the Spanish there were official attempts to link the pilgrimage and struggle with Islamic hegemonies. Though the pilgrimage, and the body of Saint James, had existed on the peninsula for some time, the veneration of the apostle took a peculiar turn in the eleventh and twelfth centuries. It was then that the legend of Santiago Matamoros took its place in monumental arts: Saint James the Apostle as he appeared to Spanish Christian monarchs, a soldier "on a white horse, with a white standard, and a great shining sword" to lead the Christians in battle against the Muslims.[27] And so, at the church of Santiago itself, we see not only the apostle who knew and followed Christ but also a contemporary, militant Saint James, with the mangled bodies of Muslim soldiers beneath his horse's hooves. Saint James has been recruited here as a soldier in the battle for the banishment not just of Islam but of those aspects of Islamic culture that informed the identity of Spanish Christians. At the end of the early medieval period northern Spanish art was firmly trapped within a structure that fused identity and hegemony with religion.

A tiny silver niello box once in the treasury of the church of Saint-Jean in Liège (cat. 43) might well have been brought there as a reliquary, acquired by pilgrims returning from Santiago.[24] The idea that relics encased in an Islamic object would witness a pilgrimage or represent a Spanish experience is an interesting one. Consider, on the other hand, the portal of San Pedro de la Rua in Estella, the principal church in the French quarter of a city squarely on the road to Santiago. Estella has no tympanum nor the hierarchical figural imagery for which the tympanum is usually the vehicle in France and Spain. Instead the portal relies for interest on polylobed arches and on the multiplication of plastic moldings, dozens one after another, each carved with a different vegetal or geometric design. The overall effect seems clearly and consciously to make reference to Islam, not through particular motifs but through the creation of an abstract, aniconic design generated by surface patterning. The Estella facade does not look like Umayyad or *taifa* architecture, however; here Islamic arts might be refracted through the Crusader experience, modified by the interests of the French populations which were a strong presence in that city.[25] The facade shows similar concerns to portals in Aquitaine where Crusaders built churches that also made reference to their victories over Islamic forces in the Holy Land. Thus Seidel has spoken of the relationship between the delicate carving of repeated moldings on such portals and metalwork brought to France as booty by the Crusaders.[26]

Does a similar if more generalized meaning function at Estella, or is this portal with its recognizably Islamic formal properties simply a reminder for pilgrims that the road to Santiago was on a frontier—that the apostolic mission was still alive, that the faith was still to be defended? In either case, patrons on the pilgrimage roads can be shown to have perpetuated the linkage of the Crusades with hegemonic struggles in Spain

Santiago de Compostela with temporary facade for celebrations on July 25, the saint's feast day. Photo: Jerrilynn D. Dodds

Today, in the twentieth century, Islam hovers at the margins of the veneration of Saint James and of Spanish identity. On the eve of the saint's feast, a temporary facade is built in front of the cathedral of Santiago and emblazoned "To the Patron of Spain." This facade represents a palace with arcades and horseshoe arches covered with a skin of red and white polychromy; it gives us, as it would have given Christians a thousand years ago, an easily recognizable, reductive vision of "Islam." On the stroke of midnight this vision of all that is Islam for Christian Spain erupts in a fabulously gaudy display of fireworks and then disappears. A visual image of Islam in Spanish culture is controlled, trivialized, and erased: that is perhaps what Spanish Christians of the early Middle Ages wished to do with that part of their identity shared with Spanish Muslims.

NOTES

1. Latin Chronicle of the Kings of Castile, in Barrau-Dihigo 1913, p. 43, quoted in O'Callaghan 1975, p. 331.
2. Jerrilynn D. Dodds in New York 1992a, pp. 11–25.
3. Dodds 1990, pp. 47–81.
4. Paul Albar, *Indicus Luminosus,* in *Patrologia Latina,* vol. 121, p. 35, trans. Southern 1962, p. 21.
5. Dodds 1990, pp. 58–70.
6. Dodds 1990, pp. 58–64.
7. Williams 1980, pp. 212–13, 217–19, with discussion 221–27.
8. Dodds 1990, pp. 84–94.
9. Gómez-Moreno 1919, pp. 253–59; Dodds 1990, p. 77. I am indebted to Fernando Miguel Hernández for information concerning his excavations at San Salvador.
10. Holod in New York 1992a, pp. 41–47.
11. The most recent dates offered for the Braga pyxis suggest completion between 1004 and 1008, while the chalice and paten are believed to have been fashioned before the death of Gonçalves in 1008 (Madrid 1992, p. 94).
12. Schlunk 1972, pp. 128–32, 137; Schlunk 1965, pp. 921–25.
13. Williams, *infra,* "León and the Beginnings of the Spanish Romanesque"; Blanco 1987, pp. 166–72.
14. Though there is evidence to suggest that there were, in the Leonese court, individuals who could read Arabic, this interpretation does not depend on an understanding of the Arabic texts. Rather, it rests on the notion that Arabic script held a direct association with al-Andalus and the culture created by Spanish Muslims there.
15. Manuel Casamar Pérez in New York 1992a, pp. 208–9.
16. Carbone, *infra,* "Box," cat. 46.
17. Williams, *infra,* "Chalice of Urraca," cat. 118.
18. Meyer Schapiro introduced the idea that Romanesque art constituted the cultural arm of a political policy aimed at controlling indigenous groups within the church through the suppression of "Mozarabic" arts (Schapiro 1939).
19. Williams, *infra,* "León and the Beginnings of the Spanish Romanesque."
20. Williams 1977, pp. 3–15.
21. Ibid., p. 11.
22. I am indebted to John Williams for sharing his unpublished research concerning this aspect of the casket with me.
23. Harris, *infra,* "Arca Santa," cat. 124.
24. George 1988, pp. 5–21.
25. Durliat (1962, p. 69) related it to Provençal cloisters.
26. Seidel 1981.
27. Crónica General, in *España Sagrada,* vol. 19, p. 331.

VISIGOTHIC SPAIN

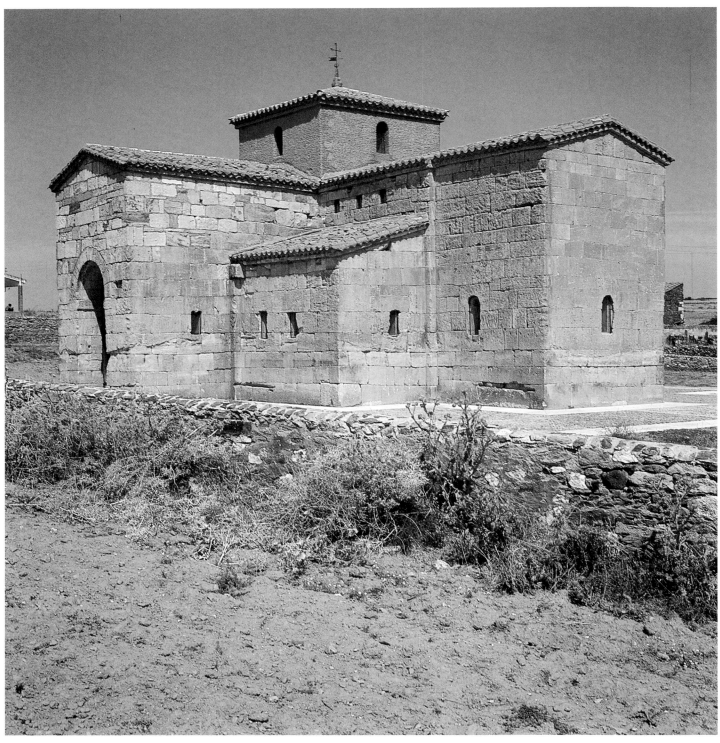

San Pedro de la Nave (Zamora). Photo: Joseph Martin

the formation of visigothic spain

GISELA RIPOLL LÓPEZ

The migration of the Goths—Visigoths and Ostrogoths —affected the whole of the "civilized" world. This process can be observed on both intellectual and cultural levels— through written documentation and through the physical evidence provided by archaeology. The long journey of these peoples—they left their eastern lands, passed the frontiers of the Danube, and gradually made their way to the West—ended in the late fifth century with the creation of two powerful kingdoms.

When the Ostrogoths took Ravenna in 493, they found a deeply Roman structure, which their highly cultivated king, Theodoric, preserved and amplified. This continuity can be seen in the refinement of Theodoric's court, still evident in his mausoleum and in the treasures consisting of objects of personal adornment that demonstrate great skill in metalworking. The Ostrogothic kingdom was, however, short-lived; it fell to the Byzantines in 540. The Visigoths were more successful in their conquest. They proved more powerful than the Vandals, Alans, and Suevi, the tribes who had preceded them in Hispania, and they controlled the entire Iberian Peninsula by the seventh century. Their sway endured until the Islamic conquest, which began in 711.

Leovigild (r. 568–86) was the first Visigothic king who understood the need to make Spain a single "nation." He laid the groundwork for a stable government and expressed a theocratic philosophy through imitating the Byzantine court and currency and founding a city on a new plan. The site of that city, Recópolis, built in honor of his son Recared, has been identified as the Cerro de la Oliva, near Zorita de los Canes (Guadalajara). Leovigild's territorial conquests formed the enormous kingdom of Toledo, which controlled the entire Iberian Peninsula except for the Byzantine province of Spania on the southern coast from Gades (Cádiz) to Dianium (Denia). The kingdom of Toledo also included the Gallic province of Septimania; recent archaeological discoveries there —sculpture, epigraphic fragments, and especially objects of personal adornment—confirm a close interdependency between the two sides of the Pyrenees.

After the death of King Athanagild in 567, Toletum, a strategically important Roman city, was named capital of the Visi-gothic kingdom; Leovigild confirmed Toletum's importance by making it the seat of his government. He nullified the law, promulgated by the emperor Valentinian I (r. 364–75) and included in the *Brevarium* of the Visigothic king Alaric II (r. 484–507), that forbade intermarriage between Romans and Visigoths. He thus encouraged demographic unification (Spain had an enormous Roman population—perhaps as many as ten million people—compared to a Visigothic minority of some 150,000 to 200,000 [there is much disagreement about these population figures; see, for example, Bernard Reilly's essay in this catalogue.—Ed.]). Despite these accomplishments, Leovigild did not reach his goal of Iberian unification. Being an Arian, he badly underestimated the importance of Catholicism to Hispano-Roman society and attempted to convert his realm to Arianism, a doctrine that had been denounced by Rome as heretical. Leovigild's championing of Arianism was opposed by Bishop Leander of Seville and by his own son

Recópolis. Photo: Archivo Fotográfico Oronoz, Madrid

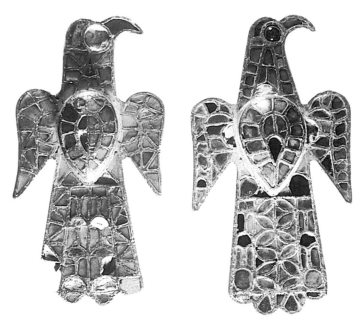

Two eagle-shaped fibulae. Gold and glass(?). Necropolis of Alovera, sixth century. Museo Arqueológico Nacional, Madrid

Heremengild, who led rebellions supported by the aristocracy of Baetica (the region that corresponds in large part to present-day Andalusia).

Unification was finally attained by Leovigild's son and successor, Recared (r. 586–601). He had been tutored by Leander and Isidore of Seville and came to realize that an understanding between Romans and Visigoths could be effected only under the Catholic faith. Some scholars therefore regard 589, the year of the Third Council of Toledo, as the date of the achievement of Spanish unification. The conversion of Recared and his aristocracy to Catholicism profoundly influenced Spanish political life and strengthened the increasingly interventionist power of the church (given its enormous holdings, the church was one of the principal economic powers in the Visigothic kingdom).

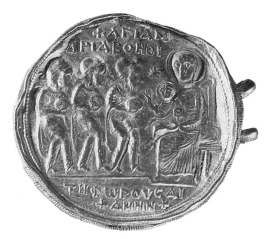

Gold fibula showing the Adoration of the Magi. Medellín, sixth century. Museo Arqueológico Nacional, Madrid. Photo: Joseph Martin

Opposition to Recared's conversion was expressed in a series of violent uprisings. The first occurred within the palace itself and was instigated by the king's stepmother, Gosiwintha, who urged Bishop Ulfila to overthrow Recared. This was foiled, as was a second revolt, which took place in Emerita Augusta (Mérida). There Bishop Masona and Claudius, the governor of Lusitania, were attacked by Arians led by Bishop Sunna and counts Segga and Vitericus. The most serious insurrection was that in Septimania prompted by Bishop Athalocus and counts Granista and Vildigernus. This revolt provoked a definitive rupture between the Visigothic and the Frankish kingdoms.

In *Laus Hispaniae* Isidore of Seville, a prominent member of Recared's court, wrote admiringly of the king's reign. The uprisings, however, testify to deep disagreement among certain sectors of Visigothic society and implacable opposition to Recared's policies of pacification and unification. It is perhaps best to regard the Third Council of Toledo not as a culmination of the quest for unification but as part of a process that would continue in the second half of the seventh century during Receswinth's reign.

The gradual conversion to Catholicism of the Visigothic aristocracy and of the urban and rural populations brought with it profound alterations that can be detected in funerary deposits. Personal adornments document a modification in style of dress, implying a change in social structure. Before the Third Council of Toledo the Visigothic populations, at least in rural areas, followed a traditional "Germanic" mode, allowing for geographic differences. Large fibulae and rectangular belt buckles—often with polychrome mosaic work—have been found throughout the Castilian meseta, indicating a well-defined area of occupation from the time of the first Visigothic kings. Important grave sites—Castiltierra and Duratón in Segovia, El Carpio de Tajo in Toledo, Herrera de Pisuerga in Palencia, and Azuqueca in Guadalajara, among others—tend to confirm this thesis and attest to three or four generations of artists with a distinctive style. The evolution of metalwork shows that Visigothic forms and techniques were influenced by Hispano-Roman and eastern Mediterranean works from the end of the fifth century through the sixth.

Toward the end of the sixth century "Germanic" traditions in dress gave way to a Latin-Mediterranean style with eastern roots. This new mode was not limited to the meseta but spread throughout the Visigothic kingdom of Toledo, from the Strait of Gibraltar to Septimania. The most characteristic adornments were small buckles with rigid plates and triangular tongues, lyriform belt buckles, and Byzantine-style clasps; these adornments were imitated in local workshops and dominated production through the seventh century. The Byzantine elements evident in these objects entered Visigothic Spain primarily through trade not only with the East but also with the lands north of the Pyrenees. Commercial connections with the East were established by the many colonies of Eastern merchants

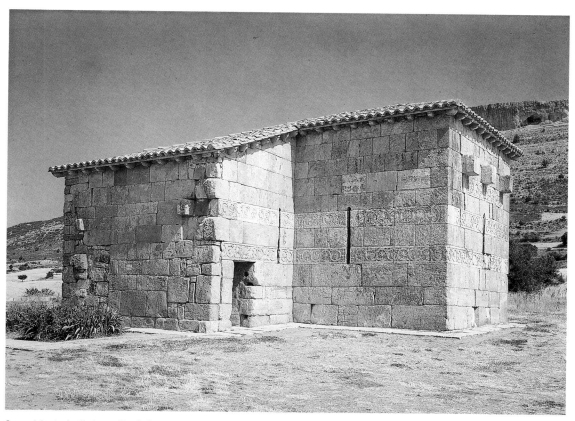

Santa María de Quintanilla de las Viñas (Burgos). Photo: Archivo Fotográfico Oronoz

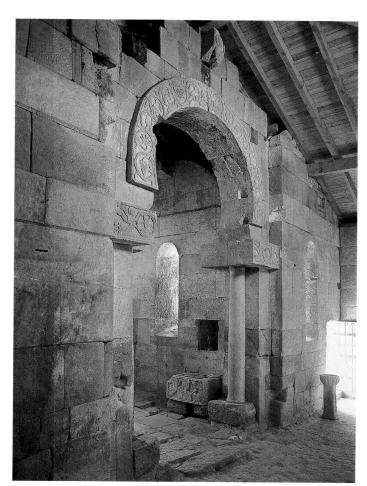

Santa María de Quintanilla de las Viñas (Burgos). Photo: Archivo Fotográfico Oronoz

who had long ago settled along the Mediterranean and Atlantic coasts of the peninsula. This trade allowed the import of objects whose aesthetic and formal values enriched Iberian culture. Byzantine influence is evident in sculpture produced in Lusitania; during the seventh century the important workshops in Olisipo (Lisbon) and Emerita Augusta would play a major role in joining sculpture and architecture in religious buildings. The *De vita et miraculis sanctorum patrum emeritensium*, an account that dates from the first half of the seventh century, mentions the silks and other eastern textiles which enriched the ceremonial pageantry of Emerita Augusta. The impact of the colonies of eastern merchants is seen in the fibula of La Granja del Turuñuelo in Medellín (Badajoz); this circular gold piece bears an image of the Epiphany and an inscription in Greek alluding to its wearer.

The finest examples of Visigothic art in Spain were produced after the Third Council of Toledo in 589 and combined the three basic elements of the Visigothic world—the Germanic, Roman, and Byzantine heritages. Most important are the churches of the meseta and the treasures of Guarrazar (cat. 12) and Torredonjimeno. Most of these architectural and decorative artifacts date from a cultural renaissance that occurred in the seventh century, especially under Swintila (r. 621–31) and Receswinth (r. 653–72). The stability Spain then enjoyed allowed palace workshops to flower. The treasures of Guarrazar and Torredonjimeno testify to the skill of these workshops and demonstrate the artists' familiarity with distant cultural heritages, most notably that of the Byzantine East.

Only rural buildings survive of the architectural programs that were sponsored and financed by the Visigothic monarchy. Some basilicas based on the early Christian model of regions with strong Roman roots have endured. One important example is the church of San Juan de Baños de Cerrato (Palencia), which combines elements of traditional early Christian architecture and transformations and innovations characteristic of Visigothic architecture. The dedicatory inscription in the church of San Juan Bautista dates from 661 and invokes the name of King Receswinth, giving evidence of courtly sponsorship. A crown from the treasure of Guarrazar (cat. 12) was an offering from this king; the letters suspended from it read RECCESVINTHUS REX OFFERET (King Receswinth gave this). Other important churches are among the group of buildings surviving from the Visigothic and Hispano-Visigothic epoch —for example, Quintanilla de las Viñas (Burgos), San Pedro de la Nave (Zamora), and San Fructuoso de Montelios (Por-tugal). The last building, which has a strong Roman flavor, has been dated about 665, since the construction of the mausoleum is attributed to Fructuosus himself. San Pedro de la Nave, cruciform in plan, is also dated to the middle or end of the seventh century; it is remarkable for its successful combination of architectural elements and sculptural ornamentation. The conjunction of architecture and sculpture is again notable in the church of Quintanilla de las Viñas, although there the iconography relies on eastern Mediterranean sources.

The Visigothic kingdom of Spain in its last period, and particularly in the time of Swintila and Receswinth, reached the culmination of the process of acculturation and the end of the Gothic journey. It had developed from a Roman base and was shaped by the power and homogeneity of the Roman world, upon which the Visigoths were able to construct a new society.

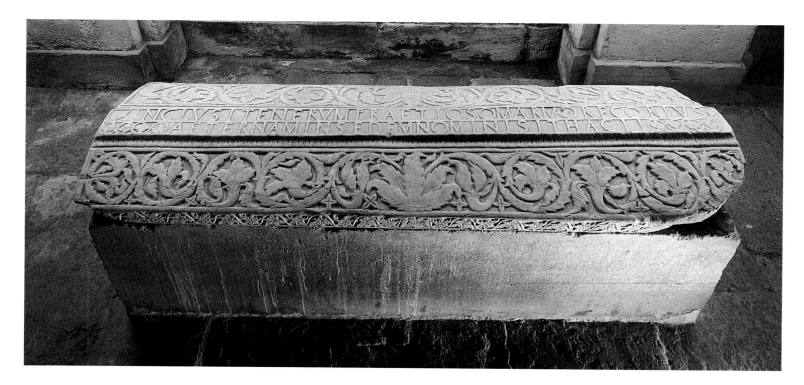

1

lid for the sarcophagus of Ithacius

Oviedo (Oviedo), first half of 6th century
Marble
9⅞ x 82⅝ x 33½ in. (25 x 210 x 85 cm)
Capilla del Rey Casto, Oviedo Cathedral

This roof-shaped lid is all that survives of the sarcophagus. The entire upper surface is decorated, as is one of its ends. The latter, partially damaged, shows a braided wreath on a column. The alpha and omega of Christ's monogram are inside the wreath, on each side of which is a cantharus flanked with doves that has leafy vines rising out of it. Both the open and curled grape leaves have prominent veins. More vines, also issuing from a central cantharus flanked with birds, wind across the narrow vertical walls of the long sides. The lid's two sloping panels are ornamented with even more elaborate foliage, leaf buds, and involute leaves. Here the vines rise out of leafy chalices in the center and twist symmetrically outward toward the ends.

The center strip along the top, framed by a cymatium, contains an inscription in raised majuscules. The Latin distich reads: INCLVSI TENERVM PRAETIOSO MARMORE CORPVS/ AETERNAM IN SEDEM NOMINIS ITHACII (Under precious marble I hold within for eternal rest the body of the youthful Ithacius).

Though there are rough parallels in early Christian sarcophagus sculpture for both the form of the lid and its ornamentation, there is no other piece precisely like it. Canthari with doves, wreaths, Christograms, and grape-

vines are common enough motifs in sepulchral art. The most closely related decorative motifs, in both the overall arrangement of the vines and the shape and structure of their leaves, are found on early Christian sarcophagi from southwestern France that can be dated to the first half of the sixth century.[1] The clear inscription would appear to support such a dating.[2] Since we know of nothing else like the Ithacius lid on the Iberian Peninsula, it is tempting to think that the work was imported from beyond the Pyrenees, though it is possible that it was carved in northern Spain but influenced by the art of southwestern Gaul.[3] Restoration undertaken in the center of nearby Gijón has brought to light three yellowish white marble fragments with the same braiding and leaf forms as those of the sarcophagus lid. The similarities are so remarkable as to suggest that they came from the same workshop—if, indeed, these are not fragments of the missing sarcophagus itself.[4] The Ithacius mentioned in the inscription is otherwise unknown; however, given the exquisite quality of his sarcophagus and especially its unusual inscription, he must have belonged to a distinguished family in late antiquity.

Ancient documents relate that the entire sarcophagus originally stood in the pantheon, or tomb chapel, of the Asturian kings in Oviedo. Even then it must have been reused as spolia. It may have been imported along with the countless other marble pieces used to decorate churches and palaces since the founding of Oviedo as a capital by Alfonso II in 785. It was not only the preciousness of the stone but above all the marbles' links with

tradition that made these pieces so attractive. They conjured up earlier epochs, before the Islamic conquest and the resulting establishment of the Asturian monarchy. It stands to reason that they should have been avidly imitated by stonecutters of the ninth century. The acanthus vines from the present piece were reproduced in simplified form, for example, on two vertical friezes for the palace basilica of Ramiro I on Mount Naranco, near Oviedo.[5] Thus we see, even before the Romanesque period,[6] how a late antique sarcophagus was utilized as a design source. The lid is now in the eighteenth-century church of Santa María.

TU/SN-H

1. Briesenick 1962, no. 71, pl. 25.1 (sarcophagus in Maguelonne).
2. See, for example, the related letters in the architectural sculpture of the Polyeuktos church in Constantinople, erected between 524 and 527: Frazer in Weitzmann 1979, pp. 640–47, fig. 96; Harrison 1989, ills. 86–88.
3. Schlunk and Hauschild 1978, p. 139. James (1977, vol. 1, p. 37) emphasizes some specific differences between this lid and Gallic sarcophagi, especially with regard to shape, and thus supports a Hispanic origin for this lid.
4. Fernández Ochoa, Encinas, and García 1989, pp. 677–79, fig. 5. The back sides of two pieces that fit together are described as being "smoothed, almost polished," their upper and lower edges chiseled to a thickness of 1⅜ in. (3.5 cm), which indicates a reworking for some second function.
5. Noack-Haley 1992, p. 174, figs. 1, 2, 4, 5.
6. Moralejo 1984, pp. 187–203.

LITERATURE: Amador de los Ríos 1877, pt. 1, p. 8 n. 1, p. 9; Miguel Vigil 1887, vol. 1, pp. 8–9, no. A 4°, and vol. 2, pl. A 11; Peirce and Tyler 1932–34, pls. 108–109a; Schlunk 1945c, pp. 193–94; Schlunk 1947a, p. 240, figs. 241, 242; Bovini 1954, pp. 164–67; Palol 1967a, p. 319, pls. 93.2, 94.2; Palol 1968b, p. 324, figs. 167, 170, 171; Schlunk 1968, pp. 441–42; Schlunk and Hauschild 1978, pp. 22, 138–39, pls. 30, 31 (with further citations).

sarcophagus fragment

Alcaudete (Jaén), early 6th century
Gray stone
22 x 48⅞ x 4⅜ in. (56 x 124 x 11 cm)
Museo Arqueológico Nacional, Madrid (309)

This is the front left side of a two-tiered sarcophagus. On the basis of the two surviving fragments, Helmut Schlunk has estimated that the sarcophagus was originally about 85 inches (220 cm) long and 30 inches (80 cm) tall.[1] The two relief sections were framed by a molding still visible along the top.

In the upper field is the Raising of Lazarus (John 11:1–45). Lazarus, wrapped in a winding-sheet, lies in his tomb, here suggested by an archway. Three men stand outside the tomb. Between them and Jesus, positioned to the left of a group of five apostles, lies Mary, one of Lazarus's two sisters. Like the other standing figures, Christ wears a long-sleeved tunic with two vertical stripes and sandals, while Mary is dressed in a long, pleated gown. Two of the men in front of the tomb hold their hands to their heads in anguish. Mary extends hers toward Christ in supplication. He holds out his right hand toward her, indicating that he is speaking to her.

Based on what survives of it, the lower scene—depicting the climax of the contest between David and Goliath (1 Samuel 17:51)—mirrors the arrangement of the field above it. Here the figures on the left, fleeing soldiers, represent the army of the vanquished Philistines. Facing them on the right are four warriors from the Israelite forces. In the open space between the two groups the youthful David bends over the dead Goliath to cut off his head. As in the Old Testament narrative, David wears no armor, only the simple garments and sling that identify him as a shepherd. Goliath wears a helmet. The men of both armies wear cloaks and helmets and are armed with shields and spears.

On the right Daniel is depicted in the lions' den (Daniel 6:16–25). A curved line indicates the pit. The prophet is seated on the floor with two lions behind him. Below and to the right are what appear to be parts of two more lions.

The style of this piece, with its elongated figures and very flat relief, is without parallel. The closest resemblances are found in two other Andalusian monuments: the Écija sarcophagus in Seville[2] and a relief slab from the Chimorra Mountains, northwest of Córdoba.[3] All three are local work and are impossible to date from their style alone. Datings suggested by scholars vary widely, but most probable is that put forward by Schlunk, who places them in the early sixth century.[4]

In his detailed study of the piece, Schlunk discussed each iconographic motif. After comparing them with numerous other versions, he concluded "that the sarcophagus betrays a familiarity with early Christian manuscripts. Whoever designed it obviously borrowed from compositions already worked out in miniatures, yet his choice of scenes is perfectly consistent with the iconographic programs of early Christian sarcophagi. The work is therefore quite unlike other sarcophagi from this early period."[5]

TU

1. Schlunk and Hauschild 1978, ill. 90.
2. Schlunk 1962, pp. 122–32.
3. Ibid., pp. 145–48.
4. Ibid., p. 151.
5. Ibid.

LITERATURE: Mélida 1908, pp. 24–25, ill. 26; Porter 1928, vol. 1, pp. 28–29, pl. 6; Schlunk 1945b, p. 241; Schlunk 1962, pp. 132–45, pls. 28–35; Palol 1967a, p. 315, pl. 94.1; Schlunk and Hauschild 1978, pp. 152–53, ill. 90, pls. 45a, 45b.

double window

Mérida (Badajoz), second half of 6th century
Gray marble
22⅞ x 34⅝ x 4⅜ in. (58 x 88 x 11 cm)
Museo Nacional de Arte Romano de Mérida, Ministerio de Cultura (461)

These two window openings were carved from a single rectangular marble slab. The decorated front side presents two horseshoe arches supported by a polygonal center pillar and pilasters on either side. The pilasters are each adorned with three trefoil designs in separate registers, the top register shorter than the two below in order for it to align horizontally with the capital of the smaller central support. The latter has been carved in imitation of a proper column, with the suggestion of a base, a shaft, a simple foliate capital, and an abacus ornamented in a zigzag pattern. A rope design between flat moldings frames the two horseshoe arches. Large trefoils with very long outer leaves fill the spandrels, and a palmette design embellishes the area between the arches.

The relief was fabricated to simulate chip carving; its execution was not especially precise, particularly the carving of the arches. The striking form of the trefoils in the corner spandrels is altogether unprecedented and may have been invented by the stonecutter himself to fill the empty space. By contrast, one is struck by the pleasing design of the center support. From it, and especially from the trefoils on the side pilasters, we can determine that the window dates from before the close of the sixth century. Similar trefoils decorate some of the large pilasters—also in Mérida—reused in the Islamic Alcazaba[1] and other monuments. Helmut Schlunk shows them to have been derived from the ornamental vocabulary of early Byzantine pilasters.[2]

This window was intended to be set into a church wall in a special spot, possibly in the apse. It was held in place by a crudely worked ridge along the top. There is no provision for the introduction of glass. In such surviving structures as San Pedro de la Nave[3] (Zamora) or Vera Cruz de Mamelar in Portugal[4] windows and their immediate surroundings were often singled out for decoration. Neither of these churches, however, has double windows or independently carved units such as this. The three-arched window from Niebla, also carved from a single block, offers a close parallel.[5] This double-arched window form was taken up and further developed in the Asturian architecture of northern Spain beginning in the ninth century.[6]

TU

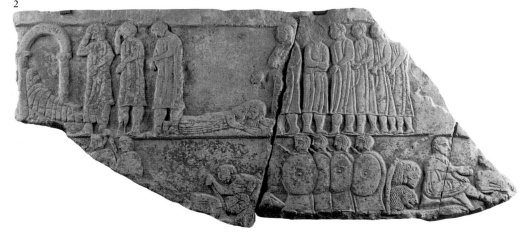

2

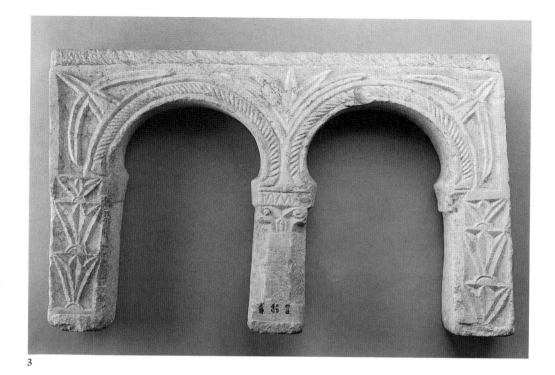

3

1. Palol and Ripoll 1988, ill. 133.
2. Schlunk 1964, p. 250, pls. 83d, 84b.
3. Schlunk and Hauschild 1978, pl. 130.
4. Ibid., pl. 114.
5. Camps 1963, p. 525, ill. 197.
6. See Schlunk 1947b, ill. 347 (San Tirso, Oviedo) and ill. 374 (San Miguel de Liño, Oviedo) for examples.

LITERATURE: Schlunk 1947a, p. 259, ill. 276; Camps 1963, p. 544, ill. 264; Cruz 1985, p. 263, no. 213.

4

PILLAR

Mérida (Badajoz), 7th century
Gray marble
80¼ x 13⅜ x 13⅜ in. (204 x 34 x 34 cm)
Museo Nacional de Arte Romano de Mérida, Ministerio de Cultura (447)

The pillar is decorated on all four sides, two of which are perfectly matched, the other two only approximately. Three sides present well-defined bases and capitals; the former are plain and topped by a strip of molding, while the latter all consist of two rows of schematic acanthus leaves and a flat abacus with volutes. On the fourth side in the place of these two elements are two panels filled with circular rosettes. Since these two panels are recessed, they probably represent a later revision.[1] Here, as on the opposite side, the pillar's shaft is adorned with a symmetrical vine motif, with two tendrils rising from a stylized trunk, undulating toward and away from each other, and ending in two leaves.

Alternating ridged and serrated leaves fill the spaces left in the center, while other foliate forms and volutes fill the remaining areas. The pillar's other two sides are divided by narrow horizontal moldings into four panels, each containing an identical palmette. In each case the bottom panel is larger than the rest, and in it the palmette rises out of a cantharus formed of leaves.

As in the Badajoz pillar (cat. 5), there are two degrees of stylization. The vine decor derives from more traditional motifs and stands in contrast to the quite abstract and highly stylized palmettes on the other sides, more likely based on patterns from textiles or handicrafts.

In Mérida, especially, a number of such pillars are preserved. The present one, for example, has an almost identical counterpart. Often material from destroyed Roman buildings, such as the soffit blocks of the theater in Mérida, were used as pillars. In those cases the size and form were thus predetermined. The pillars could not have been supports in Christian basilicas because of their modest height, quite apart from the fact that in basilicas in the region of Mérida columns were normally used as supports. It is thought that the pillars were originally used in porticoes, atriums, and other secular structures.[2]

TU

1. Cruz 1985, pp. 14–15.
2. See ibid., pp. 157–62 (this may be confirmed by a new excavation near the basilica of Santa Eulalia in Mérida).

LITERATURE: Palol 1968a, p. 96, ill. 15; Fontaine 1973, p. 141, pl. 41; Schlunk and Hauschild 1978, p. 189, pl. 86a; Cruz 1985, pp. 46–47, no. 11.

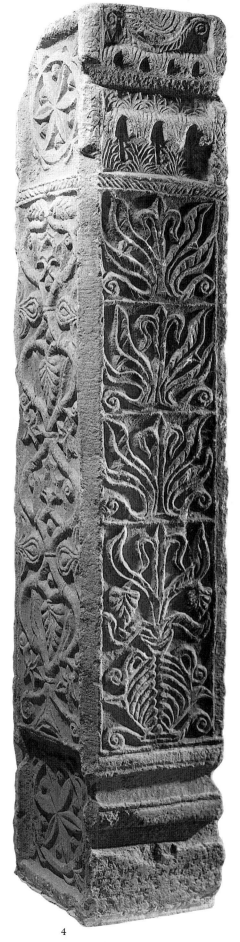

4

pillar

Badajoz (Badajoz), 7th century
Gray marble
63 x 16½ in. (160 x 42 cm), maximum d. 15¾ in. (40 cm)
Museo Arqueológico Provincial, Badajoz (901)

This pillar is decorated on all four sides, with the opposing ones virtually identical. The base section is smooth. One pair of opposing decorative panels has as its chief ornament four large circles formed by a simple winding band framed on the sides and top by a band of cording. The areas between the circles and the band at the edge are filled with small, stylized leaves. With one exception, in the circles themselves are opposing palmettes or veined leaves. The exception, the top circle on one side, contains a cross with arms of equal length—possibly an indication that this side was intended to be the prominent one. Each of the other pair of ornamented surfaces is divided into two vertical panels by a band of star-shaped flowers running down the center. Both panels are filled with alternating but not perfectly symmetrical combinations of floral motifs. At the top are two smaller crosses, again with arms of equal length.

The decoration is quite remarkable. Executed to simulate chip carving, it covers the entire surface of the stone. The botanical motifs display a strong tendency toward stylization. There is a striking discrepancy between the relatively naturalistic but crudely worked leaves and palmettes on the one pair of sides and the much more impressive forms of the stylized flower motifs on the other. The same discrepancy is found in the architectural decoration of the church of San Pedro de la Nave (Zamora; second half of the seventh century) and appears to suggest a break in the tradition of decorative sculpture in the Visigothic period, possibly occasioned by outside influences.[1]

There is another pillar in Badajoz almost identical to this one. To judge from their proportions and their modest height, they cannot have been the interior supports for a basilica, though the crosses in their ornamentation suggest their use in a Christian context. For possible functions of such pillars, see the remarks on the pillar from Mérida (cat. 4).

TU

1. Ulbert 1971, pp. 30–33.

LITERATURE: Schlunk 1944, ill. 13; Palol 1968a, p. 30, ill. 33; Fontaine 1973, p. 141, ill. 37.

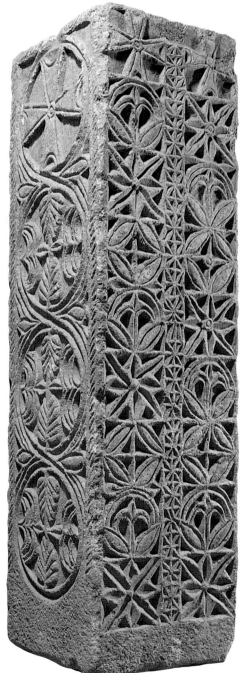

5

chancel screen relief

Salamanca (Salamanca), 7th century
Gray-white marble
32¼ x 18⅞ x 4⅜ in. (82 x 48 x 11 cm)
Museo Arqueológico Nacional, Madrid (57.764)

The back of the slab was left unworked and completely rough, whereas the sides were well polished. On one of these sides is the inscription MICAEL. Inside a smooth outer frame the front is divided into three panels by vertical and horizontal moldings ornamented with a honeycomb or fish-scale pattern. In each of the two tall rectangular panels at the bottom are vines with stylized leaves and grapes. The upper panel presents a large shell beneath a horseshoe arch decorated with cording. Trefoils adorn the hinge of the shell and the spandrels between the arch and frame.[1]

The relief was executed in chip carving. The stylized vines—the only element that helps date the piece—are highly decorative. Their closest parallels are found on church friezes in the province of Toledo, San Pedro de la Mata and Guarrazar, for example.[2] Similar vines may be seen as well in the newly discovered church of Santa Lucia del Trampal, Alcuéscar (Cáceres),[3] which also appears to date from the seventh century. A number of

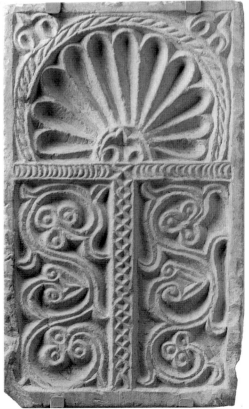

6

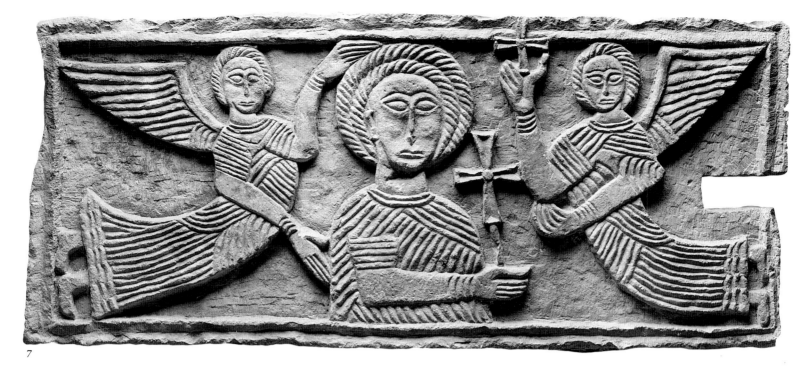

7

similar slabs are known, especially from the
Mérida region. One of them, with concave
vaulting, takes the form of a niche.[4]

There is some question about just what
function these monuments were intended to
serve, for none of them were found in their
original architectural setting. Helmut Schlunk
initially thought that similar slabs in Ravenna
were parts of Visigothic altars,[5] but boxlike
altars do not appear to have been common in
Hispanic churches at this early stage. The
Eucharist was celebrated on altar tables. All
such slabs have depictions of shells—a sym-
bol of majesty in the cult of the Roman
emperors —combined with gables and the
cross. This imagery later led Schlunk and
others[6] to suspect that such niche slabs were
placed in a special spot in the interior of a
church, possibly high up on the apse wall. If
so, they were meant to suggest the majesty of
Christ.

T U

1. Two almost identical slabs were discovered in the
 province of Zamora in 1985 (see Castellanos 1988,
 pp. 85–88).
2. Schlunk 1947a, p. 252. Illustrated in Schlunk 1970a,
 pl. 56.a–e.
3. Illustrated in Caballero 1989, p. 14.
4. Schlunk and Hauschild 1978, pl. 89.
5. Schlunk 1947a, p. 252.
6. Schlunk and Hauschild 1978, p. 69; Cruz and Cerillo
 1988, pp. 199–200.

LITERATURE: Schlunk 1947a, p. 252, ill. 263; Castellanos
1988, p. 87; Cruz and Cerillo 1988, p. 194, pl. 31.3.

7

RELIEF OF CHRIST
BETWEEN TWO ANGELS

*Church of Santa María, Quintanilla de las Viñas
(Burgos), late 7th century*
Stone
16½ x 36⅛ x 20½ in. (42 x 93 x 52 cm)
Church of Santa María, Quintanilla de las Viñas

This stone block has carving on just one side.
Centered in a panel bordered by a simple
molding is the bust of a man whose beardless
face is framed by a double wreath of hair. His
robe, draped in parallel folds, bunches up at
the neck in a tight collar. His right arm—the
only one visible—is set quite low on his body
and bends across his chest. In his right hand
he holds a short staff topped by a cross with
short side arms. This figure is flanked by
hovering angels dressed just as he is, but with
their hair forming a single wreath around
their heads. Both have wings; just one each is
visible. They are shown in full-figure, and the
wavy hems of their gowns and their feet can
be seen. They differ only in the positioning
of their arms and hands. The one at the left
places one hand on the head of the central
figure, the other hand on his body. The one
at the right carries a cross in his right hand
and appears to be supporting his right elbow
with his left hand.

It is necessary to consider this stone block—
no longer part of the church fabric—and its
counterpart, on which two angels flank a
female figure, in the context of all of the
figural reliefs from the church of Santa María.
There are today in situ two similar squared

stone imposts supporting the springing of
the apse arch.[1] Their front sides present scenes
comparable to the present relief and its coun-
terpart, only there the central busts are
replaced by round shields containing personi-
fications of the sun (Sol) and the moon
(Luna). Since the eastern section of the church
with its apse and transept is all that remains
of the church, it is tempting to think that the
present stone and its counterpart once served
as the corresponding supports for the arch
separating the transept from the nave. The
four reliefs were surely parts of a unified
iconographic program. Sol and Luna suggest
the eternity of the kingdom of God. Higher
up, still embedded in the wall above the apse
arch, is a relief block with the bust of a
bearded Christ giving benediction. Two ad-
ditional stone blocks preserved in the church
bear busts of apostles and are unquestionably
related to this image of Christ.

Most scholars have assumed that the pres-
ent relief represents Christ being borne aloft
by angels, and there is certainly ample prece-
dent for such an image. One thinks, for
example, of the Barberini Diptych in the
Musée du Louvre, an early Byzantine ivory
on which Christ again appears in association
with the sun and the moon, holding a cross
as a scepter and borne upward by angels.[2] In
the present work Christ is seen as a young
man, without a cross-shaped nimbus, in de-
liberate contrast to the mature, bearded Christ
above the apse arch, which is based on a
different iconographic tradition. Helmut
Schlunk, who in his earlier works treated the
figure between the two angels as Christ,
ultimately concluded—though for no pro-
found reason—that it is a saint instead.[3]

In terms of style, the architectural decoration of the church of Santa María has been compared, quite rightly, with that of the church of San Pedro de la Nave (Zamora).[4] The same low-relief figures with linear drapery are seen on a capital in Córdoba with busts of the evangelists (cat. 8).[5] There too the figures are reminiscent of book illumination (Biblia Hispalense), and the capital can also be dated to the seventh century.

TU

1. Arbeiter 1990, p. 413.
2. Illustrated in Volbach 1958, pl. 219.
3. Schlunk and Hauschild 1978, pp. 232–33.
4. Ibid., pp. 225–27, pls. 126–38.
5. Ibid., pls. 92, 93.

LITERATURE: Schlunk 1947a, pp. 299–306, ill. 321; Camps 1963, pp. 635–59, ill. 428; Schlunk and Hauschild 1978, pp. 230–34, pl. 148; Palol and Ripoll 1988, pp. 151–52, ill. 113.

8

capital

Córdoba (Córdoba), 7th century
Marble
H. 13¼ in. (35 cm)
Museo Arqueológico Provincial de Córdoba

This capital, with two tiers of leaves supporting the corners of the abacus, has suffered considerable damage, having been horizontally broken or cut into two pieces, which, however, have been fitted together again. In addition, the four evangelist symbols that occupy the sides of the capital were probably defaced deliberately during the Islamic period. (The virulent aniconism of the Almoravid dynasty even affected some caliphal works, such as the capital with four musicians in Córdoba [cat. 31]). The general shape of the piece and the floral decoration on the calathus and abacus (including the characteristic abacus flowers) have Visigothic parallels from the seventh century and determine the dating of the capital.[1]

These are the earliest known artistic representations on the Iberian Peninsula of evangelist symbols with human bodies and animal heads. The bust-length figures appear to be dressed in tunics, whose folds, lying in parallel curves, create a degree of plasticity. The tunics vary—that of the symbol of Saint Matthew having a knot on the shoulder—and reveal the influence of painted or drawn models.[2] The Saint Luke and Saint John symbols sport wings, and they all have nimbi except for Saint Luke. While Saint Matthew's hands are not visible, the others hold an open or closed book in their left hands. Saint John's name, IOHANNES, is inscribed on his book, identifying it unequivocally as his

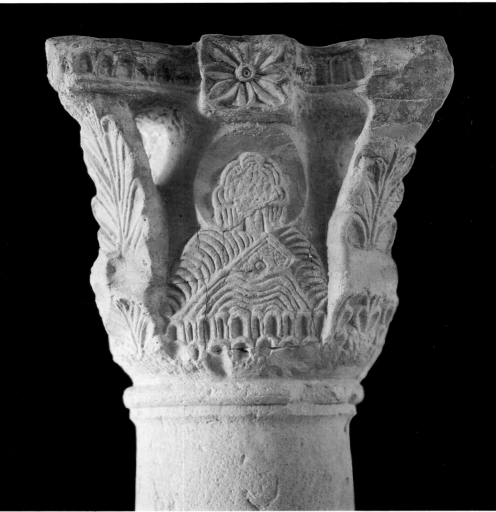

8

Gospel, and his right hand is lifted in a gesture either of pointing to the text or of some other significance, such as acclamation (depending on the further iconographic program the capital fitted into). Representing the beasts described by Saint John in Apocalypse (4:6–8) and the tetramorph described by Ezekiel (1:5–14) as busts can be traced back to the late fourth-century apse mosaics of the church of Santa Pudenziana, Rome. From the second half of the fifth century, they always carry books, which identifies them as the evangelists' symbols (rather than the Gospels themselves, as in the writing of Saint Jerome). As early as 494–519, they appear on a capital from Constantinople in Ravenna.[3] Their half-human, half-beast version, though, cannot be confirmed before the seventh century.[4]

Whereas the approximately contemporaneous full-figure evangelist symbols from the church of San Pedro de la Nave are stylistically quite distant from those on the Córdoba capital,[5] the reliefs from Santa María de Quintanilla de las Viñas (cat. 7) share more details, although they are more coarse.

The half-human, half-animal motif can be

traced further on the Iberian Peninsula: In the mid-ninth century it is documented at Ramiro I's palatine church, San Miguel de Liño, at Mount Naranco near Oviedo,[6] whose column bases have the most closely related surviving reliefs, though their execution is much more crude.[7] About the turn of the ninth century two Asturian metal caskets (cats. 70, 71) show variations on the symbols that offer immediate links to the rich Apocalypse illustrations of the tenth century. Thus the evangelist symbols in Apocalypse manuscripts—thanks to monuments such as the Córdoba capital—ultimately might have been derived from now-lost Visigothic book illumination, which transmitted the models for sculptors.

SN-H

1. Schlunk and Hauschild 1978, p. 193.
2. Schlunk 1945b, especially pp. 247–49; Werckmeister 1963a, pp. 159–63, especially p. 160.
3. Deichmann 1989, p. 309.
4. Schlunk 1945b, pp. 259ff.
5. Schlunk 1970b, pp. 245–67.
6. See the essay by Achim Arbeiter and Sabine Noack-Haley, this catalogue.
7. Schlunk 1947b, fig. 380.

LITERATURE: Schlunk and Hauschild 1978, pp. 104, 193, pl. 92a, b.

liturgical ewer

Spain, 7th century
Cast bronze
H. 10 in. (25.5 cm)
Instituto de Valencia de Don Juan, Madrid (2960)

This bronze liturgical ewer was cast in two parts, body and foot. Its body is ovoid, and its slightly flared neck and foot are conical. The lip features a series of horizontal linear moldings, which occur in greater number on the foot. The ewer is richly decorated with ornamental bands, and in the central zone of the neck are marks that can be interpreted as monograms:

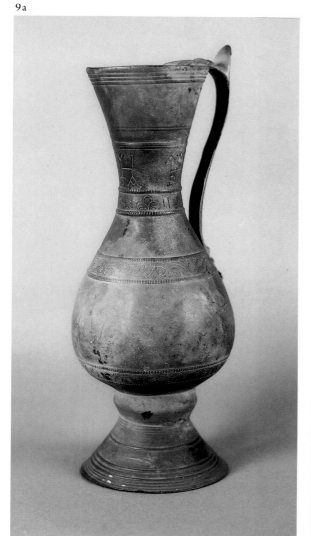

The first sign is perhaps a cross; next are a rho and an omega or possibly a proper name; then *vita* and *amen*—in short, an inscription of invocation or acclamation related to the liturgical function of this type of ewer. Below

this central band with an inscription is another ornamental register, framed by two corded lines. The decoration within this band consists of fleurs-de-lis separated by two vertical lines.

On the upper part of the body of the ewer, there is another ornamental band demarcated by corded lines, within which is a stylized design of engraved tendrils. The band of decoration on the lower part of the body also is composed of stylized vegetal forms— primarily fleurs-de-lis—but the incising is shallower than that of the neck band with fleurs-de-lis. The S-shaped handle of the ewer is intact, with schematized vegetal decoration occurring at each end and, in the center, a pattern of broad vertical fluting enclosing a central cordlike element.

This ewer fits into Pedro de Palol's type 5, which, however, includes diverse vessels, none of which are alike or form a homogeneous whole. The present ewer is probably among the latest of the surviving Spanish Visigothic liturgical bronzes. While the exact place where these bronzes were produced remains to be

determined, it appears that they were made by several workshops located principally on the Castilian meseta, on the Mediterranean coast, and in Baetica. G R L

LITERATURE: Palol 1950a, pp. 78–79, 100, n. 32, pl. XXXVIII; Schlunk and Hauschild 1978, p. 200, fig. 115b, pl. 99b.

9b

liturgical paten

Spain, second half of 7th century
Cast bronze
Diam. 6¾ in. (17 cm)
Instituto de Valencia de Don Juan, Madrid (2966)

This circular, cast-bronze liturgical paten has a hollow elongated handle, which is now detached. The handle's central zone is ornamented with a series of linear schematized leaf designs surrounding a stylized ram's head com-

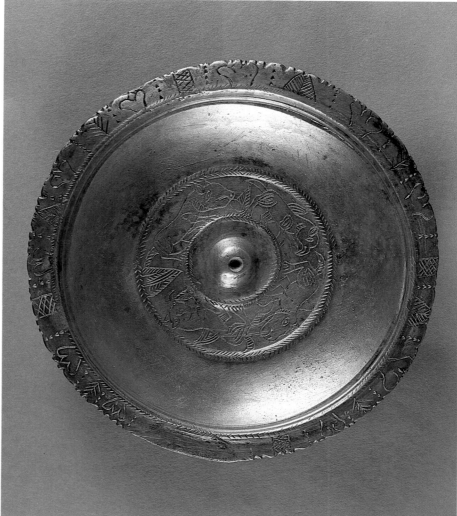

9a

9b

plete with horns. The point of union between the handle and the circular part of the paten is marked by a schematized trifoliate design. At the very center of the paten is a small, raised umbo encircled by a decorated band set off by cordlike molding. The decoration in this band features four quadrupeds, in alternating pairs. Two of them are clearly griffins, for each has the beak of a bird, lion's claws, and wings. The other two creatures are more difficult to identify: one also may be a griffin, for it seems to be winged, but its snout or muzzle is disproportionately large; the other is perhaps a wild boar—an animal often included in representations of the hunt in late antiquity. Furthermore, combat between carnivorous and feline animals such as these is a common motif in Christian iconography, signifying the struggle between good and evil.

The widest register of the paten, which was left plain, fills the area between the ornamented center and the outer rim. The latter contains a stylized vegetal design of alternating palmettes; tendrils; small, confronted volutes; and rectangles bearing a crosshatched pattern. Each of these elements is separated from the adjoining element by three vertically aligned dots.

The bronze paten corresponds to Pedro de Palol's type 1 of Spanish Visigothic objects. Textual sources relate that patens and ewers were used to hold water and wine, thus fulfilling a specific liturgical function in celebration of the Eucharist. Archaeological evidence, however, has not confirmed with absolute certainty such a function, since these objects, except in very rare cases, have not been found together in a church context. The workshops that made liturgical objects like these were active throughout the seventh century in various regions of Spain and must have been closely related—if not identical—to those operated by the artisans who produced the small articles of personal adornment that were so popular at the time. A comparison of the ornamentation on liturgical and personal objects reveals that a perfect homogeneity prevailed at the end of the sixth century, which persisted throughout the seventh century as well. The decorative motifs found on the paten, common during that period, were derived from a repertoire that was especially well known in late antiquity in all the Roman provinces and apparent in mosaics, paintings, textiles, objects of personal adornment, as well as the medallions on harness pendants. Symmetrical designs—especially of confronted animals—were frequently utilized in the work of Burgundian artisans, and these motifs, along with their craft, were exported to Spain.

GRL

LITERATURE: Palol 1950a, pp. 90–91, 104, 117–21, n. 12, fig. 26, pls. LII, LIII; Schlunk and Hauschild 1978, pp. 199–200, fig. 115c, pl. 99a; Palol 1990.

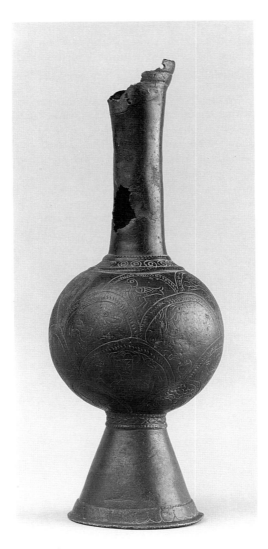

10

LITURGICAL EWER

Balbarda (Ávila), end of 7th or early 8th century
Cast bronze
H. 8⅞ in. (22.6 cm)
Museo Provincial de Ávila (M.414)

The long, virtually cylindrical neck of this bronze liturgical ewer has a broken lip. The vessel's spherical body is richly decorated with incised contiguous semicircular arcs, each of which is outlined, and thus made more prominent, with a bold rope design. Within the arcs are various highly stylized ornamental motifs, including trees of life, birds, felines, and frontal bust-length human figures. The conical foot of the vessel is decorated with a band of incised concentric semicircles along its lower border. Both the foot and the neck are set off from the body of the ewer by bands of incised geometric designs.

The ewer from Balbarda is an example of the persistence of Visigothic liturgical bronze

types into the Mozarabic period, although it reflects certain caliphal influences as well, primarily in the decoration. Despite its relatively late date—the end of the seventh or early eighth century—research suggests that this ewer belongs to or derives from type 3 of Pedro de Palol's Spanish Visigothic classification system, a group that displays the strongest Roman influence, as seen here in the vessel's resemblance to an unguentarium, or ointment jar. This group of post-Visigothic liturgical bronzes, both Mozarabic and caliphal, bears witness to the continuity of the eucharistic and baptismal liturgies. On the other hand, it is possible that these bronzes originated in a Coptic center, reaching the Iberian Peninsula by way of Mediterranean or Alpine commercial routes. The importation—and, later, the imitation—of such Coptic bronzes in Visigothic workshops has permitted scholars to localize several areas of production, centered principally in the Asturias-León region of Spain and probably also in Baetica. However, this does not preclude the existence of itinerant artisans.

Mozarabic and Romanesque miniatures—for example, those in the Beatus manuscript in Girona Cathedral (cat. 80) and in the antiphonary in León—ornamental sculpture, and archaeological discoveries have facilitated the identification of surviving Visigothic liturgical objects in later periods.

GRL

LITERATURE: Palol 1950a; Palol 1956b, p. 45, n. 28; Palol 1961–62, fig. 4; Mariné and Terés n.d.

11

LITURGICAL INCENSE BURNER

Church of El Bovalar, Serós (Lleida), second half of 7th century
Cast bronze
H. 8½ in. (21.5 cm), diam. 4⅛ in. (10.5 cm)
Fundació Pública, Institut d'Estudis Ilerdencs, Lleida (L–2116)

This incense burner was found during the excavation of the church of El Bovalar in the modern province of Lleida, along with other liturgical objects from that church. Its lid and the chains were discovered in the area of the presbytery, or choir, and the bowl, at the foot of the nave. The object was uncovered in strata corresponding in date to the time of

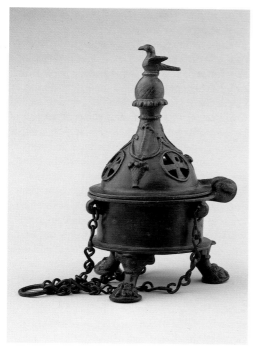

11

the church's destruction—the beginning of the second decade of the eighth century.

The incense burner is made up of three discrete parts. The three chains from which it was suspended are composed of figure-eight or double-loop links, attached to three forged rings on the bowl of the censer. The bowl itself is cylindrical and without decoration except for prominent moldings at the lower and upper borders, and it rests on three small feline paws with incised decoration. A hinge connects the bowl with its ornate lid, the hemispherical part of which is decorated with three circles. Each circle consists of a corded border enclosing a stylized openwork monogram representing Christ—the overlapping Greek letters chi and rho—with a tiny incised circle at the center. In the spaces between the circles are three baskets, probably containing bread. A swagged cordlike decoration terminating in fleurs-de-lis completes the ornamentation of this area. The lid is topped by a reticulated pinecone, upon which sits a dove with outspread wings.

What is archaeologically significant is that the incense burner from the church of El Bovalar was discovered within the context in which it was used. In addition, its perfect state of preservation makes it practically unique among seventh-century liturgical objects from the Spanish Visigothic period. It was almost surely made in one of the Coptic or Italian workshops that distributed its wares throughout the Mediterranean region.

GRL

LITERATURE: Palol 1950a; Palol 1956b, p. 45, n. 28; Palol 1961–62, fig. 4; Mariné and Terés n.d.

NOTES ON THE GUARRAZAR TREASURE

The year 1858 marked the date of one of the most important finds of Visigothic treasures. In Huertas de Guarrazar, the so-called Guarrazar Treasure was discovered by chance by a retired French officer living in Spain, Adolphe Hérouart. The first fourteen crowns unearthed were of cast bronze, but later excavations uncovered another eight votive crowns, all of them of gold set with precious stones. One year after that treasure was found, it was acquired by the Musée de Cluny, Paris. The news reached Spain, resulting in further excavations by José Amador de los Ríos on behalf of the Real Academia de Bellas Artes de San Fernando, Madrid. Four more crowns were discovered. Despite the outrage of the Spanish, yet another of the crowns found its way to the Musée de Cluny. The remaining three were given to the Real Armería in Madrid, but two of them were stolen in 1921 and have never been recovered. In 1940 Spain and France—specifically, the governments of Francisco Franco and Philippe Pétain—agreed to an exchange of national treasures. Most of the crowns from the Guarrazar Treasure were returned to Spain through the intervention of the Museo del Prado. Although three crowns remained in France, since 1943 the others have been part of the collections of the Museo Arqueológico Nacional, Madrid.

One of the votive crowns stolen from the Real Armería was of supreme importance for establishing the chronology of the treasure. A series of letters (very similar to those on the Recceswinth crown [cat. 12a]) were suspended from the band of that crown, spelling out +SU[IN]T[H]IL[A]NVS REX OFFE[RE]T (King Swintila gave this). Thus, we know that the crown was presented by the Visigothic king Swintila, who reigned from 621 to 631. Together with the crown of Recceswinth—he ruled from 653 to 672—the stolen crown established a chronology for the entire treasure that, while not absolute, afforded an approximate date for the objects. What is certain is that they all belonged to the same church and were hidden as a precautionary measure in light of the imminent threat posed by the arrival of the Muslims in 711.

The use of votive crowns to decorate the altars of churches was customary in the Byzantine world in the seventh century. Documents reveal that the practice was widespread throughout the Visigothic kingdom by the time of Recared's reign and that after 589 and his conversion to Catholicism, he offered a gold crown in the name of Felix, the martyr of Girona, which later, sources tell us, the usurper Paulus placed upon his own head when he rebelled against royal authority.

These votive crowns and processional crosses, in general, were offerings made to a church on behalf of specific rulers, although courtiers and sometimes abbots made such offerings as well. This is borne out by the two royal votive crowns of Swintila and of Recceswinth; another given by a person of high rank—possibly Sonnica; and lastly the crown of the abbot Theodosius, inscribed +OFFERET MUNUSCULUM SCO STEPHANO THEODOSIUS ABBAT (This small gift was given to Saint Stephen by Abbot Theodosius).

The Guarrazar Treasure, like the treasure of Torredonjimeno, found in ancient Baetica (Jaén), confirms the artistry of Visigothic court goldsmiths. A perfect blending of Roman traditions with those of the Byzantine East produced a royal art of superior quality. The Byzantine influence is evident when we compare the Guarrazar Treasure—the crowns, crosses, and the processional cross—with the Theodolinda Treasure, dated to about 600, in the cathedral treasury in the Italian city of Monza or with the famous cross from the treasury of the Sancta Sanctorum, formerly in the Vatican.

GRL

LITERATURE: Lasteyrie 1861; Amador de los Ríos 1861; Madrazo 1879; Sommerard 1883; Lázaro 1925; Lozinski and Lozinski 1976, pp. 379–92, fig. 8; Schlunk and Hauschild 1978, pp. 201–4; Caillet 1985, pp. 218–27, nn. 153–61; Palol and Ripoll 1988, pp. 262–75; Alonso 1988.

12a

RECCESWINTH CROWN

Huertas de Guarrazar (Toledo), second half of 7th century
Gold, garnets, pearls, sapphires, and colored glass
H. 4 in. (10 cm), diam. 8⅛ in. (20.6 cm)
Museo Arqueológico Nacional, Madrid (653.72)

The Recceswinth crown, one of the most famous objects from the Guarrazar Treasure, has five distinct components: an upper part securing the chains by which the crown itself is suspended; the chains; the hoop of the crown proper; pendent letters; and a pendent cross, which merits separate consideration. The upper part consists of two gold fleurs-de-lis, opposed at their stems; atop them is carved rock crystal resembling a column capital. Elaborate pendants consisting of gold beads, pearls, and small sapphires strung on gold wire are suspended from each petal of the fleurs-de-lis. The four chains are attached to the center of the fleurs-de-lis and to the

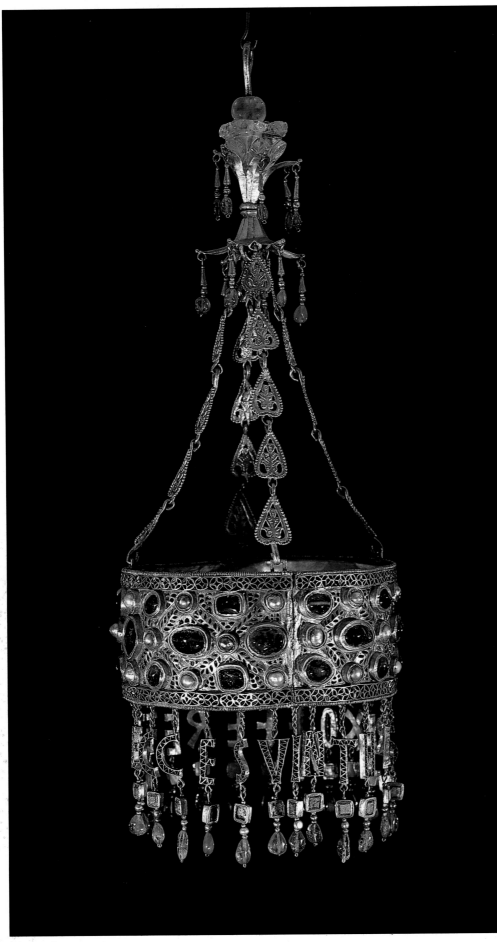

hoop of the crown by means of quadrangular links; the five filigree elements that make up each of the four chains are in the shape of pear leaves. The crown itself is composed of two hinged, semicircular bands, each formed of two sheets of gold and profusely decorated: the registers marking the upper and lower edges of the hoop of the crown are bordered by gold fillets, within which are tiny tangential circles of gold filigree filled with red glass. The wide central zone of the bands contains a series of pearl, sapphire, garnet, and colored-glass cabochons of different shapes and sizes. The gold into which the cabochons are set is characterized by decorative openwork patterns, reminiscent of stems or petals, that constitute geometric forms with strongly defined diagonals. A series of short chains bearing pendent letters are suspended from the lower edge of the crown. Each of these letters is of gold filigree whose triangular design is filled in with garnet-colored glass; beneath the glass is paste and a thin layer of gold to increase the brilliance. From each letter, a ring, a square cabochon, and an ovoid stone, in turn, hang. The letters spell out RECCESVINTHUS REX OFFERET (King Receswinth gave this), naming the individual who commissioned the crown. Finally, suspended from a chain attached to the upper fleurs-de-lis is a cross of gold and precious stones (not attached in this photograph).

The votive crown may be dated with precision between 653 and 672, the period of King Receswinth's reign, and is a supreme example of the high level achieved by Toledo court goldsmiths. The crown's decoration gives coherence to the other objects in the treasure—especially to the processional cross, whose ornamentation is virtually the same. This is one of the finest of all royal votive crowns, incorporating the traditions of Roman goldsmiths' work and those of the Byzantine Empire, which were widespread throughout the Mediterranean region.

The crown was formerly in the collection of the Musée de Cluny, Paris. G R L

LITERATURE: Amador de los Ríos 1861, pp. 92–95; Lozinski and Lozinski 1976, pp. 379–92, fig. 8; Schlunk and Hauschild 1978, pp. 202–4; Palol and Ripoll 1988, pp. 264–73, fig. 215.

12b

pendent letter R from the receswinth crown

Huertas de Guarrazar (Toledo), 7th century
Gold, garnets, pearl, sapphire, and colored glass
H. 3¼ in. (8.4 cm)
Musée National du Moyen Âge, Thermes de Cluny, Paris
(CL 2878)

12a

12b

This capital letter *R* hung from the crown of the Visigothic monarch Receswinth (cat. 12a), which was part of the Guarrazar Treasure. The crown itself was in the Cluny collection until 1940. Like the crown's other pendent letters, which form the phrase RECCESVINTHUS REX OFFERET (King Receswinth gave this), this *R* consists of a gold base with triangular-shaped cloisons filled with almandines set in paste. A small ring at the bottom of the letter holds a square collet that must have been set with a precious stone, now lost. From this collet are suspended three small beads, two gold and one pearl, and an oval sapphire.

The date for the letter is determined by Receswinth's reign, that is, between 653 and 672.

GRL

LITERATURE: Lozinski and Lozinski 1976, pp. 379–92, and figs.; Caillet 1985, p. 224, n. 157.

12c

VOTIVE CROWN

Huertas de Guarrazar (Toledo), 7th century
Gold, sapphires, emeralds, pearls, rock crystal, and amethysts
Diam. 6⅝ in. (16.8 cm)
Musée National du Moyen Âge, Thermes de Cluny, Paris
(CL 2879)

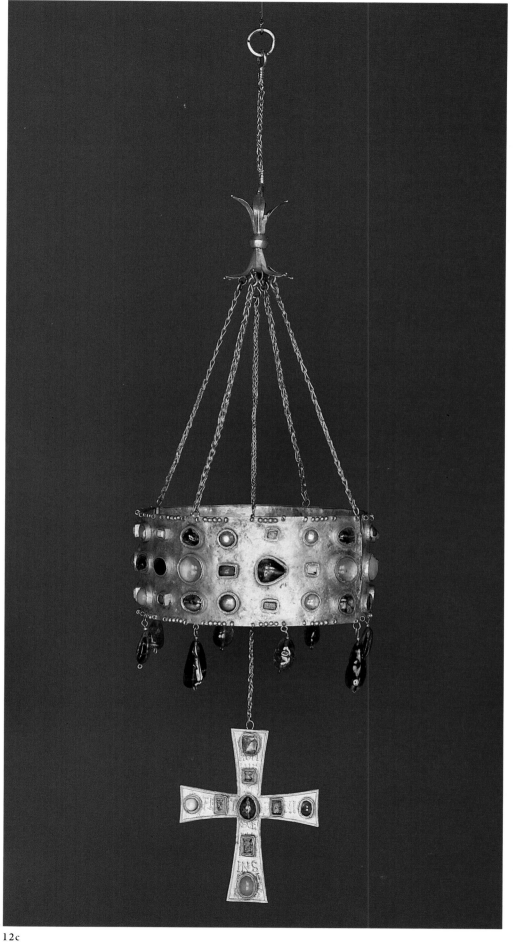

12c

In 1859 this crown entered the collection of the Musée de Cluny, Paris. Although it had been part of the Guarrazar Treasure, it was not returned to Spain through the accord of 1940.

This is an ensemble consisting of three parts: the chains from which the crown is suspended, the band of the crown itself, and a pendent cross. The entire piece hangs from a single chain ending in a large ring attached to a double fleur-de-lis, to which in turn are attached four chains. These last chains are joined to the band of the crown by means of small soldered rings.

The crown itself is formed by two hinged gold bands. Both the upper and lower edges are bordered by a continuous row of small gold beads. Seven sapphires and one ovoid amethyst are suspended from the lower edge of the crown. The smooth bands of the crown are ornamented with three horizontal rows of alternating (oval, rectangular, square, and circular) cabochons. These rows are perfectly balanced, and the stones—sapphires, emeralds, pearls, and amethysts—are set in conventional collets.

From the fleur-de-lis above the crown hangs a fifth chain to which a gold cross is fastened by a small ring. This cross is Latin in type. On one of its sides are nine irregular collets set with precious cabochon stones. The surface of the other side of the cross is filled with an inscription of several lines: IN D[OMIN]I/ NOM/INE OFFERET/SONNICA/S[AN]C[T]E/ MA/RIE/IN S/ORBA/CES (In the name of God Sonnica offers [this] to Saint Mary in Sorbaces).

"Sorbaces" is not a place name but a descriptive designation—that is, an area of *serbales*, or sorb trees. This allows us to establish the origin of the crown as Toledo, where there are many such trees. The personal name Sonnica does not refer to a Visigothic monarch; it may refer to an individual of high rank in the Toledo court during the reigns of Swintila and Receswinth, the epoch during which the Guarrazar Treasure was formed, that is, the early and middle years of the seventh century. GRL

LITERATURE: Amador de los Ríos 1861, pp. 95–99; Caillet 1985, p. 224, n. 157.

This cross—one of five from the Guarrazar Treasure—is associated with one of the latticework crowns that were transferred to Madrid after the agreement of 1940. It is a Latin cross with slightly flaring arms. Its braided chain—attached by a loop to the eye soldered to the top of the cross—terminates in a hook that originally connected with the metal fleur-de-lis from which the crown was suspended by chains. The cross's chain—longer than those holding the crown—allowed the cross to hang below the crown while centered within its circumference.

Apparently the cross was made from a single sheet of gold with smooth gold strips soldered to the edges of both the front and

12d

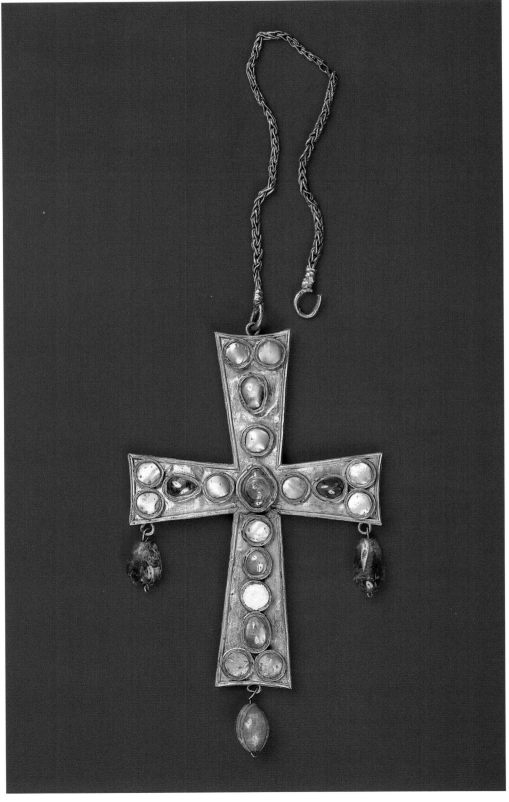

12d

VOTIVE CROSS

Huertas de Guarrazar (Toledo), 7th century
Gold, sapphires, mother-of-pearl, amethysts, and jasper
7¼ x 4¼ in. (18.4 x 10.8 cm)
Musée National du Moyen Âge, Thermes de Cluny, Paris
(CL 2880)

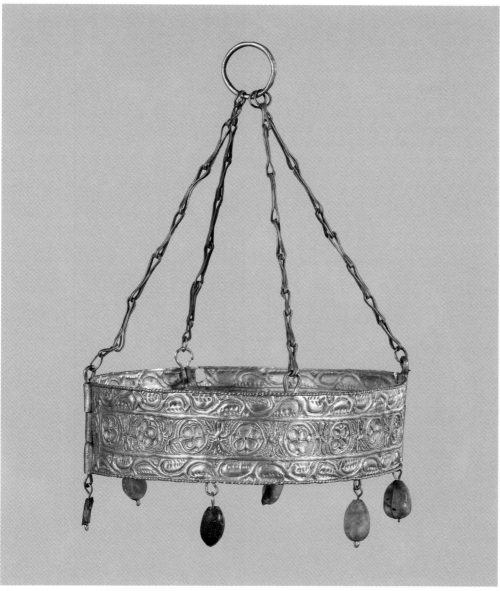

12e

Part of the Guarrazar Treasure, this votive crown (today in the Museo Arqueológico Nacional, Madrid, but formerly in the Musée de Cluny, Paris) is suspended from four chains of filiform links attached to small rings set into the semicircular bands that form the hoop of the crown proper. These two bands, containing identical symmetrical vegetal ornamentation, are articulated by means of a hinge, in which a gold pin is inserted. The central register of the crown is decorated with four-petaled fleurons, each with a prominent central boss, inscribed within a circle, alternating with a second type of floral element also composed of four petals. Framing these floral motifs above and below are undulating rows of leaves. A series of small stone pendants is attached to the lower edge of the crown.

This is one of the simplest, although no less interesting, votive crowns. It does not bear intricate decoration, nor is it embellished with precious cabochons, but its simple pattern of vegetal ornamentation is typical of the seventh-century style. These vegetal motifs, found throughout areas of Roman as well as Byzantine influence in the Mediterranean, were copied by Spanish Visigothic metalsmiths.

It is not known whether a cross was originally suspended from this crown, as was customary on other crowns, or whether at one time the crown bore the name of the donor. Unlike the Receswinth crown (cat. 12a), the present crown had no letter pendants, as there are no rings from which they could have been suspended. Therefore, if the crown did include the name of the person who commissioned it, it would have appeared on a suspended cross.

GRL

LITERATURE: Amador de los Ríos 1861, p. 101; Palol and Ripoll 1988, p. 273, fig. 63.

the back, making a continuous border. Both the front and back are decorated with cabochon stones cut in low relief and mounted in grooved settings. A central sapphire is flanked by settings containing mother-of-pearl and additional sapphires, with double settings of mother-of-pearl at the end of each arm. The lower cross stem follows the same pattern but has an additional mother-of-pearl and sapphire placed before the double settings of mother-of-pearl. At the end of each transverse arm an amethyst is suspended by means of a hook and eye. To the foot a gray-green and orange jasper is attached in the same manner.

The gold, pearls, and sapphires of this cross relate it to the Byzantine imperial tradition[1] and to the Byzantine tradition of gemmed crosses. The practice of suspending gemmed crosses from votive crowns—the

origin of which is generally attributed to Constantine the Great—has a long history in both the East and the West.[2]

KRB

1. Brown 1979, p. 57.
2. Brown 1984, pp. 11–13.

LITERATURE: Caillet 1985, p. 223, no. 156.

12e

VOTIVE CROWN

Huertas de Guarrazar (Toledo), 7th century
Gold and precious stones
Diam. 4½ in. (11.3 cm)
Museo Arqueológico Nacional, Madrid (71.205)

12f

ARMS OF A PROCESSIONAL CROSS

Huertas de Guarrazar (Toledo), 7th century
Gold, sapphires, emeralds, pearls, mother-of-pearl, and amethysts
Each, l. 8⅝ in. (22 cm)
Museo Arqueológico Nacional, Madrid (52.561)

These lateral arms of a processional cross belonged to the Guarrazar Treasure, found in the province of Toledo.

The gold arms were worked in repoussé, pierced, and set with cabochon stones. They must have once overlaid the wood core of

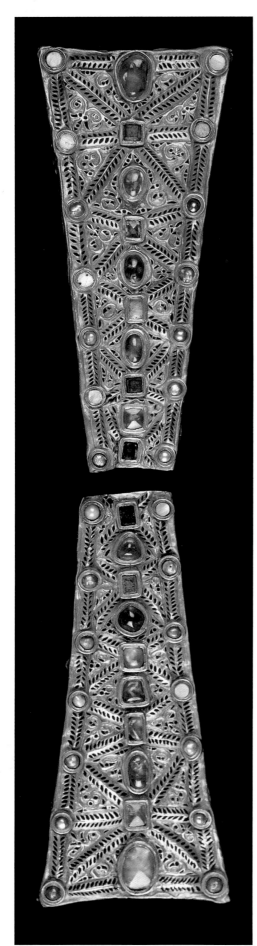

the cross. It is probable that the extremely elaborate and rich decoration covered the front of the cross, while the back was covered by a smooth sheet of gold. Along the outer edges of the arms are set fourteen circular collets, nearly all of which retain their stones. Among the cabochon stones are sapphires, emeralds, mother-of-pearl, pearls, and colored glass. A third row of stones marks the longitudinal axis of each arm. These stones are of various shapes—alternately rectangular, oval, and square—lending a symmetry to the whole. All the cabochons along the edges and the line of the central axis are linked by bands of gold pierced in the motif of a stylized sprig of wheat. The triangular areas defined by the bands are filled with stylized foliage motifs that are difficult to read.

These arms are an example of the outstanding technique of the goldsmiths at the court of Toledo. They were crafted in the seventh century, a date confirmed not only by the fact that they are an integral part of the Guarrazar Treasure but also by the style of the piercing and type of paste used to set the cabochon stones. The stylized plants appear in such other pieces as lyre-shaped belt buckles, where they are often combined with bird protomes. Characteristic of seventh-century attire, these buckles were distributed throughout the Visigothic kingdom of Toledo. In addition, the arms of this cross display exactly the same techniques of fabrication, pierced decorative motifs, and cabochons as the Recceswinth crown included in the Guarrazar Treasure (cat. 12a). Even if all the pieces in the treasure were not made by the same artist, they certainly originated in the same workshop.

GRL

LITERATURE: Amador de los Ríos 1861, pp. 123–24; Lozinski and Lozinski 1976, pp. 379–92, and figs.

12g

VOTIVE CROWN

Huertas de Guarrazar (Toledo), 7th century
Gold, mother-of-pearl, sapphires, amethysts, emeralds, pearls, and colored glass
Maximum diam. 5⅛ in. (13 cm)
Musée National du Moyen Âge, Thermes de Cluny, Paris (3211)

This crown from the Guarrazar Treasure consists of two well-defined parts. The first comprises the three chains from which the crown itself—the second major component—is suspended. The chains are made of large circular links joined to one another by figure-eight

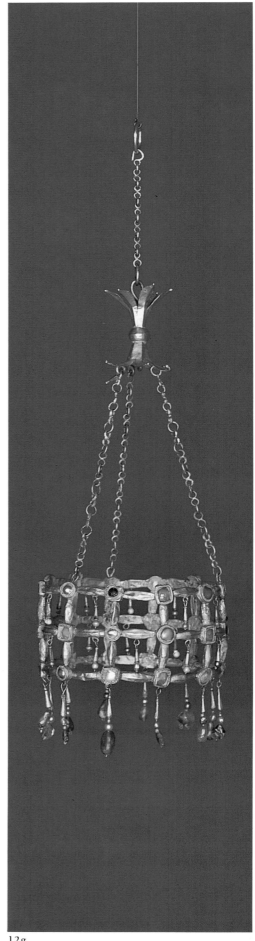

12f

12g

links. These chains hang from a twelve-petal, double fleur-de-lis, which itself is suspended from a short chain. The band is attached to the chains by means of rings soldered to its border. Unlike the other crowns from the Guarrazar Treasure, this crown is composed of a grid or lattice of gold tubular elements in two registers studded with cabochon stones at the junctions of the elements. The collets in which precious stones are set are square or round. Pendants, each consisting of an elongated conelike element and a single pearl, attach by means of small rings to the horizontal elements and hang in the center of each square. From the lower border of the band is suspended a series of similar but longer pendants ending in a gold bead, a pearl, and an ovoid stone. Formerly a Latin cross (now in Madrid), cut from gold plate and ornamented with cabochon stones and pendants similar to those attached to the lower rim of the band, hung in the center, suspended by means of another chain from the fleurs-de-lis.

A gridlike band is to be found only in this piece and in three other crowns from the Treasure of Guarrazar currently in the Museo Arqueológico Nacional, Madrid. It represents a type unique to the Toledo court artisans who made these crowns. However, certain elements, such as the cabochons, the manner in which they are set, and the suspended ornaments parallel those of the remainder of the Treasure. As in other instances, the name of the donor is not known, but there is no doubt that the crown's date corresponds to that of the other objects in the Treasure, that is, within the confines of the seventh century.

GRL

cabochon stones. The oval collet on both earrings holds a transparent cabochon stone (modern?). A small ring is joined to the oval collet, and from it falls a gold chain with three gold and two vitreous-paste beads. The chain ends with a large, irregular amethyst. The reverse of each of the collets displays molded geometric decoration whose center features a knot of Solomon encircled by a band of opposed triangles. This design is visible on the circular collets but much less clear on the other two.

These earrings are similar to other seventh-century gold objects, especially those in the Guarrazar and Torredonjimeno treasures. The similarities are particularly evident in the collets and the pendent amethyst and also in the small rings that link the discrete parts. The geometric decoration on the reverse is one that was widespread throughout the Mediterranean, especially in regions where there have been Byzantine influences, but here it is combined with animal style II motifs common in the seventh century.

These earrings are technically similar to work by seventh-century Toledo court goldsmiths, and they were probably made in Iberian workshops. However, the Byzantine-Mediterranean influence cannot be dismissed, since seventh-century metalwork responded to oriental models that reached Spain at the end of the sixth century.

GRL

LITERATURE: Vázquez de Parga 1958, p. 46, pl. XXVII.2; Palol and Ripoll 1988, figs. 201, 202.

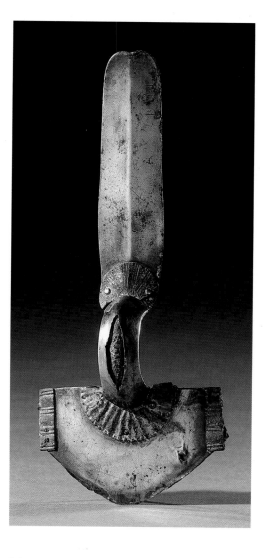

14

BOW fIBULA

Spain, end of 5th century
Bronze overlaid with silver
L. 6⅖ in. (16 cm)
Ariadne Galleries, New York

The invasion of the Gothic territories on the northwest shores of the Black Sea in 375 triggered the westward migration of the Ostrogoths and Visigoths. As was noted long ago by Nils Aberg and Bernhard Salin,[1] polychrome and silver-sheet fibulae that the Goths wore followed similar lines of development with regard to the shapes of both the head and foot. Examples of the two types can be found from southeastern Europe to as far west as France. The early fifth-century Germanic grave in Untersiebenbrunn, Austria, that yielded polychrome as well as silver fibulae (closely related to the silver-sheet fibulae) serves to confirm their observations.[2] Whereas both types have been found as far west as France,[3] no examples of polychrome fibulae have been recovered in Spain. Thus the silver-sheet fibulae—like this one— are considered

13

PAIR OF EARRINGS

La Guardia de Jaén (Jaén), 7th century
Gold, amethysts, and cabochon stones
Museo Arqueológico Nacional, Madrid (57.836, 57.837)

It is likely that these gold earrings were found between Jaén and La Guardia de Jaén. They are identical in composition. The uppermost part is formed by a circular ring, one end of which is finely pointed and the other spherical. This large ring is joined to another, smaller ring, from which the rest of the earring hangs. The pendant is composed of three gold collets—one circular, one square, and the third oval—on which are found remnants of the white paste used to set

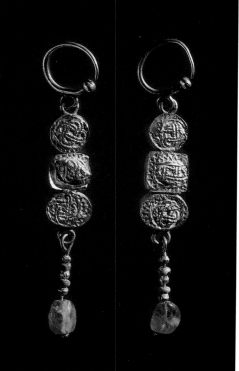

13

to be characteristic of the Visigoths, and their appearance in Spain is believed to coincide with the entry of this Germanic tribe into Spain at the end of the fifth century.

Large bow fibulae such as this were used to close a mantle. They were worn in conjunction with rectangular cloisonné buckle plates with oval loops and pairs of cloisonné eagle-shaped fibulae. Gisela Ripoll López has noted that there is a correlation between the fibulae and buckle types.[4] Fibulae like this one are made of three separate pieces: head, bow, and foot. As on this example palmettes were frequently applied to mask the junctures of the bow to the head and foot. The core of the piece is bronze. Ripoll has suggested that examples of this type of fibula were produced by a local workshop, perhaps using models from the Crimea and Hungary.[5] Indeed, the closest parallels for this type of fibula are to be found in Hungary,[6] although as might be expected comparable pieces also exist in France.

KRB

1. Salin 1935, pp. 10–20; Aberg 1922, pp. 41–48.
2. Nuremberg 1987, p. 319, figs. 33a–c.
3. Caen 1990, p. 55 (tomb of Airon), pp. 98–101 (tomb 359 of Saint-Martin-de-Fontenay).
4. Ripoll 1991b, p. 120.
5. Ripoll 1986a, p. 61.
6. For silver-sheet fibulae from Szabadbattyan and Ménfocsanak, see Nuremberg 1987, pp. 192–93.

LITERATURE: New York 1991, no. 139.

15

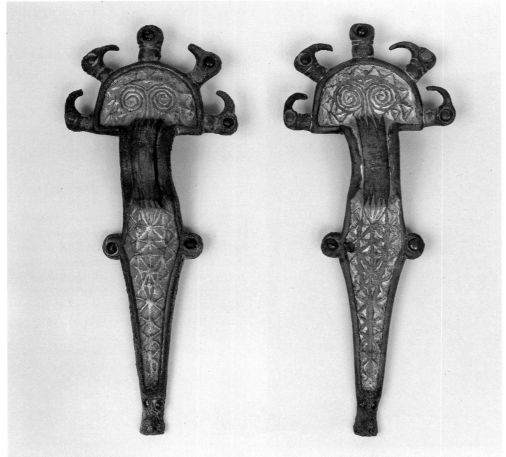

15

pair of bow fibulae

Spain, 6th century
Gilt bronze and garnets or red glass
L. 5¼ in. (15.8 cm), w. (of head) 2⅜ in. (5.6 cm)
Private collection

Chip carving embellishes the entire surface of each of these fibulae. Both heads are decorated with addorsed spirals surrounded by a border of triangular chip carving. In addition, both heads have five digits consisting of a central round digit flanked by two pairs of bird's-head digits, each of which is set with a garnet or a red glass bead. The heads are joined to the feet by bows decorated with striations. On the feet, at the base of the bows, are V-shaped sprays, below which are cross-shaped motifs. These crosses are bordered by a row of triangles. Terminating the foot of each fibula is a stylized animal head with its eyes indicated by garnets or red glass beads.

In his publication of a similar piece from Castiltierra, now in a private American collection, Stephen Foltiny noted that there were five other, similar examples of this type from different sites in Spain. He related this group of fibulae typologically to the Frankish "Champlieu type," of which the Metropoli-

tan Museum has a very fine pair.[1] The pair's semicircular heads have digits representing bird heads that are inlaid with almandine; the feet also terminate in animal heads (Metropolitan Museum acc. no. 17.191.168, 169).

Six additional examples of this type have been found at El Carpio de Tajo. Gisela Ripoll López, in her publication of the finds from this site, asserts that they represent the last stage in the evolution of Visigothic bow fibulae and can be placed, therefore, in the second half of the sixth century.[2] As is true of Visigothic cloisonné bird fibulae, these pieces are related to the production of Ostrogothic fibulae of the first half of the sixth century. A related pair of unknown provenance is with the Ariadne Galleries.[3] As suggested by Ripoll, the congruities in design and techniques seem to indicate mass production.

KRB

1. Foltiny 1977, p. 15.
2. Ripoll 1985, pls. 55, 56, no. 3, p. 214 (illus.).
3. Dallas and New York 1992, no. 220; Ripoll 1985, pls. 79, 80.

16

buckle and plaque

France, 6th century
Bronze and glass, with a single turquoise that may be a modern addition
L. 5¼ in. (13.3 cm)
Shelby White and Leon Levy

The cast, gridlike pattern of this buckle and plaque set with round and square glass-paste cabochons is comparable to allover patterns from the Near East, especially from Egypt and Syria, which made themselves evident particularly in the migration art of southwestern Europe. The oval-shaped loop is attached to the plate by a thin strip of metal bent around the thin part of the loop and soldered to the plaque. The trilobed base of the tongue is inlaid with glass, and the tongue terminates in the traditional animal head.

A significantly similar cast allover pattern occurs on a buckle in the Musée de Cluny, Paris, that was discovered at Castel near Valence d'Agen (Tarn-et-Garonne), France.[1] The loop, like that of this buckle, is decorated with two rows of small bosses, as is the tongue. On both buckles the base of the tongue is trilobed and was originally inlaid with four pieces of glass or, as on the Cluny example, garnet. While the buckle plaque of the Cluny example is gilt bronze, the present example is set with colored glass-paste cabochons.

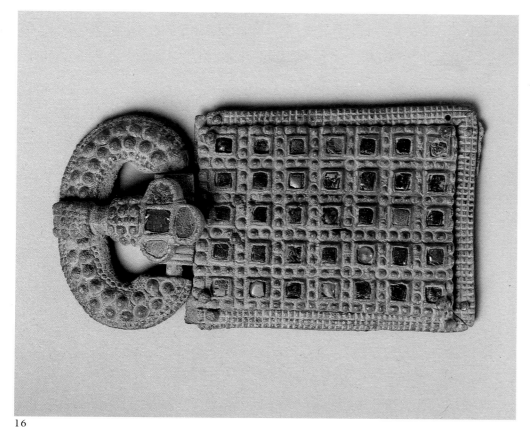

16

buckle and plaque

Spain, second half of 6th century
Copper alloy, garnets over gold foil, lapis lazuli, cuttlefish bone, green glass, and gilding
L. 5½ in. (13.9 cm)
The Metropolitan Museum of Art, New York; Rogers Fund, 1988 (1988.305a,b)

Garnets over gold foil, lapis lazuli, green glass, and cuttlefish bone surround the green glass quatrefoil in the center of this rectangular buckle plate. The base of the plaque and the cloisons consists of a copper alloy, as do the buckle and tongue. The base of the tongue originally held four pieces of garnet, but only two and a half remain. On the buckle plate several cloisons have retained traces of their original gilding; part of the tongue has also. The two projecting loops that once served to unite the buckle and the plate are now missing. They were probably made from a single piece of copper alloy, cut in the center and folded back on itself.

The use of lapis lazuli in this buckle is apparently unique in Visigothic art but was known to the Romans and the Byzantines. Its presence in this buckle bears witness to the close relationship between Byzantium and the Visigothic kings.

By the design of its cloisons this piece is related to several in the Museo Arqueológico de Barcelona, all of which are made of garnets and blue glass, in contrast to the lapis lazuli of this buckle.[1] The closest parallel among these examples has been recently published by Gisela Ripoll López as coming from tomb 58 of the necropolis of Azuqueca (Guadalajara) and datable to her level 3, that

Both of these buckles display the oriental influence that was introduced into France during the last decades of the fifth century. Although the Visigothic capital was changed from Toulouse to Toledo in 507, many of the Visigoths continued to live in southwestern France. Because the Cluny buckle was found there, and both buckles appear to be from the same workshop, we suggest that they exemplify Visigothic art in France.

A third buckle that deserves mention in connection with the barbarian and, specifically, Visigothic preservation of the allover pattern is the buckle from Monceau-le-Neuf now in the Römisch-Germanisches Museum, Cologne. This is a polychromed example consisting of garnets and green enamel.[2] Several large cloisonné buckles from Spain[3] also preserve this tradition. That it was distinctly Visigothic would seem to be indicated as well by the drawings of the designs of Spanish Visigothic buckles of phases 2 and 3 by Gisela Ripoll López.[4]

That this late Roman and oriental predilection for allover patterns, which was preserved by the Visigoths in France and Spain alike, was taken over by Muslim artists in Spain was well demonstrated by several pieces in the *Al-Andalus* exhibition: the stucco relief of the eleventh century,[5] the ivory pyxis of the thirteenth century,[6] and a "Holbein" carpet at The Cloisters.[7]

KRB

1. Caillet 1985, p. 195, no. 121.
2. Brussels and Cologne 1979, p. 127, no. 32.
3. Palol and Ripoll 1990, figs. 184–85.
4. Ripoll 1987.
5. New York 1992a, no. 44.
6. Ibid., no. 52.
7. Ibid., no. 101 (Metropolitan Museum acc. no. 53.79).

LITERATURE: New York 1990, no. 193.

17

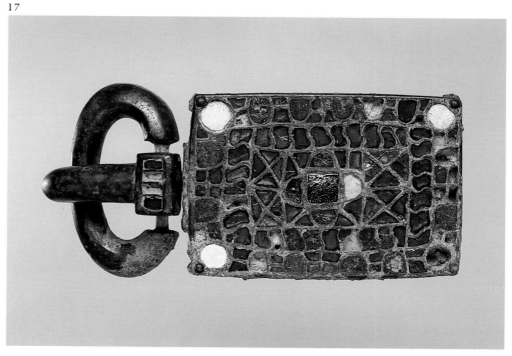

is, to between 525 and 560–80.[2] Ripoll's chronology is based on the classification of strata established by Kurt Böhner for the cemeteries of Austrasia together with that of Joachim Werner for Bülach. She also took into consideration the chronologies of Wolfgang Hübner for the Hispanic material and the relative chronological studies of Merovingian cemeteries established by Patrick Périn.[3] She has found that there are four groups of fibulae that correspond perfectly to four groups of buckles.

The first group, from level 2, is characterized by the presence of Roman objects, along with the full complement of Visigothic personal adornment, most of which spans level 3 as well. In general, the fibulae of level 2 have little or no surface decoration, and the cloisonné buckles present easily readable geometric designs, whereas the fibulae of level 3 are often gilt bronze decorated with chip carving or engraving, and the cloisonné buckles show innovation in their designs. The quaterlobed center of the Metropolitan buckle[4] is one such innovation.

A number of the cloisonné plaques have accentuated corners, often consisting of circular settings filled with a white substance like those on this buckle. A comparable example exists in the Musée de Cluny, Paris. The latter was found in Nîmes, but the circumstances of its discovery are unknown.[5]

The colors of this buckle make it important as a Western echo of the Ponto-Gothic style, which was characterized by garnets over gold foil with accents of blue and/or green. The style was developed by the Goths on the north shores of the Black Sea prior to the arrival of the Huns in 375, when the westward migration of the Ostrogoths and Visigoths began. Both tribes carried the style with them. KRB

1. Almagro 1947, pp. 73–75, pls. XXIII, XXIV.
2. Ripoll 1987, pp. 347–50, 357, 359, fig. 7.
3. Ripoll 1991b, pp. 113, 115 nn. 3, 8, p. 116 n. 13, p. 117 n. 24.
4. Ibid., p. 120.
5. Caillet 1985, p. 196, no. 122.

LITERATURE: Brown 1989, pp. 14–15.

18

Buckle and plaque

Spain, 6th century
Bronze, glass, and mother-of-pearl
L. 5¼ in. (13.4 cm)
Shelby White and Leon Levy

This buckle is unusual in the design of its cloisons, which form a circle—enclosing a cross—within a rectangular frame accented

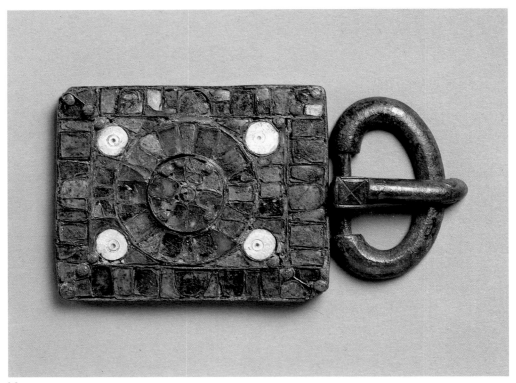

18

by four mother-of-pearl circular inlays in the interstices. Cloisonné buckle plaques are the most characteristic items of Visigothic metalwork throughout the sixth century. Whereas during the earliest phase of Spanish Visigothic art (480–525) the designs of these buckles were primarily based on rectangles within rectangles, those of the subsequent phase display a greater variety of designs. This buckle was probably made between 525

and 560 if the chronology established by Gisela Ripoll López is followed.[1] Because fill material has been added between the glass and the cloisons, and colored paste has been added under the glass, it is not possible to ascertain the initial color of the glass. However, most of the glass appears to be original. On the basis of the design three closely related buckles can be cited. The first of these was excavated from tomb 311 during the sec-

19

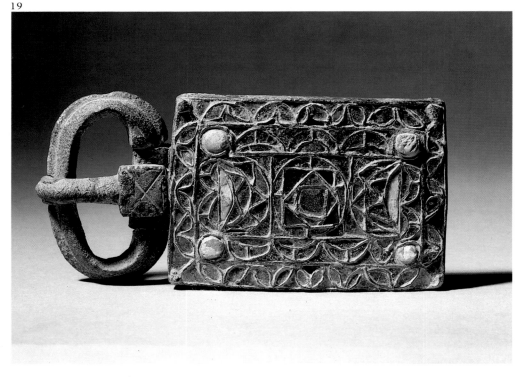

ond campaign at Madrona in Segovia.[2] Another similar example is in the Museo Arqueológico de Barcelona,[3] and a third, in a private collection, is now on display at the Meadows Museum, Dallas, Texas.[4]

The tongue of the present buckle terminates in a stylized animal head, and the loop is oval in shape. The tongue and loop had been united to the plate by loops that were most likely made by a sheet of copper alloy cut in the center and folded back on itself. As have the majority of Visigothic buckles, this buckle probably came from a woman's tomb and was originally attached to a leather strap by means of four small pins securing the plate, while the tongue and loop were attached to the other end of the strap. The tongue would have gone through the leather after the strap had been passed around the loop and knotted on itself. It is thought that such belts were worn to secure women's tunics rather than their mantles.[5]

<div style="text-align: right">KRB</div>

1. Ripoll 1991b, p. 120.
2. Molinero 1971, pl. XC, fig. 2, p. 61, listed.
3. Almagro 1947, pl. XX, no. 37, p. 69, listed.
4. Dallas and New York 1992, p. 130, no. 124.
5. Bierbrauer 1975, pp. 78–83, 363, fig. 43.

LITERATURE: New York 1990, no. 194.

yet another square. The central circle, itself enclosed by a square, is in turn flanked by semicircular sections composed of roughly triangular sections. The inner of the two borders consists of semicircles and has circular insets of mother-of-pearl in each of the four corners, while the exterior border is composed of floral motifs. A buckle characterized by similar semicircular motifs was excavated in Madrona (Segovia),[1] together with a pair of fibulae with four pairs of confronted bird's-head digits similar to the pair acquired by the Metropolitan Museum in 1990 (1990.193.1,2). The Metropolitan fibulae are extremely close to a pair from tomb 51 at Herrera de Pisuerga, which have been placed at the end of the development of the series of bow fibulae in Spain because of the increased number of digits.[2] Thus this buckle, with its intricate, sophisticated design, which is related in concept to the one from Madrona, may also be placed toward the end of the sixth century.

1. Molinero 1971, p. 54, pl. XXVI, listed.
2. Martínez 1934, p. 168, pl. XIV.

LITERATURE: New York, 1991, no. 143.

buckle and plaque

Spain, 6th century
Brass, red and blue glass, and mother-of-pearl
L. 5¹³/₁₆ in. (14.7 cm)
Ariadne Galleries, New York

This magnificent cloisonné buckle would seem to represent one of the latest in the series of cloisonné buckles because the geometric designs of the earlier buckles have been largely replaced by floral motifs. The change may coincide with the mass conversion of the Visigoths to Catholicism under King Recared in 589, after which Byzantine influence became predominant in Visigothic metalwork. The quatrefoil in the center of this plaque is found on a number of cloisonné buckles (see, for example, cat. 17 or an example exhibited at the Ariadne Galleries).[1] However, the diagonal lines radiating from the interstices of these quatrefoils to each of the four corners are usually made up of a series of cells similar in formation or of rows of bronze beads, whereas on this example they consist of long, nearly straight stems terminating in heart-shaped leaves. Between these leaves a series of

20

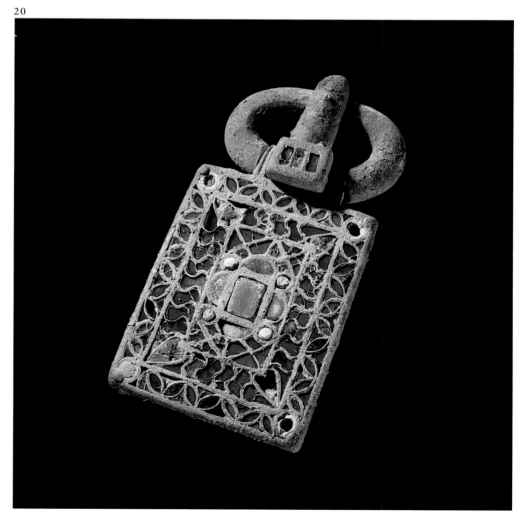

19

buckle and plaque

Spain, 6th century
Bronze, glass, and mother-of-pearl
L. 5¹/₁₀ in. (13.5 cm)
Ariadne Galleries, New York

This buckle exemplifies the pure Visigothic polychrome style of the sixth century. Earlier buckle styles betrayed Roman influences, and by the seventh century Byzantine influences—which seem to have coincided with the conversion of the Visigoths from Arianism to Catholicism—were strongly evident. The combination of green and blue glass with mother-of-pearl circular insets in each of the four corners characterizes a number of cloisonné buckles of this period.

The intricate design of this particular example displays the sophisticated bronze craftsmanship that had developed by the second half of the sixth century. As is usual, the loop is oval in shape, and the tongue terminates in a stylized animal head. Tongue and loop have been reattached to the plaque, whose design consists of a rectangle within two rectangular frames. In the center of the design is a circle enclosing a square of blue glass containing a diamond-shaped section inside of which is

S-shaped cloisons completes the inner rectangular border, while rows of stylized acanthus leaves—alternately facing inward and outward —form the outer border, of which each of the four corners is emphasized by a circular setting once containing mother-of-pearl (now missing in three of the four cells).

Whereas the floral motifs of this buckle indicate Byzantine influence, the row of S-shaped cloisons was surely inspired by the late Roman repertory of designs. It is frequently found, for example, in the borders of Roman mosaics.[2]

K R B

1. Dallas and New York 1992, no. 130, p. 74.
2. Balmelle et al. 1985, pls. 67c, e.

LITERATURE: New York 1991, no. 141.

21

buckle and plaque

Spain, 6th century
Gilt bronze, garnets, gold foil, and green glass
L. 5⁵⁄₁₆ in. (13.2 cm)
Private collection

The surface of the nearly square plate of this buckle is decorated with chip carving around a central green glass cabochon stone (now largely corroded). The border, consisting of a single row of garnets over gold foil, originally had a setting of green glass in the center of both long sides (one is now missing) and two triangular sections forming a larger rectangular section in the center of the short sides. In

each corner a rounded garnet is flanked by S-shaped cloisons. Only six pieces of garnet are missing from this magnificent buckle plate. The terminals of the loop represent stylized animal heads, as does the end of the tongue.

The tangential triangles in chip carving that embellish the surface of the plate are frequently found in Visigothic metalwork. They appear, for example, on both the head and foot of Catalogue 15. According to Gisela Ripoll López, such triangles were also common in Roman mosaics. It is not possible to ascertain whether in Visigothic art this motif was directly inherited from Roman art or created anew.[1]

K R B

1. Ripoll 1991b, p. 188.

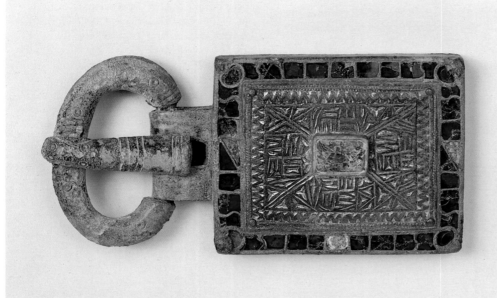

22

buckle and plaque

Spain, 6th century
Gilt bronze, gilt copper, garnets, mother-of-pearl, white paste, and green glass
L. 5⅞ in. (14.9 cm)
Private collection

A rectangular double border of garnets interrupted in the center of each side by a trefoil formed by three tangential circular settings— originally all filled with mother-of-pearl and now mostly filled with white paste—frames a gilt copper plaque set in the middle with a garnet and green glass cabochon stone. The plaque is decorated with incised and punched designs. The four corners of the garnet frame are emphasized by addorsed semicircular sections of garnet. Grooved striations mark the center and the ends of the loop, and the tongue terminates in a stylized animal head. The loop joining the buckle to the plate appears to be original.

This magnificent buckle is similar to the one unearthed at Duratón, Segovia, in tomb 475 that is illustrated by Gisela Ripoll López as a level 2 find.[1] Although the type of fibula— the silver-sheet fibula—found with the buckle at Duratón is typical of her level 2 (480–90 to 525), the buckle itself falls into her description of buckle types usually found in level 3 (525 to 560–80).[2] Thus the find would appear to be a transitional one, dating to about 525. On the basis of comparison, the present buckle may also be placed in this period. However, all of the types in level 2 continue to be found during the period coinciding

with level 3. Another example of this type of buckle is in the Museo Arqueológico Nacional, Madrid.[3]

KRB

1. Ripoll 1991b, pp. 119, 125, fig. 6.
2. Ibid., pp. 120–22, figs. 1–3.
3. Martínez 1934, pl. XVI.

23

eagle fibulae

Tierra de Barros (Badajoz), 6th century
Bronze, gold, garnets, green stones or glass, blue glass,
crystal, amethyst, and meerschaum
H. 5⅝ in. (14.3 cm)
Walters Art Gallery, Baltimore (54.421–2)

This pair of eagle-shaped fibulae was worn on the breast of a woman.[1] Although it did not come from a scientific excavation, it is said to have been found with an equally splendid pair of earrings at Tierra de Barros (Badajoz), near a Visigothic church.[2] The fibulae were crafted in gilt bronze with the fronts of the cloisons overlaid with gold.[3] Red almandines predominate, while green stones or glass, blue glass, crystal, amethyst, and meerschaum contribute to the overall polychrome effect. On each fibula the bill consists of red almandine, and the eye is made up of an amethyst bead encircled by meerschaum. The top of the head (now missing in one of the pair) is blue, and the neck is delineated by a band of three cells set with two small metal bosses. The raised round central section of the bird comprises a four-pointed star with a crystal cabochon in the middle, from which four rows of bosses radiate. Parts of the wings and all of the cloisons of the tails are bow-shaped, as opposed to those of the equally famous Ostrogothic examples from Domagnano, which are composed of rectangular cells. Each of these birds originally had three pendants—perhaps terminating in amethysts—like those of the earrings said to have been found with them as well as those suspended from contemporary Byzantine and Langobardic disk fibulae. Three of the loops for these pendants are extant.[4]

Julio Martínez Santa-Olalla placed these birds in his group 1, which he equated with large cloisonné buckles.[5] It was the round central section with radiating bosses that he used as the basis of comparison between the fibulae and a group of similarly designed buckles.[6] The round central section also relates this pair of bird fibulae to Ostrogothic examples and differentiates them from other

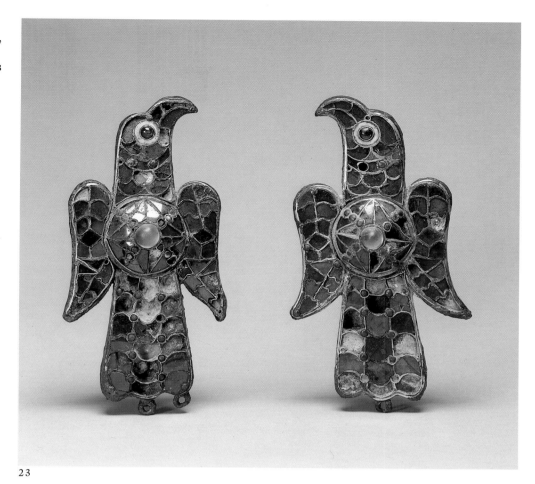

23

Visigothic cloisonné pieces that have an oval-shaped central section.

Both the bird-shaped fibula and the idea of the pendants go back to late antique prototypes, specifically, the Petroassa bird fibula with pendants. As was noted by Gisela Ripoll López, the eagle may have symbolized power.[7]

KRB

1. Koenig 1979, no. 57a.
2. Martínez 1936, pp. 47–52.
3. Ross 1961, p. 100, no. 48.
4. Koenig 1979.
5. Martínez 1934, p. 169.
6. Martínez 1936.
7. Palol and Ripoll 1990, p. 261.

24a

eagle fibula

Espinosa de Henares (Guadalajara), 6th century
Gilt bronze and glass or mother-of-pearl
H. 4⅜ in. (11 cm)
Museo Arqueológico Nacional, Madrid (52.464)

This eagle fibula was believed to have come from Calatayud (Saragossa). However, documents relating to its donation to the museum disproved that assumption. In fact this fibula originated in Espinosa de Henares (Guadalajara).

The eagle, shaped like a narrow isosceles triangle, faces left. Its beak is held high; the eye, which has lost its inlay, is circular; the ellipsoid breast is raised; the wings are extended; and the tail feathers fan out. The fibula's surface—as is usual in this type of piece—has geometric paste-filled compartments covered with a sheet of gold over which small bits of glass or fragments of mother-of-pearl are disposed. The glass pieces in this fibula are primarily red, although many of them have been lost. Part of the extreme right section of the tail is also missing.

This fibula must have had a counterpart that faced right because such fibulae—used by women to fasten the upper part of a mantle—have always been found in pairs. Similar items known to originate on the Iberian Peninsula confirm this supposition, for example, pieces from Alovera (Guadalajara), Duratón (Segovia), Herrera de Pisuerga (Palencia), La Jarilla (Galisteo, Cáceres), Tierra de Barros (Badajoz), and Spanish examples in the Diergardt Collection in the Römisch-Germanisches Museum, Cologne. Parallels

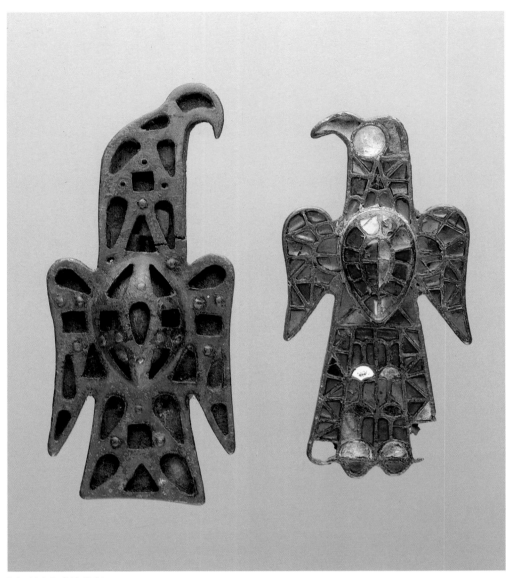

24a (right); 24b (left)

also exist from the Italian Ostrogothic culture. Eagle fibulae from the Domagnano Treasure especially come to mind. They seem to suggest a homogeneous Mediterranean production that developed independently in local and regional workshops.

Associations of eagle fibulae with various other personal adornments unearthed during excavations of funerary sites permit a dating for the fibulae with inlays to the late fifth and first quarter of the sixth century, that is, between 480–90 and about 525. Except for the examples from Estremadura, most have been found near the zone of the "Germanic"-type cemeteries of the Castilian meseta.

GRL

LITERATURE: Zeiss 1934, p. 160, pl. 6.2; Martínez 1940–41, pp. 33–54, fig. p. 32; Caballero 1981, pp. 47–50; Ripoll 1991a, pp. 168–72, 531.

24b

eagle fibula

Talavera de la Reina (Toledo), 6th century
Gilt bronze
H. 5½ in. (14 cm)
Museo Arqueológico Nacional, Madrid (52.452)

This eagle fibula was discovered in the area of Talavera de la Reina (Toledo). It faces right and is made of bronze cast in a single piece in the form of an elongated isosceles triangle. The curved beak is held high, there is no eye indicated, and the breast—alveolated like the rest of the piece—is raised. The wings, like the tail feathers, are outspread. Relatively thick bronze fillets separate the compartments that form the ornamental field. The multicolored bits of glass applied over the fine paste in the geometric spaces have been lost. Traces of some small fastening rivets remain, however.

This fibula is a variant of the Espinosa de Henares piece (cat. 24a). In both, the outlines of the cloisons are pronounced, although they are less so here. There are few parallels to this fibula on the Iberian Peninsula, although examples are known. It was probably crafted in a Spanish workshop, most likely on the Castilian meseta. Nevertheless, finds in Gaul, like the two fibulae from Castelsagrat (Tarn-et-Garonne), which are known as the Valence d'Agen fibulae, as well as pieces from Ville-sur-Cousance (Meuse), are comparable to Talavera de la Reina examples.

It is difficult to establish the chronology of this variant of eagle fibulae with precision, but it is generally agreed that the type dates from the late fifth or early sixth century and is a Visigothic product, as are the fibulae discovered in traditional "Germanic" cemeteries on the meseta. Like other eagle fibulae this example was used to secure a woman's mantle at the shoulder.

GRL

LITERATURE: Zeiss 1934, pp. 94, 196, pl. 6.1; Martínez 1940–41, pp. 33–54, fig. p. 32; Caballero 1981, pp. 47–50; Ripoll 1991a, pp. 168–72, 561.

NOTE: See Addendum, no. 24bis, Eagle fibulae, p. 329.

25

buckle and plaque

Spain, 7th century
Bronze
L. 5⅞ in. (15 cm)
The Metropolitan Museum of Art, New York; Purchase, Mr. and Mrs. Ronald S. Lauder Gift, 1990 (1990.193.3a,b)

The most striking feature of this buckle is its bright blue color, which is a form of azurite often associated with excavated objects.[1] It is commonly called a lyre-shaped buckle because of the contours of its borders. The borders, which stand in the highest relief, have canted inner edges leading down to recessed fields. Cast separately, tongue, loop, and plaque are united by an iron pin. On the back of the plaque are five integrally cast, evenly spaced lugs for attachment to a (now lost) leather belt. Incised diagonal lines embellish the borders. The recessed fields are engraved with highly abstracted foliate forms. The loop is decorated with hatchings, and the tongue with an incised cross.

This buckle belongs to a group of Spanish Visigothic buckles characteristic of the seventh century,[2] after the Visigoths had been reconquered by Justinian and when trade with Ravenna and Sicily was at an all-time high. The conversion of Visigothic King Recared

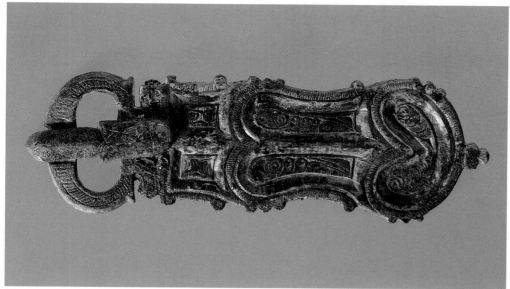

25

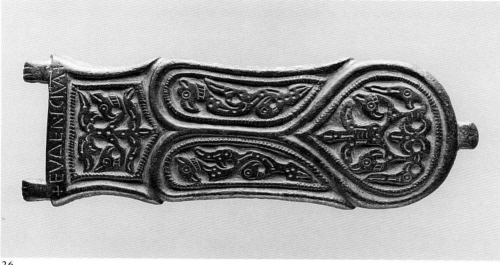

26

birds and animals in the central panels. The nearly square compartment adjacent to the buckle attachment also contains an acanthus plant motif, this time flanked by fabulous animals. On the border is the following inscription: +EV△ERICIVA+ (*Euderici vita*).[1] Soldered to this inscribed border are two loops for the pin that allows the buckle to be attached to a belt. The opposite end of the plaque has an additional loop(?).

Apart from the inscription, the most unusual feature of this plaque is the ogee arch, which forms a recessed field. An example from Santistebán, now in the British Museum, is the closest parallel.[2] Usually these terminal fields are kidney-shaped or round. Whereas most lyre-shaped plaques are decorated only with plant motifs, this piece includes animal and bird motifs as well. Unlike the Metropolitan Museum example (cat. 25)—which because of its abstracted plant motifs dates to the end of the seventh century—this plaque, showing Germanic as well as Byzantine influences, dates to the first quarter of the seventh century. KRB

1. Euderich was the name of the Visigothic owner of the piece, according to Koenig 1979, no. 61b.
2. Zeiss 1934, pl. 17, no. 1, and p. 193.

LITERATURE: Martínez 1931, pp. 58–59; Palol 1967b, fig. 22, lower left.

27

Buckle and plaque

Estables (Guadalajara), late 6th or early 7th century
Cast bronze
L. 5½ in. (14 cm)
Museo Arqueológico Nacional, Madrid (61.805)

This belt buckle was a chance discovery in the area of Estables (Guadalajara). Buckle and plaque were cast in a single piece. Characteristic of this type of buckle are the straight edges and the semicircular terminal. The entire front surface is decorated. The tongue bears an ornament that can be interpreted as a human mask, which is somewhat typical of this type of piece. On the terminal there is a second mask, and it too is apparently human, with hair caught into braids on either side of the head. The major part of the surface is filled with a heraldic animals motif—two confronted stylized lions rampant. Between them, creating a symmetrical composition, is a pitcher from which spring two vegetal motifs that continue in opposing directions along the buckle's upper edge. Between this plant motif and the lion situated in the zone at the right is a third creature, probably a

(r. 586–601) from Arianism to Catholicism and the unification of the peninsula produced a change in Visigothic art: now liturgical items came into vogue, and objects of apparel were reduced in status and changed in appearance. Lyre-shaped buckles, typical of the Mediterranean culture, replaced the polychrome cloisonné examples, and those produced in Spain were cast in bronze after Mediterranean models in precious metals.[3]

The buckle's beauty and clarity of design become all the more evident when it is compared with other Hispano-Visigothic pieces.[4] KRB

1. See conservation report on this object by Edmund P. Dandridge. Typescript in Metropolitan Museum files.
2. For other examples of Hispano-Visigothic buckles, see Zeiss 1934, pls. 17–19; Palol 1950b, p. 96, fig. 4; Palol 1968a, p. 189, fig. 12; Ripoll 1986a, p. 62; for sepulcher no. 24 from Gerona (Seville), see Ripoll 1991b, p. 132.
3. For examples of the Mediterranean models, see Weitzmann 1979, no. 304.

4. For an example similar to this one, with two cast compartments, in contrast to the more usual form with only one rectangular field adjacent to the tongue, see Palol 1950b, p. 96, fig. 4; for additional works see Zeiss 1934, pls. 17–19; Ripoll 1986a, p. 62.

26

Plaque

Spain, first quarter of 7th century
Bronze
L. 6⅛ in. (15.5 cm)
Museo Arqueológico Nacional, Madrid (61.787)

The outline of this plaque, in general similar to the one from Estables (cat. 27), falls into the broad category of lyre-shaped buckles. In the form of an ogee arch the plaque terminal contains two superimposed acanthus motifs flanked by marine animals. There are stylized

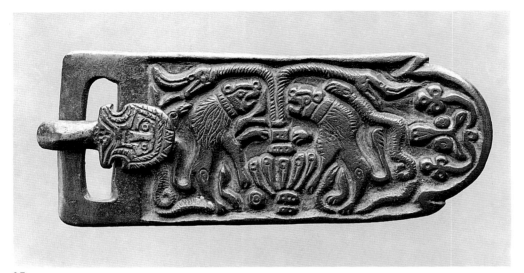

27

serpent. Its meaning is elusive, but this type of composition was common throughout the ancient world, especially during the late Roman period. Two animals—lions—drinking from the fountain of life is a traditional Christian motif seen in paintings, sculpture, and mosaics as well as in objects of personal adornment. This image is also found in Visigothic and Spanish Visigothic art.

Buckles and plaques cast in a single piece must be dated to the late sixth or early seventh century, probably to sometime after the Third Council of Toledo, which was held in 589. Because the Estables buckle displays close similarities to the ornamented Burgundian

type D plaques, its date could perhaps be moved further into the seventh century. GRL

LITERATURE: Ferrandis 1963, p. 649, fig. 436; Ripoll 1991a, pp. 183–90, 659.

28

HORSE BIT

Spain, 7th–8th century
Iron, silver, and brass
L. 11¼ in. (28.6 cm), w. 7 in. (17.8 cm)
The Metropolitan Museum of Art, New York; Fletcher Fund, 1947 (47.100.24)

This bar bit has a large tongue in the center of the bar. The latter terminates in two large rings through which the movable rectangular openwork plaques are attached. Both of the cheeks, or branches, terminate in disks in the front and in openwork rectangular plaques in back. The branches are inlaid with silver except for the front disk-shaped terminals, which are inlaid with brass. These bear a monogram. The movable openwork plaques are also inlaid in silver, each with a human head surmounted by a monogram within birds' heads. The branches are decorated with vine scrolls enclosing human heads and a cross composed of four leaves on the openwork terminal.

Dr. Helmut Nickel, former curator of the Metropolitan Museum's Department of Arms and Armor, put forward two readings for the monogram: NVNA, for the (abbess) sister of Bermudo I, king of Asturias (r. 788 or 789–91), or NVNO, for the count of Amaya, brother of Alfonso III, king of Asturias (r. 866–910), and ancestor of the Guzmán family. Both of these suggestions postdate the currently posited seventh- to eighth-century date, which is soon to be supported in a publication by Gisela Ripoll López. She has pointed out in correspondence that the monogram on a near parallel to the Metropolitan bit, formerly in the Real Armería, Madrid (now missing), was interpreted as a royal monogram: WITA for Witiza (r. 702–10). The monogram of the Metropolitan bit was read as VNONA when it was exhibited at The Cloisters in 1954.[1]

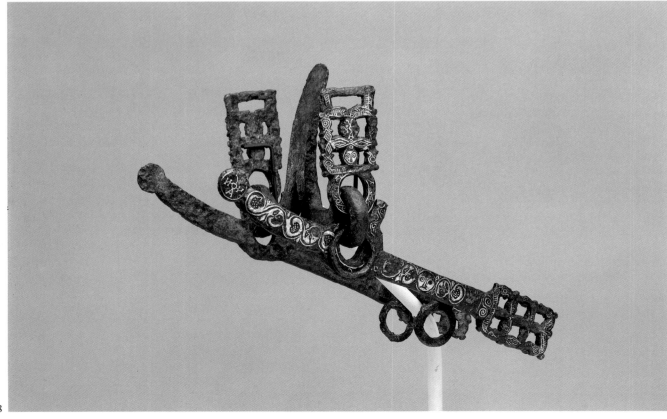

28

Although the decoration of the Metropolitan bit is close to that of the bit with the monogram of Witiza once in the Real Armería,[2] it is closer to the example in the collection of Don Rafael García Palencia, which is also a large-tongued bar bit rather than the customary snaffle bit.[3]

Ramón Menéndez Pidal pointed out that there were seven known Visigothic bits, which could be divided into two groups on the basis of their form and decoration.[4] The Metropolitan Museum's bit can be added to Pidal's group 2; it may have been used together with the one now in the collection of Rafael García Palencia. As noted by Pedro Miguel de Artíñano y Galdácano, because the latter appears to have had no fillet reins, the horse would have been led by a valet pulling two straps attached to the rings.[5] He concludes that the bit in the Palencia collection was for ceremonial use only. Thus it seems possible that the two were used in some sort of ceremony.

KRB

1. New York 1954, no. 3.
2. Madrid 1919, no. 182.
3. Ibid., no. 184; Valencia de Don Juan 1898, Real Armería F123.
4. Menéndez Pidal 1980a, pp. 711–13.
5. Madrid 1919, no. 184.

LITERATURE: Baltimore 1947, no. 352; New York 1954, no. 3.

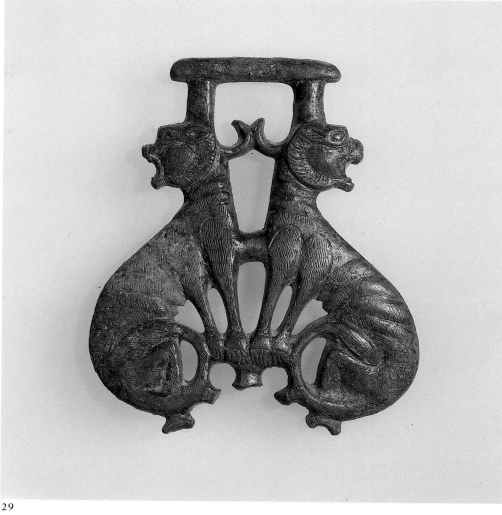

29

29

harness pendant or terminal for a bit

Spain, 6th century
Bronze
3½ x 3 in. (8.9 x 7.6 cm)
The Metropolitan Museum of Art, New York; Purchase, Rogers Fund, Stephen K. Scher, Mrs. Maxime Hermanos, and Anonymous Gifts, Gift and Bequest of George Blumenthal, by exchange, and funds from various donors, 1990 (1990.52)

These two seated, confronted panthers(?), each with its head turned backward in sharp profile, are highly stylized. Each is depicted with its chest facing outward and its hip joints clearly demarcated, recalling oriental prototypes. However, the realistic rendering of the fur by fine, engraved lines on the body and tail and the wrinkles on the neck, as well as the details of the paws, betray a knowledge of Greek art. Both have their mouths open, and their tails curve around to the front and rest on their haunches. Both are extremely erect and taut. When the piece came into the Metropolitan Museum it was noted that some form of extension from between the front paws and the tails of the animals had been lost.

At least five other Visigothic examples displaying confronted felines are known—one from Lectoure, France, one from the Walters Art Gallery in Baltimore, and three from Madrid.[1] The group of six pendants displaying confronted stylized felines is one among several groups, some consisting of openwork round plaques, some representing horses, some with animal protomes, and some with mythological scenes. Each of them has a more or less triangular section at the top and an open ring more or less in the center.[2] Pedro de Palol Salellas discussed the function of the pieces, pointing out that they were used in pairs, which were connected by a metal rod inserted into the rings. The triangular section at the top was for the strap. Although he discussed the possibility of their being used as terminals of horse bits, he was not convinced of this interpretation. Gisela Ripoll López, however, in her recent study of representations of circus and parade horses, concludes that the pierced disks, at least, were used in this manner.[3] Thus the Metropolitan piece can be reconstructed to have had a ring below the front paws of the animals and to have been used with its mate—possibly the example in the Museo Arqueológico Nacional, Madrid—in conjunction with a metal rod as a horse's bit.

KRB

1. Palol 1952, pp. 297–319.
2. Ibid., pp. 297–99.
3. Darder and Ripoll 1989, pp. 40–51.

LITERATURE: Brown 1990.

Islamic Spain

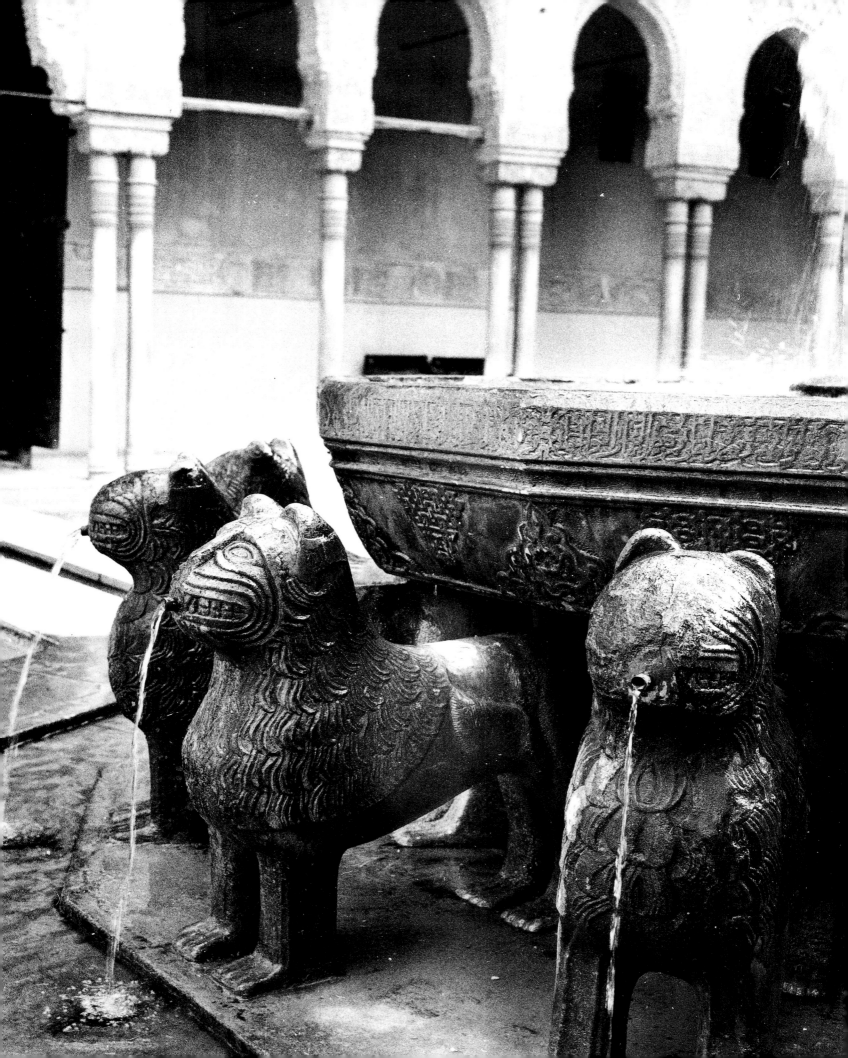

al-andalus: crucible of the mediterranean

Marilyn Jenkins

The Muslim presence in Spain from the middle of the eighth century to the close of the twelfth cannot be comprehended as an isolated phenomenon. The often dazzling Islamic civilization created in the southern part of the Iberian Peninsula during this period can be fully understood only when it is viewed as an integral part of a much larger picture, closely reflecting the history of the Mediterranean basin in general and the Maghrib in particular.[1]

It has been stated that "the Mediterranean has always been a unifying force for the countries that surround it; it is a commonplace that the spread of Greek and Roman culture depended largely upon it. And yet, in studies of Islamic art, this fact tends all too easily to be forgotten."[2] Although this statement refers specifically to Islamic metalwork, it strongly confirms my own earlier conclusions regarding pottery production, the jewelers' art, and glassmaking as practiced on the shores of this important waterway.[3] In fact, the material culture found in each of the many Islamic countries bordering this sea can only be understood when viewed from this perspective, and any study of the art of this area that is not predicated on this unity will fail to identify the multitude of threads in the rich cultural tapestry of the particular medieval Islamic state being discussed and thus to fully comprehend its civilization. In other words, Goitein's use of the term "Mediterranean society" for the area and period under discussion is applicable in a broader and fuller sense than even he could have been aware of when he coined it.

To the unity provided by this large body of water, one must add that contributed by the Greco-Roman heritage common to all the Islamic countries on the shores of the Mediterranean. Having been the prevailing tradition in the area at the time of the Arab conquests, many of its features were adopted and gradually adapted in the early Islamic period for new patrons. Finally, cohesion was supplied by the four basic characteristics of Islamic art as well: the decorative use of calligraphy, highly stylized vegetal forms, geometric patterns, and figural iconography.

The art and culture that evolved in al-Andalus during these four and a half centuries of Muslim rule that form the subject of this essay owe a great debt to the artistic styles and traditions that developed outside the peninsula under the aegis of earlier and contemporary caliphates and emirates ruling from Damascus, Baghdad, and Cairo, as well as from several capital cities in present-day Tunisia and Algeria. These influences played a considerable role in molding the civilization of al-Andalus—in essence they bear a large responsibility for the formation of Islamic art in the Iberian Peninsula. This indebtedness should not be surprising. The emirs and caliphs who ruled al-Andalus from the middle of the eighth century to the early eleventh century were constantly attempting to emulate and even surpass the life-styles of their ancestors in Greater Syria and the latter's successors in Iraq, and trade as well as family connections kept the petty kings and Berber dynasts of the eleventh and twelfth centuries in close contact with the ruling houses on the southern coast of the Mediterranean.

The seeds of civilization that were sown and cultivated during these early centuries in the region the Arabs called al-Andalus were reaped on the peninsula long after the Muslims were expelled. The harvest continues.

The earliest documented Arab presence in Spain occurred in the summer of 710. The conquest of al-Andalus began the following year, when Muslim forces fighting in the name of the Umayyad caliphate in Damascus defeated the Visigothic king Roderic at Cádiz, a victory of which the Umayyads must have been very proud, as it was soon commemorated in the fresco decoration of the royal hunting lodge, known as Qusayr 'Amrah, in the Syrian desert.[4] It was not until 755, however, that consolidation of this Muslim presence began. During that year 'Abd al-Rahman ibn Mu'awiya, one of the few princes of the Umayyad house to survive the Abbasid conquest, arrived in Spain. Governors had ruled al-Andalus in the name of his family for almost half a century, and many of his countrymen were already settled there when he arrived; it was not long before he secured his position and established an Umayyad emirate in Andalusia. Approximately one hundred and fifty years later, one of his successors, 'Abd al-Rahman III (r. 912–61), declared himself caliph and took the title *amir al-mu'minin* (Commander of the Faithful), inaugurating in al-Andalus a caliphate that was to last almost as long as had the emirate.

During these first three hundred years of Muslim presence in Spain, Andalusia was ruled from Córdoba by a house with very strong familial ties to the Levant, which manifested them-

Lions in the Patio de los Leones, Alhambra, Granada. Carved stone. Al-Andalus, 11th century. Photo: Photo Zodiaque

Window grille. Carved stucco. Syria, Qasr al-Hayr al-Gharbi,
A.D. 724–27. Photo: Marilyn Jenkins

Window grille. Carved stucco. Syria, Qasr al-Hayr al-Gharbi,
A.D. 724–27. Syrian National Museum, Damascus.
Photo: Marilyn Jenkins

selves in a multitude of ways. The first emir, 'Abd al-Rahman
ibn Mu'awiya, named his palace on the outskirts of Córdoba
al-Rusafa, after the town in Syria in which his grandfather had
his country residence. When the caliph al-Hakam II (r. 961–76)
vastly enlarged the Great Mosque in Córdoba, his new qibla
wall incorporated echoes of Umayyad architecture in Damascus,
particularly elements of its Great Mosque, including the
quartered marble and mosaic decoration.[5] It is well known
that al-Walid I (r. 705–15), who founded the Great Mosque of
Damascus in 706, imported Byzantine mosaicists to decorate
it. Al-Hakam's request to the emperor in Constantinople for a
mosaicist to adorn his addition to the Córdoba mosque approximately
two hundred and fifty years later can only be viewed
as a conscious effort to emulate both his illustrious ancestor
and his ancestor's magnificent mosque.

Contemporary texts reserved much praise for the reception
rooms and pavilions within Madinat al-Zahra', the city just
outside Córdoba that was founded by 'Abd al-Rahman III in
936 and that served as the administrative and commercial center
of al-Andalus during his reign and that of his son, al-
Hakam II. Among those buildings especially acclaimed was
Qasr al-Khilafa, which was said to have overlooked a pool
filled with quicksilver and to have incorporated another such
pool in its interior. The tradition of building palaces with
large pools of water was known to the Spanish Umayyads
from the country residences of their ancestors, such as Khirbat
al-Mafjar near Jericho, which not only had a large exterior
pool with a stone pavilion within it but which also contained
a smaller pool located in a pillared hall replete with mosaic
floor.[6]

The Andalusian vogue for stone or stucco window grilles,
as seen in cat. 33, also stemmed from their popularity in the
imperial Umayyad realms; a stucco example from the Syrian
desert palace known as Qasr al-Hayr al-Gharbi, built between

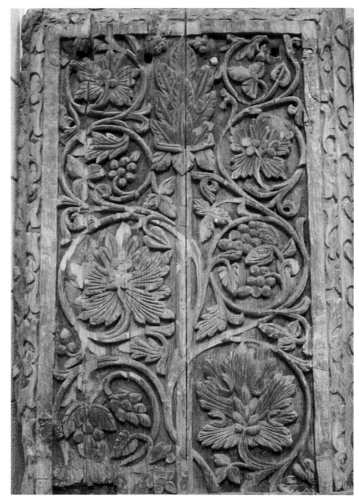

Soffit from the Aqsa Mosque, Jerusalem. Carved wood, about A.D. 715.
Rockefeller Archaeological Museum, Jerusalem

724 and 727, is seen here. Eastern Umayyad influence on the architectural decoration in al-Andalus is beautifully illustrated further by a comparison of the designs on the stucco lunette from Qasr al-Hayr al-Gharbi and a wooden panel from the Aqsa Mosque with the motif on the dado panel or doorjamb from Madinat al-Zahra' (cat. 32).

Indebtedness to imperial Umayyad art extended not only to the names of palace complexes and the design and ornamentation of elements within these complexes but also to the decorative arts in general. A bronze incense burner from Córdoba (cat. 50) incorporates most of the characteristic features associated with one type of incense burner manufactured in the eastern Umayyad realms, specifically a shallow cylindrical body on three feet with a domed lid bearing an arcade on its lower half.[7] The sole major departure from imperial examples is the use of two small handles instead of either a single long horizontal handle or rings for suspension.

The early centuries of Arab rule in Spain were contemporary with the rise of the Abbasid caliphate in the central Islamic lands, with its seat of government at Baghdad, officially called Madinat al-Salam, the City of Peace. Technically this dynasty ruled the Islamic world from the defeat of the Umayyads in 750 until the Mongols conquered Baghdad in 1258. In fact, however, their political might began to wane within a century of their ascent to power, and by the end of their second century of rule they were caliphs in name only. Yet Baghdad remained the cultural capital of the Islamic world for five centuries. Provincial governments, including those that owed their existence to the Abbasid caliphs but had long ago thrown off the Abbasid yoke and set up independent dynasties as well as those that paid only lip service to the far-off central authority in Madinat al-Salam, continued to look to that city and the life it nurtured for artistic and cultural direction.

Such a phenomenon is not foreign to us at the close of the twentieth century. Fashions are set in various cultural capitals and trickle down through the society in which they originated or, if particularly popular, are transported across continents. This diffusion often takes years, thus insuring the longevity of certain styles as well as the presence of international conventions.

Umayyad Spain was no exception to this familiar pattern. The influence exerted on life in al-Andalus by the Abbasids, most notably by the culture and institutions that evolved in Baghdad, was very pronounced. Although the means by which imperial Umayyad influence entered the Andalusian repertoire were obvious, that coming from Baghdad was for the most part rather indirect. The majority of the artistic styles and cultural traditions prevalent under the Abbasids that were adopted or adapted by the Spanish Umayyads reached al-Andalus via several of the empire's provinces, the most important of these in the present context being Ifriqiya (present-day Tunisia), which between 800 and 909 was ruled by the Aghlabid emirate, whose founder had been invested as governor by the legendary Abbasid caliph Harun al-Rashid (r. 786–809).

As was the case with other emirates under the aegis of the Abbasids, the Aghlabids strove to emulate the surroundings of their overlords in Baghdad. Concerning one of these emirs ruling from Kairouan, Abu Ibrahim Ahmad (r. 856–63), we are told that

They imported for him those precious tiles of faience for a reception room which he wished to construct, and [also] from Baghdad some teak beams for the purpose of fabricating lutes. He made of them the minbar destined for the Grand Mosque. They brought the mihrab from Iraq in the form of panels of marble; he constructed this mihrab in the Grand Mosque of Kairouan and placed those tiles of faience on the facade of the mihrab. A man from Baghdad made the tiles which he added to the first.[8]

The importation of both polychrome luster-painted tiles, destined to embellish the qibla wall of the Great Mosque of Kairouan, and a Baghdad ceramist, to train local Ifriqiyan potters to help him complete the commission on location, was to inaugurate an important ceramic tradition in the Maghrib. Production of these luster-painted tiles by native ceramists eventually led to the manufacture of luster-painted pottery, such as cat. 53, in Málaga, Spain, and ultimately culminated in the popular so-called Hispano-Moresque luster-painted ware produced in Spain during the fifteenth and sixteenth centuries.[9] Native Ifriqiyan artisans also imitated the Abbasid imports using their own techniques, an adaptation that soon resulted in the creation of inglaze polychrome painted ware that bears a very close stylistic and iconographic resemblance to that subsequently made in al-Andalus during the Umayyad caliphate and found at Madinat al-Zahra' and Elvira (cat. 52).[10]

Aghlabid Ifriqiya not only adopted, adapted, and passed along Abbasid manufacturing techniques to the western reaches of the Islamic world but also did the same with designs and motifs. The Umayyad and early Abbasid iconography employed

Left: Fragmentary dish showing an archer. Inglaze-painted earthenware. Al-Andalus, Elvira (Granada), second half 10th–first decade 11th century. On site, Madinat al-Zahra'. Right: Fragmentary tile showing an archer. Inglaze-painted earthenware. Ifriqiya, Sabra al-Mansuriyya, second half 10th–first decade 11th century. Musée National du Bardo, Tunis. Photos: Marilyn Jenkins

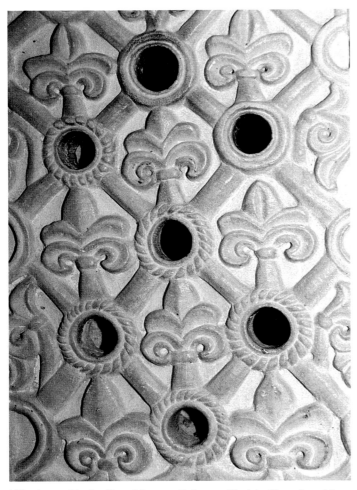

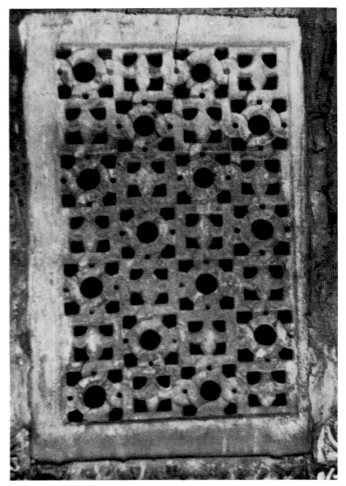

Mihrab panel in the Great Mosque, Kairouan, Tunisia. Carved marble. Iraq or Ifriqiya, Kairouan, A.D. 862/63. Photo: Marilyn Jenkins

Window grille in the Great Mosque, Córdoba. Carved marble. Al-Andalus, Cordóba, A.D. 987/88. Photo: Frisch 1966, pl. 12

by the Aghlabids in the decoration of the Great Mosque of Kairouan was, in its turn, utilized to decorate palaces and mosques in al-Andalus. The ornamentation in the dome chamber in front of the mihrab in the Kairouan mosque, for example, bears very close comparison with the decoration on the marble panel from Madinat al-Zahra' (cat. 32),[11] and the resemblance between the design on one of the ajouré marble panels of Abu Ibrahim Ahmad's mihrab in the Kairouan mosque and that on a window of the Great Mosque of Córdoba is striking.

How did these influences move from one end of the Mediterranean to the other? What linked Ifriqiya to al-Andalus at this time?

By 827 the Aghlabids had made the Muslim fleet the most powerful in the Mediterranean, a position they took from the Byzantines and were to hold for the next one hundred and twenty-five years. In addition to the power of its fleet in the ninth and tenth centuries and the security Ifriqiya enjoyed because of this, the geographical position of the country further contributed to its efflorescence. Large ships that could sail nonstop from Spain to the Levant heavily loaded with passengers and their cargo were not in common use until the elev-

enth century; before that time Ifriqiya was an essential distribution center where the goods and products of India, Egypt, and Syria—not to mention the enterprising merchants themselves—were transshipped to the flourishing Islamic West. Artistic traditions, styles, and customs followed. In the words of Marçais, "la Tunisie semble bien avoir parfois servi de relais sur la route allant de Baghdad en Andalousie" (Tunisia certainly seems to have sometimes acted as a relay on the route from Baghdad to Andalusia).[12]

Direct Abbasid influence on the art and culture of al-Andalus entered the Iberian Peninsula during the Umayyad emirate in the person of the Iraqi singer and musician Abu'l-Hasan ibn Nafi', known as Ziryab, who brought with him from Madinat al-Salam all the refinements of the capital. In the first half of the ninth century, this expatriate introduced the Andalusian aristocracy to the etiquette of Baghdad and to the way of life at the Abbasid court. This was a decisive moment in the history of al-Andalus, one that added appreciably to the almost mythical notion of life in the eastern capital held by the Andalusians. In the following century the caliphs 'Abd al-Rahman III and his successor al-Hakam II tried by means of elaborate court ceremonies "to re-create the mythic court at

Madinat al-Salam" in yet another attempt by the Umayyad caliphs to emulate and rival the other caliphate in Baghdad.[13]

Unequivocal evidence of Abbasid influence on the art of al-Andalus that, as with Ziryab, appears to have been direct is provided by a fragmentary silk textile (cat. 60). Woven in Spain, probably in Almería, the textile bears decorative motifs that incorporate an Arabic inscription in Kufic script that boldly states it was made in Baghdad! An early medieval fake? A knock-off of the epitome in silk fabrics of the eleventh century? Unfortunately, we shall never really know how textiles such as this were perceived in medieval Spain, nor will we ever know their value. Nevertheless, their message is clear.[14]

The last Aghlabid ruler fled Ifriqiya in 909, bringing to an end his family's independent emirate and leaving the way open for the establishment of the Fatimid dynasty. Midway through the sixty-year Ifriqiyan reign of this Shi'ite house, a Sanhajan Berber, Ziri ibn Manad, and his troops intervened to save the capital, Mahdia, from an imminent Kharijite threat. When the Fatimids, forever indebted to Ziri, conquered Egypt, founded Cairo, and made it their capital in 973, Ziri's son, Buluggin, was designated as the Fatimid governor of Ifriqiya.[15]

Once in Egypt the Fatimids began paying less and less attention to the Maghrib, confident in Buluggin. An autonomous Zirid dynasty in Ifriqiya soon became apparent. This Berber house attempted to imitate its overlords, a practice that Ziri himself had initiated long before his son became governor by asking the Fatimid caliph al-Qa'im (r. 934–46) for artisans, materials, and an architect when he founded Ashir in present-day Algeria.

The artistic and cultural influence of Ifriqiya on al-Andalus during the two hundred years of Fatimid and Zirid rule there, essentially the tenth and eleventh centuries, has not received the attention it deserves. Yet the arts of Andalusia during the rise and zenith of the Umayyad caliphate and the subsequent century of domination by the *muluk al-tawa'if* (the *taifa* period, or rule by the so-called party kings) cannot be fully understood unless they are viewed through a lens with an angle wide enough to include the products of these two Ifriqiyan kingdoms. Like the imperial Umayyad—and unlike the Abbasid—influences on al-Andalus discussed earlier, all of those attributable to the Fatimids and Zirids were direct and immediate, reaching al-Andalus for the most part through trade or as a result of family connections.

Numerous examples could be cited of the different types of influences that moved from the southern to the northern shores of the Mediterranean at this time; a few, however, will have to suffice. Among the contemporary, often effusive, accounts of the palaces and pavilions at Madinat al-Zahra' outside Córdoba is one that describes the impressive Qasr al-Khilafa as having eight openings on each side of its principal hall, the marble and ebony arches of which were "encrusted with gold and precious stones." Another author tells us that Qasr al-Khilafa's "streaked marble columns were mounted in gold and inlaid with rubies and pearls."[16] Although these reports have not been (and cannot be) confirmed, architectural fragments of inlaid marble have in fact been found at Alamiriya, one of the earliest residences of the very powerful chamberlain of the Umayyad Hisham II, Ibn Abi Amir, and thus datable to the end of the tenth century. These fragmentary elements are inlaid with black stone (not with rubies or pearls!), an unusual technique that also appears on an earlier Fatimid frieze from Mahdia in Ifriqiya depicting an imbibing ruler being entertained by a flutist.

The carved decoration on the marble dado panel from Toledo (cat. 35) invites very close comparison with that on any

Fragment of a volute. Carved and inlaid marble.
Al-Andalus, Alamiriya, end 10th century.
Museo Arqueológico Provincial, Córdoba.
Photo: Marilyn Jenkins

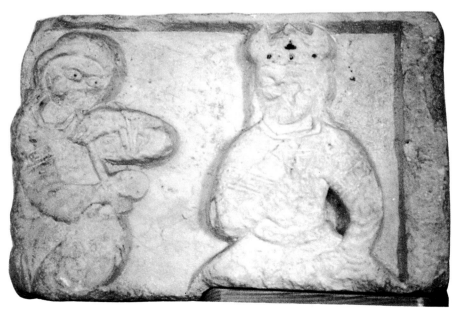

Relief showing a ruler and a flutist. Carved and inlaid marble. Ifriqiya, Mahdiyya, 10th century.
Musée National du Bardo, Tunis. Photo: Marilyn Jenkins

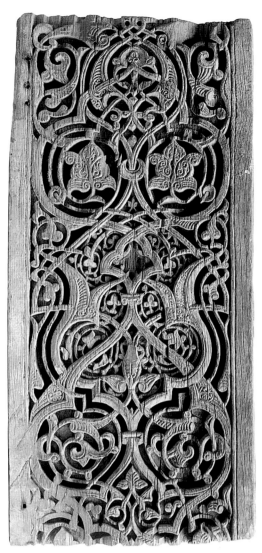

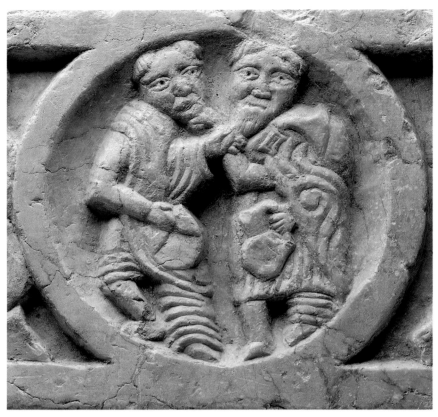

Detail of Játiva basin (cat. 37), showing a wrestling scene. Photo: Sheldan Collins

Panel. Carved wood. Egypt, first half 11th century.
Benaki Museum, Athens

Fragmentary dish showing a wrestling scene. Glazed and luster-painted ceramic. Egypt, 11th century. Museum of Islamic Art, Cairo

Fragmentary dish showing men dancing with large sticks. Glazed and luster-painted ceramic. Egypt, 11th century. Museum of Islamic Art, Cairo

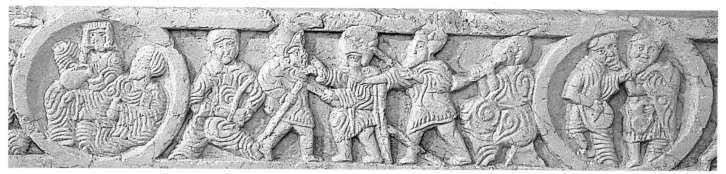

Detail of Játiva basin (cat. 37), showing (at right) men dancing with large sticks. Photo: Sheldan Collins

number of wooden door panels carved in Egypt during the first half of the eleventh century. The Fatimid carved panel seen here is particularly close to the later Toledo panel, not only in terms of the general design and its layout but also in the detailing of the vegetal design itself. Other eleventh-century parallels can be noted in a comparison of scenes of wrestlers and men dancing with large sticks on two Egyptian luster-painted bowls with those depicted on the rectangular Andal-

usian stone basin from Játiva (cat. 37). The iconography on this basin as well as its realistic figural style is highly unusual for medieval Spain, but its currency in Fatimid Egypt is well attested.

The jewelers' art in al-Andalus is also clearly indebted to the traditions of the Fatimids. The twelfth-century gold-and-enamel earrings from al-Andalus (cat. 55) betray a total dependence on earlier, eleventh-century Fatimid examples, whereas a twelfth-

Pair of earrings. Gold sheet, wire, and granulation. Al-Andalus, 12th century. Benaki Museum, Athens

Pendant. Gold, cloisonné enamel, and turquoise; originally outlined with strung pearls and/or stones. Egypt, 11th century. The Metropolitan Museum of Art, Bequest of Theodore M. Davis, 1915, 30.95.37

Pair of earrings. Gold, pearls, and enamel. Crete, first half 10th century. National Archaeological Museum, Athens

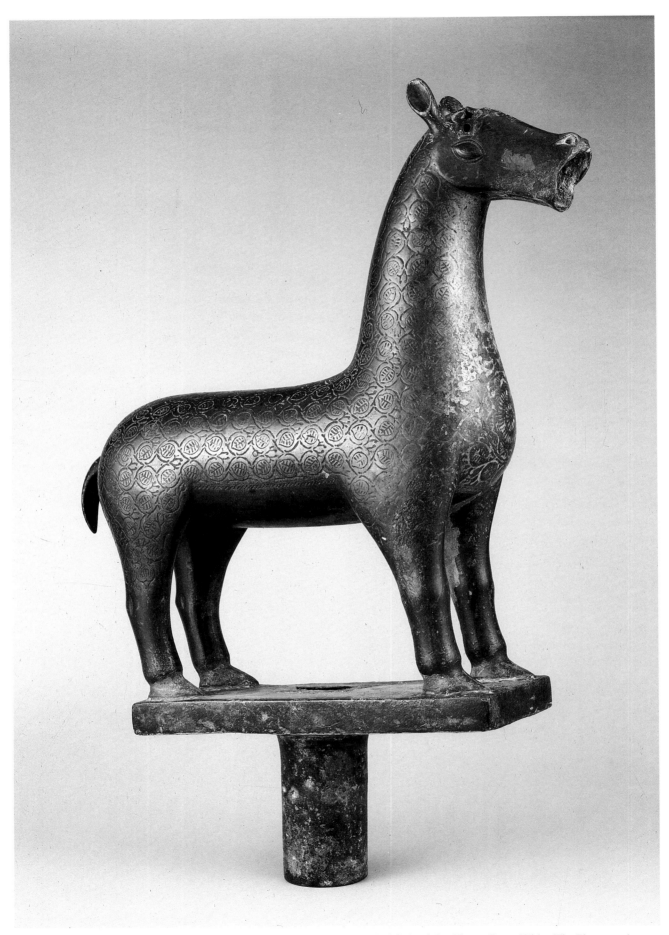

Stag. Bronze. Al-Andalus, second half 10th century. Museo Arqueológico Provincial, Córdoba. Photo: Bruce White, The Photograph Studio, The Metropolitan Museum of Art

Quadruped. Cast bronze. Ifriqiya, Beni-Khalled, 10th century. Musée National du Bardo, Tunis. Photo: Marilyn Jenkins

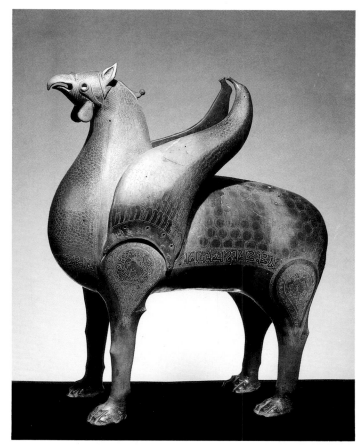

Griffin. Bronze. Ifriqiya or Egypt, 11th century. Museo de l'Opera del Duomo, Pisa. Photo: Mario Carrieri

century pair from the Benaki Museum seen here are gold versions of a type manufactured in Crete during the tenth century before the Byzantine conquest of the island in 961 and thus while it was still under Arab domination. A pair of earrings in the National Archaeological Museum, Athens, are typical of this latter type, which incorporates cloisonné plaques with Arabic inscriptions in Kufic script, triangular protrusions from the outer edge of each earring, and a semicircular profile. All of these characteristics, executed in a different technique, can be seen in the pair from al-Andalus in the Benaki Museum.

The highly realistic style of figural decoration on an eleventh-century basin (cat. 37), a style not seen on the Iberian Peninsula before that period, also has close ties to eleventh-century Fatimid art. Although one could cite numerous examples to support this contention, perhaps one of the best is a fragment of a carved wooden frieze, said to have originally decorated a convent in Cairo's Coptic sector, depicting four scenes of acrobats, including a figure dancing on a high dais or rope, another standing on his head, and another engaged in a balancing act, all accompanied by musicians playing various instruments.[17]

The examples of niello inlaid silver in this exhibition (cats. 38a, 43, 45–47), except for the Girona casket (cat. 38a), all bear similarities to niello inlaid objects manufactured under the aegis of the Fatimids in their simplicity of decoration, decorative motifs, and method of execution of both the object itself and its embellishment.[18]

A final example of the influence of Fatimid and Zirid art on that of al-Andalus during the tenth and eleventh centuries can be seen in bronze animal sculpture. The stag seen here and two other closely related animals[19] from al-Andalus all have an

Ifriqiyan precursor. This quadruped from Beni-Khalled shares with the stags from al-Andalus not only its stance but also the treatment of the eye and the manner in which the horns are attached. The Ifriqiyan example, however, is undecorated except for its plaited collar from which a crescent hangs. Growing out of a long tradition established during the Umayyad and Abbasid periods, the vogue for small and large bronze animal sculpture persisted in Egypt and the Maghrib at least until the end of the eleventh century. The most famous as well as the most beautiful example of this tradition of metal animal sculpture in the western reaches of the Islamic world is undoubtedly the so-called Pisa griffin, the immediate precursor of which was the Beni-Khalled quadruped. Made under Fatimid aegis either in Ifriqiya or Egypt during the eleventh century, the Pisa griffin could very well have been part of the large booty taken by the Pisans after their successful invasion of the Zirid capital, Mahdia, in the summer of 1087.[20]

In 997 one of the Zirid emirs gave his uncle, Hammad ibn Buluggin, the governorship of Ashir and Msila in present-day Algeria, an appointment that not only soon led to the founding of the Hammadid dynasty in the central Maghrib but also caused the emir's great-uncle, Zawi ibn Ziri, to revolt and subsequently, in 1002, to flee to Spain with his sons, nephews,

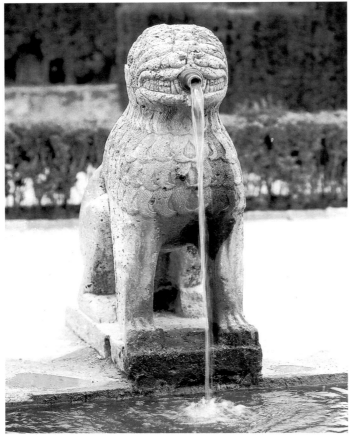

Lion in the Partal Pool, Alhambra, Granada. Carved stone. Al-Andalus, 11th century. Photo: Archivo Fotográfico Oronoz

Architectural element. Carved stone. Central Maghrib, 11th century. Stephan Gazelle Musée, Algiers. Drawing: Golvin 1965, fig. 56.2

and attendants. Once in al-Andalus, this Zirid and his relatives made themselves very useful to the Umayyads, and in return for their support the caliph Sulayman rewarded them with the entire administrative district of Elvira as a fief, which in 1012 they proclaimed an independent principality. Granada was the capital of this powerful and respected Zirid dynasty, which lasted until 1090.

By the second decade of the eleventh century, the Zirids in the Maghrib were thus divided into three branches: one in Ifriqiya, ruling from Sabra al-Mansuriyya; one in the central Maghrib, ruling from Qalʾat bani Hammad; and one in al-Andalus, ruling from Granada.

During the reign of al-Nasr ibn ʾAlannas (r. 1062–89) the Hammadid dynasty reached its apogee and eclipsed the Zirids

Detail of basin at Qalʾat bani Hammad, Central Maghrib, 11th century. Photo: Marilyn Jenkins

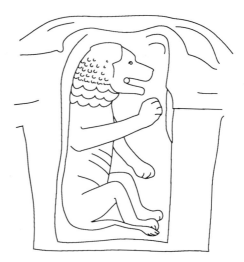

Lion on basin at left. Drawing: Irmgard Lochner

Foot of a vessel. Cast bronze. Central Maghrib, Qalʾat bani Hammad, 11th century. Musée des Arts Décoratifs, Paris. Photo: Marilyn Jenkins

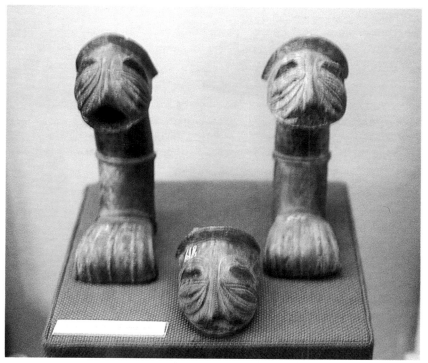

Feet of a vessel or vessels. Cast bronze. Al-Andalus, Elvira (Granada), 11th century. Museo Arqueológico Provincial, Granada. Photo: Marilyn Jenkins

in Ifriqiya. It was also during this reign that many of the inhabitants of Ifriqiya, especially those of Kairouan, emigrated to al-Qalʾa to escape from the devastation of the Arab hordes. This caused an unexpected surge of prosperity as well as a population increase in the mountain city. Scholars, students, artisans, and merchants came from far and wide because of the great opportunities the city offered to those who cultivated the sciences and the arts in addition to those involved in commerce. The eleventh-century geographer al-Bakri tells us that caravans from Iraq, the Hejaz, Egypt, Syria, and all parts of the Maghrib were attracted to this city.[21]

The architectural decoration executed under the Hammadids in the central Maghrib appears to have influenced that adorning Zirid constructions in al-Andalus. Considered the wealthiest of all the *muluk al-tawaʾif*, the Zirids in Granada were responsible for what are perhaps the most famous extant Zirid decorative elements in Andalusia, the twelve lions that now lend their name to the Patio de los Leones in the Alhambra and those at the edge of the Partal Pool in the same palace complex. These felines must originally have formed part of the decoration of a palace similar to that built by one of the Hammadid rulers, al-Mansur (r. 1088–1105), in his coastal capital of Bougie. In two different poems written by ʿAbd al-Jabbar ibn Hamdis (d. 1135) this unnamed palace is described as having interior courts of marble which seem to be carpeted with crystal and faced with the shining white of camphor; its grounds seem to be strewn with fine pearls and to exhale the

perfume of musk and amber. It is also described as having a pool bordered by marble crouching lions with water streaming from their mouths back into the basin, and gold and silver trees whose branches projected water, as did birds perched in the trees.[22]

The anonymous author of *Al-Istibsar*, a geographico-historical work of about the second half of the twelfth century, states that the building undertaken at Bougie was the work of masters from al-Qalʾa, a statement with which Idris agrees.[23] It may thus be safe to assume that the Bougie lions were similar in style to those now in the Alhambra, as the style of drawing, especially in the head area of the Granada animals, shares close similarities with a stone architectural element in the form of a quadruped from Qalʾat bani Hammad.

The important role played by large basins of water in the architecture of both the eastern and western Umayyad caliphates and the Umayyad emirate as well as Aghlabid Ifriqiya has been discussed earlier. This vogue continued in Fatimid and Zirid Ifriqiya and in the Hammadid capitals.[24] The enduring popularity of smaller basins further attests to the influences moving between the northern and southern shores of the Mediterranean during the period under discussion. The cartouche-shaped basin still at al-Qalʾa incorporates, centered on each of its four sides, a lion that sends a stream of water through an opening in its mouth into the base of the receptacle.

Additional parallels between objects made during the *taifa* period in al-Andalus and those made under the aegis of the

Hammadids in the central Maghrib can be found. One can, for example, compare the bronze zoomorphic vessel feet found at al-Qal'a with those found in Elvira and with the later so-called Monzón lion.[25]

Ceramic production in al-Andalus during the *taifa* and the subsequent Almoravid periods also reflects a strong and direct Hammadid influence. The technique of luster-painting on pottery has been shown to have passed from al-Qal'a to Bougie and from there to Málaga.[26] Elsewhere I have suggested that the black-painted and incised earthenware objects made in Zirid Bougie inspired similar products in Andalusia; in fact, one is tempted to consider such ware found in Spain as "imitation luster."[27]

Within al-Andalus, a number of concentrated forces interacted to effect the formation and influence the development of Islamic art in the peninsula during the four and a half centuries of Muslim rule discussed here. The culture in Andalusia at this time was far from being, as many have long assumed, basically an imperial Umayyad one transplanted to Spain, with the *taifa* and Almoravid contributions minimal if not nonexistent. On the contrary, the culture of al-Andalus was very much a part of the coherent art-historical and political picture presented by the Maghrib during these four hundred and fifty years.

NOTES

1. Goitein (1967, p. 43) says that the term *al-Maghreb* was used, during the period in question, to mean all of North Africa west of Egypt, including Muslim Sicily, with Spain forming a subsection.
2. Allan 1986, p. 16.
3. Jenkins 1975; Jenkins 1978; Jenkins 1983; Jenkins 1988a.
4. Sourdel-Thomine and Spuler 1973, color pl. VIII.
5. Ibid., color pl. V and fig. 24.
6. Hamilton 1959, general plan inside back cover. This concept of a palatial building overlooking a pool was also to be seen in Tunisia, in the Aghlabid royal residential city of Raqqada founded in 876 in the suburbs of Kairouan. Qasr al-Bahr, built between 905 and 909, consisted of a basin called al-Bahr (sea) capable of holding 60,040 cubic meters of water and, on the basin's shortest side, a palace of four stories called al-Arus (the bride). At a time when the dinar was equal to 4.25 grams of gold, this structure cost 232,000 dinars. The history of the Mediterranean area during the early centuries of Islam would support a hypothesis that Qasr al-Khilafa in

al-Andalus could have been inspired by either the Umayyad or the Aghlabid model or both.
7. Allan 1986, p. 27, fig. 19.
8. Marçais 1928, p. 10.
9. Jenkins 1980, pp. 335–42.
10. Jenkins 1975, pp. 91–107.
11. Creswell 1932–40, pl. 85a–b.
12. Marçais 1936, p. 107. During the ninth and tenth centuries Ifriqiya was, in fact, the economic hub of the Mediterranean. The Geniza (literally a repository of discarded writings) documents, which are such an important source of information for this period, strongly support this rubric, as do contemporary authors. The geographer al-Idrisi (1968, p. 126), speaking of Mahdia, says ships brought merchandise there in quantity and for great sums as customers were sure to be found, and the geographer Ibn Hawqal (1842, p. 173) confirms that its markets were full of merchants who were constantly arriving there.
13. Holod in New York 1992a, pp. 42–44, for a more detailed description of the many innovations introduced into al-Andalus by Ziryab, and p. 45.
14. It has been suggested that perhaps these textiles were woven in Spain on looms that were imported from the Abbasid capital. This author does not agree with this suggestion on epigraphic grounds. The peculiarity found on both of these textiles in the spelling of the demonstrative particle *hādha* is seen only in western Islamic lands. If the looms were imported, the particle would have been spelled in the classical way (Day 1954, pp. 191–94).
15. Buluggin took over the later of the two capital cities established in Ifriqiya by the Fatimids, Sabra al-Mansuria, which remained the Zirid capital until 1057, when they abandoned the city for Mahdia, which in turn remained the Zirid capital until 1148 when it was captured by the Normans. It was Buluggin ibn Ziri who also held Fez for his overlords until it was taken by the Andalusian Umayyads in 985 during the reign of Hisham II (r. 965–1013). Buluggin took the opportunity in 980 to order a minbar for the mosque of the Andalusians in the city. New York 1992a, pp. 249–51.
16. Al-Maqqari in Castejón 1961–62, p. 126, and al-Nuwayri 1917–19, p. 55.
17. Ettinghausen 1956, p. 269, fig. 7a–b.
18. Jerusalem 1987, no. 281, color pl. 10.
19. New York 1992a, pp. 210–11, and Scerrato 1966, pp. 71–73, fig. 30.
20. Jenkins 1978.
21. Al-Bakri 1913, p. 105.
22. Bercher 1922, pp. 53–54.
23. Fagnan 1900, p. 32; Idris 1962, p. 501.
24. Fatimid Sabra al-Mansuriyya incorporated a building called Qasr al-Bahr (a name subsequently given to a Fatimid palace in Cairo and one we have already met at Raqqada). This structure was eulogized by the Ifriqiyan Fatimid poet 'Ali ibn al-Iyadi. Provided with a hydraulic pleasure installation (fountains, pools, and the like), it contained a cupolated pavilion in the middle of a garden with colonnades of green columns. The pavilion was on the edge of a pool in the middle of which was a kiosk modeled on the Sassanian palace called al-Khawarnaq.

 We are told that in its turn Qal'at bani Hammad had a Dar al-Bahr that was used for nautical games. This had at its center a vast basin that required a considerable amount of water, which had to be brought from afar.
25. Gómez-Moreno 1951, fig. 397a,b, n. 19.
26. Jenkins 1980, pp. 335–42.
27. Jenkins 1978, p. 181, n. 81.

capital

Andalusia, 972–73 (dated A.H. 362)
Carved marble
H. 15 in. (38 cm)
Dar al-Athar al-Islamiyyah, Kuwait City, Kuwait; al-Sabah Collection (LNS25)

This capital was probably commissioned for a structure in Madinat al-Zahra', the city founded in 936 by 'Abd al-Rahman III al-Nasir (r. 912–61) about three miles (five kilometers) northwest of Córdoba. Named for his favorite, Zahra' (bright one, splendid one), it was intended as a place of recreation but became an administrative and commercial center once the caliph had installed himself there. According to the Arab biographer Ibn Khallikan (1211–1282), this royal residential city contained 4,300 columns. The great eleventh-century Spanish historian Ibn Hayyan, whose ultimate source is given as the son of one of 'Abd al-Rahman's architects, said that 1,013 of these were imported from Ifriqiya, 19 from France, 140 from the Byzantine emperor, and the rest from Spain itself (Ibn Hayyan's remarks are taken from a seventeenth-century account by the historian Maqqari).

Not only did 'Abd al-Rahman III undertake construction here, but his son al-Hakam II (r. 961–76) did also. The latter is mentioned in the Arabic inscription in Kufic script on this capital. The inscription reads:

بسم الله بركة من الله / وعافية شاملة وعزّ دائم / وسرور
متصل للإمام عبد الله / الحكم المستنصر بالله أمير/ المؤمنين
أطال الله بقاه (كذا) ممّا أ/مر بعمله فتمّ بعون الله / على
يدي سدق [؟] الفتى الكاتب في / سنة اثنين وستّين
وثلث مائة / عمل فليح [؟] الأسير[؟] عبده

In the name of God. Blessing from God, / general well-being, everlasting glory/and uninterrupted joy to the imam 'Abd Allah/ al-Hakam al-Mustansir billah, Commander/ of the Faithful, may God prolong his reign. From among that which he/ordered to be made and which was completed with the help of God/[under the direction] of Sadiq[?], officer and secretary, in/the year three hundred and sixty-two./Work of Falih[?], the Captive[?], his servant.

The decoration of this particularly fine capital reflects Byzantine rather than classical models. So deeply carved as to seem filigreelike, the surface of this architectural element takes on an almost veiled appearance. Which of the thousands of columns adorning the city that has been called the Umayyad Versailles was so exquisitely crowned?

M J

LITERATURE: Jenkins 1983, p. 44; Geneva 1985, pp. 340–41; Baltimore 1990, no. 23; New York 1992a, no. 39, p. 247.

LITERATURE: Jenkins 1983, p. 44; Geneva 1985, pp. 340–41; Baltimore 1990, no. 23; New York 1992a, no. 39, p. 247.

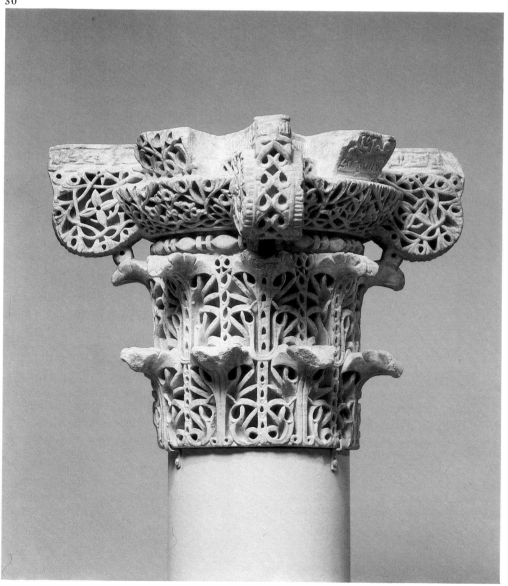

30

capital with four musicians

Córdoba (Córdoba), second half of 10th century
White marble
H. 10 in. (25.5 cm)
Museo Arqueológico Provincial de Córdoba (D/133)

This piece is unique among capitals in the Spanish Islamic tradition.[1] On each of its four faces, between large corner volutes, a musician in high relief has been incorporated into the three-tiered ornamental foliage. The figures stand barefoot on the bottom ring of leaves; their now-missing[2] heads had been placed in front of the boss of the abacus.

On the basis of its well-defined acanthus leaves, the capital can be dated to the late 960s or 970s. The carving of the foliage and figures is unequal in quality. Whereas the stonecutter's highly developed technique and skill in elaborating the Corinthian capital attest to his familiarity with the form, the figures are comparatively crude, as though he had no experience at such work.

The leaf tips provide both sculptural accents and horizontal order in the network of foliage. The leaves' central ribs are not simple verticals or variations of the same perforated for decorative effect. Instead they divide into two outward-curving veins that come together again only at the tip. Narrow leaf spikes project outward in opposing directions, producing overlappings into which smaller forms have been incorporated. The stonecutter has thus taken a new step toward the two-dimensional treatment of a three-dimensional

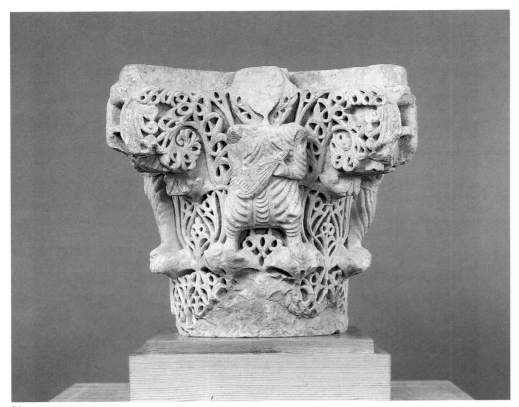

31

panel

Andalusia, 936–76
Carved marble
41 x 19¾ in. (104 x 50 cm)
Museo Arqueológico Provincial de Córdoba (487)

The important role played by imperial Umayyad artistic styles and traditions in the formation of Islamic art in the Iberian Peninsula cannot be sufficiently stressed. This marble panel, which most probably graced a dado or doorjamb at Madinat al-Zahraʾ, is an excellent example of the strong dependence of the art of al-Andalus on the earlier products of Greater Syria.

The rectangular field of the panel is filled with a palmette tree, carved in high relief, with its trunk positioned axially and giving rise to symmetrically arranged pairs of branches, each scrolling to enclose a single palmette. Each of the five pairs of leaves is different from the rest, and the manner in which the second pair from the top is depicted bears very close comparison with the treatment of the palmettes on the casket of Hisham II, datable to 976 (cat. 38a). A guilloche defines the field, and a border of small,

classical architectural element, abandoning an important aspect of the capitals of Madinat al-Zahraʾ, for example.[3]

The foliage serves as an elegant frame for the musician figures, and there are additional wreaths of leaves around their heads. Two of the musicians are lute players, a third plays the *kaman*, and the fourth is presumably either a flutist or a singer holding his hands in front of his body. This last figure wears a calf-length tunic, while the others are dressed in belted baggy trousers. The folds of their drapery appear as parallel ridges. This is evidently a band playing a familiar combination of instruments, so that the capital would have evoked the idea of a particular sound. The work dates from a period when Córdoba was the musical capital of the Islamic world.[4] For models for the musician figures, one would have to look to the minor arts or painting. Since the early Umayyad period, motifs derived from court entertainments had been employed in the adornment of caliphal palace rooms, and they were common on the ivory boxes from Madinat al-Zahraʾ.[5]

The close connection between architectural ornament and jewelry in al-Andalus that becomes evident through this capital is also frequently encountered in Asturian and Mozarabic art (cat. 66). From this later period, the wall paintings in the church of San Miguel de Liño depict a lute player who in that Christian context would belong to the heavenly sphere. This caliphal capital, by

contrast, doubtless comes from a secular palace in which musical entertainments actually took place. SN-H

1. First published by J. D. Dodds in New York 1992a, p. 248, no. 40.
2. See ibid.; the defacing presumably took place in the Almoravid period.
3. Ibid., pp. 244–47, nos. 37–39: the integrity of the leaf is still recognizable in these capitals dating between 964 and 976. For the subsequent "decadent" phase of capital production under al-Hakam II, see Marinetto 1986, pp. 79ff.
4. The *kaman* is related to the European violin and is played with a bow. A very valuable sourcebook on the instruments and history of Arabic music in Spain is Salvador-Daniel 1915; see especially pp. 119–22, 168–86, and 229–41. I am grateful to Klaus Brisch for this reference.
5. It is risky to attempt to establish a connection to antique figural capitals, to Byzantine mask or animal-protoma capitals, or even to the Cordoban Visigothic evangelist capital (cat. 8). The juxtaposition of courtly scenes and foliage is very common in contemporary ivory work from Madinat al-Zahraʾ, for example the pyxis in New York 1992a, no. 3, ill. p. 197 (dated 968). The lute player on that work also points his feet straight ahead in violation of the oriental convention of showing the feet of standing figures in profile. Portrayals of musical performances including instrumentalists and female dancers appear in decorative wall painting cycles in the eastern Umayyad and Abbasid traditions, in the palace of Qasr al-Hayr al-Gharbi, for example (floor painting with lute players and flutists, second quarter of the eighth century); the complex of Qusayr ʿAmra (vault frescoes with lute players and flutists, second quarter of the eighth century); and the palace of Jausaq al-Khaqani in Samarra (wall paintings with female dancers, 836 and 839). For illustrations, see Sourdel-Thomine and Spuler 1973, pls. XIII, XXIII; Almagro et al. 1975, pls. VI, XXVI, XLII.

LITERATURE: New York 1992a, p. 248, no. 40.

32

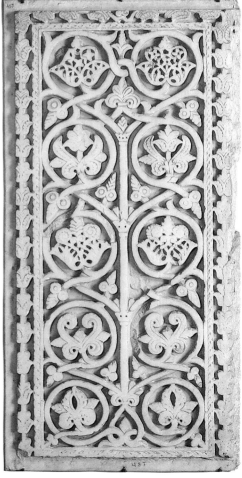

interconnected palmettes frames the panel on three sides.

This tree of life decoration, which had its origin in the late classical candelabra tree, is highly reminiscent of the depictions of the same motif on a number of stucco window grilles from the desert palace of Qasr al-Hayr al-Gharbi, built between 724 and 727 northeast of Damascus for the Umayyad caliph Hisham, and on several wooden soffits carved about 715 for the Aqsa Mosque in Jerusalem (see page 74). The motif can also be found on stone niche heads at the desert palace of Khirbat al-Mafjar, built for al-Walid II between 739 and 743 not far from Jericho.

Because Madinat al-Zahra' was originally founded as a place of recreation not unlike the two palaces mentioned above, it is not surprising that the Spanish Umayyad caliphs would also attempt to emulate the ornamentation of their ancestors' residences. The tree of life motif proved to be a particularly popular one in al-Andalus, especially for architectural decoration; and its variations are legion. One later modulation is seen on the marble panel found in Toledo (cat. 35), where the relief is considerably lower, the trunk of the tree is less obvious, and the branches are almost unrecognizable. Extant canon tables and manuscript illustrations attest that this design was also adapted for use in contemporary Christian contexts in the peninsula.

MJ

LITERATURE: Gómez-Moreno 1951, p. 184, fig. 244c; Santos 1951, p. 91, pl. 18; Sourdel-Thomine and Spuler 1973, p. 202, no. 96; London 1976, no. 486, p. 305; New York 1992a, no. 35, p. 242.

33

WINDOW GRILLE

Andalusia, 980–90
Carved marble
60¼ x 38⅝ in. (153 x 98.1 cm)
Museo Arqueológico Provincial de Córdoba (3.488)

The iconographic repertoire of Islamic artists throughout the centuries emanated from the use of four basic design elements: vegetal forms, calligraphy, figural designs, and geometric patterns. The last element was adopted from the late Greco-Roman tradition in the early Islamic period, and from the beginning these patterns were adapted and developed, becoming vehicles for great diversity and ingenuity in the hands of the Muslim artists.

In fact, no other culture used geometric repeat patterns in such inventive and imaginative ways. Perhaps the Islamic concept of God contributed to the universal popularity (from the seventh century until the present and from Spain to the borders of China) of this characteristic feature of Islamic art. Like the Divine Being, these geometric repeat patterns are infinite—that is, they have no beginning and no end.

This exquisitely carved marble window grille from an unknown Andalusian building, most probably in Córdoba or its immediate

vicinity,[1] is the inheritor of what appears to have been a very popular vogue under the Umayyads in Greater Syria for stone or stucco window grilles. In fact, the by now well known route—from the imperial Umayyad realms to al-Andalus—that so many of the decorative motifs and traditions discussed here have taken may have been traveled by this architectural device as well. For example, in Jerusalem, the western entrance of the Dome of the Rock (691) is still graced with its original ajouré stone tympanum; six beautifully carved stone window grilles of the

33

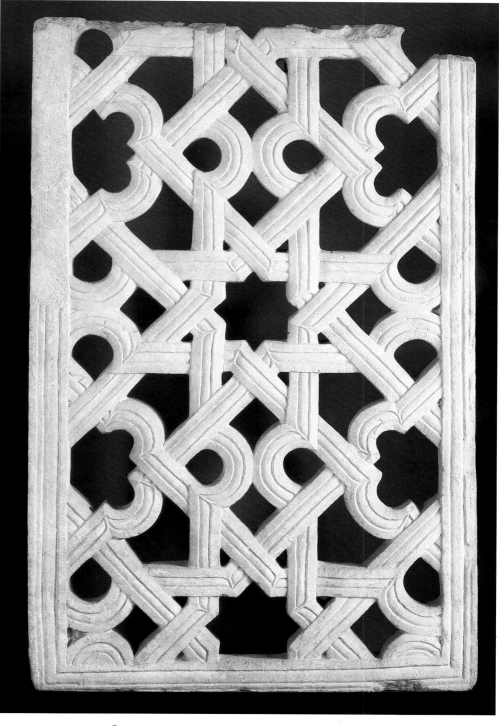

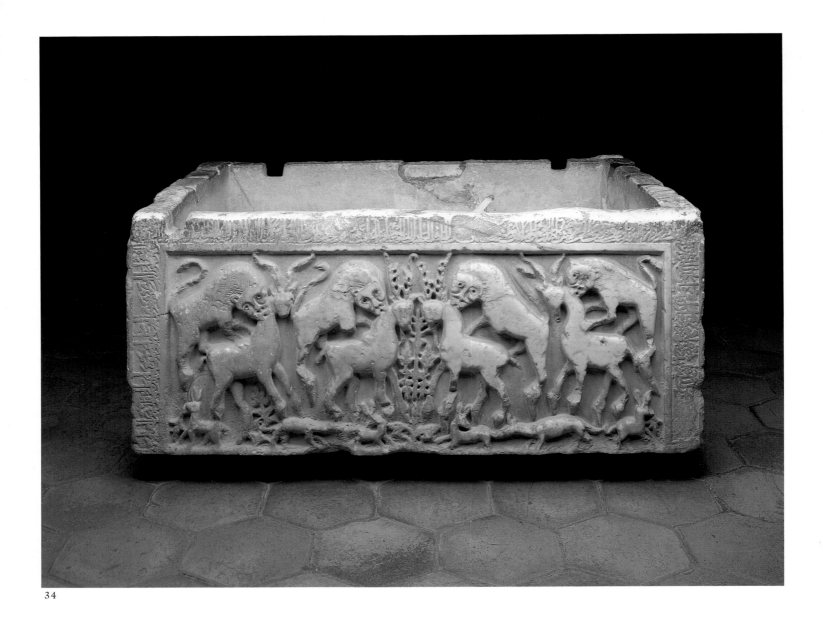

34

period of al-Walid I are to be found in the Great Mosque of Damascus (706); and carved stucco window grilles abound at the desert palaces of Qasr al-Hayr al-Gharbi (724–27) and Khirbat al-Mafjar (739–43). The vogue for grilles spread very rapidly to the western regions of the Islamic world, namely to Kairouan under the Aghlabids, Córdoba under the Umayyads, and Cairo under the Fatimids. Their appeal reflected not only their attractiveness but their functional qualities as well; in the hot Mediterranean climate, they maintained privacy while permitting visibility from indoors, and they provided ventilation while inhibiting insects. MJ

1. Brisch 1966, pp. 10–12 and pl. 7, for a smaller but otherwise identical grille.

LITERATURE: Brisch 1966, pl. 43; New York 1992a, no. 42b, pp. 252–54.

34

BASIN OF KING BADIS

Andalusia, 1038–73
Marble
24 x 34⅝ x 16⅛ in. (61 x 88 x 41 cm)
Museo Nacional de Arte Hispano-Musulmán, Granada (243)

The basin of King Badis is one of a group of important rectangular water fonts made for palatial gardens of the caliphal and *taifa* periods.[1] Like the caliphal fonts now in Marrakech[1] and the Museo Arqueológico Nacional in Madrid,[2] this example from the *taifa* period is almost entirely covered with carving, except for a strip of unadorned stone on each short side, where the water source and overflow were located. Unlike a series of shallow fonts from the same period whose function was exclusively decorative, these deep basins were almost surely intended as reservoirs for water

either for domestic use or for ablutions in a religious context.

The font's imposing white marble reliefs, however, suggest meanings beyond such functions. Each long side features a bold and aggressive relief of four pairs of lions attacking antelopes, two pairs on either side of a small and rather cramped tree of life. On one of the long sides, the feet of the antelopes and lions rest on pairs of hounds and hares frozen in the moment of capture, each hare turning to confront the hound, which has caught hold of its tail. A relief on one short side presents the same iconographical formula found in the Marrakech basin: an eagle grasping an antelope in its talons while harboring other animals—in this case, lions and rabbits—within its wings. The reworked inscription tells us that this work is a direct copy of a caliphal basin, though no other with such a rich and lively figural composition survives.

34 : Detail

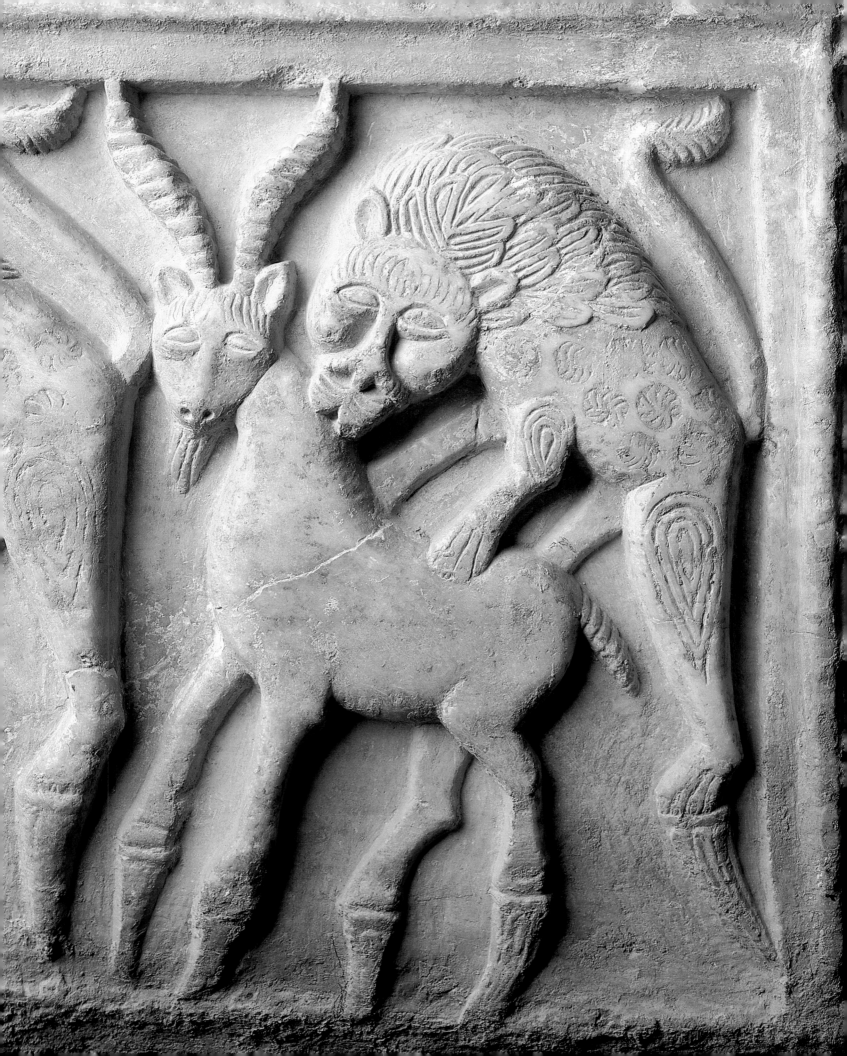

Images of lions assailing antelopes had been statements of power and hegemony since the earliest arts of Mesopotamia, and significant Islamic examples abound from the Umayyad period on. The mosaic from the bath at Khirbat al-Mafjar (739–44) is one early example. Here this repeated image not only states Badis's right to rule but also associates him with the great Umayyad sovereigns of both al-Andalus and the Fertile Crescent.[3] Head of the Zirid kingdom of Granada, Badis (1038–1073), like many of the *taifa* kings, expressed in his patronage the desire to identify his rule with the Spanish Umayyad court at a time when most of the peninsula was consolidated into one brilliant Islamic state and perhaps to identify it with the original Umayyad caliphate, which had once led the entire community of Islam.

Reliefs of hares being pursued by dogs suggest the hunt and are associated with land ownership, a topic of some importance to the *taifa* kings.[4] All of these predatory themes provide links to a possible function for the basin, since hydraulic systems in caliphal and *taifa* palaces have been shown by D. Fairchild Ruggles to carry implications of agricultural wealth and hegemony as well.[5]

The Nasrid king Muhammad V refashioned Badis's original inscription in 1305. The text not only names the font's patron but clearly designates itself a copy of an earlier basin. Such open admiration for the caliphal work lends to this appropriation of brutally hegemonic imagery a tone of nostalgia reminiscent of much *taifa* art and poetry.

JDD

1. See New York 1992a, p. 255.
2. Gómez-Moreno 1951, pp. 181–88.
3. I am indebted to Professor Juan Zozaya for this observation.
4. See Catalogue 103.
5. See New York 1992a, pp. 163–71, 261–63.

LITERATURE: Gómez-Moreno 1951, pp. 181–88.

35

panel

Andalusia, mid-11th century
Marble
57½ x 19¼ in. (146 x 49 cm)
Museo de Santa Cruz, Toledo (400)

The entire surface of this dado panel (which must have once graced a building of the *taifa* period in Toledo) is covered with a so-called tree of life decoration. The stem of the tree forms the central axis of the design and gives rise to six symmetrically arranged and verti-

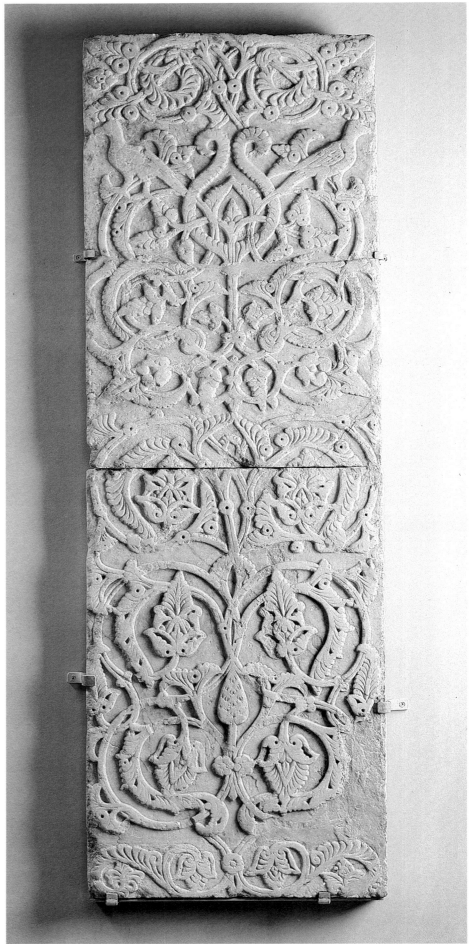

35

cally interlaced pairs of leaf scrolls, each of which terminates in a highly stylized single or triple palmette. From the top of the stem grows a large, lyre-shaped, split palmette; to the right and left is a bird perched on the uppermost pair of leaf scrolls and facing the panel's outer edge. The relief is bordered at the top and bottom with horizontally oriented vegetal scrolls.

The closest parallels for this decoration are to be found on wooden door panels executed in Fatimid Egypt during the middle of the eleventh century (see p. 78). All of the elements of the design on the Andalusian relief are to be found on such Cairene panels, which have survived in considerable numbers. That the Egyptian vogue for this design crossed religious lines is demonstrated by the incorporation of doors so decorated in both Islamic and Christian contexts. During the *taifa* period and later, trade kept the petty kings and Berber dynasts in al-Andalus in close contact with the Fatimids in Egypt. It is possible that this iconography entered the Iberian Peninsula in such a manner during the Fatimid period. However, because the motif itself (the late classical candelabra tree) was part of the late antique heritage of early Islamic art as created in the Mediterranean basin, a precise answer to the route this design took to Spain and the time of its arrival and incorporation into the iconographic repertoire there remains elusive. It could have passed into the pattern books of the artisans of Toledo directly from Greater Syria, just as easily as from Greater Syria via Madinat al-Zahra' (cat. 32) or from Baghdad via North Africa.

MJ

LITERATURE: Prieto y Vives 1926, pp. 51–55; Gómez-Moreno 1951, p. 216, fig. 272; Sourdel-Thomine and Spuler 1973, p. 256, no. 183; London 1976, no. 490, p. 307; New York 1992a, no. 48, p. 260.

36

capital and base of engaged column

Toledo(?), mid-11th century
Carved marble
Capital: h. 12⅞ in. (32.8 cm); base: h. 7½ in. (19 cm)
Museo Taller del Moro, Toledo (1.270, 1.241)

The architecture and decorative arts created for the early Muslim rulers and members of their court were dependent upon the building styles, architectural decoration, decorative techniques, types and shapes of objects, and the iconography already prevailing within

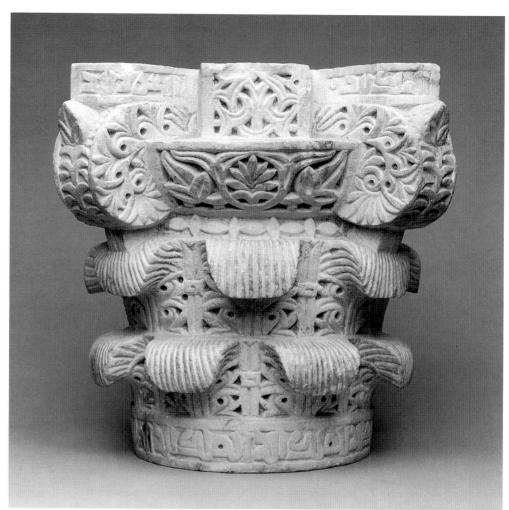

36

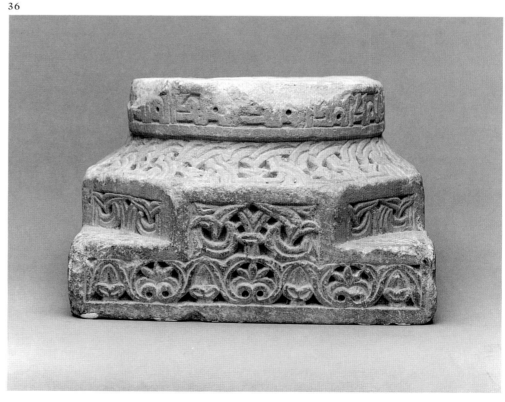

36

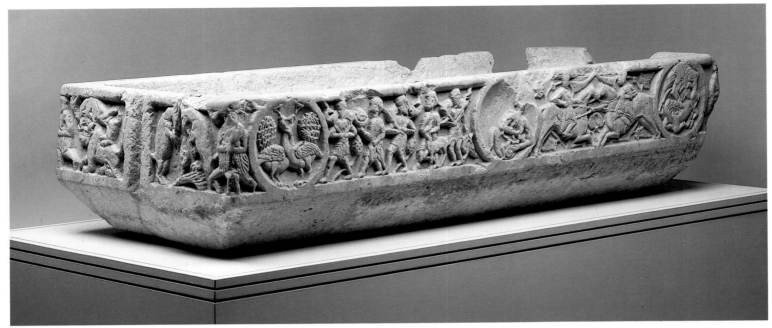

37

the cultures of those areas conquered by the Arabs. Since the late Greco-Roman tradition was prevalent on the shores of the Mediterranean when the Umayyad Dynasty (661–750), with its capital in Damascus, was founded, the first Muslim dynasty adopted and subsequently adapted the culture of late antiquity. Later many of the artistic traditions current in the Levant under the Umayyads were brought to the Iberian Peninsula during the Spanish Umayyad emirate and caliphate. There those traditions blended with and greatly reinforced the traces of the Roman artistic tradition still to be found in Spain when the Arabs crossed the Straits of Gibraltar in the early eighth century.

A beautiful Andalusian example of the Islamic adoption and subsequent adaptation of the late Greco-Roman tradition—albeit seen through a Byzantine filter—is the Corinthian capital dated A.H. 362 (A.D. 972–73) that was discussed above (cat. 30). By the middle of the following century, under the *taifa* kingdoms, the adaptation process had progressed even further—a fact to which the capital and base seen here attest. While all of the essential characteristics of the earlier capital are found on the later one, a number of changes have taken place.

The filigreelike quality of the overall vegetal decoration on al-Hakam's capital has here become geometric and somewhat flattened. This tendency toward stylization has been carried to an extreme in the depiction of the acanthus leaves, which appear as if applied to the design rather than emanating from it. Finally, the proportions of the capital have begun to change. The elongation characteristic of the capital's elements was to continue

throughout the *taifa* period and become more pronounced as the century progressed. The vegetal decoration on the base has also become more abstract, and the profile has become angulated.

The Arabic inscription in Kufic script on the abacus of the capital reads: العزة لله / الملك لله / العزة لله / الشكر لله (Glory belongs to God./Sovereignty belongs to God./Glory belongs to God./Praise belongs to God/). Incised on both the lower section of the capital and on the base and repeated four times is: الملك لله (Sovereignty belongs to God).

MJ

LITERATURE: Prieto y Vives 1926, pp. 51–55; Gómez-Moreno 1951, p. 214; Pavón 1973, pp. 99–100; London 1976, no. 493, p. 308; Revuelta 1979, p. 74; Brisch 1979–81, pp. 156–58; Valero 1987, pp. 90–91; New York 1992a, no. 47, p. 259; New York 1992b, no. 54, p. 215.

37

BASIN

Andalusia, 11th century
Carved marble
16½ x 66⅞ x 26⅜ in. (41.9 x 169.9 x 67 cm)
Museo del Almudín, Játiva (A25)

Unlike the high rectangular marble basins that have been found at various sites in al-Andalus and Morocco (cat. 34), whose original use has yet to be satisfactorily explained, basins with considerably lower sides most probably functioned as fountains. While the higher basins occur in one form only, the

extant Maghribi examples with lower sides exhibit a number of different shapes, and their ornamentation is considerably more varied. In addition to the rectangular variety seen here, square, round, and lobed basins are known as well as basins in the form of a cartouche (see p. 82). Their decoration includes vegetal, geometric, calligraphic, and figural designs. However, the basin from Játiva is the only one known to this author that bears human representations.[1]

Not only is this the sole basin decorated with human figures, but its figural style is highly unusual for medieval Spain, as is some of its iconography. In fact, the realism conveyed in several of the vignettes to be seen in the decorative band completely encircling this basin as well as certain of the motifs themselves has closer parallels in Fatimid Egypt than in the Iberian Peninsula under the Umayyads or during the *taifa* period.

One of these vignettes depicts three men eating and drinking beneath a fruit tree while being entertained by two musicians at the right and served by an attendant at the left. The reclining drinker leans against a bolster and supports himself on his right elbow; the second figure in repose, also resting against a pillow, eats a fruit from the tree. Although the iconography seen here is not uncommon in medieval Spain, the realistic handling of it is what sets this scene apart from similar depictions on contemporary ivory boxes. Highly informal poses have been substituted for the more usual hieratic representations.

The scenes of men dancing with large sticks or wrestling, while otherwise unknown in al-Andalus, can be seen on two Fatimid luster-painted dishes made in Cairo during

the eleventh century and now in the Islamic Museum, Cairo (see p. 78).[2] Another of the realistic vignettes on this basin, that of five men, some of whom lead quadrupeds and others who carry fowl or a basket of fruit or vegetables, can also be found in Fatimid Egypt, particularly on objects of wood and ivory.

This basin appears to be unique among extant Spanish Umayyad and *taifa* objects, introducing to the Andalusian repertoire a realistic figural style not seen in the peninsula before. Therefore, more important than explaining the iconography chosen to decorate this basin is the need to determine the impetus behind the newfound Andalusian interest in realism exemplified by some of its vignettes.

As has been mentioned, the influence of Fatimid and Abbasid art on that of al-Andalus was strong. Perhaps this new interest in realism in eleventh-century Spain also had spread westward from Egypt and Iraq. Not only do extant Fatimid objects attest to this fashion, but so does literature of the period. Maqrizi (d. 1442) relates the following story in his *Khitat*:

Yazuri (the chief minister of the [Fatimid] Caliph al-Mustansir [1036–1094]) invited Ibn ʿAziz from Iraq and excited his evil passions, for (the wazir) had sent for him to contend with al-Qasir, because al-Qasir demanded extravagant wages and had an exaggerated opinion of his own work . . . Now Yazuri had introduced al-Qasir and Ibn ʿAziz into his assembly. Then Ibn ʿAziz said, "I will paint a figure in such a way that when the spectator sees it, he will think that it is coming out of the wall!" Whereupon al-Qasir said, "But I will paint it in such a way that when the spectator looks at it, he will think that it is going into the wall!" Then (everyone present) cried out: "This is more amazing (than the proposal of Ibn ʿAziz)!" Then Yazuri bade them make what they had promised to do: so they each designed a picture of a dancing-girl, in niches also painted, opposite one another—the one looking as though she were going into the wall, and the other as though she were coming out. Al-Qasir painted a dancing-girl in a white dress in a niche colored black, as though she were going into the painted niche, and Ibn ʿAziz painted a dancing-girl in a red dress in a niche that was colored yellow, as though she were coming out of the niche. And Yazuri expressed his approval of this and bestowed robes of honor on both of them and gave them much gold.[3]

MJ

1. Not enough survives of the two fragments illustrated in Gómez-Moreno 1951 (p. 275, fig. 238) and called "trozo de pila" to state unequivocally that they formed parts of basins.

2. Inv. nos. 14516 and 9689.
3. Ettinghausen 1956, pp. 267–68.

LITERATURE: Sarthou 1947, pp. 8–10; Gómez-Moreno 1951, pp. 274–76, figs. 328–30; Baer 1970–71, pp. 142–66; New York 1992a, no. 49, pp. 261–63.

38

funerary stela

Córdoba (Córdoba), 1103 (dated A.H. 496)
Carved marble
14 1/8 x 12 5/8 in. (36 x 32 cm)
Museo Arqueológico Provincial, Málaga (37.999)

The face of this tombstone is configured like a mihrab, or prayer niche, its horseshoe arch resting on two stocky columns and interlacing at the top and two sides with the rectangular frame of the niche. Each of the spandrels contains a conch shell, a decorative device drawn from the classical repertoire, which is omnipresent in western Islamic architectural embellishment. The principal ornamentation on the stela is calligraphic and consists of Arabic inscriptions that were executed in a very beautiful and bold Kufic script.

The outer frame bears verse 18 from the third sura of the Koran: "God witnesseth that there is no god but He: and the angels, and men endued with knowledge, stablished in righteousness, *proclaim* 'There *is* no god but He, the Mighty, the Wise!'" The arch encloses the following inscription:

بـسـم الله الرحمٰن الرحيم / وصلّى الله على محمّد هذا قبر / بدر بـنـت الأمير أبـي الحسن / علي بن تـائشّا الصنهاجيّ / تـوفّيت رحمهـا الله ليلة الا /ثنين نصف ربيع الآخر سنة / ست وتسعين وأربعمائة

In the name of God, the Merciful, the Compassionate./The blessings of God on Muhammad. This is the tomb/of Badr, daughter of the emir Abu al-Hasan/ʿAli ibn Taʾishsha al-Sanhaji./She died, may God have mercy upon her, on Monday-eve/[Sunday night], mid-Rabiʿ II in the year 496 [January 27, 1103].

The two impost blocks inform: نقش العيّاد (Carved by/al-ʿAyyad).

The inscription places the stela in historical context. Badr was a princess, the daughter of an emir by the name of Abu al-Hasan ʿAli ibn Taʾishsha, who governed Córdoba for the Almoravid Yusuf ibn Tashufin (r. 1061–1106). The seat of the Almoravid government was Marrakech, which Yusuf ibn Tashufin founded as his capital in 1062. The princess and her father were Berbers of the Sanhaja tribe, as were the Almoravids and the Zirids before them.

MJ

LITERATURE: Lévi-Provençal 1931, pp. 30–34, no. 24; Sourdel-Thomine and Spuler 1973, p. 257, no. 185; London 1976, no. 492, p. 307.

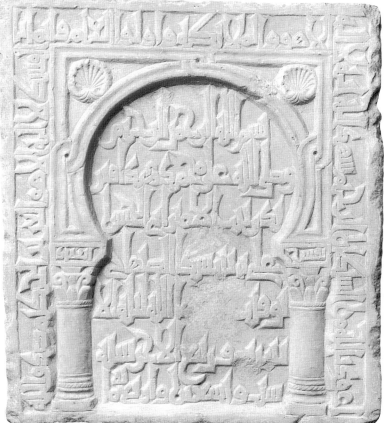

38

casket

Andalusia, 976
Wood, silver, niello, and gilt
10⅛ x 15⅛ x 9¼ in. (27 x 38.5 x 23.5 cm)
Museu de la Catedral de Girona (64)

Bearing no hint as to its original function, this casket is not only a handsome object but also an important art-historical document. Although there are numerous references in Umayyad, Abbasid, and Fatimid texts to spectacular three-dimensional objects executed in precious metals being used by various rulers and members of their courts or given as gifts of state, few such pieces have survived to corroborate these sources. A receptacle such as this, though rare, helps to substantiate these descriptions, so long thought to be highly exaggerated.

There are Arabic inscriptions in Kufic script encircling the lower horizontal edge of the lid and on the reverse of the hasp.[1] From the former inscription we learn that al-Hakam II (r. 961–76) had this object made for Hisham, his only son, after designating him crown prince—perhaps even on the occasion of his being named heir apparent in February 976, when he was less than twelve years old.

This casket was made under the direction of Jawdhar (d. 977–78), whom the Maghribi historian Ibn Idhari called "sahib al-sagha" (grand goldsmith or silversmith). It is the sole extant example of a type of silversmiths' work current in al-Andalus in the tenth century, one that from a technical point of view appears to be both *retardataire* and avant-garde. While employing the technique of niello inlay, as seen on the fine silver reliquary box in Liège (cat. 43) and numerous objects in León (see cats. 44, 46, 47), its two makers also utilized the alloy in a completely different manner from those silversmiths who crafted the smaller containers. The niello of the Liège and León objects and of the nonepigraphic decoration on the Girona casket is inlaid into the incised surface of the pieces, whereas the inscription on the casket consists of independently formed cups inlaid with niello, which are then individually attached to the surface of the object—that is, the alloy is not laid directly into the sheets forming the surface. Gilded silver objects decorated with inlaid cups soldered to the surface were to become a hallmark of the jeweler's art of al-Andalus, at least until 1492—the end of the Islamic period—while the other technique of inlaying niello does not seem to have spawned any later Andalusian examples.

MJ

1. For the original Arabic texts and their translations, see New York 1992a, p. 208.

LITERATURE: Davillier 1879, pp. 17–18, fig. 4; Madrid 1925, pp. 38–39; Lévi-Provençal 1931, no. 191, p. 185; Gómez-Moreno 1951, p. 337, fig. 399a; Torres 1957, p. 764, figs. 623, 624; Scerrato 1966, no. 32, pp. 72, 78; New York 1992a, no. 9, pp. 208–9.

39

pyxis of ziyad ibn aflah

Córdoba (Córdoba), 969–70 (dated A.H. 359)
Ivory
H. 7¼ in. (18.5 cm), diam. 4½ in. (11.5 cm)
Trustees of the Victoria and Albert Museum, London; Purchase from Weber Collection (368-1880)

Made for Ziyad ibn Aflah, the prefect of police under al-Hakam II (r. 961–76), this casket was fashioned in a Cordoban workshop. The relief, which was once quite three-dimensional, has been somewhat abraded, and a large triangular section is missing from the lid. Some traces of polychromy remain—red on the ground and blue on the reliefs themselves. A bronze fitting with an etched design runs from the top of the lid down the back of the vessel. Vestiges of a clasp of indeterminate date cling to the pyxis front.

The decoration of the pyxis consists of three interlacing multilobed medallions set in a dense jungle of carved foliage and paired animals. In its basic composition and ornamental repertory it is similar to the famous al-Mughira casket made for the brother of al-Hakam II in 968.[1] But the style of the present casket is less delicate, and the imagery is more conventional and somewhat less subtle in evoking its aristocratic patron, reminding us that its patron was not a member of the royal family but a powerful parvenu in the Cordoban court.

The central medallion features a man of authority, presumably Ziyad, seated on a dais between two retainers. It is a familiar image from Umayyad and Abbasid court arts, one that John Beckwith has traced back to Sasanian prototypes.[2] The flanking medallions contain a falconer astride a horse on one side and on the other side a rather grandiose vision of a prince traveling in state atop an elephant, though such conveyance was unknown in Spain. The figures are unusually monumental and plastic, projecting insistently from the surface of the pyxis, in contrast to the more compact figures of court ivories, which tend to be more embedded and intertwined in foliage.

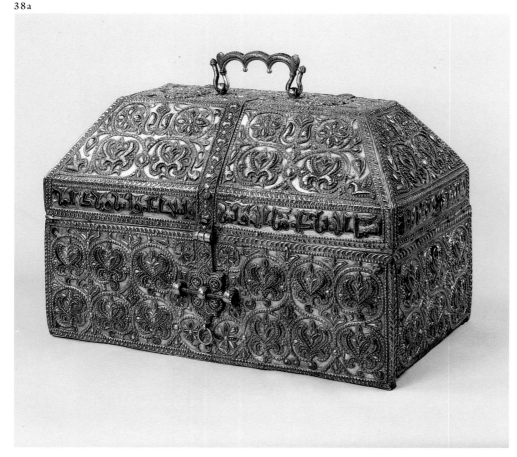

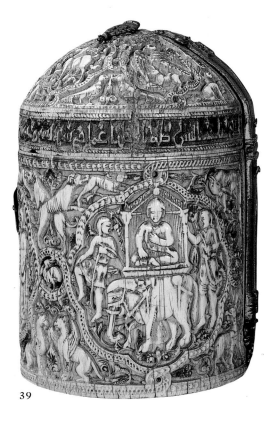

39

The imagery suggests that Ziyad was reaching to Abbasid prototypes for his vision of hegemonic grandeur. The depiction of a courtier as prince ought not to be taken lightly. In 978 Ziyad became a vizier under al-Mansur, participating in a bloody conspiracy to overthrow the caliph Hisham II (r. 976–1013) during his minority. Though not a pretender to the throne himself, Ziyad became an accomplished navigator of the corridors of power in Córdoba. He survived the aborted conspiracy by switching sides and demonstrated his lust for authority as a member of the Council of State. Such expensive and privileged gestures as the commissioning of an ivory pyxis can be seen as part of his pretensions to aristocratic status and courtly power.

In the spandrels of the eight-sided lobes are confronted eagles, peacocks, griffins, rampant hounds, and other images representing hunting, prey, ownership, and authority. A number of these motifs—common in Cordoban ivory carving—were appropriated by Christian artists. The rampant dogs appear, uncrossed, in the paintings of San Baudelio de Berlanga (cat. 103g), as does the falconer. An eagle attacking its prey is depicted on folio 104 of the Girona Beatus manuscript (cat. 80), for example.[3]

As is usual for a Cordoban pyxis, an inscription hugs the edge of the dome: "[The blessing of Allah] and prosperity and good

fortune to Ziyad ibn Aflah, prefect of police. Made in the year 359 [969–70]."

JDD

1. New York 1992a, no. 3, pp. 192–97.
2. Beckwith 1960, p. 21.
3. Ibid.

LITERATURE: Beckwith 1960, pp. 20–21; Kühnel 1971, no. 32, pp. 39–40.

40

casket

Andalusia, early 11th century
Carved ivory
8½ x 10⅝ x 6½ in. (21.5 x 27 x 16.5 cm)
Trustees of the Victoria and Albert Museum, London
(10-1866)

This casket, acquired in León in 1866, exhibits the same rectangular shape with a truncated pyramidal lid as a niello-inlaid silver receptacle in Girona Cathedral (cat. 38a).[1] It is composed of twelve carved ivory panels, four constituting the box itself and the remaining eight, the lid. Unfortunately the plaques forming the horizontal lower edge of the lid, which—judging from other ivory

objects of similar shape—would initially have been carved with an inscription, are now lost and have been replaced by plain panels. The original hinges, straps, and hasp or lock are also missing, the areas prepared to receive them having been covered when the casket was set in metal mounts during the eighteenth century.

The principal decoration is to be found in fifteen large medallions, each of which interlaces by means of a guilloche band with the others on the same panel and with the edges of that panel. The front of the box is decorated with three such roundels. Each of the roundels at the left and right contains two figures seated on what is usually considered to be a throne, although in both depictions here the figures do not appear to be royal. At the left a figure holding a beaker in one hand and a flower in the other is entertained by another playing a wind instrument. At the right a lutist plays for a figure carrying a bottle in one hand and a fan in the other.

The only other figural decorations are to be found on the lid, where there are a horseman killing a quadruped with a lance, a mounted falconer, and an extraordinary vignette depicting a human head in a howdah being carried on the back of an unidentifiable quadruped. All the remaining representations on this casket consist solely of animals and birds, which compose a real (and imaginary)

40

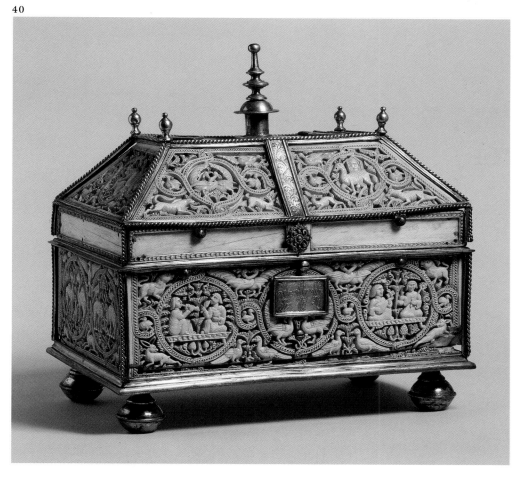

bestiary of the early eleventh century. In addition to lions, hares, dogs, and birds of several varieties, there are elephants, camels, boars, deer, griffins, and winged lions with solitary horns.

The Pamplona casket,[2] which is dated A.H. 395 (A.D. 1004–5), not only shares its shape, the basic organization of its design, and some of its figural iconography with the Victoria and Albert receptacle but also has parallels for the style in which the elephants are carved and their configuration on either side of an umbrellalike tree. In addition, winged felines with a highly unusual single horn appear on each box. Both the way in which a tree trunk becomes a plaited shaft and the convention of filling the connecting medallions with birds or animals—characteristics of the Victoria and Albert casket—are also to be found on the Braga pyxis, which is datable to 1004–8.[3] Therefore, the London container can be dated to approximately the same period or slightly later.

MJ

1. New York 1992a, cat. 9, pp. 208–9.
2. Ibid., cat. 4, p. 198.
3. Ibid., cat. 5, p. 202.

LITERATURE: Kühnel 1971, no. 37, pp. 44–45, pls. XXVII, XXVIII.

41

RELIQUARY CASKET

Andalusia, 11th century
Ivory and metal
2 x 1¼ x 1¼ in. (5.1 x 4.6 x 3.2 cm)
Real Colegiata de San Isidoro, León

This diminutive casket from the treasury of San Isidoro in León[1] is rectangular in shape with a high flat-topped cover. The body of the box is carved with animal and vegetal motifs in high relief. On the front is a pair of confronted hares, partly obscured by an outsize hinged clasp that is a later addition. The left side also has a hare, its body facing

toward the casket's front and its head turned back; the right side features a hound(?) in the same pose. The back is carved with a full leaf in the center, split leaves in the corners, and other vegetation obscured by double hinges presumably applied when the clasp was added. A pearl border within a framing band adorns the side panels, and the front and back panels have two framing bands. The sides of the cover are decorated with a guilloche band with a pearl border within framing bands, and the top of the lid is strewn with leaf forms in a rough approximation of an arabesque, misunderstood so that it does not form a scroll. The top of the cover has a pearl border within framing bands, and the hinge ends conceal some of the design. On the bottom of the casket are four lines in Latin script stating that the casket contains the relics of Saints Cosmas and Damian.

Although the crouching animals and guilloche border can be found on many Spanish Islamic carved ivories, the awkward treatment of the leaves on the back and the failed attempt at an arabesque on the lid, as well as the absence of an Arabic inscription, distinguish this reliquary from the works of known Islamic ivory carving centers, such as Córdoba, Madinat al-Zahraʾ, and Cuenca. Perhaps a local workshop, influenced by but not itself a center of the Islamic ivory carving tradition, was responsible for this casket.

MLS

1. For information about the treasury of San Isidoro at León, see cats. 45–47.

LITERATURE: Kühnel 1971, no. 51, pl. XLIII.

42

KING OR VIZIER CHESS PIECE

Andalusia, late 10th–early 11th century
Carved ivory
H. 3¼ in. (8.1 cm)
Dumbarton Oaks, Washington, D.C. (66.7)

In his epic *Shah-nameh*, the Persian poet Firdawsi (ca. 935–ca. 1020 or 1026) tells us that the game of chess was invented in India and brought from there to the Persian court of Khosrow I (r. 531–79) by an envoy. The latter carried an ultimatum to the Persians —namely, that they must determine the moves of the game and the names of its pieces, or India would not send tribute. Fortunately, a member of the shah's retinue realized that it was a game of war between two armies, each led by a king and his vizier and each consisting of four branches: the chariotry (rook,

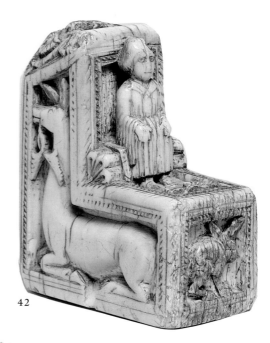

42

from the Persian *rukh*, "castle"), the elephant corps (bishop), the cavalry (knight), and the infantry (pawn). The shape of this particular chess piece is that commonly associated with either the king or the vizier (the queen in the West). The only difference between the two pieces in a given set is size: the piece representing the king is larger than that depicting his vizier.

Whereas few early gaming pieces bear decoration of the type that would permit a precise dating, the superabundance of human, animal, and vegetal designs on this chess piece provides us with a rare opportunity to place such a piece in time and space. The style of carving employed for the enthroned figure at the top front and the falconer on the back, as well as for details of their costumes, including the peculiarities of the lapels and coiffures, are all to be found on products of the ivory carvers active in al-Andalus at the turn of the eleventh century. The same can be said for the manner of depicting the animal and vegetal designs.

That sets incorporating chess pieces with abstract forms and highly stylized decoration were also being used in the Mediterranean basin at this time has been proved conclusively by the excavation of a shipwreck at Serçe Limani, off the coast of Turkey just opposite Rhodes. Eight wooden chess pieces have been recovered at the site of this wreck, two of these representing the king and the vizier. With the help of glass coin weights retrieved at the same site, we can determine that this ship sank about 1025.[1]

MJ

1. Cassavoy 1988, pp. 28–29.

LITERATURE: Weitzmann 1972, pp. 87–88, pls. LX, LXI.

BOX

Andalusia, before 1056
Silver sheet and niello
⅝ x 1½ x ¾ in. (1.5 x 3.8 x 1.8 cm)
Musée d'Art Religieux et d'Art Mosan, Liège (E358/87)

This minuscule box, the interior of which is divided into four compartments, was formerly in the treasury of the church of Saint-Jean in Liège. It has been suggested that an inhabitant of that city brought this object back from an eleventh-century pilgrimage to Santiago de Compostela, an expedition led by a monk from the Benedictine abbey of Saint-Jean. At some unknown date this box came to serve as a reliquary.

The sides and top of the box, which was executed entirely in silver sheet, are decorated with an Arabic inscription in Kufic script. The sides read: بركة كاملة ونعمة شاملة وعافية وعزّ (Perfect blessing, complete bounty, well-being and glory). The top reads: بركة لصاحبه (Blessing to its owner).

These good wishes to an anonymous owner are highlighted with niello inlay. Known since the Eighteenth Dynasty in Egypt, niello is a decorative technique that sets the design it enhances apart from the rest of the object by providing a strong contrast with the metal ground. When still in granular or powdered form, this alloy, usually consisting of silver, copper, lead, and sulfur, is laid into an area that is customarily prepared by incising. After

44

43

the inlay has been fused in place, it is filed down to the level of the surrounding surface.

The type of calligraphy and the tentative use of vegetal fillers in the spaces between the vertical letters serve to confirm a late tenth- to early eleventh-century date for this tiny box. Unfortunately, it is impossible to determine exactly where this and other Andalusian objects executed in precious metals were made. However, because there is a wide variety of

extant silver objects with niello inlay from al-Andalus, it appears that more than one manufacturing center was involved and that the vogue for such objects was long-lived. Unlike the other silver objects with niello in this catalogue, here the principal decoration is purely calligraphic, except for the vegetal fillers and a simple guilloche border. In the type of design as well as in its simplicity, this piece recalls silver objects with niello inlay made within the Fatimid realms. An Andalusian dependence on North African silver products should not be surprising, as Iberian goldsmiths were strongly influenced by Fatimid gold jewelry (see cat. 55).

MJ

LITERATURE: George 1988, pp. 5–21.

44

BOX

Andalusia, probably 13th–15th century
Silver gilt
H. 4⅜ in. (11 cm), diam. 2⅝ in. (6.8 cm)
Real Colegiata de San Isidoro, León

A dome-shaped lid surmounted by a knob tops this cylindrical box. The lid is fastened to the box by means of two long hinges nailed to the back and a lock on the front. The shape of this box is identical to that of the well-known ivory boxes, or pyxides, produced in caliphal Spain during the second half of the tenth century.[1] The walls of the box are rather thin, and the repoussé decoration is easily visible from the inside. The decoration itself is composed of eight units forming a continuous pattern. At the center of each unit is a diamond shape from the points of which extend stylized scrolls, half-palmettes, and leaves. A similar pattern is repeated on the lid. The lower part of the lid has a simple decoration consisting of a band

of closely spaced semicircular lines that curve to the right.

This box was obviously produced in imitation of the ivory boxes mentioned above. While its shape is identical, there is no attempt here to copy either the extremely fine ornament of the ivory boxes or their Arabic inscriptions. The decoration seems far from authentic Islamic patterns and is instead more reminiscent of late medieval or Renaissance models. The use of the repoussé technique rather than niello points again to a later date. It is likely that this piece is only a copy of earlier models and was produced in Spain well after the Muslims were defeated by the Christians. It probably came into the treasury of San Isidoro at a date much later than the Donation of Ferdinand and Sancha in 1063 (see cat. 45). s c

1. See, for example, New York 1992a, no. 2, p. 192, and no. 5, pp. 202–3.

LITERATURE: Gómez-Moreno 1925–26, vol. 1, pp. 164–65, figs. 131, 132.

45

casket

Andalusia, first half of 11th century
Silver, gilt, and niello
3⅛ x 7 x 4⅜ in. (8 x 17.7 x 11 cm)
Museo Arqueológico Nacional, Madrid (50.8.67)

Shaped like a low truncated pyramid, the lid of this rectangular silver box is fastened by means of three large hinges, one on the front and two on the back. The hinges are probably a later addition since they cover parts of the inscription and the decoration on top of the lid. The casket stands on four feet. The nielloed decoration is rather simple and arranged in registers. On the four sides of the casket a central band is filled with an inscription in fine Kufic on a blank background between two registers of vegetal scrolls. The lower sides of the lid bear a similar scroll, while its trapezoidal sides carry a bold inscription in Kufic. On the top of the lid there are two rows of ducklike birds with small feathery crests at the back of their heads. In the upper row the two pairs are shown back-to-back in profile; in the lower row they face each other. The casket is stippled all over with tiny round punch marks. Only the feet and the blank areas outside the registers lack stippling.

Both inscriptions appear to begin on the right side of the casket rather than on the front, as is usual. They are partially covered

by the hinges and contain some misspellings. The inscription on the body reads as follows:

بركة من الله تامة و/سلامة دائمة [وعاف]ية شاملة و/نعمة كاملة وسعادة / باقية و[. . .]ية عافية [. . .] لصاحبه

Entire blessing from God and/continuous well-being [and] complete [heal]th and/perfect favor and perpetual happiness/and [. . .] well-being to its owner.

The bold inscription on the lid has the same words but is left unfinished:

بركة تامة / وسلامة دائمة / وعافية شا/ملة ونعمة كاملة و

Entire blessing/and continuous well-being and/comp/lete[1] health/and perfect bounty and [. . .].

This casket, originally in the treasury of San Isidoro, León, was donated to the Museo Arqueológico Nacional, Madrid, in 1869. This object may have been among those mentioned in the list of donations by King Ferdinand and Queen Sancha to the church of San Isidoro on December 22, 1063. The list includes "capsam eburneam . . . et alias duas eburneas argento laboratas, in una ex eis sedent intus tres aliae capsellae, in eodem opere factae" (an ivory casket . . . and two more in ivory and silver, one of which contains three other small boxes made in the same fashion).[2] It was Angela Franco Mata who suggested that one of the three small boxes inside the larger casket might have been the present casket.[3] If one accepts that this box is the very object mentioned in the list, then the year 1063 would represent the terminus ante quem for its production.

In any case, a date in the first half of the eleventh century, during the early *taifa* pe-

riod, seems acceptable on stylistic and epigraphic grounds. The best example in the *taifa* period of a complex niello technique in which vegetal decoration is combined with inscriptions and images of animals is a perfume bottle in the Museo de Teruel datable to just before 1044–45.[4] In addition, the pairs of confronted birds on the casket, though very stylized, find parallels in earlier and almost contemporary ivories, textiles, and ceramics ranging from the tenth century to the *taifa* period.[5] s c

1. This seems the only possible reading, although one letter is redundant. The word starts on one side and ends on the adjacent side.
2. The document is published in Assas 1872, p. 174, and in Franco 1991a, p. 53.
3. Franco 1991a, p. 53.
4. New York 1992a, no. 16, p. 219.
5. See, for example, ibid., no. 6, p. 203, no. 20, pp. 224–25, and no. 32, p. 283.

LITERATURE: London 1976, no. 164; Franco 1988, pp. 37–38; Franco 1991a, pp. 52–53, figs. p. 65.

46

BOX

Andalusia, first half of 11th century
Silver gilt and niello
⅞ x 1¼ x 1¼ in. (2.1 x 3.3 x 3.2 cm)
Real Colegiata de San Isidoro, León

This miniature silver-gilt box is in the shape of a heart. It is closed by two hinges, both of which when unfastened allow the two parts of the box to be separated. The body of the

45

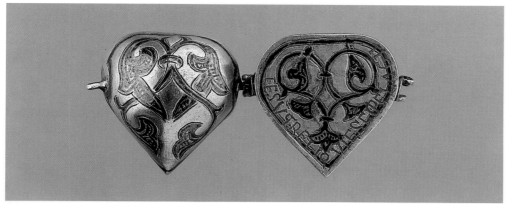

46

box is flat, while the lid is convex. The base of the box and the top of the lid are decorated with scrolls ending in half palmettes and leaves enclosed by a simple border. A Greek meander pattern runs around all four sides of the box. An inscription in Latin letters is incised on the base of the box over the border of the decoration: it is not part of the original work but was added later when the box was used as a reliquary. The inscription is visible only when the small box stands on its side or is upside down.

The abbreviated Latin inscription reads: EE SVT RELIQ/VIE SCI PELAGII (These are the relics of Saint Pelagius). This saint was a Christian martyr from Córdoba under the reign of Caliph 'Abd al-Rahman III (r. 912–61).[1]

Miniature boxes such as this were probably produced in large quantities in eleventh-century Spain. The heart shape for metal containers is certainly unusual in the Islamic repertoire, and the absence of Arabic inscriptions points to the possibility that they were produced for the Christian community in the *taifa* period. Another similar box, also containing relics of Saint Pelagius, is in the treasury of San Isidoro. It is smaller (¾ × 1¼ × ¾ in. [2 × 3.2 × 1.9 cm]), and both body and lid are convex. A second box with one hinge and more refined decoration is in the Museo Archeologico in Cagliari.[2]

The heart-shaped lid to a Fatimid rock-crystal ewer in the Museo Diocesano in Capua recalls the present box. The lid is silver with nielloed decoration and has one hinge, which is fastened to a mount placed around the ewer's neck. The mount seems contemporary with the ewer and is therefore of Fatimid workmanship.[3] Once more, as in the case of the Fatimid casket (cat. 47), the problem of reciprocal influences in metalwork production of Fatimid Egypt and Islamic Spain arises. S C

1. Gómez-Moreno 1925–26, vol. 1, p. 164.
2. Gabrieli and Scerrato 1979, fig. p. 567.
3. Ibid., figs. p. 503.

LITERATURE: Gómez-Moreno 1925–26, vol. 1, p. 164.

47

casket

Egypt, 1044–47
Silver, gilt, and niello
3 x 4⅞ x 3⅛ in. (7.5 x 12.4 x 7.9 cm)
Real Colegiata de San Isidoro, León

This small rectangular casket has a slightly convex lid fastened by means of three large hinges, one on the front and two on the back. Both the box and its lid are silver, decorated in gilt and nielloed with a fine pattern of spirals covering the entire surface. The spirals, measuring about a quarter of an inch (.65 cm) in diameter, are joined to one another and arranged in seven horizontal rows. The areas between spirals are filled with stylized half-palmette motifs, thus there are no blank spaces on the surface. The overall pattern, though repetitive, is nonetheless of fine workmanship and evokes ripples on a water surface. The curved top of the lid has

the same pattern, with fifteen rows of spirals, while the lid's four sides, about half an inch (1.4 cm) high, bear a nielloed Kufic inscription set against a stylized vegetal background.

The inscription is of exceptional importance since it indirectly suggests a date and a place of production for the casket. It reads as follows:

إستعمال لخزانة صدقة بن يوسف / سعد كامل وإقبال
شامل / وعز دائم وأمن [أمر] عالي / ودرجة رفيعة لصاحبه

A work for the treasury of Sadaqa ibn Yusuf/perfect happiness and complete good fortune and continuous glory/and perpetual power and elevated protection [or high authority]/and high rank to the owner.

Another inscription is found on the blank area underneath the fastening of the front lock, and it is therefore visible only when the box is open. The inscription consists of the signature of the artist who made the casket and seems to read: (عمل عثمان نقر [؟]) ['Uthman/engraved[?]]. I have not been able to identify 'Uthman. An artist's inscription is found in the same position on the famous casket made for Hisham II in 976 (cat. 38a).[1]

The main inscription was published in 1925 with some minor mistakes; however, no suggestion as to the identity of the owner was put forward.[2] According to the available sources, the only possible identification for Sadaqa ibn Yusuf is to be found in Fatimid Egypt and not in Islamic Spain. Abu Mansur Sadaqa ibn Yusuf al-Falahi was a vizier of the caliph al-Mustansir billah (r. 1036–94) between 1044 and 1047. He was an Iraqi Jew who converted to Islam. He was appointed vizier by al-Mustansir at the request of his

47

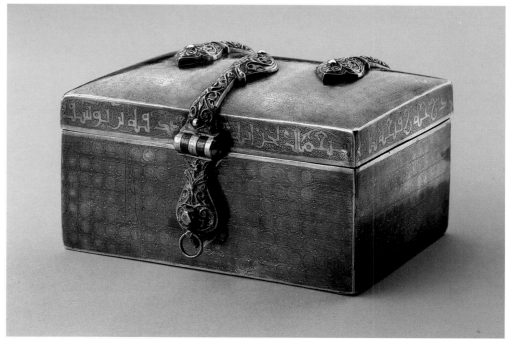

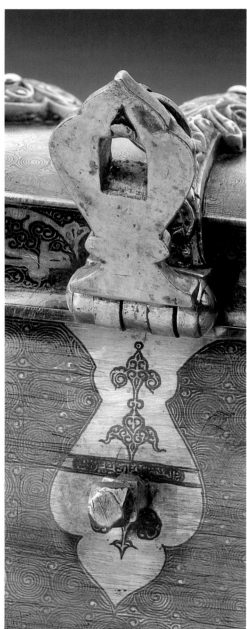

47 : Detail

cannot be overstated. It is the only inscribed object of its type ever attributed to Fatimid Egypt, and it raises questions about the reciprocal artistic influences of Islamic Spain and Fatimid Egypt in the tenth and eleventh centuries, a problem debated by scholars. The overall spiral decoration on the present casket has no exact parallels in Fatimid art, although the patterns found on the backs of two bronze stags in Córdoba and Florence and on the famous griffin in Pisa are related. The stag in Córdoba was certainly produced in Spain as it was found at Madinat al-Zahra³. The Florence stag is also probably Spanish, whereas experts are still uncertain of the griffin's attribution to Spain or Egypt. The present casket, though its decoration is comparable only en passant to that on those famous bronzes, might be of some help in clarifying the issue.

The question as to whether tenth- and early eleventh-century nielloed Spanish metalwork (such as the casket of Hisham II mentioned above) influenced later Fatimid pieces like the present casket remains open at the moment since no earlier objects from Egypt of the late Tulunid or early Fatimid periods have been identified yet. However, it seems more likely that decorative forms traveled westward, from Egypt to Spain—as happened earlier between Umayyad Syria and Spain during the caliphal period.

S C

1. New York 1992a, no. 9, pp. 208–9.
2. Gómez-Moreno 1925–26, vol. 1, pp. 163–64.
3. Imad 1990, pp. 165, 180–81.
4. Kahle 1935; Qaddumi 1990, pp. 249–50.
5. See the glossary in Qaddumi 1990, pp. 373–400.

LITERATURE: Gómez-Moreno 1925–26, vol. 1, pp. 163–64, figs. 123, 124.

predecessor al-Jirjira³i and had to share power with Abu Sa`d al-Tustari, the counselor of al-Mustansir's powerful mother. Their reciprocal enmity led first to al-Tustari's death, then to Sadaqa's imprisonment and execution in 1047.[3]

This casket was therefore produced in Fatimid Egypt, and the inscription suggests that this happened during Sadaqa's vizierate, that is, between 1044 and 1047. The casket's presence in Spain can be explained by the sack of the Fatimid treasury in 1069, after which many Fatimid objects made their way to churches in Europe.[4] Although the casket itself was probably prized during the Fatimid period, its contents were also precious: sources mention pearls, rubies, and other gems in the Fatimid treasury.[5]

The importance of this casket as a document for the study of Fatimid metalwork

48

INCENSE BURNER

Almería (Almería), 11th–12th century
Bronze
H. 9 in. (23 cm)
Instituto de Valencia de Don Juan, Madrid (3071)

The plain cylindrical base of this incense burner rests on three curved legs terminating in rather flat anthropomorphic feet. The conical domed cover is divided horizontally into two unequal zones of pierced decoration made up of half-palmette leaves and stems, elongated in the upper zone to conform to the greater height of that area. The zones are

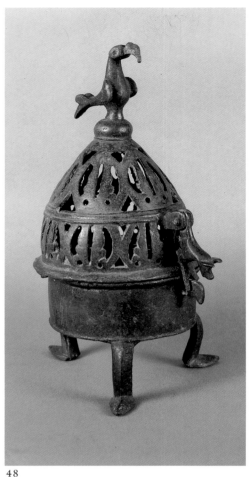

48

separated by three thin bands in low relief, which are echoed by three larger bands in higher relief between the upper and lower parts of the incense burner; the upper bands are on the lid, the lower band is on the cylindrical base. The flattened dome-shaped finial is surmounted by a stylized bird, which perhaps is an eagle or a raptor of another sort. The hinge, which extends from the lower zone of the lid to the top of the base, has an undulating profile, curving out at the top and bottom and thickening at the base. Opposite the hinge is the clasp, which is in the shape of a downward-facing dog with pricked ears and open mouth.

In his study of Islamic metalwork James Allan compares the hinge and clasp to those on a tenth-century incense burner from Volubilis in North Africa, which are similar, although simpler, in that they form flanges along the lower part of the object's cover. Allan also believes that the configuration of the pierced decoration reflects the influence of the arcaded covers of earlier domed incense burners, such as the example from Córdoba (cat. 50).

M L S

LITERATURE: Palol 1950a, pl. V; Gómez-Moreno 1951, p. 335, fig. 395a; Allan 1986, p. 28.

INCENSE BURNER

Andalusia, 11th century
Engraved bronze
H. 10½ in. (26.7 cm)
The Metropolitan Museum of Art, New York; Purchase,
Louis V. Bell Fund and Joseph Pulitzer Bequest (67.178.3a,b)

This incense burner of architectural form consists of a rectangular body, from which extends a horizontal handle, on four zoomorphic feet. It is covered with a slightly concave, barrel-vaulted lid, the supporting arches of which are decorated with crescent finials. An ornament consisting of six wing-shaped projections tops the vault.

In James Allan's study of early Islamic incense burners, he identifies five principal types, and although the Metropolitan Museum's object is not included in that publication, it fits nicely into and even builds upon the typology Allan created.[1] The openwork arcade of horseshoe arches filling the lowest register on the body of the New York object permits close comparison with the openwork arcade on an incense burner from Volubilis in North Africa that Allan has placed in his fifth category. The ajouré decoration on the handle of the Metropolitan Museum piece closely resembles the decoration circumscribing the base of the domed lid and adorning the horizontal handle of a cylindrical incense burner in Córdoba.[2] By means of their ornamenta-

tion both of these Andalusian objects can be connected to an incense burner sporting a square base in the al-Sabah Collection, Kuwait City, which has the same design on its horizontal handle. The peaked lid of the Kuwait piece also closely resembles the tiled roofs of pavilions in al-Andalus and Morocco from this period, further reinforcing the attribution of these three incense burners—all of which have an identical closure—to the western Maghrib.[3]

Furthermore, not only should these three incense burners be added to those in Allan's category grouping together cylindrical, domed, three-legged incense burners, but—since two of the three discussed here incorporate rectilinear bases and consequently four feet—we must henceforth see this category as having a variant as well. MJ

1. Allan 1986, pp. 25–34.
2. New York 1992a, p. 42, fig. 1.
3. Jenkins 1983, p. 40.

LITERATURE: Unpublished.

INCENSE BURNER

Córdoba (Córdoba), 10th century
Bronze
H. 5⅜ in. (13.7 cm)
Museo Arqueológico Provincial de Córdoba (D/92/6)

This incense burner has a cylindrical base resting on three straight, slightly faceted legs, which taper and then swell into rounded shoulders and taper again to slightly faceted, rounded knob feet (one of which is broken off). Each leg has a brace that extends from underneath the burner partway up its side and ends in a fleur-de-lis. These heavy fleur-de-lis forms obscure so much of the decoration of the body and are so massive in comparison to the shape and design elements of the piece that one suspects that the braces were added sometime after the burner was completed. Two heavy handles are placed without regard to the position of the elongated slim clasp and hinge. Each handle is shaped like two horizontally placed columns joined at the capitals; the columns have rectangular bases, rounded shafts, and flat circular capitals. Like the leg braces, they partially obscure the designs on the body and seem too heavy for the piece; perhaps they were added at the same time as the braces.

The base of the incense burner is decorated with six circular medallions, each of which contains a single animal or bird. The creatures in adjoining medallions face each other to form confronted pairs. Proceeding around the body of the burner, beginning at the left of the clasp and ending at its right, are: a pair of lions with tails that curl up and end in half palmettes; a pair of gazelles placed on either side of the hinge; and finally a pair of peacocks. Engraved details, some in the form of vegetal motifs, indicate the hair,

49

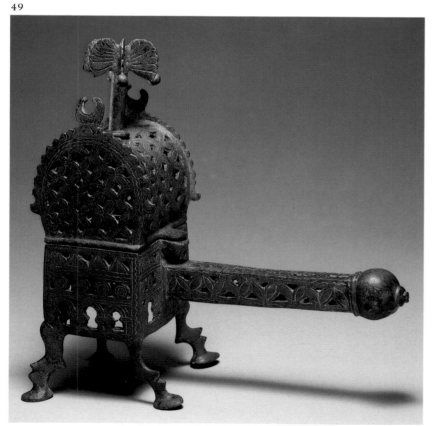

50

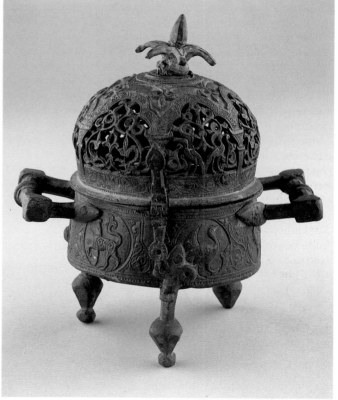

feathers, or musculature of the creatures. Arabesque scrolls appear in the interstices between the medallions, which are defined by stemlike outlines.

The pierced, slightly bulbous domed cover shows a design of arcades made up of columns, capitals, and cusped arches with engraved leaf details, with openwork arabesque scrolls filling the spaces within the arcades. The finial is a spool-shaped section surmounted by curved leaves topped by an elongated bud with faceted sections.

The cylindrical form seems to be characteristic of Spanish incense burners and harks back to early Islamic Syrian prototypes of the Umayyad period. The arcading has similar antecedents but is far more elaborately developed here than in its Syrian models.

MLS

LITERATURE: Allan 1986, p. 27.

51

GIRDLE

Lorca (Murcia), 11th century
Gold
L. 8¼ in. (21 cm)
Trustees of the Victoria and Albert Museum, London (454-1870)

The discovery of the Lorca hoard took place in the last century, but none of the objects it comprises were published until 1951.[1] It is one of the most important, original, and complete finds of any to date. Coins included in the treasure permit a dating in the first third of the eleventh century. A pair of earrings from it was exhibited in the *al-Andalus* exhibition.[2]

This girdle belongs to a type originally consisting of both metal and textile. Surviving are four hollow rectangular plaques, each formed of twin gold sheets soldered together at the edges. The two distal plaques have loops on their ends, through which a textile may be passed and tightened. Decoration is very simple: it consists of short lines in

repoussé and single and double gold wires forming circles and straight lines soldered to the outer plaques. Hemispherical bosses of two sizes are soldered to various parts of the outer plaques.

Each plaque is framed by a small inner band and a larger outer band. The outer edge of the larger frame is demarcated by a double gold thread, the inner edge by a single one. The outer band is embellished with seven hemispherical bosses on each long side and six on the short side—twenty-two in all. Repoussé lines fill the spaces between and around the bosses. There is a smaller boss at the inner edge of each of the corners. The inner frame is decorated with circles of twisted gold thread, and its corners too are marked by small bosses. The central rectangle of each plaque is divided into two rectangles by a vertical stripe, and each of these rectangles is bisected by a horizontal stripe. The vertical stripe has three large bosses, the horizonal has four small ones in each of its halves. The two rectangles are also defined by small bosses in their corners. Two doors with a horseshoe arch, each designed with a single twisted wire, fill each rectangle. The spaces between the arches and the sides of the rectangles are filled with an *opus spicatum*, or herringbone, design.

The reference to architecture seems plausible; the design is reminiscent of the door of Solomon's temple motif found in Visigothic vaulted niche stones,[3] as well as in Coptic ones inspired by Egyptian mihrabs,[4] and also recalls the well-known mihrab dated to the eighth century originally from the al-Khassaki Mosque and now in the Iraq Museum, Baghdad.[5] This archaic element and the circular elements in earrings from the Lorca hoard—direct descendants of the Visigothic hoard from Torredonjimeno— suggest the possible survival of Mozarabic goldsmiths as well as users in al-Andalus at a late date. The Lorca hoard's individual elements seem to relate more to Visigothic than to North African or oriental cultural traditions. The girdle seems to belong to a tradition present at the Charilla hoard (Jaén) of the tenth century that continues with the find from the Nasrid period that is now in Berlin.[6]

JZ

1. Gómez-Moreno 1951, pp. 339–41, fig. 402b.
2. See New York 1992a, no. 18, p. 221.
3. See for example Palol 1968a, figs. 20, 22.
4. Féhérvari 1972.
5. Basmachi 1975–76, pp. 409–10, fig. 267.
6. New York 1992a, no. 71, p. 301.

LITERATURE: Gómez-Moreno 1951, pp. 339–41; Palol 1968a; Basmachi 1975–76, pp. 409–10, fig. 267; Féhérvari 1972.

52

DISH

Andalusia, second half of 10th century
Inglaze-painted earthenware
Diam. 11 in. (28 cm)
Museo Arqueológico Provincial de Córdoba (MA/MV/2001)

The tradition to which this dish belongs can ultimately be traced to the kilns of ninth-century Baghdad, although the immediate precursors of the inglaze-painted wares with figural decoration found at Madinat al-Zahra᾽ and Elvira are those from Ifriqiya, particularly Sabra al-Mansuriyya.[1] In point of fact, the beautiful pottery produced in the Abbasid capital, Baghdad—covered with a lead glaze that had been opacified with tin and then decorated sometimes with a cobalt blue and sometimes with a green stain—appears to have had far-reaching appeal, as it soon spawned imitations, not only in Ifriqiya and farther west but also in eastern Iran, Egypt, and Sicily. This widespread vogue serves as a paradigm of the phenomenon of Baghdad as a cultural capital whose leadership in the arts gave rise to international conventions.[2] All of the provincial imitations, however, appear to have substituted aubergine for the difficult-to-secure and expensive cobalt of the Baghdad prototypes, and they also usually added green, at the very least, to the palette.

This dish, ornamented with gadrooning at the rim and bearing a representation of a horse, its left front hoof raised, is very characteristic of the type of inglaze-painted ware peculiar to al-Andalus. It exhibits a broad, flat base with low, flaring sides; an interior

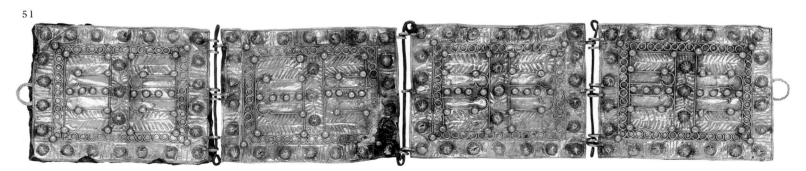

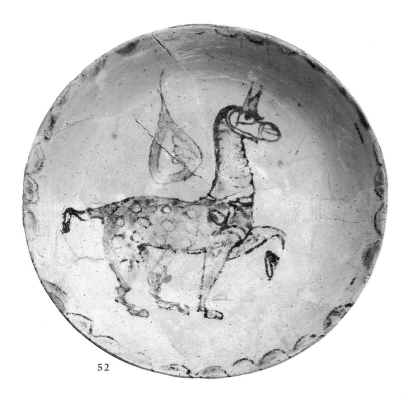

52

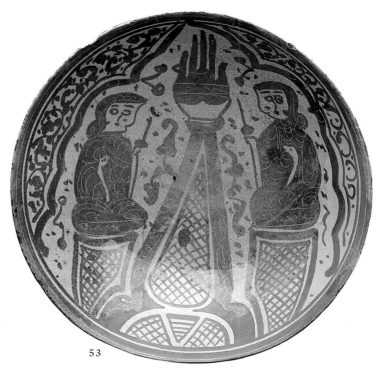

53

covered with a white glaze decorated in green and aubergine; and an exterior glazed mustard yellow. In addition to the shape, color scheme, and style of drawing, other typical conventions are the filling of the body of the quadruped with circles and treating its neck as a series of folds.

The approximate date of this dish and others having similar characteristics is provided by the inglaze-painted molding that embellishes the dome in front of the mihrab in the Great Mosque of Córdoba; it was added to the building by al-Hakam II in 965–68. This molding could only have been produced in the same kilns that manufactured such figural pottery as that being discussed here.[3] MJ

1. Jenkins 1975.
2. For more on inglaze-painted wares from Ifriqiya and on Baghdad's influence on the arts during this period, see essay by Marilyn Jenkins, this catalogue.
3. Jenkins 1978, p. 129, n. 130; pp. 197, 208–10; pl. C.

LITERATURE: Jenkins 1975, p. 101, fig. 23; Jenkins 1978, pp. 95, 133–34, and pl. XXX; Soustiel 1985, p. 175, fig. 199.

53
BOWL

Málaga (Málaga), late 11th–12th century
Glazed, luster-painted, and incised earthenware
Diam. 9 in. (23 cm)
The Detroit Institute of Arts, Detroit (26.181)

This bowl is representative of the earliest type of luster-painted pottery produced in the Iberian Peninsula. Executed in luster and highlighted with incised details, its enigmatic decoration consists of two figures seated, cross-legged, on either side of an apotropaic motif known as *khumisa* (ornament in the shape of a hand).[1] This scene is set inside a polylobed arch-shaped area against a background of isolated leafy branches and dots. Leafy scrolls fill the spandrels.

The decorative technique employed was originally used to embellish glass; it was first adapted to pottery in the ninth-century kilns of Baghdad. It entered the Mediterranean world shortly before 863, when an Iraqi ceramist was summoned to Ifriqiya (present-day Tunisia) to add to a group of luster-painted tiles that the Aghlabid ruler Abu Ibrahim Ahmad (r. 856–63) had imported from Baghdad and that were used to decorate the mihrab in the Great Mosque in Kairouan. The artisan set up an atelier and trained local potters to help him carry out his commission to augment the polychrome luster-painted tiles with additional ones exhibiting a monochromatic scheme. From Ifriqiya this decorative technique spread to what is now Algeria and from there to al-Andalus under Zirid and, subsequently, Almoravid domination.

The dating for this earliest Andalusian luster-painted pottery is provided by other examples of their group that were employed as *bacini* in the facades of Romanesque churches and/or campaniles in Italy, the dates of which range from 1063 until the third quarter of the twelfth century. The type to which this bowl belongs was the immediate precursor of the so-called Alhambra vases and also strongly influenced other later Spanish luster-painted pottery. Thus, it was the

Aghlabid attempt to emulate life in the Abbasid capital, and, more specifically, Abu Ibrahim Ahmad's desire for some Baghdad tiles and his request for a potter from the capital that were ultimately responsible for the tradition that was to have such a glorious history in the Maghrib. MJ

1. An identical *khumisa* motif can be found on an underglaze-painted bowl, manufactured in Ifriqiya and datable to the eleventh century, that was excavated in Carthage and is presently housed in the Musée de Carthage. This motif of a raised, open hand, which is subsequently to be found on several of the so-called Alhambra vases and other later Spanish luster-painted pottery, is also met with earlier on a number of Punic votive stelae from the third to second century B.C. in the Musée de Carthage. All of these Ifriqiyan examples clearly indicate the movement of this iconography from east to west.

LITERATURE: Ettinghausen 1956, fig. 33; Jenkins 1978, p. 160, pl. LXXII.

54
PART OF A KORAN

The Maghrib, late 10th–11th century
Ink, colors, and gold on parchment
16½ x 14⅛ in. (42 x 36 cm)
Bibliothèque Générale, Rabat (GL-TI)

This section is one of three[1] in the Bibliothèque Générale, Rabat, from a unique and spectacularly beautiful Koran manuscript. It includes sura 7, *aya* 20 through sura 9, *aya* 30, and the folio illustrated here (152) contains the final word of sura 7, "al-Aʿraf." The illuminated sura heading consists of the name of the sura

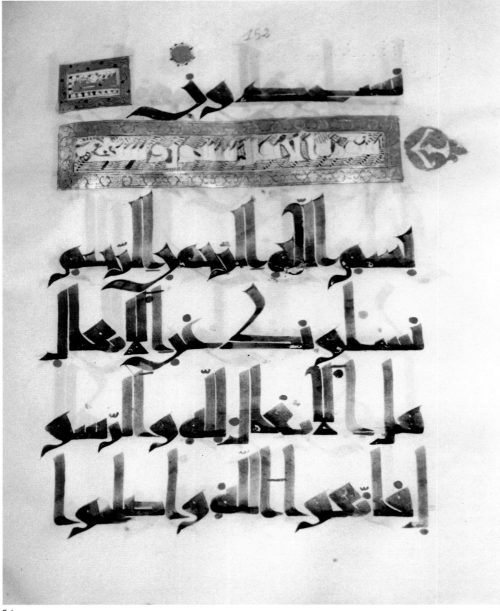

54

ever, if it was made in Morocco, one must allow time for the avant-garde calligraphic traditions in Kairouan to have spread westward, in which case these sections of a Koran manuscript should be dated to sometime during the second or third quarter of the eleventh century. In any event, all three sections preserved in Rabat should be considered as the work of the same calligrapher.[6]

M J

1. In Paris 1990, it is incorrectly stated that there are only two volumes of this Koran in Rabat.
2. Although the Koran was described as "ne portant aucun décor particulier pour les titres de sourates" (not having any special decoration for sura headings) in Paris 1990, p. 248, illuminated sura headings do exist in all three of the sections preserved in Rabat.
3. In Paris 1990, p. 78, cat. 494 is described as eighth century.
4. In Paris 1990, p. 248, two volumes (cat. 494, 495) are dated to the beginning of the ninth century.
5. These include the manner in which certain letters connect with the *alif*; some of the *lam-alifs*; the pointed *fa*, *qaf*, *waw*, and final *ha*; the *nun* ending; and the vertical orientation. Furthermore, certain of the letters, such as the initial *ʿayn*, the final *mim*, *lam*, and *ya*, anticipate the cursive script. The same can be said of other aspects of the script. While letter-pointing is completely absent, as is the case in most ninth-century Kufic texts, the vocalization follows both the earlier system of Abu al-Aswad al-Duʾali and later, more developed systems. For the Kairouan Koran, see Safadi 1978, pp. 23, 76, fig. 71, and p. 78, fig. 75.
6. Contrary to the fact that the authors of Paris 1990 (where the manuscript was first published) feel that two calligraphers were involved, I think that all three of the volumes in Rabat were the work of one calligrapher. As was the case with the previously mentioned al-Hadina Koran, which was the work of one man, the variations in the thickness of the letters from one volume to the other—rather than indicating two distinct hands—is most probably due solely to the differences in the way he cut his reed pen and mixed his ink.

LITERATURE: Paris 1990, cat. 495.

and the number of its *ayas* in a Kufic script outlined in brown ink on a ground of diagonal stripes filled with horizontal red, green, and blue lines.[2] The border is ornamented with reciprocal palmettes in gold set off by alternating red and green backgrounds. In the right margin of folio 152 a palmette design is part of but not connected to the sura heading; it is executed in gold and highlighted with green and red, which gives the sura heading the familiar *tabula ansata* form, so called because of its relationship to Roman inscription tablets.

The Maghribi script of the calligrapher is masterly, artistic, strong, and confident. Although the calligraphy has a number of archaic features that may be the reason the manuscript has been dated to the eighth[3] or the beginning of the ninth[4] century, other attributes suggest a considerably later date.

Close comparisons can be made with the calligraphy in the Koran copied, illuminated, and bound in Kairouan in 1020 by ʿAli ibn Ahmad al-Warraq for Fatima al-Hadina.[5] Likewise, parallels for the illumination can be found in Korans of varying dates; the sura headings can be compared with those in eleventh-century Korans copied in Kairouan.

The fourth holiest city in Islam after Mecca, Medina, and Jerusalem, Kairouan was a renowned theological center. The city became known for Koran production, and manuscripts made there were exported and carried to the western as well as the eastern regions of the Islamic world. At this juncture in the study of Arabic paleography, it is difficult to state where in the Maghrib this Koran was written. If it was produced in Kairouan, a date at the end of the tenth or during the first half of the eleventh century can be suggested. How-

55

PAIR OF EARRINGS

Andalusia, 12th century
Gold sheet, wire, and grains, set with cloisonné enamel
H. with earwires 1⅞ and 1¹³/₁₆ in. (4.8 and 4.65 cm)
Dar al-Athar al-Islamiyyah, Kuwait City, Kuwait;
al-Sabah Collection (LNS30 Jab)

This pair of earrings is unique among the extant examples of the jeweler's art in al-Andalus. However, like other early medieval jewelry from Andalusia, it exhibits a strong indebtedness to goldsmiths' work produced earlier in Islamic lands farther to the east. In fact, to anyone familiar with the jewelry of Fatimid Syria and Egypt (see p. 79, for example), the construction and decoration of these earrings offer many parallels. First, the

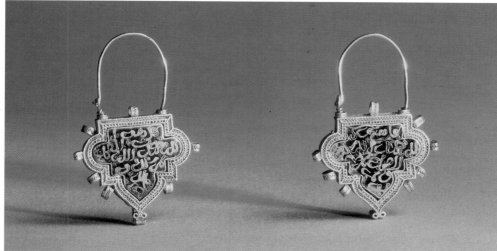

Jewelry from a hoard

Andalusia, late 12th–early 13th century
a. Two bracelets
Silver and niello
Each, Diam. 2⅜ in. (6 cm)
b. Necklace with coin pendants
Gold, electrum, tourmaline, vitreous paste, and agate
Diam. 7½ in. (19 cm)
c. Necklace
Electrum, rock crystal, and vitreous paste
Diam. 3¹⁵⁄₁₆ in. (10 cm)
d. Set of twenty-four bracteae, large star-shaped bractea,
and two fragments of a bractea
Gold and vitreous paste
Set of bracteae: 3¹⁵⁄₁₆ x 4½ in. (10 x 11.5 cm); Star-shaped
bractea: Diam. 1¼ in. (3.2 cm)
Museo de Mallorca, Palma de Mallorca; Gift of the
Societat Arqueològica Lul.liana (23816, 23812[a]; 23869,
23880[b]; 23859, 23868[c]; 23881, 23819[d])

openwork frame of both faces of each earring is fabricated solely of paired, twisted round wires, flat wire tooled into a sawtooth pattern, and granulation—all supported by a series of gold strips soldered to the back of this filigree border. The second parallel is the method by which the two faces of each object are connected, namely, by a strip of gold—in this case, constructed of wire instead of sheet —onto which are soldered ten loops constructed of paired, twisted round wires on either side of a band of sawtooth decoration, which originally held a string of pearls or semiprecious stones. Finally, the principal decoration on each face is a cloisonné enamel cup. Here, each cup bears an Arabic inscription executed in a type of Naskhi script peculiar to Spain and consisting of the first two verses of sura 112 of the Koran: "In the Name of God, the Compassionate, the Merciful/Say: He is God alone: God the eternal!/He begetteth not, and He is not begotten;/And there is none like unto Him."

Strong Fatimid influence on the jeweler's art in al-Andalus is discernible at least as early as the beginning of the eleventh century, and the boxlike construction seen in Andalusia during the early medieval period can be found on jewelry made in Spain as late as the Nasrid period (1230–1492), as can the incorporation of loops circumscribing the edges of individual elements. Cloisonné enamel insets are also a hallmark of Nasrid jewelry, although the designs are simpler in the later jewelry than in earlier examples. This strong traditionalism in the Mediterranean basin as regards jewelry is further illustrated by the echoes of Fatimid influence still to be seen in nineteenth-century North Africa.[1]

MJ

1. Jenkins 1988a, pp. 39–57.

LITERATURE: Davillier 1879, p. 28, fig. 8; Jenkins 1983, p. 91; Geneva 1985, p. 344; Baltimore 1990, no. 44.

The emergence and public exhibition of this hoard,[1] found in southern Mallorca, have enabled us to understand how jewelry-making

56a–c

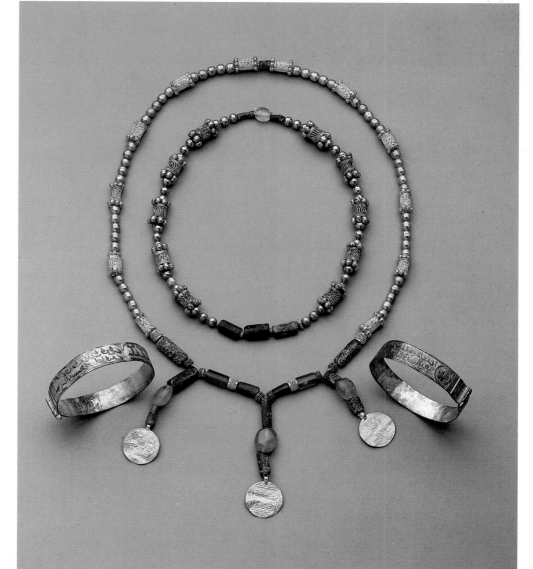

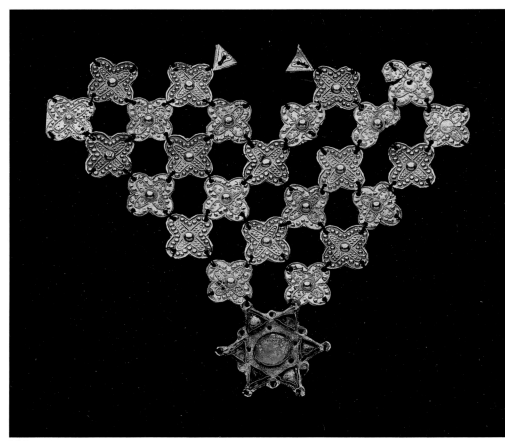

56d

evolved in al-Andalus. The objects, datable by means of coins that were part of the find, provide a link between the Umayyad and Nasrid periods, a time span from which examples were previously lacking. A significant part of the treasure is catalogued here; two other items have already been exhibited in the United States.[2]

The two bracelets are of a common plain type—a silver strip formed into a band, with incised and nielloed decoration. The endings are reinforced and bent to accommodate a pin system that locks the bracelet around the wrist. Decorating each bracelet from right to left, beginning at the lock, are: a roundel containing a *khumisa*, or "hand of Fatimah"; what may be a poem in two lines of Naskhi script; an oblong cartouche with rounded ends enclosing a motto in geometrical Kufic script (at the bracelet's center); another panel in which the two lines of poetry seem to continue; and another roundel with a *khumisa*. The poem panels have a background of scrolls and tendrils, while the background of the central cartouche and the roundels is diagonally hatched, intensifying the differentiation suggested by the overlapping of the different fields and the varying writing styles. The pin lock is flanked on both sides by a two-strand "ribbon of eternity" or interlace, itself framed by a schematic rendering of the lotus blos-

som motif. All the decorative elements except for the lotus blossom are nielloed.

The necklace of three coin pendants and beads of gold and various other materials has been hypothetically reconstructed from elements that were recovered; the simpler necklace of electrum with rock crystal and vitreous paste, also reconstructed, might conceivably be part of it. There is no evidence pointing to a characteristic length, either long or short, for necklaces at that time. The necklace components include spherical beads and cylindrical openwork beads with a ring of spherical bosses at each end, which are variations on elements that are common in Islamic jewelry. The bosses on the electrum beads are larger than those on the gold beads. Three half-dinar coins have been converted into pendants by soldering a gold ring to their edges so that the legends can still be read.

Bracteae are metal plaques of varying sizes and shapes that were sewn directly onto the clothing, following a tradition that began in the late Roman Empire or perhaps earlier. *Bracteae* were common ornaments in the dress of Germanic peoples and probably were introduced into Spain by the Visigoths. Two shapes may be observed here: one a four-lobed or rounded cross shape, the other a six-pointed star.

For the group of similar *bracteae*, a flattened

gold sheet was cut into lozenges, from which the cross shapes were formed; they were then decorated with repoussé work. A narrow plain or worked molding follows the outside contour and also outlines a smaller cross-shaped field within. Arranged between the two moldings are at least twenty-six hemispherical bosses. Within the inner cross-shaped space are smaller bosses, seven or eight in each arm. In the center a circular molding surrounds a large hemisphere. The tips of the arms are perforated so the *bracteae* can be stitched to a garment.

The star-shaped *bractea* is composed of two gold sheets soldered so that collets, which held cabochon stones of vitreous paste, could be formed—a small one on each of the six points and a large one in the center. Only the remains of white color in the central collet and green in one of the points can be identified with certainty. Small perforations in the star allow it to be sewn to clothing.

Two fragmentary triangular elements seem to be points from a star-shaped *bractea*. Soldered gold thread outlines the point and a lotus-blossom decoration within. The backs of the triangles lack a proper finish, suggesting that one side was reutilized from a presumably six-pointed *bractea* made of two gold sheets soldered together, like the one catalogued here.

Typologically, these materials raise several interesting points. They are the last known examples of the use of *bracteae* in Andalusian jewelry (none exist from the Nasrid period), and thus they illustrate a long tradition stemming from Roman times and now coming to an end. *Bracteae* in earlier centuries were very often round, but they ended up being cross-shaped, adopting the four-pointed "paradise" motif that was present in Islamic art from the beginning. *Bracteae* shaped as six-pointed stars, however, continued to be made in the same classical shape throughout. Practices common until the *taifa* period—the sewing of perforated coins to clothes as ornaments and the use of coins in diadems—seem to have disappeared by the Almohad period; instead, coins with attached rings were appended to necklaces. A discussion of innovations in jewelry styles must also take into consideration the earrings belonging to the same hoard (see note 2), which seem strongly related to eastern jewelry if not actually from the Near East.

Band bracelets of the type seen here seem to follow a North African or local tradition. New, however, is the decorative use of the *khumisa*, or five-fingered prophylactic symbol, as is the use of Naskhi script in a mature style. Another innovation is the cartouche system used to frame the poems, which also appears on a contemporaneous object, the Tortosa casket.[3] One reason this hoard is

interesting is its demonstration that African and Seljuk influences in jewelry manufacture were among the elements that eventually made their way to medieval Christian Spain.

JZ

1. Palma de Mallorca 1991.
2. J. Zozaya, in New York 1992a, no. 70.
3. Ibid., no. 51.

LITERATURE: Gómez-Moreno 1951; Palma de Mallorca 1991.

57

chasuble of saint edmund

Andalusia, 12th century
Silk
H. 61 in. (155 cm), cir. 15 ft. 1⅛ in. (460 cm)
Church of Saint-Quiriace, Provins (Seine-et-Marne)

According to tradition, this chasuble and a stole and maniple were the vestments of Edmund Rich, archbishop of Canterbury. Because of religious dissension in England, Edmund fled to France in 1240. He died there the following year and was canonized in 1247. The vestments were kept in the abbey of Saint-Jacques in Provins until the Revolution.[1]

It is the main fabric of the chasuble that is of particular interest to us. This textile is lampas woven of green silk. Despite a uniform color the pattern is visible because of differences in the weave: the ground is warp-faced and the pattern weft-faced. Roundels arranged in rows each contain a pair of addorsed parrots flanking a central tree of life. The frames of the roundels carry a Kufic inscription, العز لله (Glory to God), which appears four times in its proper orientation and four times reversed. The writing is so stylized it is close to pseudo-Kufic. Where the roundels abut they are overlapped by circular medallions containing a star rosette within a pearl border. In the interstices are geometric and stylized floral motifs.

The chasuble and a few other pieces form a group closely related to, but distinct from, the Baghdad group (see cat. 60). Among these works gold brocading sometimes occurs, the distinction between ground and pattern is rather pronounced, and the calligraphic style is consistent throughout. The group has been variously placed in the twelfth or the thirteenth century. A twelfth-century date seems most likely, since a related textile in Salamanca was used as the cover for a document dating from the reign of Ferdi-

57

nand II (1157–88), and a tunic made of fabric of this type was found in Oña in the tomb of the infante Don García, who died in 1145 or 1146.[2]

Had it not been for the special status of luxury textiles in Christian ecclesiastical and royal milieus regardless of the fabric's origin or religious association, the number of Spanish Islamic textiles preserved today would be minuscule. It is characteristic that all six Islamic textiles treated in this catalogue either were found in the context of Christian reliquaries or tombs or were adapted for use as church vestments at an early date.

DW

1. Paris 1988, p. 62.
2. Cristina Partearroyo, in New York 1992a, p. 107.

LITERATURE: Rohault de Fleury 1883–89, vol. 7, pp. 168–69, vol. 8, pl. DCVII; May 1957, p. 33, fig. 19; Shepherd 1958, p. 5; London 1976, p. 78, no. 10; Paris 1988, pp. 62–63, 255, no. 5; Cristina Partearroyo, in New York 1992a, p. 107.

58

cap of prince ferdinand of castile

Andalusia, late 12th or early 13th century
Silk and gilt membrane threads
H. 6⅛ in. (15.7 cm)
Patrimonio Nacional, Monasterio de Santa María la Real de las Huelgas, Burgos (007/001 MH)

This cap is one of the burial garments of Prince Ferdinand of Castile, firstborn son of Alfonso VIII of Castile and Eleanor of England. Ferdinand, born in 1189, died in Madrid in 1211, the year before his father led Christian forces to victory at Las Navas de Tolosa. His sister Berengaria (see cat. 59) accompanied his body to its resting place in the convent of Santa María la Real de las Huelgas in Burgos (Las Huelgas), which had been founded by his parents; Ferdinand was the first member of the royal family interred in the family sepulcher. Burial garments from Las Huelgas, now preserved in the Museo de Telas Medievales, include fine examples of Almohad textiles as well as thirteenth-century pieces that represent a further development of the Almohad style.

The cap was made of tapestry-woven cloth rich with gold (gilt animal membrane wrapped around silk thread), which is incorporated

58

into the weave. The design consists of varying parallel bands. The widest one, containing a series of eight-pointed stars fashioned from geometric interlace, is flanked by narrow ribbon-stripes and bands of floral ornament. Along the front edge of the cap is a stripe bearing a message in heavy cursive script and edged with a pearl border. The inscription has been translated as "In the Lord is our solace."[1] The writing is gold and white on a dark blue ground. Cream, light green, and light blue appear elsewhere in the fabric.

Textiles of the twelfth and thirteenth centuries that survive from Islamic Spain are relatively few in number. However, contextual dating is possible for quite a few of the examples, allowing an approximate sequence to be established and stylistic developments traced.[2] The Almoravid taste in textiles favored rows of large-scale roundels containing pairs of birds or animals (cats. 57, 60). Under the Almohads officially sponsored production of textiles seems to have diminished, at least early in the reign, but the large-roundel motif persisted. At the same time a new style appeared characterized by pattern elements, including roundels, of much smaller scale and the lavish use of intricate geometric interlace. Inscriptions in cursive script appear in Almohad art, although certain types of Kufic script were popular too; sometimes the two were combined on the same object. The cap of Prince Ferdinand displays the Almohad preference for tiny pattern elements, geometric interlace, and cursive inscriptions, which continued through the thirteenth century.

<div style="text-align:right">DW</div>

1. Gómez-Moreno 1946, p. 82.
2. The best overview of these developments is provided by Cristina Partearroyo, in New York 1992a.

LITERATURE: Gómez-Moreno 1946, pp. 25, 81–82, no. 60, pls. XXXVIa, CXII, CXIII; Bernis 1956, pp. 97–98; May 1957, p. 69; Herrero-Carretero 1988, pp. 59–61; Cristina Partearroyo, in New York 1992a, pp. 110–11.

59

PILLOW COVER OF QUEEN BERENGARIA

Andalusia, second quarter of 13th century
Silk and gilt membrane threads
33⅞ x 19⅝ in. (86 x 50 cm)
Patrimonio Nacional, Monasterio de Santa María la Real de las Huelgas, Burgos (014/004 MH)

In addition to the garments and furnishing fabrics with Almohad-style ornament that

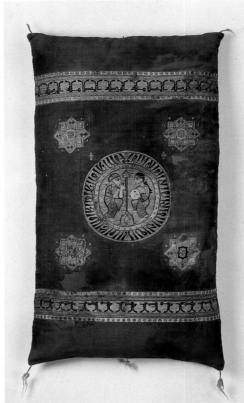

59

were produced well into the thirteenth century, there are a number of Spanish Islamic textiles with distinctive figural decoration. The best-preserved example is a pillow cover found in the tomb of Queen Berengaria, who died in Burgos in 1246. It is in remarkably good condition and must have been virtually new at the time of burial. Berengaria, the daughter of Alfonso VIII of Castile and Eleanor of England, married Alfonso IX of León. With the death of her brother Henry I in 1217, she gained the throne of Castile as well, but relinquished it in favor of her son Ferdinand. Queen Berengaria was buried in the convent of Las Huelgas in Burgos with other family members (see cat. 58); her coffin yielded this pillow cover as well as fragments of her silk brocade clothing.[1]

On the decorated face of the pillow cover, ornamental tapestry-woven panels of polychrome silk and gold (gilt membrane on a silk core) are inwoven into a plain-weave ground of dull red silk. A central roundel shows two dancing figures flanking a tree of life; one of them plays a musical instrument, probably a tambourine, and the other holds a cup. The scene is framed by a pearl border and an inscription in highly stylized Naskhi script that reads لا إله إلا الله (There is no god but God). Symmetrically disposed around the central roundel are four stars made of geometric interlace. Running across the cover near the top and bottom are bands of Kufic

inscription that are stylized to create a kind of arcade pattern. They repeat the message البركة الكاملة (the perfect blessing). The cover back is undecorated red silk.

The pillow cover of Berengaria is very similar to and probably contemporary with a silk and gold tapestry from the tomb of Don Arnaldo de Gurb, bishop of Barcelona between 1252 and 1284. The ten surviving fragments of this tapestry are dispersed among collections in Spain and the United States. The principal decoration is a series of roundels with various scenes related to royal entertainments—banqueting, hunting, picking fruit—perhaps symbolizing, in toto, the garden of paradise. The roundel frames carry the same inscription as the Berengaria cover roundel (but in Kufic, not Naskhi). The Bishop Gurb tapestry thus provides a type both iconographic and formal into which the single pillow cover roundel, with its depiction of courtly entertainment, comfortably fits. It has been proposed that the dispersed fragments originally were part of a curtain. It seems likely that textiles such as these, with figured roundels set against a plain ground, were generally employed for furnishings rather than for garments.[2]

<div style="text-align:right">DW</div>

1. Herrero-Carretero 1988, pp. 98–101.
2. The Bishop Gurb fragments are fully discussed in Shepherd 1978.

LITERATURE: Gómez-Moreno 1946, pp. 30–31, 82–83, no. 62, pls. XLIII, CXV; Bernis 1956, pp. 98–99; May 1957, p. 67, fig. 40; Shepherd 1978, pp. 116–17, 130–32; Herrero-Carretero 1988, pp. 102–3; Concha Herrero-Carretero, in New York 1992a, pp. 321–22; Cristina Partearroyo, in New York 1992a, p. 112.

60

FRAGMENT OF A TEXTILE

Andalusia, ca. 1100
Silk and gilt membrane threads
17¾ x 19⅛ in. (45 x 50 cm)
Museum of Fine Arts, Boston (33.371)

This famous textile is known both as the Burgo de Osma silk, after the cathedral where it was found, and as the Baghdad silk, after its presumed city of manufacture, named in its inscription. A repeating pattern is made up of rows of roundels, each containing a tree of life flanked by a pair of addorsed lions with harpies perched on their backs. In the roundel's wide frame the scene of a kneeling man holding two griffins appears four times. The roundel frames are linked at the cardinal points by overlapping circular medallions in which a Kufic inscription encircles a central

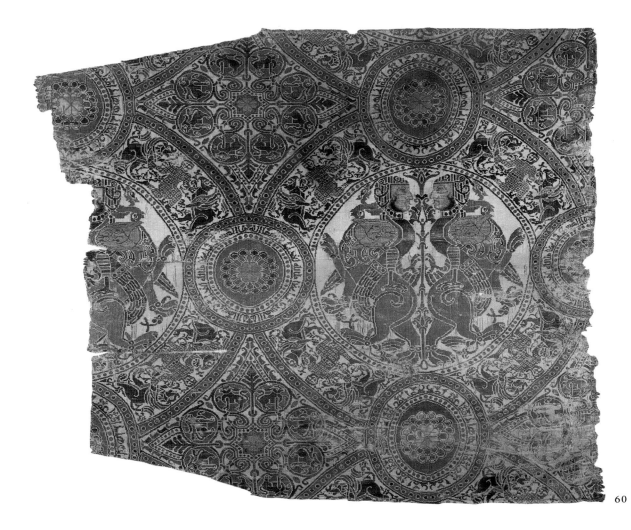

60

rosette. The interstitial design is a pattern of floral elements combined with quadrupeds in small roundels.

The inscription reads:

هاذا ممّا بد/ينة بغداد حرسها الله عمل (This is from among that which was made in the city of Baghdad. May God protect it).[1] Half of the inscription is carried in the medallions that link the roundels vertically, half in the ones that link them horizontally. Each medallion bears its message twice in the proper direction and twice in reverse. A second, smaller fragment of the Burgo de Osma silk is known that has a feature lacking in the Boston piece. Its roundel pattern is broken by a horizontal band of inscription in Kufic, which has been translated "Blessing comes from God and majesty [also]. . . ."[2]

Initially it was believed that the Burgo de Osma silk was manufactured in Baghdad. Its design is made up of Near Eastern motifs; it conforms at least in a general way to what is known, from early descriptions or actual examples, about silks from medieval Baghdad; and, of course, Baghdad is named in the inscription. But now it is recognized that this textile belongs to a distinctive and relatively homogeneous group of Spanish textiles that can be dated to the first half of the twelfth

century. Roundel designs appear consistently in this group and so do animals both real and fantastic drawn from a Near Eastern repertoire. The patterns are minute and linear. Three textiles have horizontal bands of inscription cutting across the repeat pattern. Pearl borders abound. The palette usually consists of reddish brown, dark green or blue, and small areas of yellow, on an ivory ground. The structure is lampas of a type peculiar to Spain, with weft brocading in gilt thread (bound in a distinctive honeycomb pattern) for the larger animal heads.

One textile in the group, the chasuble of San Juan de Ortega in the church of Quintanaortuña near Burgos, has an inscription thought to refer to the Almoravid ruler ʿAli ibn Yusuf ibn Tashufin, who ruled from 1107 to 1143.[3] It is on the basis of this inscription that the entire group of textiles can be assigned an approximate date and their Spanish origin confirmed (there is no basis for linking these pieces to North African production). Moreover, the inscription on the Boston fragment contains a spelling peculiarity found in Spain.[4] These textiles must have been made in deliberate imitation of Baghdad silks.

The Burgo de Osma silk was found in the

tomb of San Pedro de Osma, bishop of Burgo de Osma. It is likely that the bishop, who died in 1109, was interred with the silk, making it perhaps the earliest textile in the extant group. Where it was manufactured cannot be definitely ascertained, but Almería has been proposed as the most likely place.[5]

DW

1. Combe, Sauvaget, and Wiet 1936.
2. Elsberg and Guest 1934, p. 271.
3. Shepherd 1957, p. 373.
4. Day 1954, p. 193.
5. Shepherd 1957, pp. 381–82; Cristina Partearroyo, in New York 1992a, p. 106.

LITERATURE: Elsberg and Guest 1934; Combe, Sauvaget, and Wiet 1936, pp. 139–40, no. 2623; Day 1954; May 1957, p. 36, fig. 23; Shepherd 1957, pp. 378, 380, pl. 7; London 1976, p. 78, no. 10; Wilckens 1991, pp. 67–69, fig. 69; Cristina Partearroyo, in New York 1992a, pp. 104, 106.

the kingdom of asturias and mozarabic spain

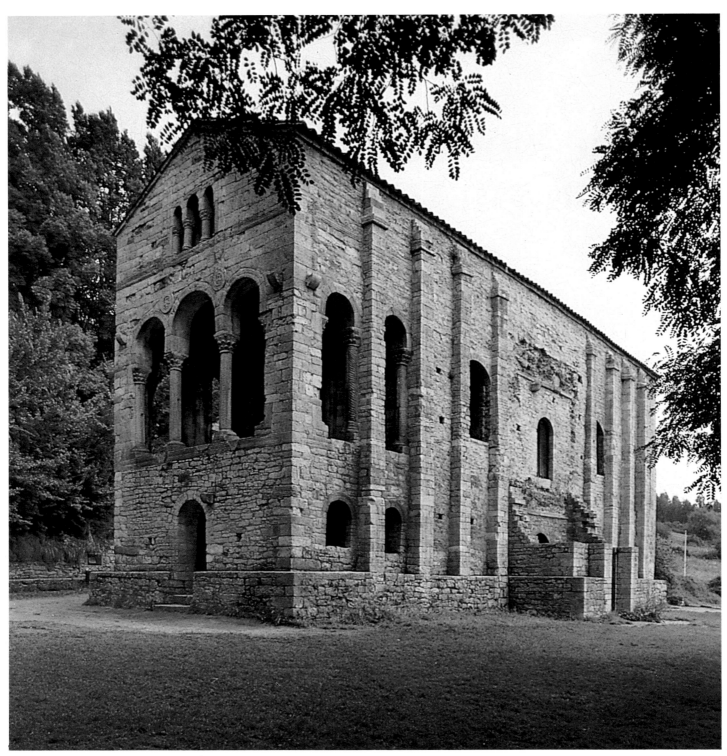

Belevedere, Mount Naranco (Oviedo). Photo: Achim Arbeiter

the kingdom of asturias

ACHIM ARBEITER AND SABINE NOACK-HALEY

With the fall of the Visigothic kingdom of Toledo in 711, the Muslims had conquered the greater part of the Iberian Peninsula. The Christians did manage to establish a small Christian kingdom in the north on the Cantabrian coast, beyond a protecting range of mountains.[1] The chieftain Pelayo had beaten back the Muslims in an armed encounter at Covadonga in 719, and it was he who established the ruling line of the new kingdom. The assertion in the informative Asturian chronicles of the late ninth century that Pelayo was of aristocratic Visigothic descent has not been verified, but his son Fáfila (r. 737–39) is known to have founded the church of Santa Cruz in 737 in the first of the kingdom's capitals, Cangas de Onís. Significantly, that structure was erected above a pagan shrine. No traces of the church survive, but an inscription copied before its destruction probably implies that it was cruciform in plan.[2]

The eighteen-year reign of Fáfila's successor, Alfonso I (r. 739–57), saw the consolidation of the kingdom. Stability permitted the construction of numerous churches—Alfonso is for that reason called "el Católico"—but unfortunately these have completely vanished. During these years the Asturians began to stage raids on Muslim-occupied territories, attempting to recapture lands for their Christian domain. These campaigns turned much of the meseta in northern Spain into a virtually unpopulated buffer zone, its inhabitants having migrated northward into the safety of the new Christian kingdom.

After moving the royal residence farther west to Pravia, the sixth Asturian ruler, Silo (r. 774–83), erected a palace church which he consecrated to Saint John the Evangelist (Santianes).[3] This is the oldest Asturian monument of which a significant part survives. It was laid out like a basilica with round-arched pillar arcades, a gallery above the vestibule at the west, probably for the king's use, a transeptlike eastern bay divided in three by arches above half columns, and a rectangular apse that was presumably much smaller than the one that is visible today. The most important surviving decorative elements are two chancel screen reliefs (cat. 63) and another relief slab with an unusual depiction of architecture.

It was at about the same time that the monk Beatus, working in a scriptorium in the Cantabrian valley of Liébana, produced his apology against the doctrine of adoptionism and commentaries on the Book of Daniel and the Apocalypse.[4]

Pravia had been selected for the location of the royal residence as part of an attempt to extend Asturian influence into Galicia. Alfonso II (r. 791–842) moved the capital once again, this time to Oviedo. At the direction of Fruela I (r. 757–68) the city had been graced with the monastery of San Vicente, a church dedicated to Santos Julián y Basilisa, and the first San Salvador church, but these were all destroyed in the Islamic raids of 794 and 795. Alfonso rebuilt Oviedo into a fortified residential city with a variety of royal structures.[5]

This reconstruction of Oviedo is recorded in three chronicles —the *Albeldensia*, the *Rotensis*, and the *Ad Sebastianum*—that are reworkings of earlier ones from the time of Alfonso III. They recount the lives and achievements of the Asturian rulers and are the most important source of information about the kingdom.[6] They describe three adjacent basilicas that were the city's monumental focus: the church of San Salvador, later a cathedral, with relics of the twelve apostles in its side altars; the church of Santa María built against it to the north, with two side altars and the royal pantheon on its west end; and the basilica of San Tirso, of which "the beautiful design can be exalted by a learned writer but is even better comprehended by seeing it oneself." Secular authority had its center in the adjacent palace complex. The chronicles make special mention of the interior furnishings of these churches—marble columns (doubtless acquired as spoils), gold and silver, and paintings like those that embellished the palace buildings. The significance of this dazzling display is triumphantly proclaimed: Alfonso II "has thoroughly restored in Oviedo, in church and palace alike, all of the ceremony of the Goths, as it had been in Toledo." Since the old capital of Toledo now lay in Islamic territory and moreover had forfeited its ecclesiastical primacy as a consequence of the theological dispute over the true essence of Christ (adoptionism), the capital of the expanding Christian kingdom to the north could legitimately assume the leadership of Christian Spain. Closely bound up with these ambitions was the "discovery" at about this time of the tomb of Saint James, near the Atlantic coast at what came to be called Santiago de Compostela.[7]

The Asturian pre-Romanesque gave artistic expression to the dynasty's championing of a Visigothic resurgence. The basilica of Santos Julián y Basilisa (San Julián de los Prados, or Santullano) outside the Oviedo city walls to the northeast,

which was built for Alfonso II, is the best preserved and one of the largest of Spain's surviving early medieval churches.[8] It has a projecting vestibule, three aisles separated by pier arcades, a high, nonprojecting transept, which has a wooden ceiling (like the aisles) and lower side rooms, and three barrel-vaulted rectangular apses that form a single block. Above the main apse is a hidden or blind chamber placed there for the sake of proportion, a feature that henceforth would become obligatory in Asturian church architecture. As at Santianes de Pravia we find here quarry-stone masonry, plastered inside and at one time outside as well, with quoins and buttresses of larger blocks of stone. The semicircular arches are constructed of brick. This is a fundamental change from the ashlar construction with horseshoe arches of the late Visigothic period that dominates our concept of seventh-century Iberian architecture. Of course, it is true that nothing survives of the large urban parish churches from that period or especially of the royal churches of Toledo that served as models for Asturian building taking place about 800—a relationship not only proclaimed in the above-mentioned chronicles but also corroborated by architectural analysis. Santullano is noteworthy for its use of Visigothic spoils, as in the blind arcade of the main apse, and for a number of distinctly byzantinizing elements, such as the triple-arch motif of the window in the blind chamber, but above all for incorporating a remarkably pure rendition of a late Roman fresco cycle.

The paintings, wonderfully preserved and with fresh colors, are among the most important and astonishing examples of early medieval wall painting in the West. Thirty-eight pictures of palaces and curtained arcades are disposed over three registers. Since there are no figures, a Christian interpretation of the fresco cycle rests on the prominent inclusion of the cross at four central points in the top register, where the palaces are meant to represent the heavenly Jerusalem. While architec-tural representations of this kind ultimately go back to antiq-uity, as is seen at Pompeii, the typological predecessors of these paintings are important mosaics like those in the rotunda of Saint George in Salonika, the baptistery of Neon in Ravenna, and the court porticoes of the Umayyad mosque in Damas-cus. The frescoes also contain floral and geometric ornaments deriving from Spanish late antique and Visigothic anteced-ents, and certain features of the architectural cycle suggest that it was modeled on a painting that is thought to have been in Toledo, although the relationship remains hypothetical. In any case, with its theme rich in associations of empire, the fresco cycle is an expression of the royal character of the structure. That the gallery in front of the north wall of the transept, not part of the original plan, was also royal in nature can only be surmised. The overpowering continuous transept is unprece-dented in architectural history.

Because of their similarity to Santullano, two rural churches are dated to the same period: the basilica of San Pedro de Nora, with its pillar arcades,[9] and the church of Santa María de Bendones, in which a transeptlike space wider than it is long served to house the congregation.[10] Of the three basilicas in the center of the city that were described above, only a por-tion of the apse wall of San Tirso is visible today.[11] The Cámara Santa, however, at one time part of the church-palace com-plex, is preserved as an annex of the modern cathedral.[12] Its design is that of the two-story martyr's chapel, like Marusinac near Salona or La Alberca near Murcia: the crypt was conse-crated to the council patron, Saint Leocadia of Toledo, while the upper Saint Michael chapel (bombed in 1934 and rebuilt) served as a treasury and reliquary chamber.

The importance of the cult of relics in this period is appar-ent from the common multiplication of one apse into three and the presence of a separate reliquary structure, as well as from the royal donation in 808 of a large cross, the Cross of

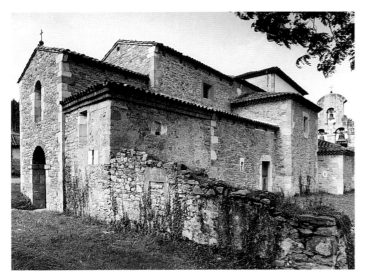

Santianes de Pravia (Oviedo). Photo: John Patterson, Deutsches Archäologisches Institut

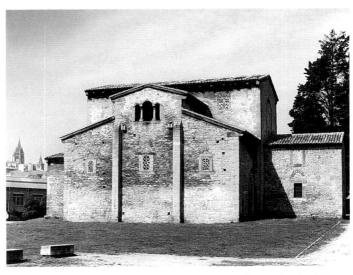

Santullano, Oviedo. Photo: John Patterson, Deutsches Archäologisches Institut

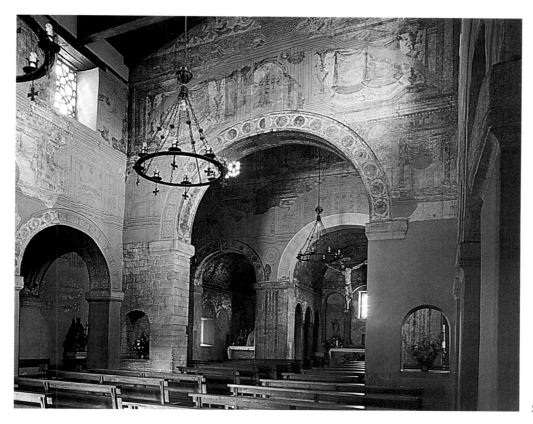

Santullano, Oviedo. Photo: Achim Arbeiter

the Angels (cat. 72), made for the housing and displaying of relics. A gold cross set with numerous jewels, it has on the back an inscription giving the date, the name of the donor—"Adefonsus humilis servus Xpi" (Alfonso the humble servant of Christ)—and a motto recalling the vision of Constantine that would henceforth serve as the Asturian emblem. (The cross was restored in the twentieth century, then severely damaged, then restored once again.)

By the close of the half-century reign of Alfonso II, the boundaries of Asturias were as firmly established as its foreign policy, its religion, its ideology, and its confidence. Ramiro I (r. 842–50) and his son Ordoño I (r. 850–66) managed to defend themselves against repeated Norman attacks from across the Bay of Biscay as well as internal unrest and continuing Islamic incursions. Ordoño even mounted some major campaigns and made further conquests. In Córdoba, meanwhile, the fanaticism of growing numbers of Christians eager for martyrdom so impaired the coexistence of the two religions in al-Andalus that waves of Mozarabic Christians were led to seek refuge in regions under Asturian control. The flowering of the small kingdom is reflected in Ramiro's ambitious building program on Mount Naranco.[13] The chronicles proudly relate that above Oviedo he constructed a whole complex of palaces, complete with a Mary church. Its buildings were of "perfect beauty," all of stone and surmounted by great numbers of ribbed barrel vaults the likes of which were not to be found "in all Spain"—at that time meaning al-Andalus. The basilica of San Miguel de Liño (or Lillo) was consecrated to

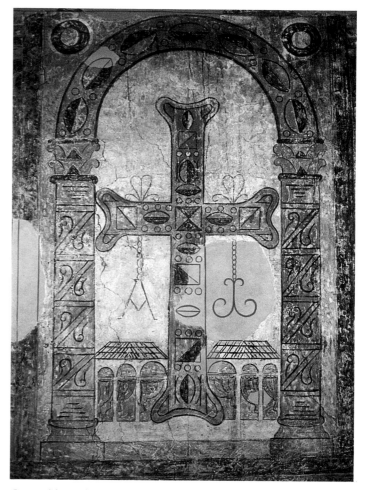

Cross with pendent alpha and omega. Wall painting in Santullano, Oviedo. Photo: Lorenzo Arias Páramo

115

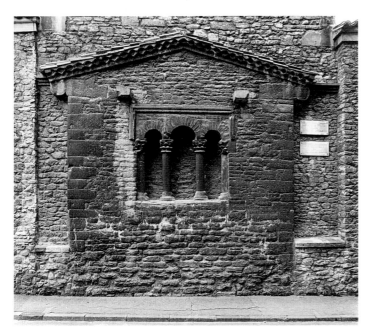

San Tirso, Oviedo. Photo: John Patterson, Deutsches Archäologisches Institut

the Virgin, but in the eleventh century at the latest it was two-thirds destroyed and had to relinquish its dedicatory altar, along with its Mary patronage, to the nearby belvedere or royal hall. The belvedere became Santa María and was resecularized only about 1930. It is almost entirely preserved. The original basilica was restored at some point and was reconsecrated to Saint Michael.

It appears that new, probably foreign influences were at work in Ramiro's building campaign. The completely vaulted ceilings, a structural innovation celebrated in the chronicles (and built of calcareous tufa), are made possible by such elements as a complex system of corresponding buttresses and interior supports. Accompanying features are a three-dimensional organization of the walls, stilted keystone arches, and a rich decorative program of sculptures and paintings.

With its tall, slender proportions, its arcades of columns (exceptional among Asturian churches), and its dramatic vaults, San Miguel de Liño is still impressive, despite its fragmentary state.[14] The work of excavation and reconstruction begun in the nineteenth century yielded definite conclusions in 1989–90. The church had three aisles and a three-apse choir. In the original, surviving western portion there are two stories; here, two symmetrical flights of stairs led to a spacious gallery that could be curtained off and was surely intended for the king. From there the monarch would have had a clear view of the high altar, on which an inscription names Ramiro and his consort, Paterna, as founders, describing Ramiro as "famulus Christi" (servant of Christ) and "princeps gloriosus" (glorious ruler), and records the church's dedication in 848.

Among the most spectacular of the building's diverse sculptural embellishments are the jamb carvings of the west portal. Here the intricacies of ivory carving have been translated into monumental sculpture, with a circus scene closely related to that on the consular diptych of Aerobindus from 506 (version in the Hermitage, Saint Petersburg). Two vertical acanthus scroll friezes in the church's interior are also apparently quotations, since they are clearly inspired by the lid of the early Christian sarcophagus of Ithacius in the Capilla del Rey Casto in the Oviedo cathedral (cat. 1). The column bases too seem related to the minor arts. Those in situ and the many now in the church museum all carry virtually identical reliefs combining symbols of the Evangelists with auxiliary figures. The museum preserves some figural bases and pillars of the liturgical choir screens as well as an unusual chancel screen which has an oriental-style, Visigothic-era griffin on one side and an imaginative floral motif in an altogether different style on the other (cat. 63). The frescoes in the vaults are faithful copies of those in Santullano, while on the high walls of the south side aisle are the first human figures to appear in Asturian wall painting: a lute player and a figure enthroned with another standing behind entwined in a grapevine.

The belvedere (Santa María)[15] at Mount Naranco is the only surviving secular palace building of the Asturian monarchy. It is a masterpiece of architectonic originality and uniformity of design. Each of the rectangular structure's two stories is divided into a large center hall with ribbed barrel vaults and two side compartments of which those on the lower level have wooden ceilings. The lower chamber on the east side was once a cistern. The loggias on the main floor have vaults as tall as those of the center hall. There were wings added on the long sides, containing on the north two symmetrically placed staircases and on the south (no longer surviving) an additional loggia. The three-arch scheme recurs in the windows of the end wall and the loggia arcades. The theme of an arcade of arches that increase in diameter toward the center is extended further in the blind arcades of the large hall. All the columns have spiral fluting; those on the exterior are topped by Corinthian capitals and those in the blind arcades, in bundles of four, have figured capitals in the shape of a truncated pyramid. The upper walls present vertical bands of relief, panels with apotropaic crosses on staffs, figures, and horsemen. In the spandrels are ornamented medallions containing fabulous beasts.

The chapel of Santa Cristina de Lena south of Oviedo may have been constructed under Ordoño I.[16] Its single nave, subdivided by a tribunal placed to the west and an elevated presbytery set off by a triple arch, is modeled on the main hall of the belvedere. Extending on axis from the four sides are a vestibule, two side chambers, and the apse. Although the interior no longer has its impressive wall paintings—which were destroyed, possibly as late as the restoration of 1894—it is still visually rich, largely because of the exquisite marble spoils from the Visigothic period that are incorporated into the screen structure.

The last ruler to occupy the residence at Oviedo was Alfonso III (r. 866–910). He enlarged the kingdom to the south

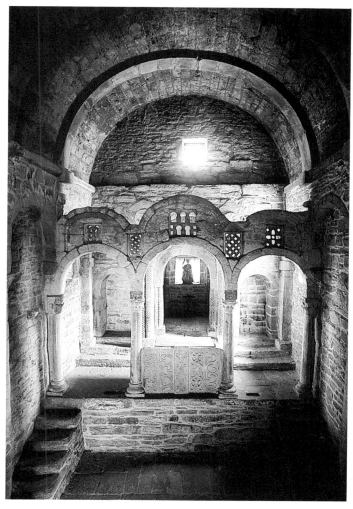

Santa Cristina de Lena (Oviedo). Photo: Achim Arbeiter

as far as the Duero and Mondego rivers, opening up new land for settlement which was soon to absorb increasing numbers of Mozarabs streaming north from the emirate. The king clearly regarded himself as the protector of all Christians on the Iberian Peninsula, and with the growth of his power that is indeed what he became; it is thought that he even advanced into the Cordoban hinterland, for the first time forcing the emir to petition for peace. Alfonso III had a remarkable awareness of both history and culture and in fact is credited by a number of scholars with the authorship of one of the original versions (dating about 880) of the Asturian chronicles mentioned above. Justly known as "el Magno" (the Great), he was nevertheless dethroned by his three sons. The capital was subsequently moved to León for strategic reasons, and in the course of the tenth century Asturias rapidly sank to the level of a mere province.

The rebuilding on a larger scale of the basilica over the alleged tomb of Saint James in Santiago de Compostela was directed by Alfonso III and embodies more than any other building project the proud religious and political pretensions of his strengthened Christian kingdom.[17] In the late tenth century the church was the target of an Islamic raid led by al-Mansur, and the Romanesque structure that is still overwhelming today was built on the ruins of Alfonso's basilica. The role Alfonso II had sought as a Christian conqueror, manifest in his commission of the Cross of the Angels, was confirmed in the crosses Alfonso III gave to the cathedrals of Santiago and Oviedo. The former is lost; the latter is known as the

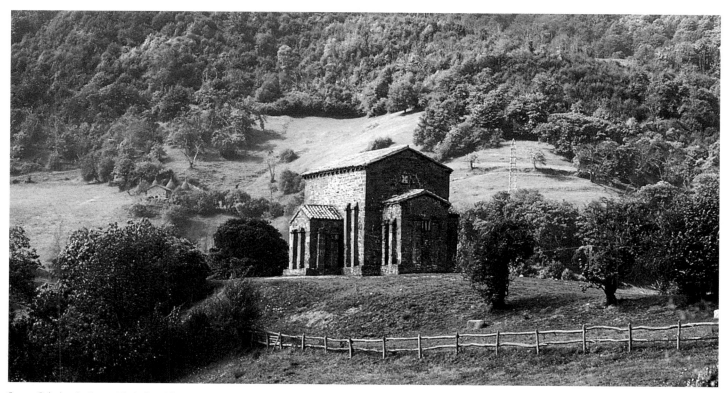

Santa Cristina in Lena (Oviedo). Photo: Achim Arbeiter

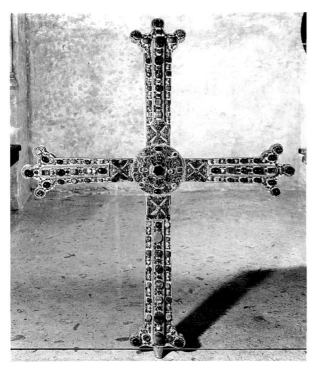

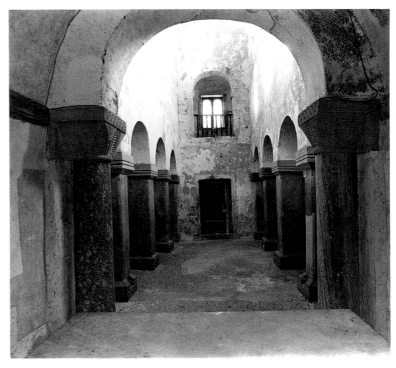

Cross of Victory. Cámara Santa, Cathedral of Oviedo. Photo:
Detlev M. Noack, Deutsches Archäologisches Institut

San Salvador, Valdediós (Oviedo). Photo: Achim Arbeiter

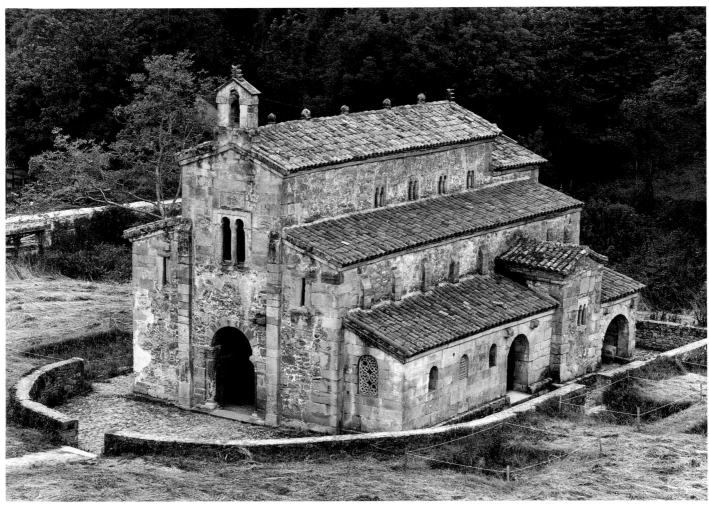

San Salvador, Valdediós (Oviedo). Photo: John Patterson, Deutsches Archäologisches Institut

Cross of Victory.[18] The stance taken by the king is vividly conveyed by less pretentious testimonials, such as the cross relief and inscription in the springhouse La Foncalada, which he donated to the citizenry of his capital. The combination of victor's cross and triumphal motto appears again and again throughout the tenth century and well into the eleventh, as for example on a relief slab in Salas (cat. 65) and in various miniatures.[19]

The best-preserved examples of architecture from the time of Alfonso III lie outside Oviedo. The small basilica of San Adriano de Tuñón to the west of the city is thought to have been built in 891.[20] It is especially important because its painted apse frieze of stepped battlements and lotus-flower scrolls, entirely Islamic in character, is probably the oldest surviving work of art produced by Mozarabic immigrants in the north of Spain. At some distance to the east of Oviedo is Valdediós, Alfonso's country estate to which he retired after being dethroned. All that survives is its church of San Salvador.[21] An inscription states that it was consecrated in 893 in the presence of seven bishops, one of them the Mozarabic bishop from Saragossa—further evidence of the ongoing relations between Asturias and al-Andalus.

This vaulted basilica with pillar arcades follows the usual scheme, including a gallery above the west end, but has blind chambers above all three apses. Grooves in the floor that once held screen slabs show clearly that the church was divided into three sections: one for the laity, one for the officiating clergy, and one—the easternmost bay—for attending clerics. The walls and vaults have again become flat, continuous surfaces articulated solely by wall paintings. However, a splendid portico designed to receive the royal retinue, a separate structure added

to the south, boasts a more complex interior organization, with blind arcades and transverse arches. Mozarabic influence is easily detected in its conspicuously rich sculptural ornamentation; the battlements that are only painted inside the church at Tuñón are here realized in stone and installed as turrets on the roof, calling to mind the crenellations atop the outside wall of the Great Mosque of Córdoba. Also of Islamic inspiration are the porch capitals, the ornate window grilles, and the double and triple windows with horseshoe arches topped by a rectangular *alfiz*, or decorative frame.

Among the last manifestations of Asturian art are the goldwork of the Caja de las Agatas (cat. 71) and the architecture of the parish churches of Santiago de Gobiendes and San Salvador de Priesca, considerably to the east of Oviedo.[22] San Salvador, consecrated in 921, was very heavily damaged in the Spanish civil war. Its structure echoes to a certain extent that of Santullano, and its architectural frescoes are clearly an imitation of those in the earlier church, although they reveal a loss of creative power and a decline in workmanship. In adding human figures to the old cycle, the fresco decoration reaches back to the artistic tradition fostered by Ramiro rather than enlarging upon the Mozarabic-influenced style paramount in the time of Alfonso III.

In northern Spain the old Hispanic liturgy continued to be used well into the eleventh century, and for at least as long the northern architecture offered echoes of the Visigothic Asturian tradition. They can be seen in Asturias itself and also in León in the church of San Pelayo,[23] which preceded San Isidoro. Later in that century, however, the earlier liturgy gave way to Roman observance, and by that time we find ourselves, in the realm of art, on the threshold of the Romanesque.

NOTES

1. For its history, see Sánchez-Albornoz 1972–75; Fernández Conde 1972, 1982; Benito 1979; Glick 1979; García Moreno 1981; Collins 1983; García Toraño 1986.
2. For art-historical overviews of the period, see Schlunk 1947b; Manzanares 1964; Bonet 1967; Fontaine 1973; Cid 1978; Nieto 1989a; Berenguer 1991.
3. Selgas 1902; Menéndez Pidal 1980b; Fernández Conde and Santos del Valle 1987–1988.
4. Vázquez de Parga 1978.
5. Uría 1967; Rodríguez Balbín 1977.
6. Prelog 1980; *Crónicas asturianas* 1985; Bonnaz 1987.
7. Engels 1980.
8. Selgas 1916; Menéndez Pidal 1941b, 1954, pp. 19–23; Schlunk 1949, 1980a, pp. 148–54, ills. 26–42, 1985, pp. 26, 27; Schlunk and Berenguer 1957, pp. 5–105; Barral 1976; Bango 1985, 1988; Dodds 1986; Noack 1986b; Marín and Gil 1989; Arias 1991, 1992b; Arbeiter 1992.
9. Menéndez Pidal 1941b, p. 33.
10. Manzanares 1957; Menéndez Pidal 1974.
11. Redondo 1974–77.
12. Amador de los Ríos 1877 (La Cámara Santa); Gómez-Moreno 1934b; Fernández Buelta 1948; Fernández Buelta and Hevia 1949; Dyggve 1952; Menéndez Pidal 1960; Schlunk 1980a, pp. 147, 148, ills. 25, 26.
13. Amador de los Ríos 1877 (San Miguel de Liño and Palacio of Ramiro I); Selgas 1909; Schlunk 1948; Camps 1948; Dshobadze 1954; Berenguer 1972–73; García Toraño 1981; Gil and Marín 1988; Arias 1988a, 1988c, 1992a; Cuadrad 1992; Noack-Haley 1992; Noack-Haley and Arbeiter (in press).
14. Llano 1917a, b, 1928, pp. 342–55; Haupt 1935, pp. 218–25; Jorge 1957; Schlunk and Berenguer 1957, pp. 109–17; González García 1974, with an unverifi-

able hypothesis regarding the westward orientation of the structure; Schlunk 1974, pp. 126–28; Gómez-Tabanera 1976; Escortell 1978; Arias 1988b; Hauschild 1992a.
15. Haupt 1916; Menéndez Pidal 1954, pp. 25–30; Hubert 1967; García García 1986; Olávarri and Arias 1987; Marín 1990; Arias 1990, 1993.
16. Amador de los Ríos 1877 (Santa Cristina); Lázaro 1894; Menéndez Pidal 1954, pp. 16–18; Berenguer 1984 considers a dating from the Visigothic period, which we reject; Álvarez Martínez 1988; Noack-Haley and Arbeiter (in press).
17. Kirschbaum 1961; Chamoso 1967; Núñez 1978, pp. 140–53; Guerra 1982; Hauschild 1992b.
18. Schlunk 1950, 1985; Elbern 1961, pp. 192–201; Manzanares 1972; González García and Suárez 1979; Fernández-Pajares 1981; Fernández Avello 1982; Cavanilles 1987; Cid 1990. Some of these also deal with the theft, destruction (1977), and restoration of the early medieval cimelia from the Cámara Santa.
19. Menéndez Pidal 1955; Bischoff 1963; Schlunk 1985, p. 36. For La Foncalada, see also Nieto 1989a, p. 173 (with 2 figs.).
20. Menéndez Pidal 1941b, pp. 26, 27, 1954, pp. 72–77; Schlunk and Berenguer 1957, pp. 118–25.
21. Amador de los Ríos 1877 (San Salvador de Valdediós and San Salvador de Priesca); Fernández Menéndez 1919; Gómez-Moreno 1919, pp. 76–81, pl. 27–32; Berenguer 1956; Núñez 1991; Noack-Haley and Arbeiter (in press).
22. Amador de los Ríos as above; Mélida 1912; Menéndez Pidal 1941a, 1954, pp. 79–82.
23. Viñayo 1967.

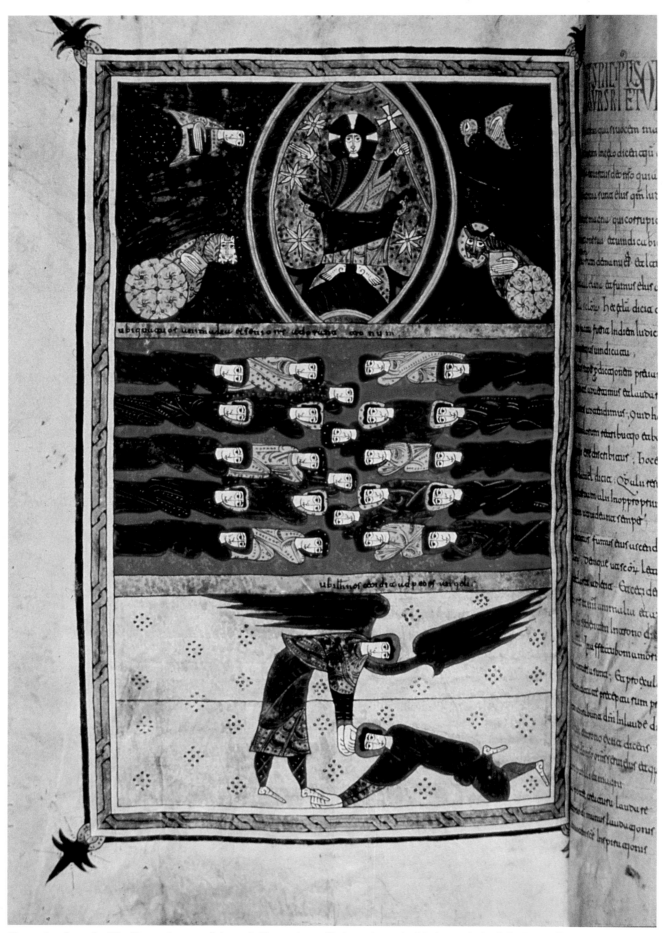

Illustration from the Silos Beatus (cat. 145; fol. 194v). Top register: Christ enthroned with the symbols of the Evangelists; second register: adoration of the One on the Throne before the Last Judgment; third register: John being lifted up. The British Library, London

ART OF THE FRONTIER: MOZARABIC MONASTICISM

O. K. WERCKMEISTER

The term "frontier monasticism" was first used in 1948 by Charles Bishko[1] to characterize the peculiar cultural position occupied by Benedictine monasteries during the struggle between the Islamic caliphate and the Christian kingdoms on the Iberian Peninsula from the eighth to the eleventh century. It complements the earlier term "Mozarabic," which in its original, narrow definition meant Christians in the southern part of Spain who, on condition of owing allegiance to the Muslim ruler and conforming to certain Islamic customs, were allowed to exercise their own religion.[2] The meaning of "Mozarabic" came to be widened into a general designation of Christian culture in early medieval Spain, on the assumption that it was decisively shaped by its coexistence with that of Islam. There are a number of salient issues pertaining to the two interrelated terms: first, the preservation of a tradition of religious culture from Visigothic times, divested of its original political backing by royal authority, which was at first allowed to subsist and was then subjected to various degrees of containment and even oppression under Islamic rule; second, the northerly emigration of Mozarabic monks to Christian territories, whose rulers encouraged them to participate in the reconstruction of areas recaptured from the Muslims; and third, the peculiar religious and political ideology derived from and for this conflict situation, which in the second half of the ninth century began to focus on the martyrdom of Christians in Islamic lands and on the anticipated triumph of Christianity over Islam through a war of reconquest.

The two overriding art-historical questions arising from this momentous confrontation concern the Visigothic sources and the Islamic borrowings of Mozarabic art and the extent to which both were conditioned by the Christian-Islamic conflict in the minds of the monastic artists and their patrons. In a deliberately antagonistic culture, where art was often used for creating images and symbols of triumphant power on both sides, did the adaptation of Islamic forms entail a critical consciousness about their origin, or was the creation of art in pursuit of aesthetic excellence unencumbered by political ideology?[3] The ninth- and tenth-century churches, abbey compounds, and palaces in the important centers of Christian Spain —Santiago de Compostela, Oviedo, León, Burgos, Pamplona,

and others—no longer exist; from the eleventh century onward they were either destroyed or replaced by larger, more ambitious structures. Those buildings that did survive, most notably the abbey church of San Miguel de Escalada of 913, seem to hold on tenaciously to traditions of Visigothic architecture with few if any Islamic features.[4] In manuscript illumination the body of extant material is larger, but the Visigothic heritage is harder to pinpoint;[5] most monuments of Visigothic art, unlike Visigothic literature, have been lost. On the other hand, illuminated manuscripts display a number of adaptations of forms and motifs from Islamic art that stand out all the more clearly for their scattered appearances.[6]

Such transcultural adaptations culminated with those Islamic works of art that ended up in the treasuries of Christian churches in northern Spain, no doubt as a result of having been looted by Christian troops. The most spectacular of these may be the ivory casket, sometimes called the Pamplona casket, made in 1004–5 in the palace workshop of Madinat al-Zahra' outside Córdoba for the army leader ʿAbd al-Malik, the son of al-Mansur (about 938–1002).[7] Its inscriptions extol the

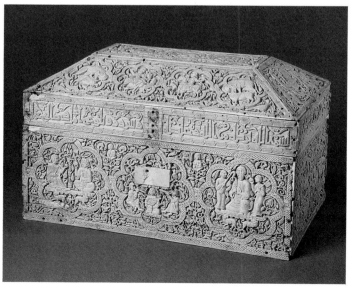

Pamplona casket. Ivory. Caliphal period, 1004/5. Museo de Navarra, Comunidad Foral de Navarra, Pamplona. Photo: Sheldan Collins

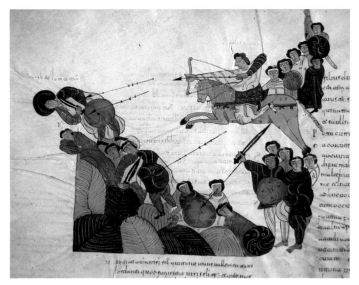

Illustration from San Isidoro Bible (cat. 108; fol. 131v). The death of Saul and Jonathan in the Battle of Mount Gilboa. Real Colegiata de San Isidoro, León. Photo: O. K. Werkmeister

Illustration from the San Isidoro Bible (cat. 108; fol. 574r). The scribes Florentius and Sanctius. Real Colegiata de San Isidoro, León. Photo: O. K. Werkmeister

recipient with his official title "Sword of the Realm," which the caliph Hisham II (r. 976–1013) had bestowed on him in 1004 in recognition of his conquest of León. After the casket fell into Christian hands, perhaps sometime in the course of the eleventh century, it was passed on to the abbey of Leyre, where it was used as a reliquary for the remains of two Mozarabic martyrs from the south, Nunila and Alodia, who had been venerated there as saints since the late ninth century. How do we account for the accommodation to this purpose of a monument that glorifies the Islamic capture of the contemporaneous capital of the Christian Reconquest? After all, it was at Leyre that Eulogius of Córdoba, shortly before 850, had read the spurious *Life of Muhammad*, the "historical" source for his denunciation of Islam.[8]

By contrast, the Bible of San Isidoro at León, written and illuminated in the Castilian abbey of Valeranica and dated 960, contains an illustration of an Old Testament battle in which the painter alludes to the Islamic-Christian conflict.[9] Here the leader of the Philistine assault against the Jewish forces of Saul and Jonathan at Mount Gilboa (1 Samuel 31:1–5) rides with his leg bent back so that his heel touches the upper outline of the horse's croup; his posture is that of the hunting king seen on Sassanian silverware and hence must have been adapted from an Islamic model. In the Visigothic liturgy David's song of mourning over Saul's and Jonathan's deaths (2 Samuel 1:17–27) was chanted among the antiphons on June 29, the feast of Saints Peter and Paul that commemorates their martyrdom. It was also chanted on January 21, the feast of the first early Christian martyrs of Spain, Saints Fructuosus, Augurius, and Eulogius. And in his *Memorialis sanctorum* Eulogius of Córdoba recounts the execution of the Mozarabic martyrs Aurelius and Felix at Córdoba and invokes Saul's and Jonathan's deaths on Mount Gilboa as a biblical precedent.

With his visual quotation of an Islamic source, the artist has given the Old Testament scene a timely connotation.

The issue of a historic consciousness guiding the adaptation of Islamic motifs and forms in the art of frontier monasticism is posed between these two extremes of Leyre and Valeranica. Perhaps it was only in the course of the eleventh century, after the Reconquest had turned victorious, that an Islamic artwork such as the casket of ʿAbd al-Malik could simply be designated as a Christian object, whereas in 960, a time of Christian defeats, the painter of the San Isidoro Bible confronted Islamic art with critical circumspection. A number of additional Islamic motifs in tenth-century Christian art that have come to light since I first collected them in 1965, however, have made me reconsider such all-too-clear-cut historical correlations. It now seems more appropriate to state that during the tenth century monastic artists to the north of the frontier were able at times to adapt Islamic motifs in a context of both rivalry and confrontation.

The Monastic Artist's Status

Artists who created images such as that just described from the San Isidoro Bible stood out from the mass of other manuscript scribes and decorators in northern Spain and enjoyed a particular social prestige. This they expressed in their dedications and colophons, where they recorded the circumstances of their work at great length, dwelling on their status within the monastic institution. In the colophon of the Bible of San Isidoro, the scribe and painter Sanctius has identified himself as a priest and notary and recorded the completion of his work on June 19, 960, giving the names of the current rulers of the kingdom of Oviedo and of the county of Castile, where Valeranica was located. On the subsequent picture, the last in

the manuscript, he depicts himself along with his teacher, the even more famous monk or lay brother (confrater) Florentius,[10] and transcribes a congratulatory blessing on the occasion of their joint completion of the task.

Such explicit, historically accurate, and socially conscious testimonies by leading book painters occur in a number of outstanding Spanish manuscripts of the tenth and eleventh centuries. They are unique in contemporaneous Europe; French, English, and German manuscripts contain a wealth of colophons but hardly ever a comparable assertion of artistic status. The Spanish colophons and dedications resemble, on the other hand, those of artists producing outstanding work for the rulers of Islamic Spain. On the ivory caskets made at the palace workshop of Madinat al-Zahra᾽, inscriptions take the regular form of a protocol, beginning with an invocation of God, the name of the recipient accompanied by a eulogy, the place and date of production, and several times the name of the supervising court official or even, though rarely, that of the artist himself.[11] The casket of ʿAbd al-Malik from the abbey of Leyre offers the most profuse information in all these respects. Each of its four panels was carved by a different artist who incorporated his signature—"Made by Khayr," "Made by Misbah," "Made by Saʾabadah," "Made by Rashid"—in the imagery, while the master of the team—"Faraj"—signed on the lid, which on its inside carried the inscription "Work of Faraj and his disciples."

The only extant illuminated manuscript of the tenth century that can be called Mozarabic in the strict sense of the term, the Biblia Hispalense, completed in Córdoba in 988,[12]

contains a lengthy colophon, which tells of the vicissitudes of the book's protracted making (cat. 85).[13] It seems, therefore, that the leading book painters both in the south and in the abbeys of the Christian north sought the distinguished position claimed by their Muslim counterparts. The convention of the colophon must have prompted the artist to aim for a comprehensive historical documentation of his work—the object is defined in terms of ruler and patron, place and date, scribe and painter, master and disciple. Such colophons tell us how the priest Emeterius, having been trained by the renowned master Magius, was called to the monastery of Tábara to finish the abbey's Beatus manuscript in 970 (cat. 79)[14] and how about 1100 the abbot of Silos had to wait for eighteen years until he could enlist a similarly competent outsider, the prior Petrus, to paint illustrations in vacant places of his own unfinished Beatus manuscript (cat. 145).[15]

At the abbey of San Millán de la Cogolla, another center of early medieval Spanish book painting, the "priest" and "notary" Belasco and his "disciple," the "scribe" Sisebutus, heeded the same convention when they composed the concluding picture of the Codex Aemilianensis of 993–94 (cat. 83).[16] In three registers are the Visigothic rulers of the past, when the texts were written; the Navarrese rulers of the present, when the codex was transcribed; and their own figures working at the behest of their bishop. All of this was explained in the colophon and through additional inscriptions in the margins of the picture itself. The two scribes in the lowermost register with their styli and tablets are identical figures presented in reverse. An initial of another manuscript produced in the scrip-

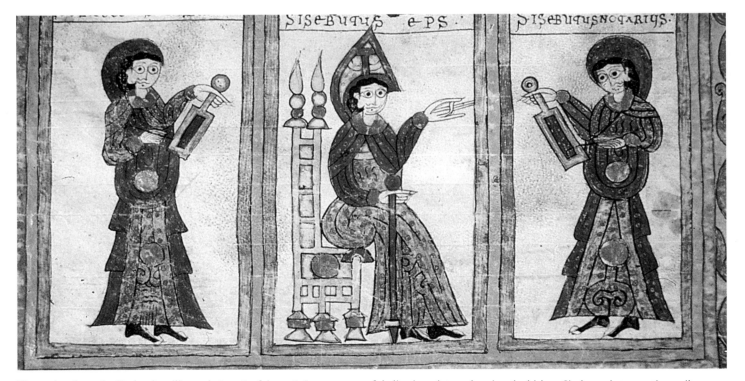

Illustration from the Codex Aemilianensis (cat. 83; fol. 453r). Lower zone of dedication picture showing the bishop Sisebutus between the scribes Belasco and Sisebutus. Patrimonio Nacional, Biblioteca del Monasterio de San Lorenzo el Real de El Escorial. Photo: O. K. Werkmeister

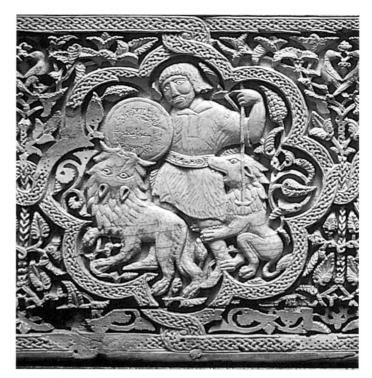

Illustration from the Psalter Commentary of 980 (fol. 303v). The initial Q with scribes. Real Academia de la Historia, Madrid. Photo: O. K. Werkmeister

Detail of Pamplona casket showing a hunter fighting off two lions. Ivory. Caliphal period, 1004/5. Museo de Navarra, Comunidad Foral de Navarra, Pamplona. Photo: Sheldan Collins

torium of San Millán de la Cogolla, the Psalter Commentary of 980,[17] shows the same symmetrical group cast in an Islamic pattern; within the circle of the initial the scribes flank a palmette, forming a decorative composition comparable to the rosettes with pairs of musicians or combatants on the ivory casket of ʿAbd al-Malik. Thus the painters of San Millán expressed their artistic standing with a pictorial formula from Islamic art.

The Monastic Artist's Task

Scribes and artists participated in the recultivation that the kings and the elite landholding warriors, who propelled the Reconquest, assigned to frontier monasteries. Their work served the cultural policy of transmitting, expanding, and updating the literary legacy of the Visigothic kingdom, which the reconquerors claimed to restore. Manuscripts which promulgated legislation, learning, and liturgy were transcribed by the scriptoria of frontier abbeys; these institutions thus made available, as an alternative to the culture of the caliphate, the literary instruments of a comprehensive, functioning civilization with its royal power, religious discipline, and intellectual expertise. The limited internal autonomy granted by the caliphate to the underlying Christian population, which was centered in the Mozarabic church, contributed to the retrospective, conservationist approach toward preserving the Visigothic cultural legacy. The literate civilization of the Christian areas in the north was derived to a large extent from this survival of the Visigothic tradition under semicolonial circumstances. This cul-

ture was now free to restore its key concept—the inviolability of Christian royal authority.

The decoration and illustration of the Visigothic literary legacy largely followed pre-Carolingian concepts of colorful book decoration, in disregard—if not in ignorance—of the new adaptations of late antique or Byzantine techniques that had been made in book painting north of the Pyrenees since the time of Charlemagne. One of the painters of the Codex Aemilianensis modified a wind rose from the cosmology of Saint Isidore to illustrate a list of the episcopal sees of the Visigothic kingdom in Spain and southern France and depicted twelve standing bishops in a circle.[18] Sixty-two small golden circles distributed across the background segments refer to the sixty-two bishops in attendance at the historic Third Council of Toledo in 584, when all of Spain was united within one Catholic church. In 993–94, when the Codex Aemilianensis was produced, this ecclesiastical unity of Christian Spain was no more than a distant memory. The picture invokes that memory both as a claim for the Reconquest and as an ideological support for contemporary Christian rulers and their monastic supporters, even in the face of the prevailing adverse historical situation, when al-Mansur was raiding the towns of Christian Spain at will.

Such aspirations for a revival of Visigothic culture were, however, balanced by the artistic prominence of a text written in the only area in northern Spain outside the Islamic hegemony. This was the lengthy Commentary on the Apocalypse that Abbot Beatus of Liébana (d. after 800) compiled in Asturias between 776 and 782 from his survey of early Chris-

tian and early medieval Apocalypse exegeses. The Beatus Commentary served as an aid and as a conclusion to the comprehensive Bible study that monks undertook in the course of the liturgical year. Throughout the text the author endeavored to prove the unity of Father and Son in the Christian notion of God by identifying the "one seated on the throne" (Apocalypse 4:2–3) as Christ Incarnate. Beatus thereby challenged the adoptionist doctrine of the separate identities of Father and Son, held by the Mozarabic episcopate in the Islamic realm, and aligned himself with Carolingian observance north of the Pyrenees. His work removed the expanding church in northern Spain from the doctrinal control of the bishop of Toledo, claiming canonical and hence administrative independence from the Visigothic church which had survived the Islamic conquest south of the frontier. Thus the Beatus Commentary became a quintessential expression of a distinct northern Spanish cultural identity. Time and again painters would decorate it with full-page images of the Cross of Oviedo, the symbol of Reconquest, and with illustrations that incorporated pictorial concepts, motifs, and forms from Carolingian sources.

The Monastic Artist's Craft

From Florentius of Valeranica to Petrus of Silos, the leading artists of tenth- and eleventh-century frontier monasteries were bent on elaborating a style of their own, no less deliberate than those of their Anglo-Saxon and Ottonian counterparts but showing absolute disregard for late antique and Carolingian notions of a continuously shaded, framed picture space with its implications for color, style, and composition. Even when faced with models from beyond the Pyrenees in which these notions were transmitted, Spanish painters stayed with indigenous traditions. Whether or not these traditions were derived from Visigothic book illumination, they were based on the relatively simple decorative concepts of pre-Carolingian painting with its flatly delineated color juxtapositions.

Florentius and Sanctius, in their illustrations for the Bible of

Illustration from the Codex Aemilianensis (cat. 83; fol. 11v). Wind rose. Patrimonio Nacional, Biblioteca del Monasterio de San Lorenzo el Real de El Escorial. Photo: O. K. Werkmeister

Illustration from the Codex Aemilianensis (cat. 83; fol. 393r). Representation of the sees of Christian Spain. Patrimonio Nacional, Biblioteca del Monasterio de San Lorenzo el Real de El Escorial. Photo: O. K. Werkmeister

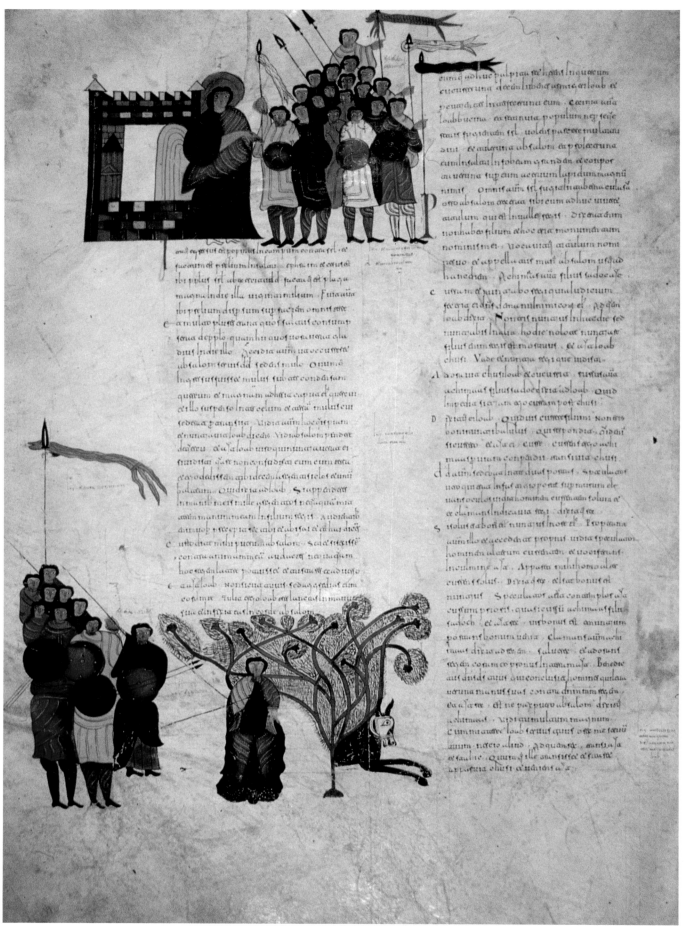

Illustration from the San Isidoro Bible (cat. 108; fol. 138v). The departure of David's troops (above) and the death of Absalom (below). Real Colegiata de San Isidoro, León. Photo: O. K. Werkmeister

San Isidoro, chose to ignore the confinement of the picture to a framed-space segment within the text column. Instead they interrelated as a compositional unit two scenes that happened to fall on one page—such as the Departure of David's Troops and the Death of Absalom seen here—and expanded the depictions into the margins. The two compact, pyramidal groups of warriors with their spears and banners, each facing a single figure attached to a building or tree, are linked across the page in dynamic counterpoint. The placement of the compressed bodies, groups, and objects on the white parchment surface maximizes the intensity of the compartmentalized color patterns. A limited palette of four pigments—red, dark blue, dark green, and yellow—is concentrated in the central areas of both pictures. These are the colors of a chord that Mozarabic illuminators adapted from their pre-Carolingian sources. In the early stages of its development, of which the First Bible of León of 920 is the best-known example, the scheme of four pigments was applied to the bare parchment. In a second phase, inaugurated by manuscripts such as the Morgan Beatus (cat. 78), a broader spectrum of colors was introduced along with a wider range of imagery, including framed pictures with continuous color backgrounds. Here the basic set of four colors was maintained as a predominating chord, to which an extended palette of four to six supplemental colors was added as a second range of modulation. In the Death of Absalom, Florentius or Sanctius used the four-color chord in the main figure, in the two foremost standing attackers, and in the sequence of the four circular shields. In the Departure of David's Troops the artist placed the rider, the two full-length attackers, and the two full-length victims along the same chord, again connecting them with a row of shields.

In the early Middle Ages traditions of book painting were linked with the knowledge of how to prepare pigments according to recipes codified in late antiquity and transmitted through such painter's handbooks as *On the Arts of the Romans* by Heraclius and the *Mappa Claviculae*.[19] This expertise, as well as the availability of materials, determined the chromatic range of any given color style. In addition to pigment formulas, the handbooks contained prescriptions for combining colors in groups of three modular steps toward systematized patterns of color composition. Painters could use these combinations for their own aesthetic purposes no matter how far removed they were from the late antique origins of their craft. Evidence exists that in tenth-century northern Spain the evolving practice of book illumination, with its prominent masters and faithful disciples, proceeded on a similar standardized base of technical knowledge and aesthetic refinement. In one of the illuminated manuscripts from San Millán de la Cogolla, the Psalter Commentary of 980, such pigment prescriptions can be deciphered in the red preparatory outline drawings for several unfinished initials. They suggest that color composition was not left to the spontaneous intuition of the painters

Illustration from the Psalter Commentary of 980 (fol. 310v). Initial P in the form of a bird, showing color indications. Real Academia de la Historia, Madrid. Photo: O. K. Werkmeister

Illustration from the Psalter Commentary of 980 (fol. 124v). Initial A with ibexes. Real Academia de la Historia, Madrid. Photo: O. K. Werkmeister

Detail of Pamplona casket showing confronted griffins and quadrupeds attacked by felines. Ivory. Caliphal period, 1004/5. Museo de Navarra, Comunidad Foral de Navarra, Pamplona. Photo: Sheldan Collins

Illustration from the Psalter Commentary of 980 (fol. 270v). The initial S in the form of a juggler. Real Academia de la Historia, Madrid. Photo: O. K. Werkmeister

at the moment of filling in the outlines but was part of the predetermined design.

The painters of San Millán de la Cogolla in particular often applied the four-color chord in an uncompromised form. In the large initial of the Psalter Commentary, it is deployed in systematic alternation in a composition grouping two large ibexes and two small dogs around a central tree according to an Islamic pattern. In another initial from the same manuscript, which takes the form of a nimbed juggler swinging with his curved arms two identical objects in different directions, a regular progression of the chord from collar to cuff indicates the rhythm of the performance. In the full-page circular image of the twelve bishops of the Codex Aemilianensis, depicting the past realm of Christian Spain, the chord unfolds in a pattern of symmetrical correspondences and interchanges according to a simple set of arithmetical proportions, creating a composition based in early medieval aesthetic theory.[20]

The Monastic Artist's Spiritual Ideal

The elaborate colophons and invocations with which some leading monastic scribes and painters in early medieval Spain commemorated the completion of their manuscripts reflect the spiritual validation of manual work in the Rule of Saint Benedict. The transcription and illumination of a codex are regarded as a journey toward the soul's redemption. Sanctius of Valeranica, early in the San Isidoro Bible, expresses the wish to "arrive without confusion at the redeemer of all men"; the concluding miniature shows him twice, standing near the Greek letter omega, symbol of Christ at the end of time, joyful for having "arrived unharmed at the end of the book." The toil of writing was sometimes related to the idea of monastic life as a *militia*, a perpetual struggle of devout Christians against the forces of evil in a hostile world. Florentius and Sanctius call themselves "fighters in the struggle" and ask to be included in the throng of martyrs and confessors that would be spared the Last Judgment and return with Christ at the end of days.

The huge pictorial survey of the Beatus Commentary provided these artists with the visual scenario for such self-redemptive aspirations. In the Girona Beatus (cat. 80) either the painter Emeterius or his female colleague, Ende, who worked with him on the task of illustration, has depicted the martyred witnesses Elijah and Enoch dressed in monastic habits and clutching abbot's staffs, following the interpretation in Isidore's treatise on the offices of the church[21] of Elijah and Enoch as Old Testament prototypes of the monk.[22] In the subsequent picture they are shown ascending on a cloud to the One on the Throne in Heaven, touching their lips in a ritual gesture of silence that denotes a traditional monastic virtue.[23] In such adaptations the monastic painters' spiritual identification with their biblical subject matter becomes apparent.

Florentius and Sanctius, the painters of the San Isidoro Bible, dramatized the prophet Elijah as a model of steadfast faith in

Illustration from the Girona Beatus (cat. 80; fol. 164r). Elijah and Enoch dressed as monks. Museu de la Catedral de Girona. Photo: O. K. Werkmeister

Illustration from the Girona Beatus (cat. 80; fol. 167v). The ascent of Elijah and Enoch to the One on the Throne. Museu de la Catedral de Girona. Photo: O. K. Werkmeister

Illustration from the San Isidoro Bible (cat. 108; fol. 129r). Elijah addresses the Israelites. Real Colegiata de San Isidoro, León. Photo: O. K. Werkmeister

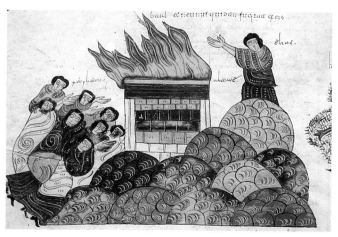

Illustration from the San Isidoro Bible (cat. 108; fol. 129v). Elijah's sacrifice. Real Colegiata de San Isidoro, León. Photo: O. K. Werkmeister

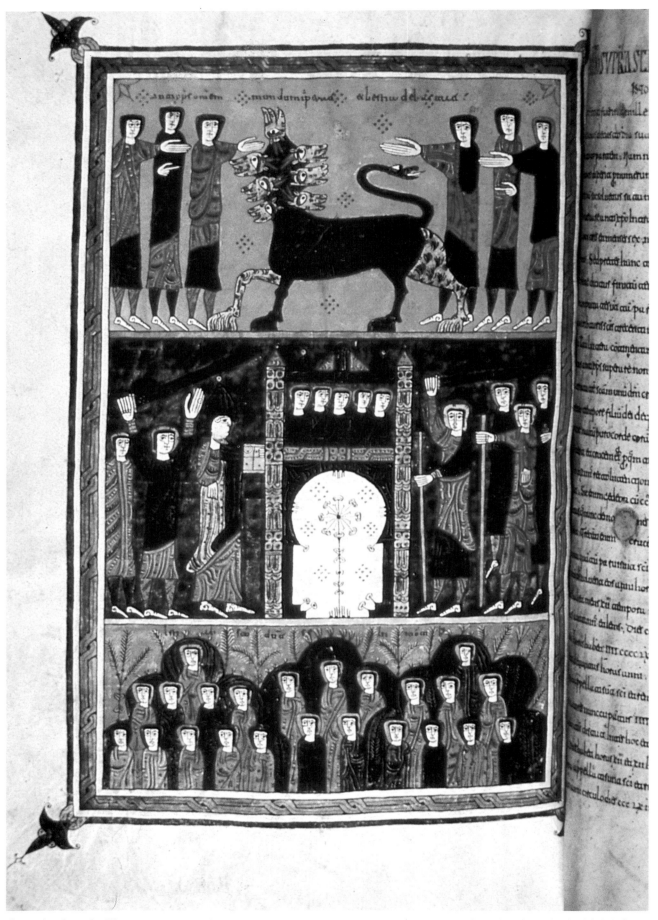

Illustration from the Silos Beatus (cat. 145; fol. 202r). The Antichrist's followers worship the Beast from the Abyss; the Antichrist's forces attack the City of God. The British Library, London. Photo: O. K. Werkmeister

the face of challenges from nonbelievers in their sequential illustrations for 1 Kings 18:20–22, 36–40. The first painting shows the prophet addressing the wavering Israelites assembled on Mount Carmel. The second shows his evening sacrifice on the same mountain, which was to prove the Jewish faith to the people of Israel, who had lapsed into veneration of the local gods of the region where they lived. When Yahweh's fire blazed down from heaven onto the altar, as Elijah had pledged it would, the Israelites prostrated themselves in adoration. In the presumptive model for the illustration, the prostrate figures most likely depicted the people of Israel. In the actual miniature, however, the painter has labeled them "prophets of Baal," even though the text does not place the pagan prophets at the offering but relates that they were later searched out and executed (1 Kings 18:40). Alvarus of Córdoba, one of the spiritual leaders of the ninth-century martyrs' movement, evoked Elijah's evening sacrifice as the biblical paradigm for the unbending profession of Christianity in a hostile environment that was required to counter the danger of apostasy within the Christian community under Islam.[24] By changing the Old Testament scene into a miraculously enforced submission of the pagan prophets to the true faith, or perhaps even their imaginary consumption by the fire descending on the altar, the painter of the San Isidoro Bible conveyed an antitypical reference to the persecutions of Córdoba.

Both these illustrations in the San Isidoro Bible present the closely packed throngs of believers either standing stiffly or prostrating themselves in submission that appear in so many Mozarabic miniatures. These stereotypical expressions of absolute spiritual conformity to either Moses' commandments or Nabuchodonor's idols, to either the One on the Throne or the Beast from the Abyss, embody the choice between spiritual righteousness and a lapse into paganism. Together with the ever-recurring images of assault and mayhem incorporating massed sword- and spear-wielding combatants, limp corpses, and severed heads, they seem to visualize a mentality obsessively focused on a spiritual struggle. In an illustration from the Silos Beatus that shows the Antichrist's followers worshiping the Beast from the Abyss and his troops assaulting the City of God, both stereotypes of reverence and aggression are configured in a regular antithetical composition reminiscent of the roundels of ʿAbd al-Malik's ivory casket. It remains an open question to what extent Mozarabic illumination was conditioned by this peculiar blend of early Christian monastic ideals, contemporary experiences, and commemoration of Christian steadfastness against Islam.

"Frontier Monasticism" and State Monasticism

Unlike their counterparts in Germany, England, and France, eleventh- and twelfth-century book painters in Spain did not draw on their early medieval tradition to any significant degree to create a new style that would have absorbed the Mozarabic heritage into the international Romanesque. There was no Spanish equivalent of the book-painting workshops at the abbeys of Trier and Echternach, Saint-Germain-des-Prés and Arras, Winchester and Canterbury. Only at Santo Domingo de Silos did the painter Petrus recast the Mozarabic style into Romanesque regularity, most likely to express an allegiance to customs about to be discarded (cat. 145).[25]

The rulers of León and Castile, once they had advanced the Reconquest to the point where they could claim to have restored the Christian kingdom of Spain, did not find it useful to draw on indigenous traditions for cultural policy or for artistic representation. They did not follow up the first attempts, made at the court of Ferdinand I (r. 1037–65) and Sancha, to recast "Mozarabic" pictorial concepts into new stylistic forms, which can be observed in some of the artworks sponsored by the royal couple. The opening miniature of their prayer book of 1055–59 (cat. 144), for example, shows Christ beneath a full-page initial letter A, a traditional Mozarabic

Illustration from the prayer book of Ferdinand and Sancha (cat. 144; fol. 1r). Christ standing below the initial A. Biblioteca Universitaria de Santiago de Compostela. Photo: O. K. Werkmeister

Illustration from the prayer book of Ferdinand and Sancha (cat. 144; fol. 66v). The initial Q in the form of a man. Biblioteca Universitaria de Santiago de Compostela. Photo: O. K. Werckmeister

Illustration from a book of homilies from San Millán de la Cogolla (fol. 134r). The initial Q in the form of a man. Real Academia de la Historia (cod. 39), Madrid. Photo: O. K. Werckmeister

device, painted on a purple ground with a white vine ornament and with golden accents, just as in contemporary German illumination. Furthermore, about a dozen text initials of the same manuscript take human shapes according to the patterns established at San Millán de la Cogolla, but they are articulated in the differentiated corporeality of contemporary work from France. Such efforts were abandoned under Ferdinand I's successors; during their reigns we know of no distinctive monastic center of representative art production with a lengthy artistic tradition. As with the indigenous liturgical and monastic observances, which were abandoned in favor of Roman and Cluniac usages, the art of "frontier monasticism" apparently did not lend itself to an art of state monasticism.

NOTES

1. Bishko 1948, pp. 559–90.
2. Taken from *The Compact Oxford English Dictionary*, 2nd ed., 1991, p. 1127.
3. Dodds 1990.
4. Dodds 1990, p. 70.
5. Werckmeister 1963b.

6. Werckmeister 1965.
7. Kühnel 1971, pp. 41ff., no. 35.
8. Wolf 1988, pp. 90–95.
9. Cf. Werckmeister 1965, pp. 948ff.
10. Williams 1970, pp. 231–48.
11. Kühnel 1971, p. 4.
12. Werckmeister 1963a.
13. Millares 1931, pp. 100–101.
14. Neuss 1931, p. 19.
15. Neuss 1931, p. 40.
16. Werckmeister 1968.
17. Pérez Pastor 1908, p. 11.
18. Werckmeister 1968, pp. 400–402.
19. Roosen-Runge 1967, vol. 1, pp. 18–29.
20. Werckmeister 1968, pp. 420–21.
21. *Patrologia latina*, vol. 83, col. 794B (Isidore, *De eccl. off.*, II, 16, "De monachis").
22. Grabar 1945.
23. Colombás 1975, pp. 196ff. (with references); Vogüé 1971, pp. 259ff. ("Théorie et pratique du silence").
24. *Patrologia latina*, vol. 121, col. 227 (Alvarus of Córdoba, *Indiculus luminosus*, 6; quoted in Colbert 1962, pp. 274–75).
25. Schapiro 1939. See also Werckmeister 1979, pp. 211–18.

I wish to thank Julie Harris and John Williams for their critical readings of this text.

gothic period, are fully developed. There is considerable use of the drill for the creation of delicate three-dimensional effects.

<div align="right">S N - H</div>

1. Gómez-Moreno 1919, p. 204.
2. For the structure, see ibid.
3. Noack-Haley 1991, pp. 96ff.
4. Ibid.

LITERATURE: Noack-Haley 1991, pp. 120f.

62

capital

Monastery of Santos Facundo y Primitivo, Sahagún (León), beginning of 10th century
Marble
H. 19⅛ in. (50 cm)
Museo Arqueológico Provincial de Palencia (229)

The church of Santos Facundo y Primitivo in Sahagún was destroyed in 883. At the instigation of Alfonso III it was rebuilt, beginning in 904, by Abbot Alfonso and the monks who had fled with him from Muslim-held territory. It was reconsecrated in 935 in the presence of Ramiro II and fifteen high dignitaries of the Church.[1] Virtually all that remains of the three-aisled vaulted basilica[2] are eight Mozarabic marble capitals, now dispersed. The present piece, which may originally have come from the nave, lacks the four corners of its abacus. Its volutes and stalks have been rendered three-dimensionally, its leaves carved with a somewhat arid precision that marks the end of the first stage in the development of the Mozarabic capital, the one in which its basic features were established. The capitals from the churches of San Román de Hornija (cat. 61) and San Cebrián de Mazote are from this same phase.[3]

The extensive series of capitals from the portico of San Miguel de Escalada and from

61

capital

Church of San Román de Hornija (Valladolid), ca. 900
Marble
H. 20½ in. (52 cm)
Church of San Román de Hornija

On the site of the church of San Román de Hornija, next to the Duero River and near the town of Toro, the Visigothic king Chindaswinth is said to have built a monastery in which he was buried in 653.[1] The abbey was first documented in 891, by which time it had doubtless been abandoned. Construction of a Mozarabic church must have been initiated a few years later, for the rebuilding of Toro at the behest of Alfonso III began in 900.[2] A sixteenth-century description of the Mozarabic structure speaks of its cruciform ground plan and horseshoe arches, but today the only traces of it are a large number of marble carvings strewn about the village of San Román de Hornija and its environs.[3] Among them are two Roman capitals, which may have been spolia incorporated in the preceding Visigothic structure. On each of them a side has been flattened to stand against

the wall; this must have been done at the time the Mozarabic church was built, for three-sided columns are unknown in Visigothic architecture.

The remarkably heterogeneous series of three- and four-sided, acanthus-ornamented capitals of Hornija—one of which is shown here—represents the beginnings of Mozarabic capital carving in the kingdom of Asturias-León.[4] Though they all present the same basic features, there is considerable variation in their details. Masterfully executed, they must have been produced by a group of well-trained stonemasons.

Unlike those of the Visigothic era, the large capital shown here attests to a new understanding of the plasticity and structure of the Corinthian capital. The classical orientation of its carvers gives it a general resemblance to the earliest Spanish Islamic capitals, which were closer to classical prototypes. Mozarabic capitals are also related to those of the emirate in their execution, with relief in sharp-edged chisel carving that is neatly set off from the basket of the capital. The foliage is clearly organized; the lobes of the leaves, not described in acanthus of the Visi-

62

the churches of Santa María de Bamba, Santiago de Peñalba, and others evolved directly from these works from Sahagún. Indeed, it appears that in the major colonizing monasteries whose capitals exhibit the culmination of this first stylistic phase an itinerant Mozarabic workshop existed,[4] one that would again and again take up new trends in the development of the Spanish Islamic capital and transform them.

S N - H

1. Gómez-Moreno 1919, p. 204.
2. For the structure, see ibid.
3. Noack-Haley 1991, pp. 96ff.
4. Ibid.

LITERATURE: Noack-Haley 1991, pp. 138–39.

63

two chancel screen reliefs

Church of San Miguel de Liño (Oviedo), Visigothic, 7th century, and Asturian, 9th century
a. Screen
Light gray marble
25¼ x 16½ x 2⅛ in. (64 x 42 x 5.5 cm)
b. Screen
Gray marble
23⅛ x 15⅛ x 2 in. (60 x 39 x 5 cm)
Museo Arqueológico Provincial, Oviedo

These two marble slabs were originally part of a chancel screen in the church of San Miguel de Liño. Such screens created a barrier between clergy and laity in Asturian churches. The present slabs are noteworthy for having decoration on both sides.[1] On one side of slab (a) there is a rooster-headed griffin, carefully carved by chisel, jumping to the right, its body adorned with floral designs. Leaves and blossoms of plants surround the griffin, filling the available space. Broad bands of a relief with geometric and stylized floral elements, set off by a corded molding, frame the panel top and bottom. Two-thirds of the bottom band has been cut away. These bands and the foliage of the center panel are distinguished by the play of light and shadow, against which the unworked body of the griffin appears to stand out. At one time its expression must have been even more lively, for some sort of stone was set into its eye.[2]

The fully intact decoration on the slab's other side (not illustrated) consists of a palm

63 a

tree with large fan-shaped leaves and three hanging clusters of dates in a panel surrounded by a plain frame. A band of ornament across the top has a symmetrical design of serpents winding toward each side.

While the palm motif occurs already on Early Christian chancel screens as a symbol of paradise, the griffin motif did not find acceptance in Christian art of the Iberian Peninsula until the seventh century.[3] Its Christian significance as an image of paradisiacal peace derives from the visions of Isaiah.[4] Serpents are found on the impost blocks in the entrance to the apse of the late seventh-century church of San Pedro de la Nave (Zamora), and Helmut Schlunk has associated them with the Expulsion from Paradise.[5]

Slab (b), of somewhat darker marble, forms a pair with the griffin slab. One side (not illustrated) shows the same palm and serpent motifs as on the griffin slab, but their execution differs. Here the relief displays strikingly wide outlines that are flat and in places crudely carved against a polished ground. The other side of this second screen appears to bear the

model for the two previously described palms. Its carving is not only much more careful— the raised lines have smooth tops and beveled sides, cleanly differentiated from the polished background—but more important, the fans of the palm leaves fan out more and are more detailed. The small volutes at the base of the leaves are more delicate and not so ungainly as in the copies.

The chronology of the two screen slabs is complex. Schlunk, who at first held the griffin to be contemporary with the ninth-century Asturian church structure, later agreed with Manuel Jorge Aragoneses that it dates from the Visigothic era.[6] Both authors also agree in dating the palm tree to the end of the ninth century. It appears, however, that Asturian artists rarely carved in marble, in general making do with local limestone. Thus the griffin screen might be a piece of Visigothic spolia[7] and the stylized palm tree on the other side from the time when San Miguel was built. There is also good reason to believe that the model palm tree of slab (b) is Visigothic as well.[8]

AA/SN-H

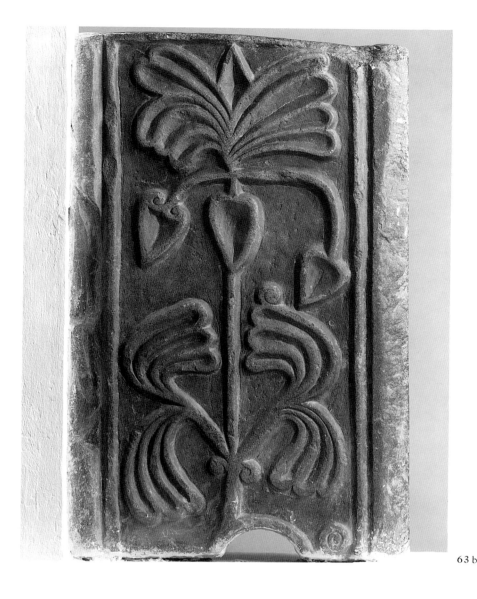

63 b

chancel screen relief

Santianes de Pravia (Oviedo), ca. 780
White limestone
37 ⅜ x 18 ½ x 5 ⅞ in. (95 x 47 x 15 cm)
Church of El Pito, Cudillero

This is one of an identical pair of screen elements from the oldest church still standing in Asturias, the residence church of Santianes de Pravia (see p. 114), built by King Silo (r. 774–83) on the lower course of the Nalón River. Although a number of finely worked stone fragments from there have been excavated more recently—among them a piece of the acrostic based on *Silo princeps fecit* (King Silo made this); a window frame with a reference to the church's patron saint, John the Evangelist; and a depiction of the facade of a tall building[1]—the screen elements, first described in detail by Fortunato de Selgas in 1902,[2] are still the most significant known components of the church's initial decoration. When Selgas wrote about them, they had long since been removed from their original locations, for the church had undergone a thorough structural alteration in recent times. Selgas moved the pair, together with the altar, into his family tomb at El Pito.

Since late antiquity it had been common in much of the Christian world to separate by means of screen structures the various participants in religious services, especially the celebrants from the laity. As the records of the Fourth Council of Toledo (633) help demonstrate, it was the custom in Christian Spain up until the tenth or eleventh century to divide churches with more than one cleric into three sections. The chancel was reserved for the celebrant of the Mass and his assistant, the choir for the attending clergy, and the nave to the west for the congregation.[3] This arrangement is still evident in several pre-Romanesque Spanish churches, where the division was effected by either screens, special curtains, or actual walls. Generally the screens themselves have been removed, but the original grooves in the floor, walls, or supports remain, allowing a reconstruction of their original design.[4] In many cases stone posts served to secure the slabs. Passageways connecting the various spaces were often quite narrow. Surviving screen slabs in museums and other collections tend to be ornamented with reliefs on one or both sides and at one time were probably painted. The decoration for the most part consists of either geometric elaborations, such as grille motifs reflecting the actual function of the screen, or depictions of symbolic plants or animals, such as vine leaves alluding to the Eucharist or birds suggesting paradise.

1. Their provenance is a matter of local tradition (Jorge 1957, p. 260). Thus we do not know whether the slabs were still used in the section of the building rebuilt for services after the collapse of the eastern two-thirds of the original structure (grooves attest to the fact that there was a screen structure in the entry to the secondary apse—a second Asturian example from the eleventh century in addition to Teverga?) or which side then faced the clergy, which side faced the laity. For the pillars that held the slabs, see Escortel 1978, pls. 19–23.
2. Jorge 1957, p. 260.
3. Cruz 1985, pp. 309–10.
4. See Schlunk 1964, p. 247, on Is. 11.
5. Luís 1961, p. 24: "zarcillos ondulados que terminan en unas cabezas de escorpión" (curved vines that end in scorpion heads); in our opinion there are clearly two serpents. For San Pedro de la Nave, see Schlunk and Hauschild 1978, p. 226, pl. 132a; Corzo 1986, fig. 121.
6. Schlunk 1947b, p. 367; Schlunk 1948, pp. 77–78; Schlunk and Berenguer 1957, p. 119, n. 223; Jorge 1957; Schlunk 1980a, vol. 2, p. 140.
7. Jorge (1957, pp. 262–63) musters a number of Visigothic examples of the animal style of this period as defined by Schlunk. We concur especially with the lion relief from Chelas (Schlunk and Hauschild 1978, pl. 116b); the steer relief in Saamasas (ibid., pl. 84a, dated to the second half of the sixth century); and the lamb relief on an impost block in San Pedro de la Nave (Corzo 1986, p. 122, fig. 145). They share the same spare internal detail in their largely unworked bodies, but

more important they are all surrounded by various botanical motifs, often including the base of a palmette.
8. The problem with this thesis is that there are no seventh-century parallels for the palm tree of slab (b) that would confirm it is Visigothic spolia. Schlunk compares the palm tree on the reverse of the griffin slab with the related fragment of a chancel screen from San Adriano de Tuñón and with Mozarabic-style reliefs in San Salvador de Valdediós and San Miguel de Escalada (cat. 77). Since Tuñón was consecrated in 891, he arrives at a dating of the end of the ninth century for its screen fragment and for the palm tree of the griffin slab (Schlunk and Berenguer 1957, pp. 118–24 [with illustration of the Tuñón slab]). However, these latter pieces and the palm of slab (b) differ stylistically from the Mozarabic reliefs. The palm of slab (b)—even more closely comparable to the Tuñón fragment than the palm on the griffin relief—then could quite possibly be Visigothic as could the Tuñón fragment since reused capitals also appear in both San Miguel de Liño and San Adriano de Tuñón.

LITERATURE: Haupt 1935, p. 223, fig. 144; Schlunk 1947b, p. 367, fig. 383; Schlunk 1948, pp. 77–78; Dshobadze 1954, pp. 145–46, pl. 8; Jorge 1957; Schlunk and Berenguer 1957, p. 119, n. 223; Luís 1961, pp. 23–25, nos. 8–9, pls. 3–4; Pita 1963, p. 27; Bonet 1967, p. 60, fig. 15; Fontaine 1973, figs. 93–94; Schlunk 1974, especially p. 126; Noack 1977, p. 13; Cid 1978; Escortell 1978, pp. 15–16, pls. 12–15; Schlunk 1980a, vol. 2, p. 140.

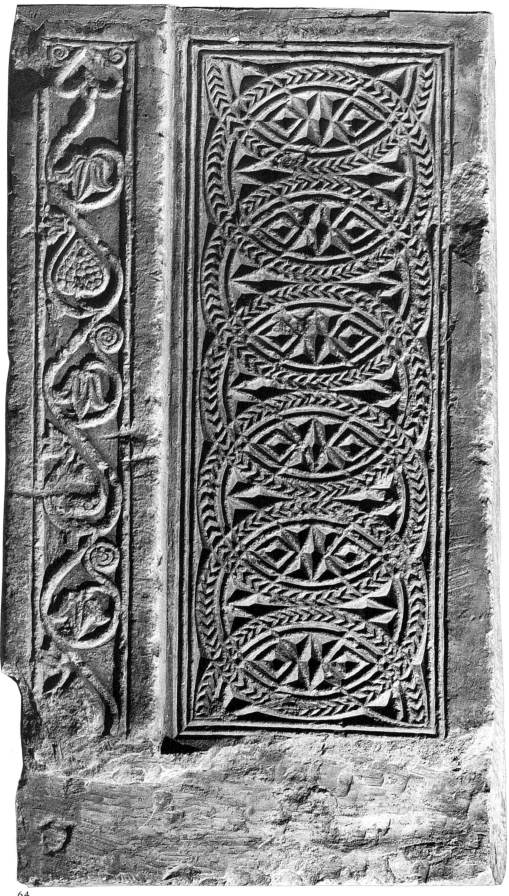

64

In the church of Santa Cristina de Lena the screen is still in situ (see p. 117), but the original location in Santianes of the pair of screen elements is not known. Surely they were symmetrically placed so as to leave a narrow passageway, perhaps the entry to the chancel. In each of the surviving elements, clearly a matched pair, a slab and a post are combined—an unusual feature but one for which there are parallels from the Visigothic period and in the Mozarabic San Miguel de Escalada (cat. 77). In any case stability was guaranteed by the flanges chipped out along the lower edge as an afterthought, by which the panels were anchored to the floor. Except for the flanges, the screen elements are quite well preserved.

The ornamentation is only on one side and is the same on the two. Both the post and the slab have vertical rectangular frames, that of the former extending farther toward the bottom, since the decorated rectangle of the slab section has a raised molding just below it. Within the frames are decorated panels. The reliefs of the two panels differ considerably, providing a charming contrast in motifs and styles: the slab has overlapping circles whose circumferences are formed of double cording; inside the circles are rhomboids and triangles. The narrower panel of the post bears an undulating vine, adjacent to which are upside-down, outlined bunches of grapes and leaves alternating with trefoil-like blossoms(?) and tendrils. At the top the vine ends with a leaf in the shape of a heart and tendrils. The geometric design of the slab's panel, carefully executed in chip carving, fills its entire surface, while in the botanical design of the post the motifs stand out against a definite flat background. With these botanical motifs the artist has managed only a schematic, inorganic approximation of older designs; he was not even concerned that the bunches of grapes point upward, a feature that has led a number of modern writers to position the pieces wrong side up,[5] even though their proper orientation can be ascertained from similar works in the Visigothic Quintanilla de las Viñas and the Mozarabic San Miguel de Escalada (cat. 77).

Both relief motifs are familiar from the later Visigothic period: the geometric one was used at Segobriga; the botanical one appears on a screen pillar from San Juan de Baños, for example.[6] The same is true of the two relief techniques employed, chip carving and high relief. They are found side by side in the church of San Pedro de la Nave, which was built in 711, not long before the Arab conquest. Some scholars have maintained that the pair under discussion are in fact recycled Visigothic work,[7] though more recently others have raised the possibility that they were created specifically for Santianes.[8]

This latter hypothesis is enhanced by the discrepancy between the pieces' two relief styles[9] and by the fact that specific decorative forms from the seventh century persisted in Asturias of the eighth and ninth centuries. Newly discovered screen fragments from Santianes lend additional support to this view.[10] The relatively soft limestone used for them and for all the other screen fragments from the church is a further argument in favor of their having been created for this specific structure. Pieces imported and reused would more likely have been in marble, which was more common in the Visigothic kingdom.

In these works there is an apparent echo of differing currents within the artistic tradition of the Visigothic era. This is hardly surprising, since they date from a mere seven decades after the Arab conquest and were created for a royal Asturian church.

AA

1. Menéndez Pidal 1980b, vol. 2, pp. 287–88, 291 (scheme 2), and vol. 3, pp. 174–75; Fernández Conde and Santos del Valle 1987, pp. 338–39, 342–43, ills. 18, 19, 22, 35.
2. Selgas 1902, pp. 33–34; Selgas 1908, pp. 205–6; Selgas 1916, pp. 36–37.
3. Vives 1963, p. 198 (canon 18).
4. See Schlunk 1971.
5. Selgas, see note 2; Lampérez 1930, ill. 155; Schlunk 1947b, ill. p. 342; Fontaine 1973, ill. 95.
6. Schlunk 1945a, pp. 305–19, ills. 12, 13; Schlunk 1947b, p. 328; Camps 1963, ill. 321; Ulbert 1971, p. 34.
7. Schlunk 1947a, p. 267; Schlunk 1947b, p. 328; Jorge 1957, pp. 265–66; Camps 1963, p. 568; Nieto 1989a, p. 206 n. 38; Berenguer 1991, p. 22.
8. Schlunk 1936, p. 13; Fontaine 1973, p. 262.
9. Ulbert 1971, p. 34.
10. Schlunk 1980a, vol. 2, p. 140, and vol. 3, p. 90; Menéndez Pidal 1980b, vol. 2, p. 293, and vol. 3, p. 174; García Díaz 1988.

LITERATURE: Selgas 1902, pp. 33–34; Selgas 1908, pp. 205–6; Selgas 1916, pp. 36–37; Lampérez 1930, p. 334, ill. 155; Schlunk 1936, p. 13; Schlunk 1947a, p. 267; Schlunk 1947b, p. 328, ill. p. 342; Jorge 1957, pp. 265–66; Camps 1963, p. 568, ill. 268; Ulbert 1971, pp. 33–34, pl. 30; Fontaine 1973, p. 262, ill. 95; Schlunk 1980a, vol. 2, p. 140, and vol. 3, p. 90; Fernández Conde and Santos del Valle 1987, pp. 337–38; Nieto 1989a, ill. pp. 30–31; Caballero and Mateos 1992, p. 181.

65

Relief panel with cross

Church of San Martín, Salas (Oviedo), mid-10th century
Soft white limestone
19¼ x 18¼ in. (49 x 46.5 cm)
Biblioteca Municipal, Palacio Valdés Salas, Salas

This panel is part of a larger set of reliefs created for a predecessor of the fifteenth-century church of San Martín that were preserved by being incorporated in various places in the present structure. Unfortunately a number of them were damaged in an effort

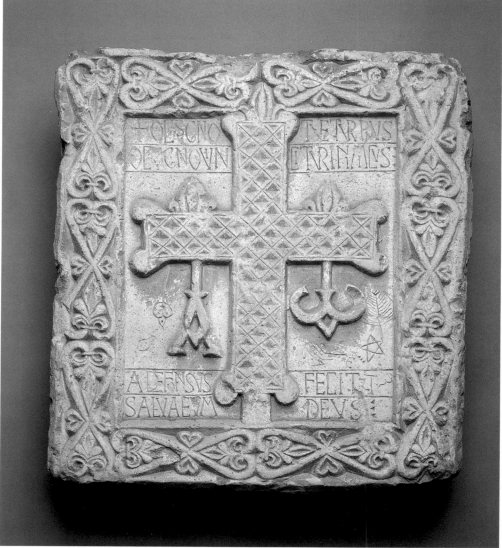

65

to remove them for safekeeping in 1980.[1] The church is first mentioned in a deed of gift of 896, by which the archdeacon Don Gonzalo, a son of Alfonso III, bequeathed it to the cathedral of San Salvador in Oviedo. Two of the surviving inscriptions tell of a renovation in the year 951.[2] In addition to architectural elements, relief decoration, and inscription panels, three panels with crosses have survived, of which the one shown here is the most carefully and richly worked.

A floral pattern in high relief fills the panel's broad, raised border, which frames a cross, also in high relief, and an incised inscription. The inscription, consisting of two lines at the top of the panel and two lines at the bottom, reads: + OC SIGNO TUETUR PIUS / OC SIGNO VINCITUR INIMICUS / ADEFONSUS FECIT ET / SALVA EUM DEUS (This sign protects the pious/believer; through this sign the enemy will be overcome. / Adefonsus made this [had this made] / and may he [his soul] be saved by the Lord). The first part ("[H]oc signo tuetur pius/[h]oc signo vincitur

inimicus") is a quotation from the Cross of the Angels (cat. 72), which was given to Oviedo Cathedral by Alfonso II in 808; it became the motto of the Asturian monarchy. The Alfonso named here, a cleric, was responsible for a restoration ("fecit"), about which more is told by an inscription panel. There all the relics from the main altar are listed, among them that of a martyr, Pelayo, who was executed in Córdoba in 925 and shortly afterward revered throughout Spain. That inscription also relates that "this temple was restored by the confessor Alfonso" in the year 989 (A.D. 951).[3] As is common in donor inscriptions, the cross panel includes an appeal to God from Alfonso for his salvation.

Hanging from the arms of the cross, whose corners are accented by tear-shaped protuberances, are the symbols of Christ from the Apocalypse—the alpha and the omega. The letters are set off from their mountings, as though this were the representation of an actual cross. The gem ornaments—depicted

in many-faceted chisel carving—and the reproduction of the inscription of the Cross of the Angels seem to suggest that that is the cross being portrayed, yet the shape of the cross is not the same. According to Helmut Schlunk, none of the three large gold crosses donated by the Asturian kings bore the alpha and omega.[4] In San Martín de Salas there is another cross slab of the same type and roughly identical format, but it lacks the decoration inside the cross and on the border.[5]

The significance of the graffiti figures, leaves, and stars surrounding the cross is doubtless altogether secular. It is worth noting that visitors seeking to leave marks of their presence selected this specific slab, an indication that they, too, were drawn by its beauty.

S N - H

1. Miguel Vigil 1887, vol. 1, pp. 505–10, vol. 2, pls. Eb v–Eb IX². Miguel Vigil (1980) presents, in addition to reprinted texts, documents relating to the partial destruction of the reliefs in 1980.
2. Miguel Vigil 1887, vol. 1, p. 60, no. A17 (the donation of June 26, 896), p. 64, no. A37 (the donation of August 29, 1006, repeating the royal donation, but now with the rank of a monastery), p. 505. Cobo, Cores, and Zarracina 1987, p. 275.
3. Miguel Vigil 1887, vol. 1, p. 508, no. Eb 13, vol. 2, pl. Eb VI.
4. Schlunk (1985, pp. 16, 26–27, 36–37) relates that since the thirteenth century the Cross of the Angels has been part of the Oviedo coat of arms, *with* the alpha and omega. Schlunk (1950, pp. 100–101) also denies that an alpha and omega were attached to the cross commissioned by Alfonso III after the pattern of the Cross of the Angels for the cathedral of Santiago de Compostela. For the apotropaic iconography of Asturian cross reliefs, see Schlunk 1985, p. 28, figs. 70–72.
5. Miguel Vigil 1887, vol. 1, p. 509, no. Eb 19, vol. 2, pl. Eb VIII; Gómez-Moreno 1919, pl. 35. A third cross slab is illustrated in Schlunk 1985, fig. 79; see also Miguel Vigil 1887, vol. 1, p. 509, no. Eb 18, vol. 2, pl. Eb VIII.

LITERATURE: Miguel Vigil 1887, vol. 1, pp. 505–10, and vol. 2, pls. Eb v–Eb IX²; Gómez-Moreno 1919, pp. 88–90, figs. 45–49, pl. 35; Cotarelo 1933, pp. 237–43; Schlunk 1985, p. 28, fig. 79; Cobo, Cores, and Zarracina 1987, pp. 275–76 (with additional references); Cid 1990, pp. 25, 26.

66

RELIEF

Church of San Cebrián de Mazote (Valladolid), early 10th century
Marble
10⅛ x 30¾ x 9½ in. (27 x 78 x 24 cm)
Church of San Cebrián de Mazote

Dating from the years before 915–16, the three-aisled basilica of San Cebrián de Mazote is the largest surviving Mozarabic monastic church. It was founded, as was San Miguel de Escalada, by an abbot from Córdoba and his brethren in the territory to the north of the Duero River. This relief, featuring two fron-

tal figures at the right and a building at the left surrounded by a border consisting of a simple vine motif, was brought to light during a restoration campaign begun in 1932. Aside from a relief of uncertain date in the church of Santa María de Retortillo, it is the only surviving Mozarabic example of this medium.[1] A groove aligned with the left side of the relief frame runs across the top surface of the block, and the stone becomes narrower at the left, suggesting that this portion may have been incorporated into masonry, perhaps like the impost blocks in the Visigothic church of Santa María de Quintanilla de las Viñas (cat. 7). The frontal bust-length figures are also reminiscent of Quintanilla;[2] however, there are significant stylistic differences.

The figure at the right has been damaged by a break along the edge of the block. Better preserved, the figure at the left raises his right hand in acclamation (probably not in benediction); in his left hand he may originally have carried a book. Like the figures from Quintanilla these are most likely apostles, or even evangelists, if the figure at the left did indeed once hold a book.[3]

It is as yet unclear whether or not this scene somehow related to further reliefs to the right. On the left side of the panel, just inside the frame of rather crude foliage, a building is represented. Its battlemented facade, indicated by a pattern of squared stones, has a broad, arched opening furnished with a draped curtain. Similar battlements on the walls of Toledo and the same ashlar masonry for the city's churches are depicted in the Albeldensia Codex (completed in 976).[4] Various door openings with draped curtains ap-

66

pear in the palace facades of the church of San Julián de los Prados's frescoes.[5] The Mazote scene most probably was based on some painted version.[6]

S N - H

1. Regueras 1990, pp. 50–51.
2. Schlunk and Hauschild 1978, p. 232, pls. 148–50, especially pl. 150, with Christ giving benediction (150a) and with apostles (150b, 150c).
3. I disagree with Fontaine (1977, p. 199), who cautiously interprets the scene as "saints in the Heavenly Jerusalem."
4. Williams 1977a, pl. 31.
5. Schlunk and Berenguer 1957, pp. 22ff.
6. The relationship between Visigothic figure reliefs and contemporary book illumination, of which there is nothing extant, is extensively analyzed in Schlunk 1945b.

LITERATURE: Gómez-Moreno 1951, p. 377; Fontaine 1977, p. 199; Rollán-Ortiz 1983, p. 51; Regueras 1990, pp. 50–51.

67

SARCOPHAGUS OF SAINT MARTIN OF DUME

Church of San Martinho de Dume (Braga), ca. 1070
Limestone
15¾ x 83⅛ x 24¾ in. (39.9 x 212.5 x 63 cm)
Museu Don Diogo de Sousa, Braga (40,40/1)

This sarcophagus, originally in the church of San Martinho de Dume, served as a cenotaph for Saint Martin of Braga (d. 580), the Apostle of the Suevi, the people of the northeast corner of the peninsula. They were converted

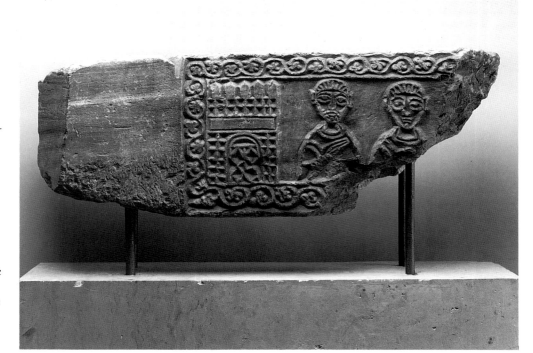

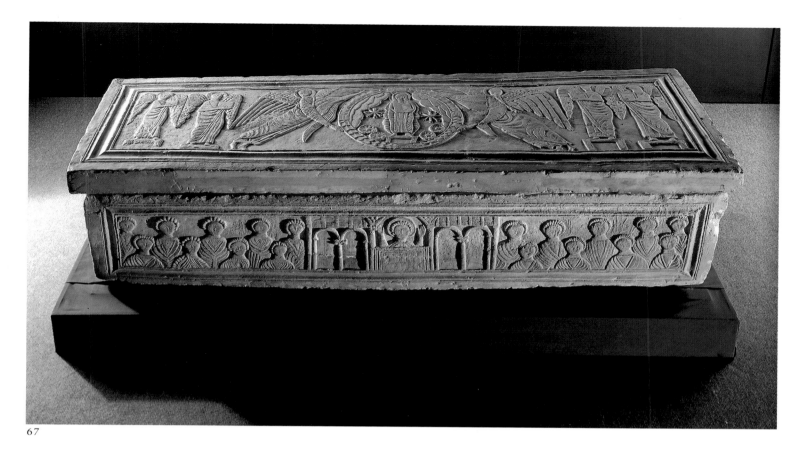

67

from Arianism to the orthodox faith through Martin's appeal to the cult of Saint Martin of Tours, in whose name he founded the monastery at Dume, about 2½ miles (4 km) outside the ancient city of Braga. Martin was archbishop of Braga as well as abbot at Dume and presided over the First Council of Braga. On the only carved side of the sarcophagus two groups of frontal figures flank an arcaded, roofed structure, which must be a church. In the center a nimbed figure (Saint Martin of Braga?) stands behind an altar with his arms raised in prayer. On the lid, within a rectangular molding of the type employed for the relief on the side, the composition is centered on a representation of Christ, who stands within a circular mandorla enclosing the celestial elements—clouds, sun, moon, and stars. Angels, in postures situated halfway between standing and the more traditional flight, carry the mandorla. The introduction of therianthropic symbols of the evangelists, human figures with beast heads who stand to either side of the composition holding books, had compromised the space available and necessitated the adjustment in the angels' poses.

67 : Detail

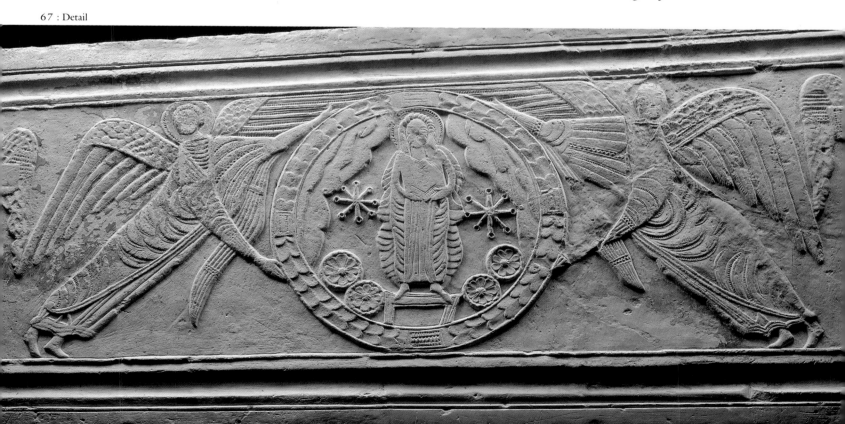

As Helmut Schlunk first recognized, the Beatus Commentary of Burgo de Osma of 1086 (cat. 82) offers parallels for the style and iconography of the lid. The Osma Beatus itself could not have been the model, of course, but a related copy could have served as the prototype. Because the Osma Beatus includes a standing Christ holding an open book before him, Schlunk chose the illustration of the Opening of the Sixth Seal (Apoc. 9:13–16) to demonstrate a connection between the Beatus tradition and Martin's tomb iconography. However, the distinctive combination of Christ in a mandorla and the therianthropic symbols is found in the illustration (fol. 149v) of the Heavenly Throng Praising God (Apoc. 19:1–10). They celebrate the fall of Babylon, the city of the iniquitous. Perhaps this theme had a special resonance for those who conceived the monument. Braga had been taken by the Muslims in 716. Only in 1064 was the area liberated, by Ferdinand I of León. An archbishop, Peter, was installed in Braga in 1070, the date that provides the most probable terminus post quem for the sarcophagus. The restoration of the city and the see may have inspired both the conception of an exceptional work that marks one of the first steps on the peninsula toward an imagistically rich Romanesque sculpture and the iconography elected for the lid. J W W

LITERATURE: Schlunk 1968; M.J.B., in Madrid 1992, no. 8, p. 101.

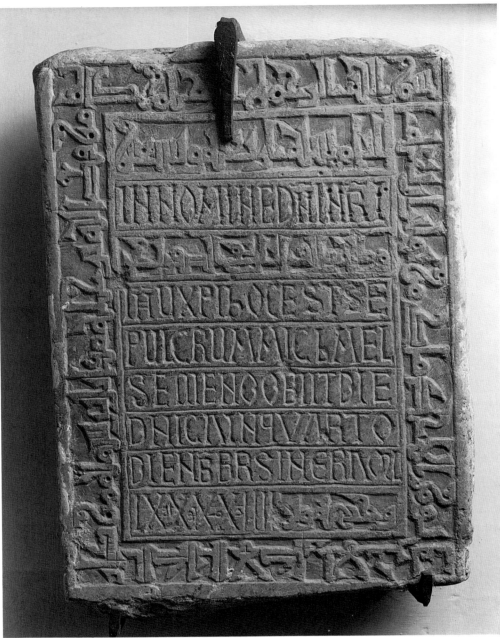

68

68

Bilingual Funerary Slab

Spain, dated 1194 (A.D. 1156)
Marble
18¼ x 13⅜ in. (47.5 x 34 cm)
Museo Taller del Moro, Toledo; property of the Parroquia de Santa Juanta y Rufina, Toledo (235)

Arabic and Latin inscriptions were carved on this grayish white marble slab. The Arabic was cut in relief in a rather hurried Kufic script, while the Latin was incised. The content of both inscriptions is very similar and reveals the name and the date of the person whose death was being commemorated. Michael, son of Semeno, was a Mozarab who

died on Sunday, November 4, 1156 (the year that corresponds to 1194 of the Spanish era, which began in 38 B.C.). The Arabic script runs along the border of the slab inside a simple frame. It begins in the upper right corner, progresses around the border, then continues on the first and third lines inside the border, and ends at the bottom, in the middle of the ninth line. The Latin inscription starts at the second horizontal line and continues without interruption from the fourth line to the middle of the ninth.

The Arabic reads:

بسم الله الرحمن الرحيم كان / من قدر الله موجله [؟]
مقايل بن سمنه من دار / الكرب الى دار الآخر / يوم الأحد
مدة من نوابر اربعة / أيام سنة اربعة وتسعين / وماية والف
[...]

In the name of God the Merciful, the Compassionate. / It was by God's foreordainment that the date [was] fixed [for the death of] Michael, son of Semeno, from the abode of torment to the other dwelling, / on Sunday the fourth day of November of the year ninety-four / and one hundred and one thousand [eulogies follow].

The Latin reads: INNOMINEDÑINR̄I / IH̄UXPIhOCESTSE / PULCRUMMICHMELH / SEMENOOBIITDIE / DNICAINQVARTO / DIENB̄BRSINERAMC / LXXXXIIII (In the name of our Lord Jesus Christ. This is the tomb of Michmel [sic] Semeno who died on Sunday, the fourth day of November of the year MCLXXXXIIII [1194]). SC

LITERATURE: Toledo 1975, no. 9; Revuelta 1979, p. 71, no. 235.

casket

Northern Spain, 8th–10th century
Ivory and gilt-copper alloy
3½ x 4⅞ x 2⅜ in. (9 x 12.5 x 6 cm)
Glencairn Museum; Bryn Athyn,
Pennsylvania (04.CR.49 a,b)

According to tradition this remarkable miniature casket once belonged to the treasury of the northern French abbey of Saint-Evroult-d'Ouche (now destroyed), which in the thirteenth century received inheritances from Navarre. The casket is formed of ivory panels joined with ivory pins and reinforced with gilt-copper alloy clips bearing faceted or chip-carved designs. The panels making up the casket illustrate episodes in the life of King Solomon. On one side Solomon is shown entering the city of Gihon on a mule (1 Kings 1: 33). The youths holding palm branches in acclamation of Solomon's arrival make clear that the image is appropriated from—and intended to be a typological reference to—Christ's entry into Jerusalem. On one end of the casket is a scene that very likely depicts the anointing of Solomon by the priest Zadok and the prophet Nathan (1 Kings 1:45): Solomon, wearing a crown, is flanked by two figures; the one on his right appears to have wings. (Alternatively, the crowned figure and the one to his left have been identified as Solomon and Sheba.) On the other side of the casket the Judgment of Solomon is represented: the king is enthroned behind a soldier who at his behest is about to divide a child in half in order to determine which of the two women claiming him is his mother (1 Kings 3:16–28). A frontal elevation of the temple of Jerusalem is depicted at the right of this scene, while, on the opposite end of the casket, there is a longitudinal two-story elevation of the same structure, presenting an unusual architectural rendering of the celebrated temple. The imagery on the top of the casket consists of arcades inhabited by unidentified figures dressed in long robes and in some cases holding books; two of the arcades are filled with processional crosses on stanchions.

The subject of the Judgment of Solomon may have been intended as a visual allegory in which the two harlots are possibly a reference to Ecclesia and Synagogue. The parallel established between the Meeting of Solomon (and Sheba?) and the greeting of Christ in Jerusalem seems deliberate, with the temple of Jerusalem functioning visually as a link between both events and the holy city. The intentional ambiguity of the entry scene on the casket is analogous to an image on a Burgundian buckle of the sixth century that,

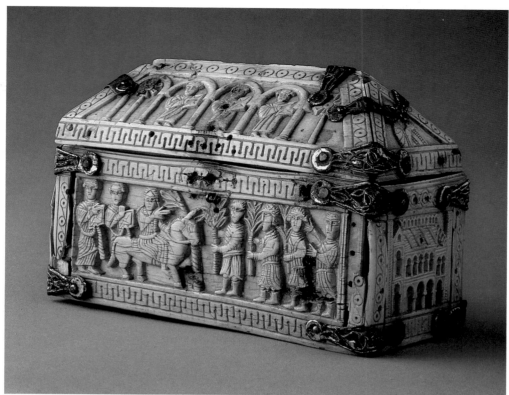

69

like the subject of the casket, has been identified as the entrance of a royal personage into Jerusalem.[1] The fact that the buckle and casket scenes include a ruler, an angel, and a welcoming crowd suggests, almost a priori, an *adventus*-kingship program: the ceremonial of the king's liturgical reception into a city reflecting Christ's entry into Jerusalem on Palm Sunday.

The reinforcing bands of gilt-copper alloy with chip-carved patterns are not original to the casket but were added at an early date. Chip carving was universal in Europe in the early Middle Ages (from the sixth to the

69

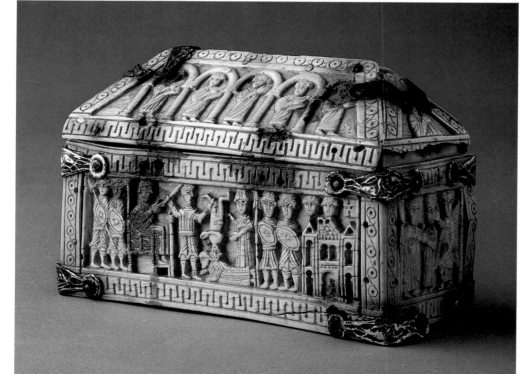

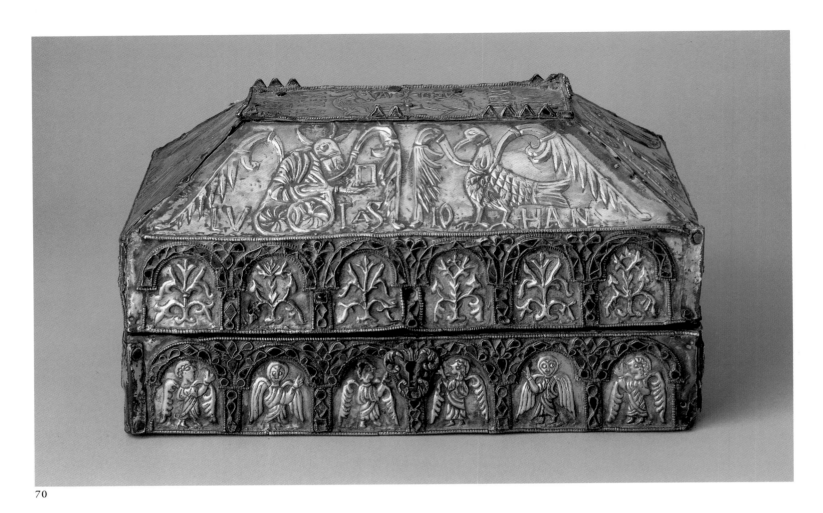

70

eighth century), yet, except in Scandinavia, by the tenth century the technique had all but disappeared.

The function of such a small casket—usually thought to be for relics—remains unclear. It may have held the chrismals used for the rite of baptism or, because of its royal themes, for coronations. The date of the casket is equally uncertain. According to tradition it is believed to be Mozarabic, dating to about the tenth or eleventh century. The architectural decoration, with its emphatic arcades composed of horseshoe arches, recalls that of San Cebrián de Mazote or San Miguel de Escalada. However, the miniaturization reduces the images to a schematic biblical structure as found, for example, in the illuminations in the Escorial Aemilianensis (cat. 83) and Vigilanus manuscripts. The figure style of the ivories and the book illustrations is also comparable, with both clearly reflecting Visigothic models. Unfortunately without surviving Visigothic manuscripts one can only assume that the Mozarabic books are near copies of such earlier works.

While the flat-relief carving technique, as well as the proportions of the figures—and especially their heavily articulated eyes and their overall frontality despite the profile view—echo the seventh-century capitals at San Pedro de la Nave (Zamora), this miniature casket is unrelated to any other ivory. It may be a precious survivor of Visigothic Spain transported to the north and, as such, an exotic example of Early Christian art.

CTL

1. Roth 1979, fig. 292a.

LITERATURE: Goldschmidt 1914–26, vol. 4, no. 80; Baum 1937, p. 99, figs. 120, 121; Pijoán 1942, pp. 412–14, figs. 603, 604; New York 1954, no. 19; Bousquet 1982, p. 47, fig. 7; Perrier 1984, pp. 38–39; Estella 1984, p. 17; Oklahoma City 1985, no. 73; New York 1987, no. 2.

70

casket

Asturias, ca. 900
Silver-gilt repoussé on a wooden core, with glass inlays
6⁵⁄₁₆ x 11¹³⁄₁₆ x 7¹¹⁄₁₆ in. (16 x 30 x 19.5 cm)
Museo de la Catedral, Astorga

The Astorga casket, one of the most complete among surviving pre-Romanesque works in silver gilt, offers a glimpse of the sumptuous quality of the objects to which royal patronage in Asturias gave rise. An inscription surrounding the Lamb of God on the top of the truncated pyramidal lid of the casket reads: A GNVS/DEI/+ADEFON/SVS REX /+SCEMENA/REGINA—a reference to its patrons, Alfonso III the Great (r. 866–910) and Queen Ximena, who gave the casket to the cathedral of Astorga during the term of office of Bishop Genadio (909–19). Inscribed on the front side of the lid are the names and symbols of the evangelists Luke and John (LV CAS/IO HAN), while those of Mark and Matthew, once on the back, are now lost. The left and right sides of the lid contain standing angels, one inscribed ANGE/LVS, the other GABRI/HEL. Around the top of the lid, at the edges, are the remains of a crenellated ridge.

The sides of the casket are divided into two registers, each with continuous arcades. Within each arch on the lower level are alternating frontal and profile heralding winged figures in repoussé, and in each arch above, there is a tree form—perhaps a reference to the tree of life. Each arch and its surrounding spandrels are faced with a raised cloisonné setting of cold-set blue and red glass. The repoussé decoration on the bottom of the casket—it originally was footed—consists of a Cross of Victory with an alpha and omega suspended from its arms and fleurons above them. It has been suggested that the overriding theme of the casket decoration is based on a canticle on the Adoration of the Lamb as recounted in Apocalypse 5:11–12.[1]

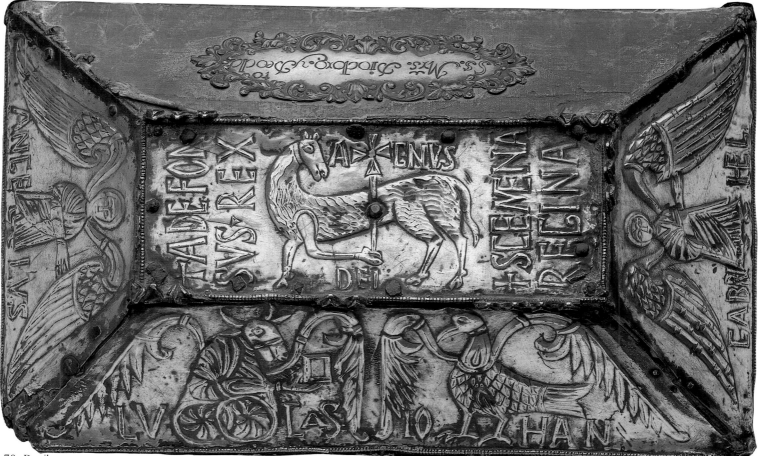

70 : Detail

The form of the Astorga casket, with its high lid, and some of the tree designs in the spandrels find their closest correspondence in the agate casket of Fruela offered to Oviedo Cathedral in 910 (cat. 71). Moreover, the Asturian connections can be extended to the carved reliefs of the evangelists on the column bases at the church of San Miguel de Liño, where similar highly abstracted figures with ropelike draperies occur. Both the design of the glass insets and the way in which they are laid down are nearly identical to those on the Cross of Victory presented to Oviedo Cathedral by Alfonso III in 908.

The imagery on the casket can also be linked to tenth-century manuscript illumination. The Lamb of God bears a striking resemblance to the lamb in the Beatus manuscript at El Escorial (cat. 81), and the angels can be compared with their trumpeting counterparts in the Beatus in the Real Academia de la Historia, Madrid, where similar large, geometrically conceived figures with enlarged eyes dominate the composition.[2]

As for the original function of the casket, it was made either to house the Host or relics, since, at least by the eighteenth century, it held the relics of Saints Diodoro and Deodato.

CTL

1. Velado 1991, p. 192.
2. Silva 1984, pls. 59, 81.

LITERATURE: Fontaine 1973, pp. 344, 346; Gómez-Moreno 1919, pp. 379–80; Gómez-Moreno 1925–26, vol. 1, p. 148, vol. 2, pls. 76–79; Hildburgh 1936, p. 36; Bonet 1967, p. 216; Schlunk 1985, p. 76; Sepúlveda 1989; Velado 1991, p. 192.

71

agate casket

Oviedo Cathedral (Oviedo), first decade of 10th century
Hammered gold and silver over wood, agate inlay, and an appliqué of chased gold with inlaid colored stones, crystal, and enamels
6¾ x 16½ x 10⅛ in. (17 x 42 x 27 cm)
Cámara Santa, Oviedo Cathedral

This precious reliquary casket was damaged in 1934, during the Spanish civil war, when a bomb hit the Cámara Santa. It was restored in 1942. It was again damaged, this time severely, during a burglary in 1977 and underwent a second restoration in Oviedo, which was completed in 1986.[1]

Nearly half of the side panels of the casket—originally probably fitted without a lock—forms part of the lid, which is shaped like a hipped roof. On the top is an ornament, a portion of an older Frankish reliquary. The

body of the casket is made of cypress wood covered with hammered gold; its underside is sheathed in hammered silver. Thin slices of agate with vivid veining are set into ninety-nine arched openings, and some 225 small gemstones and bits of coral are mounted on the gold sheathing. On the bottom, in extraordinarily fine chasing, is a depiction of a jeweled cross surrounded by the symbols of the evangelists. Four spherical feet nailed to its corners protect this relief. The donors' inscription runs around the relief panel:[2]

SVSCEPTVM PLACIDE MANEAT HOC IN
HO[NO]RE D[E]I QVOD
OFFERVNT FAMVLI X̄P̄Ī FROILA ET NVNILO
COGNOMENTO SCEMENA . HOC OPVS
PERFECTVM ET CONCES
SUM EST S̄C̄O SALVATORI OVETENSIS QVISQVIS
AVFFERRE HOC DONARIA N̄S̄A PRESVMSERI
FVLMINE DIVINO INTEREAT IPSE . OPERATVM
EST ERA DCCCC XLᴬVIIIᴬ

May this [reliquary], which the servants of Christ Fruela and Nunilo, surnamed Scemena, bestow, be gratefully accepted and remain here to the glory of God. This work was made for and given to San Salvador of Oviedo. May divine lightning strike anyone who steals our gift. It was completed in the 948th [year of the Spanish] era [A.D. 910].

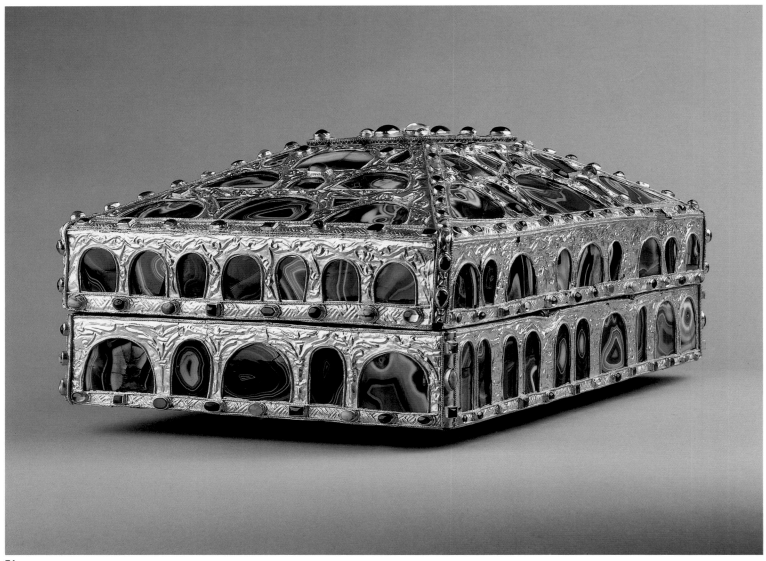

71

This inscription conforms—with a number of significant omissions—to that of the Cross of the Angels (cat. 72). It was traditional for Spanish donors, whether of royal blood or not, to identify themselves as "famuli Christi" (servants of Christ), as Fruela and Nunilo do here. Fruela had not yet taken the title of king in 910, though he had already succeeded his father, Alfonso III, as ruler of Asturias, while his brothers governed Galicia and León. The warning that any attempt at theft would be met with divine retribution continues a tradition from pagan Rome.

The carefully worked design on the base has much detail. The cross is similar to the wall painting of the True Cross in San Julián de los Prados (built by Alfonso II [r. 791–842]). The four busts of the evangelist symbols, with small wings emerging from their sides, were arranged counterclockwise beginning in the lower left in the order fixed by Saint Jerome —Matthew, Mark, Luke, and John. Each bust rests on a wheel filled with a swirling rosette and rimmed by hatching in a triangu-

lar pattern (an illustration of Ez. 1:15–21).[3] Portrayed in semiprofile, the figures have neither halos nor books. They are treated in accordance with their natures as man, lion, ox, and eagle. In the precision of its execution, the stylized naturalism of this work surpasses most painted illustrations of the Apocalypse. In its conception, if not in its details, it is very close to the canon table from the Biblia Hispalense (cat. 85).

The use of ornamental inlaid agate is in itself an innovation. In addition, there is a certain toying with the traditional arcade arrangement on the side panels, with wider arched openings alternating with narrower ones.

The ornament on top of the casket, which determined the format of the lid, has been integrated harmoniously with the rest of the piece. Lustrous red almandines set in separate cells within straight and curving bands of gold form an imposing frame, contrasting with the rest of the casket. In the intervening panels, three-colored enamels represent the

three different types of creatures that inhabit the three elements. Inlays of gemstones and crystal set in hammered gold highlight the form of the cross, which dominates the overall composition of the ornament. The presence of the cross makes it clear that the ornament originated on some religious artifact. Victor Elbern identified the piece as Frankish and dated it to the first half of the eighth century. He also provided an interpretation of its Christian cosmological iconography and determined that it was part of a reliquary.[4] It may have been a royal gift in the possession of the Asturian kings since the time of Alfonso II.[5] That Fruela chose to present it to the cathedral in Oviedo would have underscored the legitimacy of his assumption of power in Asturias.

It is useful to compare this piece with three goldsmiths' works produced in the court workshops in the castle at Gauzón and donated to other cathedrals by Alfonso III: the copy of the Cross of the Angels, which he presented to the cathedral of Santiago de

Compostela in 874, lost in 1906; the Cross of Victory, given to the cathedral in Oviedo in 908 (see p. 118); and the reliquary donated to the cathedral in Astorga by 910 at the latest (cat. 70). The same technique for setting the gemstones in hammered gold was used on the lost Santiago cross.[6] The gold cording is more lavish in both the Santiago cross and the Cross of Victory, while that of the Astorga casket is somewhat simpler. Other similarities, such as the form of the casket, the organization of its side panels, the design of the cross on the base, and the representation of evangelist symbols, pertain only to the reliquary in Astorga.

The arguments of Manuel Gómez-Moreno, pointing out the Mozarabic character of the agate casket, do not appear to me to be altogether verifiable. The small trees and vines are quite unspecific. It is only the overall form of the casket that seems clearly Andalusian.[7] That form is similarly preserved in the agate casket of Saint Isidore in León (cat. 120), which descends from the agate casket but which bears a strongly Andalusian stamp in many of its ornamental designs.[8]

The agate casket's iconographical program includes the three types of living creatures on the lid, a cross surrounded by the symbols of the evangelists on the base, and ninety-nine arches framed by vegetation on the sides. The floral motifs can be generally associated with paradise, but the number ninety-nine is probably to be interpreted in the same way as the ninety-nine stars—also clustered around a jeweled cross—in the apse mosaic of the church of Sant'Apollinare in Classe, Ravenna. It could be, as Friedrich Deichmann explains apropos of Sant'Apollinare, a matter of the numerical value of the word *Amen*, so that the decoration of the reliquary shrine expresses the glorification of God.[9]

S N - H

1. For the numerical details, an account of damages to the casket, and its two restorations, see Cuesta and Díaz 1961; Manzanares 1972; and Fernández Avello 1986, pp. 2–24. Miguel Vigil (1887, vol. 2, pl. 9 [drawing]) shows a lock for which there are no traces of mounting on the casket and that, therefore, does not appear to be authentic. The description is based on photographs taken between 1942 and 1977.
2. Where the inscription comes into contact with the figures, it appears to adapt to them and must, therefore, have been engraved after the relief was finished. Concerning the letters, see Cid 1990, pp. 9–11, 18–20.
3. For a tetramorph as a winged human being with four faces, flanked by two wheels (corresponding to Ez. 1 : 6ff.), on a silver and partially gilt sixth-century liturgical fan from Constantinople, see V. H. Elbern, in Weitzmann 1979, p. 593, and G. V[ikan], in ibid., p. 617, no. 553 ill. For cross forms in Asturias, see cats. 65, 72 (relief slab with cross from San Martín de Salas; Cross of the Angels). For the Hispanic tradition in the depiction of the evangelists as half-human, half-animal, see cats. 8, 70 (capital with four evangelists from Córdoba; Astorga casket).
4. Elbern 1961; see also Werckmeister 1967, p. 158.
5. Schlunk 1950, p. 107.
6. For the crosses, see Schlunk 1985, figs. 22–52.

7. This view, first put forward by Gómez-Moreno (1919, p. 381), has persisted in the literature. For purposes of comparison, and with no suggestion of any direct connection, I cite the Altheus reliquary in Sitten (Switzerland, seventh century). See Holmquist 1968, fig. 4. The form of the lid (but with border molding, above a chest in the form of a truncated pyramid) is already found, for example, in the Projecta casket (Rome, fourth century [K. Shelton, in Weitzmann 1979, pp. 330–32, no. 310]). Gómez-Moreno (1919, p. 380) points out that all surviving Cordoban caskets are of a later date; see New York 1992a, nos. 4, 7, 9.
8. Gómez-Moreno 1919, p. 382, pls. 143, 144; Franco 1991b, p. 82 (with fig. 3).

9. For an interpretation of the number ninety-nine, see Deichmann 1969–89, vol. 2, pp. 256ff.

LITERATURE: Amador de los Ríos 1877, pt. 1, pp. 41–42, with two figs.; Miguel Vigil 1887, vol. 1, p. 19, no. A 22, vol. 2, pl. 9; Gómez-Moreno 1919, pp. 380–81, pls. 140–42; Pijoán 1942, pp. 468–69 (with figs. 673, 682–83); Schlunk 1947b, pp. 414ff. (with figs. 426–28); Cuesta and Díaz 1961; Palol and Hirmer 1967, p. 44, pls. X, 41; Manzanares 1972, pp. 18–20, pls. 22–25; Fontaine 1973, pp. 344–45, pls. 154–55; González García and Suárez 1979, pp. 89–99; Yarza 1979, p. 65; Schlunk 1985, p. 34, fig. 101; Fernández Avello 1986, pp. 20–24; Cid 1990, pp. 9–11, 18–20.

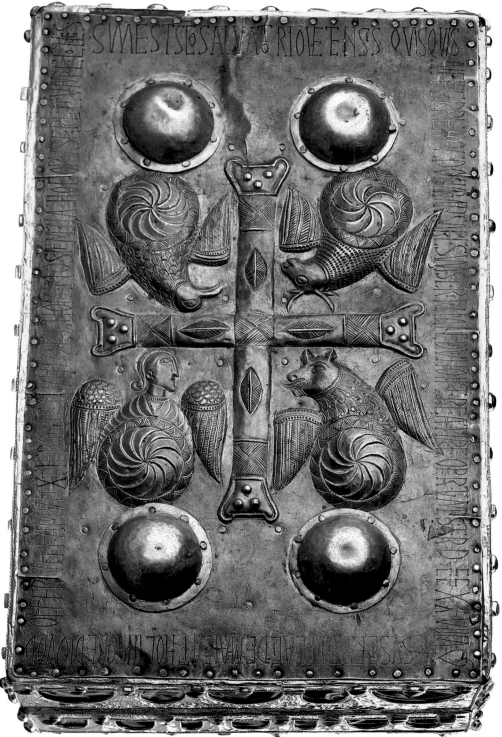

71 : Detail

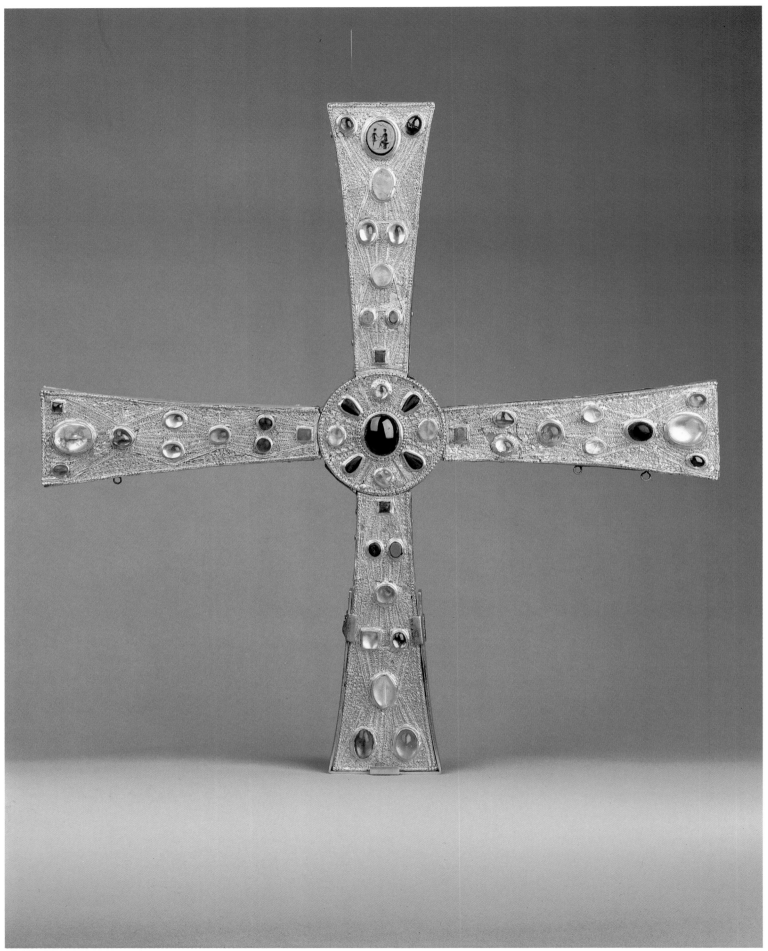

72: Front

the cross of the angels

Oviedo (Oviedo), 808
Gold foil over wooden core, gems, and pearls
18¼ x 17¾ x 1 in. (46.5 x 45 x 2.5 cm)
Cámara Santa, Oviedo Cathedral

The Cross of the Angels of Alfonso II, the most characteristic work of art from the kingdom of Asturias, appears today in the coats of arms of the city and archdiocese of Oviedo. It belongs, along with the Cross of Victory (see p. 118) and the agate casket (cat. 71) of a century later, to one of the most outstanding groups of western goldsmithing work from the early medieval period. All three objects are preserved in the treasury of Oviedo Cathedral. They survived the bombing of the Cámara Santa by rebels in 1934 with only slight damage,[1] but in 1977 they were mangled in a theft. They were subsequently recovered in incomplete fragments and once again restored in Oviedo, a process that was completed in 1986.

The cross was commissioned by Alfonso II (r. 791–842), who was determined to make Asturias the major Christian bulwark against the Córdoba emirate and to develop Oviedo as a fortified residence. In its materials, artistic richness, and bold inscription, the work is a perfect expression of the ruler's confident self-esteem.

It is a Greek cross with arms of almost identical length extending from a central disk and growing wider toward the ends. It was not intended to hang, for there are no traces of the necessary loops. A post running downward from the bottom arm may have existed from its creation, suggesting that in addition to being carried in processions, the work once stood in Oviedo's main church, which was built at this same time and dedicated to Christ.

The body of the cross, containing small chambers for relics,[2] was made of wild cherry, which was then covered with sheets of gold. At one time there were jewels (*perpendulia*) hanging from the loops on the undersides of the cross arms. The front side, completely covered with filigree, is set with forty-eight jewels—surely a significant number. On the back, in addition to the inscription, there are five stones surrounded by double wreaths of pearls. Originally eight, now only six of the cross's stones were gems from the Roman period; among them, in the center of the back, is a large cameo with the profile bust of a young woman.[3]

Crosses were donated to Spanish churches even in Visigothic times. Among them surely is to be counted the large example, two arms of which are preserved, from the Guarrazar

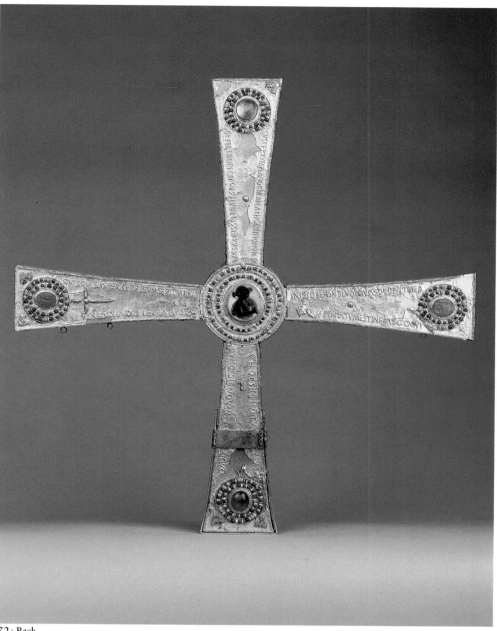

72: Back

Treasure. However, the Cross of the Angels is similar in size and form to the roughly contemporary Desiderius Cross in Brescia, and there are more features—the filigree technique, the threading, and the circular arrangement of the pearls—that relate it to Byzantine and North Italian works. These features led Helmut Schlunk, the foremost expert on the work, to assume that it was commissioned from foreign artists.[4]

The inscription, which was soldered letter by letter onto the back of the four arms, reads:

+ SVSCEPTVM PLACIDE MANEAT HOC IN
 HONORE D̄N̄I
⋄ OFFERT ADEFONSVS HVMILIS SERVVS
 X̄P̄I
QVISQVIS AVFERRE PRESVMSERIT MIHI
NISI LIBENS VBI VOLVNTAS DEDERIT
 MEA

FVLMINE DIVINO INTEREAT IPSE ♡
HOC OPVS PERFECTVM EST IN ERA
 DCCCXLVI
♡ HOC SIGNO TVETVR PIVS ♡
♡ HOC SIGNO VINCITVR INIMICVS ♡

May this gift, presented by Alfonso, the humble servant of Christ, be received with favor and remain to honor God, and may whoever dares to take me away except where it pleases my will to give it, be struck by divine lightning. This work was completed in the year of the [Spanish] era 846.[5] Beneath this sign the faithful finds protection. Beneath this sign the enemy is defeated.

Alfonso II (the Chaste) is the only Spanish king to have called himself "servant of Christ," a formula borrowed from earlier ecclesiastical worthies. In doing so, he underscored his

sense of himself as almost a cleric.[6] The closing phrase, alluding to the Vision of Constantine, became the motto of the Asturian kingdom and would be repeated in association with the Cross of the Angels in the book illumination of subsequent centuries.[7]

In 874 Alfonso III commissioned a copy of the Cross of the Angels for the church of Santiago de Compostela, which he had enlarged. That work was stolen in 1906.[8]

The earliest known depiction of this cross, accompanied by angels, dates from the end of the tenth century in the Codex Aemilianensis (cat. 83). The first documentation of the legend maintaining that the work was created by angels comes from the eleventh and early twelfth centuries.[9]

The restoration completed in 1942 was not scholarly, and the one undertaken after the piece was greatly damaged in 1977 was also somewhat controversial. Some of the gold foil is still missing, and the wood core has for the most part been replaced, as has the post. Some of the precious stones are new, and the large cameo is a copy.[10] Fortunately color reproductions show what the work looked like in the late nineteenth century.[11]

AA

1. Cuesta 1947, pp. 5–8, pl. 2; Gómez-Moreno 1934b.
2. Cuesta 1947, pp. 11–12; Schlunk 1985, pp. 12–13, ill. 5.
3. Amador de los Ríos 1877, "La Cámara Santa," pp. 25–32 (ill.); Manzanares 1972, pp. 8–9, pls. 7–14; González Garcia and Suárez 1979, ills. on pp. 45, 49–50, 55–56, 58, 61–65; Schlunk 1985, pls. 1, 20; Salcedo 1987.
4. Schlunk 1950, pp. 94–99; Schlunk 1985, pp. 17–20 (with comparative plates).
5. As always in the Hispanic early Middle Ages, one has to subtract thirty-eight years, so that this becomes A.D. 808.
6. Schlunk 1980a, pp. 142–44; Schlunk 1985, pp. 21–22.
7. For an overview of the monuments, see Menéndez Pidal 1955, pp. 290–93; Bischoff 1963, pp. 27–29; Schlunk 1985, p. 36 (with ills.). It is tempting to think that this symbol took on special significance in light of the Reconquest (see Menéndez Pidal).
8. Schlunk 1950, pp. 99–101, ills. 10–13; Schlunk 1985, p. 25, ills. 22–25.
9. Regarding the Codex Aemilianensis in the Biblioteca de El Escorial (d.I.1), see Fernández-Pajares 1969, p. 290, ill. 8; Silva 1984, pp. 369f., pl. 13; Cid 1988, p. 20. For the most extensive discussion of the legend, see Cid 1990, pp. 27–33.
10. Cavanilles 1987; Schlunk 1985, pp. 12, 18–20; presented in great detail in Fernández Avello 1986.
11. See Amador de los Ríos 1877, "La Cámara Santa," ill.; Rada 1880, ill.

LITERATURE: Amador de los Ríos 1877, "La Cámara Santa," pp. 18–32, ill.; Rada 1880, pp. 538–40, ill.; Miguel 1887, pp. 16–17, pl. 7; Cuesta 1947, pp. 5–14, pls. 2, 4, 5; Schlunk 1950, pp. 91–99, ills. 1–13; Menéndez Pidal 1955, pp. 279, 281; Prieto 1956; Bischoff 1963, pp. 27–29; Manzanares 1972, pp. 6–11, pls. 3–14; González Garcia and Suárez 1979, pp. 44–59, 61–67; Schlunk 1980a, vol. 2, pp. 141–44, and vol. 3, pp. 94–97; Fernández-Pajares 1981, pp. 192–95; Schlunk 1985, pp. 12–25, ills. 1–21, 53ff.; Fernández Avello 1986, pp. 3–19; Salcedo 1987; Cid 1988; Cid 1990; Cid 1992.

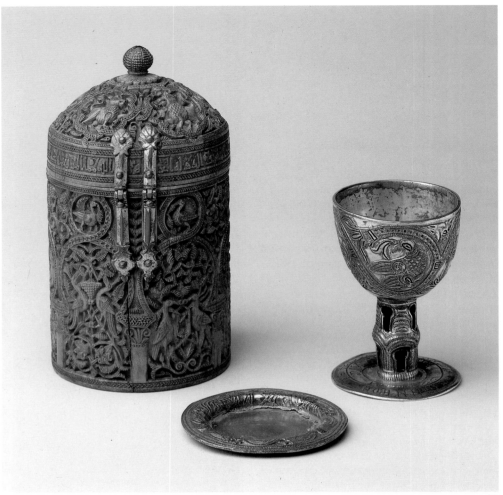

73

73

chalice and paten of san geraldo; pyxis of sayf al-dawla

a, b. Chalice and Paten
Mozarabic, before 1008
Silver gilt
Chalice: H. 4⅜ in. (11 cm), diam. 3 in. (7.5 cm)
Paten: Diam. 3½ in. (9 cm)
c. Pyxis
Andalusia, 1004–8
Ivory and silver gilt
H. 7⅞ in. (20 cm), diam. 4⅛ in. (10.4 cm)
Treasury of Braga Cathedral

An inscription on the base of the chalice reads: IN N[OMI]NE D[OMI]NI MENENDUS GUNDISALVI ET TUDAD [O]MNASUNM [?] (In the name of the Lord, Mendo Gonsalvez and Toda). The naming of this Portuguese count and his wife, Dona Toda, allows the chalice and paten to be dated before 1008, the year that Don Mendo died.

The decoration of this ensemble, unlike that of the chalice from Coimbra (cat. 140), employs the stylistic vocabulary of Mozarabic art—particularly in the stylized bird forms and the keyhole openings of the stem. The

proportions are squatter than the ones established later in the century, with the cup still set on a short stem and the base flat rather than splayed. As throughout the Middle Ages, the chalice and paten are conceived as an ensemble, like a cup and saucer reversed.

The chalice and paten are at present associated with this ivory pyxis with Islamic carving, which is of about the same date. The pyxis is distinguished by an arcade of six horseshoe-shaped arches inhabited by paired birds, animals, and humans harvesting and eating the lush vegetation that decorates the entire surface. Around the lid is an inscription reading:

بسم الله بركة من الله ويمن وسعادة للحاجب سيف الدولة
أعزه الله مما أمر بعمله على يدي الفتى [الكبير زهير بن
محمد] العامري

In the name of God. Blessings from God, prosperity and happiness to the hajib Sayf al-Dawla, may God increase his glory. From among that which was ordered to be made under the supervision of the chief page [Zuhayr ibn Muhammad] al-ʿAmiri.

According to Renata Holod, "the pyxis is datable to a period between 1004, when the hajib ʿAbd al-Malik received the title Sayf

al-Dawla, and 1007 . . . when he received the additional title al-Muzaffar, or 1008 . . . when he died in battle."[1]

The dimunitive size of the chalice and paten, which allows them to fit inside the pyxis, suggests that the three objects functioned as an ensemble. It would not be inconsistent with the career of Don Mendo Gonsalvez for him to have obtained the ivory during a campaign against the Muslims and then donated it to the church of the Virgin at Braga, along with the gift of a chalice and paten contained within. However, there is no documentary evidence that the chalice and paten were created to fit inside the box. The seventeenth-century inventory of the cathedral specifies that an elaborately carved, hinged ivory pyxis, apparently this example, was in use as a reliquary. BDB/CTL

1. New York 1992a, no. 5, p. 202.

LITERATURE: Madrid 1992, no. 3, pp. 95–96 (with previous literature); New York 1992a, no. 5, p. 202.

arms from a processional cross

Monastery of San Millán de la Cogolla (Logroño), late 10th century
Ivory, with traces of gold inlay
a. 14⅝ x 5¼ in. (37.3 x 13.5 cm)
b. 14¼ x 5⅜ in. (36.2 x 13.6 cm)
a,b: Musée du Louvre, Paris (OA 5944, 5945)
c. 14⅝ x 5½ in. (37.2 x 14 cm)
Museo Arqueológico Nacional, Madrid
(63.935)

What must once have been a truly monumental processional cross of gold and ivory is reflected in these magnificent remains. The decoration on both sides of each cross arm consists of a broad continuous band of deeply cut rinceaux inhabited by symmetrically paired griffins, lions, giraffes, and other quadrupeds, as well as birds. The vines issue from a

monstrous mask placed at the inner end of the arm, closest to the center of the cross. Originally the interstices of the decorative border were filled with gold, of which a few traces remain. The deep cavity in the center of each side of the arms would have contained panels of repoussé gold. The arms undoubtedly slotted into a large central medallion where they were held with pins.

It has been suggested that these three arms come not from a single cross but from a pair of crosses. The reasons given are the slightly differing dimensions and the orientation of the decoration: on the horizontal arm, the motifs would be displayed sideways rather than upright.[1] These factors are not significant enough to support the theory of two crosses; a single cross is more likely.

These cross arms and a portable altar with ivory panels of related style that was preserved at the monastery until the end of the nineteenth century[2] (Museo Arqueológico

74a

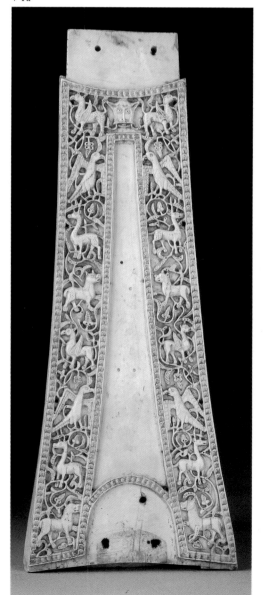

74b

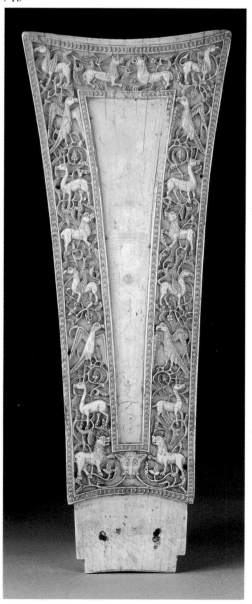

74c

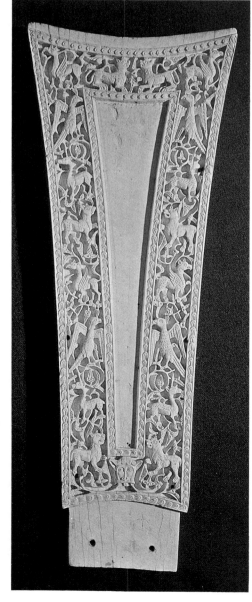

Nacional, Madrid) are the principal evidence that a Mozarabic ivory workshop existed at San Millán de la Cogolla (although some maintain that the ivories were the work of Muslim craftsmen working for Christian patrons rather than of Mozarabic artists trained in the styles of Islamic art). Mozarabic ivories must have been made first at San Millán, since these works are apparently the oldest examples. They are more academic and less lively[3] than Islamic ones produced in Córdoba and lack the sophistication of the Córdoba ivories. The Christian ivories are heavily indebted to works produced in Córdoba: the direct influence of caliphal ivories can be detected in the arrangement of the decoration, the deeply cut relief, and the motif of a continuous arabesque. Manuel Gómez-Moreno dated this group of Mozarabic ivories to about 970 based on their relationship to the caliphal ivories.[4] More recently Danièlle Perrier has placed them in the early eleventh century, pointing to an oliphant in Paris with related decoration that has been called a Hispano-Islamic work produced under Byzantine influence and dated to the eleventh century.[5] However, a date around the time of the reputed dedication of the church of San Millán in 984 is likely.

The processional cross must have been a highly venerated object. Its association with Saint Aemilian himself is suggested by a Greek cross with splayed-leaf arms held by the tomb statue, traditionally regarded as a representation of the saint, that was carved for San Millán de Suso at the end of the twelfth century. A miniature depiction of the San Millán de la Cogolla cross appears on the ivory originally mounted on the end of the reliquary of San Millán (cats. 125a–g); it shows the saint on a bier and the cross on a standard by his head.[6] Reconstructed, this processional cross would be the largest example in ivory known from the Middle Ages.

CTL

1. Gaborit-Chopin 1978, p. 91; Kühnel 1971, no. 49.
2. Kühnel 1971, no. 50.
3. Silva 1984, p. 90.
4. Gómez-Moreno 1919, p. 373.
5. Perrier 1984, pp. 97–98.
6. Goldschmidt 1914–26, vol. 4, no. 86.

LITERATURE: Kühnel 1971, nos. 49, 50 (with previous literature); Gaborit-Chopin 1978, p. 91, nos. 114, 115; Fontaine 1977, pp. 371–72; Toledo 1975, no. 47; Silva 1984, pp. 89–92; Perrier 1984, pp. 97–98.

BIBLE

Asturias(?), first half of 9th century
Tempera on parchment
12⅝ x 10½ in. (32 x 26.8 cm)
Biblioteca della Badia, La Cava dei Tirreni (MS. memb. I.)

The La Cava Bible, certifiably peninsular on the basis of its text and Arabic glosses (fols. 32, 34, 35, 98, 147v, 191, 193), is an extraordinary witness to an unknown scriptorium in Spain. It is arguably the supreme monument of peninsular paleographic art. The scribe responsible, identified as Danila on folio 166v, combined texts of various ancient types (*capitalis rustica*, uncial, half-uncial) and wrote in an antique format of three columns. The ornament, especially in terms of the scribal ingenuity displayed in the title enframements, also evokes prototypes from the first centuries of manuscript illumination, including examples from the Byzantine East. Some folios are stained blue (220, 221), some are purple (194, 224, 253), another feature associated with the first centuries of manuscript art.[1] At the same time, there is a rich ornamental use of opaque color, a phenomenon that would not surface again in Spain, to judge by surviving manuscripts, until the Bible of 920 (León Cathe-dral, Cod. 6) appeared. The identification of the site of the scriptorium in which the La Cava Bible was produced has to be speculative and based on evidence other than manuscripts. Oviedo is frequently mentioned because of the prominence of the cross in its decoration, notably the cross form of the text on folio 200 and the crosses on folios 1v, 100v, and 143. The latter have been likened to the Cross of the Angels (cat. 72), the gold cross given to Oviedo Cathedral by Alfonso II in 808, but their shapes are quite different. Closer in form to the crosses in the La Cava Bible are those carved on Visigothic altar supports.[2] It may be that the ornament of our manuscript is based, in part, on that in a Visigothic model. Nevertheless, the royal capital of Oviedo or monasteries close to it during the reign of Alfonso II (791–842) provide the most likely context for the La Cava Bible.

If it is correct to interpret a contemporaneous marginal gloss as a reference to the predesti-

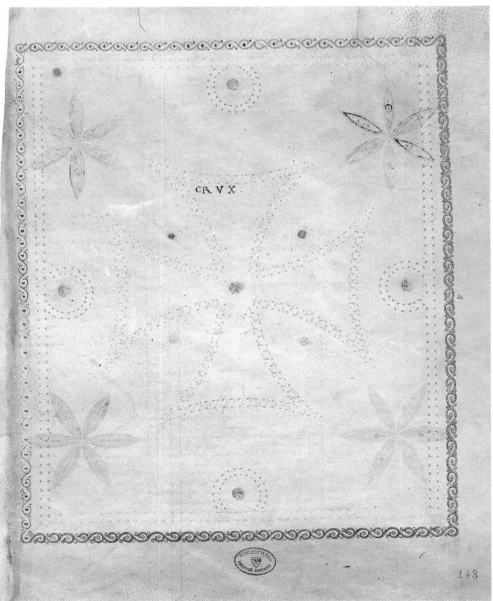

75: fol. 143. Cross page

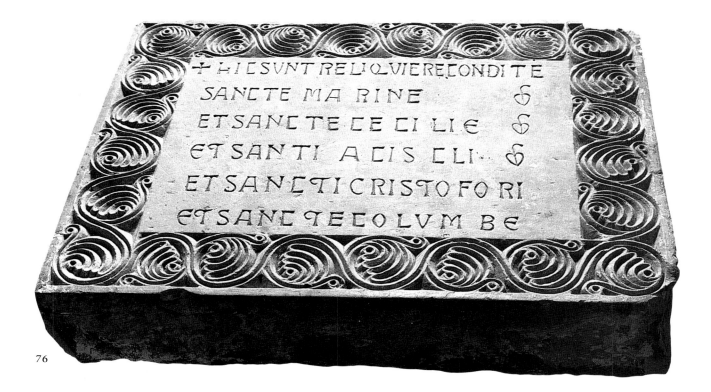

76

nation controversy associated with Gottschalk and the Council of Mainz of 848, it is not possible to assign a date as early as the first half of the ninth century to this Bible.[3] The influence of the scriptorium of Tours has also been proposed for the appearance of various scripts in these pages.[4] However, the ornament is essentially pre-Carolingian in nature. One of its most striking features, the elaborate painted frames provided for the quire numerals, has its best parallels in Merovingian manuscripts of the middle of the eighth century.[5] The capitals also are based on Merovingian prototypes of the same date.

Since there is no certain evidence regarding how the Bible got to La Cava, we do not even know the identity of the last peninsular home of our manuscript. Marginal notes in Beneventan script of the twelfth century, however, indicate the Bible had reached La Cava at least by that date. Ambrogio Amelli proposed as the agent of transfer Mauritius Bordinho, bishop of Coimbra and then archbishop of Braga, one of the French clerics recruited by Bernard d'Auch.[6] As for its original home, the murals of the church of San Julián de los Prados (Santullano; see p. 115), the suburban Oviedan church erected by Alfonso II, offer a comparably unexpected well-executed reprise of antique decorative schemes that may have been intended to invoke the empire and its capital at Constantinople—leading to the conclusion that the stained pages of the La Cava Bible and its archaic ornament may have been part of the same enterprise.

JWW

1. For the staining of parchment, see Lowe 1954, pp. 266–68.
2. Palol 1967b, figs. 13, 16.
3. Lowe 1937, p. 329. Lowe's observation that "a few curious marginal entries . . . seem to refer to the theological disputes then raging on the question of predestination" has been the basis for modern discussion of a mid-ninth-century or later date. A French connection of a reverse direction, from Spain to France, has been proposed (Vieillard-Troiekouroff 1968) to explain the supposed influence of a Hispanic model on some of the Bibles produced under Bishop Theodulf of Orléans, a Spanish refugee. For the arguments against such an influence, see Nees 1987, pp. 43–44.
4. Lowe 1937, pp. 327–28.
5. Rome, Vat. Reg. Lat. 257 (Zimmermann 1916, pl. 101c) and Bibl. Vallicelliana, Rome (B. 62) (Lowe 1947, no. 433).
6. Lowe 1937, p. 330.

LITERATURE: Lowe 1937; Ayuso 1956; Grabar and Nordenfalk 1957, pp. 162–63; Fischer 1963, pp. 562, 568, 594; Vieillard-Troiekouroff 1968; Petrucci 1976, pp. 837–39; Rotili 1978, vol. 2, pp. 21–44.

76

altar slab

Monastery of San Miguel de Escalada (León), 913
Limestone
L. 40⅛ in. (103 cm), w. 32¼ in. (82 cm)
Monastery of San Miguel de Escalada

Three altar slabs with inscriptions and reliefs have been preserved from the basilica of San Miguel de Escalada. On this altar slab from the north side apse the inscription panel is framed by a broad scroll that has been carefully laid out with a compass, with alternating but otherwise identical branching half-

palmettes. The inscription reads[1]: + HIC SVNT RELIQUIE RECONDITE/SANCTE MARINE ɸ /ET SANCTE CECILIE ɸ /ET SANTI ACISCLI ɸ /ET SANCTI CRISTOFORI/ET SANCTE COLVMBE (Preserved here are relics of Saint Marina and Saint Cecilia and Saint Acisclus and Saint Christopher and Saint Columba [they are all Christian martyrs]).

The cult of relics began to have a special significance during the Visigothic period, and the number of altars kept growing as they were the preferred depositories for relics.[2] The altar slab usually rested on a pier that had a hollow space inside for the reliquary casket.[3] On a seventh-century altar slab from Salpensa, near Seville, there is a list of relics running around the edge, as was customary.[4] However, there the surface of the slab is framed by a raised band of molding with relief ornament. Helmut Schlunk pointed out the close similarity in design between the Salpensa piece and the altar slab with a dedication to the Virgin that comes from Mount Naranco, near Oviedo, and dates to the time of Ramiro I (r. 842–50).[5]

Oddly enough, the three altar slabs from Escalada do not have a raised border, and the relief—like the inscription itself—is carved into the surface of the stone. This is worth noting, for in the preparation of the Eucharist, crumbs of bread and drops of wine could have easily fallen onto the altar, and in some cases, as on the altar from Mount Naranco mentioned above, a small channel was provided in the border molding to make their removal easier.[6] Crumbs would have been extremely difficult to collect from the present

altar slab in San Miguel,[7] and accordingly one assumes that the stone was covered with a tablecloth of white linen like those mentioned in inventories of the tenth and eleventh centuries. Antependiums, either embroidered or woven of colored threads, were also hung in front of the altar.[8]

Manuscript illuminations reveal that the pier was still the most common type of altar support in the ninth and tenth centuries. Piers decorated with blind horseshoe arches have survived from that period in the churches of San Pedro de Rocas (Orense) and San Martín de Tours, Luco (Álava).[9] When the entire interior of the church at Escalada was excavated, a rectangular base for a pier, dating from the first Mozarabic phase of the structure, was discovered beneath the floor of the central apse. However, from the second phase—namely the structure dedicated in 913—a flat rectangular depression was found, which suggests that the surviving altar slab was supported by a bigger block of stone —and presumably those of the side apses were as well. Three examples of large altar blocks from Asturias survive, one from the church of San Julián de los Prados, or Santullano (from the time of Alfonso II [r. 791–842]), one from Mount Naranco (Ramiro I), and one from the church of San Salvador de Valdediós (Alfonso III [r. 866– 910]). These represent the entire span of the ninth century. The four holes in the corners of the rectangular depression at Escalada, which the excavators interpret as the locations of four legs, could possibly be connected to the documented restoration of the main altar in 1126.[10] S N - H

1. Æ has become E throughout.
2. See essay by Achim Arbeiter and Sabine Noack-Haley, this catalogue. Examples of Visigothic choirs with three apses—signifying at least three altars—are found in El Bovalar (Lleida), Las Tamujas (Toledo), and Alcuéscar (Badajoz).
3. In the Mérida region alone there are six known piers and capitals containing a loculus. See Cruz 1985, pp. 219–20, figs. 189–93, 425. An especially splendid pier, richly adorned with relief, is preserved in the Great Mosque in Córdoba (see Palol and Hirmer 1967, pl. 17, below). Pagan Roman altars were often reused for such purposes, with an opening provided for a reliquary casket. There is an example from as late as the tenth century in São Pedro de Lourosa, near Guarda (Portugal). The type was by no means confined to the Iberian Peninsula.
4. Schlunk and Hauschild 1978, p. 63, fig. 42. The inscription, visible in an eighteenth-century watercolor, dates it to 642.
5. Schlunk 1948, pp. 87–88. Altar slabs with broad moldings around the edge were still known in the early eleventh century, as, for example, in the cathedral of Girona (see Palol and Hirmer 1967, pl. 54, below).
6. Schlunk 1980a, pp. 161–62.
7. The supposition that all three altars were intended solely for the veneration of relics and that a fourth existed for the celebration of the Mass can doubtless be discounted.
8. Gómez-Moreno 1919, p. 335; Iñiguez Herrero 1978, pp. 173–78, 240–48; Braun 1924, vol. 2, p. 28.

9. For Rocas, see Gómez-Moreno 1919, pp. 94–95, pl. 36; for Luco, see Calleja and López 1990. For examples in illumination see Neuss 1931, vol. 2, pls. 43 (below: with tablecloths; some altars with piers and four legs), 46, 53, 59 (above), 70 (left).
10. For the excavation, see Larrén 1985, p. 117, plan 2. Larrén considers the table legs as part of the version from the second Mozarabic phase. For Asturian block altars, see Schlunk 1980a, pp. 160–61. For the general evolution of the altar table see Braun 1924, vol. 1, pp. 125ff.; concerning Spain see especially pp. 155, 157, 165.

LITERATURE: Gómez-Moreno 1919, pp. 159–61; Schlunk 1965, pp. 923–25, pls. 24, 25; Iñiguez Herrero 1978, pp. 167–252; García Lobo 1982, p. 62.

77

chancel screen panel

Monastery of San Miguel de Escalada (León), 913
Limestone
36⅛ x 22 x 9½ in. (93 x 56 x 24 cm)
Monastery of San Miguel de Escalada

Many Visigothic and Mozarabic churches had elaborate chancel screens that divided the nave from the choir and the clergy in the choir from the celebrant of the Mass. No longer in situ, four panels from the church of San Miguel de Escalada screen are now displayed in the passageways leading from the side aisles to the transept.[1] Altogether, nine of the screen panels survive, plus fragments of one or two others. They were originally created in pairs (the presumed counterpart to the present panel is preserved only in fragments). Their fronts are richly decorated with reliefs, while their backs were polished smooth. In each case the monolithic panel consists of a "post" and a "grid" (see the screen from Santianes de Pravia, cat. 64). The post is located on the side of the panel that was unattached, while the opposite edge was anchored with a flange in some architectural element. From the carefully polished surface of the panel's two components—the post and the grid—rises the sharp-edged, chisel-carved relief with detailed and lively designs. The compartments of the grid pattern contain birds pecking at bunches of grapes or their own feet (some of these are only partially preserved at the right), a shell, palmettes, and foliage designs, including grapes. The post panel contains a severely symmetrical tree with branching, many-pointed half-leaves describing elegant curves. Confronted birds peck at bunches of grapes either beneath their feet or above their heads. A small palmette inscribed in a circle crowns the whole.

There is a delightful homogeneity to the decoration of San Miguel de Escalada as a result of the repetition of style and motifs in the stucco and limestone friezes that adorn the choir area, the altars, and the capitals. On

one of the panels there persist traces of a fine, white chalky coating painted in polychromy. There, the bodies of the birds, for example, once had alternating red and green stripes, in a manner that is somewhat related to that of the León Bible of 920 (León Cathedral, Cod. 6).[2] Doubtless the present slab was also painted,[3] as were the friezes and capitals, on which there are still traces of red and black. It is only in rare instances that the chalky coating has survived the weathering of centuries, yet all Mozarabic architectural decoration may have once been brightly colored. This was probably also the case with churches from as early as the Visigothic period, though as yet we have no proof. In Mozarabic buildings, however, color was chiefly displayed in the wall paintings (see, for example, the churches of Santiago de Peñalba and San Cebrián de Mazote).[4]

The screen panels from Escalada form the largest and latest group on the Iberian Peninsula.[5] In their decoration they combine Umayyad elements with motifs found both in Visigothic examples from the second half of the sixth to the late seventh century and in Byzantine parallels and their Asturian adaptations.[6] Scroll trees are not uncommon on Visigothic pillars;[7] however, the design on the present piece, with a central trunk, is a type that originated in al-Andalus (see, for example, a relief pillar in Madinat al-Zahra', with a two-ribbed trunk emerging from a base leaf and ending in a calyx and standing bunches of grapes).[8] Filling the squares of the grid with a variety of motifs also seems to have been inspired by Islamic decorative practice (see, for example, the minbar and mihrab of the Great Mosque in Kairouan).[9] The grid pattern itself was probably adopted from Islamic models. A pierced grid can be found in a window grille in the Great Mosque in Córdoba; a stucco relief grid decorates the wall panels of a building in the eastern Umayyad palace complex at Khirbat al-Mafjar; and a grid with slight variations ornaments the above-mentioned minbar at Kairouan.[10] Yet there is a Byzantine precursor for the grid as well, namely a pierced marble chancel screen from the church of San Vitale in Ravenna, which was produced in Constantinople.[11]

What distinguishes the Mozarabic treatment of such motifs is the degree of abstraction (see, for example, the braided border of the main altar of Escalada). In contrast to the examples mentioned above the effect of the interlacing of the grid is wholly impressionistic.

In terms of iconography these various images are to be read as symbols of paradise. To the faithful in the nave and the attending clergy in the choir, the screens provided visual testimony to the promise of the Mass being celebrated in the sanctuary they veiled from view. S N - H

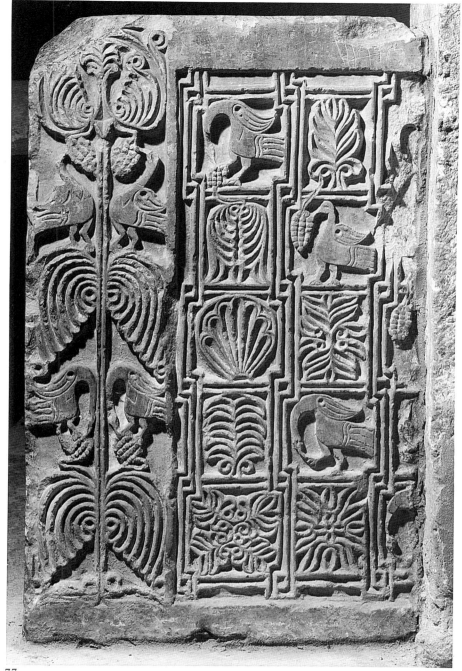

77

1. Larrén 1985; Gómez-Moreno 1919, p. 158.
2. Williams 1977a, pl. 3, p. 44. For friezes and capitals see also Schlunk 1965, pp. 921–23, pls. 18–21; Schlunk 1974, pp. 129, 130, pls. 56, 57.
3. Gómez-Moreno 1919, pl. 51: countless traces of the chalk layer, now partly lost as the result of cleaning, are still visible.
4. Regueras 1990, pp. 47f.
5. From the following period only a few isolated fragments survive, such as the one from San Adriano de Boñar (Gómez-Moreno 1919, pp. 163–64, pl. 55 [top]).
6. For animals in grids, see Ulbert 1971, p. 28; for the individual forms of the birds and grape clusters, see the reliefs in San Pedro de la Nave (Schlunk and Hauschild 1978, pp. 226, 227 [referring to pl. 133b]) and the closely related Oviedo window grille (Fontaine 1973, pl. 143); for the form of the shell, see San Juan de Baños (Schlunk and Hauschild 1978, pl. 105); foliage forms of a related type are found on relief slabs from the Iberian Peninsula dating from the second half of the sixth century on (for example,

Barcelona, Tarragona; see Schlunk and Hauschild 1978, pls. 60, 61), and more precise parallels can be seen on a relief from the seventh century in Lisbon (ibid., pl. 117), though Fontaine (1977, caption to ill. 66), seeing the palmette forms of the Escalada slabs as "unfamiliar to the Hispanic precursors of the Escalada sculptors," is doubtless correct. Compare Schlunk 1965, p. 923, pls. 22, 23; Schlunk 1974, p. 130, pls. 58, 59.
7. Pijoán 1942 (figs. 580–82) compares the slab in the tympanum with a Visigothic-era pillar in London and concludes that they are contemporaneous. In doing so, however, he overlooks a number of significant discrepancies.
8. Noack 1987, pl. 1a; Schlunk 1965, p. 923, fig. 5; Schlunk 1974, p. 130, pl. 59; for the step from the vine to tree, see Bab al-Wuzara', a west door of the Great Mosque at Córdoba. See Fernández Puertas 1979–81, fig. 2. For Islamic trees with realistic birds, see Gómez-Moreno 1951, figs. 272b, 369a, 369b.
9. Schlunk 1974, p. 130. See also Noack 1987, pp. 587–88.

10. In Córdoba, see Brisch 1966, pl. 4, no. 5a. Also related to this is a Mozarabic window grille from the portico of San Salvador de Valdediós, for which see Schlunk 1965, pl. 8, fig. 9. For Mafjar, see Hamilton 1959, fig. 140. For Kairouan, see Fontaine 1977, fig. 23; Schlunk 1974, pl. 58.
11. Deichmann 1969–89, vol. 1, p. 71, fig. 79.

LITERATURE: Gómez-Moreno 1919, pp. 158–59; Gómez-Moreno 1951, p. 372; Schlunk 1965, p. 923, pls. 22, 23; Palol and Hirmer 1967, p. 52, pl. 45 (other Escalada chancel barriers); Schlunk 1974, p. 130, pls. 58, 59; Fontaine 1977, pp. 87, 133–34, pls. 24, 25–28 (group of Escalada chancels); Rollán-Ortiz 1983, p. 14, figs. 14–16 (general); Watson 1989, vol. 1, p. 82.

78

COMMENTARY ON THE APOCALYPSE BY BEATUS AND COMMENTARY ON DANIEL BY JEROME

Monastery of Tábara(?) (León), ca. 940–45
Tempera on parchment
15¼ x 11¼ in. (38.7 x 28.5 cm)
Pierpont Morgan Library, New York (MS. 644)

Because of its early date and the richness of its pictorial content, this copy of the Commentary on the Apocalypse, a text compiled by the monk Beatus about 776 at Liébana and known to us from twenty-six illustrated copies, has always been recognized as a particularly valuable witness to the long tradition of illustrated Commentaries (see cats. 79–82, 143, 145, 147, 153, 154). Its colophon is unusually informative:

Let the voice of the faithful resound, and re-echo! Let Maius, small indeed, but eager, rejoice, sing, re-echo and cry out!

Remember me, servants of Christ, you who dwell in the monastery of the supreme messenger, the Archangel Michael.

I write this in awe of the exalted patron, at the command of Abbot Victor, out of love for the book of the vision of John the beloved disciple.

As part of its adornment I have painted a series of pictures for the wonderful words of its stories so that the wise may fear the coming of the future judgment of the world's end.

Thus this book from beginning to end is completed in the era of twice two [and] three times three hundred and three times twice ten.

Be glory to the Father and to his only Son, to the Holy Spirit and the Trinity from age to age to the end of time.[1]

The Maius identified here as author of a series of pictures was to be buried in the Leonese monastery of Tábara and was the chief scribe of its important scriptorium. However, the colophon makes clear that this

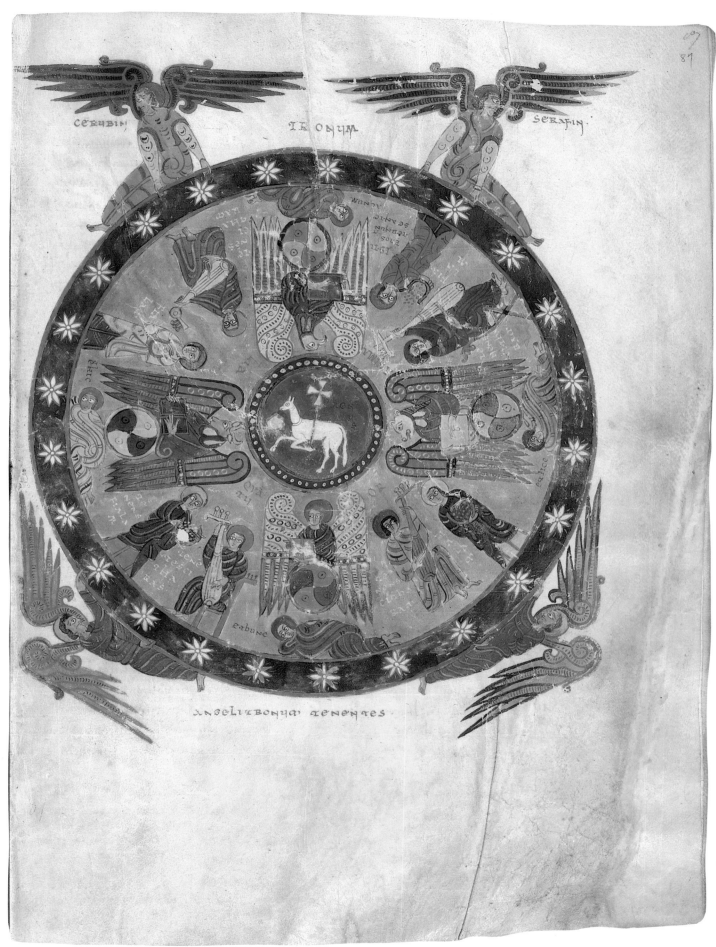

78: fol. 87. The Adoration of the Lamb

copy was destined for a monastery of Saint Michael, headed by an Abbot Victor. Maius attempted to present a date in cipher form in the colophon; the text, which includes an erasure, reads 926. From the evidence of other illuminated manuscripts, however, this is an impossibly early date. Striking similarities with the Moralia in Iob written in 945 by Florentius in the Castilian monastery of Valeranica (cat. 84) suggest that the Morgan Beatus is a contemporary, but slightly older, product. The numerous parallels between the illustrations of the Book of Daniel in the Valeranican Bible of 960 (cat. 108), for which Florentius probably supplied the model, and the Daniel pictures in the Morgan Beatus suggest that Maius must have been familiar with work by Florentius.

The interlace initials of the Morgan Beatus are different from Florentius's, however, and are based on formulas elaborated at the French monastery of Saint-Martin de Tours in the ninth century. Manuscripts from this important Gallic scriptorium may also have inspired the introduction of frames around the miniatures and of banded, polychromatic backgrounds; the Morgan Beatus constitutes the earliest surviving evidence of these innovations in the Beatus pictorial tradition. Although the Morgan Beatus cannot be confirmed as the first manuscript incorporating the format of banded grounds and numerous whole-page or double-page illustrations with frames—a departure from the more modest original Beatus format of frameless column pictures—it is probable that Maius was responsible for these reformulations. The formal language of intense colors juxtaposed in small compartments and the virtually total suppression of space and volume are typical of tenth-century Spanish illumination, usually termed Mozarabic, whereas Maius's figures have a complexity that seems to echo a more plastically conceived style.

The colophon offers the most explicit acknowledgment of the purpose of the some one hundred pictorial restatements of the texts of the Apocalypse and of the Commentary of Saint Jerome on the Book of Daniel that adorn the book: they are meant to sharpen the monks' awareness of the inevitability of the Last Judgment. JWW

1. Translation by E. A. Lowe (files, Pierpont Morgan Library, New York).

LITERATURE: Neuss 1931, pp. 9–16; Williams and Shailor 1991; Williams 1993, vol. 2, no. 2.

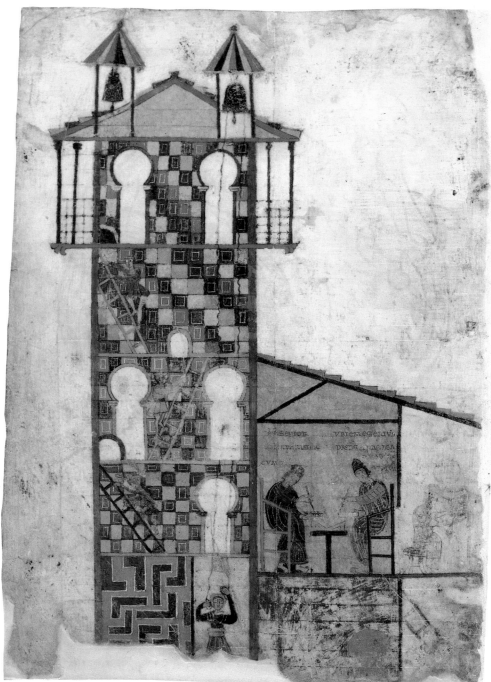

79: fol. 168. The tower and scriptorium of San Salvador de Tábara

79

commentary on the apocalypse by beatus and commentary on daniel by jerome

Monastery of Tábara (León), 970
Tempera on parchment
14⅛ x 10 in. (36 x 25.5 cm)
Archivo Histórico Nacional, Madrid (Cod. 1097B)

Although this Beatus Commentary has lost most of its illustrations, it has a signal role in recovering the history of the tradition. Among its surviving miniatures is a unique colophon consisting of an image of a tower with a scriptorium on its second floor (fol. 168r). This is the oldest surviving portrayal of a medieval scriptorium. Here three individuals are depicted at work. At the right one sits and cuts parchment with shears. A writing figure in the main room is identified as Emeterius, who was in charge of bringing the copy to completion, according to the written colophon (fol. 167). Facing him is another scribe labeled Senior, a monk involved five years later in the production of the Girona Beatus (cat. 80) at the same scriptorium of Tábara.

The written colophon provides a history of the manuscript's origin:

O truly blessed man, whose body lies in a coffin in the cloister and who wished to see the book brought to completion and bound. This was Magius, priest and monk, the worthy master painter. He gave up the work he began when he went eternally to Christ on the feast of Saint Faustus, the third day before the ides [October 13]. The calends of November had their third day before he departed out of time, era 1006 [October 30, 968]. Then I, the monk Emeterius, formed by my master, Magius, was called to the monastery that was raised under the protection of the Savior when they wished to complete the book for the most exalted Lord, and I took it up once more. From the calends of May [May 1] to the sixth calends of August [July 27] I completed the book in all its authority. May he deserve to be crowned with Christ. Amen. O tower of Tábara, tall and of stone, the first place where Emeterius sat for three months bent over and with all his limbs maneuvered the pen. The book was finished the sixth calends of August era 1008 [July 27, 970], in the ninth hour.[1]

From this colophon it can be deduced that Magius, the scribe illuminator of the Morgan Beatus (cat. 78)—the oldest surviving Commentary in the expanded pictorial format that came to be associated with the tradition—was a monk at Tábara. Senior's presence suggests that the Girona Beatus of 975 (cat. 80) also was a product of Tábara. The very prolixity of the colophon confirms, as if the depiction of the scriptorium did not, Tábara's importance in the realm of manuscript production. None of these three Commentaries is a replica of the other. Despite the involvement of Maius/ Magius in both the Morgan Beatus, copied several decades earlier, and the present Beatus, color and even composition are notably different, and the glorification of Magius in the colophon must be seen more as a tribute to the eminent, founding(?) painter of the scriptorium than as an actual record of its production.

The Tábara Beatus eventually played a role in the final efflorescence of the Beatus tradition in the kingdom of Castile. As is immediately apparent from the tower of Tábara's portrayal, it was the very manuscript used in 1220 as the model for the Beatus associated with the convent of Las Huelgas outside the capital of Burgos and now in the Pierpont Morgan Library (cat. 147). To judge by extraordinary parallels in both text and pictures, it was also the inspiration for the Commentary of about 1175 now in the John Rylands University Library, Manchester (cat. 154).

<div style="text-align: right">JWW</div>

1. My translation.

LITERATURE: Crespo 1978; Mentré 1986; Galtier 1988; Williams 1993, vol. 2, no. 5.

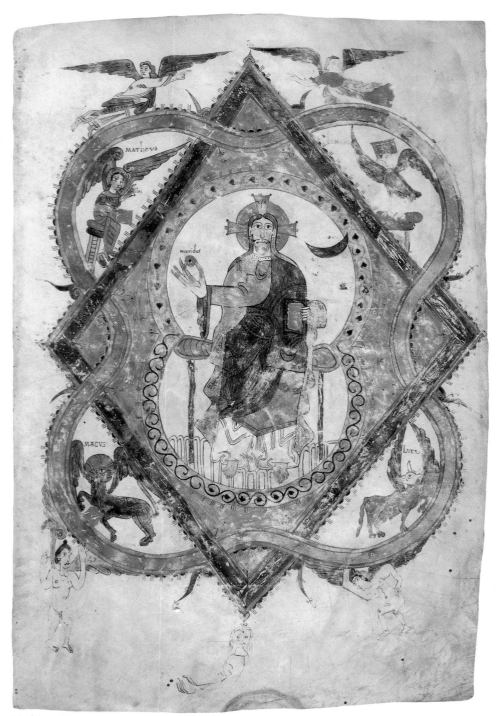

80: fol. 2. Christ in Majesty

80

commentary on the apocalypse by beatus and commentary on daniel by jerome

Monastery of Tábara (León), 975
Tempera on parchment
15¾ x 10¼ in. (40 x 26 cm)
Museu de la Catedral de Girona (7[11])

This is one of the most richly decorated of the Beatus Commentaries, and one of the best documented. At the conclusion of the text (fol. 284) the reader is told that "Presbyter Senior wrote it." Above the majestic Omega of the verso the patron is identified: "Abbot Dominicus had the book made." Below the Omega "Ende painter and servant of God" and "Emeterius monk and presbyter" are named as the illuminators. The colophon

continues with the notice that "the book was successfully completed on Tuesday, July 6. In those days Fredenando Flaginiz was at Villas, the Toledan town, fighting the Moors. The year was 975." By 1078 this Commentary was at Girona Cathedral, but its origin was Leonese. Emeterius and Senior were, surely, the monks involved in the copying of a Beatus Commentary five years earlier at the monastery of Tábara (cat. 79). The team had now been augmented by a new painter, Ende, whose title "depintrix" identifies her as a woman. It is probable that she was a nun, but we have no confirmation of this. As far as we know, Tábara was not a duplex monastery housing monks and nuns.

The Girona Beatus displays a singularly broad range of images. Seven pages (fols. 15–18) present the largest cycle of scenes of Christ's life, from the Annunciation to the Resurrection, known to Spanish art by 975. They include Apocryphal subjects not found elsewhere that must be based on ancient, unknown traditions. The sources of the Cross (fol. 1v) and Majesty (fol. 2) frontispieces are not obscure: details on these pages originated in the illustrated biblical manuscripts produced early in the ninth century at Saint-Martin de Tours. The figure style of the Girona Commentary also seems to reflect developments north of the Pyrenees. Yet at the same time this manuscript reveals a degree of knowledge of Islamic iconographic traditions unmatched in other Spanish Commentaries. The mounted warrior spearing a serpent (fol. 134v), the mythical Senmurv (fol. 165v), the animal hunts, and the musicians found in the Girona Beatus also occur among the subjects carved on ivory boxes from Córdoba (cat. 39) and painted on the ceiling of the Norman palatine chapel at Palermo in the twelfth century by Muslim artists. These celebratory themes belonged to a Mediterranean tradition that served Muslim and Christian alike.

JWW

LITERATURE: *Sancti Beati a Liébana* 1962; *Beati in Apocalipsin* 1975; Growden 1976; Yarza 1986a, p. 124, no. 63; Williams 1993, vol. 2, no. 6.

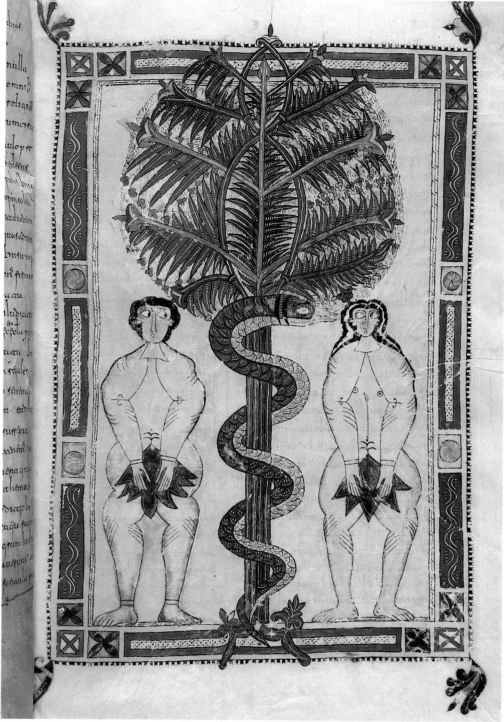

81: fol. 18. Adam and Eve

81

commentary on the apocalypse by beatus of liébana

Monastery of San Millán de la Cogolla(?) (Logroño), ca. 1000
Tempera on parchment
13¼ x 8⅞ in. (33.5 x 22.5 cm)
Patrimonio Nacional, Biblioteca de El Escorial (&.II.5)

Like the Burgo de Osma Beatus (cat. 82), this copy of the Beatus Commentary represents the earlier of two families of texts—the one that does not include in its family tree an ancestor with such Mozarabic features as horseshoe arches, banded backgrounds, and polychromy, features seen in the Morgan Beatus (cat. 78) and other Leonese Commentaries. Another mark of its family-one status is our manuscript's failure to conclude with Saint Jerome's Commentary on the Book of

Daniel. Even so, it shares with the Mozarabic copies a suppression of any sense of plasticity and illusionistic space, depending rather on complex surface patterns and such expressive details as wide, staring eyes and emphatic gestures.

Nevertheless, this Beatus has a distinctive style. The heavy frames employed for the illustrations are unable to retain the compositions they surround, and figures overlap the frames in configurations that crowd the text. Opaque,

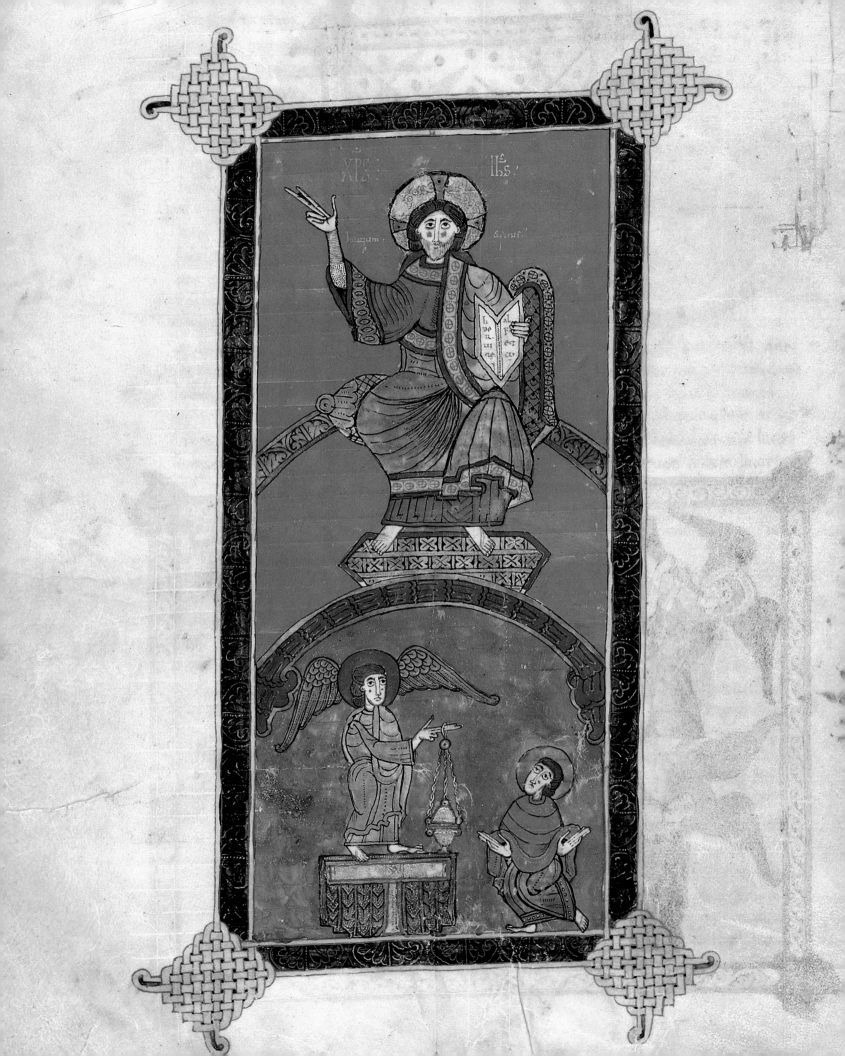

dark colors, frequently brown and green, are relieved by juxtaposition with yellow grounds. A comparison of the Escorial Beatus with the great conciliar Codex Aemilianensis, which was copied in San Millán in 994 (cat. 83), provides the most compelling evidence that this Commentary was probably executed at San Millán de la Cogolla. A peculiar formula for rendering faces, in which the nose—with a single nostril depicted as an undulating line—and one eyebrow are delineated as straight lines that meet at a right angle, is found in both manuscripts. Another persuasive sign that San Millán was the home of our Commentary is the Christ carried in a mandorla in its illustration of the Heavenly Throng Praising God (fol. 142v). A similar bust-length depiction of Christ, with distinctive waves of locks resting on his shoulders, is seen in an initial in the Aemilianensis and in another manuscript from San Millán.[1] Finally, the portraits of Adam and Eve, which take the place of the Map of the World in our Beatus (fol. 18), have a counterpart in the Aemilianensis.[2]

JWW

1. Silva 1984, fig. 10.
2. Ibid., pl. 15.

LITERATURE: Klein 1976, pp. 438 n. 7, 559 n. 107; Díaz 1979, pp. 207–9; Silva 1984, pp. 61–64, 116–19; Williams 1993, vol. 3, no. 10.

82

COMMENTARY ON THE APOCALYPSE BY BEATUS OF LIÉBANA

Monastery of Santos Facundo y Primitivo, Sahagún (León), 1086
Tempera on parchment
14 x 8⅞ in. (36 x 22.5 cm)
Cathedral Archive, Burgo de Osma (Cod. 1)

The citation of the year 1086 in a note within the text on folio 10v probably refers to the year this Commentary was undertaken. The precise day provided there—*III n[ona]s In.*—might mean either January 3 or June 3; because milder temperatures meant better working conditions in the monastery, it was probably the latter. On folio 138v in a request for commemoration—MEMENTO MEI PETRUS CLERICUS SCRIPSIT—a Petrus is identified as the scribe. Although he had the major responsibility for the writing of the manuscript, variations in the script reveal the assistance of several others. A different name appears at the end of the manuscript beneath the omega of folio 163r: *Martini Peccatoris Mementote*. It is reasonable to identify this Martin as the illuminator. No place of execution is specified, but the character of the writing and the

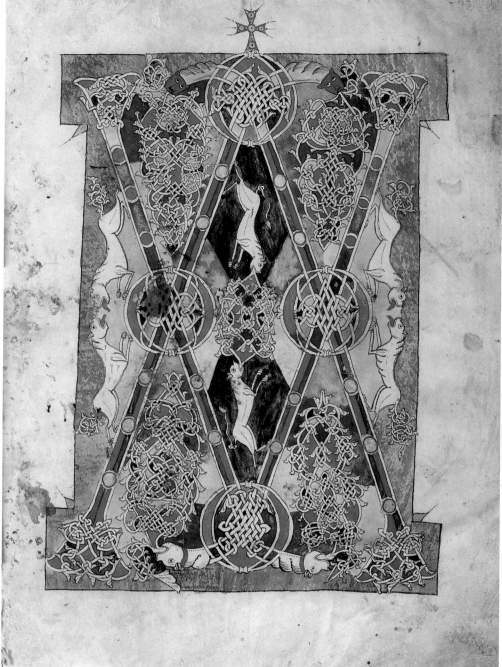

82: fol. 1. Alpha page

provenance of fragments of a replica of this Commentary in the Archivo de la Chancellería in Valladolid (Pergaminos, Carpeta 1, nos. 26, 27) leave no doubt that it was carried out at the important Leonese monastery at Sahagún.[1] In 1086 the abbot of Sahagún was Bernard d'Auch, a former Cluniac monk. Just how the Osma Commentary subsequently arrived in Burgo de Osma, a see founded only in 1101, is not known. However, the first bishop of Burgo de Osma, Peter of Bourges, had been recruited by Bernard and was appointed archdeacon in Toledo when Bernard became archbishop there. Perhaps Bernard and Petrus were instrumental in the transfer of the Commentary to Burgo de Osma from Sahagún,

with its Cluniac connections.[2] An ancient link between Osma and the Beatus tradition stems from Beatus's having served as the mentor of a bishop of Osma, Etherius, who helped Beatus compose his reply to the unorthodox pronouncements on the nature of the Godhead by the eighth-century archbishop of Toledo Elipandus. The final of three versions of the Commentary text produced during Beatus's lifetime carried a dedication to Etherius.

This copy, however, represents the earliest of the textual traditions of Beatus's Commentary, a fact that explains the absence of the particolored banded backgrounds so prominent in the Commentaries of the Mozarabic

82: fol. 102v. Saint John's vision of Christ (Apoc. 8:2–5)

school. It may also explain the fidelity of the Map of the World (fols. 34v–35r) to the archetypal Beatus map, but the Burgo de Osma map's rich content and its inclusion of elements postdating Beatus's era suggest that it is less a faithful record of the archetype that Beatus had appropriated from Isidore's *Etymologies* than a learned re-creation of it.[3] Extraordinary inventiveness also characterizes the illustrations. Their revolutionary character is seen in the willingness to add details based on the biblical text (fol. 55v), to introduce versions of the *Majestas Domini* (fols. 73v, 102v), and to employ a decidedly Romanesque manner of articulating drapery patterns, including the flying fold (fol. 135r). The date of this copy of the Beatus Commentary on the Apocalypse, 1086, reveals the scriptorium of the monastery at Sahagún's acting as a foyer for the introduction of the Romanesque style in the painting of the Iberian Peninsula, a role played in the medium of sculpture by the workshop where the slightly later sarcophagus of Alfonso Ansúrez (cat. 107) was made. J W W

1. Shailor 1992.
2. Williams 1992c.
3. Moralejo 1992b.

LITERATURE: Neuss 1931, vol. 1, pp. 37–38; Rojo 1931; *Apocalipsis Beati Liebanensis* 1992.

83

CODEX AEMILIANENSIS

Monastery of San Millán de la Cogolla (Logroño), 994
Tempera and gold on parchment
18 x 12 in. (45.7 x 30.5 cm)
Patrimonio Nacional, Biblioteca de El Escorial
(Cod. d.1.1)

The great collection of the decrees of seventy-three Spanish, Greek, African, and Gallic church councils included in the Codex Aemilianensis was the central reference work for the Spanish church. The interweaving of civil and ecclesiastical concerns and the inclusion of the text of the Visigothic Book of Decisions (*Liber Judiciorum*) in the canons of the Spanish, more particularly Toledan, councils meant that these canons could function as something of a constitution. The councils of Toledo, the capital, were of special importance in this respect, and that series opens with a full-page portrayal of the "royal city" (fol. 129v) and its churches of Saint Mary and Saint Peter, as well as an assemblage of clerics above the tents that served as shelters.[1] With the new political and ecclesiastical alignments of the end of the eleventh century the relevance of the Spanish canons would be undermined.

This copy was made in 994,[2] in the Navarrese

83: fol. 129v. Depiction of Toledo

monastery of San Millán de la Cogolla. Although offering variations and endowed with several additional illustrations, it is a virtual replica, in text and pictures, of a conciliar codex completed in 976 by the monk Vigilanus in the nearby monastery of San Martín de Albelda.[3]

Most of the illustrations are unframed and appear at the head of the texts of the councils. In each of them a bishop or a ruler, distinguished by a miter or a crown, addresses a group of clerics. Others are full page and framed. At the end of the text (fol. 453) a page is devoted to portraits.[4] The Visigothic kings Chindaswinth, Receswinth, and Eciga, the rulers responsible for the *Liber Judiciorum*, stand within framed spaces in the uppermost

register of this page. In the central register the Navarrese king who reigned at the time of writing, Sancho II Garcés (r. 970–94), stands between his queen, Urraca, and her brother Ramiro. In the lowest register Bishop Sisebutus is flanked by those responsible for the production of the manuscript: Belasco, the scribe, and Sisebutus, the notary, each of whom puts a stylus to a tablet, receive dictation from the seated bishop. It is a composition echoing others within the manuscript that illustrate the dictation of conciliar canons by kings and bishops. A comparable image, with rulers and jurists, opened the Breviary of Alaric (Bibliothèque Nationale, Paris; lat. 4404), a Gallic collection of laws of the first half of the ninth century.[5]

It is not obvious that this collection of portraits required the inspiration of some earlier model, and the cross of folio 16v[6] belongs to a well-established Spanish tradition. However, the *Maiestas Christi* (fol. 13v),[7] where Christ, enclosed within a diamond-shaped frame, sits upon a globe and holds in his hand the small disk of the eucharistic wafer, is clearly indebted through these details, as is the Christ in Majesty of the Girona Beatus (cat. 80), to a formula that originated in the ninth century in the Carolingian scriptorium of Tours.[8] A Lamb in Majesty with the symbols of the evangelists closes the manuscript (fol. 454).[9] Neither it nor the radial composition of bishops in our manuscript (fol. 392v)[10] is found in the Albelda copy. Although only twelve unidentified bishops are represented on our page, this picture appears with a text listing Spanish sees and sixty-eight bishops. The number twelve and the circular scheme employed in the illustration suggest for the Spanish church a universality and perfection far different from its actual state on an occupied peninsula.[11]

The style employed for the figures lacks the more rational details of that in the copy from Albelda, where there is some suggestion of plasticity and the design of drapery is frequently related to bodily structure. In contrast, in the Aemilianensis the figures are resolutely flat upon the page with drapery schemes that reduce cascading folds to jagged sawtooth patterns, and profiled faces are distorted to a degree approaching those in the León Bible of 920. On the other hand, the elaborate interlace initials and other instances of ornament are carried out with an exuberance and lavishness, in details such as the liberal distribution of gilt medallions, that make the Aemilianensis a grand climax of the tradition that emerged in León-Castile toward the middle of the tenth century.

JWW

1. Silva 1984, pp. 403–4, pl. XXII.
2. A marginal note on folio 453 seems to give the date of completion as "era T XXX," that is, as 1030 of the Spanish era, or 992. This date is frequently assigned to our manuscript, but the cipher has been shortened by the trimming of the margin, and it has been reasonably restored as era T XXXII, or 994 (Vives and Fábriga 1949, pp. 138–39).
3. Silva 1984, pp. 446–52.
4. Ibid., pl. XXVII.
5. Porcher 1965, p. 63, pl. XXVII.
6. Silva 1984, pl. XIII.
7. Ibid., pl. V.
8. See the Vivian Bible (Bibliothèque Nationale, Paris; lat. 1, fol. 329v), Mütherich and Gaehde 1976, pl. 23. For the influence of Tours in Spain, see Williams 1987.
9. Silva 1984, pl. VII.
10. Ibid., pl. XXVIII.
11. Werckmeister 1968.

LITERATURE: Antolín 1910, pp. 320–68; Menéndez Pidal 1958; Werckmeister 1968; Díaz 1979, pp. 155–61; Guilmain 1981, pp. 393–99; Silva 1984, pp. 68–72, 136–41.

84: fol. 2. Christ in Majesty with the symbols of the Evangelists

84

MORALIA IN IOB

Monastery of Valeranica (Castile), 945
Tempera on parchment
19¼ x 13¼ in. (48.8 x 33.7 cm)
Biblioteca Nacional, Madrid (Cod. 80)

While resident in Constantinople from about 580 to 583, Leander, the bishop of Seville and brother of Isidore, came to know Gregory the Great, whom he asked for a commentary on the Book of Job. The Moralia in Iob that resulted is a lengthy collection of sermons interpreting the text of Job in an allegorical manner. This commentary came to be a work of great influence in the monastic culture of Spain and elsewhere in Europe. As we know from its informative colophon (fol. 500v), this copy was finished on April 11, 945, at the Castilian monastery of Valeranica by the scribe and illuminator Florentius. Florentius was Spain's finest scribe, and the initials of the Moralia are the earliest surviving examples that reveal the revolution in the style of peninsular initials, wherein pre-Carolingian models were replaced by ones based on Carolingian illumination.[1] At Valeranica, presumably at the initiative of Florentius, Carolingian prototypes were supplied by the Franco-Saxon school. Florentius's portrait stands with that of his disciple, Sanctius, at the end of the

Bible of 960 (cat. 108), another product of Valeranica. In the Moralia, too, there is an Omega (fol. 501) with two figures, in this case anonymous, that prefigure the scribal portraits of the Bible.

The Moralia was never associated with a canonical set of images, and the pictures attached, chiefly as a series of frontispieces, to this luxurious copy suggest an ad hoc assemblage rather than the faithful copying of a set encountered in the model for the text. Gregory interpreted Job as a Christ figure, and the illumination is dominated by a christological theme. The Alpha (fol. IV) and Omega (fol. 501) are inspired by the text of the Apocalypse, or Book of Revelation: "'I am the Alpha and the Omega,' says the Lord God, who is and who was and who is to come, the Almighty" (1 : 8). Although peninsular illumination would be identified with the Apocalypse through the Commentary by Beatus, this is the first surviving pictorial version of the subject produced in Spain. The first surviving example in Spanish illumination of another subject, a *Majestas Domini*, follows the Alpha (fol. 2). The striking similarity between this composition and the Adoration of the Lamb in the Commentary on the Apocalypse carried out for Escalada by Maius (cat. 78) suggests that it was inspired by a copy of the Beatus Commentary. The Chi-Rho (fol. 2v) that follows enhances the christological nature of the iconography, but in a more traditional peninsular form than in the *Majestas Domini*. The page opposite (fol. 3), on which Florentius asks to be remembered in a typical scribal way, FLORENTIUS INDIGNUM MEMORARE, also uses the compositional formula of the acrostic, or labyrinth, which was popular in the peninsula. The full-page peacock of folio 3v is extraordinary. Like the page with medallions in the Bible of 920 (fol. 3v),[2] it can best be compared to medieval mosaic floors, although Byzantine and Islamic textiles were also prominent carriers of the motif. With its traditional symbolic reference to the Resurrection and paradise, the peacock could function christologically.

The lengthy colophon of folio 500v ends with a poetic lament for the tribulations of scribes: "A man who knows not how to write may think this no great feat. But only try to do it yourself and you shall learn how arduous is the writer's task. It dims your eyes, makes your back ache, and knits your chest and belly together—it is a terrible ordeal for the whole body. So, gentle reader, turn these pages carefully and keep your finger far from the text. For just as hail plays havoc with the fruits of spring, so a careless reader is a bane to books and writing."[3] That it was copied word for word in the Silos Beatus (cat. 145) may mean that some lost Valeranican Beatus

Commentary served as the model for that work.

On the original guardian page of the Moralia (fol. 1) is a small, undecorated note in Arabic declaiming: بسم الله الرحمن الرحيم (In the name of God, the merciful, the compassionate!). Another, illegible, appears on the last folio (fol. 501v). Although Valeranica has been considered a Mozarabic foundation because a monk mentioned in the colophon of the Moralia is named Abogalebh, these notes were probably added when the manuscript was in the collection of Toledo Cathedral, its home before 1869, when it came to the Biblioteca Nacional. Arabic was the language of Christians in Toledo until the thirteenth century.

J W W

1. Guilmain 1981, pp. 376–80.
2. León Cathedral, Cod. 6; Gómez-Moreno 1925–26, vol. 2, fig. 82.
3. Grabar and Nordenfalk 1957, p. 168.

LITERATURE: Torre and Longás 1935, pp. 187–93; Williams 1970; Williams 1972–74.

85

BIBLIA HISPALENSE

Andalusia, mid-10th century
Tempera on parchment
17¼ x 13 in. (43.8 x 33 cm)
Biblioteca Nacional, Madrid (MS. Vit. 13-1)

From a note on the final folio (375v) we know that this Bible was originally owned by Bishop Servandus of Écija, who gave it to his friend Johannes, successively bishop of Cartagena and Córdoba, and that Johannes presented it to Seville Cathedral on December 23, 988. This date provides a terminus ante quem. The script, in an antique format of three columns, has sometimes been dated as early as the ninth century, but since the note providing the résumé of the history of the manuscript terms Servandus *auctor*, it is reasonable to ascribe the commissioning to him. Thus a date for the Bible of no earlier than a generation from the time of its deposit in Seville seems probable.

The surviving canon table, the final one of an original set of twelve(?), reveals that the Bible was made at a very capable scriptorium. Since its history points to an origin in al-Andalus, this is an example of a truly Mozarabic manuscript, that is, one carried out by Christians living within the territory dominated by Muslims. This cultural background is revealed by the bird and fish

capital at the head of the Book of Daniel (fol. 201v). The motif is common in Christian manuscripts, but the legend on the neck of the bird, "The Beginning of the Story of Daniel," is rendered in Arabic إنّبرأ خَبر دَنيَل.[1] The oriental nature of other elements of the ornamental vocabulary also indicates an Islamic cultural base. Thus the painted capitals of the canon table arcades prominently display cornucopias like those carved on Byzantine capitals and imitated in mosaic in the Dome of the Rock in Jerusalem.[2] They appear again in the manuscript medium in a sura heading in a tenth-century Koran.[3] The split acanthus filling the outer columns of the arcades of our canon table follows a pattern found in carving in the palace of Madinat al-Zahra' outside Córdoba.[4] None of these formulas appear in contemporary manuscripts copied in the Christian kingdoms of the north. Nor is there a counterpart in the so-called Mozarabic manuscripts of the north for the disciplined rendering of the symbols of Luke and John seen in our Bible. Since the ornament depended on models from al-Andalus, it is probable that the figures of the minor prophets Micheas (fol. 161), Nahum (fol. 162v), and Zacharias (fol. 165v), which, like the decorated initials of the manuscript, are drawn rather than painted, were also based on Islamic conventions. Because no painted figures from al-Andalus survive, this conclusion is no more than an assumption. It is an assumption that, at least, is not contradicted by the appearance of a head outlined in red on the wall of a passage at Madinat al-Zahra'.[5] The Biblia Hispalense, as our Bible is termed from its stay at Seville, offers a unique view into the artistic culture of Mozarabic Spain.

J W W

1. I am grateful to James Monroe for this translation.
2. Cresswell 1932, figs. 189, 178.
3. Pope 1938, vol. 5, pl. 930a.
4. Torres 1957, fig. 528.
5. Ibid., fig. 567. This head has virtually disappeared. An opposing view of the style of the prophets was offered by Werckmeister (1963a), who maintained that for ideological reasons it was deliberately non-Islamic and based on Visigothic traditions. His argument was founded in part on the perception, dating back to A. M. Burriel (d. 1762), that the Proemia of the Minor Prophets, Isidore's text, were added after the original writing and expanded to include the figures. It is not certain that this assumption is justified.

LITERATURE: Simonet 1903, pp. 627–28, 640; Millares 1931, pp. 99–130; Torre and Longás 1935, pp. 1–12; Werckmeister 1963a; Koningsveld 1977, p. 45; M. Sánchez Mariana, in New York 1985, pp. 47–49.

85: fol. 278. Canon table x

ROMANESQUE SPAIN

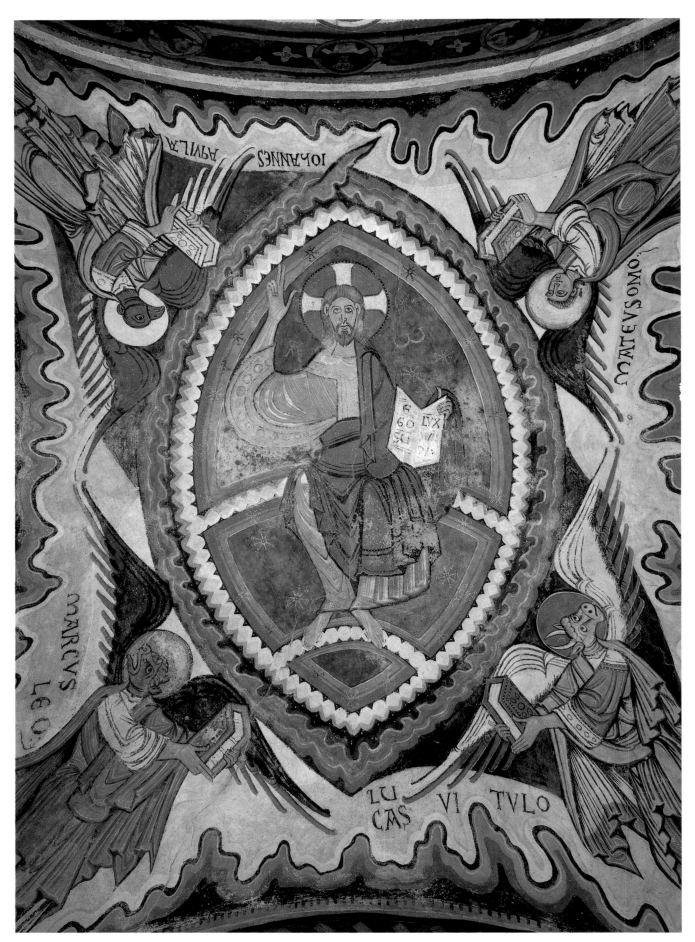

Fresco in the Pantheon of Kings showing Christ as Pantocrator with symbols of the Evangelists. San Isidoro, León. Photo: Joseph Martin

león and the beginnings of the spanish romanesque

John W. Williams

The kingdom of León encompassed the northwest corner of the Iberian Peninsula. It had begun as the kingdom of the Asturias, a narrow territory behind a range of mountains that after the invasion served as an effective barrier to Islamic occupation. The kingdom received its name early in the tenth century when the capital was moved south from Oviedo to León, a city whose name reflected its origin as the headquarters of a Roman legion in the first century. In the time between the mid-eleventh and the mid-twelfth century, which saw the decisive shift of power from al-Andalus to the Christian north, León was the most aggressive of the Christian states; it is the kingdom most responsible for bringing about that momentous change.

The city became a much more important capital under King Ferdinand I. His father, Sancho III (el Mayor) of Navarre (r. 1000–1035), had fashioned an empire in the states to the east of León, including the county of Castile, which was Ferdinand's legacy. In marrying Sancha, heir to the Leonese throne, Ferdinand became king of León as well and ruled over the combined kingdom of León and Castile from 1038 to his death in 1065. Emulating his father, he took steps to introduce European standards into his domain. Among the most visible of his Europeanizing initiatives was an alliance forged with the great Burgundian monastery of Cluny.[1] As a result of successful military campaigns which made Islamic cities such as Seville and Toledo his tributaries, Ferdinand and his son Alfonso VI (r. 1065–1109) were able to bestow enough gold on Cluny to pay for the erection of the huge culminating church there.[2] The gift was inspired by admiration for Cluny's spirituality, but the Europeanizing of Leonese culture was one of its most conspicuous results. In time Alfonso VI would marry Agnes, a daughter of the duke of Aquitaine; and on her death Constance, daughter of the duke of Burgundy and niece of Abbot Hugh of Cluny and King Robert of France; and on her death Berta, an Italian princess. It is true, of course, that León was one of the cities through which pilgrims passed on their way to the great shrine at Santiago de Compostela and that Leonese churches, including the palatine chapel of San Isidoro, reflected architectural developments in sites along that route from Toulouse to Santiago. But León's evolution as a center for artistic patronage was most powerfully fueled by royal initiatives and the intention to establish a palatine complex that would function as a visible sign of sovereignty. The consequences are to be seen in the works collected by Ferdinand and his descendants in León or disseminated to favored foundations, often at the instigation of female members of the royal family.

Although León had functioned as a capital for more than a century before Ferdinand's assumption of the throne, the new king converted the city into the kind of capital that Alfonso II had conceived for Asturias when he founded Oviedo about 800. One must assume that Ferdinand had the model of Oviedo in mind. By marrying Sancha, he took a place in the genealogy of the Asturian kings and inherited those claims to a special, if undefined, authority within the peninsula implicit in the fact that the title *emperor* was reserved for the kings of Asturias-León.[3] According to this neo-Gothic ideal, the kingdom of Asturias-León was the legitimate successor of the Visigothic kingdom of Toledo and had a special responsibility to restore the peninsula to its original condition as a Christian state. Ferdinand's rejection of his original identification with Castile in order to assume the mantle of Asturias-León is confirmed in an episode in a well-informed chronicle called the *Historia Silense*:

> Seeking an audience with Ferdinand, Queen Sancha persuaded him to build a church in the cemetery of the kings in León where their bodies too should be interred in state. Ferdinand had originally decreed that his burial would be in Oña [in Castile], a place he had always loved; then, in San Pedro de Arlanza [in Castile]. But since her father, Alfonso [V of León], of blessed memory, rested in Christ in the royal cemetery of León, as did her brother the most serene king Vermudo, Queen Sancha labored hard to the end that she and her husband might be buried with them after death. Acceding to the petition of his faithful wife, the king ordered builders to work assiduously on this worthy task.[4]

The dedication of this new palatine church, San Isidoro, took place on December 21, 1063, with the assistance of seven bishops of the realm and abbots of the important Galician and Castilian monasteries. Although the church was rebuilt in the twelfth century, its original foundations and some of its

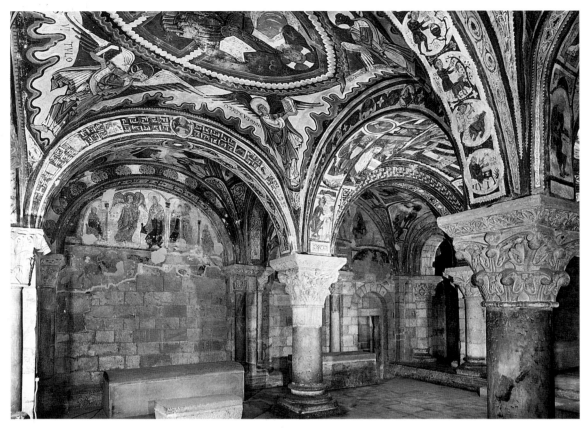

The Pantheon of Kings, San Isidoro, León. Photo: Hirmer Fotoarchiv

walls survive.[5] Its resemblance to the church erected at Valdediós more than a century and a half earlier by the Asturian ruler Alfonso III (r. 866–910) is further evidence that Ferdinand took his new rule very seriously. At the same time, León's link with the preinvasion past was signaled by the dedication of the new church to Saint Isidore, the learned seventh-century bishop of Seville. The translation of his remains from Seville to León effectively established the cult of Saint Isidore, who was converted from the literary figure whose encyclopedic *Etymologiae* could be found in almost every monastic library in Europe into a healer, a miracle worker, and eventually a warrior saint who assisted in the Reconquest of Spain. The neo-Gothic foundation of the decision to bring Isidoro's body to León is clearly revealed in the *Acts of Translation,* an almost contemporary account of the event, in which the translation of the remains, the building of the church, and the church's endowment with a grand treasury of costly liturgical objects and books are all glorified as acts contributing to the restoration of the Spanish church.[6]

Indeed, on the day after the dedication of their new palatine church, Ferdinand and Sancha donated to it furnishings and property of a scope that made clear the extraordinary nature of the palace complex.[7] The list of objects recalls, and rivals, that drawn up by Alfonso II in 812 for donation to the cathedral of Oviedo.[8] The gifts included a gold altar frontal encrusted with emeralds and sapphires, three silver altar frontals, three golden votive crowns, two other crowns of the re-

galia type (one of which was being worn at the moment of the donation), a crown presumably resembling the one worn by Ferdinand as depicted in the frontispiece of the diurnal commissioned by Sancha in 1055 (cat. 144), a chalice and paten of gold and gems, two gold censers, and a gold cross studded with jewels and enamels. Many luxury items were also named as gifts, including a number of textiles of Islamic manufacture.

Of all these items, only the "ivory cross with the effigy of the crucified Lord" bearing the names of Ferdinand and Sancha is certainly identifiable today (cat. 111). Other objects catalogued here, such as the gold and ivory casket of Saints John the Baptist and Pelagius (cat. 109), an ivory casket with an unusual iconography of the Beatitudes (cat. 117), and an ivory plaque with a Majesty and Saints Peter and Paul (cat. 112), cannot readily be recognized among the named translation gifts. Nevertheless they certainly were bestowed by Ferdinand and Sancha, whose largesse had begun at least as early as 1047, when they gave the church a lavish copy of the Commentary on the Apocalypse by Beatus of Liébana (cat. 143).

The stylistic homogeneity of these ivories points to the existence in León of an ivory workshop sponsored by the king. To be sure, in Córdoba there had ceased to be such an institution only half a century earlier. But for Christian kingdoms, this was an exceptional phenomenon; it indicates a peculiar concentration of patronage of the kind we associate with such imperial centers as Aachen and, in the eleventh century, the Ottonian capitals. In fact, objects in Ottonian treasuries have

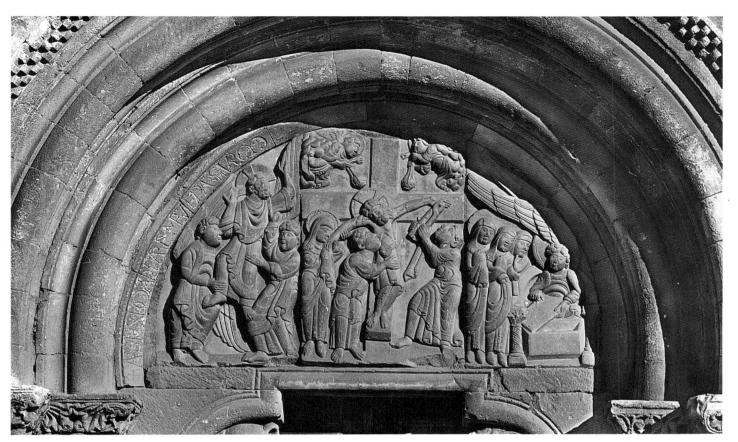

South transept portal showing the Deposition, the Three Marys at the Tomb, and the Ascension. San Isidoro, León. Photo: Hirmer Fotoarchiv

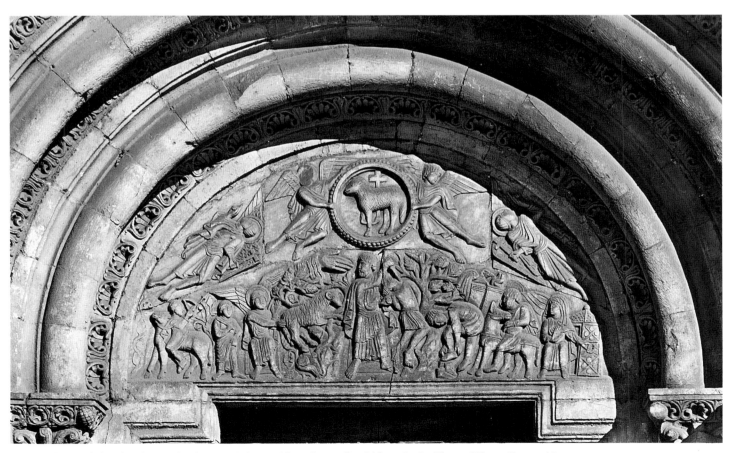

South aisle portal showing the Lamb of God and the Sacrifice of Isaac. San Isidoro, León. Photo: Hirmer Fotoarchiv

repeatedly been invoked in discussions of the ivories produced under Ferdinand. In at least one case, that of the *arca* of San Isidoro (cat. 110), the Ottonian connection is beyond debate. It is likely that Abbot Hugh of Cluny was the link between Ottonian artistic resources and Leonese consumption. The imperial pretensions of the Leonese dynasty make it reasonable to ask whether the dependence on Ottonian models went beyond the practical—turning to the European culture most richly endowed with traditions of *ars sacra*—to the symbolic, attempting to appropriate imperial associations.

The Leonese dynasty was explicitly equated with the Holy Roman one when Cluny accorded Ferdinand and Sancha, and after them Alfonso VI (r. 1065–1109) and his queens, the same extraordinary commemoration within the Cluniac liturgy that the Holy Roman emperors and empresses received.[9] With the urging of Abbot Hugh of Cluny and despite local opposition, Alfonso VI had seen to it that in León and Castile the standard Roman liturgy prevailed over the traditional Hispanic one. The eager reception afforded the new artistic language in León was a like phenomenon. A shift to European styles took place that was deliberate, rapid, and of Leonese inspiration. Its extent may be measured by the comparison of two manuscript illuminations: the Alpha page of the diurnal commissioned in 1055 by Sancha (cat. 144), and the Alpha page of the Beatus Commentary executed for Sancha and Ferdinand only eight years earlier (cat. 143). Although the Alpha of the 1055 work was surely modeled on that of the earlier manuscript, the Mozarabic style of the Beatus Commentary had been radically emended by the addition of details which closely reflect Gallic works north of the Pyrenees.

Another side of the imperial question is raised by the collection of Islamic boxes accumulated in the treasury of San Isidoro (cats. 44, 46, 47), even though none is recognizable in the 1063 inventory of objects. Fine Islamic work was valued in Ferdinand's time, as the sumptuous Islamic textiles lining caskets of the period make clear (cats. 109, 110), and it is likely that at least some of the boxes arrived during his reign. It may have been their primary attraction that they represented luxury of the highest order, making them worthy items of royal treasure or containers for saintly remains, but a political function as trophies, signaling the succession of their original owners by Christian ones, cannot be ruled out.

The decision to establish a dynastic center at León had stemmed from Queen Sancha's initiative, and the subsequent embellishment of the site also owed a particular debt to female members of the Leonese royal family. Urraca (d. 1101), the firstborn of Ferdinand and Sancha, took extraordinary interest in her parents' foundation. At his death Ferdinand bequeathed dominion over the monasteries of the realm to Urraca and her sister Elvira, who spent most of her life in Oviedo. The *Silense* goes out of its way to acknowledge Urraca's role as donor: "All of her life [Urraca] followed her desire to adorn sacred altars and the vestments of the clergy with gold, silver and precious stones." Many extraordinary items mentioned in the literature have disappeared, but a surviving chalice (cat. 118) testifies to both the sumptuousness and the Germanic forms of altar furnishings commissioned by Urraca.

On the strength of her epitaph there is good reason to assign Urraca a preponderant role in the expansion of the palatine complex. It states that she "amplified" the church and enriched it with gifts. The mention of amplification must be a reference to the so-called Pantheon of the Kings, the splendid narthex of six vaulted bays; it was once filled with dozens of eleventh- and twelfth-century tombs of members of the Leonese royal family, some of which are still there. Although for years this vaulted porch was seen as the funerary chapel built by Ferdinand to honor Sancha's request reported in the *Historia Silense,* modern scholarship tends to reject such a precocious date and places the pantheon in the 1080s, when Alfonso VI, Ferdinand's son and Urraca's brother, ruled. Even at this date, its set of compound piers with figured capitals represents an effort to build in a Romanesque style that is pioneering for the peninsula.

Before her death in 1101 Urraca may also have directed work on the large Romanesque structure that was replacing the modest church of Asturian style erected by her father. In the two public portals of San Isidoro the visitor was addressed by elaborate sculptural ensembles. Sculpture in the south transept portal, which illustrates the Ascension and the Marys at the Tomb, is in the style born in Toulouse and naturalized in Spain at Santiago de Compostela. The transept and its sculpture were installed by masons from Santiago in the second decade of the twelfth century, even before the church was completed. The chief portal, called the Portal of the Lamb, opened into the south aisle. It must have been designed and carried out earlier than the transept and is in a style associated with the churches of Frómista and Jaca. The capitals within again reproduce the styles of Frómista-Jaca and Toulouse (cats. 88, 90). San Isidoro was on the pilgrimage road. Despite the fact that royal interest and initiative gave León its creative framework, these are the styles that were subject to continual exchange along the road to Santiago, making it one of the places where Romanesque sculpture began.

Although the sculpted capitals in the Pantheon of the Kings had no wide-ranging influence, the monastery of Sahagún, south of León, which was highly favored by Ferdinand and the preferred residence of Alfonso VI, did play a role in the formation of a Romanesque sculpture style. At this site where ancient remains were almost obliterated during the last century, the surviving tomb of Alfonso Ansúrez (cat. 107) offers a glimpse of the first stage of the Frómista-Jaca school. Contemporary with that sculpture is the first manuscript of the Beatus Commentary illuminated in a Romanesque style; it was made at Sahagún in 1086 and is now in Burgo de Osma (cat. 82). Sahagún was under the rule of a former Cluniac monk, Bernard, who was instrumental in recruiting French

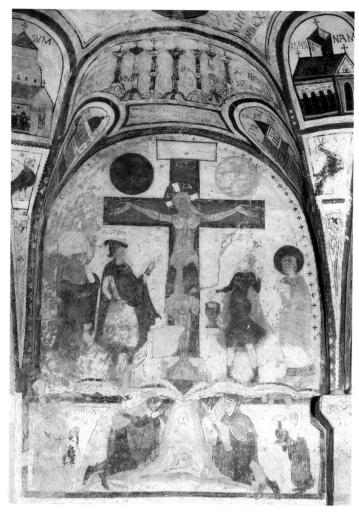

Fresco in the Pantheon of Kings showing the Crucifixion with Ferdinand and Sancha. San Isidoro, León. Photo: Joseph Martin

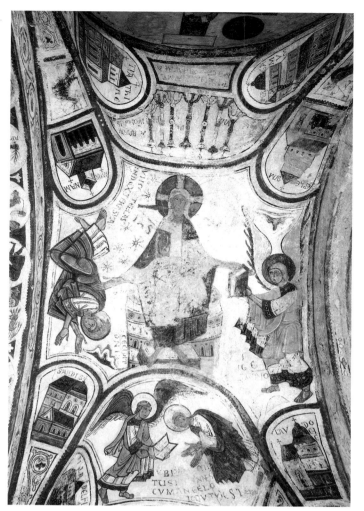

Fresco in the Pantheon of Kings showing John's apocalyptic vision of Christ. San Isidoro, León. Photo: Joseph Martin

clerics for positions on the peninsula. The thoroughly Gallic character of the Missal of Sahagún (cat. 148) shows that some of these were scribes and illuminators.

In 1086 Bernard became the first archbishop of Toledo since before the Islamic conquest. The capture of this ancient Visigothic capital by Alfonso in 1085 marked a momentous step in the campaign to reclaim the peninsula. León was publicly identified as the spiritual center of the Christian effort to recover the land, as is evident in the tympanum relief over the main entrance to the new, Romanesque, church of San Isidoro.[10] It illustrates Genesis, an unusual subject for tympanum sculpture anywhere, with a composition in which Isaac, destined to succeed Abraham as leader of the chosen people, is played off against his half brother Ishmael, regarded as the progenitor of the Arabs. The pivotal point of the composition is devoted to the offering of Isaac, the event that assured the elevation of Abraham's house in salvational history. God promised Abraham, "Your descendants shall possess the gate of their enemies" (Gen. 22 : 17), a pledge that was recalled in the Vigil of

Easter, part of the Catholic liturgy in which Ferdinand and Alfonso had been raised.

As genealogy underlay the Reconquest iconography of the tympanum, so does the genealogical, dynastic dimension of the Leonese enterprise emerge clearly in the frescoes that were painted on the walls and vaults of the Pantheon of the Kings early in the twelfth century. They are in a byzantinizing style then current in central France, and thus, like the treasury accumulated earlier, they proclaimed the European and modern nature of León's palace complex. Its founders, Ferdinand and Sancha, are explicitly honored: in the Crucifixion which concludes the series of Passion scenes, they are depicted kneeling at the foot of the cross. Less traditionally conceived is an allusion to the royal pair in the Apocalypse frescoes in the vault just above. The subject is the commissioning from Saint John of the Apocalypse, and the composition is specifically based on two illuminations in the Beatus Commentary commissioned by Ferdinand and Sancha in 1047 (cat. 143). Finally, when the Pantheon was added to the church of Ferdinand and Sancha,

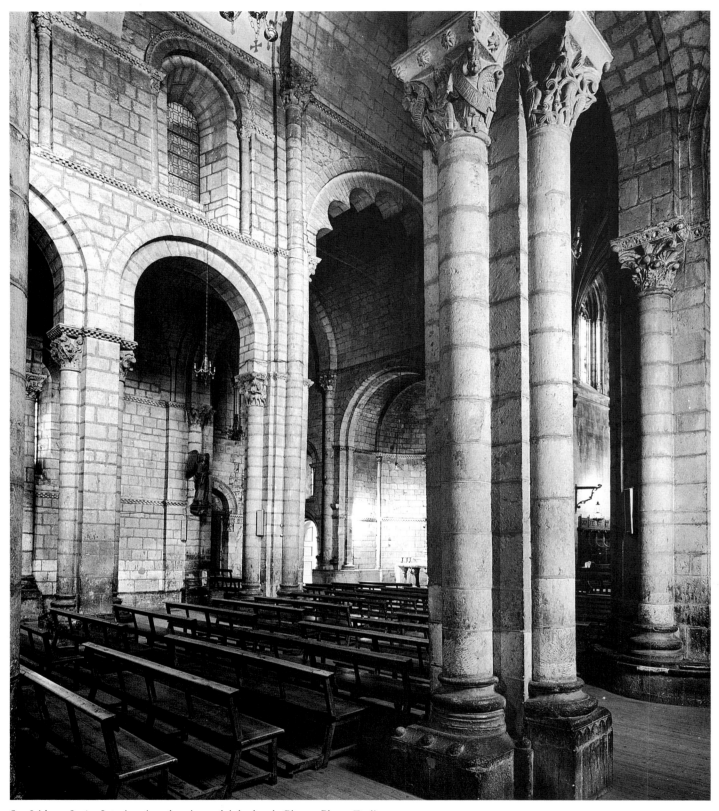

San Isidoro, León. Interior view showing polylobed arch. Photo: Photo Zodiaque

a carved inscription taken from the primitive church was prominently placed over the doorway, where it was inserted into the tympanum and framed by two painted angels:

This church which you see, formerly that of Saint John the Baptist, made of brick, was built of stone by the most

excellent King Ferdinand and Queen Sancha. They brought here from Seville the body of Archbishop Isidore. It was dedicated on December 21, 1063. Then on April 26, 1065, they brought here from Ávila the body of Saint Vincent, brother of Sabina and Cristeta. In that same year the king, returning here from the enemy forces before

Valencia, died on the 27th of December, 1065. Queen Sancha then dedicated herself to God.[11]

It is not certain that the frescoes were installed before Alfonso's death in 1109, but it seems likely. The reign of Urraca (d. 1126), Alfonso's daughter and his successor in 1109, was turbulent. Still, her principal residence was León, and the final stage of the basilica's construction, including the transept, must have been undertaken in the middle of her reign. Whereas history recorded her namesake as an extraordinary benefactress of church treasuries, Queen Urraca acquired a reputation, deserved or not, as a despoiler. According to the admittedly unsympathetic *Historia Compostellana*, in 1122 she "stripped the churches throughout her kingdom of their gold and silver and their treasures."[12] Indeed, on one page of the Valladolid Beatus (fol. 3r) a note states that in 1117 Queen Urraca stripped the silver from a cross given to the monastery of Eslonza by Elvira, daughter of Ferdinand. The *Chronicon mundi* by Lucas of Tuy, who had once been a canon at San Isidoro, puts Urraca and her husband, Alfonso I (of Aragon), el Batallador, at the center of an aborted attempt to appropriate wholesale the "crosses and chalices, images and reliquaries" from the treasury of San Isidoro. However, the account includes a clear reference to the chalice of Ferdinand's daughter Urraca, which in fact is still in place (cat. 118).[13] Behind these stories lies a demand for gold and silver to fund the war between Urraca and her husband. Moreover, the flow of tribute gold from Muslim princes had by then dried up.

Whether León continued to function as a center for ivory carving at that time is not known. The pair of ivory plaques with the Noli Me Tangere and other post-Passion scenes may have been a gift to San Isidoro during Urraca's reign (cat. 115). If the plaques are indeed examples of ivory carving still practiced in León long after Ferdinand's death, they demonstrate that the Germanic sources that provided models for the artworks in Ferdinand's treasury had subsequently been replaced by sources from Languedoc. A stylistically related ivory, although of slightly later date, is the Christ in Majesty on a pax in the Leonese treasury (cat. 113).

Urraca was succeeded in 1126 by her son Alfonso VII (d. 1157). The basilica must have been brought to completion during his reign. Its architect, Petrus Deustamben, was buried in a tomb which stood in the south aisle of the basilica. Engraved on it is the image of a shrouded body with two censing angels and an inscription stating that Petrus had "overbuilt" (*superedificavit*) the church and had been responsible

for a bridge, and that he was entombed by his sovereigns, Emperor Alfonso [VII] and Sancha.[14] The word *superedificavit* seems to refer to the vaults. An outstanding feature of the church is the polylobed arches of Islamic inspiration at the crossing. This is one of the earliest appearances of a motif that would occupy a prominent place in the ornamental vocabulary of architecture during the final decades of the Romanesque era. A formal dedication of the church took place only on March 6, 1149, when a council of the realm had drawn together an assembly, but it is an improbably late date for the completion of the building we see.

The situation under Alfonso VII resembled the rule of Alfonso VI: a reigning brother who campaigned continuously, most often in Burgos and Toledo, and an older sister, Sancha, who was devoted to the site at León. Things had changed, however. The portable altar that is the only object we can connect to Sancha[15] is modest in both conception and execution compared to the furnishings commissioned by her ancestors. In the *Chronicon mundi* Lucas of Tuy recounts that one day Sancha was praying at a window of the palace's tribune gallery that looked directly down on the high altar of the church of Ferdinand and Sancha. There she was visited by Saint Isidore, who told her it was unseemly for a woman to live within the church's precinct.[16] She therefore ceded the palace to the canons, erecting another next to the church but separate from it. In other ways too the royal family lost its close attachment to the palatine church. On occasion an object of considerable ambition might be commissioned for San Isidoro, such as the Bible of 1162 (cat. 150), but as its lengthy colophon reveals, the ruler and his family had no part in the manuscript's history.

NOTES

1. Bishko 1980.
2. Williams 1988.
3. For this phenomenon, see within a voluminous literature Menéndez Pidal 1950; Maravall 1964, pp. 23ff.
4. Pérez de Urbel and González 1959, pp. 197–98. The *Silense* was probably written at the Leonese monastery of Sahagún, which was favored by the Leonese rulers. See Canal 1980, pp. 94–103.
5. Williams 1973.
6. *España Sagrada*, vol. 9, pp. 370–75.
7. For the charter see Blanco 1987, pp. 166–72.
8. Floriano 1949, pp. 118ff.
9. Bishko 1984.
10. Williams 1977b.
11. Viñayo 1972, pl. 51.
12. Falque 1988, lib. II, cap. liii, 7, p. 322.
13. Puyol 1926, pp. 384–85.
14. Whitehill 1941, p. 153.
15. Gómez-Moreno 1925–26, vol. 1, pp. 206–7, vol. 2, pl. 225.
16. *España Sagrada*, vol. 35, pp. 205–6.

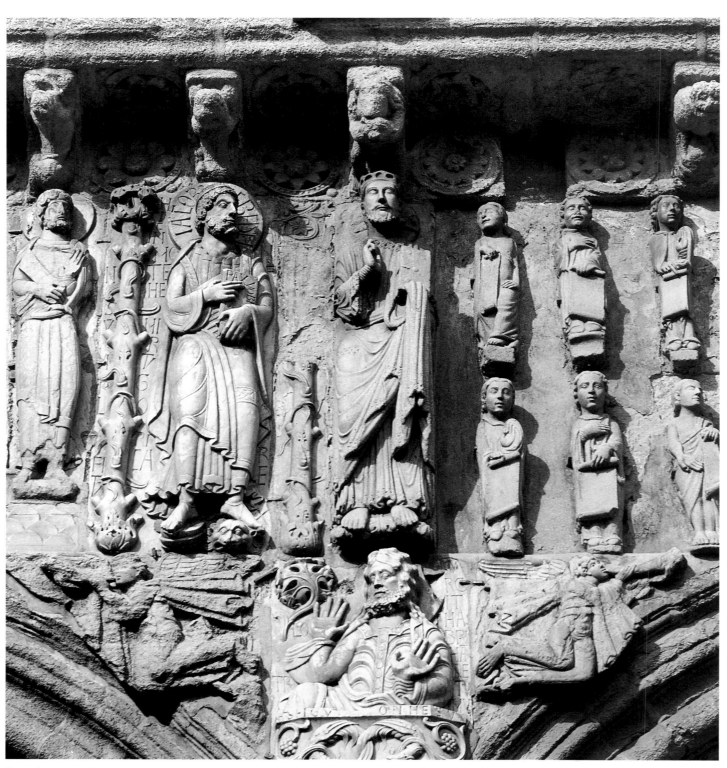

Central section of the Puerta de las Platerías, Santiago de Compostela. Photo: Joseph Martin

on the road: the camino de santiago

SERAFÍN MORALEJO

The cultural transformations that occurred in the western kingdoms of Spain during the last third of the eleventh century are comparable to those undergone in Great Britain during the same period, that is, in the time following the Norman conquest. We could even say that Spain came close to having its own 1066, if we accept the declaration in the *Historia Compostellana* that Bishop Diego Peláez was dismissed in 1088 because Alfonso VI suspected him of wanting to surrender Galicia to the Normans. We know from Wace's *Roman de Brut* that the horse William the Conqueror rode at Hastings had been bred in Santiago, but we shall never know whether the monarch had it in mind personally to return the steed to its homeland.

The year 1088 also saw the beginning of construction on the third church at Cluny, an event with manifold significance in Spanish history. The enormous cultural and artistic debt Spain owed to Cluny was in a sense paid with interest through financial contributions made by the kings of León toward the maintenance of the Burgundian abbey. It has been calculated that half of the cost of building the church of Saint Hugh was met by Spanish gold. Whatever such economic bloodletting meant for the treasury of León, it seems to have had its effect on the architectural enterprises undertaken by Alfonso VI (d. 1109) in his own kingdom. It is significant that the beginning of Cluny III in 1088 coincided with an interruption or reduction in the flow of funds for the construction of the cathedral at Santiago de Compostela, following the discharge and incarceration of its prelate. While the revenues of the vacant see of Compostela were confiscated by Alfonso VI, Cluny received a single gift of ten thousand dinars from the monarch, and one of its monks, Bernard d'Auch, was elevated to the metropolitan see of Toledo, newly restored to its former primacy over all the churches of Spain. It is far from accurate to present Cluny as the principal promoter of the cult of Saint James and of pilgrimages to Santiago—at least during the period that concerns us here.

Alfonso's attitude toward Compostela had been very different during the early years of his reign. His first official act after the recovery of his kingdom in 1072 was to abolish the toll levied on pilgrims and merchants in Santa María de Autares at the gateway to Galicia. The monarch's patronage of the new cathedral of Santiago, probably begun in 1075, is well corrob-

orated. Bernard F. Reilly and Fernando López Alsina have called our attention to a document that records that Alfonso was in Compostela in December 1074 and January 1075 to preside over a great council attended by eight bishops and the principal magnates of his kingdom.[1] The decision to reconstruct the cathedral of Santiago was probably made at this solemn gathering, as suggested by the document and by the inscriptions accompanying images of Alfonso VI and Bishop Diego Peláez carved on two of the capitals in the cathedral's Chapel of the Savior.[2]

The council's purpose, according to the document, was "the restoration of the faith of the church," suggesting that the council was concerned with Gregorian reform, particularly the imposition of the Roman liturgy on the peninsular kingdoms. The most recent instruction from Rome on this subject would have been the letter sent by Gregory VII to Alfonso VI in the spring of 1074 in which the pope pressed the king to forsake the ancient Spanish rite and replace it with the Roman liturgy. This demand was preceded by a short version of the history of Spain that could not have pleased Alfonso. The letter stated that Spain was evangelized by Saint Paul and by seven envoys from Rome but that its faith and its rites had subsequently been tarnished by the Priscillian and Arian heresies as well as by invasions of Goths and Muslims. A return to the original communion between Rome and the Spanish churches required the abandonment of a liturgy suspected of heresy.

Ecclesiastical and architectural history have often traveled divergent roads. At the same time that it was decided to reconstruct the church of Santiago with a grandeur rare for its time, Rome was preparing to disavow, with eloquent silence, traditions regarding the role Saint James played in the evangelization of Spain and regarding the discovery of his body at Compostela. One is tempted to believe that the undertaking of a new cathedral was part of the response of the king and his court to the papal exhortation. The "restoration of the faith of the church" required by the pope would be rooted in Spain in the sepulcher of Saint James. This enterprise was directed toward tradition and purity but was manifested in an architecture that was both exotic and novel.

A possible reflection of the decision taken at the council of 1074–75 is suggested in the *Historia Turpini*, included in the

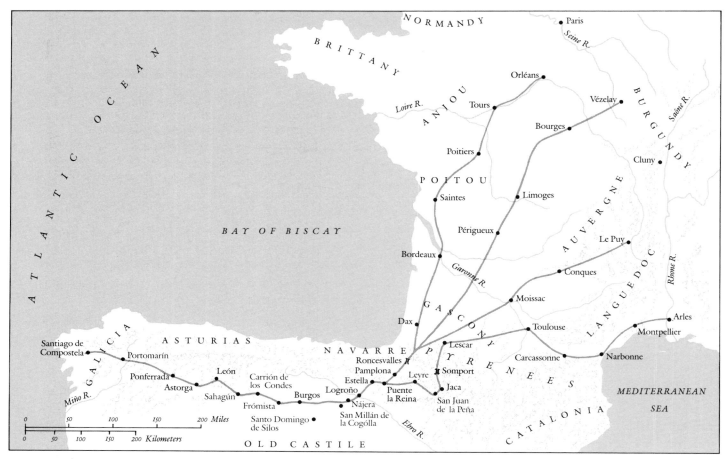

The Camino de Santiago

compilation *Liber Sancti Jacobi*. This fabulous account in epic form of Charlemagne's campaigns in Spain often appropriated and transformed historical events in which the real royal protagonist was Alfonso VI. Such seems to be the case with the emperor's visits to Compostela, which are narrated in chapters 5 and 19. In both instances Charlemagne is presented as restorer of the church of Santiago, generously contributing some of the booty won from the Saracens. As Bernard Reilly has pointed out,[3] it is very likely that during his visit to Compostela in 1074–75 Alfonso VI made an offering to the apostle of part of the thirty thousand gold dinars he had just received as tribute from the Muslim king of Granada and that the gold was used to finance the construction of the new cathedral. Moreover, the *Historia Turpini* refers to the consecration of the cathedral by Archbishop Turpín, at the behest of Charlemagne, on the occasion of a "council of bishops and princes" celebrated there.[4] The resolutions of this assembly led to the de facto recognition of Compostela as the apostolic and primatial see of Spain.

It is therefore possible that at the great council of 1074–75 Alfonso VI encouraged the apostolic ambitions of the church of Santiago. No direct record remains of accords that might have proven embarrassing after the resolution of the liturgical question, which took place in 1080, and the restoration of the primacy of Toledo. The information that is available, how-

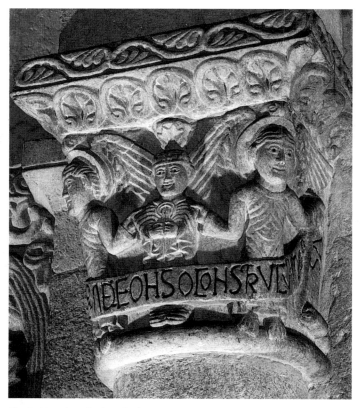

Capital bearing the inscription REGNANTE PRINCIPE ADEFONSO CONSTRUCTUM OPUS (This work was constructed by the reigning king, Alfonso). Santiago de Compostela. Photo: Photo Zodiaque

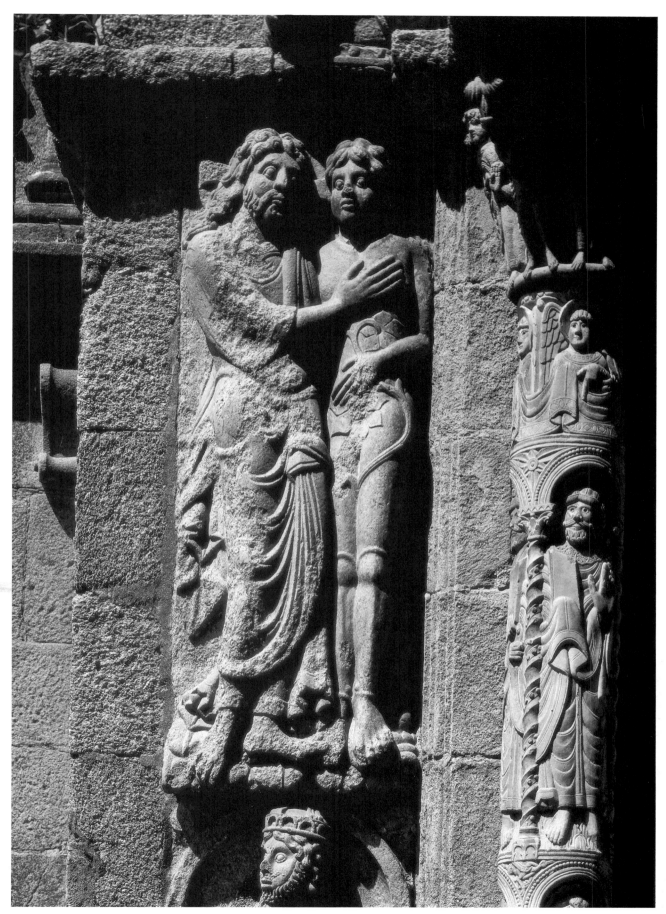

Creation of Adam. Puerta de las Platerías, Santiago de Compostela. Photo: Joseph Martin

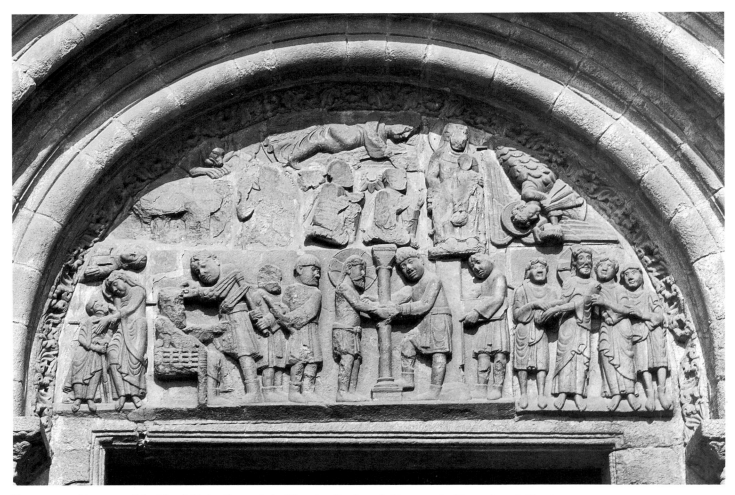

Tympanum with scenes of the life of Christ. Puerta de las Platerías, Santiago de Compostela. Photo: Joseph Martin

ever, confirms both the sudden ascendancy of the Compostela church about 1075 and its fall into disfavor in 1088.

For Alfonso, 1075 seems to have been a year of spiritual renewal that resulted in important artistic enterprises. San Salvador de Oviedo, which the king and his court visited during Lent, provided an appropriate ritual setting for the disclosure of the fabulous relics of the Arca Santa (cat. 124). The very name by which this altar-reliquary is known, and the nature of some of the relics—remains of manna and splinters from the staff of Moses which were supposed to have come from Jerusalem—evoke the ark of the covenant, even to the point of reflecting its physical proportions (Exod. 37:1). During the years that Alfonso VI affirmed his supremacy over the other peninsular kingdoms, the Oviedo ark came to embody the religious interpretation of the Reconquest: a triumphant exodus of a new chosen people, confronting enemies whom the contemporaneous chronicles referred to as Agarenes, Chaldeans, Amorites, and Moabites, the names of the biblical foes of the Israelites.

This parallel became particularly explicit in the writings of Bishop Pelayo, who attributed to Alfonso II (r. 791–842)—

"another Solomon"—the construction in Oviedo of a temple that would eventually house the Arca Santa. Until then the ark had repeated the itinerant fortunes of its biblical archetype, sheltered in "caves and tabernacles," since being carried from Toledo to Asturias by a group of Christians after the Islamic invasion.[5] The journey from Jerusalem to Oviedo, passing through Toledo—and earlier through Seville, according to the *Historia Silense*—sanctioned a *translatio imperii*, or transfer of authority. Pelayo reinforced this idea with his providentialist interpretation of the wild geography of Asturias: God had encircled Asturias with an impenetrable wall of mountains to ensure that after the fall of sinful Toledo, that latter-day Babylon, there would be a New Jerusalem for the Spanish church.

The two outstanding artistic undertakings of the reign of Alfonso VI—beginning the new cathedral of Santiago and richly refurbishing the altar-reliquary of Oviedo—seem to have had a nearly simultaneous origin in the aspirations both sees cherished for moral and actual supremacy over the Spanish church or at least over the church of Castile-León. The sees of Iria-Compostela and Oviedo owed their existence to the Is-

lamic invasion, and ironically both churches found their ambitions frustrated by the advance of a reconquest whose spiritual goals they fervently supported.

In any case, Compostela already had a significance that placed it somewhat above the peninsula's complex ecclesiastical politics. The council of 1074–75 provided the opportunity to rebuild its church, but in fact that undertaking was already necessitated by an ever greater influx of pilgrims from western Europe. Moreover, it does not seem coincidental that the existence of the Arca Santa was revealed at the same time that construction was beginning on a new cathedral for Saint James. The Oviedo church wanted not only to establish itself as the legitimate heir to Toledo but also to emulate Compostela and become an international center for pilgrimages. It appears that even before the end of the eleventh century the list of relics contained in the Arca was circulating in northern France.

Another royal endeavor of 1075 was the initiation of work on the Romanesque cathedral of Burgos, constructed on the grounds of a palace, donated by Alfonso VI, which stood on the road already known as the Camino de Santiago.[6] The mention in 1092 of altars dedicated to Saint James and to Saint Nicholas, patron saint of travelers, confirms a deliberate intention to link the Burgos Cathedral with pilgrimages to the shrine of Saint James.

In the 1073 act of consecration for the León Cathedral he himself restored, another Pelayo, the bishop of León, proudly proclaimed that he had been a student at the church of Santiago. Pelayo's loyal defense of the interests of Compostela and of pilgrimages to the church there is noted in important documents of Ferdinand I and Alfonso VI; the prelate also founded a hostel for pilgrims in León in 1084.[7]

Pelayo's predecessor, Alvito, may have harbored higher ambitions for his church. Sent to Seville by Ferdinand I in 1063 to bring back the relics of Saint Justa, he was unable to find them and had to content himself with the remains of Saint Isidore, who revealed their location to him in a dream. This use of the scholar of Seville as an impromptu replacement for an unavailable candidate expresses an important hagiographic belief: it is the saints, not their devotees, who decide the destiny of their relics. In choosing León, Isidore transferred to it the prestige of the see of Seville, which, because of his unrivaled authority, might be regarded as having superseded Toledo. Alvito died before returning to León; perhaps lost with him was a glorification of his city not unlike that attempted in Compostela and Oviedo years later.

The resting place of the relics of Saint Isidore was not León's cathedral of Santa María but its church of San Juan Bautista, recently rebuilt by Ferdinand I (1018–1065) and now named for the saint of Seville. There Ferdinand had established the pantheon that would legitimize his dynasty—intruders in the kingdom of León—and there the monarch died as a penitent, an event commemorated in the vast iconographical program of the narthex his daughter Urraca added to the church between

1072 and 1101. This establishment of a royal pantheon was a form of *translatio imperii*, one that was more effective than futile efforts to inherit Toledo's ecclesiastical primacy. León had displaced Oviedo in the tenth century, and then under Ferdinand I—Navarrese by paternal lineage and Castilian on his mother's side—had itself been on the verge of being supplanted by the monasteries of San Salvador de Oña and San Pedro de Arlanza in Castile. León's ultimate victory in the contest for spiritual leadership was not, however, definitive. In the same years that the narthex of San Isidoro de León was being built, one of his sons, Alfonso VI, chose the Leonese abbey of Sahagún for his family pantheon and made it the head of a broad monastic empire reformed along French lines. In 1080 the Cluniac monk Bernard d'Auch (later archbishop of Toledo) was put in charge of Sahagún itself, which became the Saint-Denis and Cluny of the kingdoms of León and Castile. With these arrangements Alfonso paid a double debt: to

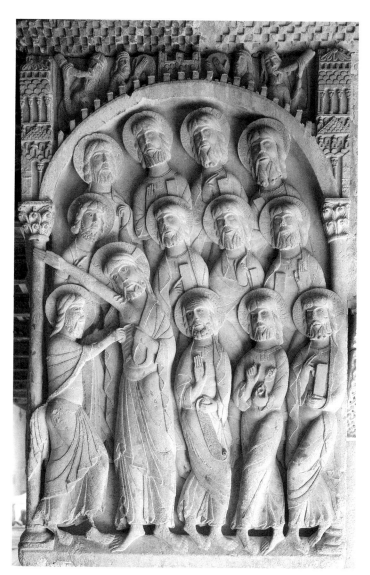

Pillar showing the Apostle Thomas touching the wound in the side of the risen Christ. Santo Domingo de Silos (Burgos). Photo: Joseph Martin

179

the Leonese abbey and to the Burgundian ones whose intercession had secured his freedom after his defeat at the hands of his brother, Sancho II of Castile, in the battle of Golpejera (1072). That is, at any rate, the Cluniac version of events, and Alfonso's generosity to Cluny after he recovered his kingdom seems to bear it out.

The gift of San Isidro de Dueñas, made to the Cluniac order in 1073, was followed by an additional half-dozen monasteries, among them Santa María la Real de Nájera (1079); the latter gifts were made after Alfonso had added a portion of Navarre to the kingdoms already in his possession—León, Galicia, and Castile. The fact that the greater number of these monasteries, like Sahagún, were located along the Camino de Santiago is not as significant as it might first appear to be. If Cluny and other institutions sought proximity to the bustle of the camino, the camino itself had earlier been laid out so that it passed through the most powerful centers in the Hispanic kingdoms, both urban and monastic. All the royal cities—Jaca, Pamplona, Nájera, Burgos, and León—were on that route, and most of the royal pantheons were either on it or nearby: San Juan de la Peña, San Salvador de Leyre, Santa María de Nájera, Las Huelgas de Burgos, Sahagún, San Isidoro de León, and Santiago. In founding a hostel in León, Bishop Pelayo had been

conscious that the pilgrims offered the prayers "for the king, for the bishop, for all the clergy."

Proximity to the camino did not, however, always mean unconditional adherence to the cause of Saint James. A Gascon cripple on his way to Compostela was said to have been healed in Carrión through the intercession of Saint Zoilus, whose relics were venerated there. The healed man was thus able to return home without a further pilgrimage to Compostela. This disloyal competition came out of a monastery donated to Cluny in 1076 by Condesa Teresa Díaz, who also bequeathed to the abbey a hostel and a bridge on the camino.

Interestingly Gascony was the home of Bernard d'Auch, and in that province are found the closest parallels to the sculpture at San Martín de Frómista—a structure related in turn to what remains of the monasteries and priories in Tierra de Campos that were sympathetic to or dependent upon Cluny: Carrión, Sahagún, San Salvador de Nogal, and San Isidro de Dueñas. Although the first two are on the Camino de Santiago, Nogal and Dueñas are not. Artistic development along the camino, erroneously thought to be the key to the origins of monumental sculpture in the western kingdoms of Spain, does not seem as pertinent here as the network of relationships within the monastic empire of Cluny. It is in the coveted mesopotamia of the Cea and Pisuerga rivers that Charles J. Bishko sets the *praeparatio* for Cluny, dating from the time of the intervention of Sancho III, el Mayor, of Navarre (r. 1000–1035) into the affairs of Castile and León.[8]

We may more properly speak of a "Camino de Santiago art" beginning on the day that the principal sculptor of Frómista abandoned the workshop of that Castilian church and transferred his attention to Jaca in Aragon. While the traces of his passage through Nájera testify to his connection with Cluny, his production was prolific at the cathedral in Jaca and then extended as far as Toulouse and, retracing the camino, back to León and Compostela. At that time the camino was not only a channel for artistic interchange, it was an industry. The cities on the road were taking on the monumental character that still defines them, and an intense demand for construction concentrated in a limited period of time resulted in a large group of homogenous works that allow us to speak of a "Camino de Santiago" architecture and sculpture.

It is true that in some respects the churches of León and Compostela anticipated Frómista and Jaca. The narthex of San Isidoro in León is, however, more an exercise of dynastic affirmation than a sanctuary on the camino, and the declared Francophilia of Alfonso VI and his court shaped this pioneering Romanesque version of the traditional Hispanic pantheon. As for the cathedral at Compostela, in its inception it is better understood as a pilgrimage church than as the fruit of an art of the camino. The sculptural enrichment of its first campaign, with roots in Conques, Auvergne, and the southwest of France, uses some basic features of the *jaqués* capital; in general, however, the architectural style would long be an exotic import in

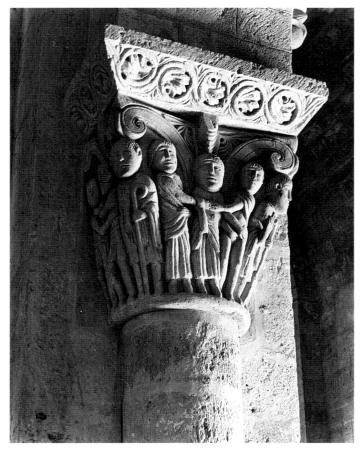

Capital. San Martín de Frómista. Photo: Photo Zodiaque

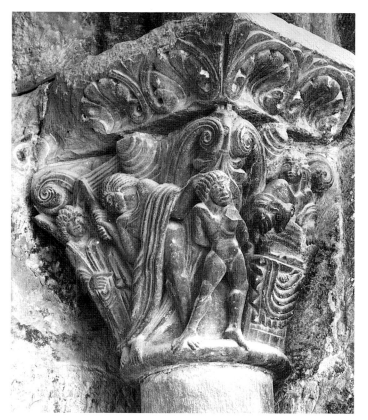

Capital showing the Sacrifice of Isaac. Cathedral of Jaca (Huesca). Photo: Photo Zodiaque

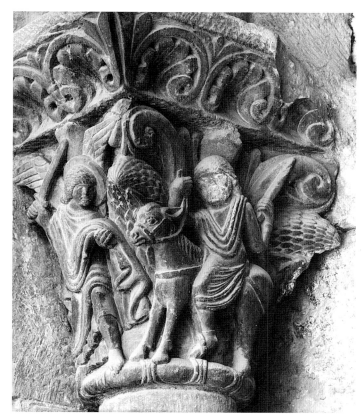

Capital showing Balaam, who rides an ass, being confronted by an angel with a drawn sword. Cathedral of Jaca (Huesca). Photo: Photo Zodiaque

Spain. Only in the cathedral of Braga, consecrated in 1089, may a similar style have been attempted, although Braga is closer to Sainte-Foy-de-Conques, according to Manuel L. Real. The rivalry between the metropolitan see of Braga and its sister at Compostela had then an architectural prologue.

Jaca, on the other hand, owed everything to the camino or, more accurately, to the roads that intersected it. Jaca was situated at the foot of the Somport Pass, where the trade route began that linked the kingdoms beyond the Pyrenees with the rich Spanish *taifas* and that the merchants and pilgrims followed toward Navarre, Castile, León, and Galicia. Once a simple defensive castle, by 1077 Jaca was a flourishing city and episcopal see. The kingdom of Navarre had by then disappeared; King Sancho Ramírez thus found himself in possession of the two doorways to the camino through the Pyrenees, emblems of the double function—trade and pilgrimage—that made the road so important. The battle of Roncesvalles, which was lost by the French under Charlemagne's commander Roland, was transformed in legend into a victory over the Saracens, and the Reconquest was glorified, in the French interest, as an exploit of Charlemagne. (We have seen how tribute from the king of Granada that Alfonso VI donated to help finance construction of the cathedral at Compostela was transformed in the *Historia Turpini* into booty Charlemagne had exacted from the Muslims.) Jaca, in contrast, offers exemplary testimony to

the significance of the Camino de Santiago, which served as the hub of the commercial revolution and renaissance in Spanish cities. According to a document that is suspect in form and context but perhaps has a basis of truth, the cathedral at Jaca was financed by the very prosaic rental income from the customs office at Canfranc in the Somport region.

In the end the continuing progress of the Reconquest left Jaca an urban backwater. After the recapture of Huesca in 1096 and of Saragossa in 1118, Romanesque art had for all practical purposes reached its southern boundaries in Aragon, the same outcome that had occurred in Castile with the recovery of Toledo in 1085. As was the case when Rome confronted Greece, in Spain the conquered ended by defeating their conquerors, who were captivated by the culture and arts of those they had vanquished.

In the north Pamplona and Compostela were to succeed Jaca. It is documented that in 1101 one master Esteban worked on the Pamplona Cathedral, the same Esteban who also was—or had been—partly responsible for the cathedral in Compostela. Aside from the doubtful sculpting career that has been claimed for him, our knowledge of Esteban's movements from place to place seems to substantiate our observation of a common style in the monumental decoration of churches along the camino during the first decades of the twelfth century, from Jaca and Toulouse to Compostela and passing through

Pamplona and León. Along with other names of French, Aragonese, and Leonese derivation, an Esteban appears on the list of wayfarers (*viatores*)—roadworkers and travelers alike —who, according to the guidebook *Liber Sancti Jacobi*, were engaged in maintaining the camino.[9]

A similar mobility is found among the patrons who employed these artisans. Pedro de Rodez, the prelate who commissioned Esteban to work at Pamplona, had come from Saint-Pons-de-Thomières and had been a novice at Sainte-Foy-de-Conques. His presence in Compostela was recorded in 1105 when his friend Bishop Diego Gelmírez allowed him to consecrate the chapel dedicated to the martyr of Conques in the cathedral at Compostela. About 1110 Pedro de Rodez made a pilgrimage to the Holy Land, and five years later he died during a popular uprising in Toulouse, the city of his birth. The interest this prelate evidenced in Roncesvalles has prompted speculation that he played some role in elaborating and localizing the epic of Roland. Taken together, the names of the places that mark out his career compose a vast geography of the pilgrimage culture.

Just as Cluny had been involved in Compostela's fall from favor in 1088, so too was it behind the spectacular resurgence of Compostela during the last years of the eleventh century. Bishop Dalmacio had come from Cluny, and during his brief tenure he was responsible for the de jure establishment of the see of Iria-Compostela in the city of Compostela (1095) and its exemption from dependence on any authority other than Rome, which at that time was governed by another Cluniac, Pope Urban II. Dalmacio consecrated the altar of Saint James in Cluny, and Diego Gelmírez, his successor at Compostela, knew very well that the arduous road between Rome and Compostela was paradoxically shortened by a detour through the great Burgundian abbey. Gelmírez arrived there about 1104, seeking the support and counsel of Abbot Hugh before he made his appearance at the papal court to apply for the privileges of the pallium (a vestment worn by an archbishop). In his personal journey the stations on the caminos leading toward Santiago become indistinguishable from the most important Cluniac establishments of southern and central France: Saint-Mont, Auch, Toulouse, Moissac, Limoges. Gelmírez thus could be said to have reconciled, *avant la lettre*, the opposing theses proposed by Arthur Kingsley Porter and Jean Hubert to explain the diffusion of French Romanesque sculpture: along the pilgrimage routes, according to the American scholar, and through channels that linked Cluny with its southern priories, according to the French one.[10]

Twenty years later Gelmírez would evoke the designs of monasteries and cathedrals he knew "beyond the pass" to justify his intention of donating a cloister with attached chapter rooms to the cathedral in Compostela. His experiences as a traveler bore immediate fruit for the work in Compostela, however, beginning with his first visit to Rome in 1099. From Rome he carried ideas and models, and he found artisans to carry out his designs in the many lively workshops along the camino. The ciborium and the confessio he donated to the sanctuary of Santiago and the *paradisus*, or atrium, that extended across its north facade were explicit quotations from Saint Peter's in Rome. The ornate decoration of the two facades of Santiago's transept combined the handiwork of artists and workshops from Conques, Toulouse, Moissac, Frómista, Jaca, and Loarre; some of the artisans subsequently took the road to León and Pamplona. Compostela thus anthologized the art of the routes that led to it, conferring on all the distinctive stamp of a Camino de Santiago art.

The pilgrimages to Compostela were not, of course, the only factor in the artistic flowering along the camino. Even without pilgrimages, the road that linked all the Hispanic kingdoms from Aragon to Galicia to the rest of Europe would hardly have been without importance. The dynasties ruling those kingdoms would still have expressed their power through ambitious architectural undertakings, and tribute paid by Islamic kingdoms would still have financed building programs. Cluny would still have sought the generosity of Leonese monarchs, and those monarchs would have pursued the spiritual and worldly influence of the Burgundian monastic empire. Rome would still have imposed its discipline upon the Spanish church, which for its part would still have been noted for innovative architectural and iconographic programs. French merchants, crusaders, and colonists would still have made their way through the passes of the Pyrenees, drawn by prospects of commerce or conquest. With the frontier of Toledo not yet secure, the economic spine of the Christian kingdoms could only have been this road which, even without the pilgrims, would have been called "French."

These remarks are not intended to diminish the immense cultural and civilizing impact of the pilgrimages honoring Saint James; rather I want to acknowledge the pilgrimages' catalytic effect on other important phenomena. Reconquest, repopulation, commerce, urban rebirth, the consolidation of the peninsula's monarchies, and Gregorian and Cluniac reforms all found their stimulus in the pilgrimages, but even beyond that the pilgrimages created an audience, a clientele, a sphere of powerful resonance. The camino represented a privileged means of communication in the traffic not only of goods and peoples but also of information. Everything that was said, preached, sung, recounted, sculpted, or painted along the camino—called the *strata publica*, or public way—reached many people and traveled great distances. Without the pilgrimages Spain would still have witnessed the production of Romanesque art, but that art would have lacked the integrity, monumentality, and consistency that came from its origins on the long and prosperous camino.

The *Historia Silense* attributes the laying out of the Camino de Santiago to a single man, Sancho III, el Mayor, of Navarre, although it misstates the historical circumstances that generated such an enterprise. Closer to fact is the version in the *Crónica*

Najerense, where the establishment of the camino is mentioned after an account of the expansion of Sancho's power beyond Navarre to Castile and León. It is logical that, for reasons of strategy and government, the monarch would have wanted to create an artery for travel and communication throughout his domains. The existence of a single Camino de Santiago helped achieve an ephemeral political unity, and later in the century the consciousness of the road's unique character fostered the monumental urban character that still defines it. The five kingdoms that resulted from the legacy of Sancho III, el Mayor, and his sons would by the time of Alfonso VI and Sancho Ramírez be reduced to two. These latter monarchs and their followers provided the impulse for an art that had as its territory a camino without frontiers.

NOTES

1. Reilly 1988, p. 84; López Alsina 1988, pp. 410–11.
2. Moralejo 1992a, pp. 212–13.
3. Reilly 1988, p. 84.
4. Moralejo, Torres, and Feo 1951, p. 456.
5. Pelayo refers to Solomon and to the protection of the mountains in his *Liber testamentorum;* see García Larragueta 1962, pp. 511–12.
6. Karge 1989, pp. 27–28.
7. Vázquez de Parga, Lacarra, and Uria 1948–49, vol. 2, pp. 254–55.
8. Bishko 1980.
9. Moralejo, Torres, and Feo 1951, p. 509.
10. Porter 1923, vol. 1, pp. 171ff.; Hubert 1977, pp. 43–77, 79–86.

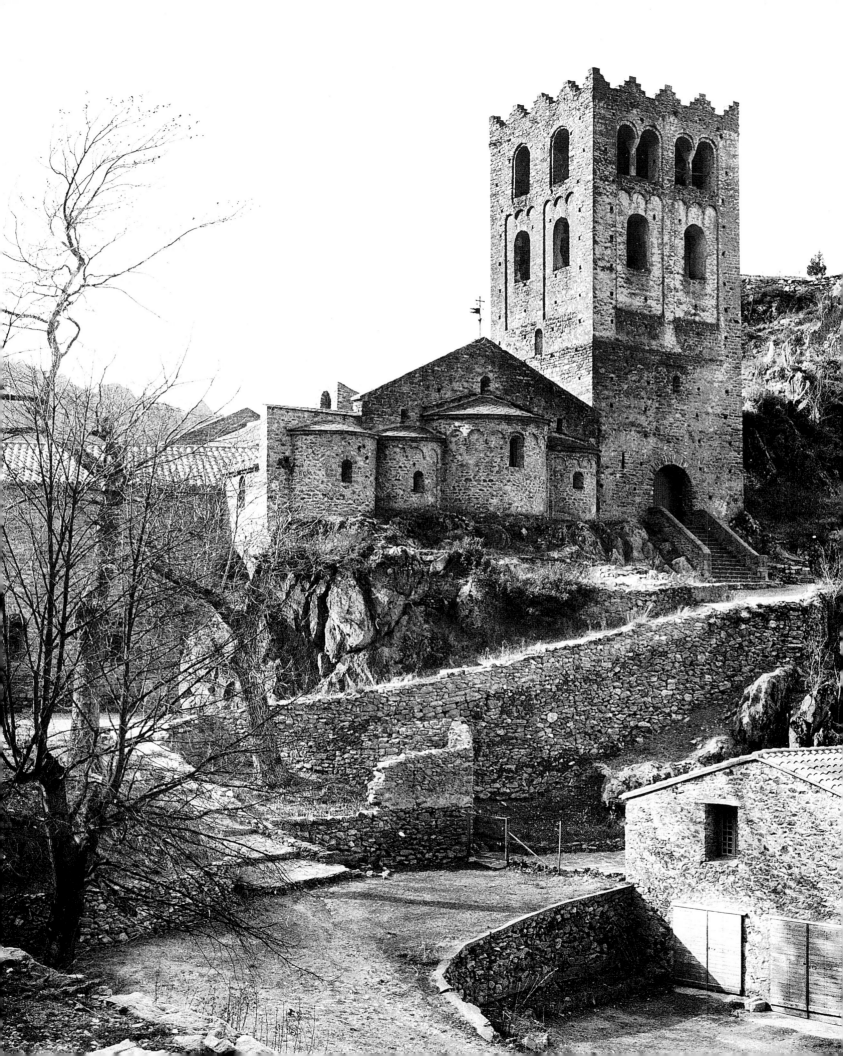

the Romanesque in Catalonia

PETER K. KLEIN

During the Middle Ages Catalonia followed a course of its own that set it apart from the Iberian Peninsula and brought it close to the rest of Europe, especially France and Italy. At the end of the eighth century the northern heartland of present-day Catalonia was wrested from Islamic rule by the Frankish troops of Charlemagne and attached to the Carolingian Empire as Marca Hispanica, or the Spanish marches.[1] While the other Christian regions of northern Spain tended to preserve the cultural and political traditions of the vanished Visigothic Empire in law, liturgy, literature, and art, Catalonia was quick to adopt the standards and innovations of mainstream Europe. By 840 the Roman-Frankish liturgy replaced the Visigothic, or Mozarabic, one[2] as ties to the papacy were renewed and strengthened.[3] In the same century Carolingian minuscules replaced the so-called Visigothic script.[4] There were also fundamental changes in the legal and social sphere. The Catalan counties were rapidly distributed as hereditary fiefdoms in accordance with the classical feudal system of Carolingian and post-Carolingian France.[5] During the reign of Wilfred the Hirsute (r. 878–97), the first of the hereditary counts of Barcelona, the larger part of Old Catalonia, notably the regions around Ripoll, Vic, and Montserrat, was taken from the Muslims and resettled.

While the Catalan Reconquista continued with the recapture of Tarragona in 1090, Tortosa in 1148, and Lleida in 1149, political and ecclesiastical ties to France unraveled, and by 1258 Catalonia was legally independent of the French royal house. As a result of the marriage of the count of Barcelona to the heiress to the Aragonese throne in 1137, Catalonia, though still legally a county, had already been incorporated into the kingdom of Aragon.

One first encounters the name Catalonia, or Catalan, at the beginning of the twelfth century for the region encompassing —besides actual Spanish Catalonia—the modern French counties of Roussillon, Conflé, and Vallespir.[6] From about 1000 to 1200, various political, religious, and economic forces shaped the development of Romanesque art in this region. Beginning in the first half of the eleventh century Catalonia enjoyed increased economic prosperity. The region's relations with its neighbors, the Islamic caliphate and its successor states to the south and the Capetian Empire to the north—especially southern France—became more cordial, and its ecclesiastical, economic, and political ties to Rome and the Italian city-states

were remarkably close. In the mid-eleventh century the spirit of religious reform took hold in Catalonia; this emanated from southern France, not so much from the Cluniac centers like Moissac as from the Benedictine monastery of Saint-Victor in Marseilles and the collegiate church of Saint-Ruf in Avignon. Finally, Catalonia's feudal system, more highly developed than that of the other Christian realms of northern Spain, produced a line of strong Catalan counts, abbots, and bishops, most of them from the same families of the Catalan high nobility, who served as patrons and builders, especially in the early phase of the Catalan Romanesque.

The Early Romanesque in Catalonia

The beginnings of Romanesque architecture in Catalonia belong to the so-called First Romanesque, a style dating to the late tenth century and the first half of the eleventh in a region stretching from Dalmatia across Lombardy and northern Burgundy into Catalonia.[7] Characteristic and easily recognizable features of this style are: small quarry-stone masonry; blind arcades supported by small pilasters (Lombard arches); barrel and cruciform vaulting (first for the choir and the crypt, later for the nave and transept as well); a drum cupola over the crossing; and tall, freestanding bell towers. In floor plan the dominant type is the three-aisled basilica, with or without transept. With striking frequency—a fact generally overlooked in French and Spanish studies—these structures take the form of stepped barrel-vaulted halls in which the center aisle, the walls of which are without windows, is only slightly taller than the side aisles.[8]

This new architectural style most probably originated in Lombardy. It was once assumed that a troop of migrant builders, the *magistri comacini,* or stonecutters from Como, helped to spread it to other European regions, but there is no mention of such migrant Lombard builders in the documents from this early period and a number of more recent scholars have firmly rejected that theory.[9] In twelfth-century Catalonia, to be sure, Lombard stonecutters were so ubiquitous that the designation "lambardi" was applied to all practitioners of the craft, regardless of their origins.[10] Most of the important structures of the Catalan First Romanesque can be linked to the prominent abbot and bishop Oliba (971–1046), who had extensive contacts in Italy and made repeated trips to that country.[11] It is

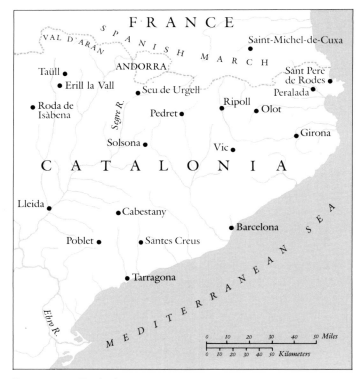

Romanesque Catalonia

projects were three structures that he consecrated himself: additions to the abbey churches of Ripoll (1032) and Cuxa (1035) and the cathedral at Vic (1038). That the two abbey churches were enlarged so soon after their completion is a clear indication of the extent of this building boom in the early eleventh century.

Unfortunately, none of Oliba's structures have survived intact. All that is left of the cathedral at Vic are its bell tower and crypt.[13] The abbey church at Ripoll, to the nave of which Oliba added a splendid transept with seven apses, was so extensively restored after a devastating fire in 1835 that the present-day basilica is essentially a nineteenth-century reconstruction. Of Oliba's additions to the abbey church at Cuxa, one of the two bell towers survives; it is among the most elegant yet monumental structures of its kind, placed as in Italian churches at the end of the transept.[14]

Much better preserved than the Oliba structures is the church of the former Benedictine abbey of Saint-Martin-du-Canigou, established by monks from Cuxa on a remote peak of the Canigou massif. It was built in two phases: the first dedication was in 1009 (with Oliba in attendance), the second in 1014 or 1026.[15] It is a double church with a cryptlike lower sanctuary and a larger one above, each with three aisles and fully vaulted. The type of the double church with no connection between the two sanctuaries (in contrast to the Aachen Palace Chapel and its successors) is not uncommon in the First Romanesque[16] and belongs to a western European tradition that includes two-story palace chapels like the Asturian Cámara Santa in Oviedo and the Sainte-Chapelle in Paris.[17] Its freestanding bell tower and simple arcaded frieze on the exterior of the apse are altogether typical of the First Romanesque.

One of the most striking and original structures of Catalan architecture from this period is the abbey church of the former Benedictine monastery of Sant Pere de Rodes, which stands in ruins on a picturesque site on the east slope of a mountain above the Gulf of Rosas. Rodes was one of the most important Catalan monasteries of the tenth and eleventh centuries. It was under the protection of the French kings and received rich donations from the Catalan nobility. In addition it was given possession of all papal holdings in Septimania and Spain. Pilgrims unable to journey to the tomb of Saint Peter in Rome were afforded the same indulgences if they visited Sant Pere de Rodes.[18] The church's charm derives from its blend of conservatism and innovation. As in other Catalan structures of the period, the nave at Rodes is a three-aisled, stepped barrel-vaulted hall, to which are joined a barrel-vaulted transept with two apses and the choir. The center aisle is twice as wide as the side aisles, and the massive barrel vaults of the nave and transept are structured by transverse arches. These same features are found in the nearby church of Santa Maria de Rosas, which is documented as having been consecrated in 1022 and apparently followed the building at Rodes.[19] It is nevertheless striking that the choir of the abbey church at Rodes is ringed by

therefore altogether possible, even probable, that Lombard architects and stonecutters did collaborate on some early Catalan structures.

These structures are not only the best-preserved monuments of the First Romanesque in the south but also the most numerous and in many respects the most significant.[12] In this period Catalonia served as the most important buffer state between Islam and the West. Here the designs and building practices of the First Romanesque came into contact with Arab mathematics—evidenced in manuscripts of the Catalan monastery at Ripoll—and vaulting techniques. The balance of power between Catalans and Muslims changed significantly after the fall of the caliphate of Córdoba. No longer under Islamic military threat, the Catalans retook territories they had once held. Starting in the reign of Ramón Berenguer I the Elder (1035–76), smaller neighboring Islamic states (*taifas*) were obliged to pay tribute to the counts of Barcelona. These payments (*parias*) were mainly made in gold, a factor, along with the resettlement of conquered territories, that led to Catalonia's relatively early economic expansion.

Returning to Abbot Oliba for a moment—it can hardly be coincidence that almost all of the early structures of the Catalan First Romanesque were erected under his aegis or by people close to him. In this regard he was a worthy successor to his uncle, Miro Bonfill, count of Besalú (967–84) and later bishop of Girona, who founded Rodes (974), Saint-Genis-des-Fontaines, and Sant Pere in Besalú (977) and consecrated the structures of Cuxa (974) and Ripoll (977). Oliba's own chief

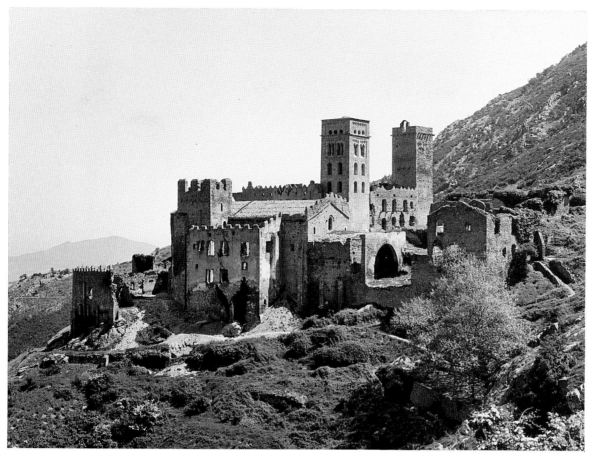

Sant Pere de Rodes. Photo: Hirmer Fotoarchiv

an ambulatory like that of the crypt below: a unicum in Catalan architecture of the time and one of the earliest examples of European Romanesque architecture.[20]

Also notable in the First Romanesque in Catalonia is a rich variety of architectural sculpture, especially capitals, just as in contemporary churches in Roussillon. Even more striking and unusual is the design of the nave pillars, with freestanding columns on three sides of each pillar. This type points forward to the compound piers of the High Romanesque.

Less innovative than Rodes but just as important is the former collegiate church of Sant Vicenç in Cardona, the masterpiece of the First Romanesque in Catalonia and in terms of the history of architecture one of the most important structures of the entire eleventh century. The church rises above a sloping hillside and was once part of a castle complex, now demolished, belonging to the viscounts of Ausona and controlling the approach to the plain of Vic. The castle and the city of Cardona were rebuilt after the Muslims destroyed them at the end of the tenth century. Viscount Bremond began the rebuilding of the church in 1019, endowing it as a collegiate church on the advice of Oliba, then bishop of Vic. The new structure was consecrated in 1040—again with Oliba in attendance. Like other Catalan buildings of the period it is completely vaulted, and like Sant Pere de Rodes it rises to a considerable height, yet it is a basilica rather than a barrel-vaulted hall. The center aisle is considerably taller than the

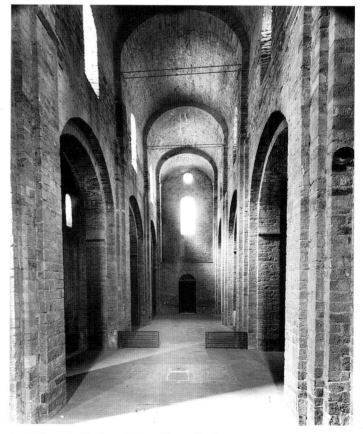

Sant Vicenç in Cardona. Photo: Photo Zodiaque

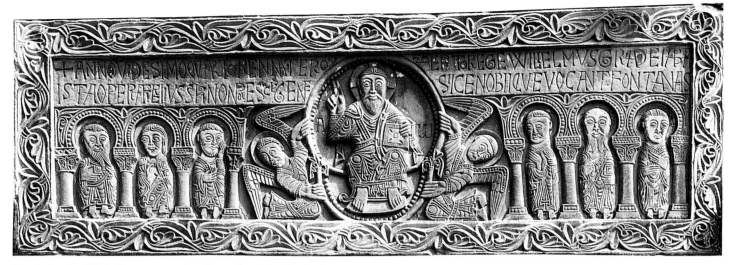

Lintel showing Christ between angels and apostles. Saint-Genis-des-Fontaines (Pyrénées-Orientales). Photo: Photo Zodiaque

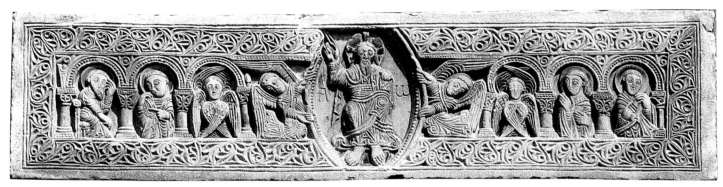

Lintel showing Christ between angels and apostles. Saint-André-de-Sorède (Pyrénées-Orientales). Photo: Photo Zodiaque

side aisles and is lit by clerestory windows. The church has a narrow narthex, a nave consisting of three great bays, a barely projecting transept with two apses, and a choir bay opening into the main apse. A three-aisled crypt extends across the entire width of the raised chancel. A rich variety of vaulting and support systems is used.

The interior of the church, with the exception of high blind niches in the choir and simple wall abutments and pier pilasters, is almost completely free of architectural ornament. The exterior is enlivened somewhat by Lombard arches and small niches below the eaves.

The layout and structural design of Sant Vicenç in Cardona were imitated in countless slightly later Romanesque structures in Catalonia such as Sant Ponç de Corbera, Sant Jaume de Frontaya, and San Saturnino de Tabérnoles. However, none of these churches approaches the clarity and stringency of Sant Vicenç. It may seem odd that such an epoch-making structure arose in Cardona, today an unimportant provincial backwater. At that time, however, Cardona was one of the five most important cities of Catalonia and lent its name to the *strata cardonensa,* an important trading route linking Catalonia to the Islamic borders.[21] It had its own market, merchants, and

mint and an ambitious citizenry with numerous rights and freedoms.[22] Salt mining in the mountains above the city, traces of which are still visible today, was a source of great profit for the viscounts, who permitted the citizenry to dig for themselves one day a week.[23] Obviously the viscounts were able to draw on sizable financial and technical resources in building this church, which was doubtless intended to reflect their power. Just where the overseeing architect came from we do not know.

Architectural Sculpture

The architecture of the early Romanesque, especially in Lombardy, is generally entirely free of ornament. Catalonia again proves unique in this respect, playing a somewhat pioneering role. In no other region has such a rich variety of architectural sculpture from this period survived, and nowhere else are the essential elements of later Romanesque portal sculpture so clearly anticipated.

In the decades before the invasion of al-Mansur in 985, Catalonia maintained close and peaceful ties with the caliphate of Córdoba. A series of capitals and column bases from this period—especially the bases and capitals of the abbey

church of Ripoll, consecrated in 977, and capitals from the basilica of Cornellá de Llobregat—has precedents in the Great Mosque of Córdoba.[24]

There was a continuation and further development of Spanish-Islamic and Carolingian traditions in Catalan architectural sculpture of the First Romanesque in the eleventh century. The most important examples are the capitals in Sant Pere de Rodes and the figural facade reliefs on three churches in Roussillon. At Rodes, Corinthian capitals follow Islamic-Cordoban patterns, as do their abaci, which are decorated with elegantly curving and interwoven palmette vines like those of the frieze and voussoirs in the Salón Rico of Madinat al-Zahra'.[25] The block capitals are unique, but the interlace patterns are ultimately northern and Carolingian in origin; their simple interlace knots, some ending in animal heads, recur in certain initials of the contemporary Ripoll Bible.[26]

A group of figural and ornamental facade reliefs surviving in Roussillon is related to the capitals at Rodes. These include the portal lintel of Saint-Genis-des-Fontaines (1019–20), the lintel and window frame of the facade of Saint-André-de-Sorède (about 1030), and the tympanum relief and window frames of Sainte-Marie in Arles-sur-Tech (about 1046). Supple interwoven palmette vines of Cordoban provenance appear on the frames of the lintel at Saint-Genis and the window at Sorède, both by the same master. Similar vine motifs recur in cruder, more three-dimensional forms on two window frames of the church in Arles-sur-Tech.[27]

The sculptural schools of Roussillon also employed local techniques and elements of the Carolingian pictorial tradition. The two Roussillon lintels present an Ascension-Majestas, a prevalent subject of later Romanesque portals.[28] Such anticipation of the High Romanesque is even more clearly in evidence on the facade at Sorède. There the motif of the Ascension-Majestas of the lintel is linked to the Evangelists' symbols, seraphim, and trumpeting angels of the window frame in such a way that it is reinterpreted as the Second Coming.[29] Here we see the first rudimentary attempts at a facade program that would be typical of the High Romanesque.[30] The facade reliefs of Roussillon are thus not only the last offshoots of the pre-Romanesque but also the first steps toward High Romanesque portal sculpture.[31] Nevertheless, there does not appear to be a direct link to later Romanesque sculptural portals. A span of nearly fifty years lies between them.

Early and High Romanesque Book Illumination

In its quality and iconographic richness, early Catalan book illumination is without parallel in the contemporary European Romanesque. The most important examples are found in manuscripts produced in Ripoll, which had a productive scriptorium a few years after its founding in 879–80.[32] By the middle of the tenth century its scribes were copying manuscripts from Rome and Naples.[33] Even then the Ripoll library

was noted for its rich holdings of scientific and literary manuscripts, and it was at this time that Gerbert of Aurillac (later Pope Sylvester II [r. 999–1003]), the most important scholar of his time, spent several years studying scientific theory in Ripoll and Vic.[34]

The monastery and library of Ripoll reached their zenith in the time of Abbot Oliba (1008–46).[35] At the beginning of the eleventh century the library owned 111 manuscripts,[36] but at Oliba's death it had more than doubled its holdings to 246.[37] Ripoll had, after Toledo, the most important library in all of Spain; its only equals in the rest of Europe were the renowned collections in the monasteries of Saint Gall, Bobbio, Reichenau, and Lorsch.[38]

The inventory of the Ripoll library made after Oliba's death listed three complete Bibles. Some scholars have suggested that

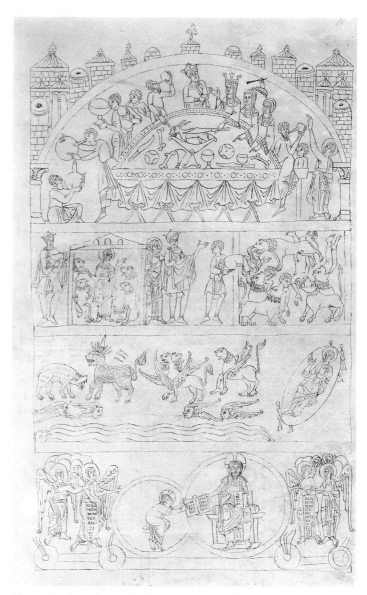

Illustration from the Roda Bible (cat. 158; fol. 66r). Scenes from the Book of Daniel; first register (top): feast of King Belshazzar; second register: Daniel in the lions' den; third register: Daniel's vision of the four winds of heaven and the four great beasts; fourth register (bottom): Daniel's vision of the elders of judgment. Bibliothèque Nationale, Paris

these may have included the Ripoll Bible (cat. 157) and the Roda Bible (cat. 158), the two finest Catalan manuscripts from the eleventh century. It now seems likely, however, that while the earlier Ripoll Bible may have been in the library at that time, the Roda Bible was not. The style of the illuminations and initials of these two Catalan Bibles reflects the eclecticism of the buildings and sculptures of the Catalan First Romanesque. The painters of the older workshop (the chief painter of the Ripoll Bible and the first painter of the Roda Bible) produced figures with highly animated, often elongated limbs, hunched shoulders, and small heads—a style that, like their latticework initials of a Frankish-Saxon type, represents a last offshoot of late Carolingian art. In contrast the younger painters of the Roda Bible, who were anticipated in a rudimentary way by the earlier artist,[39] worked in a true early Romanesque style. Their figures are ponderous and serene, with stylized hair and drapery rendered in clean lines, and posed in clear, well-ordered compositions. Stylistic elements evident in these Romanesque painters, especially in the Roda Bible—the bell and fan folds of the draperies, the heart-shaped outlines of the hair, and the elongated proportions—have been not only compared to those of northern French and Anglo-Norman manuscripts but also shown to derive from Italo-Byzantine traditions.[40]

The iconographic models for the two Bibles are similarly diverse. For the most part it appears that, like the primary sources for the text of the two Bibles, these exemplars were Spanish Bible cycles of early Christian provenance.[41] The extensive New Testament picture cycle of the Ripoll Bible is close to Byzantine traditions, doubtless transmitted by way of Italy. The model for the Roda Bible's Apocalypse cycle, which follows a widespread central European tradition, probably came from Italy as well.[42] Surprisingly the illuminations of the Books of the Prophets in the Roda Bible parallel those of English Bibles from the twelfth century, especially the Lambeth and Winchester Bibles, and must have been based on similar models.[43]

The Ripoll Bible and the first two volumes of the Roda Bible appear to have been created at Ripoll (the last two volumes of the Roda Bible may have come from the workshop at Rodes itself). Other important centers of manuscript production in this period between 1050 and 1150 were Vic, Girona, and Cuxa. By the later twelfth century Catalan book illumination had declined in both quality and quantity and had been supplanted by wall and panel painting as the leading artistic forms.

Monumental Arts of the High Romanesque in Catalonia

The High Romanesque appears to have begun in Catalonia with the reign of Count Ramón Berenguer III (1096–1131). Under his rule political and economic expansion increased. His marriage to Dulce of Provence helped to cement ties with

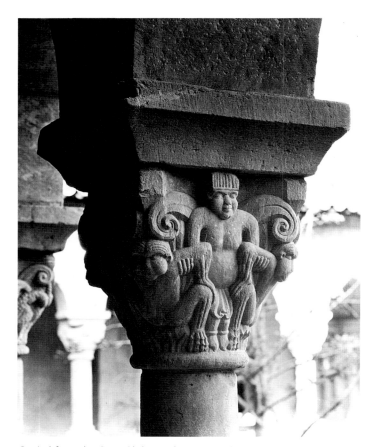

Capital from the Cuxa Cloister. The Metropolitan Museum of Art, The Cloisters Collection, 1925

southern France, and alliances with the Norman duke of Calabria and the city-states of the north brought closer bonds with Italy. French and Italian influence is everywhere apparent in the Catalan High Romanesque.

The extreme conservatism of Catalan architecture made the transition from early to High Romanesque quite gradual. Until well into the twelfth century the "Lombard" style continued to dominate. Examples of this are Sainte-Marie-de-Serrabone in Roussillon (enlarged 1151), Santa María de Barbará in Vallès (about 1116–37), and Sant Climent in Taüll (1123). While the frescoes of the so-called Master of Sant Climent are among the most important and innovative achievements in all Romanesque wall painting, the simple architecture of the church in which they were painted—a three-aisled basilica with an open roof—follows the early Christian pattern.[44] The design and simple architectural ornaments of the cathedral at Urgell (1131–95), one of the most important Catalan structures from the second half of the century, still imitate Catalan-Lombard architecture of the eleventh century. The major cathedral buildings in Tarragona (1171–1331) and Lleida (1203–78), begun in the late Romanesque period, combine strikingly simple and old-fashioned ground-plan solutions with individual details that are already Gothic in feeling. There are a few structures, to be sure, that reflect more advanced French forms. One of these is the abbey church of Sant Joan de las Abadeses (about

1114–50), which has an ambulatory with radiating chapels and numerous figural capitals.[45]

The change in style of Catalan architectural sculpture came relatively late, about 1130–50, and just as they had at the beginning of the eleventh century, the workshops of Roussillon led the way. The oldest known work in the new direction is the cloister of the former abbey church of Saint-Michel-de-Cuxa, built about 1130–40 under the abbot Gregory (about 1125–44).[46] The capitals of the Cuxa cloister, the largest Romanesque cloister in Roussillon, were sold in the nineteenth century, and most of them are now in American collections (including those of the Metropolitan Museum). The range of motifs in these capitals is limited and does not reveal any specific program. The individual forms—vegetal decor, animals, and figures—are strongly modeled but are somewhat crude and swollen; faces have puffy lips and protruding eyes. There is also a marked use of the drill. The masterpiece of these workshops is the nearly contemporary tribune of the Augustinian priory of Sainte-Marie-de-Serrabone, completed in 1151, which resembles the Cuxa tribune in type and iconography but is more three-dimensional and expressive and of higher quality in its individual forms.[47]

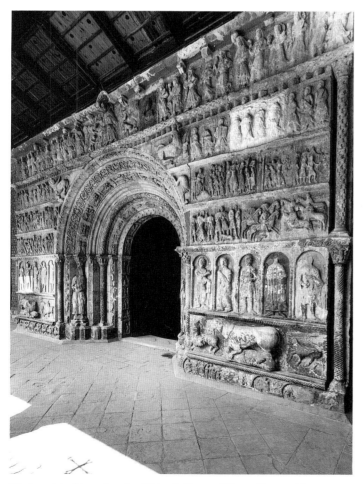

West portal, abbey church of Ripoll. Photo: Hirmer Fotoarchiv

The sculpture workshop of Cuxa and Serrabone apparently worked on commission in a large area.[48] It had a number of imitators in Rousillon—see, for example, the cloister capitals at Saint-Martin-du-Canigou and Saint-André-de-Sorède and the portal of the church in Villefranche-de-Conflent—and also seems to have influenced the most important centers of twelfth-century Catalan sculpture in Ripoll and Vic.[49] Equally strong are the similarities between works by the sculptors of Ripoll and Vic and the works of Gilabertus in Toulouse; compare, for example, the jamb figures of the Ripoll portal and the pillar figures of the former chapter hall of Saint-Étienne in Toulouse.[50] The two closely associated workshops of Ripoll and Vic made a series of sculptural ensembles of which only the most important, the west portal of Ripoll, is preserved intact.[51]

Created about 1150–60, the west portal at Ripoll was placed as a kind of facade in front of the lower part of the west wall of the old abbey church.[52] Its overall structure, with figural friezes on either side and above the richly ornamented doorway and flanking superimposed columns, has frequently been compared to that of the triumphal arches of antiquity and their early medieval successors. The upper part is a synthetic depiction of various chapters (1, 4, 5, and 7) from the Apocalypse of Saint John, displaying the triumphal theophany of Christ and his church. Scenes from the Old Testament books of Exodus and Kings follow in the adjoining two registers, with Moses and David as protagonists. These were patterned after two illuminated folios of the Ripoll Bible.[53] The remaining sections depict other biblical episodes and personages, various animals, and the labors of the months. What first strikes one about this comprehensive program are the many Old Testament scenes—a common feature of Catalan art of the twelfth century[54]—and specific motifs that are clearly of Italian provenance, such as the figures of elders and the use of a cellarman to represent the month of August.[55] In addition to its dogmatic intent, the triumphal program may also have had political implications, for this portal facade was erected at the very moment when the Catalan Reconquista had been brought to a victorious conclusion with the conquest of Lleida and Tortosa in 1148.[56]

Mention must also be made of a major artist of this period, the Cabestany Master, so called after one of his important works, the tympanum of the church in Cabestany (Roussillon).[57] His personal style and that of his workshop is easily recognized by its hard contours, strong contrasts, and at times wildly expressive, asymmetrical facial features with slanting eyes. This artist was chiefly inspired by late antique sarcophagi, both early Christian and pagan, with their frequent use of the drill. The proximity to early Christian sarcophagi is especially apparent in the tympanum relief from Sant Pere de Rodes (cat. 161), which depicts the Calling of Peter and Andrew.

The second half of the twelfth century saw the construction of several major cloisters with rich sculptural ornament. Possi-

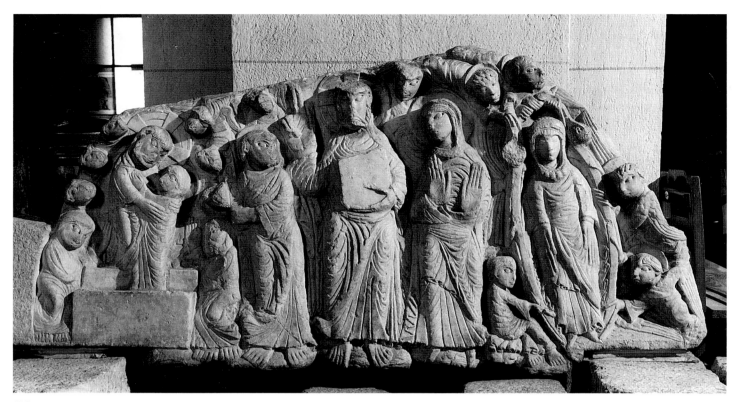

Cabestany Master. Tympanum showing the Assumption, the Glorification, and Christ receiving Mary's soul. Saint Marie, Roussillon.
Photo: Photo Zodiaque

bly the most important of these are the two stylistically related cloisters of the cathedral at Girona[58] and the abbey of Sant Cugat del Vallès, near Barcelona.[59] Both are distinguished by a large number of biblical subjects. In Girona the Old Testament predominates, in Sant Cugat the New Testament. The Old Testament scenes may have been based on Catalan Bible illumination, though not directly on those from the Ripoll and Roda Bibles.[60]

The High Romanesque in Catalonia is also distinguished by the large number of extraordinary polychrome wood sculptures. These are limited in their subject matter to a few basic types: Christ on the Cross, usually wearing a long, belted tunic (the Majestas);[61] the Madonna and Child Enthroned; and the Deposition.[62] While Romanesque Madonna figures are encountered throughout Europe, monumental Deposition groups and crucifixes of the Majestas type are otherwise common only in Italy. Since the Catalan Majestas can be derived from the type of the Italian Volto Santo (Holy Face), the Catalan Deposition groups could have also been inspired by Italian precedents. The majority of Italian examples, however, date from only the thirteenth century.[63] Moreover, the iconography of the Catalan groups corresponds to a Byzantine type that was perhaps introduced to Catalonia by way of art from the Mosan region.[64]

The significance of these wood iconlike images remains unclear, since they attained meaning in a liturgical context, which could change over time. The type of the Volto Santo in Lucca, for example, was created during the eleventh-century religious reform movement (and so the emphasis on the priestly quality of the crucified Christ).[65] This image later took on an imperial tone with the addition of a crown and purple cloak, which may have reflected the theology of the time.[66] It remains to be determined what special import and function the Catalan Majestas may have had. In these works Christ never wears a crown. His drapery frequently imitates the rich embroideries and ornamental patterns of oriental and Islamic fabrics;[67] in the Majestat Batlló (cat. 168; Museu d'Art de Catalunya, Barcelona), perhaps the best-known Catalan crucifix, the bottom hem of his garment is adorned with ornamental pseudo-Kufic script. The older Catalan Majestas, which date from the first quarter of the twelfth century and some of which have survived only in fragments, do not display these ornamental motifs (see the Majestas in Caldes de Montbui and San Cristóbal de Baget).[68]

While the Majestas stress, as their name implies, the triumphal and majestic aspect of the crucified Christ, the Descent from the Cross groups emphasize the sufferings of Christ and the sorrow of his followers. In Catalan representations of the Deposition special importance is given to the Virgin, whose compassion demonstrates her intercessory role in the drama of salvation; in fact, some of these groups were placed on altars dedicated to her.[69] Monumental wood Deposition groups were most common in the Pyrenees valleys of the Ribagorça (see, for example, the fragment from Mig-Arán in Viella [cat. 166] or the group from Erill la Vall, now in Vic and Barcelona [cat. 164]). However, the most important Catalan Descent,

that from Abadeses, comes from another region, presumably from Ripoll, and belongs to the period of transition to the Gothic style. Commissioned in 1250 by a wealthy burgher named Dulcetus for the abbey of Sant Joan de las Abadeses, it was completed the following year. In contrast to Italian examples, this group was not originally placed near the choir screen,[70] but—like most of the other Catalan examples—on the high altar.[71] Most striking in the Abadeses group is the figures' solemn calm. It has been pointed out that Joseph of Arimathea and Nicodemus demonstrate to the faithful the possibility of sharing in Christ's triumph and inspire contemplative absorption in the suffering and death of Christ.[72] In this sense the Catalan Deposition groups have been described as the "oldest three-dimensional devotional figures."[73] The Deposition groups also had a eucharistic significance. In the liturgical tracts from the early and high Middle Ages, from Amalar of Metz to Sicardus of Cremona, the celebratory actions of the deacon and priest in the Mass—especially in the Minor Elevation—were likened to the taking of the body of Christ from the cross by Joseph and Nicodemus.[74] Appropriately, then, three portions of a host were placed in the forehead of the Christ figure of the Abadeses group—probably at its consecration—and were discovered during restoration work in 1426.[75]

Doubtless no aspect of Catalan Romanesque art is so well known, especially to the broader public, as its wall paintings. No other European region can match Catalonia in its quantity and variety of surviving Romanesque frescoes.[76] The number of such paintings preserved in other regions in the north of Spain is relatively modest. Even in Catalonia itself the distribution of frescoes is very uneven. Most come from the Pyrenees valleys in the northwest, for example Taüll, Boi, Burgal, Sorpe, Esterri d'Aneu, Urgell, Mur, Orcau, and Engolasters. There are also a number in the dioceses of Vic and Girona, namely in Osormort, Brull, Bellcaire, Sescorts, and Cardona, but only a few from the Barcelona region in the south (Barbarà, Tarrasa, Polinyà) or Roussillon in the north (Fenollar, Arles-sur-Tech, Écluse). Doubtless as a reflection of the strengthened political and economic ties with other countries at the beginning of the High Romanesque,[77] these works display a great range of competing styles. Influences from northern and southern Italy, southern France, and even from England are represented, most of them mixed with various Byzantine strains. However, there is no Mozarabic element in Catalan Romanesque wall painting, contrary to what has generally been assumed.[78] Native artists then processed these diverse features, ultimately integrating them into a distinct Catalan style.

The earliest of these paintings are nearly all from Pallars and the adjoining county of Urgell. We know that the counts of Pallars took part in the Aragonese Reconquista under Alfonso I, el Batallador (r. 1104–34). A number of wealthy cities were recaptured from the Muslims between 1100 and 1120, among them Saragossa, Tudela, Calatayud, Barbastro, and Daroca. Plunder from these campaigns as well as direct pay-

ments from Alfonso brought new wealth to Pallars and the adjacent Urgell region. It has been suggested that most of it was spent building and ornamenting churches[79] and that the successes of the Aragonese Reconquista thus financed the boom in Romanesque wall painting in northwestern Catalonia. Moreover, it has been pointed out that a majority of the surviving Catalan paintings come from simple parish churches.[80] Accordingly, they must have been conceived for the laity, which may explain the naive, more popular character of many of the paintings in the side aisles of these structures (Sant Climent and Santa Maria in Taüll, for example), the section traditionally reserved for the congregation. The iconography and typology of Catalan frescoes are relatively limited. Apses tend to be dominated by a Majestas Domini, sometimes a Majestas Mariae. Apse walls frequently have standing figures of the apostles and the Virgin in arcaded frames and scenes from the life of Christ or from the Old Testament, especially from Genesis. Nave paintings also presented Old Testament figures and incidents from the lives of saints and martyrs. Close study of details indicates that specific stylistic devices and motifs found their way into Catalonia from Italy and France through pattern books and books of sketches and through migratory artists.

The most important achievements of the anonymous Catalan painters and workshops fell within the relatively brief period

Pedret Master. The Parable of the Wise and Foolish Virgins. Detail of a wall painting in Sant Quirze de Pedret. Photo: Hirmer Fotoarchiv

between roughly 1090 and 1130. The first significant painter of the Catalan Romanesque was the Pedret Master, so called after the wall paintings in the church of San Quirze de Pedret in Berga (now in the Museu Diocesà, Solsona, and the Museu d'Art de Catalunya, Barcelona).[81] This painter and his assistant[82] were obviously from Lombardy. Their works reveal close parallels in style and motifs to North Italian paintings, especially the frescoes in San Pietro al Monte in Civate.[83] Since the frescoes in Civate and related paintings in the Ticinum (Negrentino, Sorengo) are dated to the end of the eleventh century,[84] these paintings from Pedret have generally been assigned to the same period.[85] The paintings in Pedret are distinguished from their successors not only by their greater stylistic proximity to North Italian painting but also by their vivid, narrative manner and their complex iconographic program, again linking them more closely to Italian precedents than to later Catalan wall painting.

The towering figure in twelfth-century Catalan wall painting is the Master of Sant Climent, named after the wall paintings in the main apse of the church of that name in Taüll, securely dated to 1123. Unlike the Pedret Master, he did not form a school, and in contrast to the narrative, detailed style of his Lombard colleague, the Master of Sant Climent constructs his truly monumental compositions out of only a few massive figures. In bearing they are calm and stately, yet they wear intense expressions and display a "storm of movement in the folds and hems" of their drapery.[86] His style derives from that of southern France, more specifically Languedoc and Poitou.[87] The iconography of the apse of Sant Climent in Taüll is simple but effective: in the conch of the apse we see the gigantic figure of Christ enthroned in a mandorla, surrounded by symbols of the Evangelists presented by angels; on the lower apse wall standing figures of the apostles and the Madonna are placed in a majestic row.

A painter who worked in the nearby church of Santa Maria in Taüll was receptive to the art of the Master of Sant Climent. This Taüll artist, known as the Master of Santa Maria in Taüll, painted the center apse at Santa Maria with a Madonna and Child enthroned with the three magi that derives from the Pedret school (see Esterri d'Aneu, Tredòs). All the other motifs and especially the overall style are taken from the Master of Sant Climent (compare the brilliant colors, the energetic drawing, and the three-dimensional execution of the

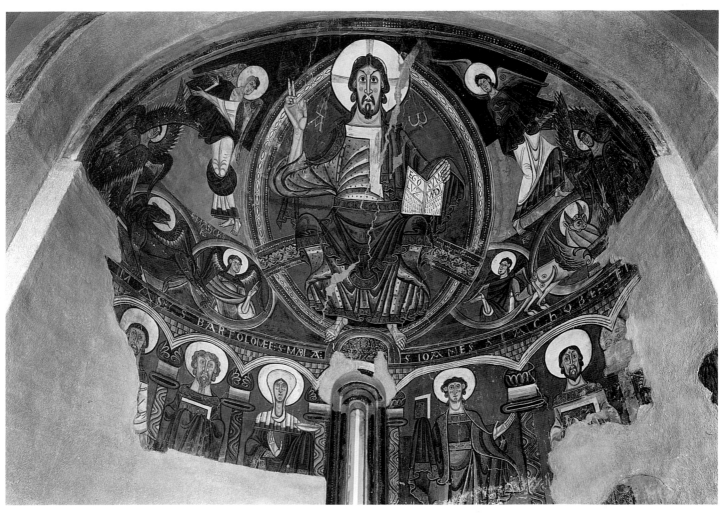

Master of Sant Climent. Majesty. Apse painting in Sant Climent de Taüll. Photo: Hirmer Fotoarchiv

details). This painter achieves none of the animated line and noble grandeur of the Sant Climent Master, but interestingly enough he had a greater influence, as he was more easily imitated. We find traces of his style not only in the frescoes from Sant Pere de Sorpe by a later representative of the Pedret school (Museu d'Art de Catalunya, Barcelona),[88] but also in the "Castilian" paintings from the churches of San Baudelio de Berlanga and Maderuelo (these now in Madrid, New York, and Boston).

In addition to the Sant Climent Master of Taüll, there were also other groups of Catalan wall painters who were dependent on patterns from southern France, especially Poitou, but who used them without the sovereignty and independence of the Master of Sant Climent. The earliest example of this is provided by the frescoes from Sant Joan in Boí and Sant Pere in Urgell, both from the first quarter of the twelfth century (both in the Museu d'Art de Catalunya, Barcelona). The frescoes from Boí are especially reminiscent of the paintings in the crypt of Saint-Savin in Poitou.[89] The paintings from the center apse at Sant Pere in Urgell present a simplified version of the apse program of Sant Climent in Taüll. Their style also appears to be a more two-dimensional variant of the art of the Sant Climent Master but has been compared to a southern French manuscript from La Grasse from about 1086–1108.[90] More remarkable is the fact that these frescoes reveal stylistic parallels to contemporary panel paintings from the same region (that is, the antependiums from Hix, Urgell, and Esquius).[91] Other Catalan workshops from the first half of the twelfth century that also adopted French influences are less important. This is true, for example, of the works of the Osormort Master, active in the vicinity of Vic (frescoes from Osormort, Bellcaire, and Brull), which have recently been compared to the wall paintings of the Trinité in Vendôme.[92]

At the beginning of the thirteenth century a new Byzantine flavor became evident in Catalonia. The last masterpieces of monumental Romanesque painting in the region of Catalonia-Aragon—the frescoes from Sigena (cat. 104)—also reveal a distinctly Byzantine stamp. In the early thirteenth century a foreign artist, an English painter of the Winchester school, was summoned to Aragon to paint the chapter hall of the former nunnery at Sigena. In glowing tempera colors in the Byzantinesque-classicizing style of the English High Romanesque, he painted scenes from the Old Testament and the infancy and Passion of Christ. These wall paintings, unusual in their iconography, had a lasting influence on later wall painting in Catalonia, Castile, and even Navarre (see the chapter hall in Arlanza, the monastery churches in Sigena and Artajona, and the tower chapel of San Pedro de Olite).[93] Catalan Romanesque wall painting thus began and ended with the arrival of important foreign artists—the Lombard Pedret Master and the English Sigena Master. The intervening decades saw an extremely creative interchange with the wall painting of southern France.

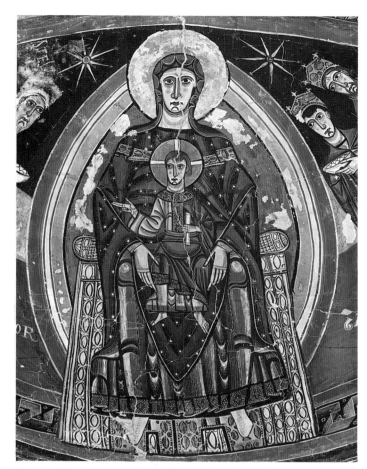

Master of Santa Maria. Detail of the Adoration of the Magi. Apse painting in Santa Maria de Taüll. Photo: Hirmer Fotoarchiv

One further area in which the Catalan Romanesque is uncommonly rich is altar frontals.[94] These were painted on wood, generally poplar or pine, their decorative portions—frames and backgrounds—ornamented with painted stucco. Usually such panels covered both the front and sides of the rectangular altar; however, there are only a few instances in which both front and side panels have survived, namely the altars from Sagás (Museu Episcopal, Vic; Museu Diocesà, Solsona), Llussá (Museu Episcopal, Vic), and Encamp (Museu d'Art de Catalunya, Barcelona). They served as inexpensive substitutes for extremely costly antependiums produced by goldsmiths for large cathedrals and abbeys, mentioned in the documents but no longer preserved. Such works were found in the cathedrals of Elne and Girona and in the abbey church of Sant Cugat del Vallès.[95] In other regions of Spain and in Europe generally the situation was doubtless very similar, though there the ratio of painted antependiums to gold and silver ones was not necessarily so high. The oldest of these antependiums came from the same region in which Romanesque wall paintings make their first appearance in Catalonia, namely the northwestern Pyrenees region of Catalonia. Panel painters apparently formed permanent workshops in which they painted inexpensive antependiums, baldachins, and other liturgical furnishings on commission and apparently in series.[96] The market for affordable panel paintings, especially painted

antependiums, then seems to have spread to the other regions of Catalonia.

Catalan antependiums are remarkably consistent—almost stereotypical—in format, composition, and iconography up until the end of the Romanesque, though no two surviving examples are exactly alike. Their rectangular front sides average a meter in height and roughly a meter to a meter and a half in width.[97] The front panel is generally divided into five compartments: a larger center panel, usually filled with a Majestas Domini (as in the antependium from the diocese of Urgell [cat. 169] or possibly a Majestas Mariae (as in the antependium from Avià [cat. 171]), and two to four side panels, one above the other, frequently presenting the apostles or narrative scenes. Early on, the Majestas was often replaced by the figure of the patron saint of the particular church, in which case the side panels were devoted to scenes from his life and martyrdom (as in the antependium from Durró [cat. 170]).

Saints and martyrdom scenes became increasingly prevalent in later Catalan antependiums from the second half of the twelfth century.[98] The Majestas type of antependiums clearly borrowed from the programs of apse paintings, though they by no means replaced them, as has been erroneously suggested.[99] In fact, in a number of cases the antependiums came from churches that also had Romanesque wall paintings (for example, San Climent and Santa Maria in Taüll, Esterri de Cardós, and so on).[100] This predominance of triumphal theophanies and the simultaneous lack of Last Judgments and scenes of Hell, both in apses and on antependiums, was surely rooted in theology: both apses and antependiums were found in the eastern part of the church, the direction associated by medieval exegetes with epiphanies and theophanies of Christ (the Incarnation, Resurrection, Ascension, and Second Coming), while the western part was linked to negative events and persons (the Day of Judgment, Hell, and Satan).[101]

After a period of superficiality and decline during the second half of the twelfth century, panel painting experienced a creative renewal owing to Byzantine influences that originated in Italy and gained increasing strength above all in Roussillon and in central Catalonia. This new style is especially clear in the antependium of the church of Oreilla in Roussillon: the extremely Byzantine facial types with strong contrasts and the sharp-edged drapery folds reveal the hand of a painter of Italo-Byzantine origin.[102] Toward the end of the twelfth century the most important Catalan master of this Italo-Byzantine group was the painter of the antependium from San Andreu de Valltarga (Museu d'Art de Catalunya, Barcelona).[103] The panel from Valltarga follows the traditional Catalan scheme of the Majestas type; its glowing blues, reds, and yellows and especially its noble gestures and massive draperies of a classical-Byzantine type herald the transition to the Gothic style. A similar proto-Gothic style is evident in the antependium from Santa Maria de Avià, which dates from the early thirteenth century.

Romanesque panel painting in Catalonia thus developed in the same fashion as did wall painting. Impressive works from the beginning of the twelfth century were followed in the second half of the century by a period of decline, which was followed in turn by a revitalization in the period about 1200.

NOTES

1. On the Spanish marches under the Carolingians, see Abadal 1926–55; Abadal 1969, vol. I, pp. 135ff; Salrach 1987, pp. 151–81.
2. Amiet 1978, pp. 77, 100; Fábrega 1980, p. 1451.
3. Kehr 1907, pp. 5ff.
4. See Villada 1923, vol. I, pp. 89–91.
5. See, for example, Valdeavellano 1963, pp. 286–300.
6. In the *Liber Maiolichinus de gestis Pisanorum ilustribus,* from the early twelfth century, the Catalans are referred to as "catalanenses" and Count Ramón Berenguer III as "catalanicus hero." See Bleiberg 1981, vol. 3, p. 397; Vicens 1972, vol. I, p. 413.
7. The term was coined by the Catalan architectural historian Josep Puig i Cadafalch. See Puig 1928 and 1932.
8. Kubach 1964, pp. 79–80, and 1968, pp. 14–15, and Köhler-Schommer 1992, pp. 92ff.
9. See, for example, Schlunk 1978, pp. 144ff.
10. Dalmases and José 1986, p. 88 (with examples).
11. Abadal 1948 (reprinted 1970, vol. 2, pp. 141–277); see also Junyent 1971.
12. Conant 1978, p. 112.
13. For the crypt, see Junyent 1966.
14. Compare, for example, the contemporary North Italian cathedral at Aosta (Duliart 1982, p. 59).
15. Both dates are documented. For the history of the building, see Delcor 1972 and 1981, and Durliat 1982, pp. 538–39.
16. Compare San Salvador de Leyre in Aragon, San Fermo in Verona, San Guglielmo di Goleto, and the cathedral in Trani. See Wagner-Rieger 1971, p. 32.
17. Hacker-Sück 1962; also Wagner-Rieger 1971, p. 32.
18. For the history of the monastery, see Zahn 1976, pp. 14–21, and Dalmases and José 1986, pp. 108–9.
19. Zahn 1976, p. 101.
20. Zahn 1976, pp. 71–72.
21. Bonassie 1975, vol. I, pp. 366 and 417 and map p. 367.
22. Bonassie 1975, vol. I, pp. 312–16 (citizens' exemption from taxes and duties), p. 368 (markets), p. 386 (mint); vol. 2, p. 856 (merchants).
23. Hernández 1930; Galliard 1938, pp. 9–31.
24. Bonassie 1975, vol. I, p. 314, and vol. 2, p. 833.
25. See, for example, Pavón 1981, pls. VIII–IX, figs. 143–46.
26. Dalmases and José 1986, p. 204.
27. Gudiol Ricart and Gaya 1948, fig. 44; also Durliat 1986, pls. 45, 46.
28. Klein 1989, pp. 140–41.
29. Klein 1990, pp. 164–70.
30. This is but one of the arguments against Ponsich's thesis that the Sorède lintel, like that of Saint-Genis, was originally an altar retable and only later came to serve as a lintel. See Ponsich 1977, pp. 190–91, and Ponsich 1980, p. 317. For arguments against Ponsich, see Klein 1990, pp. 163–64.
31. Grodecki 1973, p. 64; Klein 1989, pp. 141–42.
32. Neuss 1922, p. 19.
33. Villanueva, vol. 15 (1851), pp. 36ff.; Beer 1907, pp. 38ff; Neuss 1922, p. 19; Delcor 1974, p. 47.
34. Beer 1907, pp. 46–59.
35. See n. 11 above.
36. Dominguez 1930a, p. 37, and Dominguez in Dominguez and Ainaud 1962, p. 83. According to Neuss 1922, p. 20, the figure was 121.
37. According to the 1047 inventory; see Beer 1907, pp. 99ff.
38. Neuss 1922, pp. 20–21.
39. See frontispiece on fol. 1r, which was bound in after the rest of the Bible was complete (Neuss 1922, fig. 1).
40. Dodwell 1971, pp. 116–17.
41. Neuss 1922, pp. 74–75, 139–40.
42. Klein 1972–74, pp. 292–97; Klein 1979, pp. 144–48, 159.
43. Kauffmann 1975, pp. 39, 100, and 110 and figs. 30–40.
44. In fact a stepped hall, as there is no clerestory (Köhler-Schommer 1992, p. 95).

45. Conant 1978, p. 306; Durliat 1962, p. 19; Junyent 1976, pp. 73–86.
46. Durliat 1986, pp. 73–78, and Ponsich 1984, p. 6. In an early list of the abbots at Cuxa, we read of Abbot Gregor: "hic fecit claustra marmorea, postea fuit archiepiscopus Tarragona" (He made a marble cloister; afterward he was archbishop of Tarraconensis). A marble slab with a portrait of Abbot Gregor from the old cloister at Cuxa recently appeared on the art market; its inscription identifies him as both abbot and archbishop. See Cazes and Durliat 1987.
47. Ponsich 1987.
48. Gudiol Ricart and Gaya 1948, p. 55.
49. Gudiol Ricart and Gaya 1948, pp. 64, 66, 68; Barral 1973b, pp. 352–53; Barral 1983 in Avril, Barral, and Gaborit–Chopin, p. 91; Dalmases and José 1986, pp. 222–23; Gros 1991, p. 18, nos. 4–6.
50. Goldschmidt 1939, pp. 104–10; Barral 1973a, pp. 156–60; Baral 1973b, pp. 353–54.
51. For the sculptures in Ripoll and Vic, see Barral 1973b; also Stockstad 1970, pp. 311–59.
52. For the portal, see especially Gudiol 1909; Gaillard 1959, pp. 151–59; Junyent 1960, vol. 1, pp. 249–56; Barral 1973a.
53. Pijoan 1911–12, pp. 479–88; Neuss 1922, pp. 22–25.
54. Presumably influenced by Catalan Bible illustration.
55. Barral 1973, pp. 146, 152.
56. Junyent 1960, vol. 1, p. 256; Barral in Avril, Barral, and Gaborit-Chopin 1983, p. 118.
57. For the Cabestany Master, see most recently Durliat 1973; Gardelles 1976; Barrachina 1980.
58. Cid 1951; Marqués 1963.
59. For the cloister of San Cugat, see Baltrusaitis 1931; Alcolea 1959; Lorès 1984.
60. This has frequently been suggested; see, for example, Puig 1911, vol. 2, pp. 39ff.; Junyent 1961, vol. 2, p. 97; Palol and Hirmer 1965, p. 173.
61. Trens 1923; Trens 1966; Bastardes 1978.
62. For the last named, see Schälicke 1975 and Delcor 1991.
63. For the Italian groups, see Francovich and Maffei 1957 and Carli 1960.
64. Schälicke 1975, pp. 83–97.
65. Kurz 1990.
66. Suggested by Kantorowicz 1957, p. 61; see also Pertusi Pucci 1985–86, pp. 365–98 (cf. p. 348).
67. Junyent 1961, vol. 2, p. 269. Ainaud (1973, p. 93) calls particular attention to a Spanish-Islamic fabric venerated in the Roda Cathedral as the sudarium of Saint Ramón.
68. Dalmases and José 1986, figs. pp. 254, 255.
69. Schälicke 1975, pp. 155–56.
70. Barral in Avril, Barral, and Gaborit-Chopin 1983, p. 356.
71. Schälicke 1975, p. 154.
72. Schälicke 1975, pp. 156–57.
73. Schälicke 1975, pp. v, pp. 157–58.
74. Schälicke 1975, pp. 104–15, and Delcor 1991, pp. 195–96. The mourning figures of Mary and John are, however, not mentioned in these treatises. It would therefore appear that these commentaries on the Mass cannot have been the only textual source for the Descent from the Cross groups.
75. Schälicke 1975, p. 28; Delcor 1991, pp. 190–91.
76. This term is generally applied to Romanesque wall paintings even though only a very few were executed in true fresco, that is with the colors applied to fresh wet plaster. Most were done in fresco secco, that is, on remoistened plaster, or in tempera with various binders. See Demus 1968, p. 40.

The Romanesque wall paintings in Catalonia were rediscovered toward the end of the nineteenth century. Beginning in 1919, they were placed in museums (notably that in Barcelona), and in part because of this protection, their colors have survived remarkably well. See Pijoan 1924 and Barcelona 1993.

77. Avril, Barral, and Gaborit-Chopin 1983, p. 232.
78. See, for example, Grabar 1958, pp. 68ff.; Demus 1968, pp. 76–77; Dodwell 1971, pp. 190–92; Wettstein 1971, pp. 98–100; Avril 1983, p. 236.
79. Ainaud 1957, p. 14; Ainaud 1973, p. 108.
80. Dalmases and José 1986, p. 161.
81. For the Pedret frescoes, see Yarza 1985c, vol. 12, pp. 218–34; see also Schmiddunser 1990. Museu Solsona 1990, pp. 67–72; Barcelona 1992a, pp. 126–31, no. 5; Barcelona 1993, pp. 40–42.
82. According to Yarza 1985c, vol. 12, p. 224, two painters collaborated on the Pedret frescoes, though heretofore they have been considered the work of a single artist. The two best-preserved apses are obviously the work of the master.
83. See Demus 1968, p. 77; Ainaud 1973, p. 73; Stothart 1975, pp. 220ff.; Cook and Gudiol 1980, p. 27; Yarza 1985, pp. 223–24; Dalmases and José 1986, p. 159; Schmiddunser 1990, pp. 82–87.
84. Demus 1968, pp. 59, 112–14.
85. Palol and Hirmer 1965, pp. 127–28, 170; Demus 1968, p. 157, pl. 155; Ainaud 1973, pp. 82–83; Avril 1983, p. 233; Yarza 1985, p. 225.
86. Demus 1968, p. 78.
87. Demus 1968, p. 79; Avril 1983, p. 236. Compare also the elongated saints in the wall paintings of Saint-Hilaire-le-Grand in Poitiers and the curved sleeves and richly ornamented hems of some Christ figures of the nave frescoes of Saint-Savin-sur-Gartempe (Demus 1968, pl. 96, XLVIII).
88. The depiction of the Madonna and Child enthroned follows the precedent in the apse of Santa María in Taüll in part down to the smallest detail, though the iconographic context is different. See Toubert 1969, pp. 167–89.
89. Dodwell 1971, p. 200; Dalmases and Jose 1986, p. 282.
90. Ainaud 1973, p. 61.
91. Gudiol 1929, vol. 2, pp. 85–86; Cook and Gudiol 1950, p. 193; Ainaud 1973, p. 65. For an opposing view, see Barcelona 1992a, pp. 136, 138 (Milagros Guardia).
92. Dalmases and Pitarch 1986, p. 285.
93. Demus 1968, pp. 81, 169; Cook and Gudiol 1980, pp. 92–93, 96–98.
94. The most important studies of them are Gudiol 1955; Folch 1956; Cook 1960; Carbonnell-Lamothe 1974.
95. See, for example, Cook 1960, pls. 11, 18, 19, 31, 33; Dalmases and José 1986, pls. on pp. 290, 291; Gros 1991, pp. 56–59.
96. See Gudiol 1929, vol. 2, p. 28; Folch 1956, pp. 124–25; Sureda 1981, p. 44.
97. Cook and Gudiol 1950, p. 123.
98. For measurements, see Carbonnell-Lamothe 1974, pp. 72, 84–86.
99. Dalmases and José 1986, p. 292.
100. Borras and Garcia 1978, pp. 349–50.
101. Sureda 1981, p. 45.
102. Klein 1993.
103. See Durliat 1961, p. 8, and Carbonnell-Lamothe 1974, p. 76.
104. Cook and Gudiol 1950, p. 216 and figs. 189, 190; Ainaud 1973, p. 154, no. 15804; Sureda 1981, pp. 359–60, no. 119; Barcelona 1992a, pp. 64–67, no. 1.24.

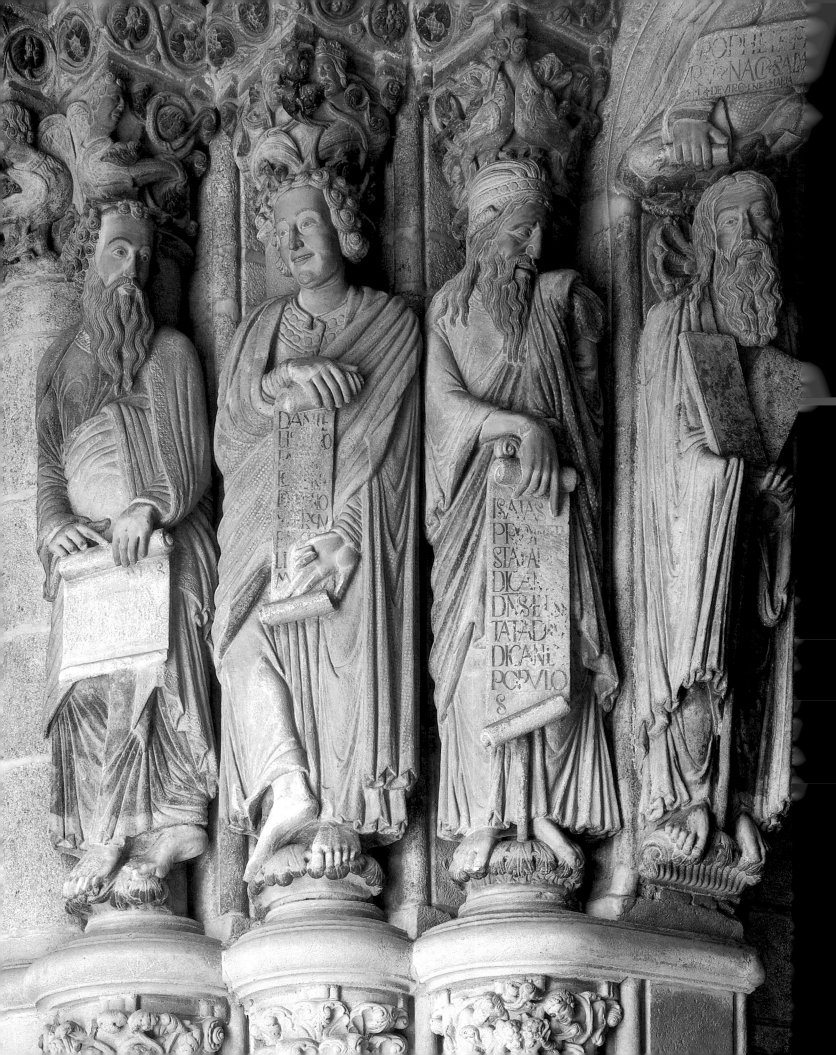

late Romanesque art in spain

David L. Simon

Spanish art from the middle of the twelfth century to the beginning of the thirteenth century is notable for its constancy in adhering to a Romanesque aesthetic. This is not to say that the art was unchanging or that artists were unresponsive to new developments elsewhere. Forms were borrowed both from the Islamic culture, with which Christians shared the Iberian Peninsula, and from beyond the Pyrenees. The basis of a new style, *opus francigenum*—what we today call Gothic art—had already been established in northern Europe, and Spanish artists were certainly aware of the new trends. But when they appropriated motifs and devices, the foreign elements were so well assimilated that the spirit of the art remains profoundly Spanish or, put another way, profoundly Romanesque.

Many late Romanesque monuments in Spain reflect contact, either direct or indirect, with the art of France or of other European centers. The capitals in the cloister of Pamplona Cathedral in northern Spain, carved about 1140 (cat. 96),[1] have been associated with a French tradition and compared specifically to sculpture from Moissac.[2] They may also be linked to an artistic current that appears in Provence, for example at Avignon. Conversely, it is generally thought that sculptures in several northern Spanish churches—Santa María in Uncastillo, San Martín in Unx, and perhaps San Pedro de la Rua in Estella—depend on developments at Pamplona.[3] Pamplona's position seems to exemplify a broad pattern of the Spanish Romanesque: forms from diverse sources are molded at one center into a distinctive style which then establishes regional currency. The paradox is that internationalizing forces—the frequent passage across the Pyrenees of artists and ideas —produced local or regional schools.

The Pamplona capitals are more than the sum of their stylistic details: an astonishing emotional intensity is achieved in these highly plastic sculptural compositions with their dramatic gestures and arrangements, their expressive use of texture and line. The same corporeal drama is enacted on a number of late Romanesque monuments from central and western Spain, for example the Pórtico de la Gloria at Santiago de Compostela, the facade of the church of Santiago in Carrión de los Condes, and the sculptures from the second workshop in the cloister of Santo Domingo de Silos. In these sculptures deep undercutting and effusive drapery establish an expressiveness that is at once moving and exhilarating. All these works,

together with coeval sculptures in the Cámara Santa at Oviedo and the west portal at San Vicente in Ávila, have been shown to have ties with monuments in France—in Languedoc and Burgundy as well as in the Île-de-France, where the Gothic style had already been firmly established.[4] The connections, both stylistic and iconographic, appear indisputable.

One is struck, however, by a force that seems to override those bonds: a resistance in Spain to Gothic aesthetic solutions. For example, in the Pórtico de la Gloria, where Master Mateo signed the lintel of the central portal and included the date 1188, the column figures of apostles on the portal jambs show little of the French Gothic interest in spiritualized, denaturalized forms. These are figures whose emotional intensity suggests the physical and indeed psychological presence

Apostle. Santiago in Carrión de los Condes (Palencia). Photo: Hirmer Fotoarchiv

Jeremiah, Daniel, Isaiah, and Moses. Pórtico de la Gloria, Santiago de Compostela. Photo: Joseph Martin

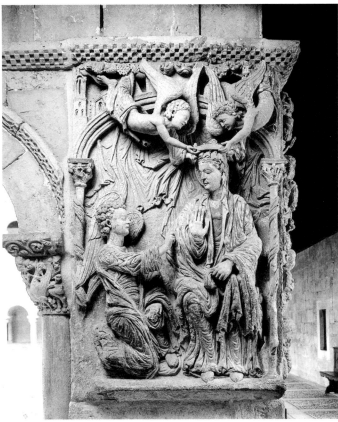

Annunciation. Santo Domingo de Silos (Burgos). Photo: Bruce White

workshops and not by a single artist or school. (The same formal concerns are expressed in sculpture throughout much of northern Spain and in other mediums as well, as a comparison of the enameled metalwork *urna* of Santo Domingo de Silos [cat. 134] with the column figures of the Cámara Santa in Oviedo makes clear.)[7]

Attempts have been made to sort out the artists who participated in these large decorative programs, particularly at Silos, where two, three, or sometimes four distinct artists have been distinguished within the second atelier,[8] and at the Pórtico de la Gloria of Santiago, where according to some accounts, Mateo directed the work of at least three identifiable assistants.[9] But certainly more striking than the distinctions between masters are the broad similarities at a given site, suggesting artists working under other artists or ateliers that were part of a larger atelier. The situation may well differ from that of the earlier Romanesque period, when styles were less unified than they became in the later Romanesque period. Interesting in this connection is Elizabeth Valdez del Alamo's suggestion that the second workshop of the Silos cloister, active at least a few generations after the first cloister work was completed, integrated its sculpture to a substantial degree, both formally and programmatically, with the noble achievements of its predecessors.[10]

of the apostles as historical or at least legendary individuals. The portal, supporting a wealth of anecdotal detail, is a composition of many separate units. The archivolts of the center and left doorways are Romanesque in the radial arrangement of their sculpture and in the way the torus serves as a prop to support the figures placed either behind or on top of it. This format is seen elsewhere in Spain: for example, at San Miguel and Santa María in Uncastillo. On the archivolts of the right portal, however, the figures follow the curve of the arch, in keeping with innovations developed in France before the middle of the twelfth century. In constructing a portal at once groundbreaking and traditional, Master Mateo drew upon foreign sources but perhaps equally fascinating is the way his style concentrated into a kind of regional Galician school and also spread to a broader area, particularly to Zamora and Ciudad Rodrigo in the kingdom of León.[5]

Emotional and dramatic qualities connect Mateo's art at Santiago de Compostela with other Spanish works of the later twelfth century, mentioned above, at Silos, Ávila, Carrión de los Condes, and Oviedo. Some scholars argue that a pupil of Master Mateo's worked at Silos and some of the other centers mentioned above; some see the influence going in the other direction; some concentrate on what distinguishes the art of a particular site.[6] Despite their interrelationships sculptures in these diverse centers were produced by distinct artists or

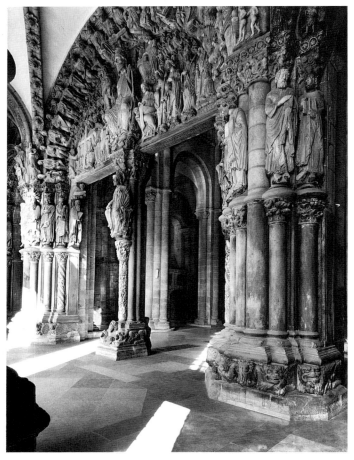

Pórtico de la Gloria, Santiago de Compostela. Photo: Hirmer Fotoarchiv

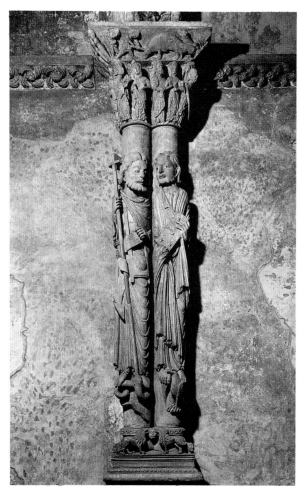

Saints James the Greater and John the Evangelist. Cámara Santa, Cathedral of Oviedo. Photo: Hirmer Fotoarchiv

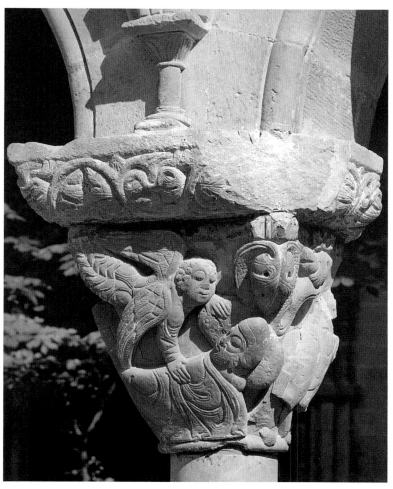

San Juan de la Peña Master. Capital showing the Dream of Joseph. San Juan de la Peña (Huesca). Photo: Hirmer Fotoarchiv

This style in which heightened emotions are expressed through high relief and deep undercutting is evident across a broad geographical area and in sculptures of lesser quality. In many of these reflective works the forms have hardened, and the subtle sense of unfolding drama attained by the founding artists gives way to a pantomime of histrionic gesture amid heavy shadow. This is the case with the bulging-eyed figures of the San Juan de la Peña Master, which are common in late-twelfth-century Aragon and appear in Navarre as well. His manner and ultimately that of his followers undoubtedly derive from the much finer Castilian sculptures.[11] A similar comparison can be made between sculpture at Moarbes in Palencia, nearby sculpture at Aguilar de Campóo and Santa María de Lebanza, and the two Palencian capitals from the Walters Art Gallery (cat. 99), on the one hand, and sculptures from the church of Santiago in Carrión de los Condes, the models for those works, on the other. This tendency to produce austere and indurate forms has resulted in the identification of artists or schools that seem individual, indeed idiosyncratic, such as the Cabestany Master. Sculpture in his style appears in Navarre and Catalonia in Spain, in France, and in Italy, where

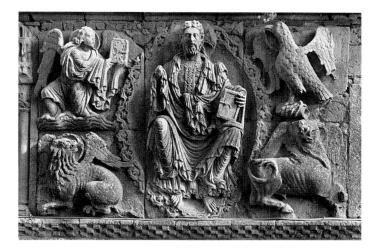

Christ with the symbols of the Evangelists. Santiago in Carrión de los Condes (Palencia). Photo: Hirmer Fotoarchiv

his career is generally considered to have begun (cat. 161).[12] The Cabestany Master may not have been Spanish, but it is not surprising that his style was well received in Spain.

While much of Spanish Christian art is northern-looking, the political intentions of Christian Spain were toward the

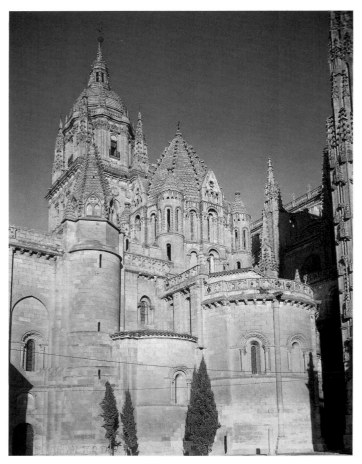

Old Cathedral, Salamanca. Photo: Archivo Fotográfico Oronoz

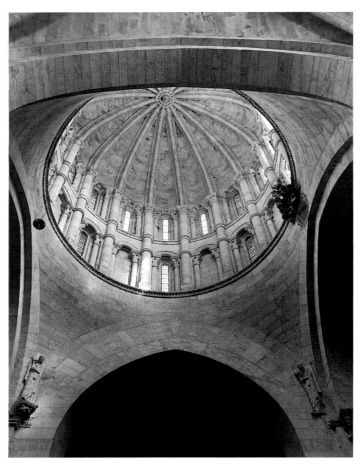

Dome, Old Cathedral, Salamanca. Photo: Hirmer Fotoarchiv

south. In the later twelfth century Spanish forces were engaged in a continual effort to conquer lands controlled by the Muslims, who by this time had occupied much of the Iberian Peninsula for more than four hundred years. A decisive moment came in 1212, when the united troops of the Christian kingdoms and counties of Spain were victorious in battle at Las Navas de Tolosa. When Seville fell a few years before the middle of the thirteenth century, the Christian conquest was virtually complete; all that remained of al-Andalus was the relatively small kingdom of Granada. With these victories came the responsibility to establish the security of the newly conquered territories, which required first of all that they be repopulated. This was no easy matter, since for a long time much of Spain had been underpopulated. Settlement in Christian territories was encouraged by offering *fueros*, or charters, to willing settlers, many of whom were foreigners. Issued by Spanish kings and lords, the *fueros* stipulated favorable taxation, generous economic support, and provisions for personal freedoms.

There was a concomitant need for social and religious services in these newly settled growing areas. Salamanca in southern León is a case in point. Salamanca was recaptured about 1055, and by the beginning of the twelfth century many for-

eigners had settled there as a result of encouragement from Alfonso VI. The cathedral, which was soon built, proclaimed the vitality of the culture and the faith of the conquerors. Salamanca Cathedral was under construction by 1158 and was completed in the early years of the thirteenth century; along with the nearby cathedral of Zamora, begun in 1151 and largely complete by 1174, it introduced into the Spanish building repertory the crossing dome supported by pendentives.[13]

The pendentive, although innovative for Spain, was a venerable form in medieval architecture. One might imagine that the pendentive and the domed cupola were chosen at this time to accentuate the height and mystical quality of the cathedral space—the effect they had achieved in the early Byzantine churches for which they were invented. Such a dematerialization of the architecture could in fact be compared, in conceptual terms, to changes taking place in France during the later twelfth century, early in the Gothic period. In Salamanca and Zamora, however, the domed cupolas seem to place a lid on the spaces they enclose, serving more to delimit the space than to expand it. It is as if architects in Spain made use of the dome on pendentives to implement a continued Romanesque interest in broadly conceived, clearly demarcated horizontal spaces. The architects of Salamanca Cathedral do show their

awareness of French Gothic developments by their use of pointed arches, cross-ribbed vaulting, and compound piers, but at the same time the two-story elevations, the unadorned walls, the long stretches of horizontal molding above the nave arcade, and individualized capitals, many of them figural, mark the cathedral as a late Romanesque work. Indeed, the two levels of windows in the dome are so nearly overwhelmed by the columns flanking them that they become another of the horizontal forces defining the interior. In architecture as in sculpture, then, the tendency in Spain was to continue the Romanesque style beyond what seemed its natural lifetime in other countries, or at least in France.

The exteriors of the Salamanca and Zamora cathedrals, capped by conical roofs, punctuated by rhythmic arcades, and adorned with decorated lanterns, spires, and aediculae, recall more than anything else the structural and decorative treatments of Aquitanian churches (although admittedly this effect is heightened by the imbricated roof tiles, which probably represent overrestoration). It is precisely in Aquitaine that domed churches proliferated during the height of the Romanesque period. Moreover, both marriage and diplomacy linked the Spanish monarchs of León and Castile with their southern French counterparts. In fact, as early as 1102 Count Raymond of Burgundy, who was married to Urraca, the daughter of Alfonso VI and Inés of Aquitaine, was asking Bishop Jérôme of Périgord to help him obtain plans for the cathedral of Zamora.[14] The dynastic connections with France were renewed throughout the century: in 1170 Alfonso VIII, grandson of Urraca and Raymond, married Eleanor of England, daughter of Eleanor of Aquitaine and Henry II of England.

It should also be remembered that Aquitaine sent many of its most valiant knights and large numbers of soldiers to fight for the Christian conquest of Spain. On a popular level, and for clear enough reasons, the struggle in Spain was seen as equivalent to the effort to regain the Holy Land. In fact, the decisive campaigns of 1212 were officially recognized as a Crusade by Pope Innocent III. Knights from northern Europe who had participated in Crusades to the East came to Spain to battle, and some stayed. Among them was Count Gaston of Béarn, who fought under the Aragonese king Alfonso I, el Batallador, and for his efforts was named lord of Saragossa. Not surprisingly, military orders that had figured importantly in the eastern Crusades participated in Spanish campaigns as well. So great and perhaps so benighted was Alfonso I's gratitude to the military orders that at his death in 1134 his will named the orders of the Holy Sepulcher, the Hospital, and the Temple as heirs to his kingdoms of Aragon and Navarre. Apparently even the beneficiaries did not consider this plan realistic; the day after Alfonso's death the nobles of Aragon elected his brother Ramiro II as king, and the military orders raised no objection.

The international military orders and their local Spanish derivatives, the orders of Alcántara, Calatrava, and Santiago, established numerous monasteries and churches. In quite a few cases, buildings connected with these orders made definite allusions to monumental architecture of the Holy Land. For example, the churches of Santo Sepulcro in Torres del Río and Vera Cruz in Segovia and the castle-church of Tomar in Portugal, with their central plans and elaborate vaulting patterns, recall buildings in the East. Other formal elements employed to suggest eastern architecture are drawn from buildings closer to home. While Santo Sepulcro in Torres del Río[15] has a wall elevation so western in style that some scholars characterize it as virtually Cistercian, its intricate vaults, which in a general way recall Holy Land buildings, much more specifically mirror forms employed in al-Andalus. So striking is the relationship between vaults at Torres del Río and those in the Great Mosque at Córdoba that some scholars claim Muslim or Mozarabic artisans produced the Torres del Río vaults and the lobed corbels that support them.[16] We know that the warrior knights admired much of what they conquered. This sentiment is particularly evident in the areas of literature and music, where Andalusian culture played an influential role in the development of western genres. One imagines that knights of the military orders, finding in Spain a rich architecture that they associated with the Holy Land and artisans skilled in its execution, willingly appropriated the forms and employed the artisans for building that met their own purposes.

It is therefore not surprising to find that the impact of al-Andalus on Christian art is widespread, evident not only in vaulting designs such as those at Torres del Río but also in borrowed decorative motifs, such as cusped arches and various geometric patterns. Kufic inscriptions appear in some buildings and on precious objects like the enameled cover of the *urna* of Santo Domingo de Silos of about 1170.[17] But perhaps what is most astonishing is not the fact that Islamic motifs entered Spanish Christian art, but the limited nature of their incursion. It cannot be said that Islamic material was rejected because of its basis in the creed of the adversary, since there is much evidence that Christians were receptive to broad aspects of Islamic culture. Certainly Christian rulers were not reluctant to acquire Muslim mistresses and wives or Islamic works of art of the highest quality, many of which were placed in church treasuries. It is rather that Islamic forms entered the repertory of Christian art without the context of their original devising. Islamic motifs were integrated into established artistic systems or modes of expression, which were enriched by this potent infusion. In fact, one might well ask whether the Spanish resistance to a French Gothic aesthetic was based upon the capacity of Romanesque art to develop further in Spain than in the north, precisely because of the vitality of new forms. It is also a fact that the proximity of the foreign, intrusive religion and culture of Islam meant Romanesque forms still had a role to play, expressing as they did a sense of security, Christian tradition, and control.

Perhaps the exception to these general rules is the style that

Mudejar tower, Santa María in Mediavilla, Teruel. Photo: Archivo Fotográfico Oronoz

constitute a style, and it is possible to regard Mudejar monuments as traditional western European buildings with Andalusian surface decoration applied to them. Indeed, some prefer the terms "Mudejar Romanesque" and "Mudejar Gothic" to describe the style of these works. Mudejar buildings convey a sense of harmony with the landscapes and cityscapes that surround them, in part because the rich brick designs can be appreciated to full advantage in the strong Spanish sun.

The complex visual patterns on Mudejar churches and their integration into the Spanish landscape provide a metaphor for the achievement of Spanish late Romanesque art, which established a rich synthesis between stylistic impulses from beyond the Pyrenees and those that emerged from the mix of cultures sharing the Iberian Peninsula. Opportunities for artistic growth came with the expansion of Christian territories, even as the successful Reconquest deepened the encounter with Andalusian culture. The vitality of late Romanesque art in Spain may well rest on the determination of artists to express their expansive fervor by newfound means but in forms that maintained the integrity of the Romanesque, thus sustaining the Christian values that that tradition embodies.

NOTES

1. Vázquez de Parga 1947; Ubieto 1950, pp. 77–83; Goñi 1953, pp. 311–27.
2. Yarza 1979, p. 217.
3. Lojendio 1967, p. 230.
4. Buschbeck 1919; Weise 1927, vol. 2; Gudiol Ricart and Gaya 1948, pp. 337–54; Pita 1952, pp. 371–83; Pita 1955; Moralejo 1973b, pp. 294–310.
5. Pita 1953, p. 222; Yarza 1979, p. 276.
6. For a recent and thorough evaluation of the literature, see Valdez del Alamo 1986. See also Porter 1923, vol. 1, pp. 251–53; Pita 1955; Gudiol Ricart and Gaya 1948; Gaillard 1963, pp. 142–49.
7. Gauthier 1972, p. 90.
8. Yarza 1970, pp. 342–45; Lacoste 1973, pp. 109–14; Yarza 1980, p. 171.
9. Otero 1965, pp. 961–80.
10. Valdez del Alamo 1986.
11. Lacoste 1979, pp. 175–89.
12. Zarnecki 1964, p. 536; Pressouyre 1969, pp. 30–55.
13. Viñayo 1972, p. 343.
14. Palol and Hirmer 1967, p. 132.
15. For a discussion of the question of the attribution of the church of Santo Sepulcro to the Templars, see Lojendio 1967, pp. 266–68; Munteau 1977, pp. 27–40.
16. Gudiol Ricart and Gaya 1948, p. 147; Lojendio 1967, pp. 266–300; for a discussion of the importance of the lobed corbel, see Torres 1936, pp. 1–63, 113–50.
17. Gauthier 1972, p. 328.
18. For a crisp discussion of the problems presented by Mudejar art and relevant bibliographic references, see Yarza 1979, pp. 311–22.

is often labeled Mudejar, that is, the art produced by or under the influence of Muslims living in Christian-dominated territory. This style, if it can properly be called that,[18] is generally characterized by brick construction and by decoration based on geometric and structural patterns workable in brick. The style is found predominantly, but not exclusively, in territories of the Reconquest, usually areas where clay is a natural material, and is generally executed in brick of local manufacture. It may have originated from a need in these areas for fast, inexpensive construction combined with the availability of Muslim laborers skilled in brickwork. However, these characteristic materials and decorative forms may not in themselves

Relief of two women with a lion and a ram

Church of Saint-Sernin, Toulouse (Haute-Garonne),
ca. 1115–20
Marble
53⅛ x 26¾ x 5½ in. (135 x 68 x 14 cm)
Musée des Augustins, Toulouse (502)

In its style, composition, and technique, this relief, often called the Signs relief, manifests the close relationship between the sculptors who worked at Saint-Sernin in Toulouse and those who worked at the great cathedral of Santiago de Compostela. So close is the relationship that the Signs relief and certain figures on the Puerta de las Platerías of Santiago, such as the King David, have been described as identical in style.[1]

The sculpture, whose meaning has been difficult to decipher, represents two women seated cross-legged, heads turned toward each other. The woman at the left restrains a snarling lion in her lap; the other encircles a ram with her arms. Each woman has one foot shod—the foot resting on a tiled roof at the center—and the other, bare, foot rests on a lion's head at either edge of the plaque. On the surface behind them, the inscription reads: SI/G/NV[M]/L/E/O/NIS//S/I/G/NU[M]//ARI/E/TIS/H/OC/FU/IT/FA/CT/UM/T/TEMPO/RE/IULII//CE/SA//RI/S (The sign of the lion/The sign of the ram/This happened in T[oulouse]/In the time of Julius Caesar). Exactly what the signs of the lion and ram mean and what their relation is to the two women have remained an enigma.

One of the more distinctive artists who worked at the church of Saint-Sernin is the sculptor who carved the Signs relief. It appears to be one of the later works of the workshop of Bernardus Gilduinus, which operated at Saint-Sernin from about 1096 and continued its activity under the supervision of the canon Raymond Gayrard until his death in 1118.[2] Because the sculptural decoration of Saint-Sernin was incomplete at the time of Gayrard's death, many reliefs produced under his administration were never set into their intended locations, which are now unknown to us; such was the case with the Signs relief. It was described by sixteenth- and seventeenth-century antiquarians as placed near the baptismal font inside the south transept portal of the church.[3] Since 1800 the relief has been in the Musée des Augustins, Toulouse, along with other sculptures removed from Saint-Sernin during the French Revolution. It is possible that the Signs relief was originally meant to form part of the never-completed decoration of the west facade of the church.[4]

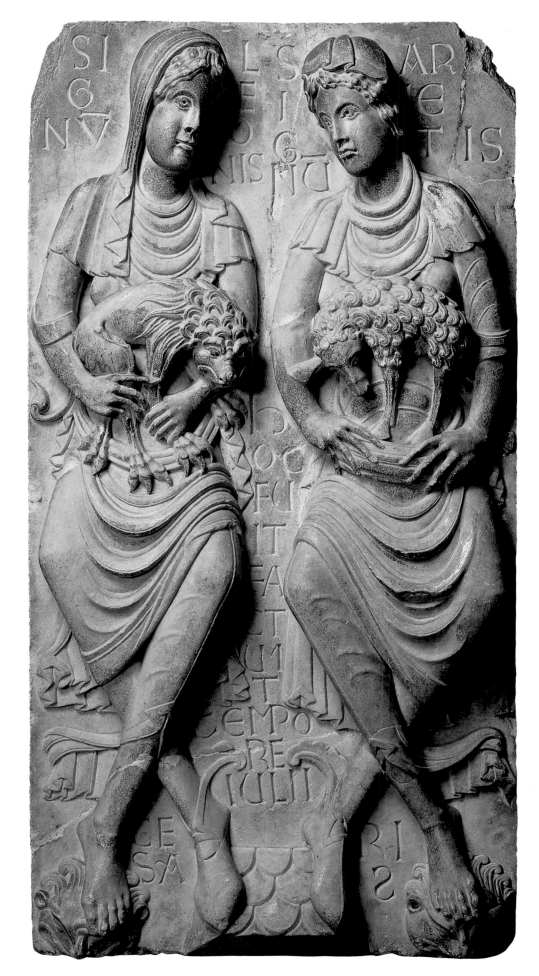

As with the other sculptures produced by the Gilduinus workshop, the figures are rendered in high relief with an emphatic roundness of form. What sets the two women apart as later works are their attenuated proportions. Their rectangular heads contrast with the strong-jawed square heads of their predecessors on the Porte Miègeville of Saint-Sernin. Their drapery has more supple folds, which disappear gradually as their garments stretch across their limbs, unlike the raised upward hooks that characterize the drapery folds of the Porte Miègeville figures and even the figure of King Antonius from the west facade of Saint-Sernin.[5] Like those other sculptures, the two women have large heads supported by narrow shoulders and relatively short, tubular arms that seem almost without bones. Long, expressive fingers, however, demonstrate a fine understanding of human form. Their hair is rendered in pronounced clusters of wavy locks; their rounded cheeks call attention to their expressive faces; and their garments' hems fly away in angular, carefully pleated folds. Drilling and deep undercutting, especially around the eyes and mouths, are used to animate facial expressions, giving the two women and the animals they hold a lively and assertive presence. The ferocious lion, with its flattened flanks and sharp, angular claws, is very similar to lions on capitals still on the west facade and to others identified as being from the cloister of Saint-Sernin.

A multitude of similarities between the sculptures of Toulouse and Compostela between about 1080 and 1120 has led many scholars to conclude that the Signs relief is identical in style to many pieces on the Puerta de las Platerías of Santiago. The motif of a seated, cross-legged woman holding an attribute or offering, such as an animal or perhaps fruit, is found in both Compostela and Toulouse. At Santiago, on the Puerta de las Platerías, for example, there is another woman with a lion on the right embrasure of the right doorway; in the tympanum above, the so-called Adulterous Woman holds a skull in her lap; and from the north facade, there is a woman holding a bunch of grapes (cat. 91). Such figures are derived from antique compositions like a mother goddess with a lion in her lap or Aphrodite with a ram, but whether they continued to share any meaning with these ancient forms remains an open question. Many seated figures with crossed legs, King David, for example, may be found at both Santiago and Saint-Sernin.

The reliefs on the Platerías portal most often compared with the Signs relief are the woman with a lion and the King David. The David lacks the puffy cheeks of the two women of Toulouse, however, and the Compostelan artist did not use a drill to pierce either the pupils of the eyes or the corners of the mouth. Instead, David has fleshy lips, more rounded arms, and a generally fuller body. His drapery hems are more controlled and do not fly away as do those of the two women. The woman with a lion at Compostela, while damaged, can be seen to have an exaggeratedly swollen cheek and chin and windblown hair. As she twists to look upward, her tunic forms large teardrop folds that emphasize her right breast. The sensuous treatment of this figure is comparable to that of the Adulterous Woman in the tympanum above, and the two were probably carved by a different artist from the ones responsible for the David and the two women of Toulouse. It would be difficult to affirm whether or not the same hands were at work in both places, but the two women have no precise stylistic equal in Compostela.

Several explanations have been proposed for the Signs relief. Some scholars read these figures as signs of the zodiac according to the Julian calendar. Another interpretation has them representing vices. The most frequently cited basis for understanding this work is a legend of Toulouse falsely attributed to Saint Jerome, in which two virgins give birth to a lion and a lamb, portents of the Last Judgment. Two problems with this explanation are that the relief's inscription specifies a ram, not a lamb, undoing the christological reference, and that the earliest recorded versions of this legend appear in the thirteenth century, too late to be the source for the Saint-Sernin relief.[6]

The two women of Saint-Sernin probably have a significance specific to that locality, since the composition was not repeated widely. It has been suggested that the two women are the *Saintes Puelles* (Holy Maidens) who buried Saint Saturninus (Sernin in French) after his martyrdom in Toulouse and whose cult is still celebrated in the region.[7] Guillaume de Catel, in 1633, wrote of an image of two women placed at the side of the main altar of Saint-Sernin, convinced that they could only be the *Saintes Puelles*.[8] The other possible known instance of this image occurred in the nearby town of Nogaro (Gers). Found in 1954, in the course of the laying of telephone lines, were two matching plaques, only one of which was extracted from the ground.[9] That relief was of a woman with a lion in her lap and a shortened version of the Toulouse inscription, M LEONIS, on her halo.

EVA

1. Cabanot 1974, p. 144; Gaillard 1929, p. 361.
2. Mesplé 1961, p. 206; Durliat 1965a, pp. 237, 240–41; Milhau 1971, pp. 45, 50–52.
3. Noguier 1556, pp. 53–54; Daydé 1661, p. 276.
4. Scott 1964, p. 280; Durliat 1965b, p. 222; Durliat 1978, pp. 121–23.
5. Mesplé 1961, fig. 207.
6. Mély 1922, p. 96.
7. Valdez del Alamo 1979.
8. Catel 1633, pp. 818, 821–22.
9. Samaran 1955, pp. 253–60.

LITERATURE: Bertrandus 1515, fol. 66v; Noguier 1556, pp. 53–54; Catel 1633, pp. 818, 821–22; Daydé 1661, pp. 276, 280; Du Mège 1828, pp. 101–2, no. 244; Saint-Paul 1897, p. 96; Lahondès 1903–6, pp. 452–55; Mély 1922, pp. 88–96; Gaillard 1929, pp. 360–61; Weisbach 1945, pp. 119–22; Samaran 1955, pp. 253–60; Mesplé 1961, pp. 206–10, fig. 206; Scott 1964, p. 280, fig. 24; Durliat 1965a, p. 237; Durliat 1965b, p. 222; Milhau 1971, pp. 6, 45–55, no. 19; Cabanot 1974, p. 144; Durliat 1978, pp. 121–23, figs. 48–50; Valdez del Alamo 1979; Mora 1991.

87

head of a youth

Church of Saint-Sernin, Toulouse (Haute-Garonne), ca. 1115–20
Marble
H. 7 11/16 in. (19.5 cm)
The Metropolitan Museum of Art, New York; Gift of Ella Brummer, in memory of Ernest Brummer, 1976 (1976.160)

This three-quarter life-size head of a youth exemplifies the problem of the relationship between the art of Santiago de Compostela and Saint-Sernin, Toulouse. Originally described as a sculpture from southern France or northern Spain, the head was identified by Charles T. Little as being from the sculptural decoration of Saint-Sernin and as having been carved by the same artist who produced the Signs relief.[1] Like that piece, this fragment forms part of the enormous body of Romanesque works sharing the broadly unified style of northern Spain and the south of France, from which derive many attribution problems. A careful comparison, however, between individual works from specific sites usually demonstrates clear differences between them.

Made of the same gray marble as the relief depicting two women with a lion and a ram from Toulouse (cat. 86), the sculpture represents the head of a youth with a Phrygian or a seafarer's cap. The cap's pleats form a peak over his high forehead and sweep down toward the back of his neck, while his long, wavy hair flows out from under the brim. The carving technique, size, and style of this youth clearly indicate that the same artist produced both this head and the relief of the two women. Several traits are characteristic of his work. The figures have long faces that are indented where the cheekbone meets the temple to produce a head in the form of a figure eight. Full cheeks counterbalance a firmly set, expressive mouth with narrow, curved lips. Most striking are the eyes. Set under a deeply cut brow, the heavy upper lids arch over projecting lower lids. The deeply

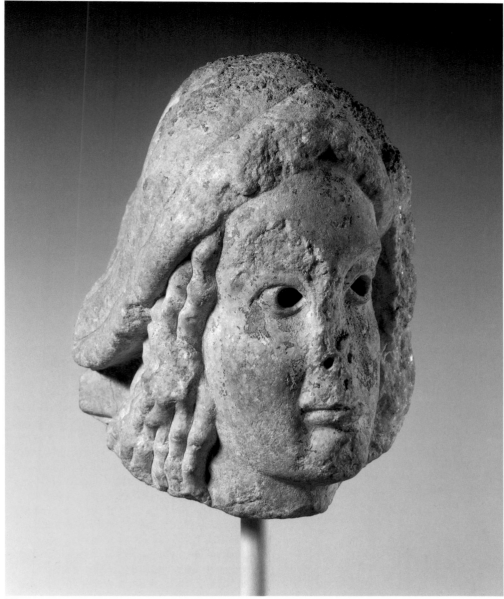

different from the head of the youth. Those vigorous figures have squared heads with watchful eyes, bowed lips, and brows clearly defined by incised lines; their heavy-jawed appearance is quite far removed from that of the delicate youth. In general, during this period Spanish sculpture has a corporeality that differs from the attenuated figures of the two women of the Signs relief and the youth with the Phrygian cap from Toulouse.

Like the Signs relief, the head of a youth was probably part of the sculptural ensemble of Saint-Sernin left incomplete upon the death of Raymond Gayrard in 1118. Hypothetical reconstructions of the reliefs on the west facade, based on sixteenth- and seventeenth-century descriptions, indicate that the intended program included the life and martyrdom of the church's patron saint, Saturninus, and representations of other saintly bishops associated with Saint-Sernin.[2] The youth may have been a participant in one of these scenes. His cap recalls some of the exotic caps and turbans on figures found on the Porte Miègeville. Thus, even this detail supports the attribution of the head to Saint-Sernin in Toulouse.

EVA

1. *Annual Report* 1976, p. 51; "Chronique" 1977; Little 1979, pp. 22–23.
2. Scott 1964; Durliat 1965b.

LITERATURE: *Annual Report* 1976, p. 51; "Chronique" 1977; Little 1979, pp. 22–23.

87

drilled pupils repeat the almond-shaped form of the eye, so that the face achieves an animated intensity, striking in this youthful head despite its having been damaged. The artist's fondness for asymmetry finds expression here in the slight upward slant of the right side of the face, visible when the head is seen from the front. It was, however, intended to be seen from the left as a three-quarter view, and from that angle the irregularity serves to further animate the youth's forcefully expressive features. The faces of the two women from Toulouse are rendered in the same fashion.

Many of the works from Santiago de Compostela with which the Signs relief is frequently compared can also be related to this head. Two additional comparisons may be made with objects from the Spanish pilgrimage route included in this exhibition: the fragment of a relief with a woman holding

bunches of grapes from the north facade of the cathedral of Santiago (cat. 91) and the capital with figures and snakes from the cloister of the cathedral of Jaca (cat. 88), both produced about 1110. The woman holding bunches of grapes has the full, melon face with fleshy lips, prominent cheeks, and rounded chin typical of so many figures found at Santiago de Compostela. Her ungroomed hair tumbles in curly locks around her shoulders, emphasizing her sensuous corporeality. By contrast, the Toulousan youth's long face is framed by carefully controlled hair with much tighter curls. His prominent yet narrow lips are set in an expression of determined concentration, enhanced by his drilled pupils, whereas her soft lips are parted as she looks into the beyond with unarticulated eyes. The figures on the Jaca capital, while comparable to the earlier sculpture from Saint-Sernin on the Porte Miègeville, are also quite

88

capital

Jaca Cathedral (Huesca), first quarter of 12th century
Limestone
H. 16⅛ in. (41 cm)
Church of Santiago and Santo Domingo, Jaca

When the Romanesque cloister of Jaca Cathedral was dismantled and modernized in the eighteenth century, at least thirty of its sixty original capitals were dispersed around the cathedral and the city, serving as building components or simply as decorative objects.[1] One of these capitals, now in the church of Santiago and Santo Domingo in Jaca, has been employed as the support for a baptismal font for many years, perhaps since the eighteenth century. The Santiago and Santo Domingo capital may be linked to the Jaca cloister on the basis of size, since its measurements are commensurate with those of the original cloister impost blocks that remain in situ. The carving on this capital is of extremely high quality and on stylistic grounds

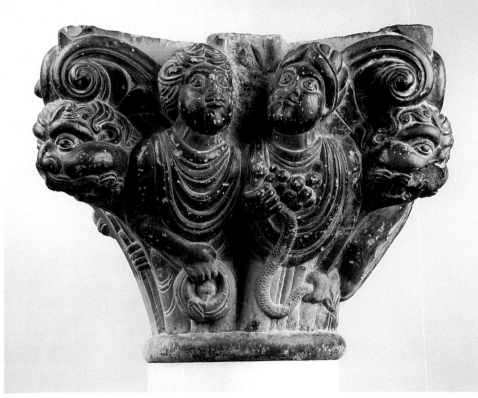

88

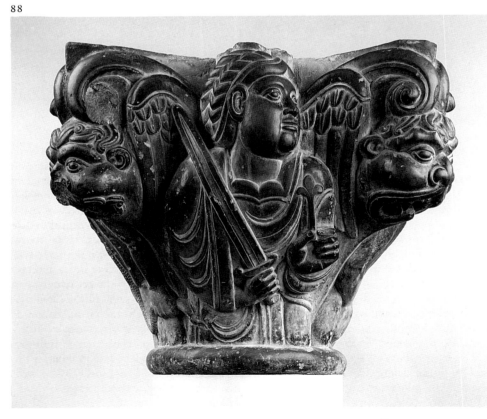

88

one holds a snake and the other a round, wreathlike object. While both figures have bibs characterized by ropy folds, the bib of the right-hand figure is filled with round objects, possibly fruit. On the next side a veiled female figure holds a large leaf in front of her so that only her head and shoulders are visible. The contiguous face of the capital contains a semidraped youth with flamelike hair, who clasps a scalloped object in his left hand. A winged man is represented on the fourth side of the capital, gripping a sword in his right hand and a small staff topped with a fleur-de-lis in his left hand.

An iconographic identification of the figures depicted on this capital is difficult at best. Their attributes as well as their classicizing appearance recall Roman sarcophagi with representations of the Four Seasons[2] and Roman calendar illustrations,[3] which are known to have influenced Romanesque art. According to this interpretation, the figure with the fruit-filled bib could be Autumn; the woman with the leaf, Spring; the youth with the flamelike hair, Summer; and the male figure with the sword and fleur-de-lis-ornamented staff, Winter. Another interpretation, again suggested by the style and attributes of the figures, depends on classical and early medieval depictions of the planets. Thus, the woman with the leaf could be the moon; the youth with the flamelike hair, the sun; and the man with the sword and fleur-de-lis staff, Jupiter. These attributes are, in fact, traditional symbols of the seasons and the planets found in classical art. While each of these explanations is appealing for its own reasons, each remains flawed as well, since the numbers do not match up. There are five figures on the capital and only four seasons, while at the time seven planets, including the sun and moon, were known to exist.[4]

The wreathlike attribute held by the fifth figure provides the best clue to the subject of this capital: it is, in fact, an *ouraborus*—a scaly, winged, and beaked creature, symbolic of Time, who bites its own snakelike tail, constantly devouring itself.[5] A similar figure occurs in a manuscript dating from about 1100, where it is labeled Saturn.[6] The figures may symbolize the Four Seasons, four of the seven planets, or both the seasons and planets. However, in any interpretation the figure holding the *ouraborus* represents earthly and heavenly time.

It might be questioned how or why seemingly pagan subject matter would be found in a Christian context, such as the Jaca Cathedral cloister. It should be emphasized that the planets were associated with the seasons in very early Christian literature, and that, according to medieval exegesis, both were part of the great cosmological design of the universe under God.[7] The scenes on the Santiago

may be associated with the artistic current that manifested itself in other monuments along the pilgrimage route at sites including Saint-Sernin in Toulouse (France) and Loarre, León, and Santiago de Compostela (Spain).

The five bust-length figures carved on the four sides of this capital are delicate yet robust and very beautiful and clearly were inspired by antique works. A lion's head occupies each corner of the capital. All four lions are shown with their jaws half open, as if snarling, but one lion appears to have been left unfinished, as he has no teeth.

On one side of the capital are two figures:

and Santo Domingo capital depict the ever-renewing cycles of the year as analogies for birth, death, resurrection, and salvation—most appropriate subjects for any Christian monument. SCS

1. Simon 1979a, p. 117, fig. 15; Simon 1979c, p. 125; Simon 1980b, p. 240; Simon 1981b, pp. 151–52.
2. McCann 1978, p. 240; Hanfmann 1951, vol. 1, pp. 151, passim.
3. Stern 1953, passim.
4. Saxl 1957, vol. 1, pp. 76–77; Stern 1953.
5. Saxl 1938–39, p. 73; Panofsky 1962, p. 74, n. 12.
6. Remigius's Commentary on Martianus Capella (Cod. Monac. Lat. 14271 fol. 11r).
7. Saxl 1957, vol. 1, pp. 76–77.

LITERATURE: Panofsky and Saxl 1933, pp. 228–80, figs. 27, 39; Saxl 1938–39, p. 73; Hanfmann 1951, vol. 1, passim; Stern 1953, passim; Saxl 1957, vol. 1, pp. 76–77; Barcelona 1961, pp. 570–71, no. 1896; Panofsky 1962, p. 74, n. 12; Silos 1973, p. 27, no. 16; McCann 1978, no. 17, pp. 94–106; Simon 1979a, pp. 107–24; Simon 1979c, pp. 125–29; Simon 1980b, pp. 239–48; Simon 1981b, pp. 151–57; Gent 1985, pp. 468–69, no. 595.

89

Relief of Saint (John?)

Church of San Isidoro, León (León), ca. 1115–20
Marble
H. 23¼ in. (58 cm)
Museo de León (7)

This fragment of a nimbed saint holding a book has always and logically been related to the sculpture of the south transept of the church of San Isidoro in León. Our saint shares with the San Isidoro examples a formal language associated with the south transept portal of the cathedral of Santiago de Compostela and, indirectly, with the church of Saint-Sernin in Toulouse. The head and upper torso of a young, beardless male—the remains, presumably, of a standing figure—are part of a broken block that would have attached it to a wall. The dimensions of the figure are comparable to those of the standing figures of Saints Peter and Paul[1] in the spandrels of the south transept portal of the church of San Isidoro. Its original location is not known, but no area seems more logical for the emplacement of this figure than a spandrel of the north transept facade. The installation of a chapter house against the north transept facade at the end of the twelfth century may have been the cause of its removal.[2] The saints traditionally associated with the church, Isidore and Pelagius, are represented as seated figures in the spandrels of the major portal opening into the south aisle of the church. The pairing of Peter and Paul on the southern transept facade suggests

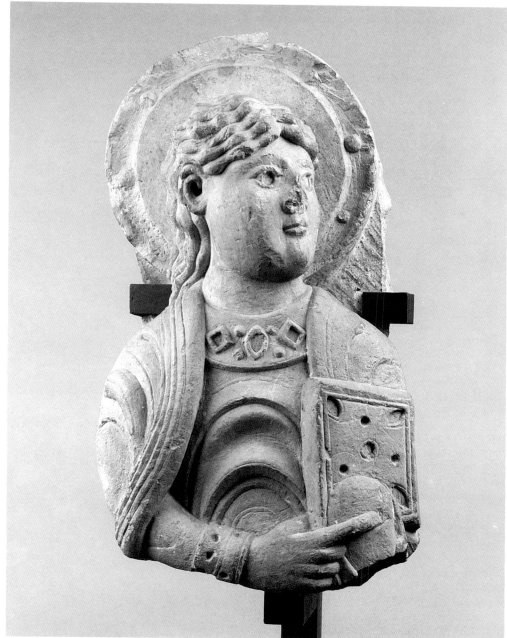

89

the inspiration of Cluny, where the figures of Peter, Paul, James, and John appeared in the spandrels of the main portal. The youth of this figure and the book are consistent with an identification of the saint as John the Evangelist. Whether there ever was a representation of James at San Isidoro is not known. Several small fragments of figures comparable in style to this one were found during the restoration of San Isidoro in the 1950s.

From sutures in the masonry of San Isidoro and the discovery of foundations for an original transeptless plan,[3] we know that the transept was an afterthought in the evolution of the church. The character of the newly introduced masons' marks indicates that the construction of the transept was carried out by a

team of masons from the cathedral of Santiago de Compostela. It is likely that the transept campaign in León was made possible by the completion of work on the south transept of Santiago about the middle of the second decade of the twelfth century. At any rate, there is little doubt that it was entrusted to the master responsible for the marble columns with apostles and other subjects on the Compostelan doorway because they are so similar to the sculpture of the León transept. That master's formation in Toulouse, to judge by the employment of a style virtually identical with that of the relief of the Two Women with a Lion and a Ram (cat. 86) in the Musée des Augustins in Toulouse, for example, seems certain.

JWW

1. The block to which Saint Paul is attached is approximately 15¾ inches (40 cm) wide; our saint's block is 12⅝ inches (32 cm) wide.
2. The tympanum is undecorated and in a state that seems unfinished. There is no sign that it ever had relief sculpture, but a relief of a Crucifixion measuring 22½ x 21 inches (57 x 53 cm) in the collection of Juan Torbado Flórez (in León?) is in the same style and once may have occupied the tympanum with other subjects that are now lost.
3. Williams forthcoming, fig. 6.

LITERATURE: Deschamps 1923, p. 338; Gómez-Moreno 1925–26, vol. 1, p. 311; Torres 1934, p. 895; Gaillard 1938a, pp. 82–83; Durliat 1990, pp. 388–89.

90

two capitals

Church of San Martín de Frómista (Palencia), ca. 1090
Limestone
Each, H. 22 in. (60 cm)
a. Nude Figures and Serpents
b. Human Figures and Lions
Museo Arqueológico Provincial de Palencia (227, 236)

Frómista was the retreat of Doña Mayor, widow of Sancho III, el Mayor, of Navarre, who in her will, executed in 1066, granted to three monks a monastery that "had begun to be built" there, with an additional bequest of several parcels of property. Although the document makes mention of an already existent church, it would be difficult to attribute an edifice as complex as San Martín to such an early date and to such an exiguous monastic community. Doña Mayor bade her descendants (upon whom she conferred the patronage for this endeavor) to see to its continued prosperity and growth, and, to judge by the quality of the present building, her heirs must have carried out her wishes. In 1118 Queen Urraca gave the monastery to San Zoilo of Carrión de los Condes, a Cluny priory located, like Frómista, on the pilgrimage road.

The sculptural style of San Martín's sanctuary is reflected in the lid to the sarcophagus of Alfonso Ansúrez (cat. 107), who died in 1093, which suggests that work had been in progress at the monastery since about 1090; stylistic and documentary evidence from before 1094 points to the presence of the principal master of Frómista at Jaca Cathedral. That Frómista predated Jaca is confirmed by the obvious influence on capital (a) exerted by the Hadrianic Oresteia sarcophagus that was then in the church of Santa María de Husillos, some fifteen miles south of Frómista, and is now in the Museo Arqueológico Nacional, Madrid. As numerous quotations or reminiscences of this piece are also found on the decoration of Jaca Cathedral, it may be concluded that the sculptor worked at San Martín before going on to Aragon. From

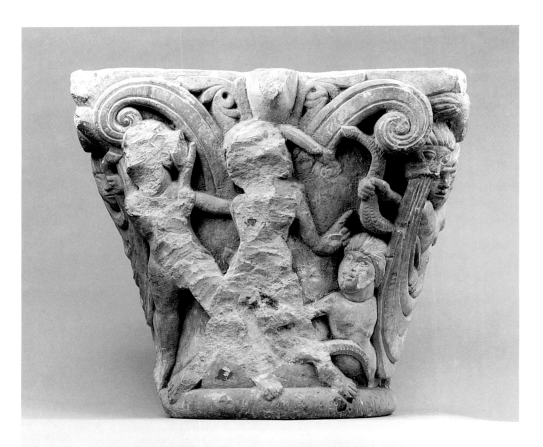

90a

90a

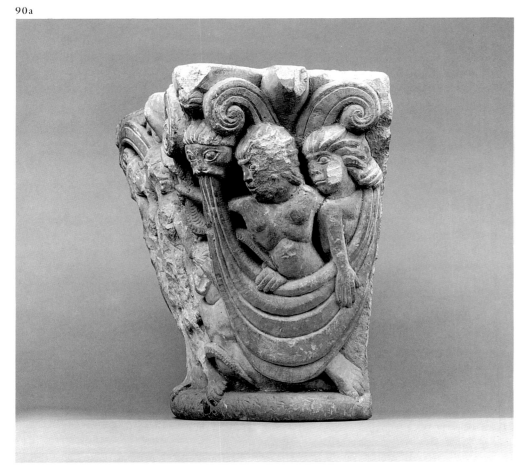

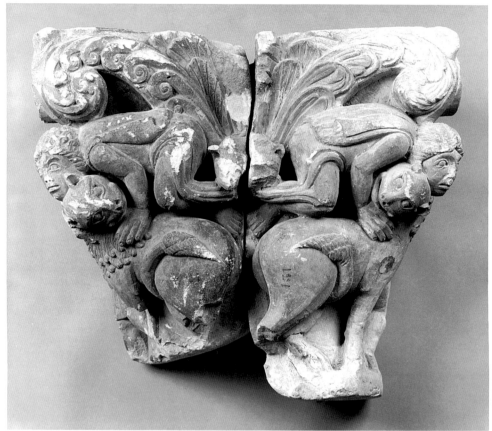

90b

Both capitals were removed from their location in the sanctuary of San Martín and replaced by copies on the occasion of the abusive restoration this church underwent at the beginning of the present century. The damage exhibited by piece (a) was caused deliberately after the capital had been lowered from its place. A photograph published by Enrique Serrano Fatigati shows it when still intact, allowing us to certify the correctness of the copy that has replaced it in the church.[2] SM

1. Bertaux 1906, p. 244.
2. Serrano Fatigati 1901, pp. 35–45, with two unnumbered plates.

LITERATURE: Serrano Fatigati 1901, p. 40; Bertaux 1906, p. 244; Gómez-Moreno 1934a, p. 88; Gaillard 1938a, pp. 147–49; García Guinea 1975, pp. 90–93; Moralejo 1976, pp. 427–34; Moralejo 1979, pp. 85–87; Moralejo 1984, pp. 187–203; Moralejo 1986, pp. 27–37; Moralejo 1990b; Moralejo 1990c; Durliat 1990, pp. 285–87; Bredekamp 1992, pp. 101–12.

91

fragment of female figure with grape clusters

Cathedral of Santiago de Compostela (La Coruña),
1105–10
Marble
15⅛ x 8¼ in. (39 x 21 cm)
Museo de la Catedral, Santiago de Compostela

there, his style spread to the church of the castle of Loarre, to Saint-Sernin, Toulouse, and, back again along the pilgrimage road, to San Isidoro, León, and to the cathedral of Santiago de Compostela (cat. 92).

Encompassing a wide range of forms and themes, capital (a) offers exceptional testimony of the compelling influence ancient art had on the recovery of monumental plastic art during the Romanesque era. Traces of an ancient model are as intense as the interpretation is creative, which suggests that the piece represents the genesis of a style. In the subtle compositional cadences of the Oresteia sarcophagus frieze, the master of Frómista discovered rhythmic accents that he used to articulate the plastic architecture of the capital, such as the x-shaped postures of the figures stretched across the fork formed by the volutes and the ample curves describing the draperies with which he closes and gives balance to the composition of the side faces.

Added to the fascination that, in the words of Émile Bertaux, "la beauté oubliée"[1] exerted upon the sculptor is an imagery that for him must have been as enigmatic in regard to meaning as it was obsessive. The calm nudes, man and woman, who find themselves threatened by sinister individuals flourishing serpents, seem to suggest an allegory of the fallen human condition, impossible to translate verbally. In later quotations and para-

phrases of the same model, particularly in Jaca Cathedral, the same motifs are inserted into the more accessible context of biblical imagery. In the Aragonese cathedral the adaptation of the ancient family tragedy narrated on the Oresteia sarcophagus to the drama—also familial—of the sacrifice of Isaac is masterful.

Capital (b), the work of the same master, inaugurates a thematic and compositional formula of exceptional success in later sculpture, as demonstrated by other pieces in Frómista itself, in Jaca, in Loarre, and in Compostela. It consists of the contraposition of two lions, male and female, on which are balanced two youthful figures that seem to emerge from the mask of a lion situated upon the axis of the front face of the capital. On the right face of the capital a naked youth with a vine around his neck is depicted; on the left face, a second youth, clad in a short tunic, rests his right hand on a lion standing beside him and seems to be slipping his left arm around the neck of a third lion peering from beneath the volutes.

Although the motifs and their composition are genuinely medieval in the powerful plasticity of their treatment—particularly the bare limbs—and in the subtle variations that animate the structural symmetry, the previously mentioned debt of this master to ancient sculpture is nevertheless patent.

In its complete form this fragment may have been a seated figure with crossed legs, reminiscent of the woman holding a lion cub in her lap on one of the jambs of the Puerta de las Platerías at the cathedral of Santiago de Compostela.[1] Since the so-called Pilgrim's Guide in the Codex Calixtinus describes figures of apostles on those jambs, it is probable that the woman with the lion was originally on the north portal, where the guide locates "images . . . of women," whereas women were not mentioned in connection with the Las Platerías facade. Both figures also share a similar morphology: prominent facial features framed by long, unruly hair and tense bodies beneath clinging robes grooved in the calligraphy characteristic of Toulouse. Although the antecedents for these facial types apparently were figures on capitals in Frómista (cat. 90) and Jaca—in turn inspired by the Furies on the Oresteia sarcophagus now in the Museo Arqueológico Nacional, Madrid—their formulation in Compostela and Toulouse[2] seems to have been enriched by knowledge of ancient models with fuller faces, particularly those from the Dionysiac repertoire. The strange form of the lion upon which the

91

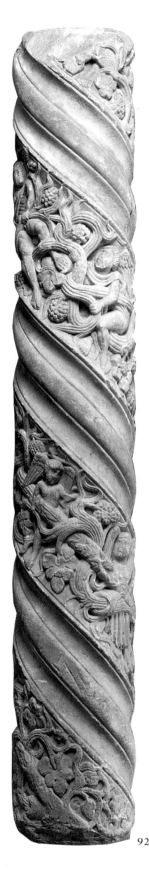

92

transept. The subtle plasticity that the master of Frómista and Jaca learned from ancient sculpture was subjected to a graphic discipline culled from works by the marble workers of Languedoc, who in turn were indebted to the sumptuary arts. The powerful effect of this piece is born of the tension between the two filiations. s m

1. Durliat 1990, fig. 366.
2. See the superb corbel bracket of the Porte de Miègeville published by Hearn 1981, fig. 100.
3. Durliat 1990, fig. 355.

LITERATURE: Gaillard 1938a, pl. CXXVIII; Guerra 1962, p. 293; Moralejo 1969, pp. 639–40; M. C., in Gent 1985, no. 18, pp. 214–15; Durliat 1990, pp. 342–43.

92

column shaft decorated with putti gathering grapes

Cathedral of Santiago de Compostela (La Coruña),
1105–10
Marble
72 x 9⅞ in. (183 x 25 cm)
Museo de la Catedral, Santiago de Compostela

This column shaft forms a group with three similar pieces and with fragments of three others (two of them currently mounted as a single piece), which were found in different sections of the cathedral of Santiago de Compostela. Smaller remains, which had been smashed for use as filler, were discovered in 1988 during the dismantling of the altar from the so-called Catedral Vieja, or crypt, of the Pórtico de la Gloria.

The attribution of the group to the lost north portal, or Porta Francigena, of the cathedral has prevailed against suggestions that their provenance is the Pórtico de la Gloria or the west portal that supposedly antedated the Pórtico de la Gloria. The stylistic arguments for a Porta Francigena provenance are supported by those of an archaeological and iconographic nature as well. The dimensions of the shafts harmonize perfectly with the spaces that remain in the internal jambs of the north portal between the traces of the primitive Romanesque bases and those of the lintels. The ancient flavor that imbues these pieces also argues in favor of their having been placed facing the *paradisus*, the square with which Bishop Diego Gelmírez undoubtedly wished to evoke the atrium of the same name at Old Saint Peter's in Rome.

Certain pilaster fragments found in the Esquiline in Rome are evocative of these columnar types and allow us to imagine the ancient model that the sculptor had before him. Helicoidal bands filled with putti gath-

woman on the Platerías jamb is seated, as well as the panther skins that adorn Bacchus and his followers and the faunlike ear of the Saint Andrew on the same portal,[3] confirms the workshop's familiarity with classical works on the Dionysiac theme.

In iconography the two Compostela figures are related to the two women sustaining the *signum arietis* and the *signum leonis* in a well-known relief in Toulouse (cat. 86), although the latter differ in their veiled heads and modest bearing and in their faces, which lack the carnal pathos characterizing the former. It is doubtful, therefore, that the Compostela figures share the positive significance conferred upon the Toulouse figures by their controversial epigraph—thought to be a portentous announcement of the coming of Christ—despite there being a textual base to relate them (Isidore of Seville, who calls Mary "mater agni et leonis," also evokes her as "mater vitae et vitis" [mother of life and of the vine]). An account related that on the north portal of Santiago de Compostela the months of the year were represented in the traditional series of labor and rest governed by the calendar (cat. 94), and there is a possibility that this figure formed part of a parallel series alluding to the cycle of the seasons, which would not necessarily exclude a reading of it as religious allegory.

Stylistically, this figure is a fine example of the synthesis of traditions in Jaca and Toulouse that characterizes some of the best pieces on the portals of the Compostela

ering grapes alternate with others decorated with moldings similar to the ones on the Compostelan pieces. Although the bands with moldings on the Esquiline fragments do not run parallel to the figural bands (as they do on the Compostelan column shafts), there

92: Detail

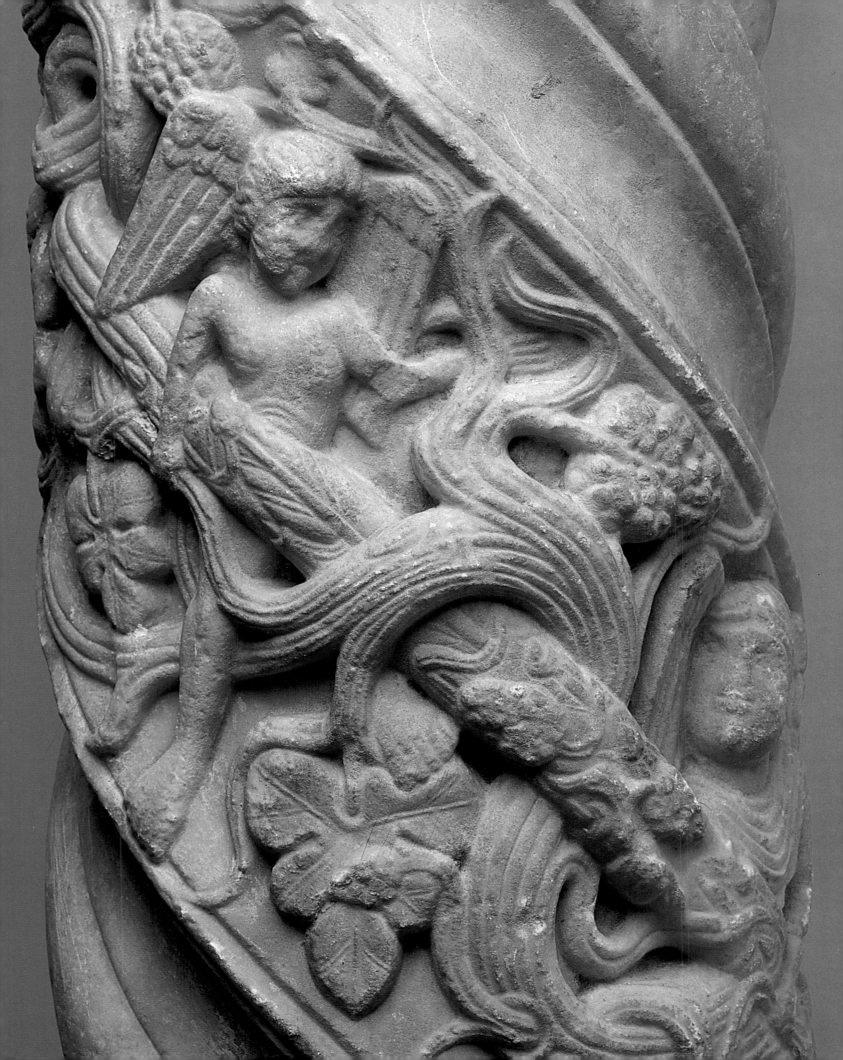

are Roman columns without figural decoration whose moldings adopt the same twisting rhythm found on these fragments.

The piece exhibited here is the one that seems to follow most faithfully the hypothetical ancient model common to the entire group. This is suggested by its greater integration of the figured bands into the structure of the column shaft (its helicoidal rhythm is echoed in the thick grapevine stalk that cuts through the lower bands) and by the lively chiaroscuro of its relief work, which recalls the pictorialism of Roman sculpture from the middle of the third century A.D. What is undeniably a style with connections to Jaca may be seen to have acquired new characteristics that are due not so much to a process of internal evolution as to the experience of new models.

On another column shaft from Santiago de Compostela, the exuberant vines inspired by antiquity are replaced by interwoven branches without leaves or fruit, and instead of grape-gathering putti there are figures that, with one exception, have no wings. These reiterate motifs inspired by the Hadrianic sarcophagus formerly in the church of Santa María de Husillos, near Frómista (see cat. 90). In addition to the influence of this model, there is more plastic, concise modeling along the lines that characterize the reliefs on the Puerta del Cordero at the church of San Isidoro, León.

Combined with these two variants from the tradition that is common to Frómista and Jaca, a third style, the fruit of the synthesis of this same tradition with that of Toulouse, is also in evidence. This eclectic inspiration can be seen in the most richly decorated column shaft of the series, where among the scenes of the grape harvest—which are limited to its lower half and include figures of a larger scale—there is a putto carrying fruits in his chlamys, whose provenance appears to be a Four Seasons sarcophagus. On the other hand, on the first band of its upper section, the vegetation adopts ornamental patterns—volutes with birds—that are more appropriate to the sumptuary arts and have clear parallels to the nielloed rinceaux border on the Celanova altar, in the Museo Catedralicio, Orense. This invites the supposition that the column shaft may reflect the production of the goldsmith's workshop engaged at the time in decorating the frontal and ciborium of the Santiago altar. The series of columns from the Porta Francigena therefore constitutes a remarkable stylistic intersection that permits us to establish chronological connections or correlations among the most flourishing sculpture workshops on the pilgrimage road to Santiago: Frómista, Jaca, Toulouse, Compostela, and León.

The contrast between the exuberant vines

that decorate some of these column shafts and the branches without leaves or fruits seen on the others should also be understood from an iconographic point of view. It is more than likely that the bare branches allude to the biblical theme of the devastated vine. This is perfectly congruent with a program centered on original sin and the promise of redemption and with the ideals of the Gregorian reform that was prevalent at the time. The *Historia Compostellana* tells us that Bishop Dalmacio and his successor Diego Gelmírez found their church to be like "an uncultivated vine" and zealously dedicated themselves to its regeneration. Similar statements are also found in texts concerning other reformist prelates of their generation, such as Saint Gerald of Braga, Saint Peter of Bourges (Osma), or San Ramón (Roda de Isábena). One of the column shafts from the same series constitutes an exceptional case. Its vegetation, without leaves or fruit, serves as a background to episodes of an epic nature, including what appears to be an early version of the Tristan legend. These have been adapted to the form and structure of the Column of Trajan. The motif of the swooning hero sailing in a rudderless vessel could not fail to be of interest in a sanctuary that had received the body of its patron saint in the same marvelous fashion. S M

LITERATURE: López 1900, p. 116; López 1905, p. 447; Gómez-Moreno 1934a, p. 132; Gaillard 1938a, pp. 218–19; Naesgaard 1960, p. 86; Moralejo 1969, pp. 656–60; Moralejo 1977, pp. 97–98; Moralejo 1980, pp. 224–26; Moralejo 1985c, pp. 61–70; Moralejo 1985d, pp. 416–21; Moralejo 1987, pp. 268–69; Durliat 1990, pp. 342–45; Whitaker 1990, pp. 90, 92–93; Stones 1991, pp. 32–34, fig. 7.

93

altar support with apostles matthew, simon, and judas

Monastery of San Paio de Anteltares, Santiago de Compostela (La Coruña), ca. 1152
Marble
H. 45¼ in. (115 cm)
Fogg Art Museum, Harvard University Art Museums; Gift of the Republic of Spain through the Museo Arqueológico Nacional and Arthur Kingsley Porter (1933.100)

In the early seventeenth century, this column, along with three similar pieces, supported the main altar table in the monastery church of San Paio de Anteltares, near the cathedral of Santiago de Compostela. The ensemble was completed by a marble altar stone—a reutilized Roman epitaph—set into the altar table and by a semicolumn with the following

inscription consisting of a Latin distich: "This column, like the inscribed altar stone above, came here with [the body of] Saint James/ whose disciples consecrated them both, as we believe, and with them erected his altar."[1] After this grouping was disassembled, one of the columns with figures—the one, in fact, displaying the image of Saint James the Greater—was lost, and the various elements were dispersed to their present locations. The altar stone and the semicolumn stayed in the monastery, while the three remaining columns became part of the collection of the Museo Arqueológico Nacional, Madrid; one of the three—the present work—subsequently went to the Fogg.

That the altar stone referred to is a reutilized Roman work is perfectly consistent with the belief that the altar of the basilica consecrated to Saint James by Alfonso III in 899 had been erected by the apostle's disciples, as reported in the Act of Consecration. The same information appears in the *Historia Compostellana*, where it refers to Bishop Gelmírez's early twelfth-century reorganization of the main chapel of the new basilica. At that time the primitive altar was retained and hidden beneath the Romanesque altar consecrated in 1105.[2] That was also the location noted in the so-called Pilgrim's Guide in the Codex Calixtinus before 1135, which reiterates the altar stone's attribution to the disciples of Saint James, although without any reference to the supposed arrival of it and its support with the body of the apostle. In a different passage of the Codex Calixtinus there is an explicit refutation[3] of a legend about the huge stone (*pedrón*) that had provided the name (Padrón) for the place where the body of the apostle had miraculously appeared, which makes it doubtful that the inscription was on the semicolumn at that time or that the semicolumn was being used as a support for the altar. The same may be said of the columns with figures, for there would scarcely be room for them in an altar closed on three sides and with a silver frontal on the fourth.

This is not to say that the alternative uses proposed for these pieces as supports for the ciborium of an altar or as part of the cloister Gelmírez wanted to construct in 1124 deserve any greater credence. The excess height imputed to them as the reason they could not have served as support for the altar stone is belied by the dimensions—between 39 and 49 inches (100 and 125 cm)—of the altar of the cathedral of Santiago and by the 40½-inch (103 cm) height of the central altar support in the cathedral of Orense, which is also decorated with a figure in relief. The semicolumn remaining in Anteltares as the single support for the altar table measures 45 inches (114.5 cm), excluding the portion embedded in the base. Its height, then, is similar to that

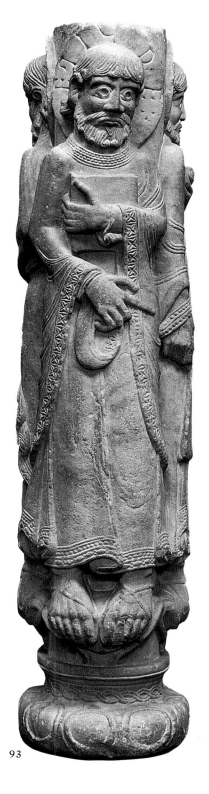

aries of their respective properties and claims of the monks to part of the offerings from the altar at Santiago. It is very possible that the monks received the primitive altar as a Solomonic compensation and that it was they who were responsible for its new presentation, treating it as a kind of relic and enhancing it by adding the supports with the figures and the aforementioned inscription on the central semicolumn. The fact that the archbishop who signed the accord of 1152, Bernard of Agen, was buried in Antealtares the following year suggests that the conflict had been resolved in a manner satisfying to the monastery—at least for a time.

This chronology is much more congruent with the stylistic character of the pieces. While vague parallels have been pointed out with reliefs in the cloister of Silos or with figures of apostles from Saint-Étienne de Toulouse, a more obvious relationship exists with sculpture in the churches of Sainte-Marie, Oloron; Sainte-Foy, Morlaàs; Saint-Pierre, Sévignac-Thèze; and Lacommande, Béarn. This Béarnaise current reached across the Pyrenees to churches in Uncastillo and to certain Castilian workshops, particularly in Segovia, among them those of the churches of San Martín, Fuentidueña (examples from which are in the Metropolitan Museum's Cloisters), and San Justo, Sepúlveda, where Aragonese influence was not uncommon. In the domain of the sumptuary arts, an equivalent to this style can be found in the plaque of the Adoration of the Magi in the Victoria and Albert Museum, London (cat. 141). The columns of Antealtares must be considered meridional responses to the northern invention of the Gothic statue-column rather than early prefigurations of it. SM

1. Gent 1985, no. 8, pp. 207–8.
2. Falque 1988, pp. 43–44. See Williams 1984, pp. 274–76.
3. Moralejo, Torres, and Feo 1951, p. 394.

LITERATURE: López 1898, pp. 277–79; Porter 1923, vol. 1, p. 220; Porter 1927b, pp. 96–113; Porter 1928, vol. 1, pl. 59, vol. 2, pp. 4–8; Carro 1931, pp. 8–9; Tyler 1941, pp. 45–52; Gaillard 1957, pp. 171–79; Chamoso 1961, pp. 136–38; L. Seidel, in Providence 1969, nos. 34–36; Bergman 1978, pp. 374–75; Cahn and Seidel 1979, no. 53, pp. 200–204; Mortimer 1985, no. 142; Moralejo 1988a, pp. 108–9, nn. 28–30; Moralejo 1990a, pp. 212–14.

When describing the lost Porta Francigena, or north portal, of the cathedral of Santiago, the Pilgrim's Guide in the Codex Calixtinus records that on it "are seen in relief the months of the year and many other such allegories." The presence on the south, or Platerías, portal of a relief featuring a centaur standing for Sagittarius, apparently reutilized, led to the supposition that the months of the year were represented by the zodiac, which meant overlooking the fact that this piece had its formal and thematic counterpart in the form of a siren in a similar relief on the same portal. The piece catalogued here confirms, however, that the series on the Compostela facade was the traditional Labors of the Months evoking the flow of human time —the first, as far as we are aware, to accord the calendar such monumental proportions on a portal.

The relief presents a peasant youth wrapped in a hooded rain cape and seated on a stool set before a fire, with one foot shod and the other bare. The broken upper right corner prevents our knowing whether the raised left hand held some object or was merely turned to the fire for warmth. Beneath the seat we sense a fagot of firewood.

The composition of this scene has numerous medieval parallels in the imagery for the month of February, which it doubtless was meant to represent, but it diverges from the most characteristic versions in the amiable, ephebic features of the figure, which are typical of the stylistic tradition to which the piece belongs. Since it is not known how the other figures of the series were characterized,

93

of the three columns with figures, doubtless conceived for the same ensemble.

The altar stone must have been moved from the cathedral to the monastery in 1147 or—more likely—in 1152, both of which are dates of negotiations attempting to resolve the continuing dispute between the monastery of San Paio de Antealtares and the cathedral of Santiago de Compostela that had begun in 1077—a quarrel over the bound-

94

PERSONIFICATION OF THE MONTH OF FEBRUARY

Cathedral of Santiago de Compostela (La Coruña),
1105–10
Granite
16½ x 10⅛ in. (42 x 27 cm)
Museo de la Catedral, Santiago de Compostela

94

it is impossible to judge whether the allusion here was to smallness. February is sometimes called *chico* (youngster) as it is the shortest month of the year. For this reason and because of the volatility of its weather, as well as the substratum of ancient mythology, the medieval February frequently assumed the pejorative image of a rustic with grotesque facial features and coarse clothing that at times did not succeed in covering his genitals. Ancient taboos in matters of sexual modesty and hygiene in proximity to the hearth fire—held to be sacred—thus survived in the medieval iconography of this month as a simple sign of the absence of good manners. A similar implication may be inferred from the bare foot of the Compostela February held near the fire as well as from other examples. "Pedem in focum non impendere" (Do not bring your foot close to the fire), says an old Roman maxim collected by Varro—another ancient taboo about the body and the fire converted into a simple indication of bad manners.

Through the sermons of the Codex Calixtinus, we know the symbolism given to the months of the year in the Compostela of the time. This symbolism underscores the opportune coincidence of the two festivals honoring Saint James—his election and translation, December 30, and his martyrdom, July 25—with the two poles of the agrarian year: the passive winter rest and the harvest, the respective symbols, equally implicated, of the future life and the earthly life that leads to it. In the twelve months a prefiguration of the twelve apostles—represented on the Las Platerías portal—can be seen. Agrarian metaphors widely prevailed in communicating the ideals of Gregorian reform of the third quarter of the eleventh century. Given that the Pilgrim's Guide in the Codex makes reference to "the months of the year and many other such allegories," it is probable that the entire series lent itself to an allegorical interpretation.

Despite the infelicity of the material and the summary execution, the solid composition of the Compostela February gains our attention, animated as it is by the formal rhythms of the carving representing folds and flames. Such play with figurative ambiguity was especially pleasing to the master of Frómista and Jaca, who practiced it above all with drapery and water. This work, then, must be placed in the wake of that master and under a second influence, that of the Toulouse master of Las Platerías, which can be perceived in the activities of that workshop at San Isidoro in León. SM

LITERATURE: Guerra 1962, p. 296; Moralejo 1969, pp. 645–48; Moralejo 1977, p. 96; Gent 1985, no. 17, pp. 213–14; Durliat 1990, p. 348; Castineiras 1993.

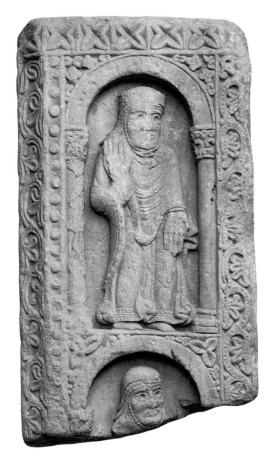

95

fRAGMENT Of RELIEF WITh TWO fEMALE fIGURES

Monastery of San Paio de Antealtares, Santiago de Compostela (La Coruña), ca. 1150
Marble
29½ x 15⅜ in. (75 x 39 cm)
Museo de la Catedral, Santiago de Compostela

A female figure, crowned, and the head of another woman, coiffed in a toque, are framed in two superposed arches. The figures are carved from a slab, beveled on the left edge, that seems to have been a jamb. Except for the arches, the immediate background of the figures, and the small column at the right, the entire surface of the relief is filled with a compact decoration of vegetal themes, pearling, and interlacing.

From the stylistic point of view, the concordance of these figures with those on the columns from the monastery of San Paio de Antealtares is evident, both in facial type, with eyes deeply hollowed to accommodate deposits of paste, and in drapery, with smooth surfaces clinging to vaguely defined body lines and grooved by a series of folds. Such resonances are broadened when we consider the many relationships among all these columns (see cat. 93). Moreover, the head of the figure in the lower arch recalls the head of the Virgin in an Epiphany on a capital in the

church of San Martín, Fuentidueña,[1] and, to a lesser degree, the head on a capital with a similar theme in Lacommande in Béarn.[2] On the other hand, the disposition on jambs of figures beneath superposed arches is as rare in Spanish Romanesque sculpture as it is frequent in Italy, particularly in Emilia. Always excepting differences in quality, a comparison of the Compostela piece with reliefs originating in the monastery of San Benedetto al Polirone[3] would invite a reopening of the much-debated dossier on possible contacts among Italian and Hispano-Languedocian workshops.

With regard to style, information that situates the discovery of the piece in the Compostela monastery of San Paio de Antealtares is very suggestive, although it should be added that it was placed there in safekeeping for an individual who said he had found it on an estate near Santiago. As it has not been possible to verify this version, it is likely that the piece came from the monastery and was carved in the same workshop that produced the columns of the primitive altar in Santiago. Also considered to be among the Galician productions of this workshop is a figure of Christ carved on the shaft of a column (the head was reworked in the fourteenth century) originating in the church of Santiago de Vigo and now in the Museo Arqueológico Nacional, Madrid.

The iconography of the crowned figure is characteristic, although not exclusively, of the Mary of the Annunciation. However, the omission of a halo prevents total acceptance of that interpretation. Jesús Carro García, to whom we owe discovery of the relief, thought he could read SANT . . . on the arch that frames the figure, but no clear indication of those letters remains today.[4]

 SM

1. Simon 1984, p. 146, fig. 4.
2. Tucoo-Chala 1976, fig. 1.
3. Verzar 1983, pp. 277–78, figs. 1, 2.
4. Carro 1944, pp. 39–44.

LITERATURE: Carro 1944, pp. 39–44; S.M., in Santiago de Compostela 1988, p. 97; R. Y. P., in Santiago de Compostela 1990, no. 78, pp. 188–89.

96

fOUR dOUBLE CAPITALS

Romanesque cloister of Pamplona Cathedral (Navarre), ca. 1140
Limestone
Each, h. 12¼ in. (31 cm)
a. Scenes from the Life of Job
b. Scenes from the Passion of Christ
c. Scenes from the Entombment and Resurrection of Christ
a–c: Museo de Navarra, Comunidad Foral de Navarra; Gift of the Chapter of the Cathedral of Pamplona, 1948
d. Foliate Capital
Museo de Navarra, Comunidad Foral de Navarra; Gift of the Chapter of the Cathedral of Pamplona, August 27, 1954

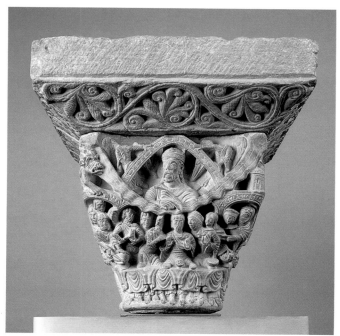

96a: Job and His Children

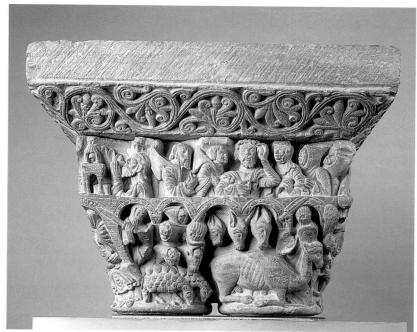

96a: Destruction of Job's Flock

A group of three historiated and six foliate double capitals and seven abaci, preserved in the Museo de Navarra, is all that survives of the Romanesque cloister of Pamplona Cathedral. Begun by 1122,[1] the cloister was finished by 1141 or 1142, according to some scholars,[2] and as early as 1137, according to others,[3] but neither date has been established by art-historical analysis. Although the Romanesque cathedral suffered a rebuilding in the eighteenth century, the cloister seems not to have been dismantled until the following century.[4] A number of artists or ateliers worked on the cloister, and it is certainly possible that the variety of styles, which have not been recognized as such in the literature, indicates that construction might have been interrupted and resumed, as documents suggest.[5] For example, strikingly different techniques were employed to carve the foliate capitals—which is particularly evident in the way the drill was used for the luxuriant and organic foliage of one capital inhabited by birds, animals, and human figures—while other capitals display flatter rinceaux, in which incision produces a more superficial treatment of the plastic forms.

The three surviving historiated capitals contain complex narratives: Two are devoted to the Passion and one to an account of Job's travails. One capital depicts the events leading to the Crucifixion, including that scene as well as the Kiss of Judas, Judas Leaving the House of Caiaphas, Saint Peter Cutting Off the Ear of Malchus, and the Crucifixion of the Good and the Bad Thief. The second Passion capital begins with the Descent from the Cross and includes the Entombment, the Holy Women at the Tomb, and the Magdalene Announcing the Resurrection to the Disciples. The Passion scenes are arranged in long, friezelike narratives that wrap around the capitals. The scene of the Crucifixion is

96a: Destruction of Job's House

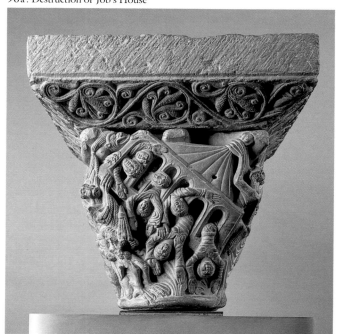

96a: Job on the Dunghill

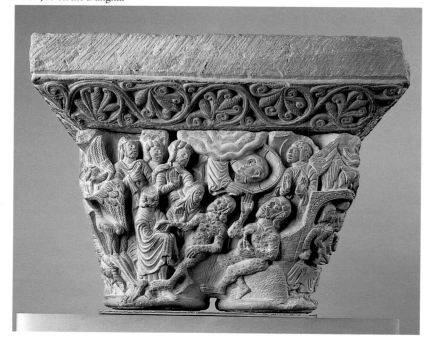

isolated on a short end of the capital, thus relegating the Good Thief and the Bad Thief to each of the capital's long sides, but their relationship to the other scenes on the long sides seems dubious at best. Even so, the dramatic quality of the events depicted is conveyed in active compositions with deep undercutting, a rich interplay of texture and pattern, and vivid gestures. In fact, Francisco Iñiguez has suggested—albeit with more intuition than evidence—that the decorated and swathed arcades that frame some of the scenes reflect theatrical settings that might have accompanied the performances of mystery plays.[6]

Based largely on the fullness of the iconographic program of the Passion and on the fact that representations of the Job stories are very rare in Romanesque art, frequent comparisons have been made between the historiated capitals from Pamplona and sculpture from La Daurade in Toulouse,[7] where there is both an elaborate Passion cycle and a series of scenes from the life of Job. However, the La Daurade capitals have little stylistic affinity with the Pamplona capitals, and one should accept Kathryn Horste's recent suggestion that some of the thematic relationships between the two series might well be based on common sources rather than on direct influence.[8] What is particularly intriguing is that those capitals from La Daurade with vegetal decoration, assigned by Horste to the second workshop employed there,[9] bear comparison with foliate examples from Pamplona,[10] even if it should be acknowledged that the type of foliate basket capital was current in many areas of Languedoc and Aquitaine.[11] Gaillard attempted to find sources for the style of the Pamplona capitals within Spanish Romanesque art, particularly in Aragon,[12] although a case can also be made to establish the influence of the Pamplona carvings on the art of that region—as, for example, on works at Uncastillo. Stylistic parallels between the Pamplona capitals and sculpture from Provence, which have been ignored in scholarly literature, are very suggestive, as can be seen by comparing the figure styles and stagelike architectural settings of the Pamplona capitals with a capital (today in the Fogg Art Museum, Harvard University) from the cloister of the cathedral of Notre-Dame-des-Doms in Avignon, dated to the middle or third quarter of the twelfth century. Indeed, the rich, drilled foliage of the inhabited capital from Pamplona described above bears comparison with Provençal sculpture,[13] even though, as noted, this Pamplona capital is stylistically distinct from the more basketlike rinceaux capitals—that is, those closer to Languedocian and Aquitainian examples. DLS

1. Goñi 1964, pp. 281–83.
2. Ubieto 1950, pp. 77–83.

3. Goñi 1964, pp. 281–83.
4. Vázquez de Parga 1947, pp. 4–7.
5. Ubieto 1950, pp. 77–83.
6. Iñiguez Almech 1968, p. 197.
7. Vázquez de Parga 1947, pp. 4–7; Vázquez de Parga 1941, pp. 410–11; Gaillard 1960a, pp. 146–56; Gaillard 1960b, pp. 237–40; Mesplé 1963, pp. 255–62.
8. Horste 1982, pp. 51–52.
9. Ibid., pp. 55–56, n. 13; Mesplé 1961, nos. 170, 171. See also Milhau 1971, p. 21.
10. Gaillard 1960a, p. 153; Gaillard 1967, p. 20.
11. Rivère 1978, pp. 161–79, 329–40, 459–77; Rivère 1979, pp. 165–74; Durliat and Rivère 1979, pp. 17–32; New York 1982, pp.67–69; Little, Simon, and Bussis 1987, pp. 61–62, 69–72.
12. Gaillard 1960a, p. 153; Gaillard 1967, p. 21.
13. Thirion 1977, pp. 94–164, especially fig. 17.

LITERATURE: Porter 1923, pl. 270; Byne 1926, pls. 101–3; Vázquez de Parga 1941, pp. 410–11; Vázquez de Parga 1947, pp. 3–11; Gudiol Ricart and Gaya 1948, p. 166, figs. 276–80; Ubieto 1950, pp. 77–83; Gaillard 1960a, pp. 146–56; Gaillard 1960b, pp. 237–40; Mesplé 1963, pp. 255–62; Durliat 1964, p. 71, pls. 119, 120; Goñi 1964, pp. 281–83; Palol and Hirmer 1967, pp. 156, 158, 483, pls. 137–43; Lojendio 1967, pp. 20–22, 221–34, pls. 86–99; Iñiguez Almech 1968, pp. 182–200; Uranga and Iñiguez 1971–73, vol. 2, pp. 263–69, pls. 118–33; Yarza 1979, p. 217; Horste 1982, pp. 51–52; Fernández-Ladreda 1983, pp. 25–50; Jover 1987; Melero 1992.

97

two double capitals

Church of Santa María la Real, Aguilar de Campóo (Palencia), last quarter of 12th century
Limestone(?)
Each, h. 19⅝ in. (50 cm)
a. Christ the Redeemer and Angels with Instruments of the Passion
b. Scenes from the Entombment and Resurrection of Christ
Museo Arqueológico Nacional, Madrid (50.188[a], 50.201[b])

These two double capitals, preserved in the Museo Arqueológico Nacional, Madrid, originally capped engaged columns in the monastic church of Santa María la Real in Aguilar de Campóo. The capitals were part of a group of thirty-two transferred from the monastery to the Museo Arqueológico in 1851,[1] seventeen years after the monastery's secularization and abandonment.[2] Represented on capital (a) is the triumphant Christ the Redeemer, showing the signs of his martyrdom. He is flanked by two angels on the central face and two angels on each of the sides of the capital; the angel to his right and the adjacent one on the contiguous face of the capital hold the arms of a cross, around which a sudarium is draped. The other angels also hold instruments of the Passion, including the lance, nails, and a sponge. The Three Marys at the Tomb is the main scene on capital (b). The three women carry ointment jars and confront an angel, who points to a sarcophagus from which drapery emerges—an

indication that the tomb has been opened —while soldiers sleep beneath. On the right side of the capital Mary Magdalene kneels in front of Christ, and a tree in the background establishes the location for the scene of the Noli me tangere. On the left side of the capital Christ raises one hand to reveal his wound, which Thomas is poised to touch and to which Christ gestures with his other hand.

The capitals from Aguilar can be related on the basis of style to those from Santa María de Lebanza (cat. 98).[3] That the only two surviving capitals from Lebanza represent precisely the two scenes depicted on these Aguilar capitals must be an accident of history. However, the unusual iconography that connects the images of the Redeemer at Aguilar and Lebanza is more than circumstantial—which is not to say that there are no differences between the capitals. Although the Lebanza Christ is surrounded by the four apocalyptic beasts, which are missing at Aguilar, at both Lebanza and Aguilar Christ's pose, with bent and spread knees, suggests that he is seated, even as his splayed feet make it appear that he is standing. As Linda Seidel has pointed out, this iconography must derive from the tympanum of the Pórtico de la Gloria at Santiago de Compostela.[4] There are affinities of style between the two capitals as well, although certainly not sufficient to identify both works as the product of the same workshop. Rather, both are related to a general stylistic current that had wide appeal in Spain in the second half of the twelfth century. The Aguilar sculpture has been compared to the tomb of Saint Vincent in Ávila;[5] both Lebanza and Aguilar capitals—particularly the figures on the side faces of the Redeemer capital and the figures in the scenes of the Noli me tangere and the Doubting Thomas at Aguilar—can be compared to sculpture from the Cámara Santa at Oviedo.

Vicente Lampérez dated the capitals from Aguilar to the middle of the twelfth century, prior to the occupation of the monastery by the Premonstratensians in 1162.[6] Given that order's interest in sobriety of decoration, such a conclusion would be logical, were it not for the fact that the other sculptures to which the Aguilar capitals are related most closely should be assigned a later date. An inscription of 1185 on an abacus from Lebanza gives it an approximate date, which corresponds to Werner Goldschmidt's dating of the Aguilar sculpture based on the comparison to the Ávila tomb.[7] DLS

1. García Guinea 1961a, p. 191.
2. Ibid., p. 189.
3. Cahn and Seidel 1979, pp. 204–10, figs. 213–15.
4. Ibid., p. 207. Other locations in the region where a similar subject may be seen are the tympanums at Báscones de Valdivia (Palencia) and Tablada de Rudrón

218

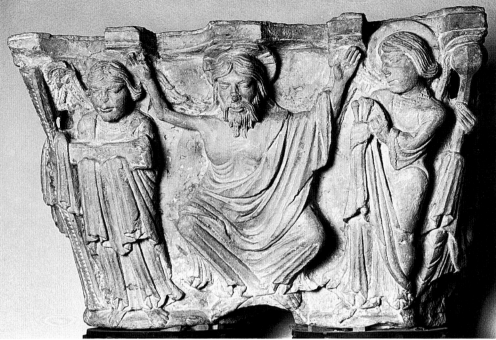

97a

(Burgos). See García Guinea 1961a, p. 342, pl. 252; Pérez Carmona 1975, pp. 240–41, fig. 56.
5. Goldschmidt 1936, p. 170; García Guinea 1961b.
6. Lampérez 1908a, p. 218. María Isabel Bravo Juega and Pedro Matesanz Vera date the granting of the monastery to the Premonstratensian order to 1169 and their occupation to four years later (Bravo and Matesanz 1986, pp. 13–17).
7. Goldschmidt 1936, p. 170.

LITERATURE: Lampérez 1908a, p. 218; Goldschmidt 1936, pp. 215–21; Navarro 1939, pp. 259–71; García Guinea 1961a, p. 191; García Guinea 1961b, pp. 158–67; Silos 1973, p. 28; Pérez Carmona 1975, pp. 240–41, fig. 56; Cahn and Seidel 1979, pp. 204–10; Bravo and Matesanz 1986.

97b

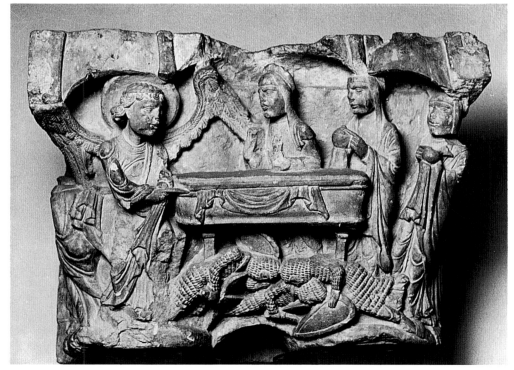

two capitals

Church of Santa María de Lebanza (Palencia), 1185–90
Limestone
Each, h. 25 in. (63.5 cm)
a. Christ the Redeemer and Angels with Instruments of the Passion
b. Scenes from the Entombment and Resurrection of Christ
Fogg Art Museum, Harvard University, Cambridge, Massachusetts (1926.4.1, 1926.4.2)

These two capitals, which surmounted paired engaged columns, are the sole remains of the Romanesque abbey church of Santa María de Lebanza (or Alabanza) in the province of Palencia. Although the monastery was founded in the tenth century, these capitals undoubtedly were part of a late twelfth-century rebuilding program at the abbey. A document of 1179 records the concession of indulgences by Bishop Raimundo to those who contributed to the rebuilding. Mentioned specifically in this document as well as in one signed by Cerebruno, archbishop of Toledo, is the fact that both church and cloister were under construction.[1] This presumably is the construction commemorated in an inscription on the abacus of one of the Fogg capitals, which mentions that both church and cloister were built by Prior Peter in 1223 of the Spanish era—that is, A.D. 1185.[2] The old church was transformed under Charles III in the eighteenth century, at which time the two Fogg capitals were embedded in the sides of an arch within the new church.[3]

One capital shows an enthroned Christ framed by a mandorla. Christ is surrounded by the four apocalyptic beasts, which by virtue of arrangement and gesture, accentuate his central importance. The angel and the eagle support Christ's wrists in order to display the signs of his martyrdom. On each of the sides of the capital are two figures facing toward the center; the figures on the left side carry a cross and those on the right, a lance and nails—the instruments of the Passion. Although Christ is depicted as enthroned, his feet straddle the twin astragals of the capital in such a way that he appears to be simultaneously seated and standing. This double reading reflects the double role of Christ as Judge and Redeemer. Linda Seidel has shown that the iconography of this capital undoubtedly reflects that of the Pórtico de la Gloria at Santiago de Compostela, which is, in fact, often connected on the basis of style to sculpture in Palencia—specifically to the portal at the church of Santiago in Carrión de los Condes. The inscribed date of 1188 on the Compostela portal correlates with the date on the Lebanza abacus.

A representation of the Three Marys at the Tomb extends across the center and right

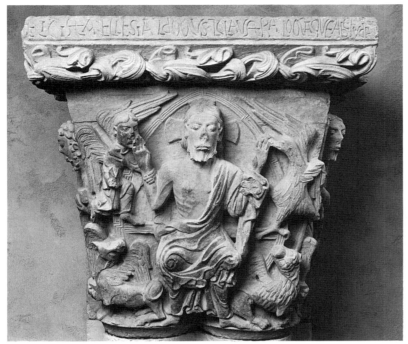

98a

Magdalene mistakes him after the Resurrection (see John 20:15, the verse between the visit of Mary Magdalene to the tomb and the Noli me tangere). This suggestion is problematic at best; however, a reference to the Noli me tangere on a capital with the Three Marys at the Tomb would not be inappropriate. Such an association occurs often in medieval art; examples appear as early as the mid-ninth century on folio 58 of the Drogo Sacramentary (Bibliothèque Nationale, Paris; MS. lat. 9428) and in the twelfth century at Saint-Lazare in Autun and in the cloister of San Pedro de la Rua in Estella. A Noli me tangere is depicted on a side face of a capital from the Palencian church of Aguilar de Campóo (cat. 97), the center of which is occupied by the Three Marys at the Tomb. This capital and another from Aguilar on which Christ is represented as the Redeemer compare with the Lebanza capitals on the basis of both style and iconography.[4]

DLS

1. García Guinea 1961a, pp. 155–56.
2. Ibid., p. 156.
3. Porter 1928, n. 883.
4. Cahn and Seidel 1979, pp. 206–8.

LITERATURE: Byne 1926, pl. 105; Porter 1927a, pp. 91–96; Porter 1928, vol. 2, p. 32, pls. 103, 104; Navarro 1939, pp. 186–92, 275–76; Pijoán 1944, p. 537, figs. 845–48; Gudiol Ricart and Gaya 1948, p. 257, figs. 404, 405; García Guinea 1961a, pp. 154–57, pls. 101–8; Providence 1969, p. 119, fig. 42a; Glass 1970, p. 58; Cahn and Seidel 1979, pp. 204–10, figs. 213–15.

faces of the second Fogg capital. The Marys carry ointment jars and gesture in sorrow, while an angel points to the tomb, on which is inscribed SIMILE:SEPVLCRO:DN [*Domine*] QĀdO [*Quodammodo*] (In some measure this is a likeness of the tomb of Our Lord). On the left side of the capital a man wearing a short garment and a long cloak holds a mattock. The identification of this figure is un-

clear, for by neither attitude nor attribute does he seem to be one of the soldiers often represented asleep at the tomb or one of the apostles—Peter is usually depicted—who rushed to the tomb, according to John 20:2–8. Given the instrument he carries—an agricultural tool still popular in Spain today—it is possible that the figure is Christ, represented as a gardener, for it is as such that Mary

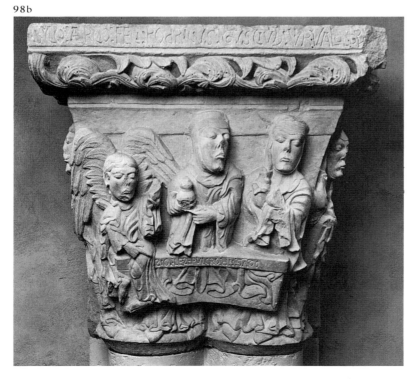

98b

99

two capitals

Palencia (Palencia), last quarter of 12th century
Limestone
a. Scenes of Combat
H. 13⅛ in. (34.6 cm)
b. Scenes of Judgment
H. 13½ in. (34.3 cm)
Walters Art Gallery, Baltimore (27.304, 27.305)

This pair of capitals, each carved on three sides, is attributed on the basis of style and iconography to the region of Palencia. Represented on the central side of capital (a) are two warriors, dressed in long garments and engaged in hand-to-hand combat. One of the warriors holds a shield with his left hand, while he raises his right hand to wield a club or mace. On the left side of the capital a woman takes the hand of a bearded figure, who gestures toward the warriors in the combat scene. On the third side of the capital, a beardless figure, identified by some as a man and by others as a woman, grabs its garment with one hand and raises the other hand to its hair in an apparent gesture of shock or despair. Beatriz Mariño has shown

99a

99b

that by virtue of the weapons they carry and the costumes they wear the figures on the central side of the capital are involved in a duel that takes on the character of an ordeal, or *Dei judicium* (literally, "judgment of God").[1] Here, the duel is apparently to settle a dispute over the virtue of a woman,[2] an adulteress, who might be the woman accompanied by the bearded man or possibly the solitary, anxious figure, the others perhaps being her parents. While the precise identification of individual figures is difficult, the general sense of the scene on the capital is clear.

Capital (b) is also concerned with issues of judgment. On the central side two figures place their hands in the jaws of a lion's mask, which functions as a boss for the capital. On the left side are two figures, one of whom is masked. On the right side two figures clasp hands. The tradition of a hand placed in a lion's mouth is a venerable test of truthfulness best known from the Bocca della Verità in Santa Maria in Cosmedin in Rome. The concern for true testimony evident here might be related to the theme of the other capital,

since combatants were required to swear to their honesty.[3]

The concerns for judgment expressed on these capitals reflect the increasing importance given to issues of civil conduct in late twelfth-century Spain. This subject was particularly appropriate for the decorative program of a church, where it may have been regarded as paralleling the overriding Christian concern with eschatology. The combination of scenes of trial and ordeal taken together suggests a complex narrative, and, in fact, the connections between the representations on these two capitals are such that José Pijoán was mistakenly led to describe them as forming a single capital.[4] Given their function as architectural elements and the fact that they must have originally belonged to a much larger program, their survival is indeed fortuitous.

Mariño has shown that the subjects depicted here appear together in the decoration of a number of Romanesque churches in Palencia—as, for example, at the church of Santiago in Carrión de los Condes, the church of the Assumption in Perazancas, and the church at Arenillas de San Pelayo[5]—that is, precisely in the region to which these capitals have always and convincingly been attributed on the basis of style. They also have been compared with capitals from the Palencian church of Santa María de Lebanza (cat. 98).[6] Broad planar modeling is accentuated by chiseled faces, while heavy drapery has a tendency to take on a decorative life of its own, swirling into circular or spiral patterns. Based on stylistic analysis, the present capitals can be dated to the last quarter of the twelfth century—which is corroborated by an inscription of 1185 on the capitals from Lebanza.

DLS

1. Mariño 1986, pp. 349–64.
2. Glass 1970, p. 58.
3. Mariño 1986, pp. 356–57.
4. Pijoán 1944, pp. 534–37.
5. Ibid., pp. 349–54.
6. Glass 1970, p. 58.

LITERATURE: Pijoán 1944, pp. 534–37, figs. 841–44; New York 1954, nos. 36, 37; Providence 1969, pp. 116–19, fig. 42; Glass 1970, pp. 57–59, figs. 21, 22; Cahn and Seidel 1979, p. 209; Mariño 1986, pp. 349–64, fig. 11.

100

head of an old testament figure

Astorga Cathedral (León), 1170s(?)
Limestone
9⅞ x 6¹¹/₁₆ in. (25 x 17 cm)
Museo de la Catedral, Astorga (496)

This beautifully articulated head of an Old Testament figure originally must have adorned the facade of the Romanesque cathedral of Astorga, few traces of which remain today. Nothing is known of the building campaign that produced this sculpture and the other late Romanesque decorative elements that now are either randomly placed as spolia on the walls of the late Gothic cathedral (begun in 1444) or else survive as fragments in the cathedral museum. The exceptional quality of the remaining facade decoration reflects the central position that Astorga occupied in the Middle Ages as one of the principal churches along the pilgrimage route.

The main significance of the head—whose drilled eyes once may have been inlaid with lead or jet and whose long, curled locks of hair are held in place by a band—is that it represents the first impact of northern French art, especially that produced at Saint-Denis and at Chartres, in Spain in the late twelfth century. It has been claimed that the sculpture of Master Mateo at Santiago de Compostela derives from such influences. However, the present work rather appears to reflect the tendencies of early Gothic sculpture as seen in several ambitious facade designs of the second half of the twelfth century and especially that at Sangüesa, where Old Testament column figures with drilled eyes form part of a Last Judgment program.

Together with the fragments from the cathedral of Coimbra in Portugal (cat. 101), the Astorga decoration bears testimony to the far-reaching artistic links that existed between the Iberian Peninsula and northern Europe in the twelfth century. CTL

LITERATURE: Cosmen 1989, pl. 7; Velado 1991, fig. 17.

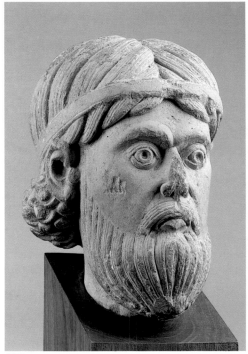

100

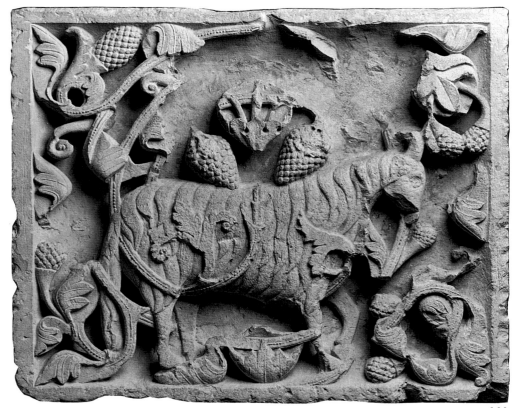

101

CRUCIFIX

Convent of Santa Clara de Astudillo (Palencia), second half of 12th century
Cross: red pine; Christ: white oak and polychromy
H. 8 ft. 6½ in. (260.4 cm)
The Metropolitan Museum of Art, New York; Samuel D. Lee Fund, 1935 (35.36ab)

This majestic crucifix from the convent of Santa Clara de Astudillo expresses simultaneously the human and divine natures of Christ. Nails pierce both the hands and feet, and his swollen belly sags; however, his solemn expression, spiritual composure, and crowned head convey his divinity. Unlike later images of the Crucifixion, this mid-twelfth-century work deemphasizes Christ's intense human suffering by minimizing the expression of his anguish and by omitting graphic wounds. Christ's golden crown, open eyes, and impassive mouth underscore his indifference to physical pain and, more significant, his inevitable triumph over death.

According to tradition, this crucifix once hung in a chapel in the convent of Santa Clara de Astudillo, located not far from Palencia. Above the cross an inscription carved in the stone recorded the unlikely date of 1047 as the year the cross was donated to the church. The cross's style is, however, inconsistent with a mid-eleventh-century date, and María de Padilla, mistress of Pedro the Cruel, did not found the convent of Santa Clara until 1354. No doubt, as David Simon has suggested, the cross was originally given to another church and later transferred to Santa Clara.[1]

The moving quality of the Santa Clara crucifix in part results from the tension between the transcendental nature of the event and the obvious artificiality of its depiction. Attention is drawn to the artifice of the work through the perfect symmetry of Christ's body; the startling contradiction between his nudity and crown; the abstract, gravity-defying folds and oversize knot of the perizonium; and the emphatic rib cage composed of a cascade of pronounced curving lines decreasing in size and anchored in the middle of the chest by the sternum's curved tip. The artist, however, also used artifice to disguise and conceal. Parchment was used to smooth over joints in the wood. Gesso—so thick in places that it is actually carved—covers the sculpture, creating a more receptive surface for its painted decoration and simulating a texture closer to that of flesh. Although much of the polychromy has been scraped from the perizonium, it still colors much of the sculpture.

Both the front and back of the cross are decorated, suggesting it was displayed in such a way that both sides were visible. Dark

101

Relief of the Lamb of God

Coimbra (Coimbra), late 12th century
Limestone
29⅛ x 35⅜ x 8¼ in. (74 x 90 x 21 cm)
Museu Nacional Machado de Castro, Coimbra (614)

This rectangular relief, which depicts the Agnus Dei, or Lamb of God, surrounded by decoration consisting of richly carved acanthus leaves and flower buds, is a surprising reminder of the often superior quality of sculpture in Portugal in the twelfth century. Unfortunately little is known of the origins of this highly accomplished relief except that it was found in the Milreus area of Coimbra, where the demolished convent of São Bento once stood. More probable, however, is that the relief is from the old cathedral of Coimbra, of which virtually no traces remain. After the death in 1180 of Bishop Manuel Salamão of Coimbra, the cathedral's principal patron, its sculpture workshop was dispersed, which establishes an approximate date for the relief.

Likewise, the function of the relief has been debated. Traditionally, it has been assumed to have been part of the tympanum of a church, like that of the north portal of São Martinho de Cedofeita in Oporto—a stylistically close parallel. Yet, because there is no evidence of weathering, it is more likely to have been part of the decoration of an ambo (pulpit).

Due to the lack of comparable Romanesque sculpture in Portugal displaying similar fully undercut spiraling acanthus forms, it has been proposed that the relief is the work of an itinerant sculptor. Most significant is that the vocabulary and the spirit of the carving appear closely linked to the decorative fragments that survive from the rebuilding of the cathedral of Astorga in Castile-León.[1] In addition, a tomb, dated 1194, at the monastery of Las Huelgas (Burgos) bears a related rinceau pattern on its lid.[2] These examples have nearly identical floral motifs and in technique display a marked predilection for undercutting. The frequent imitation in stone of forms that are typical of goldsmiths' work is a further demonstration of the parallels existing between sculpture and other media. These nearly contemporary works also are not unlike the designs composed of spiraling acanthus rinceaux inhabited by fantastic creatures in the mid-twelfth-century antiphonary at the monastery of Las Huelgas,[3] which reflect the strong influence of Romanesque Burgundy. CTL

1. Velado 1991, fig. 18.
2. Gómez-Moreno 1946, p. 10, pl. III.
3. Herrero-González 1988, pls. 39–56.

LITERATURE: Madrid 1992, no. 31 (with previous literature).

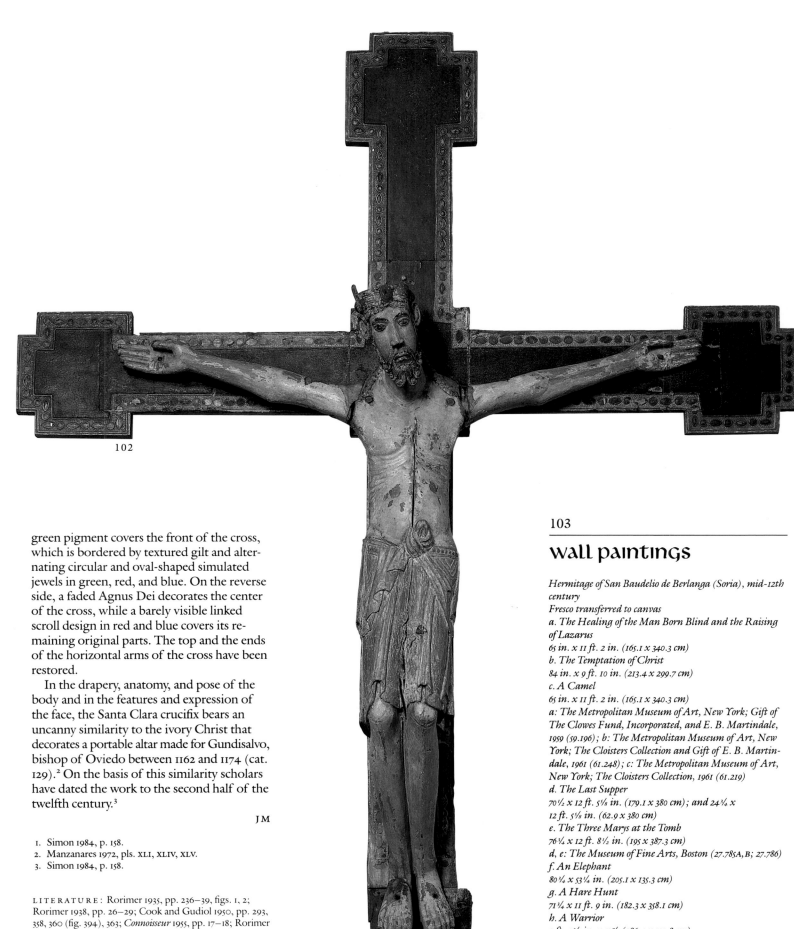

102

green pigment covers the front of the cross, which is bordered by textured gilt and alternating circular and oval-shaped simulated jewels in green, red, and blue. On the reverse side, a faded Agnus Dei decorates the center of the cross, while a barely visible linked scroll design in red and blue covers its remaining original parts. The top and the ends of the horizontal arms of the cross have been restored.

In the drapery, anatomy, and pose of the body and in the features and expression of the face, the Santa Clara crucifix bears an uncanny similarity to the ivory Christ that decorates a portable altar made for Gundisalvo, bishop of Oviedo between 1162 and 1174 (cat. 129).[2] On the basis of this similarity scholars have dated the work to the second half of the twelfth century.[3]

JM

1. Simon 1984, p. 158.
2. Manzanares 1972, pls. XLI, XLIV, XLV.
3. Simon 1984, p. 158.

LITERATURE: Rorimer 1935, pp. 236–39, figs. 1, 2; Rorimer 1938, pp. 26–29; Cook and Gudiol 1950, pp. 293, 358, 360 (fig. 394), 363; *Connoisseur* 1955, pp. 17–18; Rorimer 1963, fig. 16, pp. 39–41; Cahn 1968, p. 51; Providence 1969, pp. 109–10; Manzanares 1972, p. 33, figs. XLI, XLIV, XLV; Young 1979, pp. 20–21; Simon 1984, pp. 157–58; additional citations are available in Simon 1984.

103

wall paintings

Hermitage of San Baudelio de Berlanga (Soria), mid-12th century
Fresco transferred to canvas
a. *The Healing of the Man Born Blind and the Raising of Lazarus*
65 in. x 11 ft. 2 in. (165.1 x 340.3 cm)
b. *The Temptation of Christ*
84 in. x 9 ft. 10 in. (213.4 x 299.7 cm)
c. *A Camel*
65 in. x 11 ft. 2 in. (165.1 x 340.3 cm)
a: *The Metropolitan Museum of Art, New York; Gift of The Clowes Fund, Incorporated, and E. B. Martindale, 1959 (59.196)*; b: *The Metropolitan Museum of Art, New York; The Cloisters Collection and Gift of E. B. Martindale, 1961 (61.248)*; c: *The Metropolitan Museum of Art, New York; The Cloisters Collection, 1961 (61.219)*
d. *The Last Supper*
70½ x 12 ft. 5⅛ in. (179.1 x 380 cm); and 24¼ x 12 ft. 5⅛ in. (62.9 x 380 cm)
e. *The Three Marys at the Tomb*
76¼ x 12 ft. 8½ in. (195 x 387.3 cm)
d, e: *The Museum of Fine Arts, Boston (27.785A,B; 27.786)*
f. *An Elephant*
80¼ x 53¼ in. (205.1 x 135.3 cm)
g. *A Hare Hunt*
71¼ x 11 ft. 9 in. (182.3 x 358.1 cm)
h. *A Warrior*
9 ft. 4¾ in. x 51⅞ (286.4 x 131.8 cm)
f–h: *The Metropolitan Museum of Art, New York; The Cloisters Collection; on loan to the Museo del Prado, Madrid (57.97.5, 57.97.1, 57.97.3)*

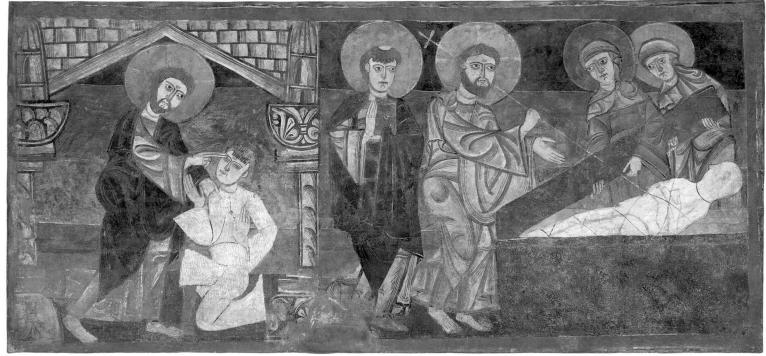

103a

The hermitage of San Baudelio de Berlanga was constructed in the beginning of the eleventh century at the heart of the frontier between Islamic and Christian lands. One hundred fifty years later, its extraordinary palm-vaulted interior was transformed with the addition of two cycles of vibrant wall paintings. The frescoes, of which the major part were removed and sold in 1926, are traditionally divided into two groups. The upper walls of the church were decorated with an elaborate christological cycle in a hand easily datable to the twelfth century (a, b, d, e), while the lowest register includes more simple, boldly painted hunt scenes; unrelated panels of animals; trompe l'oeil tapestries; and two bellicose figures that float on a white or potent deep red ground (c, f, h).

The densely peopled christological cycle is so specific and graphic in its narrative that it and the paintings of the lowest register would seem at first to represent totally divergent artistic and thematic goals. Inevitably, this has resulted in scholarly attempts to separate the cycles chronologically. Today, however, much of what may be said to constitute authorship or workshop practice reveals the paintings' contemporaneity: the use of the brush, the quality of line, and certain broad aspects of the draftsmanship of some of the animals and human figures are the same in both registers.[1] Furthermore, all the paintings were executed in the same technique:

103b

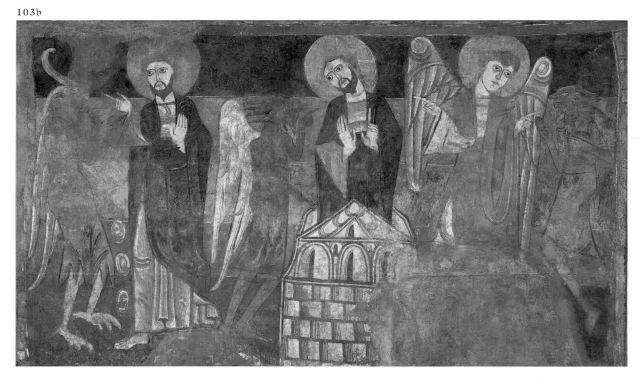

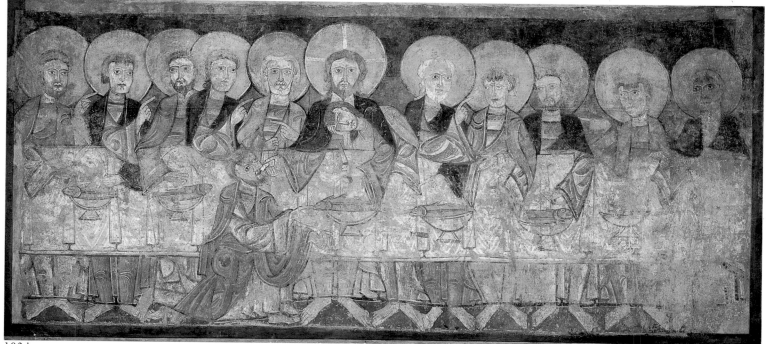

103d

sketches of buon fresco and fresco secco were finished with details added in tempera. The surface was then polished with lime milk and smoothed with intonaco joints.[2] Both cycles seem to be the work of artists from the same atelier, in styles that show great sympathy with the paintings from the hermitage of Veracruz at Maderuelo and the church of Santa Maria de Taüll. We are then left to ask how those who decorated San Baudelio meant these two divergent but contemporary lan-

guages of painting that are both secular and sacred, emblematic and narrative, to be experienced.

The christological cycle occupied two registers of the upper walls of the hermitage church. It featured a group of densely figured compositions punctuated by stiff but imposing gestures, brightly patterned architecture, and occasional dramatic breaks in its solemn, repetitive groupings. Thus, in the Last Supper from Boston (d) the table, the apostles'

bodies, and the heads and their halos all form horizontal registers—broad bands of color in a long, rectangular composition. Only the figure of Judas, who receives the Eucharist from Christ's hand, breaks the rhythm, cutting across the peace created by the composition with a diagonal completed by Christ's arm. Judas's three-quarter pose suggests his imminent action; Christ's iconic, frontal position communicates his omnipotence and —at the same time— acceptance of Judas's

103e

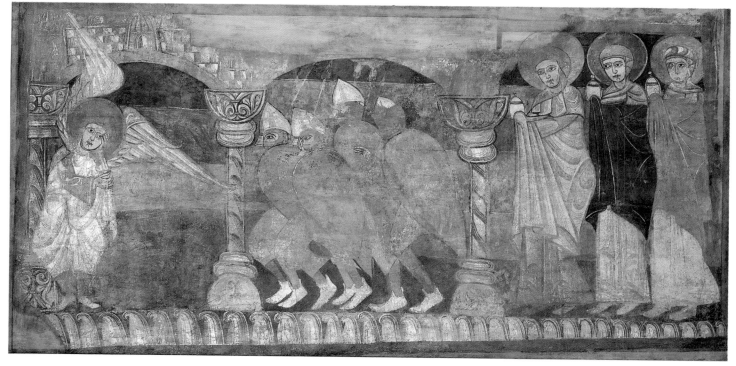

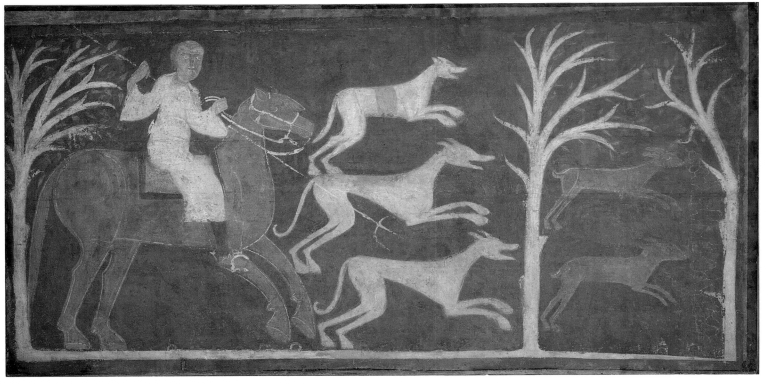

103g

act. And Christ's arm, meeting that of the errant apostle, confirms his complicity in his own demise. In its repetitive stasis but at the same time implicit movement, the broad meander that ran along the lower edge of the painting served to underline the tensions of the image, the intensity contained in its severed order.

The earliest events of Christ's life in this context, like the Temptation (b), occupied the western wall of the nave. The Last Supper and the Three Marys at the Tomb (d, e) originally faced each other at the extreme eastern ends of the north and south walls. In the latter, the holy women and the soldiers strain forward toward an undepicted tomb represented only by the angel who faces them, his back to the east, as if the tomb lay in the apse of San Baudelio itself. Indeed, the chris-tological scenes at San Baudelio were ordered, not for sequence or to facilitate the unfolding of the story, but so that the church's eastern portions might be the physical location of those events that took place in Jerusalem. Thus, to allow the Last Supper and the Three Marys to hug the eastern extremities of the hermitage church, the Healing of the Man Born Blind and the Raising of Lazarus (a) were positioned opposite the scene that ought to have followed—the Entry into Jerusalem.

Thus, the arrangement of paintings serves to convert Berlanga from a tenth-century Mozarabic building with Islamic appropria-

tions to a twelfth-century building that em-bodies Holy Jerusalem. This decoration would have had the effect of channeling Berlanga's central plan and exotic vaulting into the then more current theme of both the contemporary and future Jerusalem. It would ally Berlanga with a number of Templar churches con-structed at the time—like Santo Sepulcro at Torres del Río—that used a central plan and even Cordoban-type ribbed vaults to create an emblematic copy of the Holy Sepulchre. The intent was to call to mind the Holy Land and yet another confrontation with Islam for the sovereignty of Christian worship. Indeed, only two generations had passed since Pope Alexander II (r. 1061–73) commuted penance for those who took up arms on the Church's side in Spain. The introduction of a fashion-able concern with Jerusalem in architecture and painting and the appropriation of tenth-century architectural forms, this time to sig-nify the idealized battle for Jerusalem, are thus the visual expression of the drive to convert the Spanish conquest into yet an-other Crusade.

Most scholars have sought without success a reading that would make the lower paint-ings of San Baudelio into worldly metaphors for the sacred scenes above. Examples of nonsacred imagery of significantly smaller scale and prominence abound in northern Spain and Catalonia. What is extraordinary about Berlanga is that its animals and hunt

scenes are enormous and float boldly on contrasting monochromatic grounds. They were thus easier for the viewer to discern than the sacred cycle. This monumentality becomes even more puzzling when one confronts Juan Zozaya's discovery that every scene from the Berlanga secular cycle can be found on an Islamic object.[3] Though it was his conviction that the models were Fatimid, most of the subjects exist on objects manufactured on the Iberian Peninsula. The Elephant, now in the Prado (f), can be seen on the Ziyad casket (cat. 39), a famous caliphal ivory, as can Berlanga's Falconer (Cincinnati Art Museum) —the latter a very common sign of Islamic aristocratic and kingly status that appears often on Cordoban vessels and boxes. The Camel from The Cloisters (c) and hunting scenes from the Prado (g) seem unusual in the context of a Christian hermitage at Ber-langa, but these subjects are among the most common of the refined images of aristocratic power and pursuits that characterize the courtly fine arts of the Umayyad caliphate and *taifa* monarchies. Such works were known and admired by denizens of the Christian king-doms in the twelfth century. Even Berlanga's extremely rare representation of an archer hunting deer on foot can be found on the Palencia casket, a piece executed for the *taifa* kings of Toledo. This box, like many of those to which the Berlanga paintings have been compared, passed into one of the church

treasuries in the north through lords and kings who received them as booty or tribute.

Clearly these images do not formally resemble their prototypes. They are divorced from the jungle of ornamentation that had embraced them in Islamic objects, which were framed by a taste that viewed the figure as part of a set of complex, abstract relationships. Here they are isolated and made easier to see and understand for an audience for whom animate beings are the bearers of meaning in art. For the audience at Berlanga, the strange combination of exotic animals

and hunting scenes was probably associated with the sumptuous luxury arts from which they came, not through any attempt to reproduce Islamic style, rather to replicate subject matters occurring in Islamic art. What is being appropriated from al-Andalus is the notion of worldly luxury, a concept best expressed even in the north in terms of goods from "Islam"—material culture coveted because of its costly materials, unparalleled craft, and hegemonic implications. It is a case in which a veiled reference to an object associated with Islam fulfilled that meaning better

than any object or image from Christian culture could have.

An intriguing context for this idea can be found in the extensive hunting cycle of the lower paintings, for instance, the Hare Hunt at the Prado (g). In late antique villas, images of their owners hunting have been shown by André Grabar to represent their possession of their lands and their sovereignty over their holdings.[+] Indeed, in no fewer than three Spanish villas of the Early Christian period, the only portrait of the landowner shows him as a hunter. This is not surprising when one

103h

103c

227

103f

to just this issue, the Christian appropriation of the land and authority over the newly captured frontier on which San Baudelio stood. If the animals can, on one level, allude to Islamic material culture seized like booty, then the hunters provide the link to the newly conquered land and give us a metaphorical, secular meaning that dovetails with the sacred appropriation of the christological paintings. In this way it can be said that Berlanga's meanings truly reflect the tensions of frontier.

<div style="text-align: right">JDD</div>

1. For instance, the horse in the painting of the falconer from the lower cycle (Cincinnati Art Museum) and the horse in the Entry into Jerusalem from the upper cycle (Indianapolis Museum of Art) were executed in the same style.
2. Frinta (1964, pp. 9–11); "An Attempt to Decipher the Painting Procedure of the Frescoes from San Baudelio de Berlanga" (unpublished manuscript in the files of The Cloisters, The Metropolitan Museum of Art).
3. Zozaya 1977, pp. 307–31.
4. Grabar 1968, pp. 51–53.

LITERATURE: Frinta 1964, pp. 9–13; Zozaya 1977, pp. 307–31; Guardia 1984; Sureda 1985, pp. 68–73, 319–27; M. S. Frinta, "An Attempt to Decipher the Painting Procedure of the Frescoes from San Baudelio de Berlanga" (unpublished manuscript in the files of The Cloisters, The Metropolitan Museum of Art).

104

portrait of Joseph

Convent of Santa María, Sigena (Huesca), ca. 1190–1200
Painted plaster
26⅜ x 21¼ in. (67 x 54 cm)
Museu Nacional d'Art de Catalunya, Barcelona
(MNAC/MAC 86705)

This bust-length portrait of Joseph (the son of Mattathias, not Joseph of Nazareth) is from an extensive cycle of images of some seventy of Christ's ancestors depicted on the soffits of the five diaphragm vaults spanning the rectangular chapter house of the royal convent at Sigena, in northern Aragon. Painted soon after the convent was founded in 1188, the mural program also included an Old Testament cycle in the spandrels of the vaults and a New Testament cycle on the chapter house walls. The paintings survived in a remarkable state of preservation until 1936, when the chapter house was gutted by fire during the Spanish civil war, severely damaging them and causing their discoloration. Before their near destruction, the Sigena murals constituted the most completely preserved early chapter house decoration. They

reviews hunting legislation from the late antique and early medieval periods. Hunting rights were the terms in which land ownership was often written in the Middle Ages. They were the concrete and symbolic proof of a landowner's sovereignty over his land. It is a poignant theme in view of Berlanga's status in the twelfth century.

Berlanga was only definitively wrested from the hands of Islamic forces in 1124, when it was conquered by Alfonso VII. Its status as a fledgling Christian holding was so novel that

it was the focus of a covetous battle between the bishop of Osma and Bernard of Agen, the French bishop of Siguenza. The paintings surely date from the heat of this conflict, about 1125. Berlanga was at that moment part of the Church's booty of war; that put the Church at the center of a struggle for the lands and income that inevitably came with newly conquered lands and for the authority over a brand-new, lucrative slice of Christian Europe. Perhaps the hunting scenes of the lower paintings at Berlanga carry an allusion

also represent the finest example in monumental painting of the Byzantine-inspired classicizing style current about 1200 and provide important evidence of the transmission of English artistic traditions to the Iberian Peninsula manifest in such other works as the illustrated Commentary of Peter Lombard, from Sahagún, and the polychromed antependium from Avià (cats. 156, 171).

The Sigena murals are remarkably close in style to the work of a team of anonymous artists known from their illuminations for the Winchester Bible of about 1185.[1] While not absolutely identifiable as the work of these particular artists, the murals are unquestionably by individuals in the same circle—a group also responsible for miniatures in the Westminster Psalter and in a Gospel book produced for Saint Albans Abbey.[2] The style employed by these English artists is reminiscent of that of the mosaics of Norman Sicily executed by Byzantine craftsmen, particularly the mosaics at Monreale Cathedral, completed in the mid-1180s. The apparent familiarity with Monreale and the active commerce between England and Sicily suggest that the artists may have actually visited the cathedral while the Byzantine mosaicists were at work.

The only known medieval ancestor cycle more extensive than that of the Sigena vaults originally included some eighty-six stained-glass portraits installed in the clerestory of Canterbury Cathedral beginning about 1176.[3] In addition to their considerable length, both cycles stand apart from the bulk of western medieval imagery dealing with Christ's genealogy—such as the Tree of Jesse—by not depicting Christ's ancestors exclusively as kings bearing crowns and scepters. The figures in both cycles also share a similar variety of poses and gestures, such as Joseph's self-referential pointing finger. Although stylistically slightly removed from Canterbury, these similarities suggest that the Sigena artists were familiar with the windows there.

Viewed in connection with the adjacent Old Testament scenes in the spandrels of the chapter house vaults, the ancestor cycle on the soffits appears to have served as part of a pictorial textbook of biblical history. The combination of an extensive cycle of Christ's ancestors and a nearly identical series of Old Testament themes is found, for example, in Peter of Poitier's *Compendium historiae in genealogia Christi*. Composed shortly after 1167, this illustrated genealogy of Christ, which is annotated with historical commentary, was widely employed for the rudimentary education of clerics in biblical history. Such a function for the Sigena murals accords well with the use of the chapter house, where daily activities included reading from the Gospels, sermons, religious discussions, and the education of novices.

K F S

1. Winchester Cathedral Library; see Kauffmann 1975, pp. 108–11, no. 83.
2. British Library, London, Royal MS. 2.A.XXII, and Trinity College, Cambridge, MS. B.5.3; see Morgan 1982, pp. 49–51, nos. 3, 4.
3. See Caviness 1982, pp. 107–15.

LITERATURE: Pächt 1961; Oakeshott 1972; Avril, Barral, and Gaborit-Chopin 1983, pp. 248–51, 256–57.

104

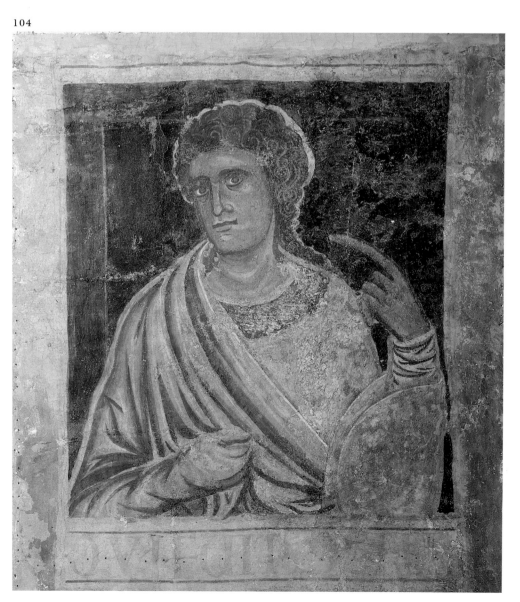

229

105

SARCOPHAGUS OF DOÑA SANCHA

Convent of Santa Cruz de la Serós (Huesca), first quarter of 12th century
Stone
25⅛ x 81⅛ x 34¼ in. (65 x 206 x 87 cm)
Benedictine Monastery of Santa Cruz, Jaca

This stone sarcophagus, now in the Benedictine convent in Jaca, was carried there from Santa Cruz de la Serós in 1622, when it was decided to move the convent to the larger city from its more remote situation.[1] One of the long sides of the sarcophagus is divided into three sections. In the center two angels support a nude figure enclosed within a mandorla. At the right are three women, with the one in the center, who holds a book and sits in an X-shaped chair, somewhat larger than the two figures who flank her. At the left three tonsured clerics are engaged in a liturgical rite. This tripartite division is echoed

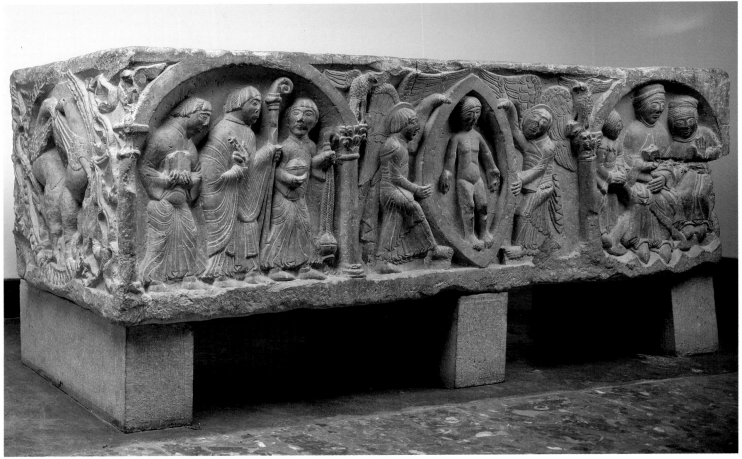

105

on the other long side of the sarcophagus, where each of the three arches is occupied by a figure. Within the center and left sections mounted and armed horsemen face each other; the figure on the right—a man whose hands are placed within the open jaws of a lion that he is riding or straddling—has variously been identified as the long-haired Samson or the youthful David. Carved on one end of the sarcophagus are addorsed griffins within a decorated roundel, and represented on the other end is a jeweled chrismon with the Agnus Dei at its center.

The sarcophagus was carved by two sculptors or workshops, as evidenced by the two distinct styles apparent on its two long sides. Even so, the ateliers would seem to have been contemporaneous, since the sarcophagus is related to a number of works in Aragon that display the same two styles. These are found at Jaca Cathedral, at the church of San Pedro el Viejo in Huesca, and, not surprisingly, at the monastery church of Santa María at Santa Cruz de la Serós. On the basis of stylistic comparisons with works at these other sites—particularly Jaca Cathedral, from late in its building campaign—the sarcophagus can be dated to about the second decade of the twelfth century.[2] Attempts to trace the origins for at least one of the styles of the sarcophagus to workshops active in northern

Italy in the late eleventh and early twelfth century remain unproven, if suggestive.[3]

The sarcophagus has been associated with Sancha (ca. 1045–1097), daughter of Ramiro I of Aragon and sister of his heir, Sancho V Ramírez, since its first known reference in an early seventeenth-century literary account.

105

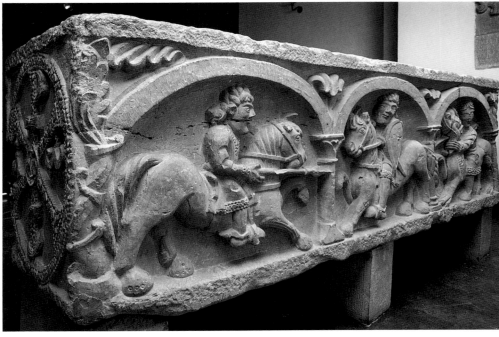

However, the evidence for identifying the sarcophagus with her remains circumstantial,[4] although not without merit. Given the dating suggested above—that is, almost a generation after Sancha's death—it is conceivable that the sarcophagus was, in fact, commissioned sometime after she died. As such, it

105: Detail

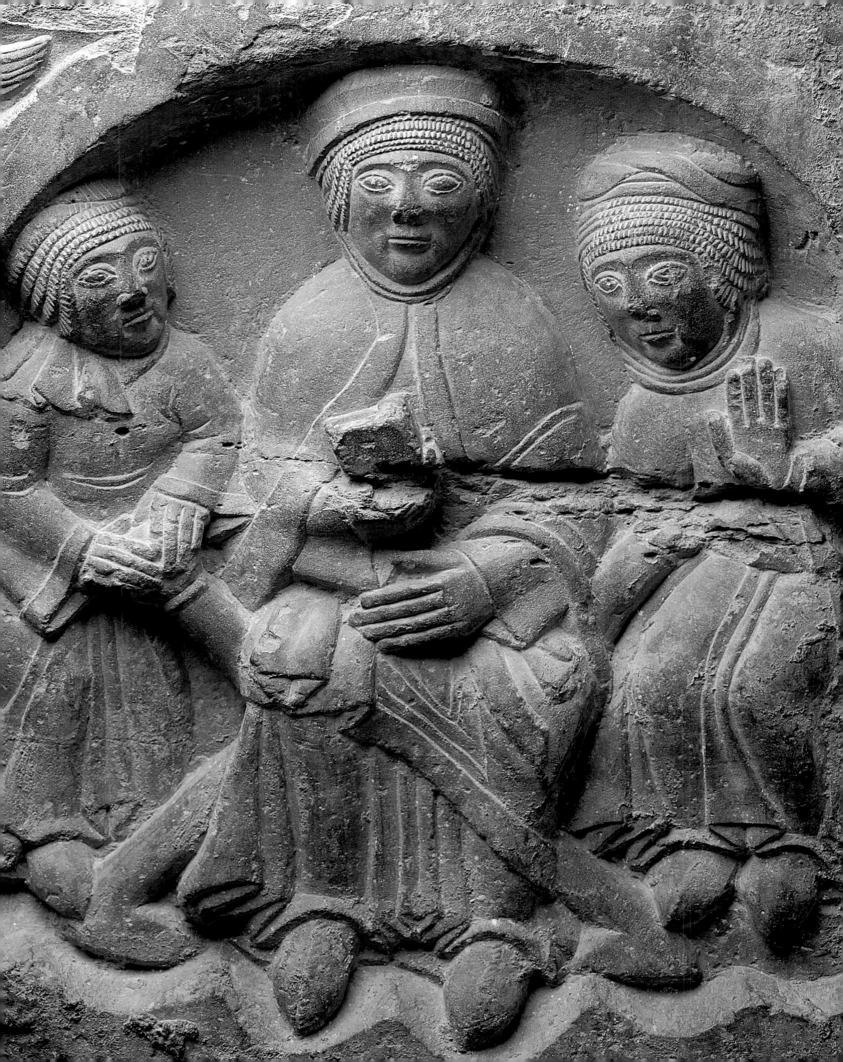

would not only have served to house her remains, but it would have been a memorial monument to a figure who was a forceful presence in royal and political circles and, in the eleventh century, the most important patron of the monastery in which the sarcophagus was found.[5]

An accurate interpretation of the scenes on the sarcophagus has been difficult, in part because some representations appear to be very specific and others very generalized. Many scholars have identified the seated figure as Sancha herself, framed by her two real-life sisters, who resided with her in the convent of Santa Cruz.[6] The scene in the left section on this same side has been identified by action and attribute as a bishop celebrating the Mass for the Dead. These two scenes, together with the depiction of the translation of the soul into heaven that they flank, seem to refer to the function of the sarcophagus. Attempts to link the figures on the other long side with known warriors, that is, Christian and Moor, or Roland and Farragut,[7] have not found acceptance in the literature.[8] Rather, these figures have more recently been acknowledged, in a much more general sense, to be symbolic either of the combat between good and evil[9] or of images of social violence.[10]

<div align="right">DLS</div>

1. An inscription of 1622 on a plaque, today placed above the sarcophagus, explains that the bones of Sancha and her two sisters, Urraca and Teresa, were transferred from the Convent of Santa Cruz in that year.
2. Simon 1979a, pp. 112–23.
3. Porter 1924, p. 165; Beenken 1925, pp. 108–11; Frankovich 1940, pp. 225–47; Salvini 1956, pp. 58, 106–7.
4. Simon 1979a, p. 110.
5. González Miranda 1956, pp. 185–202; Durán Gudiol 1962.
6. Carderera 1855–64, vol. 1, no. 4; Arco 1919, pp. 158–61.
7. Lejeune and Stiennon 1971, vol. 1, pp. 26–27.
8. Simon 1975, pp. 110–11; Besson 1987, p. 117.
9. Ruíz 1978, pp. 75–81.
10. Besson 1987, pp. 113–26. Besson does not take into account the specific context in which these scenes are represented, that is, on a sarcophagus, nor does he consider how the warrior scenes might relate to the other scenes which decorate the sarcophagus.

LITERATURE: Carderera 1855–64, vol. 1, no. 4; Arco 1913, pp. 431–55; Arco 1919, pp. 158–61; Porter 1923, p. 248, ill. 527; Porter 1924, pp. 165–79; Beenken 1925, pp. 97–118; Porter 1928, vol. 1, pp. 64–73, 94, pls. 48–51A; Frankovich 1940, pp. 225–94; Gudiol Ricart and Gaya 1948, p. 135, fig. 246; González Miranda 1956, pp. 185–202; Salvini 1956, pp. 185–202; Durliat 1964, p. 69, pl. 109; Panofsky 1964, p. 59, pls. 235, 236; Palol and Hirmer 1967, p. 104; Pijoán 1944, fig. 143; Oliván 1969; Canellas-López and San Vicente 1971, pp. 235–39; Lejeune and Stiennon 1971, vol. 1, pp. 26–27; Uranga and Iñiguez 1971–73, vol. 2, pp. 86–88, pls. 46–49; Simon 1975, pp. 104–18; Zarnecki 1975, p. 271, fig. 269; Ruíz 1978, pp. 75–81; Simon 1979a, pp. 107–24; Yarza 1979, p. 215; Simon 1980a, pp. 249–67; Simon 1981a, pp. 159–60; Besson 1987, pp. 113–26; Hassig 1991, pp. 140–53.

106

LID FOR THE SARCOPHAGUS OF DOÑA BLANCA

Pantheon of the monastery church of Santa María la Real, Nájera (Logroño), 1156
Limestone
19⅛ x 66⅞ x 28⅜ in. (50 x 170 x 72 cm)
Church of Santa María la Real, Nájera

A poetic and intensely personal sarcophagus was designed to commemorate Doña Blanca of Navarre, wife of Sancho III of Castile, after she died in childbirth in 1156. Only the gabled lid of the sarcophagus has survived, and it provides a valuable document of the high quality of aristocratic tombs of the mid-twelfth century. On the lid's front the lower register represents Blanca's death and the mourning of the court, a scene that includes her bereft husband swooning at the right. Above is Christ in Majesty with the symbols of the four evangelists, flanked by the twelve apostles. On the reverse are a damaged Epiphany, the Judgment of Solomon, and the Massacre of the Innocents. These scenes are placed under a representation of the Wise and Foolish Virgins, also damaged, processing toward a centrally placed Bridegroom; at the far right are two additional women, probably the vendors of the oil for the maidens' lamps. By means of

composition and gesture the designer of the sarcophagus interwove this suggestive combination of images of maternity, martyrdom, and salvation to commemorate the royal mother who died.

Doña Blanca Garcés was an infanta of the kingdom of Navarre. Nájera was the capital, the residence of the kings, and a stop along the pilgrimage route to Santiago de Compostela. Blanca's burial in the royal pantheon of Santa María in Nájera was traditional for her family, the Navarrese kings. Perhaps during the sixteenth-century rebuilding of the pantheon, when the medieval tombs were replaced by new ones, the ends of Blanca's sarcophagus lid were cut off, and the tomb was set into a niche.[1] Today the lid is displayed freestanding in the south aisle of the church. An inscription under the queen's deathbed, REGINA DONA BLANCA, identifies the tomb as hers, and the year of her death, 1156, is recorded in donations made by Sancho in memory of his wife.[2] The carving of the tomb may be securely dated to this time because Sancho died two years later in 1158 and was buried with his father, Alfonso VII, in Toledo. The child to whom Blanca gave birth became Alfonso VIII, one of the great kings of medieval Spain.

Apart from the expressive, fine carving, the sarcophagus lid is valuable as a dated monument that allows us to place similar works in time. The style of the reliefs has been related

106: Detail

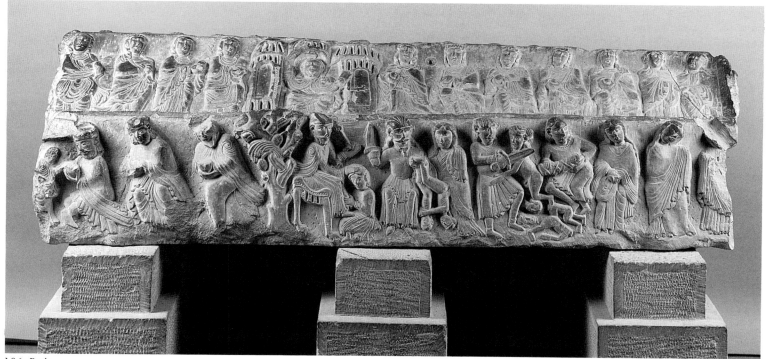

106: Back

to a number of important monuments of the second third of the twelfth century in southern France and northern Spain, including the cloister capitals of Pamplona Cathedral (cat. 96), the facade of Santa María la Real, Sangüesa, and the later cloister sculpture of Santo Domingo de Silos and Saint-Étienne, Toulouse, and even to Burgundian monuments.[3]

The international style and subject matter of the sarcophagus reflect the familial and political connections of the royal houses of Navarre and Castile with Languedoc and Burgundy. Artistic relations with Burgundy might reasonably be posited due to the presence of Cluniac monks at Santa María la Real, Nájera. Artistic links between Nájera and Pamplona would arise naturally from the function of both cities as capitals of Navarre. The sculptor of the Nájera tomb appears to have been familiar with the capital represent-

ing the Arrest and Crucifixion of Christ in Pamplona.[4] In addition, satisfying comparisons may be made with the sculptures of Saint-Étienne in Toulouse, as Arthur Kingsley Porter pointed out.[5] Another close comparison can be made with the Solsona Virgin and Child often attributed to Gilabertus, who worked in Saint-Étienne. Perhaps only by coincidence, the two different types of drapery style evident on the sarcophagus lid may

106: Front

also be found on the apostle reliefs of the cloister of Saint-Étienne.[6]

Whether differences in drapery style and figural proportions between the lid's two registers are due to two different artists working together on the sarcophagus or to one artist manipulating style to mark iconographic distinctions is difficult to determine with certainty.[7] Several elements, however, point to a single artist; these include the relationship between hair, mouth, and beard and the carving of the eyes, which are very much alike in both registers. Also, the swirling folds that activate the figures of the Christ in Majesty, the Bridegroom, and the damaged figure of the Infant in the Epiphany strongly resemble one another. In addition, there are groups of figures in which a gradual transition between these two styles is marked.

This stylistic unity finds a parallel in the devices used to integrate the various biblical episodes and the two levels of the sarcophagus with each other. The angels lifting Blanca's soul, represented as a newborn child, up to Christ in Majesty above provide a link between the dramatic lamentation scene on earth and the celestial hierarchy above. Christ as Judge on the upper level of this side is echoed both visually and thematically by the Bridegroom on the upper level of the reverse. The parable of the Wise and Foolish Virgins, which contrasts foresight and foolishness, is a metaphorical presentation of the Last Judgment as a wedding ritual. By 1156 the parable had often been associated specifically with the Last Judgment and the Resurrection of the Dead. The themes of judgment, wisdom, and foolishness are developed in the biblical stories illustrated below: the Child, who personifies wisdom, receives homage from the Three Kings; the wise king Solomon makes a judgment between two mothers who claim the same child; the Massacre of the Innocents, commanded by the foolish king Herod, takes place. The theme of mourning is carried from one side of the lid to the other by the mothers of the Innocents, who mourn their death, walking away from the Massacre in the direction of the women of the court, who mourn Blanca's death. The reliefs as a whole express the grief of the court and the expectation of Blanca's entry into heaven. The selection of biblical scenes in which women are major actors indicates a desire to devise an iconography appropriate to the royal mother who lost her life giving birth to a future king. EVA

1. Illustrated in Arco 1954, pl. x; removed by Iñiguez Almech during a restoration, for which, see Iñiguez Almech 1968, p. 200.
2. Sandoval 1634, pp. 335–36; Bernard 1894, pp. 536–38.
3. Cook and Gudiol 1950, p. 364; Alvarez-Coca 1978, pp. 35–36; Porter 1928, vol. 2, p. 27.
4. Iñiguez Almech 1968, p. 201.
5. Porter 1923, vol. 1, p. 241.
6. Mesplé 1961, figs. 1, 7, 8, 11, 15, 19, 22, 24.
7. Iñiguez Almech 1968, p. 201; Alvarez-Coca 1978, pp. 36–39.

LITERATURE: Yepes 1617, fol. 131v; Sandoval 1634, pp. 301–2, 333–36; Carderera 1855–64, vol. 1 (III), pp. 1–3; Bernard 1894, pp. 536–38; Madrazo 1886, pp. 633–34; Porter 1923, vol. 1, p. 241, vol. 5, ill. 719; Porter 1928, vol. 2, pp. 25, 27, pl. 83; Cook and Gudiol 1950, p. 364; Arco 1954, pp. 16–17, 125, 238–40, pl. x; Jacob 1954, pp. 84, 85, 119, 197; Iñiguez Almech 1968, pp. 200–3, figs. 63–72; Alvarez-Coca 1978, pp. 27–39, ills. pp. 29–30, 33; Franz 1981, p. 82, n. 29; Castillo, Elorza, and Negro 1988, pp. 28–29, 46, 56–57, figs. 80, 81; Gómez 1988, pp. 31–50, fig. 1; Hassig 1991, pp. 144–45, fig. 10.

107

LID FOR THE SARCOPHAGUS OF ALFONSO ANSÚREZ

Church of San Benito, Sahagún (León), December 8, 1093
Stone
W. 77⅛ in. (196 cm), d. 24 in. (61 cm)
Museo Arqueológico Nacional, Madrid (1932/115)

Opinions as diverse as those held by Manuel Gómez-Moreno, Arthur Kingsley Porter, and Georges Gaillard on the development of Hispano-Languedocian Romanesque sculpture find a relative point of agreement in this singular piece, whose epigraphic information removes it from a debate centered almost exclusively on questions of chronological precedence. These three authors coincided in underscoring the apparent Hispanism of the stone, even if concluding with differing theses. For Porter and Gómez-Moreno, the Mozarabic traces they believed they recognized in its design were evidence of a fundamental Hispanic contribution to the definition of Romanesque style. For Gaillard, on the other hand, those characteristics and others, presumably Asturian, that he pointed out merely revealed the atavism of its still preRomanesque conception.

Neither the place of its origin nor the nature of those who devised it seems in principle the most adequate factor for justifying a traditionalism—whether creative or regressive —belied by the execution itself. The young Ansúrez was the son of Count Pedro Ansúrez, one of the most influential persons of the reign of Alfonso VI (d. 1109). His name and those of close family members appear frequently in documents of the time in association with the Cluniac implantation in Tierra de Campos. That presence, in fact, reached its climactic episode in Sahagún in 1080, when King Alfonso appointed Bernard d'Auch head of the abbey in order to make it the Cluny and the Saint-Denis of his kingdom.

The type of lid alone—with two sloping sides articulated by a flat molding at the top,

along which the epitaph is disposed—has a clear Hispanic precedent in the lid for the sarcophagus of Ithacius (cat. 1)—a piece as unusual for its time as its formula was common between the eleventh and thirteenth centuries. The scrolls that decorate the Oviedo cover, however, are replaced in the Sahagún lid by a figurative program, for which relative precedents and parallels are found only beyond the Pyrenees and in different types of pieces. The tomb lid at Sahagún seems, in fact, to combine a disposition typical of sarcophagus covers—conceived to offer an independent visual approach to each of its sides—with an axial composition more characteristic of tombstones. Pieces of the present type are likely to depict such motifs as the segment of starry sky from which the Divine Hand is extended —identified here as the *dextera Christi*— blessing an Alfonso termed *defunctum*. The image of the deceased, apparently at the moment of death, may then best be understood as an allusion to his resurrection, and in a funerary context the appearance of the eagle is common as both the sign of John the Evangelist and a symbol of the resurrection of the flesh. After the eagle, the archangels Michael and Gabriel are represented—while Raphael is on the other side—all summoned in the *Ordo commendationis animae* (Order to commend the spirit) to receive the soul of the dying man. The attributes they carry —cross, thurible, and book—are those of officiating clergy in contemporaneous representations of funerals, which establishes this group as an early version of the "Mass of the Dead Performed in Heaven"—to use Erwin Panofsky's term—that was to be developed in Gothic funerary imagery. Beside Raphael are the three other evangelists shown as angels carrying books, according to a formula documented in Anglo-Saxon miniatures and having sculptural parallels in the Auvergne. With their index fingers, the three angels are pointing to the chalice in their midst, the *calix salutis perpetuae* (the chalice of perpetual bliss) of the Canon of the Mass, guarantee of the promise contained in John 6:54: "He who eats my flesh and drinks my blood has eternal life, and I will raise him up at the last day." Despite these evident compositional incongruities, the piece reveals a strict coherence in its program, centered in the hope of resurrection. From the stylistic point of view, the type of massive faces, with bulging eyes and strong chins, evokes those of corbel brackets from the church of San Martín de Frómista, where parallels are also found for the elemental tubular solutions given the treatment of the folds. Undoubtedly, the master who carved this piece was trained in the workshop of the Palencia church, so that the data on the death of the young Ansúrez become a valuable point of reference for

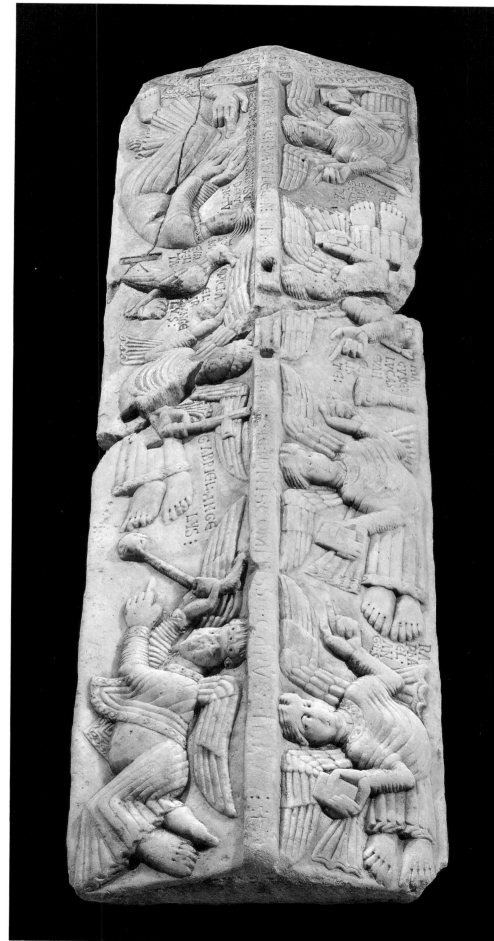

setting the chronology of the most creative sculpture current on the pilgrimage road.

SM

LITERATURE: Porter 1926a, pp. 243–44; Porter 1928, vol. I, pp. 59–60; Gómez-Moreno 1929, pp. 348–49; Gómez-Moreno 1934a, p. 160; Gaillard 1938a; Moralejo 1985a, pp. 63–100 (with previous literature); Hassig 1991, pp. 140–53.

108

BIBLE

Monastery of Valeranica (Castile), 960
Tempera on parchment
19 x 13⅝ in. (48.5 x 34.5 cm)
Real Colegiata de San Isidoro, León (Cod. 2)

This large, complete Bible is written in two columns in Visigothic minuscule, the Hispanic form of script that was employed on the peninsula between the seventh and the twelfth century. It opens with a page devoted to Christ with the four evangelist symbols and ten pages of tables tracing in a series of linked medallions the ancestors of Christ, beginning with Adam and Eve; this is a series unique to the Spanish tradition and present in the Beatus Commentaries as a feature borrowed from Bible illustration. The illumination of the New Testament consists of seventeen canon tables and small figures of Saint Paul beside the beginning of his Epistles. In contrast, the Old Testament is extraordinarily rich in illustrations. Although Genesis has only two pictures—the popular subjects Adam and Eve and the Offering of Isaac—the Old Testament books that follow display more than eighty subjects in narrative illustrations inserted in the columns of text immediately after the passages that supply their themes. This system of illustration is one associated with the earliest stages of Christian illumination; it soon gave way to a preference for framed miniatures less tightly linked to the texts that they illustrated. The column-picture format and parallels between the pictorial organization and compositional formulas associated with early Bible illustration outside of Spain are signs that this Bible represents an ancient tradition of illumination. Another such sign is the presence of numerous glosses in the margins of the Old Testament giving the Old Latin versions of the Vulgate text, which became standard about 400. It is probable, then, that the León Bible of 960 was copied from a Spanish Bible from the Visigothic period or earlier, which itself must have been based upon illustrated books from important Christian

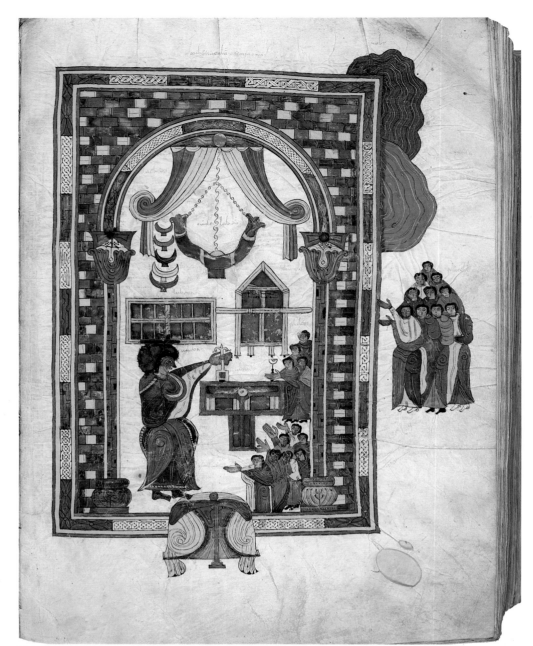

108: fol. 50. The Wilderness Tabernacle (Exodus 35:10–12)

Reliquary of Saint Pelagius

León (Léon), 1059 or earlier
Wood, ivory, gold, and silk
12 x 19 x 10¼ in. (30.5 x 48 x 26.2 cm)
Real Colegiata de San Isidoro, León

Thanks to the record made during a visit to León by Philip II's tireless bibliographer, Ambrosio de Morales, we know that this reliquary once carried in a gold inscription the date of its creation, 1059, and the names of the saints it honored, John the Baptist and Pelagius, as well as the names of its commissioners.[1] Morales saw the casket to the right of the reliquary of Saint Isidore (cat. 110) in the church of San Isidoro. The reliquary originally housed the jawbone of John the Baptist, whose name was given to the palatine church founded or refounded in León by Alfonso V early in the eleventh century. Pelagius was a youthful hostage martyred by the caliph ʿAbd al-Rahman III in Córdoba in 925. Only a few decades later he was celebrated in a lengthy poem by the German nun Hroswitha, and in 966 his body was deposited in the convent of San Pelayo in León. Threats of Muslim destruction at the end of the century led to the translation of the body to Oviedo. With the security that came to the Leonese kingdom under Ferdinand, a relic of Pelagius was brought from Oviedo to the capital in 1053, and this reliquary became its home in the church of John the Baptist.[2] The casket eventually held a relic of Saint Vincent.

The church of Saint John the Baptist would be rebuilt and rededicated to Saint Isidore of Seville by Ferdinand and Sancha in 1063 and showered by them with the gifts that today make its treasury extraordinarily rich.[3] This reliquary is the earliest dated object in the treasury, manuscripts excepted. Early in the tenth century Alfonso III had commissioned the Astorga casket (cat. 70), a shrine of comparable house shape but half the size and with the imagery worked out in metal rather than in the ivory employed on the Leonese reliquary. The Apocalypse is the source of the program on each, however. On our shrine, as on the Astorga casket, Christ, surrounded by the symbols of the evangelists, is present at the apex of the structure in his symbolic guise of a Lamb. The heavenly realm is expanded to include cherubim/seraphim and, presumably, archangels. Michael is depicted in a plaque beneath the Lamb in combat with the dragon of Apocalypse 12. The battle of Michael's angels continues in a plaque on the opposite side of the lid.[4] The paradisiacal character of the ensemble is developed in images in the corners of

centers outside the peninsula. This manuscript is, therefore, a valuable witness to the early stages of the history of Christian illumination.

From the colophons and a magnificent picture of Sanctius beneath a grand Omega saluting with a raised cup his master, Florentius (fol. 514), it is clear that this manuscript was copied by Sanctius at the Castilian scriptorium of Valeranica, south of Burgos. Florentius had been responsible for the Moralia in Iob of 945 (cat. 84) and also for a Bible of 943, now lost, that probably served as the model for the Bible of 960 and for the Bible completed in 1162 for San Isidoro in León (cat. 150). Beyond producing its model, it is not clear what role, if any, Florentius had in

the Bible of 960. Figures in this Bible resemble those in other Spanish manuscripts of the tenth century in that they do not display any sense of plasticity and are enveloped in complex drapery folds patterned in a mosaic of different colors.

JWW

LITERATURE: Pérez Llamazares 1923, pp. 4–18; Galindo 1960; Werckmeister 1965, pp. 948–67; Williams 1965; Williams 1967; Williams 1977a, pp. 55–61; Cahn 1982, pp. 66–70; Burgos 1990, no. 12, pp. 54–57.

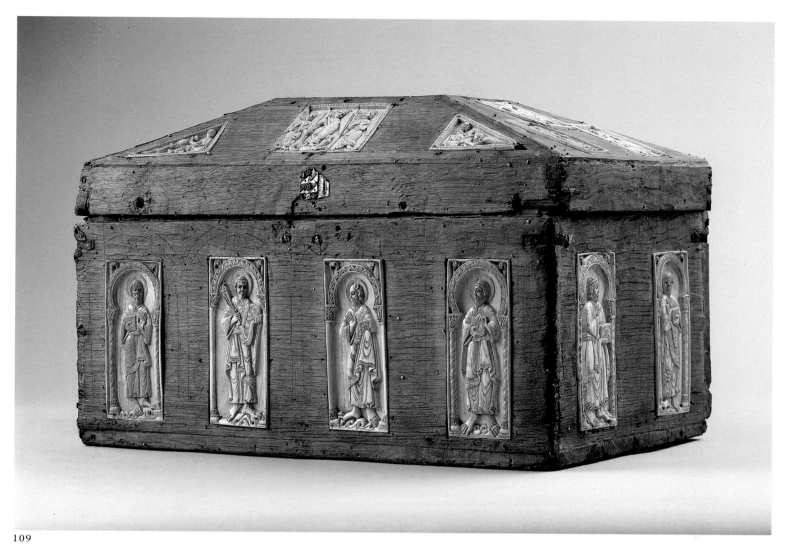

109

the lid of the Four Rivers of Paradise personified by seated males holding amphorae with flowing streams. A full set of apostles completes the program, with Peter, holding a set of keys spelling out Petrus, and Paul, bearded and balding, flanking the central axis of the front. Morales described the casket as presenting more gold than ivory, but it was stripped by Napoleonic soldiers, and only the small gilt nails that would have fixed the gold sheets to the wooden core remain. A lost system of arcades is visible in engraved lines that indicated the positions of columns and arches enclosing the apostles. At the center on the lower part of the back and in the upper right-hand corner of the front are small fragments of gold filigree against a gold ground. Small fragments of a gold repoussé vine scroll are found at the bottom corner of the left side and beneath the crisscross silver patch at the site of the original clasp above the figures of Peter and Paul. Perhaps this second technique was employed for the base of the bottom of the casket and for the vertical part of the lid. The silver fragment may represent a restoration.

109: Michael the Archangel in combat with the dragon of the Apocalypse

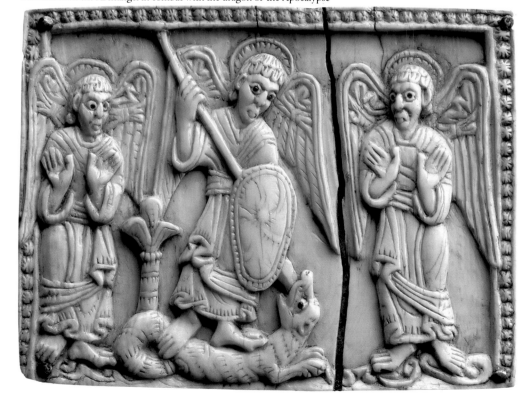

237

109: Lining of Lid

In the tenth and eleventh centuries ivory was a medium commonly worked by Muslim carvers (cats. 39, 40) or Christian artisans who borrowed liberally from the Islamic repertory and did not use Christian subjects (cat. 74). From the time of Arthur Kingsley Porter, Germanic inspiration, especially the ivories of the Echternach school, has been proposed for our casket. It is true that Ottonian sites were major producers of ivory carvings for combination with metalwork, some for shrines similar in shape to this one. The Echternach ivories do display a comparable combination of linear accents and plasticity. Northern Europe is, moreover, the locale of the representation of river-gods as dressed males. And, more to the point, the reliquary of Saint Isidore in the same treasury as our shrine (cat. 110) was probably the responsibility of someone who had been formed in the Rhenish tradition. However, the resemblance of our casket to Germanic ivories is too slight, despite the stylistic parallels to the Echternach ivories, to lead to the conclusion that its carver was Rhenish-trained, even

though awareness of Ottonian art provided an essential background for the conception. In a prayer book (cat. 144) commissioned by Sancha in 1055 from a painter with a Spanish name, Fructuosus, a connection with Ottonian conventions is also displayed: figures are rendered with a balance of the linear and the sculptural in patterns resembling those presented by the apostles on our reliquary.[5]

This reliquary, like the reliquary of Saint Isidore, was lined with a magnificent Islamic textile. This silk lining must have been new, or virtually so, in 1059, when it was inserted in the chest. It is unlikely that sacred relics would have been placed next to fabrics of less than the highest quality or the freshest condition available. There are few extant *taifa* textiles, and this and the lining of the San Isidoro reliquary assume special significance because they can be dated with reasonable precision.

In terms of structure (samite, or complementary weft twill) and coloring, the lining of the Saint Pelagius reliquary is closely related to other presumably *taifa* silks.[6] Our

sample of *taifa* textiles is so small there is no way to know whether or not the design is representative, but it does stand apart from the others: its bands of relatively small-scale elements contrast notably with the more common bands of large-scale single or paired animals. Here there are bands with bird pairs, pairs of dragons and hares, and scrolling vines that form compartments containing single-crested birds and griffins. These figured bands are flanked by bands of Arabic inscriptions in Kufic script and separated by red bands with a faint diamond-lattice pattern. The inscription consists of a brief phrase that appears in its proper orientation and then is repeated in reverse. The inscription cannot be deciphered except for the last word, الملك (kingship).[7]

JWW/DW

1. Morales 1765, pp. 47–48. The inscription read ARCULA SANCTORUM MICAT HAEC DUORUM BAPTISTAE SANCTI JOANNIS SIVE PELAGII/CEU REX FERNANDUS REGINAQUE SANTIA FIERI IUSSIT. ERA MILLENA SEPTENA SEU NONAGENA.
2. Viñayo 1982.

3. See "León and the Beginnings of the Spanish Romanesque" by John W. Williams, this catalogue.

4. Estella (1982, p. 28) identified the angel in this plaque as Raphael because of the presence in his right hand of a fish. It is difficult to identify the object raised in this hand, but there are no markings suggesting it is a fish.

5. Perrier 1984, p. 79.

6. Others include the San Isidoro lining; the lining of the reliquary of Saint Aemilian (cats. 125a–g); the so-called witches' cloth in Vic; and possibly also the lining of the reliquary of Saint-Chaffre in Haute-Loire.

7. An alternative reading (king) is unlikely because the inscription does not otherwise seem to contain a name. Either reading means that Gómez-Moreno's interpretation, "lo más útil para personaje de país celestial" (1951, p. 348), is incorrect.

LITERATURE: Pérez Llamazares 1925, pp. 113–27; Gold-schmidt 1914–26, vol. 4, no. 81, p. 25, pls. XXII–XXIV; Robb 1945; Gómez-Moreno 1951, p. 348, figs. 406b, 406c; May 1957, p. 27, figs. 15, 16; Lasko 1972, p. 148; Viñayo 1972, pp. 103–4; Estella 1982, pp. 27–28; Perrier 1984, p. 79; Valladolid 1988, no. 102, pp. 186–87; Franco 1991a, pp. 42–44.

110

reliquary of saint isidore

León (León), ca. 1063 or earlier
Silver gilt, wood, niello, silk (chest), and silk and metallic threads (lid)
13 x 32 x 17½ in. (33 x 81.5 x 44.5 cm)
Real Colegiata de San Isidoro, León

When the relics of Saint Isidore arrived from Seville in December of 1063 as a result of Ferdinand I's subjection of that Muslim city, they were at once, or soon afterward, deposited in this chest. No previous Hispanic shrine of comparable size, technique, or iconography is known, and, indeed, this one anticipates the large reliquary shrines of the twelfth century from elsewhere in Europe. In the next century Saint Isidore's relics would be placed in a still grander shrine. That reliquary, now lost, was described in a history of

the collegiate church of San Isidoro written at the end of the nineteenth century as being some six feet in width and half that in height and covered in sheets of gold with enameled images of Christ and the apostles and other subjects.[1] It is a shrine that seems to have resembled the one fashioned for Santo Domingo at Silos in the third quarter of the twelfth century. In 1808 the San Isidoro shrines were damaged during the Napoleonic occupation of the *colegiata*, and our casket was restored in 1847 by Manuel Rebollo, a local goldsmith. At that time, presumably, extensive remountings and relocations were carried out. The cover took on a lower profile, to judge by the angles of its sheets containing the effigies of courtly figures, and the lobed arches and the figure of Saint Isidore on the cover were added. Two destroyed narrative scenes were replaced by the niello plaques mentioned below. Although no restorations disfigured the narrative scenes that survive, their plaques seem to have been remounted. As many as

110

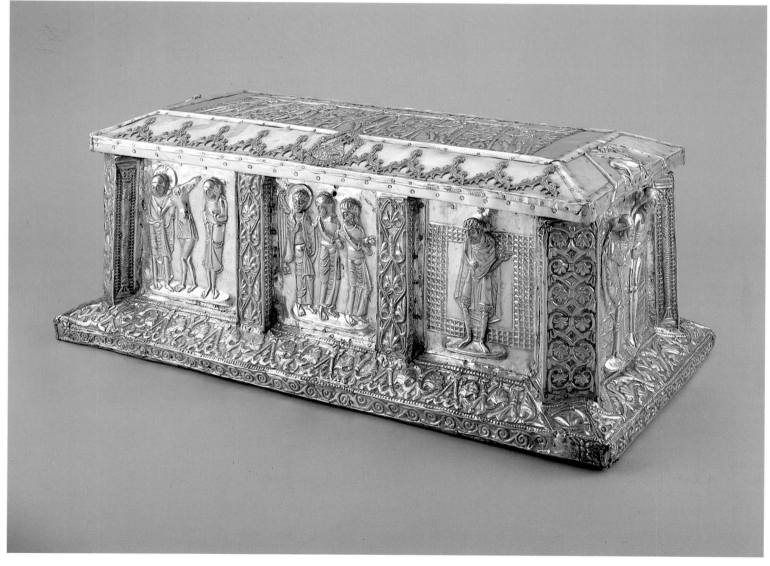

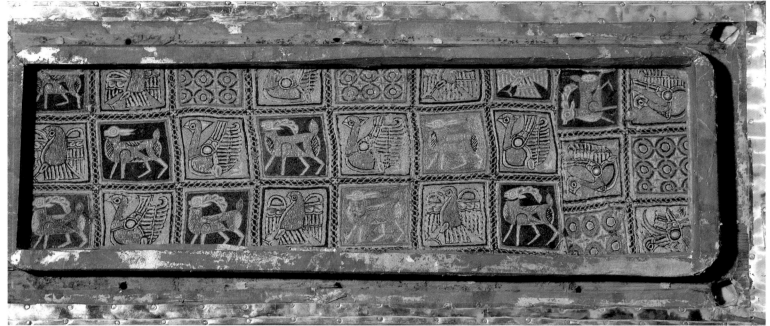

110: Lining of Lid

110: Interior

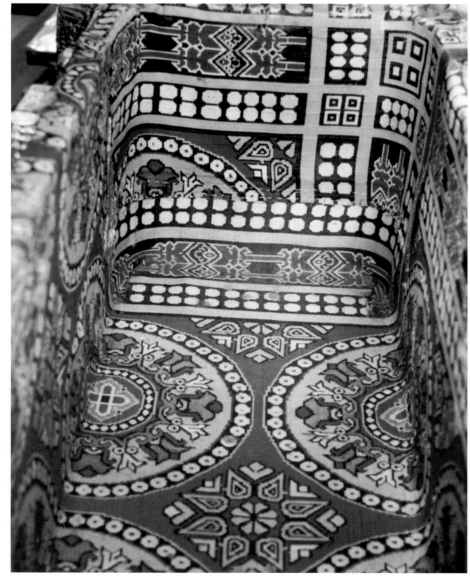

three levels of silver sheets are visible. Repoussé vine-scroll patterns appear behind the plaque with the figure identified as Ferdinand I and the Temptation of Adam, and the same pattern fills the four patches on the bottom, where lion's feet are reputed to have been located. A similar repoussé pattern appears on the bottom of a casket from San Isidoro now in the Museo Arqueológico Nacional, Madrid (cat. 120); all three additions seem to have been appropriated from a silver object available to the restorer. The rinceaux of the base of the front, the most complex of the four sides, seem to have been conceived some 4 inches (10 cm) shorter than the base of the final work.

Around the sides are five scenes in repoussé illustrating (in a disrupted order stemming from the restoration) episodes from the Book of Genesis, three of them with their original inscriptions: the Creation of Adam (HIC FORMAT[UR] ADA[M] ET INSPIRAT[UR] A D[E]O); the Temptation of Adam (DE LIGNO DAT MULIER VIRO); the Accusation of Adam (DIXIT D[EU]S ADA[M] VBI ES[T]); the Robing of Adam and Eve; and the Expulsion of Adam and Eve. Two additional inscriptions allow the identification of two lost scenes: the Naming of the Animals (ADDUXIT D[OMI]N[US] AD ADA[M] OM[N]M CRE[A]TVRA[M]) and the Creation of Eve (D[OMI]N[U]S EDIFICAT COSTA[M] AD[A]E IN MULIER[M]). The bareheaded standing figure of the front may represent Ferdinand I of León in a penitential guise. It must be assumed that he is also the ruler depicted on the roof flanked by courtiers or the artists responsible for the reliquary.[2] The roof once may have had a complementary set of courtly

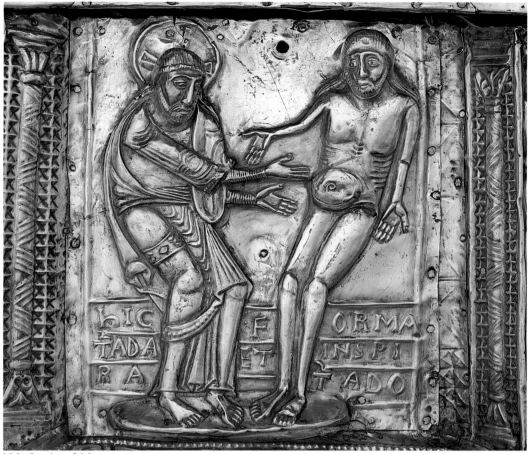

110: Creation of Adam

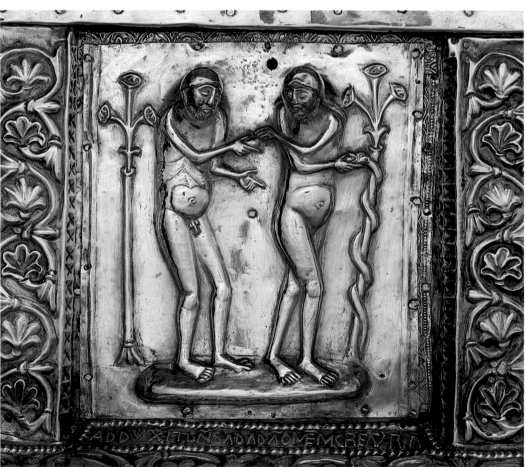

110: Temptation of Adam

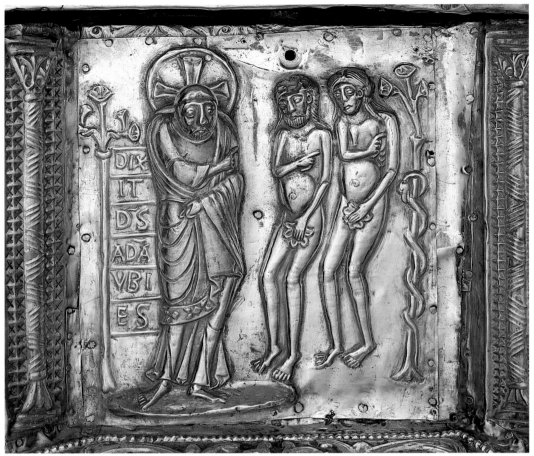

110: Accusation of Adam

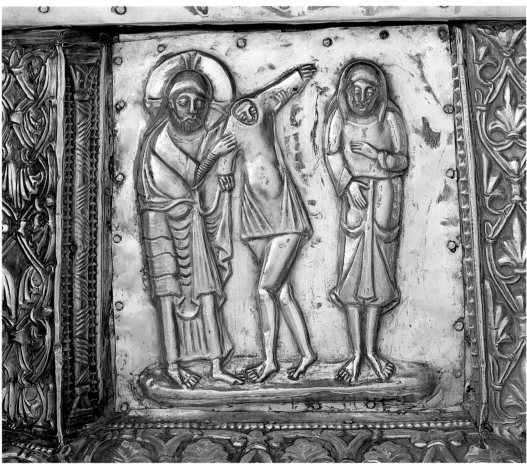

110: Robing of Adam and Eve

242

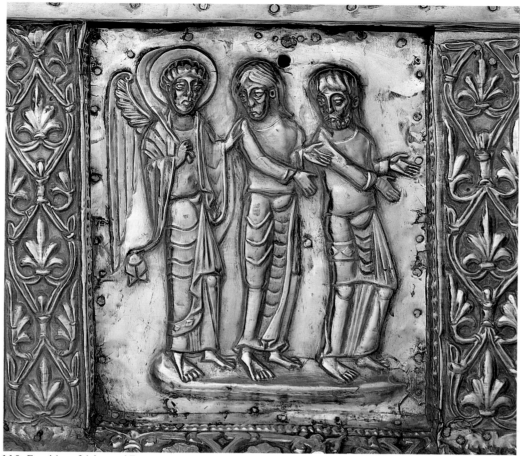

110: Expulsion of Adam and Eve

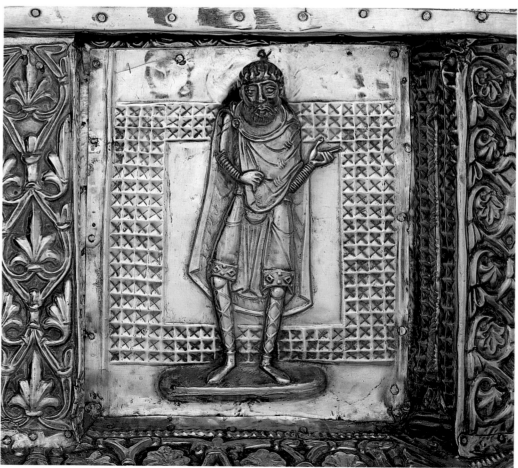

110: Ferdinand I (?)

figures centered on Queen Sancha. There is no evidence that there were ever more than the two symbols of the evangelists, the lion of Saint Mark and the ox of Saint Luke.

The presence of scenes based on the life of Isidore on an object dating to 1063 would have been extraordinary. Adam and Eve appeared on shrines of the Byzantine and western worlds in the tenth and eleventh centuries. However, the particular compositions employed and the inclusion of such a rare subject as the Robing of Adam and Eve link the series on the San Isidoro casket to the Genesis tradition associated with Bibles produced in the ninth century at the Gallic monastery of Saint-Martin de Tours and with the bronze doors of Saint Michael's at Hildesheim (1015) in Saxony. In style, too, the figures of the reliquary closely resemble those of the Hildesheim doors. The inscriptions, in a kind of Caroline script not to be expected at this date in León, are another sign of the intervention of an artist from outside the peninsula. The complicated vine-scroll patterns on the pilasters dividing the scenes and the angular interlace panels of the lid also have counterparts in mid-century Rhenish art.[3] These details point to the German formation of the artist responsible for the casket. However, peninsular assemblage is indicated by the silks lining the reliquary. These and the niello panels that are substituted for two of the narrative scenes are of Islamic origin and are possibly older than the reliquary itself.[4]

Pieces of two different fabrics line the reliquary. The inside of the chest is faced with a silk that features rows of pearl-bordered roundels containing stylized floral motifs. Its palette is similar to that of the Saint Pelagius textile (cat. 109). The design—Near Eastern in origin—harks back to Sasanian and Byzantine models; it is closest to an Umayyad silk made in the factory of Ifriqiya (modern Tunisia).[5] The suggestion has been put forward that this textile may have covered the bier of Saint Isidore in Seville before it was transferred to León.[6]

The lining of the lid is very different in nature. Embroidered in split and couching stitches, its design comprises rows of squares containing various birds, quadrupeds, and grids of circles. While this textile may not be Islamic, it does relate in significant ways to pieces that are unquestionably Islamic. The animals and birds are part of a repertoire popular throughout the Islamic world. The employment of circles and dots within circles and the use of juxtaposed light and dark blue are reminiscent of features found in a famous tenth-century tapestry in Madrid.[7] In addition, there are other Spanish Islamic textiles of similar technique.[8]

J W W / D W

1. "Historia de la Colegiata," MS. XCI, Archivo de San Isidoro de León, quoted in Astorga 1990, pp. 43–44.
2. In tenth-century Spanish manuscripts, full-page collections of portraits of rulers included portraits of the scribes who carried out the commissions. See Silva 1984, pls. XXV, XXVI. In 1925 Gómez-Moreno (1925–26, vol. I, pp. 195–96) attributed the San Isidoro reliquary to the same artist responsible for the Arca Santa of Oviedo on the basis of a perceived resemblance between the two objects and dated it to about 1073; however, he came to believe that the San Isidoro reliquary had been a legacy of Ferdinand I's father, Sancho el Mayor (d. 1035), who would be the king portrayed on its cover with his four sons (Gómez-Moreno and Vázquez de Parga 1965, p. 7).
3. See the borders of the wooden doors of Sankt Maria im Kapitol, Cologne, in Wesenberg 1972, figs. 41–48, for interlace with angles, and figs. 39, 40, for rinceaux organized into lozenge shapes.
4. The panels, whose floral patterns combine repoussé and niello, recall the Islamic casket made for Hisham II, for which see Catalogue 38a.
5. Victoria and Albert Museum, London, 1314-1888 and T.13-1960.
6. Gómez-Moreno 1951, p. 348.
7. Instituto de Valencia de Don Juan, 2071.
8. The shroud of Saint Lazarus (Musée de Cluny, Paris; CL.21.865) and the chasuble, made in Almería, now in Fermo Cathedral, Italy.

LITERATURE: Manzano 1732, pp. 38–41; Gómez-Moreno 1925–26, vol. I, pp. 195–96; Pérez Llamazares 1925, pp. 85–86, 113–28; Gómez-Moreno 1932, pp. 205–12; Gómez-Moreno 1951, pp. 347–48, figs. 405a, 406a; May 1957, p. 27; Gómez-Moreno and Vázquez de Parga 1965, p. 7; Lasko 1972, p. 149; Perrier 1984, pp. 87–91; Williams 1987, pp. 382, 394; Williams 1987, pp. 203–5; García Lobo 1987, pp. 48–49; Valladolid 1988, no. 13, pp. 48–49; Williams 1988, pp. 97–98; Astorga 1990; Franco 1991a, pp. 47–52.

111

CROSS OF FERDINAND AND SANCHA

León (León), ca. 1063
Ivory, gold, and burnished sapphires
H. 21³/₈ in. (54.2 cm)
Museo Arqueológico Nacional, Madrid (52.340)

This cross with a carved figure of Christ, which was in the treasury of San Isidoro in León until 1869, is assumed to be that listed among the gifts of Ferdinand I of León and Sancha to the palatine church of San Isidoro on the occasion of the translation there of the body of Saint Isidore of Seville on December 20, 1063: "et aliam [crucem] eburneam in similitudinem nostri redemptoris crucifixi" (and another ivory cross with a likeness of our Redeemer crucified).[1] The royal couple's sponsorship of the cross is confirmed by the inscription at its foot: FREDINANDVS REX SANCIA REGINA. The splendor of the gift was enhanced by the addition of gold, traces of which adhere to the crevices of its reliefs. A cavity in Christ's back reveals that this cross, like the slightly later one now in the Museo

Arqueológico Provincial de León (cat. 114), functioned as a reliquary, presumably for a piece of the true cross.

Although the cross had already played a prominent role in the liturgical arts of Spain, this example marked a significant departure from earlier traditions. Ivory crosses had been produced on the peninsula in the previous century (cat. 74), but neither they nor the gold and bejeweled Asturian predecessors (cat. 72) included representations of the body of the crucified Christ. By any European measure such a cross, combining a cross and corpus of ivory and an extensive Last Judgment imagery, was extraordinary.[2] A Germanic inspiration for our cross seems likely because crucifixes displaying the body of Christ were prominent within the treasuries of Ottonian churches and because there is a Germanic background detectable in the reliquary of Saint Isidore (cat. 110), also from León and the same time. Although the vocabulary of forms is expanded here, the workmanship resembles that of the reliquary of Saint Pelagius and John the Baptist of 1059 in the treasury of San Isidoro (cat. 109). The theme of death and resurrection that dominates the Leonese cross is carried out in a manner unique to it and has been associated with Ferdinand's own sense of decline and imminent death and the inspiration of the Spanish liturgy of death.[3] The theme of resurrection is enunciated at Christ's feet with the unusual, dynamic figure of Adam and at his head with a risen Christ holding a cross. Christ appears again at the level of the corpus's right hip as a diminutive figure still holding the cross, in a scene that must be taken as a somewhat unorthodox version of the Descent into Hell. Perhaps the highly detailed couple at Christ's feet should be interpreted as Adam and Eve. The borders of the cross have numerous nude figures undergoing judgment. To the left of the crucified Christ's feet men and women rise out of tombs, and on both sides of his body they ascend or descend according to their fates. On the faces of the cross arms nudes are intertwined with vines and animals, a symbolic reference to the torments of evil. This type of inhabited scroll—the best analogies for which have been found in northern Europe[4]—is continued, but in more complex form, on the reverse of the cross. That artists in León had access to exotic patterns of this kind is documented by the presence of the Scandinavian box of walrus ivory with interlace in the treasury of San Isidoro (cat. 121). The iconography of the reverse, with the Lamb in the center and the symbols of the evangelists at the ends of the arms, is more traditional than that of the front.

J W W

1. Blanco 1987, p. 170.

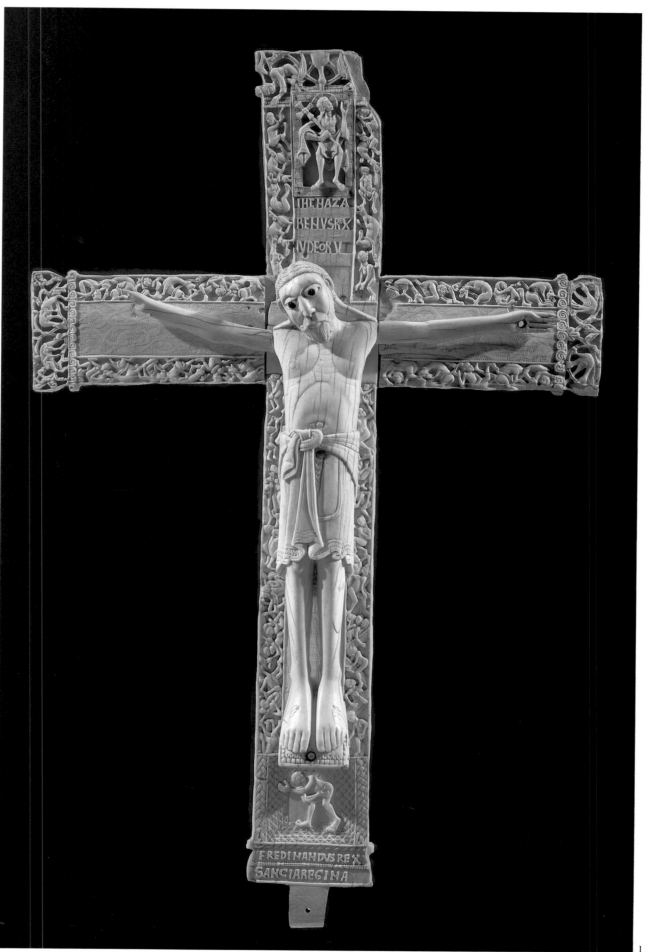

IHC HAZA
REI IVSREX
IVDEOR V

FREDI HAHDVS REX
SANCIA REGINA

111

2. Gómez-Moreno cited the Danish Gunhild cross in the Nationalmuseet, Copenhagen, as an iconographic parallel, since medallions with several nudes being judged appear at the ends of its two arms (in Gómez-Moreno and Vázquez de Parga 1965, p. 10). However, the center is occupied by Christ in Majesty, and the cross dates to the twelfth century, rather than to about 1075, as he thought (Paris 1992, no. 607).
3. Werckmeister 1980, pp. 174–80.
4. Park 1973.

LITERATURE: Goldschmidt 1914–26, vol. 4, no. 100, p. 30; Gómez-Moreno and Vázquez de Parga 1965; Lasko 1972, pp. 149–50; Park 1973; Werckmeister 1980, pp. 174–80; Estella 1984, pp. 14, 20–24; Franco 1991a, pp. 57–61.

112

christ in majesty with saints peter and paul

León (León), ca. 1063
Ivory
10⅜ x 5½ in. (26.4 x 13.9 cm)
Musée du Louvre, Paris (OA 5017)

The central figure of this large ivory plaque is an enthroned Christ in Majesty. He gestures toward Saint Peter on his right, who holds aloft keys bearing the letters of PETRUS; with his left hand Christ holds out a book to Saint Paul, who in turn receives it. Were it not for his beard and the balding head—signs that this is Saint Paul in his customary role with Peter as the Princes of the Apostles—he might be taken for Saint John offering the Book of the Apocalypse, the textual source for the Lamb over Christ's head and the evangelist symbols in the corners. Four angels in a row in the bottom half complete the figural composition. They all gesture with one hand. With the other hand the angel beneath Christ's left foot holds a fold of his own robe, while the angel next to him holds what may be a scroll; the angels in the margins perhaps hold palm branches. Behind the angels in the center is an outline of a cross somewhat tentatively carried out and only partially filled with a pattern. From a medallion between the angels issue the streams, presumably, of the rivers of paradise.

This unusual combination of Christ in Majesty above a cross is encountered in an Anglo-Saxon ivory of about A.D. 1000.[1] Moreover, the Anglo-Saxon ivory employs the same combination of a globe beneath and a mandorla behind Christ, a formula—like the outward-facing evangelist symbols—found in other northern European works as well.

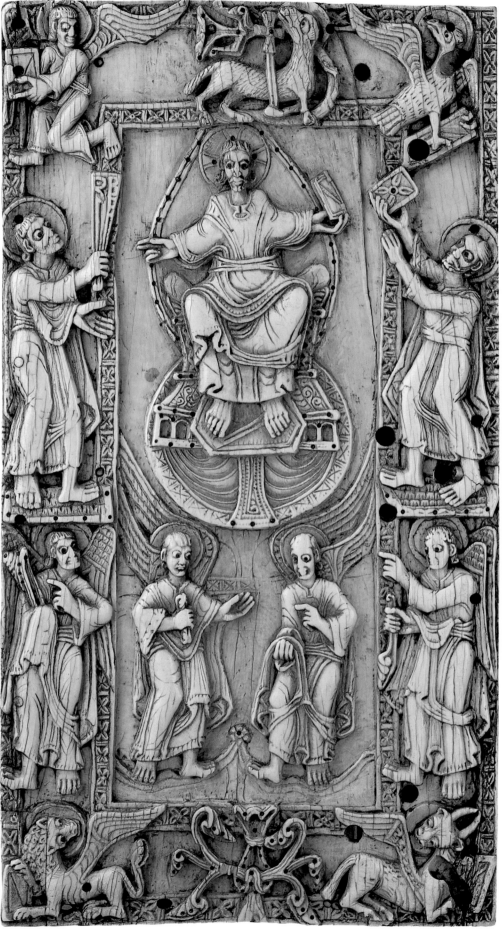

Such a nonpeninsular source is consistent with the pattern of influences in the other Leonese works associated with the Leonese crown in the middle of the eleventh century. Although it cannot be identified with any of the gifts in the Donation of 1063 made by Ferdinand and Sancha, this plaque must have been commissioned about that time, for it shares characteristics with the reliquary of Saint Pelagius (cat. 109) and the Cross of Ferdinand and Sancha (cat. 111), most especially in the exceptional kneeling posture of the evangelist Matthew. There is no counterpart in those ivories for the vine-scroll vignette filling the lower border between the symbols of Mark and Luke, an abbreviated version of which is found behind the Lamb. However, the formula employed—vines forming a pattern of addorsed cradles—was employed in repoussé for the border of the Gospel book cover attributed to Tuotilo of about 900 at Saint Gall.[2] The drilling of individual leaves seen here was common in Spanish Islamic ivories.

The original purpose of this ivory is not known. Although it is a matter of speculation, the subject, size, and proportions of this plaque would have made it ideal for the cover of the Bible of 960 (cat. 108), which probably entered the library of San Isidoro as a gift from Ferdinand and Sancha. If this ivory plaque functioned as part of a cover, it presumably rested within a border of gold filigree and gems, and the convertible value of this part of the cover might have led to its journey north with the retreating Napoleonic troops who had occupied San Isidoro in 1808.

J W W

1. Beckwith 1971, no. 18, fig. 41. I am grateful to Ruth Morss for pointing out this parallel.
2. Gaborit-Chopin 1978, p. 76, pl. 98.

LITERATURE: Goldschmidt 1914–26, vol. 4, no. 107, p. 32; Park 1965, pp. 17–21; Estella 1984, pp. 60–61.

113

RELIQUARY

León (León), early 12th century
Ivory, silver gilt, gold, and glass
H. 5¼ in. (13.2 cm)
Real Colegiata de San Isidoro, León

This reliquary in the shape of a mandorla is supported by a foot that projects 2¾ inches (7 cm) from the back. In the sixteenth century Ambrosio de Morales termed this piece

113

a pax, the implement that allowed officiating clergy and the faithful to exchange the kiss of peace at mass without physical contact, and this description has been followed in most of the modern literature. It may have functioned as a pax, or *osculatorium*, at one time, but probably was not created for that purpose, since paxes appear for the first time in the inventories of the thirteenth century and were particularly popular in the next two centuries.[1] The object's original function as a reliquary is revealed by an inscription engraved on the back (de LIGNO D[OMI]NI & DE UESTIM[EN]TO ET SORTE PARTITO & DE CAPILLIS S[AN]C[T]I PETRI APOSTOLI & OS S[AN]C[T]I STE[PHA]NI PRIMI [MAR]TIR[IS]), which announces that it enclosed a piece of the true cross, part of Christ's robe, hair from Saint Peter the Apostle, and a bone from Saint Stephen the First Martyr.

On the front of the reliquary is a Christ in Majesty carved in ivory with eyes with pupils of black glass. Christ's raised right hand has been lost, and some of the sheets of silver gilt covering the pinewood frame in the form of a mandorla have disappeared. Beneath the figure is an embossed arc that represents the globe of the world. The pairing of mandorla and globe in depictions of the Majesty had become common by the Romanesque period and also occurs in the ivory image on a book cover made for Ferdinand and Sancha of

León (cat. 112).[2] Beaded gold filigree once covered the entire ground within the mandorla, but a portion of it is missing. The remaining filigree, unlike the filigree on the Urraca chalice (cat. 118), which it otherwise resembles, is secured by small gold jump rings. The foot that projects from the back is covered with tangential circles with small x's at their centers. It is not a pattern that evokes the period of the rest of the decoration, and the space that interrupts the inscription to accommodate the foot indicates that the original foot was of a different shape from the present one and reached a point higher on the back.

In style this Majesty has advanced beyond the ivories of Ferdinand's time in augmenting the complexity and plasticity of the robes that envelop Christ, as a comparison with the earlier book cover in the Louvre reveals. Most notable in this respect are the curves and countercurves of the drapery covering the middle of the present figure. It is still conceived, however, in terms of hooking parallel curves, defined by pairs of lines or pairs of raised folds, in the manner of the Hispano-Languedocian style of the end of the eleventh and beginning of the twelfth century. The nature of these curves and the plasticity with which they are developed distinguish this drapery sharply from that of the Majesty from the reliquary of Saint Aemilian (1060–80; cat. 125d). The complexity of the Leonese work might suggest an advanced date in the twelfth century, but the inscription confirms an earlier date: it is of a transitional script between the Visigothic of the eleventh century and the Caroline of the twelfth and clearly distinct from the Caroline used for the inscription of the portable altar of Doña Sancha of 1144.[3] Although our reliquary patently was created by a different carver, the complexity of its design parallels that of the Noli me tangere, Deposition, and Entombment ivory plaques traditionally associated with León (cats. 115a–c).

J W W

1. For the history of the pax, see Braun 1932, pp. 557–72. It is included as a disk reliquary in Braun 1940, p. 295.
2. Goldschmidt 1914–26, vol. 4, no. 107, p. 32.
3. Museo de San Isidoro, León, Gómez-Moreno 1925–26, vol. 1, pp. 206–7, pl. 225. Gómez-Moreno (p. 194) dated the letters of the inscription on the reliquary to the eleventh century; García Lobo (1987, p. 382) described the writing as "Caroline with Visigothic reminiscences" and of the "end of the eleventh and beginning of the twelfth century." The supposed pilgrimages of Sancha, the infanta resident at San Isidoro until her death in 1159, on which Franco (1991a, p. 67) bases an advanced date in the twelfth century, are considered fictional by most historians. See García Calles 1972, pp. 58–61.

LITERATURE: Morales 1765, p. 50; Pérez Llamazares 1925, pp. 94, 170–75; Goldschmidt 1914–26, vol. 4, no. 111, pp. 33–34; Gaborit-Chopin 1978, pp. 118, 176, 202; Estella 1984, pp. 31–32; Manuel Valdés Fernández, in Valladolid 1988, p. 64.

Reliquary corpus (carrizo christ)

León (León), last quarter of 11th century
Ivory, jet, gold, and vitreous paste
H. 13 in. (33.5 cm)
Museo de León (13)

This finely carved Christ has a circular cavity behind the shoulders for a relic. The nearly upright and frontal posture and almost rigid arms of the figure and, even more, the exaggerated size of the head and the large eyes of white and black glass rimmed with gold impart to this corpus an extraordinarily iconic quality. It is made up of five pieces of ivory, the head, arms, and feet being attached to the single piece of the legs and body. Originally the Christ was a less austere figure, for numerous cavities of the loincloth and the border of the suppedaneum beneath the feet once would have held precious or semiprecious stones. To judge by descriptions of contemporary crucifixes, it is likely too that the cross that originally supported the figure would have been covered with gold. The precious metal must have been stripped and melted down.

In comparison with the Christ of the ivory crucifix given in 1063 to San Isidoro by Ferdinand I and Sancha (cat. 111), the Carrizo Christ has advanced toward a Romanesque style. Not only the head but the limbs as well are conceived without strict regard for normal proportions, and although they are only slightly flexed, the knees combine with the angled feet and the forward thrust of the head to instill a dynamic energy that is absent from the 1063 crucifix. Stylistically the Carrizo Christ is closer to the San Millán ivories (cats. 125b–g) than to the ivories of Ferdinand's time (cats. 109, 111), and a more advanced date is therefore indicated. There is no ivory in the San Isidoro treasury of a comparable style.

Our reliquary cross entered the Museo Arqueológico Provincial de León in 1898 and, according to tradition, came from the Cistercian convent of Santa María de Carrizo, west of the city of León. However, this convent was founded only in 1176, so our figure's provenance is an open question.[1] Urraca (d. 1101), the daughter of Ferdinand I and Sancha (see cat. 118), was associated with several crosses now lost, but none was described as having an ivory corpus; therefore it is impossible to make a certain connection between Urraca and our ivory figure, even though its style suggests the period of her activities.[2]

JWW

1. It is curious that in his publication of the work in 1905, Ramón Alvarez de la Braña, who was himself a

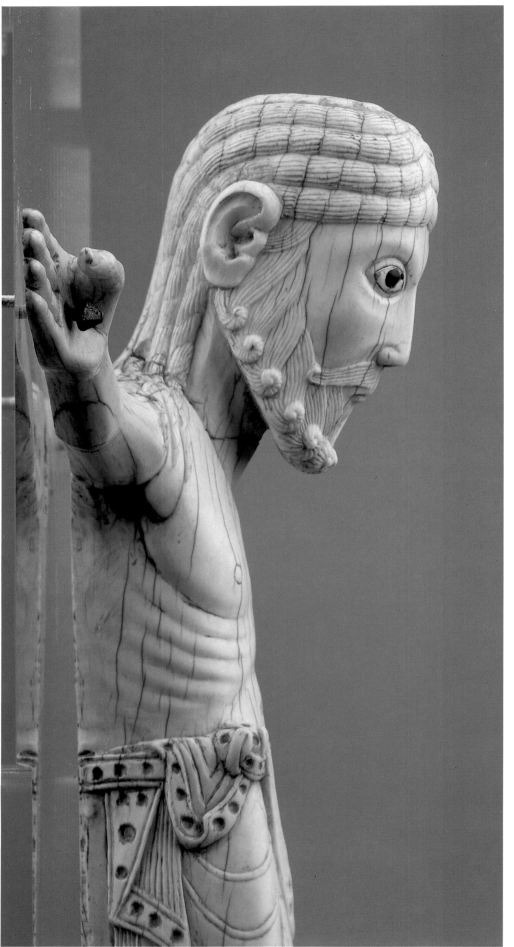

114: Detail

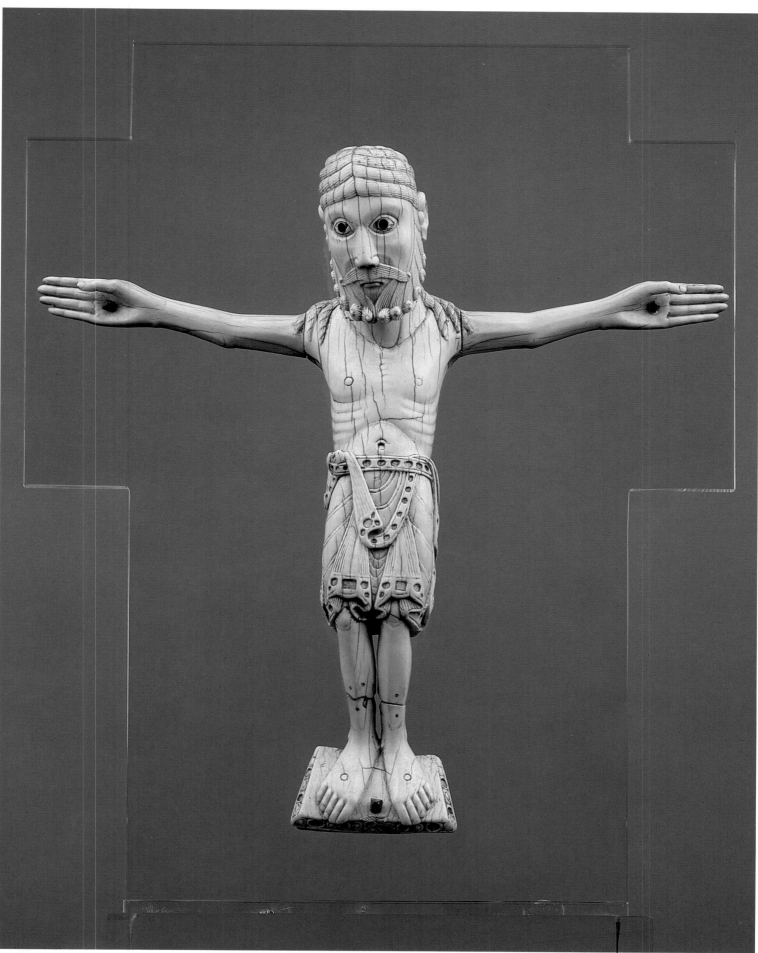

donor to the Museo Arqueológico Provincial de León, omitted any mention of a connection with Carrizo and concluded that it must have come from San Isidoro (Alvarez de la Braña 1905–6, p. 149). Gómez-Moreno was the first to maintain in print that it was from Carrizo; he asserted, however, that it had been purchased by an unnamed individual in the city of León (Gómez-Moreno 1925–26, vol. 1, p. 310). For legends surrounding the modern history of the Carrizo cross, see Cook 1928, p. 283.

2. Estella (1982, pp. 24–26) proposed that the gold cross mentioned as a gift to the cathedral of León in 1073 should be identified as that of the Carrizo Christ (*España Sagrada*, vol. 36, p. LIX). Another lost ivory crucifix on a cross of gold, a gift of Urraca's, was in San Isidoro at least until the eighteenth century, but since the cross was described as almost seven feet in height (Manzano 1732, p. 383), the possibility that its corpus was the one associated with Carrizo is unlikely.

LITERATURE: Alvarez de la Braña 1905–6; Gómez-Moreno 1925–26, vol. 1, p. 310; Goldschmidt 1914–26, vol. 4, no. 104, pp. 31–32; Cook 1928, p. 283; Estella 1982, pp. 24–26; Avril, Barral, and Gaborit-Chopin 1983, p. 313; Perrier 1984, p. 126; Seville 1992, pp. 86–88.

115

three plaques from a reliquary

León (León), ca. 1115–20
Ivory
a. *The Deposition*
5¼ x 5¼ in. (13.2 x 13.2 cm)
Masaveu Collection, Oviedo
b. *The Women at the Tomb*
5⅜ x 5¼ in. (13.5 x 13.2 cm)
State Hermitage Museum, Saint Petersburg (10)
c. *The Journey to Emmaus and Noli Me Tangere*
10⅝ x 5¼ in. (27 x 13.2 cm)
The Metropolitan Museum of Art, New York; Gift of J. Pierpont Morgan, 1917 (17.190.47)

The plaques in Saint Petersburg and Oviedo were originally united. To judge by the holes that penetrate .4 inch (1 cm) at the midpoints of both sides of the ivory in the Metropolitan Museum and the 1.5 inch (4 cm)-wide channels on the top and bottom edges of the same piece—details that accord better with installation on a chest than with a coupling with another plaque to form a diptych—these plaques originally belonged to a reliquary shrine. If they were once part of a complete series of scenes dealing with the last events of Christ's life, the Passion, the shrine they belonged to may have been comparable in scale to the one that presented the life of Saint Aemilian to visitors to the monastery of San Millán de la Cogolla (cats. 125a–g). However, the possibility that these were the only plaques adorning a reliquary casket of a smaller format cannot be eliminated. That the scenes represented are contiguous in the Gospel narrative and their inscrip-

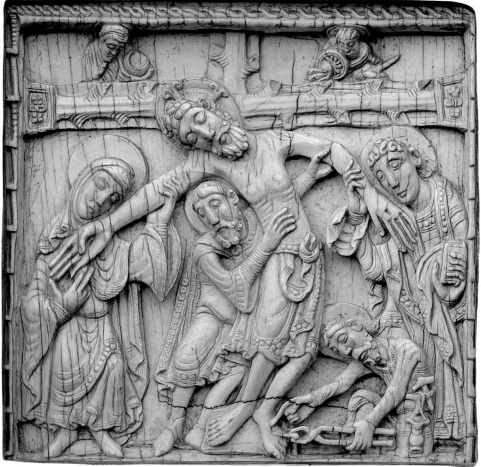

115a

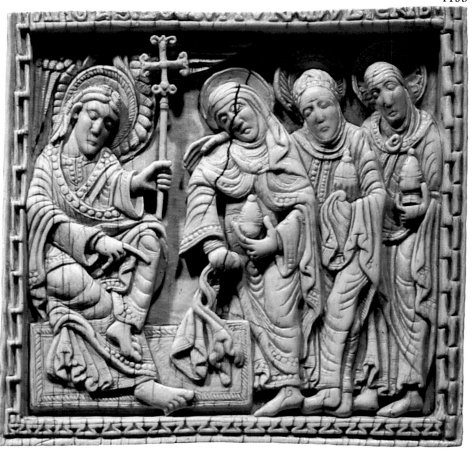

115b

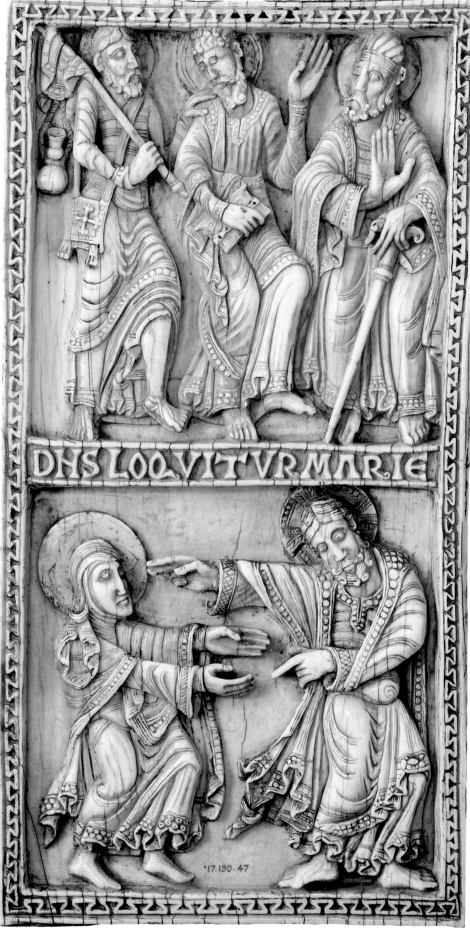

DHS LOQVITVR MARIE

·17.190·47

115c

tions symmetrical—ANGE[LV]S LOQVITUR MVLIERIB[IS] (The angel addresses the women) and D[OMI]N[V]S LOQUITUR MARIE (The Lord speaks to Mary)—favor the latter conclusion. Christ's identity in all of the scenes was made unambiguous by a special distribution of gold: whereas all the nimbi were gilded, the garments of Christ alone reveal traces of gold.[1] Even at a distance from the shrine, his position, both spatial and hierarchical, would have clearly registered.

The narrative order proceeds from top to bottom, the earliest of the scenes being the Deposition, or the removal of Christ from the cross. The composition invests the scene with a sense of dramatic immediacy: Mary clings to her son's arm, and Nicodemus kneels in order to remove the nail. In fact, these formulas belonged to a long iconographic tradition in Greek and Latin Christendom. However, the decision to fill Nicodemus's belt with tools indicates the particular carver's fondness for descriptive detail. The number of women in the next scene and the presence of a single angel follow the account in the Gospel of Mark (16:1ff.), in which the women, who had bought spices to anoint the dead Christ, are identified as Mary Magdalene, Mary the Mother of James, and Salome. In that account the angel instructs the women to spread the news of the Resurrection, and his gesture and the inscription still legible at the upper border capture this detail. In the illustration of the Journey to Emmaus, the action in the Gospel account (Luke 24:13ff.) is adhered to faithfully. Jesus is said to "draw near" the two unidentified disciples, and in the ivory's depiction he overtakes the striding pair from the left and detains the nearest journeyer by placing a hand on his shoulder. Moreover, as Christ was unrecognized by the disciples at this point in the Gospel narrative, the carver omitted the customary crossed nimbus here. Jesus' identification is assured, however, not only by narrative logic but also by the medieval convention of outfitting him with the accoutrements of the pilgrim—the staff, bottle, and pouch. The last displays an equal-armed cross, the form that signified Crusaders, which may be meant to identify the scene with Jerusalem, although the floral terminations of the arms do not belong to the traditional cross of the Crusaders. In the relief of this subject at the monastery of Silos and on the portal of Santa Marta de Tera, works slightly later than our plaques, Christ's pouch bears the sign of the shell, the emblem of pilgrimage to Santiago de Compostela. In the scene at the bottom of the Metropolitan plaque, Christ's warning to Mary Magdalene not to touch him—Noli me tangere—only two figures have to share the space, and in their layered, swinging garments and interactive, dynamic postures the style is epitomized.

It has been customary to assign these plaques to a Leonese school, but they represent a broad stylistic current, aptly dubbed "Hispano-Languedocienne."[2] Among ivories, the reliquary of San Felices (see cat. 127), particularly the detail of the Raising of the Widow's Son at Nain, offers the best parallel, but our plaques are far more plastically conceived, either because of a later date or because of the carver's more ambitious approach. One detail serves as a visual metaphor for the carver's aggressive plasticity: the folds of Christ's heavy mantle that swing toward Mary Magdalene have been tied in a knot, a peculiar feature repeated in the Magdalene's scarf, Christ the Pilgrim's lower hem, and a fold of the mantle of the disciple he touches. A counterpart for the style of the plaques is found in figures in the vault frescoes of the Pantheon of the Kings in San Isidoro, León, and a configuration like the knot that is the hallmark of our carver appears on the drapery of the most developed of the figures there.[3] Since León was a center of ivory carving in the eleventh century––as is well attested to (see cats. 109, 111–13)—and continued to serve as an important capital thereafter, it is usual to assign our plaques to this city; however, there is no evidence beyond the presence of a twelfth-century ivory reliquary in the treasury of San Isidoro (cat. 113) to confirm the existence of an ivory workshop in León after Ferdinand's era. The frescoes of the Pantheon are not dated, but both they and our plaques probably were realized soon after the first decade of the twelfth century. The aggressive plasticity of their style has an apt counterpart in the sculpture of the south transept of the church of San Isidoro. The melon cap worn by the second disciple of the Emmaus scene is a type that appears along the pilgrims' road,[4] another sign of the rapprochement between carving on the monumental and the minor scale in the Romanesque era, a rapprochement not seen in the eleventh century.

JWW

1. This observation was made on the plaque in The Metropolitan Museum of Art.
2. Moralejo 1982, pp. 290, 292.
3. See the symbol of Matthew in the Christ in Majesty vault, Viñayo 1971a, pl. 31.
4. For the melon cap, see Silos (Porter 1923, pl. 667). See also Toulouse and Arles, Souillac, and Moissac.

LITERATURE: Goldschmidt 1914–26, vol. 4, nos. 108, 109; Cook and Gudiol 1950, p. 291, fig. 275; Dresden 1975, no. 125; Moralejo 1982, pp. 291–92; Gaborit-Chopin 1983, pp. 310–13; Estella 1984, pp. 61–63; Moralejo 1990a, p. 205.

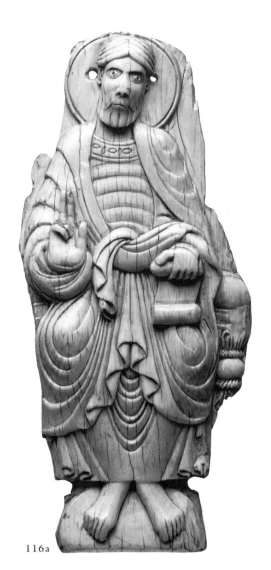

116a

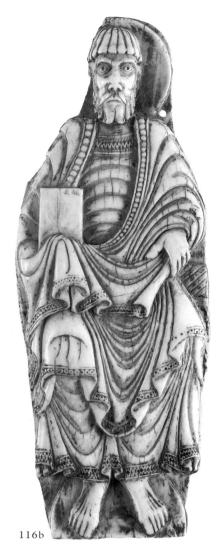

116b

116

three seated apostles

León (León), first half of 12th century
Ivory
a. Apostle
H. 6⅛ in. (15.5 cm)
Private collection, Providence, Rhode Island
b. Apostle
H. 6³⁄₁₆ in. (15.7 cm)
c. Saint Peter
H. 5¾ in. (14.6 cm)
b, c: Glencairn Museum, Bryn Athyn, Pennsylvania

This group of seated figures with voluminous draperies arranged in concentric pleats is not entirely homogeneous stylistically. All three figures are approximately the same size, and the backgrounds have been cut away in a similar manner. Moreover, each has a hole through the nimbus, which was a common method of mounting figures—in this case, probably for later reuse.

Reputedly, the Rhode Island ivory, Apostle (a), came from a monastery in the province of León—a supposition in general terms that

accords with its style. The shape of the eyes and manner of indicating the braided hair and beard are strikingly similar in the Carrizo Christ (cat. 114). The identity of the figure, however, is problematic: He blesses with his right hand, a gesture more characteristic of a Christ in Majesty, but he also holds a scroll, an attribute that is in keeping with an apostle or prophet figure. Furthermore, the lack of a cruciform nimbus and the bare feet would seem to indicate that he is, indeed, an apostle.

Apostle (b) holds a book in one hand, which is covered up by drapery, while clutching his mantle with his other hand. The monumental strength of the figure is emphasized not only by the highly controlled mass of the drapery, with its pearled borders, but also by his deeply set eyes and high cheekbones. These and other features link the figure more closely to the workshop that produced the Leonese Passion ivories discussed in Catalogue 115.

Apostle (c) is a somewhat flatter ivory relief than the others and displays a more calligraphic treatment of the drapery. The

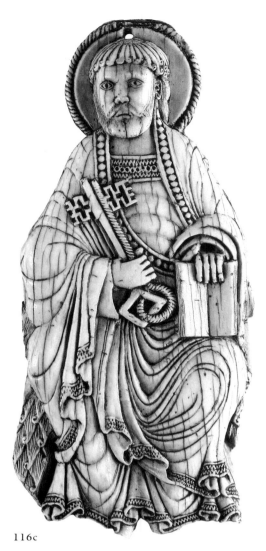

116c

large keys that the figure holds identify him as Saint Peter, but the open book in his other hand is unusual. The remains of a lion's mane on either side of his throne are without precedent as well, possibly suggesting a lineal connection equating the chair of Peter, the first apostle, with Solomon's Throne of Wisdom. The figure's face is broader than those of his two companions, and there is more ornamentation in the carving, especially in the locks of hair ending in fishhook spirals and in the rope pattern of the nimbus.

The ivories originally must have been part of a series of apostle figures that decorated a shrine like that of Saints John the Baptist and Pelagius (cat. 109), or, alternatively, they may have come from an altar frontal. Their Leonese context is established by the Carrizo Christ and the Passion ivories, suggesting that the figures must date to the first half of the twelfth century.

CTL

LITERATURE: Cook 1928, pp. 283–84, figs. 7, 8; New York 1968, nos. 75–77 (with older literature cited); Bousquet 1982, p. 52, fig. 15; Estella 1984, p. 97, fig. 22.

117

Beatitudes casket

Church of San Isidoro, León (León), 11th century
Ivory on wood
6 x 7½ x 4⅝ in. (15.2 x 18 x 11.9 cm)
Museo Arqueológico Nacional, Madrid (52092)

Six ivory boxes are mentioned in the Donation of 1063, a list of precious objects willed by King Ferdinand and Queen Sancha to the church of San Juan Bautista, later San Isidoro, in León.[1] Although not specifically named, the Beatitudes casket has been connected to the Donation because it originally belonged to San Isidoro and because the carving of its plaques so closely resembles other known Leonese ivories. Indeed, most ivories of the Donation share conventions of drapery, gesture, and figure style, and all display large, inlaid eyes.

The casket's decoration represents the Beatitudes, the series of declarations made by Christ in his Sermon on the Mount (Matt. 5: 3–10). Each Beatitude is rendered by an angel and a haloed male figure who encounter each other under an architectural frame that bears the Gospel text. The sequence, beginning on one short side and continuing around the casket, is composed of the following texts: Beati pauperes spiritu; Beati mites; Beati pacifici; Beati misericordes; Beati mundo corde; Beati qui lugent; and Beati qui persecutionem patiuntur (Blessed are the poor in spirit; Blessed are the meek; Blessed are the peacemakers; Blessed are the merciful; Blessed are the pure in heart; Blessed are those who mourn; and Blessed are those who are persecuted for righteousness' sake).

Only seven of the eight Beatitudes are represented, one to a plaque. The fourth Beatitude, Beati qui esuriunt et sitiunt iustitiam (Blessed are those who hunger and thirst for righteousness), is missing, and the extant plaques do not follow the Gospel order. At some point, possibly as a result of damage sustained during the Napoleonic invasion of Spain, the casket was redesigned and the plaques' original order was disrupted. The application of Islamic ivory fragments to the casket's fourth side must also date to this rearrangement.[2] These pieces are products of the Cuenca ivory atelier and must have come from an imported casket then in the San Isidoro Treasury. As it stands, the proportions and dimensions of the casket's wooden armature would not allow a coherent distribution of eight plaques on four sides without metalwork to fill in the empty space. Enframements of precious metals and gems were standard on Spanish caskets of this period, but no example survives intact.

The casket's iconography is rare, and its means of representation is unlike any other known depiction of the subject.[3] There is evidence to suggest that the subject was

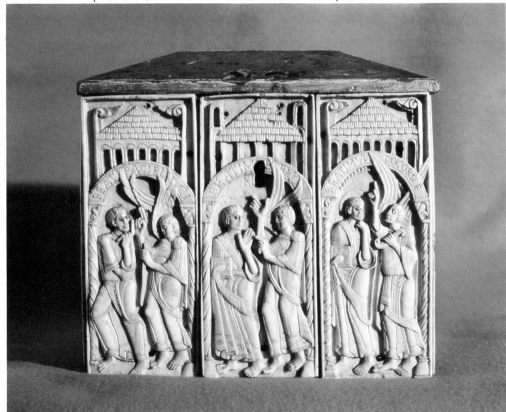

117: Blessed are the peacemakers; Blessed are the merciful; and Blessed are the pure in heart.

inspired by the Mozarabic liturgy, which, unlike the Roman rite later adopted in Spain, featured the Beatitudes in a number of liturgical practices.[4] In particular, they were intoned in services honoring the saints. Since most ivory caskets functioned as reliquaries on altars, the iconography is well chosen.

JAH

1. Blanco 1987, document 66, pp. 169–73.
2. For the Islamic pieces, see Kühnel 1971, no. 41.
3. Harris 1990.
4. Ibid.

LITERATURE: Porter 1923, vol. I, p. 39; Goldschmidt 1914–26, vol. I, no. 94; Ferrandis 1928, p. 151; Kühnel 1971, no. 41; Lasko 1972, p. 150; Gaborit-Chopin 1978, p. 116; Estella 1984, pp. 28–29; Perrier 1984, pp. 69–73; Blanco 1987, pp. 169–73; Franco 1988, pp. 31–32; Harris 1990; Franco 1991a, pp. 54–56.

118

CHALICE OF URRACA

León (León), 11th century
Sardonyx, gold, gilt silver, crystal, glass, and gems
H. 7¼ in. (18.5 cm)
Real Colegiata de San Isidoro, León

An inscription in beaded gold letters above the foot, IN NOMINE D[OMI]NI VRRACA FREDINA[N]DI, marks the chalice as the gift of Urraca (d. 1101), the daughter of Ferdinand I of León. A cup and a dish of sardonyx of shapes consistent with an antique origin have been united by gold mounts to form a Christian liturgical chalice. The cup was lined with gold and provided with a gold rim richly adorned with pearls, a crystal, and gems held in oval and rectangular settings. Gold filigree both scrolls around the gems and is built up in beehive-shaped projections. Gold jump rings that probably secured strings of pearls are attached to the rim. Present in the frieze of gems is a white paste-glass masculine head; its inclusion recalls the widespread medieval practice of incorporating antique cameos in Christian metalwork, but clearly it is not antique.[1] As a small glass head, it is without a local parallel. Although the long nose and pointed chin seem foreign to eleventh-century models, the convention of parallel locks with bulbous endings used for the hair is similar to that of the figure of Ferdinand on the reliquary of Saint Isidore (cat. 110) and of the apostles on the 1059 reliquary of Saint Pelagius (cat. 109). Extraordinary as it may be, it is difficult to imagine that the head is the result of a postmedieval initiative. Four gold straps fasten the cup to a gold knop decorated in the manner of the rim, but with the addition of

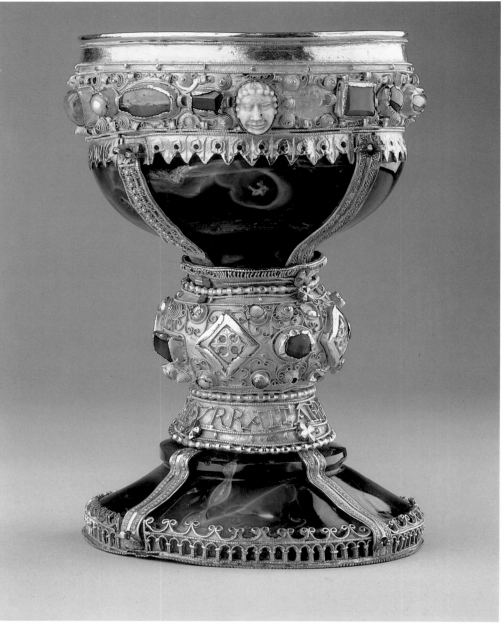

118

four floriate crosses incorporating green glass medallions, most of which are lost. Four gilt silver straps anchor the knop to the sardonyx foot, which is framed by a gold rim articulated with a miniature arcade.

Comparable conversions of Classical sardonyx vessels into chalices had been accomplished for the emperor Romanus in Constantinople in the tenth century.[2] However, the materials and techniques employed for the Urraca chalice have their closest parallels in the products of the German imperial workshops of the middle of the eleventh century.[3] Such a connection is consistent with the character of the reliquary of Saint Isidore identified above, which entered the treasury of San Isidoro through the gift of Ferdinand and Sancha—who granted a host of objects to the new palatine church in 1063 on the occasion of the arrival there of the relics of

Saint Isidore of Seville. Urraca, Ferdinand and Sancha's first-born child, may have been thirty years of age in 1063. She very likely presented the chalice to the church as her independent gift, sometime after her father's death in 1065, but it remained within the Germanic artistic sphere that characterized her parents' articles of liturgical furniture and may have been made early, while the original stylistic connections were still intact. With its dependence on foreign artistic traditions, her chalice stands in the strongest contrast to the chalice made at about the same time for Abbot Domingo of Silos (d. 1073).[4] A special consciousness of a Leonese tradition of metalwork, even, perhaps, of the Urraca chalice, is reflected in the frescoes installed in the Pantheon of the Kings, the narthex attached to the basilica of San Isidoro during Urraca's residence there. Among the saints

whose portraits appear in the frescoes is the Gallic Saint Eligius, the patron of goldsmiths, who is shown applying a tool to a chalice—in what seems to be the earliest example of this subject known.[5]

J W W

1. See the antique Medusa cameo of the enameled cross in the cathedral treasury of Essen of ca. 1000 (Küpers and Mikat 1966, pp. 41–45, pl. X).
2. New York 1984, pp. 129–40. For a comparable, but later, combination of two sardonyx cups, see the Santo Cáliz, once at San Juan de la Peña and now in Valencia Cathedral (Beltran 1960; Lapeña 1989, p. 428).
3. See, for example, the Cross of the Holy Roman Empire, Schatzkammer, Vienna (Swarzenski 1954, fig. 79), and the buckle fibula of Agnes of Poitou, wife of Henry III (d. 1077), Römisch-Germanisches Zentralmuseum, Mainz (Mainz 1992, pp. 263–64, pl. p. 261).
4. In the monastery of Santo Domingo of Silos; see Alcolea 1975, fig. 127.
5. Viñayo 1971a, fig. 46. The Eligius legend was associated with a chalice once at the abbey of Chelles. See Leclercq 1921, cols. 2676–78.

LITERATURE: Pérez Llamazares 1925, pp. 185–88; Gómez-Moreno 1925–26, vol. I, pp. 205–6; Metz 1932, p. 245; Gómez-Moreno 1934a, pp. 31–32; Hernández 1961, p. 106; Elbern 1963, p. 44, no. 19, p. 71; Lasko 1972, p. 154; Avril et al. 1983, pp. 306–8; Caldwell 1986, pp. 19–20; Valladolid 1988, no. 104, p. 190 (M. V. F.); Franco 1991a, pp. 63–64; Seville 1992, p. 82.

119

119

BROOCH

Northern Italy, early 11th century
Gold sheet, gold wire and granulation, cloisonné enamel, and wax
2⅛ x 2⁹/₁₆ in. (6.7 x 6.5 cm)
Museo de la Catedral, Astorga

This gold brooch is distinguished by its micro-architectural settings composed of delicately patterned gold wire and granulated domes surrounding four medallions of cloisonné enamel that depict the symbols of the evangelists. The central image is now lost, but it appears to have been a repoussé Agnus Dei, or Lamb of God, whose impression is faintly visible in the wax that functioned as a backing. Originally the loops surrounding the medallions with the evangelists' symbols must have contained strung pearls. Decoration comprising arcades ringed with loops of strung pearls is also found on the fibula in the treasure of Empress Gisela in Berlin.[1] In addition, the method of constructing the different levels of the brooch with a series of wire patterns is nearly identical to that of various Ottonian and Salian objects produced in the late tenth and early eleventh centuries.[2] At one time the brooch was nailed onto a sixteenth-century polychrome statue of Saint Toribio in Astorga Cathedral, which explains the four large holes.

The cloisonné enamels (or more accurately *Senkschmelze*)—in transparent blues, greens, and reds—closely approximate Byzantine enameling techniques. The cartoonlike quality of the images finds parallels in the figures adorning the arms of the Guelph Treasure cross (Berlin), who, in addition, have distinctive "Byzantine" double halos.[3] The Italianate quality of the brooch is further observed in the designs in each of the corners; the repetitive pattern of small arcs also occurs (in an identical manner) on the arm reliquary in Dubrovnik Cathedral. Other comparable objects are found in Italy and include especially the reliquary cross in Naples Cathedral and the "pax" made for Chiavenna, a Milanese work.[4] Thus, these technical elements point to an origin for this handsome brooch in northern Italy, where strong Byzantine influences persisted and where there were many links with Germany as well.

The almost total absence of cloisonné work in Christian Spain indicates that this brooch, like several other objects, was probably a valuable gift to Astorga Cathedral. The technical and stylistic qualities of the enamels on the brooch and on the Cross of Victory in Oviedo (908; see p. 118) cannot be easily linked with any object known to have originated in Spain, suggesting that such prized works were, indeed, sent there as royal gifts or exchanges.

CTL

1. Mainz 1992, p. 264.
2. Ibid., pp. 262–78.
3. Kötzsche 1973, pl. I, no. I.
4. Petrassi 1982, pp. 22–23, pl. 80; for the Chiavenna "pax," see Mainz 1992, pp. 378–80.

LITERATURE: Barcelona 1961, no. 1717; Velado 1991, p. 214.

120

BOX

León(?), 11th century
Sardonyx, gilt silver, niello, and pine
5¼ x 7¼ x 5⅛ in. (13.5 x 18.5 x 13 cm)
Museo Arqueológico Nacional, Madrid (51.053)

The fifty-seven small sardonyx plaques of this box, which came from the treasury of San Isidoro, are held by a framework of gilded and nielloed silver organized into fields of rectangular and circular shape. Some of the rectangles enclose arcades of horseshoe arches resembling portals. Rosettes are applied at junctures of the framework on the front and back. The box is fitted at the top with an arching handle the midpoint of which is circled by a ring. The cover is hinged on the back, and on the front a hinged clasp decorated with an engraved vine scroll fastens over

120

a ringed lock. The bottom has a silver cover with a repoussé scroll. Since this same pattern appears on patches on the reliquary of Saint Isidore in the San Isidoro treasury (cat. 110), it can be assumed that the nineteenth-century restorer employed after the Napoleonic occupation of the site made the additions to both the reliquary and the box from parts of another silver object.

The other precious boxes from the treasury of San Isidoro either have an overt Christian function or were imported from al-Andalus. The present box does not unambiguously declare its origin, but parallels with other objects and certain details indicate that it was probably fashioned by a Christian. An outstanding precedent is provided by the agate casket given by Fruela II and Nunilo in 910 to Oviedo Cathedral (cat. 71). Although that casket is more than twice the size of this box, it too is composed of numerous small plaques of sardonyx held in place by a framework of metal—in this case gold. Moreover, the bottom register, most completely on the back, is made up of an arcade. No Islamic object that employs sardonyx in this way is known, and although the organization of the bands of the silver frame into interlacing loops based on the so-called Constantinian knot recalls details in Islamic manuscripts, this motif is found in tenth-century Christian manuscripts as well.[1] The silver box given by Bishop Arianus (r. 1073–93) to Oviedo

Cathedral[2] may provide a clue to how our small box was used. Except for its Latin inscription, it is without an outward Christian sign. The Latin inscription CONVVIIS XPI CELESTIS MENSSA PARATUR. ARIANUS EPS FECIT (The celestial meal of Christ is prepared) indicates that it was employed as a pyx or to reserve communion wafers. Such a function may have been served by this box.

JWW

1. Williams 1980, p. 215, figs. 17–19.
2. Manzanares 1972, p. 28, pls. 71, 72.

LITERATURE: Gómez-Moreno 1919, p. 382; Toledo 1975, no. 55, p. 22, pl. XI; Fontaine 1977, pp. 375–76, fig. 105; Franco 1991a, pp. 53–54, figs. p. 42; Franco 1991b, p. 82, fig. 3.

121

OPENWORK BOX

Scandinavia, early(?) 11th century
Walrus ivory, with copper-alloy gilt mounts
H. 1¾ in. (4.5 cm); max. w. 2⅛ in. (5.5 cm)
Real Colegiata de San Isidoro, León

This curious walrus-ivory box bears dramatic witness to the far-reaching contacts that prevailed in medieval Spain. The openwork box,

with its delicate ajouré carving, is the field for the playful depiction of a creature whose fantastic head projects at the base and whose abstract body makes up much of the cylindrical form of the box, along with interlacing ribbons and tendrils. The box is surmounted by an openwork copper-alloy gilt cover composed of interlacing tendrils, which is secured with pins; the bottom lid (also of openwork interlace) is hinged for opening. The function of such a box is uncertain, but it might have been made to hold aromatics or unguents —or perhaps, like the Islamic silver and niello boxes in the San Isidoro treasury, it was transformed into a reliquary container.

Executed in the Viking art style known as Mammen and Ringerike, the box is close to the so-called Kunigunde casket originally in the Bamberg Cathedral treasury (now in the Bayerische Nationalmuseum, Munich) and the casket (now destroyed) formerly in Kamien Cathedral in Poland, both dating to the early eleventh century.

The means by which such an object arrived in Spain is unclear. Viking raids in the tenth and eleventh centuries may have been one source, but trade and even diplomatic exchanges probably provide the most likely explanation. Nevertheless, such unusual foreign objects must have had an impact on Leonese styles of ivory carving. For example, some of the decorative designs on the Cross of Ferdinand and Sancha (cat. III) seem to be transpositions of Scandinavian forms.

CTL

LITERATURE: Goldschmidt 1914–26, vol. 4, no. 298; Gómez-Moreno 1925–26, vol. 1, p. 195, vol. 2, figs. 195, 196; Gaborit-Chopin 1978, no. 113.

121

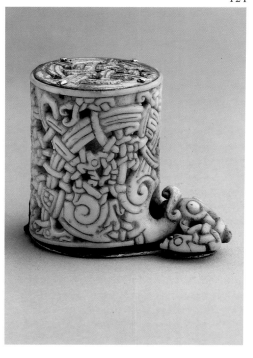

shrine of saints adrian and natalia

Monastery of San Adrian de Boñar(?), (León),
12th century
Silver and oak
6¼ x 10 x 5¾ in. (15.9 x 25.4 x 14.5 cm)
The Art Institute of Chicago; Buckingham Gothic Room
Fund (43.65)

Adrian was a guard at the court of the emperor Galerius Maximianus. In 304 he and his companions were dismembered at Nicomedia (Izmit) because they were Christians. Natalia, his wife, surreptitiously retrieved his hand and took it to Constantinople. A cult developed around Adrian and spread to Rome and other sites in the West. The cult, which had come to incorporate Natalia, was introduced into the peninsula in the seventh century.[1] The first episode of Adrian's passion is depicted in repoussé relief on a short side of this casket; here Adrian, accompanied by Natalia, declares his Christian faith to the emperor. On a long side, beneath a pendent arcade, Adrian is dismembered by five men, and Natalia, as the Passion of Saint Adrian stipulates, appropriates the severed hand of her fallen husband. An inscription on the skirt of the reliquary below this scene declares the shrine's purpose: MARTIRIS EXIMINI SACRUM (Sacred [to the memory of] the exalted martyr). The story continues on the other long side, where two dismembered bodies, one minus a hand, frame the prostrate figure of Natalia, who clutches the detached hand of her husband. The inscription under this scene offers some explanation for the pictorial narrative: QUI MARTIR FACTUS SPREVIT EUM ([Adrian] was made a martyr, [Natalia] removed him). The tale is completed on the other short side, which shows Natalia with two companions taking the severed hand by boat to Constantinople. The accompanying inscription, like the first, identifies the nature of the shrine: [JA]CET HIC ADRIAN (Here lies Adrian).

The Spanish origin of this reliquary is undocumented, but the popularity of the cult of Adrian and Natalia on the peninsula, the figure style, and the format make such a provenance believable. The Arca Santa of Oviedo (cat. 124) confirms that Spanish Romanesque reliquary iconography was carried out in silver repoussé at least by the twelfth century. Moreover, Spanish artists were in the forefront of composing hagiographical narratives for reliquaries, as the shrine of Saint Aemilian, from the second half of the eleventh century, testifies (cats. 125a–g). A silver casket fashioned after the middle of the twelfth century for Toledo Cathedral for the remains of Saint Eugene

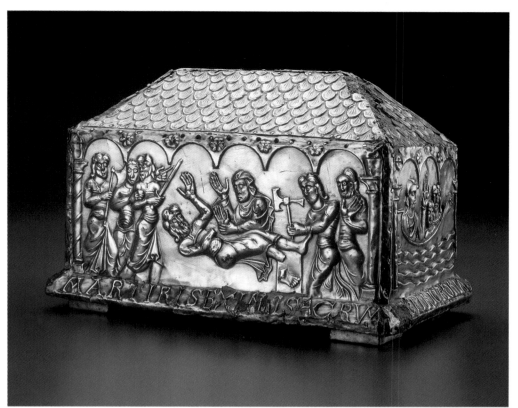

122

incorporates several scenes from his passion in a repoussé technique.[2] Although the Adrian shrine also employs what may be termed a generic Romanesque style, one of its formulas —the bladder shape given drapery over the midriff—appears in works of the early part of the twelfth century, such as the lid of the Arca Santa of Oviedo, where it is seen on the angels, and the Romanesque part of the Beatus from San Millán (Real Academia de la Historia, Madrid; Cod. 33, fol. 165, etc.). One of the notable monasteries dedicated to Saint Adrian was founded at Boñar, east of León, in 920 by Count Gisvado and his wife, Leuvina, who themselves had secured relics of Adrian and Natalia in Rome. With the death of Ferdinand I, this monastery fell to the oversight of his daughter, Urraca, a noted patroness of the liturgical arts.[3] She rebuilt the church of San Adrian de Boñar and in 1099 ceded it to the more important monastery of San Pedro de Eslonza.[4] The quarry at Boñar supplied the stone for the palatine church, San Isidoro, that Urraca planned for the capital. There is no document connecting our shrine with San Adrian de Boñar, nor certainty that it was made as early as 1099. However, no other church dedicated to Adrian and Natalia and no circle of patronage other than the Leonese royal family offers a better prima facie claim to responsibility.

JWW

1. García Rodríguez 1966, pp. 199–201.
2. Nieto 1966.

3. See essay "León and the Beginnings of the Spanish Romanesque" by John W. Williams, this catalogue.
4. Yepes 1959–60, vol. 2, pp. 239ff., esp. p. 243.

LITERATURE: Donnelly and Smith 1961; Hernández 1961, p. 105; Leningrad 1990, no. 34.

123

casket of saint demetrius

Aragon, ca. 1100
Gilt-copper alloy with cabochons, on wood core
13¾ x 23⅝ x 15¾ in. (35 x 60 x 40 cm)
Church of San Esteban, Loarre (Huesca)

The reliquary casket of Saint Demetrius and the book cover commissioned by Queen Felicia (cat. 128b) are virtually the only early Romanesque sumptuary works from Aragon that survive. The casket's four sides are engraved with images of the twelve apostles under arcades separated by bands of rinceaux. The front of the lid depicts Christ in a mandorla surrounded by symbols of the four evangelists; on the back of the lid a Christ triumphant is flanked by four angels. The dynamic, even ecstatic, attitudes of the apostles, with their upward-looking gazes, indicate that both body and lid of this casket are iconographically linked to the theme of the

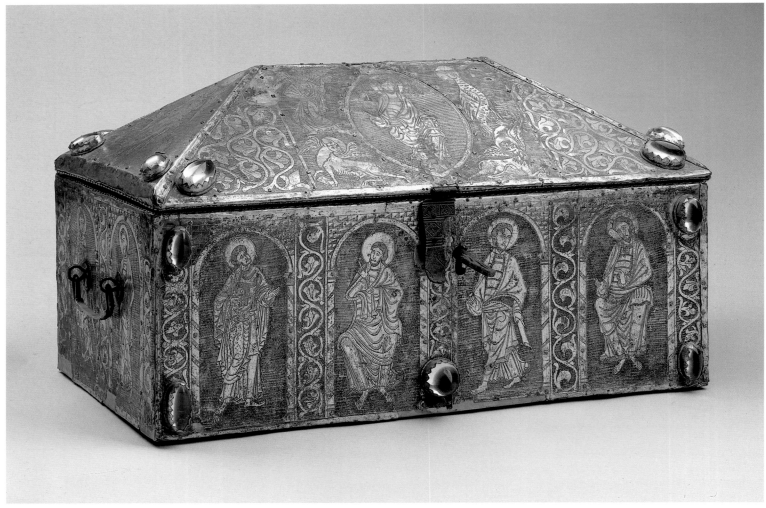

123

Ascension and the Second Coming, as described in the Acts of the Apostles.

The engraved images of the apostles are characterized by an emphasis on line, by sharp, radiating folds of drapery, and by torsional movement. Serafín Moralejo has pointed out their relation to the manuscript illumination of Aquitaine and Languedoc in the early twelfth century.[1] Even more striking is the resemblance of the dynamic drawing style of the casket to illustrations in a copy of the Acts of the Council of Jaca of 1063, in which bishops with linear, radiating drapery stand in exaggerated postures. The similarity suggests that the two works were produced in the same artistic orbit, although the document illustrations are more provincial than the engravings on the casket.[2]

Inside the casket a second, smaller casket was found that contained the relic of Saint Demetrius. It is also of gilt copper, but its engraving consists exclusively of vegetal and geometric designs with a formal vocabulary decisively influenced by the art of al-Andalus.

CTL

1. Moralejo 1982, p. 287.
2. Ibid.

LITERATURE: Moralejo 1982 (with previous literature).

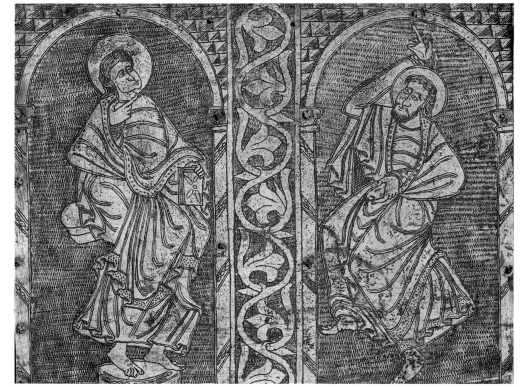

123: Detail

ARCA SANTA OF OVIEDO

Oviedo (Oviedo), late 11th or early 12th century
Black oak and gilded silver
28¾ x 46⅞ x 36⅝ in. (73 x 119 x 93 cm)
Cámara Santa, Oviedo Cathedral

The Arca Santa is a large reliquary casket in Oviedo Cathedral's Cámara Santa. The reliquary, which recalls an altar in form, is made of black oak sheathed in gilded silver. Repoussé figures are present on three of its four faces, and an engraved Crucifixion scene appears on its lid. The figural decoration is Romanesque in style.

According to the *Liber testamentorum*, a record of the principal donations to Oviedo Cathedral compiled about 1120, the original Arca was carried from Jerusalem—where it was constructed by disciples of the apostles—to Oviedo, with stops in Africa, Seville, and Toledo.¹ It was brought to Oviedo in the eighth century to escape the invading Muslims. The story of the casket's manufacture and journey is repeated in a number of other documentary sources.

The Arca Santa differs from most medieval reliquaries in terms of its contents. Rather than preserving a single saint's relics, it held relics of numerous saints and such items as wood from the true cross, bread from the Last Supper, and milk from Mary's breast. An inscription on the casket's lid lists some of these contents; others are named in additional inventories. Although the Pilgrim's Guide (the fifth book of the mid-twelfth-century Codex Calixtinus) ignores Oviedo, references to the relics had appeared in France by the late eleventh century.²

On October 11, 1934, the Cámara Santa suffered an explosion that severely damaged the Arca Santa. Using earlier photographs, documents, and the remaining pieces, Manuel Gómez-Moreno reconstructed the reliquary.³ He published an article in 1945, establishing the Arca's date by connecting it to document 72 in the Oviedo Cathedral archives. Dated March 14, 1075, this document describes the ceremonial enumeration of the Arca's contents by Alfonso VI of León.⁴ Thus in his article Gómez-Moreno posited that the date of 1075 belonged in a missing section of the casket's inscription. Although it is inconsistent with the mature style of the Arca's decoration, 1075 has been accepted because the inscription in question names Alfonso and credits him with donating artistic materials. Prior to the 1934 explosion that damaged the casket, however, antiquarians recorded the same inscription on three occasions without once mentioning a date for Alfonso's gift. Since the authentic-

ity of document 72 is also now questioned, the shrine's chronology should be investigated afresh.⁵

The Arca Santa has yet to receive a thorough scholarly analysis, and some aspects of its decoration are puzzling. Its front panel recalls contemporary antependium design, featuring a centrally placed Christ in Majesty in a mandorla carried by four angels. Six labeled apostle figures, in two arcaded rows of three, appear at both the left and right sides of the central group.⁶ This entire field is circumscribed by a Kufic border with an evangelist symbol inserted at each corner. The corrupt nature of the Kufic inscription indicates that the artist was not completely familiar with Arabic.

The Arca's left side bears scenes from the

Infancy of Christ cycle in a narrative sequence that traverses two registers in a counterclockwise manner. Beginning with the Annunciation on the upper right, it moves to the Annunciation to the Shepherds and the Visitation above, then on to the Nativity and the Flight into Egypt below. Arcades are used to clarify and enhance the narrative. A banded inscription separates the two registers. Reading from the left is MARIA ET IOSEP POSUERUNT DOMINUM IN PRESEPIO ANIMALIU (Mary and Joseph put the Lord into the animals' manger); it continues ANGELUS APARUIT IOSEP DICENS FUGE IN EGIPTUM ESTO IC (An angel appeared to Joseph saying, "Flee into Egypt").⁷ Figures are labeled in every scene except the Annunciation to the Shepherds.

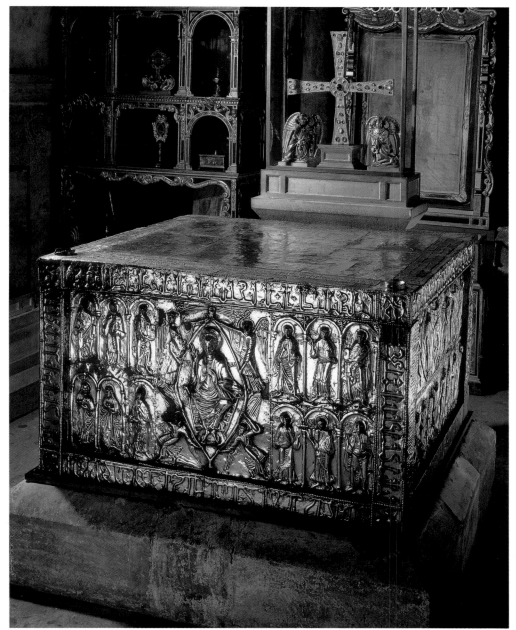

124

259

One unusual aspect of the iconography is Saint Anne's appearance in both the Annunciation and the Flight into Egypt. Saint Anne is also featured in the frescoes of the Pantheon of the Kings in neighboring León, which are dated to about 1120. Her depiction there could be seen as evidence of Byzantine influence because the cult of Saint Anne was well established in the East; it was not widespread in the West until the fourteenth century. The fact that many of the Arca's relics are Byzantine in origin would seem to support this hypothesis, but the influence of contemporaneous English interest in the Immaculate Conception of Mary should also be considered.

The panel on the Arca's right side is also arranged in two registers. In the upper register, at the left, is the standing Christ in a mandorla supported by two angels. At the right a cherub and seraph flank Michael the Archangel as he battles the dragon. Below, eight labeled apostles stand in various attitudes. As before, an inscribed band separates the two registers. It reads: ASCENDENS XPS IN ALTUM CAPTIVAM DUXIT CAPTIVITATE (Christ, ascending on high, led the prisoner from captivity) and MICHAEL ARCANGELUS PUGNAVIT CUM DRACONE (Michael the Archangel fights the dragon). The original Kufic border remains at the top and at the right edge of the field. The bottom and left edge are covered with a patterned revetment.

The casket's lid features nielloed engraving rather than repoussé decoration. Its Crucifixion includes the thieves, Mary, and Saint John and roundels containing the sun and moon. The shrine's rear is covered with a simple geometric revetment. Since modern times the reliquary has lacked a base, but presumably it once stood on four feet as many Ottonian altar reliquaries do.

The Arca's figures achieve a mature Romanesque style, something that sets it apart from such earlier shrines as the reliquary of Saint Isidore (cat. 110), whose figures demonstrate Ottonian influences on Spain's minor arts. Just what the Arca's stylistic antecedents were is difficult to surmise as few comparable objects exist.[8] Gómez-Moreno emphasized its Mozarabic nature, but more recently Serafín Moralejo has found convincing parallels for its figures in English and Anglo-Norman manuscripts.[9] Moralejo's suggestion is particularly interesting in light of the possible English iconographic influence mentioned above.

JAH

1. Fernández Conde 1971, pp. 111–18.
2. The earliest inventory of the relics was published by Bruyne in 1927. Another eleventh-century reference to the Arca's relics is discussed by Gaiffier 1968, pp. 67–81, and Gaiffier 1971, pp. 27–28.
3. Gómez-Moreno 1934a, pp. 125–36.
4. For document 72, see García Larragueta 1962, p. 214.
5. See Reilly 1985, p. 7, n. 7; 1988, p. 85; and 1992, p. 258.
6. Williams believes that a textile altar frontal, donated by Alfonso III to Oviedo Cathedral in 908, may have been the source for this iconography (Williams 1972–74, p. 233, n. 41).
7. The Latin inscriptions were recorded before the explosion (Miguel Vigil 1887, p. 116).
8. Descriptions by antiquarian Ambrosio de Morales suggest that the Arca's closest companions would have been those commissions, now lost, made by Alfonso VI at Sahagún and by Gelmírez at Santiago de Compostela.
9. Moralejo 1982, pp. 288–89.

LITERATURE: Morales 1765, pp. 71–72; Hübner 1871, pp. 82–83; Miguel Vigil 1887, p. 15; Gómez-Moreno 1934a, pp. 28–30; Gómez-Moreno 1945, pp. 125–36; García Larragueta 1962, p. 214; Fernández Conde 1971, pp. 111–18; Palol and Hirmer 1967, pp. 90–91, 152, 174; Gaiffier 1968, pp. 67–81; Manzanares 1972, pp. 20–28; Yarza 1979, p. 210; Moralejo 1982, pp. 288–89; Reilly 1985, p. 7, n. 40; Reilly 1988, p. 85; Moralejo 1989a, pp. 38, 47–48, n. 22; Moralejo 1992a, p. 212, n. 14; Reilly 1992, p. 258.

125a

ARCA ANTIGUA

Monastery of San Millán de la Cogolla (Logroño), 1060–80
Wood and silk
22⅞ x 40½ x 13 in. (58 x 103 x 33 cm)
Monasterio de Yuso, San Millán de la Cogolla

This wooden armature of a large reliquary shrine was made in the second half of the eleventh century for the relics of Saint Aemilian (San Millán), a Visigothic hermit believed to have lived, worked miracles, and died in 574 at the Riojan site that now bears his name. In its original state the reliquary had a rich and unprecedented decorative program. Each long side featured eleven carved ivory scenes in two registers depicting the life of the saint. The source for this narrative was the *Vita Sancti Aemiliani* written by Saint Braulio, bishop of Saragossa, in the seventh century.[1] The reliquary's short ends, or gables, featured labeled portraits in ivory and precious metals depicting the artistic, monastic, and royal personages responsible for its creation.

The reliquary was severely damaged and stripped of its precious metals and gems by French troops who sacked San Millán de la Cogolla in 1809. In the following years the vacant monastery was plundered, and many of the ivory plaques—deemed worthless by the troops—were also lost. Some reappeared years later in museums throughout the world; indeed, sixteen of the lateral and nine of the gable ivories have since been identified. The most recent of these plaques to surface was purchased by the Metropolitan Museum in 1987.[2]

When the monastery was resettled in 1817, the surviving ivories were assembled on a simple wooden casket within which was sealed the reliquary's original wooden armature. In 1931 most of these plaques were transferred along with other monastic artifacts to the Museo Arqueológico Nacional in Madrid for safekeeping. After the Spanish civil war public outcry demanded their return to the monastery. These efforts culminated in 1944, when the saint's relics—hidden in a jar during the civil war—were translated to a new casket, which now displays most of the surviving ivories. Although some effort was made to comply with a detailed description of the reliquary made by Prudencio de Sandoval in 1601, the modern arrangement is an attractive display rather than a scientific re-creation.

The original wooden armature of the reliquary was recently rediscovered, still sealed inside its protective container. When juxtaposed with Sandoval's description and the surviving ivories, the Arca Antigua—as it is called at the site—allows scholars to generate an accurate reconstruction of the reliquary for the first time. Indentations made in the Arca's wood to accommodate gems and plaques are clearly visible today. Especially noteworthy is an opening in the roof—originally probably covered by a flap—that would have allowed pilgrims closer access to the saint's relics. It has been established that this particular spot was overlaid with depictions of posthumous miracles taking place at San Millán de la Cogolla, which bear witness to the reliquary's function in a pilgrimage context. Rediscovery of the Arca Antigua is also of interest to textile specialists since its interior is sheathed with a magnificent Islamic silk.[3]

It is difficult to determine a precise date for the reliquary of Saint Aemilian as no contemporary documents attest to its manufacture. The earliest account, *De translatione Sancti Aemiliani*, written by the monastic chronicler Fernando in the thirteenth century, implies that the completed reliquary was used for the second translation of Aemilian's relics in 1067.[4] This account, however, is contradicted both by internal evidence and by biographical information known about persons depicted on the reliquary's gabled ends, or frontispieces. It may be possible that Fernando conflated two separate events or that additional portraits were added to the reliquary after its use in the 1067 translation.

In either case a date in the 1060s or 1070s accords well with the plaques' pre-Romanesque attributes, which recall, to a certain extent, those of the Leonese pre-Romanesque school. Despite the tenth-century production of ivory objects at the monastery of San Millán, there

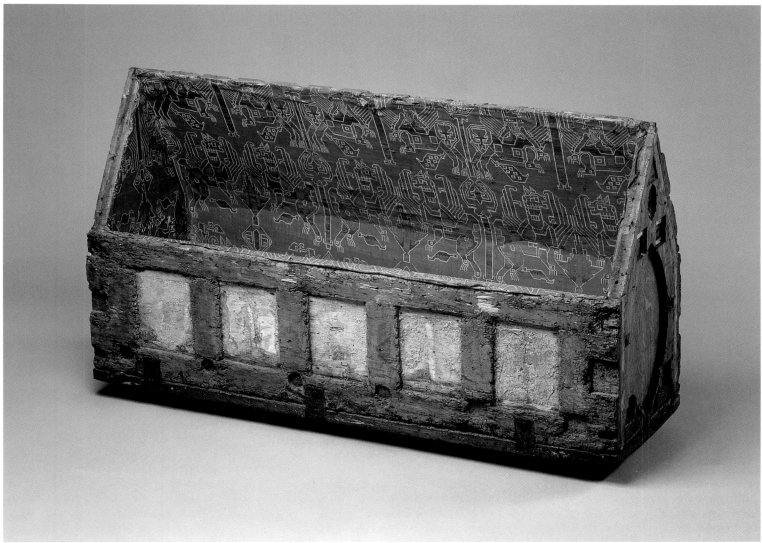

125a

is no documentary evidence to prove that the early atelier persisted at the site into the eleventh century.[5] Indeed, the reliquary's carving style contradicts theories of an isolated continuity, as most of its plaques owe little to the earlier atelier's Andalusian-inspired forms.

Stylistic analysis suggests that as many as four ivory carvers may have worked on the reliquary. The most accomplished of these was well acquainted with the Leonese atelier, exhibiting in his plaques the same looping drapery, taut surfaces, and bony figures found on the Beatitudes casket (cat. 117). Furthermore, the Germanic names—Engelramus and Redolfo—of the artists depicted on one of the reliquary's plaques (cat. 125b) indicate that the reliquary should best be seen in the light of Spain's awakening to trans-Pyrenean influences, a phenomenon that accelerated in the second half of the eleventh century and that would eventually result in the production of fully Romanesque ivories.

JAH

1. For the *Vita Sancti Aemiliani*, see Vázquez de Parga 1943.
2. Little 1987.
3. Cristina Partearroyo in New York 1992a, p. 229.
4. Fernando's account survives in two manuscripts in the Real Academia de la Historia in Madrid: RAH Aem. 10 and 23. The most recent edition of his work appears in Dutton 1967, pp. 31–35. The first translation of the relics occurred in 1030, during the reign of Sancho III, el Mayor. The most reliable document to that effect is a short charter of April 13, 1030. See Gaiffier 1967, pp. 140–49, especially p. 145; for the charter see Ubieto 1976, no. 192, p. 191.
5. Parts of two Mozarabic crosses and a portable altar are connected to San Millán's first ivory atelier. See Kühnel 1971, nos. 48–50; Gaborit-Chopin 1978, no. 85.

LITERATURE: Sandoval 1601, fols. 23v–27v; Mecolaeta 1724; Breck 1920, p. 219; Porter 1923, vol. 1, p. 38; Porter 1925, pp. 235–50; Goldschmidt 1914–26, vol. 4, no. 84; Ferrandis 1928, pp. 157–74; Camps 1933; Gómez-Moreno 1947, p. 165; Cook and Gudiol 1950, p. 292; Palol and Hirmer 1967, p. 94; Weitzmann 1972, pp. 83–86; Uranga and Iñiguez 1971–73, vol. 2, pp. 82–84, fig. 28; Gaborit-Chopin 1978, p. 116, and nos. 173, 174; Peña 1978; Hermosilla 1983, pp. 186–96; Estella 1984; Perrier 1984, pp. 107–22; Silva 1985, pp. 33–34; Cologne 1985, vol. 1, p. 251; Cutler 1987, p. 444, n. 103; Little 1987, p. 15; Silva 1988; Harris 1989; Harris 1991; Cristina Partearroyo, in New York 1992a, p. 229.

125b

IVORY CARVERS AT WORK (PLAQUE FROM RELIQUARY OF SAINT AEMILIAN)

Monastery of San Millán de la Cogolla (Logroño), 1060–80
Ivory
2⅜ x 1¼ in. (6 x 4.5 cm)
State Hermitage Museum, Saint Petersburg (2909)

This gable plaque from the reliquary of Saint Aemilian, bearing the inscription ENGELRA-MAGISTRO ET REDOLFO FILIO (by Master Engelramus and his son Redolfo), may be the earliest-known self-portrait by an ivory carver. Engelramus, the master, is shown seated, smoothing out a large piece of ivory in preparation for carving. Redolfo, the son, stands and steadies the ivory while his father works. This small but unprecedented depiction testifies to the use of lay, itinerant craftsmen in Spanish monasteries. Close stylistic analysis suggests that there were more than

125b

1934a, pp. 25–26, 32–33; Gómez-Moreno 1947, p. 165; Cook and Gudiol 1950, p. 292; Stiennon 1958; Egbert 1967, p. 26; Palol and Hirmer 1967, p. 94; Weitzmann 1972, pp. 83–86; Uranga and Iñiguez 1971–73, vol. 2, pp. 82–84, fig. 28; Dresden 1975, p. 48; Gaborit-Chopin 1978, p. 116, and nos. 173, 174; Peña 1978; Hermosilla 1983, pp. 186–96; Estella 1984; Perrier 1984, pp. 107–22, 133–37; Silva 1985, pp. 33–34; Cologne 1985, vol. 1, p. 251; Cutler 1987, p. 444, n. 103; Little 1987, p. 15; Joris 1988, pp. 6–11; Silva 1988; Harris 1989; Harris 1991; Cristina Partearroyo, in New York 1992a, p. 229.

two—possibly as many as four—hands at work on the casket's ivories.

Arthur Kingsley Porter placed the reliquary of Saint Aemilian in the Ottonian minor arts tradition, basing his hypothesis on the artists' Germanic names and on his belief that the casket's figure style was linked to that of the Echternach Master. Another work—from León and slightly earlier (ca. 1063)—the reliquary of Saint Isidore (cat. 110), whose figures can be compared with those on the Hildesheim doors, further supports Porter's assertion. In addition a German artist—Almanius—fashioned the now-lost golden retable for Santa María de Nájera in 1056.[1]

Stylistic analysis contradicts Porter's belief that the reliquary's artists belonged to the Echternach tradition; it does, however, suggest that artists from the north were influential in Léon and later at San Millán. Due to the similarities between Leonese and San Millán pre-Romanesque ivories, it is possible that one northern workshop influenced both centers in turn. One region that may have had such a workshop is the Lower Lorraine, which was an active center for the minor arts earlier in the eleventh century. In the second half of the century, documented contacts between Spain and Liège include a pilgrimage to Santiago in 1056.[2] Furthermore, merchants from the Lorraine traveled throughout Spain in order to obtain Andalusian fabrics.[3]

JAH

1. Gómez-Moreno 1934a, pp. 32–33.
2. Stiennon 1958.
3. Joris 1988, pp. 6–11.

LITERATURE: Sandoval 1601, fols. 23v–27v; Mecolaeta 1724; Breck 1920, p. 219; Porter 1923, vol. 1, p. 38; Porter 1925, pp. 235–50; Goldschmidt 1914–26, vol. 4, no. 84; Ferrandis 1928, pp. 157–74; Camps 1933; Gómez-Moreno

125c

scenes from the life of saint aemilian (plaque from reliquary of saint aemilian)

Monastery of San Millán de la Cogolla (Logroño), 1060–80
Ivory
6⅛ x 3 in. (16.9 x 7.6 cm)
The Metropolitan Museum of Art, New York; The Cloisters Collection, 1987 (1987.89)

In his 1601 description of the reliquary of Saint Aemilian, Prudencio de Sandoval placed this plaque in the first position (the far left) on the upper level of what he considered the reliquary's first side. The plaque, which depicts Aemilian's early life and his climb up Mount Dircetius, was purchased by the Metropolitan Museum in 1987.[1] It had not been published before its purchase by the Museum, although both Sandoval and Diego Mecolaeta had described it in situ before the reliquary was damaged in the early nineteenth century. The circumstances of its removal and initial purchase are unknown.

The ivory presents two vertically arranged scenes, the lower chronologically preceding the upper. Below, the seated saint, complete with shepherd's gear, tends his flock. Resting a hand on his crook, he lifts and blows an oliphant with his other hand. Also shown is a kithara, which Braulio mentions in his *Vita Sancti Aemiliani*.[2] A full two chapters later in the *Vita*, the former shepherd climbs to solitude on Mount Dircetius after meeting his religious mentor, Felices, and returning briefly to Vergegio (modern Berceo). The upper register depicts the robed and barefoot Aemilian scrambling up a steep hill covered in vegetation. As he approaches, the hand of God bestows a blessing. The plaque's inscriptions, FUTURUS PASTOR HOMINUM ERAT PASTOR OVIUM (The future shepherd of men was a shepherd of sheep) and UBI EREMUM EXPETIT MONTIS DIRCECII (Wherein he sought the remoteness of Mount Dircetius), encapsulate the narrative. The first of these inscriptions quotes Braulio's text directly.[3]

The image of the shepherd and his flock originated in classical pastoral imagery and was readily used to depict Christ as the Good Shepherd. This particular version is rare in that Aemilian is seated and blows a horn to summon his flock. A medieval secular variant of the scene appears on the Carolingian flabellum of Tournus, where it illustrates a passage from Virgil's *Eclogues*.[4]

Likewise the upper register's figure, a climber with outstretched hands, is represented in a number of biblical scenes. In this case it probably can be associated with Moses Receiving the Law, as both the *Vita Sancti Aemiliani* and the reliquary's own inscription contain references to him. Comparable examples appear in the seventh-century Ashburnham Pentateuch (Bibliothèque Nationale, Paris; cod. n. acqu. lat. 2334), which may have been produced in Spain, and a tenth-century Psalter from Byzantium (Bibliothèque Nationale, Paris, cod. grec. 139).

Several stylistic characteristics set this plaque apart from others in the San Millán series. For example, while the other compositions also use arches to frame the scene and to carry

125c

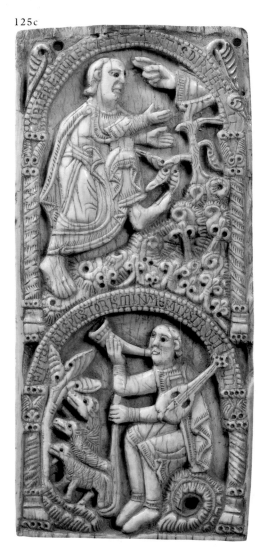

inscriptions, a straight border always separates the two registers and may even act as a groundline for the action above. In this ivory alone, inscription-bearing arches provide both the horizontal and vertical borders of the scenes.

The plaque is also distinctive in the variety of its surface textures. In particular its drilled vegetation is quite unusual and may reflect knowledge of Andalusian ivory-carving practices. The drapery style differs from the majority of the reliquary's plaques in its reliance on a few subtle lines looping across the body to define volumes beneath the fabric. This more accomplished carving style is apparent as well in the plaque depicting Aemilian flanked by Asellus, Gerontius, and Sofronius at San Millán de la Cogolla. In most of the reliquary's plaques, however, figural volume is obscured by the drapery's linear patterning.

JAH

1. Little 1987.
2. Vázquez de Parga 1943, p. 14, l. 10.
3. Ibid., l. 8.
4. Lasko 1972, fig. 42.

LITERATURE: Sandoval 1601, fols. 23v–27v; Mecolaeta 1724; Breck 1920, p. 219; Porter 1923, vol. 1, p. 38; Porter 1925, pp. 235–50; Goldschmidt 1914–26, vol. 4, no. 84; Ferrandis 1928, pp. 157–74; Camps 1933; Vázquez de Parga 1943; Gómez-Moreno 1947, p. 165; Cook and Gudiol 1950, p. 292; Palol and Hirmer 1967, p. 94; Lasko 1972, fig. 42; Weitzmann 1972, pp. 83–86; Uranga and Iñiguez 1971–73, vol. 2, pp. 82–84, fig. 28; Gaborit-Chopin 1978, p. 116, and nos. 173, 174; Peña 1978; Hermosilla 1983, pp. 186–96; Estella 1984; Perrier 1984, pp. 107–22, 133–37; Silva 1985, pp. 33–34; Cologne 1985, vol. 1, p. 251; Cutler 1987, p. 444, n. 103; Little 1987; Silva 1988; Harris 1989; Harris 1991; Cristina Partearroyo, in New York 1992a, p. 229.

125d

christ in majesty (plaque from reliquary of saint aemilian)

Monastery of San Millán de la Cogolla (Logroño), 1060–80
Ivory
10⅝ x 5⅜ in. (27 x 13.7 cm)
Dumbarton Oaks, Washington, D.C. (48.12)

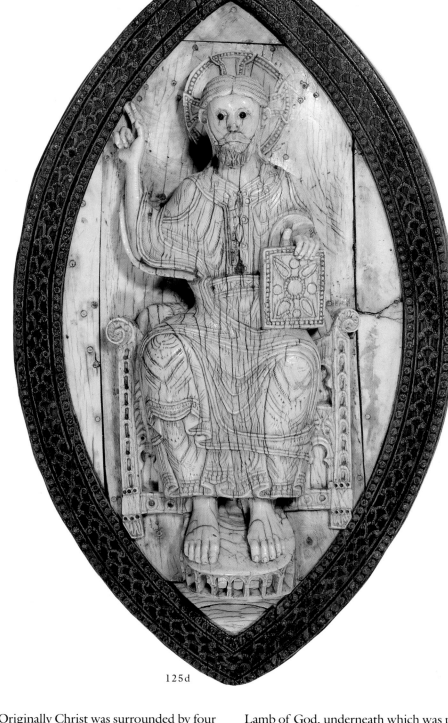

125d

Adolph Goldschmidt recognized this piece in the Dumbarton Oaks Collection as belonging to the reliquary of Saint Aemilian. According to Prudencio de Sandoval's description of 1601, Christ in Majesty was the centerpiece of one of the casket's two gables—that which featured the most prominent of the reliquary's donors. Indeed, the hollow made to accommodate Christ's mandorla, which was originally of precious metal, is clearly visible on the casket's wooden armature (cat. 125a), as are spaces left for additional decorative features.

Originally Christ was surrounded by four small plaques representing the evangelist symbols. Adjacent to this group were four gold figures of angels presenting the Navarrese patrons Sancho IV (r. 1054–76) and his wife Placentia to Christ. Below Christ's feet, prostrate, were ivory figures of Munius the Scribe and Blasius the Abbot, the latter deemed by inscription the project's organizer: BLASIUS ABBAS HUIUS OPERIS EFFECTOR (Abbot Blasius, instigator of this work). Fitting neatly into the gable's triangular pinnacle was the Lamb of God, underneath which was placed a large "carbuncle," as Sandoval puts it. A laudatory inscription surrounded the entire composition. Of this ensemble, in addition to Christ, only the figures of Munius and Blasius survive. They are presently at the monastery of San Millán de la Cogolla.

Christ sits on a wooden throne decorated with horseshoe arcades. His feet rest on a small stool. His pose is traditional: the right hand is raised in blessing, while the left props a book upon the thigh. Kurt Weitzmann

noted the unusual three-dimensionality of the Christ figure, for which he found comparison only in the Virgin and Child in the Landesmuseum, Mainz—an Ottonian ivory carving of the mid-eleventh century.[1] Christ's beaded nimbus, which Weitzmann suggested was copied from a Romanos-group ivory,[2] could also support an Ottonian artistic ancestry. Typically Spanish, however, are the inlaid eyes, which are characteristic of both the Leonese and the San Millán schools of ivory carving, and the throne's horseshoe arches.

This plaque vividly demonstrates the craft of ivory carving. When viewed from the rear, the tusk's pulp cavity is visible. This figure's unusually high relief forced the carver to work nearly the entire width of the tusk, even including the oldest and most brittle ivory, which is found just beneath the husk.[3]

JAH

1. See Lasko 1972, pl. 121; Goldschmidt 1914–26, vol. 2, no. 40.
2. The Romanos group, comprising ivories connected to the tenth-century Byzantine emperor Romanos II and his wife Eudoxia, is best exemplified by an ivory in the Cabinet des Médailles, Bibliothèque Nationale, Paris, for which see Goldschmidt and Weitzmann 1930–34, vol. 2, no. 85.
3. Cutler 1985, pp. 1–5.

LITERATURE: Sandoval 1601, fols. 23v–27v; Mecolaeta 1724; Breck 1920, p. 219; Porter 1923, vol. 1, p. 38; Porter 1925, pp. 235–50; Goldschmidt 1914–26, vol. 4, no. 84; Ferrandis 1928, pp. 157–74; Camps 1933; Gómez-Moreno 1947, p. 165; Cook and Gudiol 1950, p. 292; Palol and Hirmer 1967, p. 94; Weitzmann 1972, pp. 83–86; Uranga and Iñiguez 1971–73, vol. 2, pp. 82–84, fig. 28; Gaborit-Chopin 1978, p. 116, and nos. 173–74; Peña 1978; Hermosilla 1983, pp. 186–96; Estella 1984; Perrier 1984, pp. 107–22, 133–37; Cutler 1985, pp. 1–5; Silva 1985, pp. 33–34; Cologne 1985, vol. 1, p. 251; Cutler 1987, p. 444, n. 103; Little 1987, p. 15; Silva 1988; Harris 1989; Harris 1991; Cristina Partearroyo, in New York 1992a, p. 229.

125e

two monks (plaque from reliquary of saint aemilian)

Monastery of San Millán de la Cogolla (Logroño), 1060–80
Ivory
3 x 1½ in. (7.7 x 3.8 cm)
State Hermitage Museum, Saint Petersburg (2906)

This plaque was part of the reliquary's second gable ensemble, one that centered around a large ivory depicting Aemilian mourned on his bier (cat. 125f). Prudencio de Sandoval's 1601 description of the original gable records that its labeled portraits featured all ranks of monastic personnel—from refectory worker

to scribe. This plaque, which shows Abbot Petrus (PETRUS ABBA) and Munius (with a garbled inscription meaning *ad ecclesiam*, "to the church"), appeared at the right of the gable, in the uppermost of three tiers of decoration. It was matched at the left by a similar plaque depicting two additional standing figures.

The hazy chronology of events at the monastery of San Millán makes securing the reliquary's history a difficult task. The traditional account has Abbot Blasius presiding over the second translation of the relics in 1067, for which the reliquary was designed. Documents backing up this claim, however, have been excluded from the modern edition of the monastic cartulary, which indicates instead that Petrus was abbot from the late 1050s until 1069.[1]

Because Petrus witnessed documents in the monastic cartulary as late as 1075, Joaquín Peña believed he remained abbot of the monastery's original foundation in the mountains, while Blasius directed the newly erected

125e

center in the valley.[2] While Peña's notion would untie some of the chronological knots facing historians, there is no evidence to support the hypothesis that two monasteries operated simultaneously at the site.

Although its complete history will never be recovered through documents, the reliquary itself reveals something about the relative status of the two abbots. Petrus does not share with Blasius (BLASIUS ABBAS HUIUS OPERIS EFFECTOR [Abbot Blasius, instigator of this work]) a place of honor at Christ's feet on the first gable but instead appears on this second, lesser gable with other patrons and monastic personages.

JAH

1. Ubieto 1976.
2. Peña 1978, pp. 33–36.

LITERATURE: Sandoval 1601, fols. 23v–27v; Mecolaeta 1724; Breck 1920, p. 219; Porter 1923, vol. 1, p. 38; Porter 1925, pp. 235–50; Goldschmidt 1914–26, vol. 4, no. 84; Ferrandis 1928, pp. 157–74; Camps 1933; Gómez-Moreno 1947, p. 165; Cook and Gudiol 1950, p. 292; Palol and Hirmer 1967, p. 94; Weitzmann 1972, pp. 83–86; Uranga and Iñiguez 1971–73, vol. 2, pp. 82–84, fig. 28; Ubieto 1976; Gaborit-Chopin 1978, p. 116, and nos. 173, 174; Peña 1978, pp. 35–36; Hermosilla 1983, pp. 186–96; Estella 1984; Perrier 1984, pp. 107–22, 133–37; Silva 1985, pp. 33–34; Cologne 1985, vol. 1, p. 251; Cutler 1987, p. 444, n. 103; Little 1987, p. 15; Silva 1988; Harris 1989; Harris 1991; Cristina Partearroyo, in New York 1992a, p. 229.

125f

death of saint aemilian (plaque from reliquary of saint aemilian)

Monastery of San Millán de la Cogolla (Logroño), 1060–80
Ivory
6⅞ x 2⅝ in. (17.5 x 6.6 cm)
Museum of Fine Arts, Boston (36.626)

The second of the reliquary's gabled ends centered around an ivory plaque that depicted the death of Aemilian. At some undetermined time this plaque was divided into two pieces. Eventually, the right portion entered the Museum of Fine Arts, Boston, and the left portion entered the Museo Nazionale del Bargello, Florence.

When the two pieces are joined, the plaque shows the dead saint being mourned at the monastery, while his soul—represented by a nude body as is customary in medieval art—is raised into heaven by angels. The piece in Florence depicts the head of the bier, where the priest Asellus stands by a Mozarabic processional cross. By including the priest,

the artist reveals how closely he followed the *Vita Sancti Aemiliani*'s account of Aemilian's demise.

Because a saint's death was considered essential to a hagiographic narrative and to visual interpretations of such a narrative, a second portrayal of the death scene was included in the narrative sequence on one of the reliquary's long sides. The present ivory stresses the saint's role as intercessor for the living, as such representations generally do.[1] That is, his body remains a focus of devotion at the monastery, while his soul resides in heaven. The plaque's inscriptions also reflect this dichotomy. Heavenly activity is the theme of an inscription running along the plaque's upper border: UBI ANGELI DEI GAUDENTES AD CELUM CONSCENDUNT ANIMAM BEATI EMILIANI PORTA[N]TES (Where the angels of God rise with joy toward heaven carrying the soul of Blessed Aemilianus). The monastic realm is described by inscriptions on the plaque's inner arcade: DE EIUS OBITU ET OBSEQUS (Of his death and compliance) and ASELLI PRESBITERI (Of Asellus the priest).

In both the side and gable depictions of Aemilian's death, a distinctive processional cross marks the setting as San Millán de la Cogolla. Indeed, three arms of two such crosses found at the site are now displayed at the Musée du Louvre, Paris, and at the Museo Arqueológico Nacional, Madrid (cat. 74).[2]

JAH

1. See Svoboda 1983, p. 162, n. 2, for other examples of death scenes; and Abou-el-Haj 1975, pp. 74–77.
2. For the Mozarabic crosses, see Kühnel 1971, nos. 48, 49, and Gaborit-Chopin 1978, no. 85.

LITERATURE: Sandoval 1601, fols. 23v–27v; Mecolaeta 1724; Breck 1920, p. 219; Porter 1923, vol. 1, p. 38; Porter 1925, pp. 235–50; Goldschmidt 1914–26, vol. 4, no. 84; Ferrandis 1928, pp. 157–74; Camps 1933; Gómez-Moreno 1947, p. 165; Cook and Gudiol 1950, p. 292; Palol and Hirmer 1967, p. 94; Kühnel 1971, nos. 48, 49; Weitzmann 1972, pp. 83–86; Uranga and Iñiguez 1971–73, vol. 2, pp. 82–84, fig. 28; Abou-el-Haj 1975, pp. 74–77; Gaborit-Chopin 1978, p. 116, and nos. 85, 173, 174; Peña 1978; Hermosilla 1983, pp. 186–96; Svoboda 1983, p. 162; Estella 1984; Perrier 1984, pp. 107–22, 133–37; Silva 1985, pp. 33–34; Cologne 1985, vol. 1, p. 251; Cutler 1987, p. 444, n. 103; Little 1987, p. 15; Silva 1988; Harris 1989; Harris 1991; Cristina Partearroyo, in New York 1992a, p. 229.

125g

125f

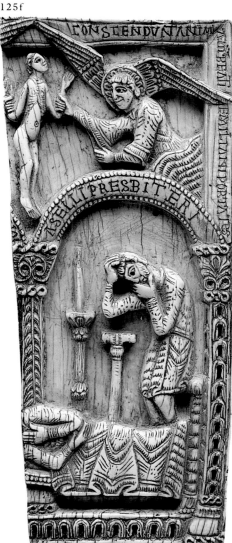

125g

king Ramiro and a companion (plaque from Reliquary of saint Aemilian)

Monastery of San Millán de la Cogolla (Logroño), 1060–80
Ivory
3 1/8 x 1 1/8 in. (8 x 4 cm)
State Hermitage Museum, Saint Petersburg (2908)

This plaque originally appeared on the reliquary of Saint Aemilian's second gabled end, or frontispiece, in the middle of three tiers of decoration and to the left of the ivory depicting Aemilian mourned on his bier (cat. 125f). Two lay donors, King Ramiro of Aragon (RANIMIRUS REX [r. 1035–63]) and a second figure (APPARITIO SCOLASTICO), are represented. Both figures are shown presenting their donations to the monastery. Ramiro holds what seems to be an ivory pyx, and his companion holds a money bag.

Although there are no extant records of donations by Ramiro I of Aragon to the monastery of San Millán de la Cogolla, his brother García Sánchez III of Navarre (r. 1035–54) bestowed funds for construction of a new church in 1053. It is possible that García may have involved Ramiro in ongoing efforts to promote Aemilian's cult. On several occa-

sions Ramiro I allied himself with the Navarrese against León-Castile in struggles over the monastery's home region—the Rioja. The Castilians successfully annexed the Rioja in 1076.

Ramiro's death in 1063, four years before the translation of the saint's relics, might seem to disqualify him as the living figure represented here. Another Ramiro—the count of Calahorra—who lived until 1083 and made donations to San Millán, is sometimes suggested instead.[1] Count Ramiro, however, never became king and is, therefore, undeserving of the label RANIMIRUS REX. Until stronger evidence is presented to the contrary, it is best to view the donor as Ramiro I of Aragon.

Ramiro's companion, Apparitio Scolastico, may be the noble Apparicio who witnessed a donation to the monastery in 1075.[2] It is more likely, however, that the label is a title for someone involved with schools or that the gift is an endowment to the monastic school. Prudencio de Sandoval's 1601 description of the original gabled end ensemble supports this interpretation by including two other plaques, SANCCIUS MAGISTER MUNIO INFANS (Holy teacher, defender of childhood)

and DOMININUS INFANTIUM MAGISTER
(Domininus, teacher of children), which de-
picted figures at work in San Millán's school.

<div align="right">JAH</div>

1. Lacarra 1972, vol. 1, p. 264, no. 59.
2. Ubieto 1976, document 424.

LITERATURE: Sandoval 1601, fols. 23v–27v; Mecolaeta
1724; Breck 1920, p. 219; Porter 1923, vol. 1, p. 38; Porter
1925, pp. 235–50; Goldschmidt 1914–26, vol. 4, no. 84;
Ferrandis 1928, pp. 157–74; Camps 1933; Gómez-Moreno
1947, p. 165; Cook and Gudiol 1950, p. 292; Palol and
Hirmer 1967, p. 94; Lacarra 1972, vol. 1, p. 262, n. 59;
Weitzmann 1972, pp. 83–86; Uranga and Iñiguez 1971–73,
vol. 2, pp. 82–84, fig. 28; Ubieto 1976, document 424;
Gaborit-Chopin 1978, p. 116, and nos. 173, 174; Peña 1978;
Hermosilla 1983, pp. 186–96; Estella 1984; Perrier 1984,
pp. 107–22, 133–37; Silva 1985, pp. 33–34; Cologne 1985,
vol. 1, p. 251; Cutler 1987, p. 444, n. 103; Little 1987, p. 15;
Silva 1988; Harris 1989; Harris 1991; Cristina Partearroyo,
in New York 1992a, p. 229.

126

plaque with scenes from genesis

Northern Spain, early(?) 11th century
Ivory and glass
9¼ x 4 in. (23.5 x 10.2 cm)
State Hermitage Museum, Saint Petersburg (2)

The ivory panel is divided into three registers
with three scenes taken from the Book of
Genesis. At the top is an atypical representa-
tion of the Temptation of Adam and Eve.
Eve is depicted accepting the forbidden fruit—
which takes the form of bunches of grapes—
from the serpent in the tree, while an angel
warns of the consequences. The middle reg-
ister also presents an unusual image: Noah's
ark is surrounded by eight identical figures in
attitudes that seem to suggest the construc-
tion of the ark; two birds frame the mast.
(The description of the ark in Genesis 6:14–16
does not correspond to this depiction, which,
instead, is rather generalized.) The lower
scene shows Abraham's sacrifice of Isaac (Gen-
esis 22:9–13), with an angel interceding to
offer the ram in place of Abraham's son.
Peculiar to all three scenes is the liberal visual
interpretation of the corresponding biblical
account, indicating either that the artist was
not interested in following a particular picto-
rial model or else that an approximation of the
episode as set forth in the text was sufficient.

The function of the panel is uncertain. It
has been suggested that the numerous holes
and the existence of a thin lip on the reverse,
possibly for wax, are evidence that it was part
of a diptych.

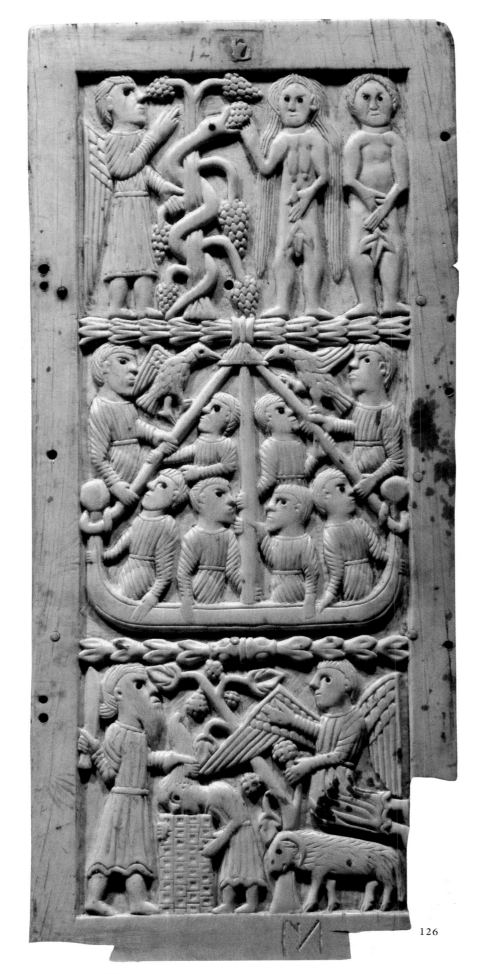

<div align="right">126</div>

The simple, straightforward style of the figures, with their enlarged heads and inlaid glass eyes, has been linked by some scholars to the ivories of the reliquary of Saint Aemilian (cats. 125b–g) at San Millán de la Cogolla; others regard the plaque as chronologically earlier, suggesting that it foreshadows these eleventh-century works. Clearly, in style the panel is further removed from the Glencairn casket of the eighth to tenth century (cat. 69) and closer to works at San Millán de la Cogolla dating from the third quarter of the eleventh century.

CTL

LITERATURE: Goldschmidt 1914–26, vol. 4, no. 92; Volbach 1923, no. 259; Perrier 1984, pp. 32, 112; Leningrad 1986, no. 1 (with previous literature).

127

fragments of plaque from reliquary of san felices

Northern Spain, ca. 1090
Ivory
57.880: 6⅛ x 2¾ (15.7 x 7 cm); 1986/91: 6⅛ x 1¾ (15.6 x 4.6 cm)
Museo Arqueológico Nacional, Madrid (57.880, 1986/91)

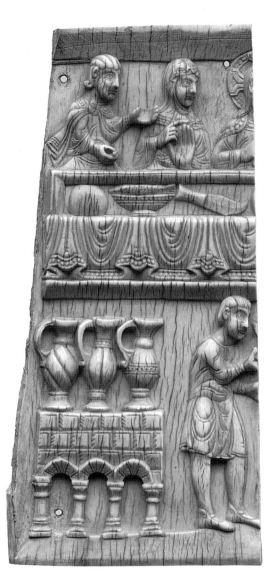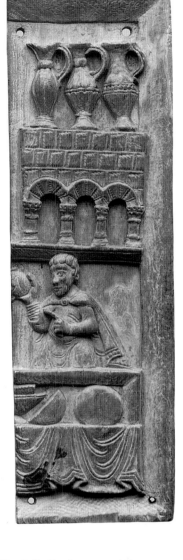

127

The relics of Saint Aemilian's teacher, Felices of Bilibium, were translated to the monastery of San Millán de la Cogolla in 1090. The ivories of the reliquary of San Felices were presumably prepared for this occasion. Prudencio de Sandoval saw the reliquary at San Millán in 1601. Even then, however, it was not the original Sandoval saw but a reconstruction that bore an inscription dating it to 1451. One of the ivory plaques he described—"la otra es de dos mesas cons sus anforas" (the other one is of two tables with their amphorae) —could easily be either one of the two fragments in the Museo Arqueológico Nacional, Madrid. Sandoval's relatively vague description of the plaque may indicate that it was already damaged when he saw it. The smaller of the two fragments was recently discovered in Burgos.[1]

There is general agreement that the plaques represent the Marriage at Cana (John 2:1–11). In addition to these fragments, five other plaques depicting New Testament scenes survive from the reliquary. At San Millán, now assembled on a modern casket, are the Last Supper, the Cure of the Blind Man (with possibly the Cure of the Paralytic beneath), the Raising of the Widow's Son at Nain (or

the Raising of Jarus's Daughter), and the Entry into Jerusalem. Another plaque, formerly in the Berlin-Dahlem collection but now lost, represents Christ and the apostles.

Unlike the ivories of the reliquary of Saint Aemilian (cats. 125b–g), those of the reliquary of San Felices depict christological rather than hagiographical scenes. Probably too little was known about Felices—who is only briefly mentioned in the *Vita Sancti Aemiliani* and was never the subject of his own *vita*—to construct a narrative cycle of his life. He is depicted just once, as Aemilian's teacher, in a scene on the reliquary of Saint Aemilian. The creation of a second ivory-plated reliquary at San Millán attests to the expansion of Aemilian's cult and the reliquary's success in attracting pilgrims to the site.

The reliquary of San Felices differs stylistically from the reliquary of Saint Aemilian in that its figures are monumental and somber and its drapery is marked with the double-incised lines found in the Romanesque sculpture of Bernardus Gilduinus at Saint-Sernin, Toulouse (1096) and in later manifestations

of his work. Danielle Perrier argued for an Aragonese provenance for the casket on the basis of its similarities to frescoes from the Romanesque church in Bagues (now in the Museo Diocesano, Jaca) and to sculptural reflections of Gilduinus's style in Aragon. Serafín Moralejo, on the other hand, found stylistic continuity between the two eleventh-century ivory workshops at San Millán de la Cogolla and asserted that the reliquary of San Felices is a link between the transitional illuminations of the Beatus from Saint-Sever, Gascony, and the fully Romanesque sculpture of Jaca and Toulouse.[2]

JAH

1. Moralejo 1989b.
2. Perrier 1984, pp. 125–26; Moralejo 1973a, pp. 14–16.

LITERATURE: Sandoval 1601; Yepes 1609; Debenga 1916–17; Porter 1923, p. 41; Goldschmidt 1914–26, vol. 4, nos. 98, 99; Ferrandis 1928, p. 185; Camps 1933, pp. 13–16; Gómez-Moreno 1934a, pp. 26–27; Cook and Gudiol 1950, p. 292; Barcelona 1961, no. 1777; Lasko 1972, p. 153; Moralejo 1973a, pp. 14–16; Lyman 1978, p. 124; Peña 1978, pp. 123–32; Yarza 1985d, p. 209; Bousquet 1982, p. 51; Estella 1982, p. 445; Moralejo 1982, p. 292; Estella 1984, pp. 38–40; Perrier 1984, pp. 123–26, 127–30; Moralejo 1989b.

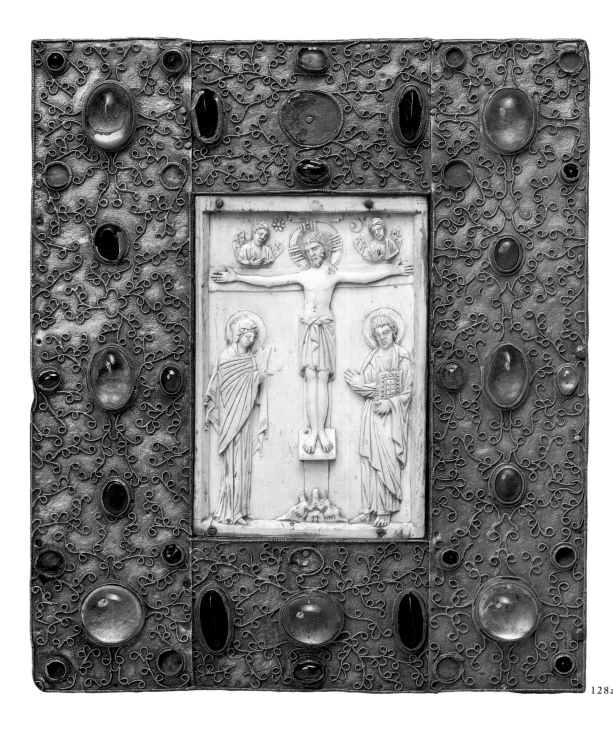

128a

128

two book covers(?) from the monastery of santa cruz de la serós

a. Setting: Jaca, before 1085
Silver gilt with pseudofiligree, a sapphire, glass, and crystal, on wood
Ivory: The Crucifixion
Constantinople(?), late 10th century
10¼ x 8½ in. (26 x 21.6 cm)
b. Setting: Jaca, before 1085
Silver gilt with pseudofiligree, cloisonné enamel, and glass, on wood
Ivory: The Crucifixion
Jaca, before 1085
10½ x 7½ in. (26.7 x 19.1 cm)

a: The Metropolitan Museum of Art, New York; Gift of J. Pierpont Morgan, 1917 (17.190.134)
b: The Metropolitan Museum of Art, New York; Gift of J. Pierpont Morgan, 1917 (17.190.33)

The first plaque (a) incorporates a Byzantine ivory of the Crucifixion, with the Virgin, Saint John, and Angels, which was probably produced in Constantinople at the end of the tenth century. Originally, the ivory formed the central panel of a triptych. Such eastern ivories were highly prized in the West, and its inclusion in a precious setting reveals the special homage accorded these works of art. As is the case with a book cover commissioned by Bernward of Hildesheim (993–1022) that combines a similar ivory in the design,

this type of reuse adds to the value of such objects. Also, just to the right of the Byzantine ivory on the book cover is an early Islamic sapphire sealstone inscribed in Arabic with four of the ninety-nine Islamic "Beautiful Names" of God.

The second plaque (b) also contains an ivory Crucifixion, but this one is not based on the available Byzantine model, thus demonstrating a certain artistic independence. Here, the appliqué figures are attached to a repoussé silver ground, divided into four panels by the cross. An inscription that extends across the two lower panels, FELI/CIA/ REG/INA, links this—and presumably the other Byzantine cover—to Queen Felicia

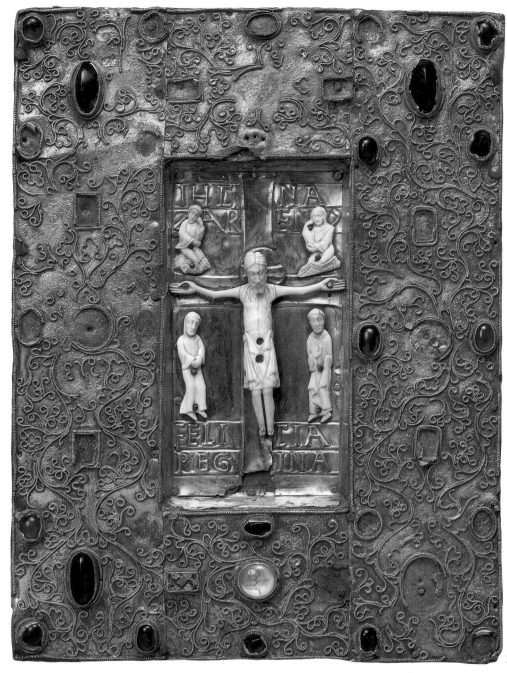

128b

(daughter of Armengol, count of Urgel), the wife of Sancho V Ramírez (ca. 1037–1094), king of Aragon and Navarre. Her death in 1085 thus establishes a terminus ante quem for the plaque. The two upper repoussé panels bear the inscription: IHC/NA/ZAR/EN/VS (Jesus Christ of Nazareth). Small and delicate figures of the Virgin and Saint John frame the living "Christus victor," and above them are personifications of the sun and the moon, which, curiously, display the contemplative, mourning gestures normally reserved for the Virgin and Saint John. Despite their small size, the figures reveal an integrity associated with large-scale sculpture. Furthermore, stylistically, there are no other compa-

rable northern Spanish ivories in Aragon and Navarre from this formative period.

Each frame is constructed of silver-gilt sheets with a meandering floral pattern in pseudofiligree; small pieces of colored glass, mounted to simulate precious stones, surround the central image. Just below the main scene on plaque (b) is one remaining cloisonné enamel that may be of Byzantine origin or, alternatively, it may represent a unique surviving example of this technique as practiced in Aragon.

The celebrated Benedictine monastery of Santa Cruz de la Serós, near Jaca, was reputedly founded by Queen Felicia, who bestowed upon it many gifts, among them an

evangelary that has traditionally been linked to book cover (b). However, neither plaque has any obvious means of attachment in order for it to have functioned as a book cover. Either they were remounted at a later date, as the physical evidence seems to suggest, or else they never were used as book covers at all but perhaps served a votive purpose instead.

CTL

LITERATURE: Madrid 1892, vol. 2, pl. X; Hildburgh 1936, pp. 33–34, fig. 11; Steenbock 1965, no. 68 (with earlier literature); Grodecki, Mütherich, and Tanalon 1973, p. 337, fig. 357; Keene 1981, p. 38, fig. 3; Bousquet 1982, pp. 40–41; Estella 1984, pp. 59–60; Frazer 1985–86, pp. 18–19; Naval 1991, p. v.

Reliquary Diptych of Bishop Gundisalvo Menéndez

Oviedo (Oviedo), early 12th century and 1162–74
Silver, silver gilt, niello, ivory, and glass cabochons, on a
wood core
6½ x 10¼ x 3 in. (16.5 x 26 x 7.6 cm)
Cámara Santa, Oviedo Cathedral

Both the inside and outside of this diptych contain very similar iconographic themes, which is unusual for one object: the Crucifixion with the Virgin and Saint John and Christ in Majesty surrounded by the symbols of the evangelists. The niello design and the style of the figures on the exterior are more characteristic of northern European models. Likewise, the representation of Christ on a cross of pruned branches indicative of the tree of life is another feature found more often in the north. The niello images have been compared to the engraved Majesty on the casket of Saint Demetrius (cat. 123) in Loarre, of about 1100, and to the portable altar from Celanova now in Orense, of 1090 to 1118,¹ suggesting that the diptych originally consisted of only the niello images in the early twelfth century.

Represented on the interior of the left panel of the diptych are the Crucifixion, with ivory appliqués of the mourning Virgin and Saint John on either side of the cross; above at the right, an angel with the moon symbol remains; and below, Adam rising from the grave. Until it was lost in an explosion at the Cámara Santa in 1934 there was above Christ a small enthroned late thirteenth-century ivory Virgin and Child, which was added at an unknown date. On the right side of the diptych Christ is shown in a mandorla surrounded by the symbols of the evangelists. (The head of Christ here was also lost in that same explosion.) Each scene is recessed in the field of the diptych and is enframed by a silver-gilt pseudofiligree border set with cabochons within a niello frame in which there is an inscription that extends around all four sides of the panel. The inscription on the left side reads:

+ IN NOMINE : DN̄I : NR̄I : IHV XPI/
GVNDISALVVS : EP̄S : ME : IVSSIT : FIERI : HE :
SVNT/RELIQVIE : QVE : IBI : SVNT : /DE
LIGNO : DN̄I : S : M[A]RIE : V̄G : S.IDHĪS :
ALPI : ET ĒVGLĒ :

In the name of our Lord Jesus Christ, Bishop Gundisalvo commissioned this work; here are found [the relics] of the wood [cross] of the Lord, of the Virgin, of Saint John [the Apostle and Evangelist].

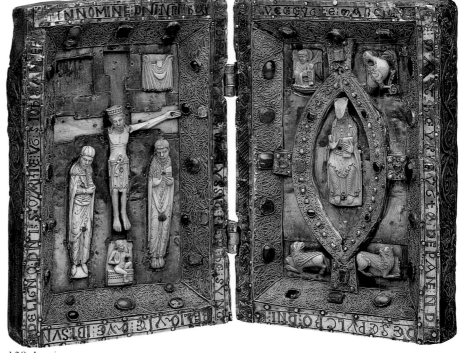

129: Interior

The inscription on the right side reads:

LVCE ĒVGLĒ : MARCI ĒVG/LĒ : MATHEVS :
ĒVGLĒ : DE PANE : N̄DN̄I/DE SEPVLCRO : DN̄I :

Of Evangelist Luke, of Evangelist Mark, of Evangelist Matthew, of the bread of our Lord, of the sepulcher of the Lord.

Serafín Moralejo has observed a different epigraphy for the portion of the inscription that mentions Bishop Gundisalvo Menéndez, who held office from 1162 to 1174, and suggests that he commissioned the remaking of

129: Exterior

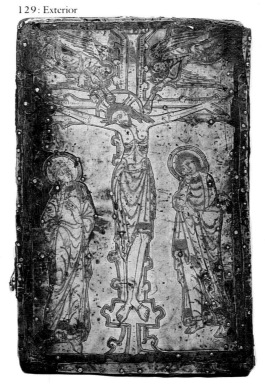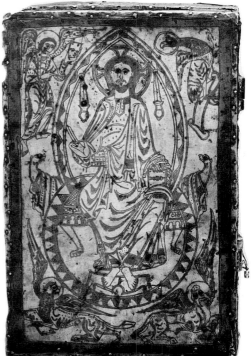

the diptych (including the ivories) to accommodate the relics when in actuality he was attaching his name to an older object.² Nevertheless, the function of the diptych was not only devotional, but it also served both as a receptacle for the many relics enumerated in the inscription and as a portable version of the Arca Santa (cat. 124). A date in the third quarter of the twelfth century conforms perfectly with the style of the ivory carvings. Moreover, the fleshy repoussé vine-scroll patterns in silver and silver-gilt filigree on the

borders and edges of the diptych are virtually identical to the designs on the silver processional cross from San Salvador de Fuentes (cat. 130), indicating that both were the product of a single workshop in Oviedo.³ The impact of northern sculpture is especially evident in the ivories, which appear to have been inspired by the sculpture on the west facade of Chartres Cathedral.

<div style="text-align: right;">CTL</div>

1. Moralejo 1982, p. 290.
2. Ibid., p. 290, n. 48.
3. Manzanares 1972, p. 36.

LITERATURE: Manzanares 1972, pp. 30–36, pls. 41–52 (with previous literature); Moralejo 1982, pp. 288–91.

130

RELIQUARY CRUCIFIX

Church of San Salvador de Fuentes (Asturias), ca. 1150–75
Silver, silver gilt, and niello repoussé, over a wooden core, with pearls, antique intaglios, semiprecious stones, glass, a sapphire, and a garnet(?)
23¼ x 19 in. (59.1 x 48.3 cm)
The Metropolitan Museum of Art, New York; Gift of J. Pierpont Morgan, 1917 (17.190.1406)

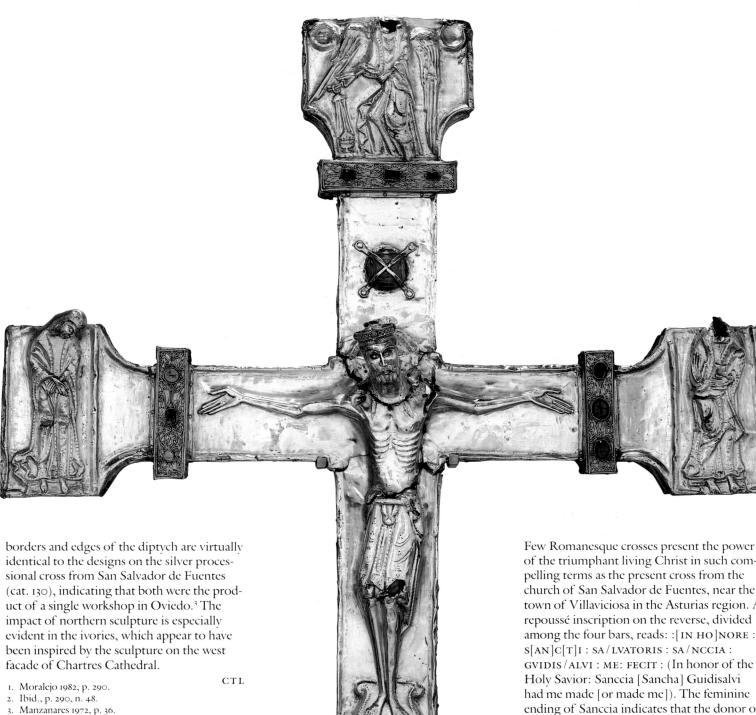

130

Few Romanesque crosses present the power of the triumphant living Christ in such compelling terms as the present cross from the church of San Salvador de Fuentes, near the town of Villaviciosa in the Asturias region. A repoussé inscription on the reverse, divided among the four bars, reads: :[IN HO]NORE : S[AN]C[T]I : SA/LVATORIS : SA/NCCIA : GVIDIS/ALVI : ME : FECIT : (In honor of the Holy Savior: Sanccia [Sancha] Guidisalvi had me made [or made me]). The feminine ending of Sanccia indicates that the donor or maker was a woman, although apparently nothing is known about her.

The small church of San Salvador still stands in the remote hills some fifty miles east of Oviedo. Probably a royal foundation, the church was established in the eleventh century and dedicated either in 1023 or 1063; part of the present structure dates to the twelfth century, and the rest is later. The cross remained there until the end of the nineteenth century.

Originally conceived for processional use, the cross is constructed on a wooden core. Hardened wax forms underneath add stability to the repoussé silver panels. In addition, on each terminal is a bar of silver-gilt pseudo-

filigree that originally contained three settings of glass or intaglios of antique origin. Only two intaglios remain, one showing a Nike with a laurel wreath and torch and the other a male nude with a fish and a spear. These mounted intaglios are similar in character to those on the Cross of the Angels (cat. 72), and their reuse in both cases signifies a like reverence for such precious objects.

The body of the crowned Christ triumphantly rests on the suppedaneum of the cross—an image frequently seen in Romanesque Spanish art (see cat. 102). On the terminal to his right is the mourning Virgin and on the terminal to his left is Saint John. The lower terminal contains the resurrected Adam rising from his tomb, recalling the figure at the foot of the Cross of Ferdinand and Sancha (cat. 111). On the upper terminal is a censing angel between the symbols of the sun and the moon. Of these four terminal figures, only the Virgin is complete; the heads of the others are missing. A hemispherical clear crystal with red glass bosses is fastened above Christ, covering a reliquary cavity, inside of which there are unidentified relics of a raw-silk textile.

The reverse of the cross contains a repoussé image of the Lamb of God at the central crossing and the symbols of the four evangelists on the terminals (the angel of Matthew is missing). The rich and exotic rinceau pattern on the arms is probably a reference to the cross as the tree of life.

The date of the cross can be established because of its stylistic relationship to the diptych of Bishop Gundisalvo Menéndez of Oviedo (cat. 129), which was made between 1162 and 1174. The pseudofiligree work on the diptych and on the New York cross is the same in technique and in spirit of design, and the repoussé rinceau patterns on the edge of the diptych are virtually repeated on the cross—similarities close enough to suggest that both objects are the product of the same hand and must have been created in Oviedo by an artist employed by the Church or ruling house. The exceptional quality of the workmanship and, above all, the special interest in including antique intaglios (for which there was considerable admiration) in the designs reveal a veneration for the art of the past not unlike that which led to the incorporation of Islamic works in Christian contexts.

CTL

LITERATURE: Amador de los Ríos 1877, vol. 5, pp. 35–37; Ferrandis 1928, p. 147; Hildburgh 1936, p. 84, no. 5, pl. XVI, fig. 33; Manzanares 1972, p. 36; Moralejo 1982, p. 301, no. 48; Little and Husband 1987, pp. 52–53.

131

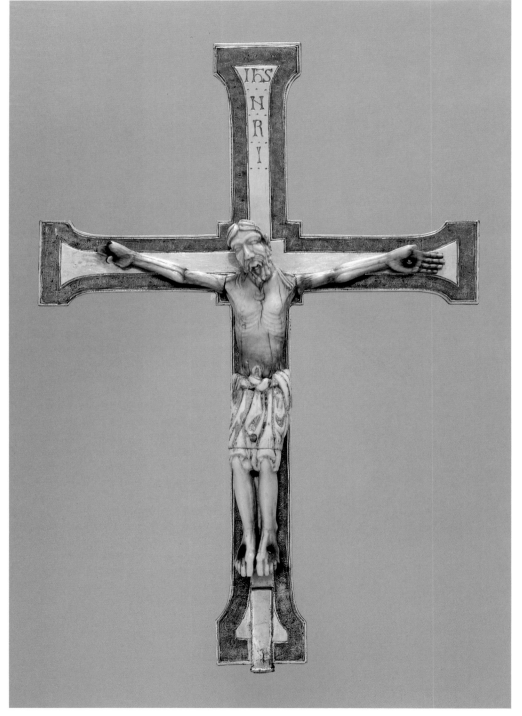

131

CRUCIFIX

Northern Spain, second half of 12th century
Silver, silver gilt, niello, and ivory with gilding
10⅜ x 7 in. (26.4 x 17.8 cm)
The Metropolitan Museum of Art, New York; Gift of
J. Pierpont Morgan, 1917 (17.190.221)

Christ is depicted here without a nimbus or crown, and his suffering is conveyed in exceptionally naturalistic terms. His fleshy, sagging cheeks and prominent ribs reveal the sculptor's unusual interest in anatomical detail, yet the hands and feet are disproportionately large. The arms, the lower portion of the perizonium, and the legs are carved from separate pieces of ivory. Between Christ's shoulders are two small cavities—one rectangular and the other circular—that functioned as receptacles for relics in a way similar to those found on the Cross of Ferdinand and Sancha and the Christ of Carrizo (cats. 111, 114).

The silver cross itself is barely large enough to contain the corpus, suggesting that it may be an early replacement. Inscribed on the vertical shaft are the letters IHSINRI, an abbreviated form of Iesus Nazarenus Rex

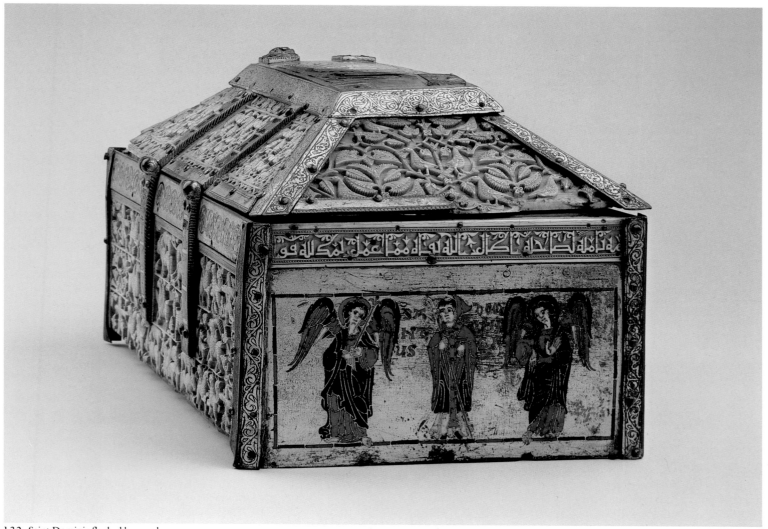

132: Saint Dominic flanked by angels

Iudaeorum. A tongue originally projected from the base of the cross, so that it could be attached to a foot for an altar setting or for carrying in a procession. The borders of the arms of the cross are decorated with a niello pattern of repeating semispirals, and on the reverse there is a niello border of circles and an inset schematic leaf design.

Despite the lack of a known provenance, the crucifix may be compared with other similar examples whose origins are known. In spirit, the carving is not unlike that of the twelfth-century torso of the Christ from Mig-Aran (cat. 166); it also has been compared with another ivory crucifix, in Canosa di Puglia (Italy), that is dated about 1100. The bold and direct presentation recalls a number of Leonese ivories (cats. 115a–c). Chronologically it appears to follow the ivory image on the diptych of Bishop Gundisalvo Menéndez (r. 1162–75) in Oviedo (cat. 129).

CTL

LITERATURE: Goldschmidt 1914–26, vol. 2, no. 27; Breck 1929, p. 52; Cook and Gudiol 1950, p. 293; Gaborit-Chopin 1978, p. 202; Bousquet 1982, p. 45; Estella 1984, pp. 76–77.

132

Reliquary casket of saint Dominic of silos

Casket: Cuenca (Cuenca), 1026 (dated A.H. 417); mounts: Monastery of Santo Domingo de Silos (Burgos), ca. 1150–75
Ivory and wood, with gilt-copper and champlevé enamel mounts
7½ x 13⅜ x 8¼ in. (19 x 34 x 21 cm)
Museo de Burgos (106)

A truncated pyramidal cover surmounts this rectangular casket, which was originally composed entirely of ivory panels attached to a wooden core. However, the box has been damaged, and the areas sustaining losses have been replaced with enamel decoration.

The design of the front and back of the box is laid out in three horizontal bands carved with animal and plant motifs and human figures. The top panel on the front of the casket displays, proceeding from each corner toward the center, a vertical arabesque scroll, a running archer, two pairs of rearing lions with crossed bodies—the foreground pair confronted, the background pair addorsed—a

lion on the back of a bull it is attacking, and a vertical arabesque scroll. In the center is an umbrella with a rectangular space beneath it for the casket's now absent clasp. The middle register has, at either of its ends, a two-tiered arabesque design in candelabrum form; in its left half, a pair of confronted winged griffins separated by a tree of life flanked by a pair of small confronted quadrupeds (foxes?) with heads turned back; and in its right half a pair of confronted winged ibexes separated by a smaller tree of life with one quadruped to its right. Beneath the space left for the clasp in this register is a small arcade formed of half palmettes with a palmette in the center of each arch. The decoration in the bottom panel repeats that of the top register, with the addition in the center of a mounted warrior with sword and shield who combats a lion attacking from the rear. The three panels were surrounded by a narrow guilloche border, the bottom of which is now missing. The carving of the back of the casket is like that of the front, except for changes in spacing, size, and number of motifs demanded by the presence of double

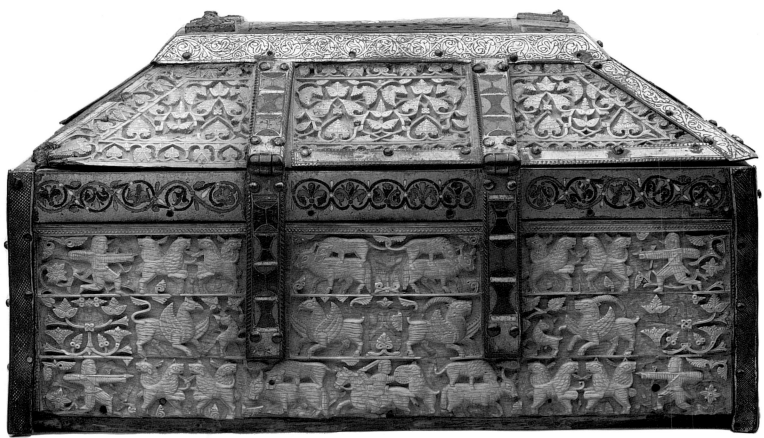

132: Back of casket

hinges: the half-palmette-tipped tails of the lion and bull pairs in the top center are here intertwined, and the four small quadrupeds in the middle panel of the front are here reduced to what seem to be two diminutive lions.

The decoration of the right end of the casket is also organized in three horizontal panels, but the upper and lower ones are each subdivided into five sections: two smaller areas at either end, and a larger central area. Each outer compartment contains a full-faced lion, biting a gazelle from behind. In the top center a stag(?) appears to munch a large leaf spray. The center section of the bottom panel contains five quadrupeds (deer?) within circular stems that sprout into arabesque scrolls at the top of the field. The undivided middle panel shows a pair of peacocks with intertwined necks in the center, flanked by two stags, each surrounded by half-palmette leaves and scrolls. The front and back of the lid, separated by the clasp and hinges into two and three sections, respectively, are carved with an arabesque design bordered by a leaf scroll. The left side has birds scattered through half-palmette leaves and scrolls. The right side is missing.

A band with an inscription in floriated Kufic runs along the top of the left and right sides of the casket but is missing from the front and back, where it is replaced by enamel decoration. It reads:

قو[نكة] [سنة] سبع عشرة وأربع مائة عمل محمد بن زيان عبده أعزّه الله (؛

. بة تامنة لصاحبه أطال الله بقاه ممّا عمل بمدينة

. . . enduring for its owner, may God prolong his life. From among that which was made in the city of Cu[enca] . . . [in the year] four hundred seventeen [A.D. 1026]. The work of Muhammad ibn Zayyan, his servant; may God grant him renown.

E. Lévi-Provençal states that the formula "May God prolong his life" was used for sovereigns. It might be assumed that a casket such as this would have been made for the most important dynasty of the eleventh century in the area, the Dhu al-Nun of Toledo. However, in 1026 this dynasty was not yet in power, nor was Cuenca within Toledo's orbit. Lévi-Provençal suggests that the casket may have been made for Abu Bakr Yaʿish ibn Muhammad ibn Yaʿish al-Asadi, who ruled in Toledo until 1031 and was the immediate predecessor of Ismaʿil al-Zafir ibn Dhu al-Nun, King of Toledo, or for the father of al-Zafir, ʿAbd al-Rahman ibn Dhu al-Nun, the lord of Santaver, of which Cuenca was a dependent. Ernst Kühnel believes that the latter is the more likely candidate.[1]

As Kühnel has pointed out, a new compositional principle prevails in this casket, namely the disposition of the design in horizontal bands rather than within the medal-

lions or arcades of caliphal period examples from Córdoba. The design elements themselves are derived from a variety of sources. The lion and bull pair, the winged griffin, the crossed lions, and the animals with intertwined necks or tails, for example, are based on earlier Near Eastern motifs.[2] The arabesque and vegetal forms in particular echo precedents from Córdoba/Madinat al-Zahraʾ, but, like the rest of the elements, are considerably cruder, more repetitive, and flatter than their caliphal prototypes.[3] These characteristics contribute to a certain almost barbaric vigor that gives this object considerable appeal.

Treasured for its preciousness of material and workmanship, the Islamic ivory casket was adapted for use by the Benedictine monks of the monastery of Santo Domingo de Silos in the mid-twelfth century. Whereas the imagery of some Islamic ivories, such as the pyxis preserved at Braga (cat. 73) or the Madrid Cuenca coffret, was not substantially altered for Christian use, in this example both decorative strapping and Christian subjects were added. An enameled plaque set in the left end represents the patron saint of the monastery of Silos flanked by angels. A second rectangular enamel plaque set into the lid depicts the Lamb of God with the Alpha and Omega enclosed in a circular medallion and surrounded by paired fantastic dragonlike creatures.

It is not clear whether the casket was meant

132: Detail of back

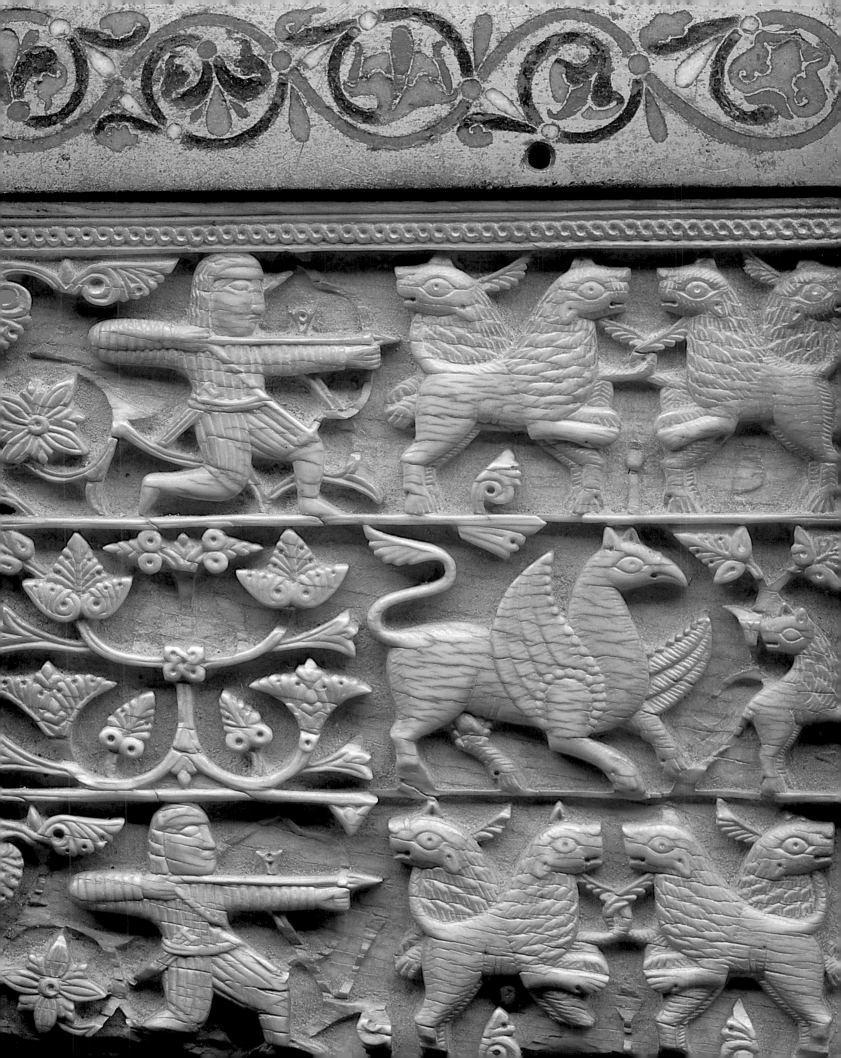

specifically to house relics of Saint Dominic, whose body was translated in 1076 in the presence of Alfonso VI and then moved again to the sepulcher below the altar of the new chapel before the thirteenth century. The coffret has been identified as the one described in the 1440 inventory of the abbey as "una arca de marfil labrada a la morisca, la cual se llena de reliquias de las honze mil virgines" (an ivory coffret worked in the moresque manner, which is filled with relics of the eleven thousand virgins [companions of Saint Ursula]).

The vermiculé patterns of the gilt bands on the roof and the muscular figure of the Lamb of God are very close to those on the reverse of the cross in the Metropolitan Museum (cat. 136). The creatures surrounding the Lamb resemble ones on the rectangular plaques of the Silos *urna* (cat. 134). Stylistic comparisons can also be made between metalwork preserved at Silos and objects produced for the Limousin. The beasts surrounding the Lamb of God of the casket parallel the hy-

brid forms of the casket from Champagnat (cat. 133) in both form and palette; and the figural style of the Saint Dominic plaque can be compared with that of the same casket, notably in the figures' curling mops of hair, the rendering of the hands, and the use of reserved metal to define facial features.

To account for these similarities, it is important to remember that champlevé enameling on copper was an established tradition in south central France from at least the early eleventh up to the fourteenth century and that there are no known antecedents for or descendants of the group of enamels made for Silos in the twelfth century. It is therefore reasonable to suggest that a goldsmith schooled in the Limousin created the enamels of the reliquary casket of Saint Dominic.

B D B / M L S

1. Lévi-Provençal 1931, no. 206, p. 190; Kühnel 1971, no. 40, p. 47.
2. Kühnel 1971, p. 47, and text figs. 2, 3, 47, 48.
3. The casket from the cathedral of Palencia, now in the Museo Arqueológico Nacional in Madrid, made in

the same workshop in 1049–50, is still flatter in its carving and more repetitive in its design. See New York 1992a, ills. pp. 204–6.

LITERATURE: Roulin 1899, pp. 252–55; Lévi-Provençal 1931, no. 206, p. 190; Juaristi 1933, pp. 181–82, fig. 49; Hildburgh 1936, pp. 55, 67, 77, 92, pl. VIa; Beckwith 1960, p. 30, pl. 31; Gauthier 1962, p. 400; Kühnel 1971, no. 40, pls. XXXII–XXXIV; Lasko 1972, p. 229, fig. 263; Gauthier 1987, no. 68.

133

reliquary casket

Castile or the Limousin, ca. 1150–75
Champlevé enamel on gilt copper; modern wood core
4⅞ x 7⁷⁄₁₆ x 3⅜ in. (12.4 x 18.9 x 8.5 cm)
The Metropolitan Museum of Art, New York; Gift of J. Pierpont Morgan, 1917 (17.190.685–687, 695, 710–711)

The brilliantly contrasting colors and boldly animated vegetal and figural forms of this casket are hallmarks of a small number of

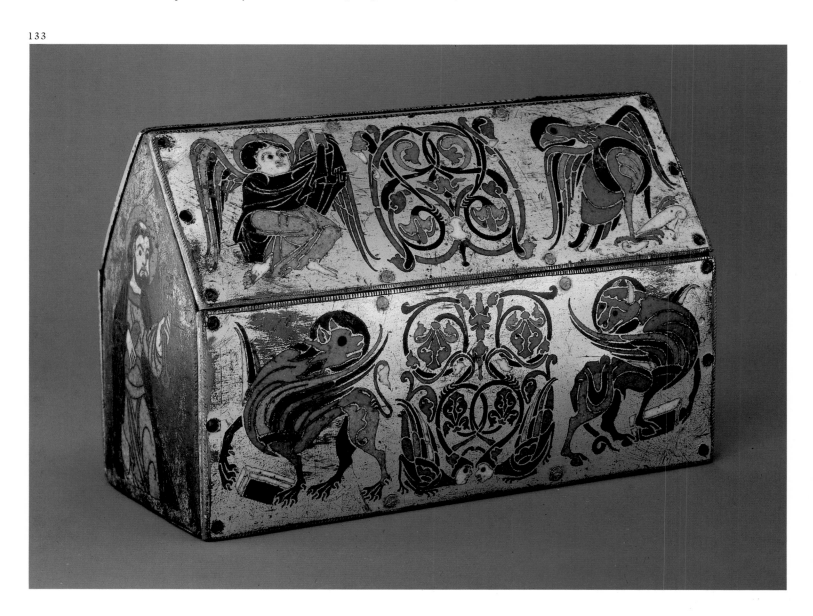

works from French and Spanish collections whose place of manufacture has been debated by scholars for decades. The interlacing hybrid forms in the lower central back panel of this casket closely relate to the decoration on enamels created for the monastery of Santo Domingo de Silos, especially the intertwining dragonlike beasts on the *urna* (cat. 134) and the enameled plaque crowning the ivory reliquary casket of Cuenca preserved in Burgos (cat. 132).

There is no documentation for medieval enamelers at Santo Domingo de Silos or Burgos as there is for Limoges. Yet the presence of goldsmiths at Burgos can be inferred, since the city had a royal mint in the twelfth century.[1] Furthermore, close political and monastic links between the two realms argue for the creation of enamels in Castile as in the Limousin. Alfonso VIII of Castile and his wife, Eleanor of England, were documented patrons of the monastery of Santo Domingo de Silos between 1177 and 1202.[2] Limoges was a jewel in the crown of Eleanor's parents, Henry II and Eleanor of Aquitaine, who wished to make the abbey of Grandmont, north of Limoges, their royal necropolis. Monastic personnel moved between the two regions. It is reasonable to suggest that goldsmiths in monastic or royal employ might create works for affiliated communities, as is documented to have been the case with traveling goldsmiths in eleventh-century England, for example.[3]

Iconographic and documentary evidence indicate that the present casket was intended for use in the Limousin. Christ appears at the center front, beneath the roof plaque with the hand of God and two angels swinging censers. Flanking him are "Maria," holding a palm frond and unguent jar, and "Marcialis." Saint Peter, holding the keys to the kingdom of heaven, and Saint Paul, the other principal apostle, appear on the sides. Symbols of the four evangelists decorate the reverse. "Maria" has often been identified in the literature as the Magdalene, though it is curious that she should be given more prominence than the apostles. More likely she represents the Virgin Mary, as on the chasse preserved at Bellac, where she likewise holds a palm as an attribute and is identified by inscription as Mary, Mother of God.[4] The elevation of Saint Martial, the first bishop of Limoges, to a position next to Christ, more prominent than that of either Saint Peter or Saint Paul, is a distinctly Limousin choice. The relics of Saint Martial were venerated at Limoges, one of the important stops on the pilgrimage road to Santiago. Devotion to him likewise existed in Spain: his name appears in the calendars of Silos manuscripts by at least the eleventh century,[5] and he is depicted in the twelfth-century frescoes in the church of San Isidoro,

León. Only at Limoges, however, was Saint Martial ranked with the apostles by decree of a church council convened there in 1031;[6] this status would entitle him to the place he occupies on the present casket, parallel to that assumed by Saint Peter on the eucharistic casket attributed to Master Alpais from the collection of the Musée Municipal, Limoges.[7]

The casket, lacking the plaque of Saint Peter, appeared in the Laforge collection sale in Lyons in 1868. The plaques were already separated from their wood core when they were seen on the art market by Molinier in 1891. The plaque with Saint Peter was reunited with the group by the time the enamels were in the Hoentschel collection (after 1900—sold to J. Pierpont Morgan, 1911). Marvin Ross discovered the reliquary's original disposition and its provenance recorded in a drawing made before 1864, when it belonged to the church at Champagnat (Creuse), located about 62 miles (100 km) northeast of Limoges. The church, dedicated to Saint Martial in the ninth century, and the property of the counts of La Marche and then of Henry II, was probably the original destination of the casket that gives prominence to its patron saint.

B D B

1. See Rueda 1991, pp. 63, 66.
2. Férotin 1897, pp. 103–25.
3. See Dodwell 1982, p. 58.
4. Gauthier 1987, no. 57.
5. See Schapiro 1939, p. 96 n. 197.
6. See Lasteyrie 1901, pp. 74–80.
7. See Wixom 1967, no. III/35, pp. 114, 358–59.

LITERATURE: Molinier 1891, pp. 132–33; Hildburgh 1936, pp. 57–58, 77, 89, fig. 8b; Ross 1939, pp. 467–77; New York 1954, no. 8, pl. VII; Hoffmann 1970, no. 140, pp. 136–37; Lasko 1972, pp. 229–31, fig. 262; Gaborit-Chopin 1983, pp. 324–25 (ill.); Gauthier 1987, no. 132, pp. 123–24; Gauthier 1990, p. 386.

134

panels from urna of saint dominic of silos

Burgos or Silos (Burgos), ca. 1150–70
a. Lid
Émail brun
20½ x 99⅝ x 1 in. (52 x 253 x 2.5 cm)
Monastery of Santo Domingo de Silos (Burgos)
b. Front
Gilt copper, champlevé enamel, and cabochons on wood core
33½ x 92⅛ x 1⅛ in. (85 x 234 x 3 cm)
Museo de Burgos (106)

Sometime after 1076 and before the beginning of the thirteenth century, the body of Saint Dominic, founder of the monastery at Silos and venerated as its patron saint, was moved to a new tomb below the altar of the new chapel. According to the early thirteenth-century chronicler Pedro Marin, the tomb bore an image of Christ in Majesty and the twelve apostles that nevertheless allowed the stone of the underlying sarcophagus to be seen. The enamel and émail brun friezes preserved at Burgos and Silos were identified by Manuel Gómez-Moreno in 1939 as surviving elements of that tomb and are known as the *urna* of Saint Dominic. By examining the wooden supports, Gómez-Moreno determined that the enamel panel, which had been taken to Burgos in 1831, had once occupied the front face of the tomb's revetment and the émail brun panel still at Silos had covered its sloping roof. Through the arcading at the bottom of the front panel, the faithful would have been able to see the original stone sarcophagus. Indeed, the wooden support underlying the copper is blackened from the burning of votive candles.

In the center of the front panel Christ appears in majesty, set in a jeweled mandorla, sitting on a rainbow, his feet on a footstool. He rests his left hand on a book and raises his right hand in blessing. Around him are the symbols of the evangelists holding the books of their gospels. Extending to the right and left of Christ are arcades between whose columns the twelve apostles stand, their heads in high relief against their haloes, which are brilliantly colored and inventively designed so that no two are alike. From the arches spring fictive roofs and towers suggesting the Heavenly Jerusalem. On horizontal bands above and below engraved with vermiculé decoration, rectangular plaques containing enameled intertwining creatures alternate with settings for now-missing cabochon stones. At the panel's left and right ends are narrow foliate bands. The spandrels of the open arcade at the bottom carry checkerboard decoration.

The *urna* enamels bear comparison with others in this catalogue. The stylized birds in the framing bands are particularly close to decoration on the back of the casket from Champagnat (cat. 133); the palette and the articulation of the drapery recall the book-cover plaques in Paris and Madrid (cats. 135a, b).

The *urna* is unusual among surviving twelfth-century works for its extensive use of émail brun, the medium in which the roof panel is executed. At the center of this lid is an image in relief of the Lamb of God in front of a cross and inscribed in a circle of vermiculé once set with cabochon stones. To the left and right stand twelve nimbed figures holding books as their attributes, positioned

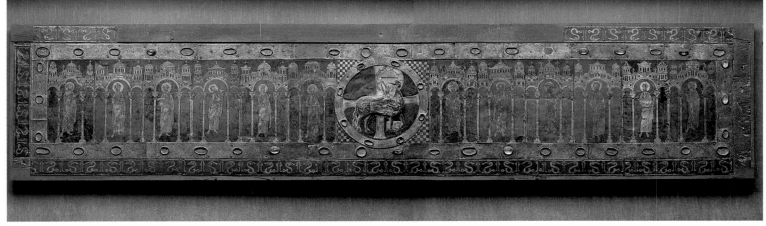

134a

within an arcade that supports another pano-
ramic display of a Romanesque skyline. The
whole is framed, first by a band of vermiculé
decoration into which large collets are placed,
and then by bands of a Kufic inscription in
which the word *yumn* (happiness) is repeated.
A checkerboard pattern frames the circle of
the Lamb.

The émail brun panel shares qualities of
design and decorative motifs with the enamel
panel, but the style of its figures is quite
distinct. These standing figures are consider-
ably more lithe and their actions more animated
than those of their enameled counterparts,
suggesting that they were made later in the
twelfth century. Indeed, Peter Lasko has pro-

posed that the émail brun panel represents a
later addition to the *urna* in which aspects of
the earlier design were adapted. The com-
bined iconographic program of the two pan-
els is curious. The figures flanking the Lamb
hold books, seeming to indicate that they are
apostles; in that case they duplicate the enam-
eled figures. But if the émail brun figures are
prophets, as Marie-Madeleine Gauthier sug-
gests, their placement above the figures of
the apostles implies an unlikely hierarchical
relationship for a work produced in the
Middle Ages.

Of other enamel-faced tombs of the twelfth
century either partially preserved or known
from documentary evidence, the most use-

fully compared to the Silos *urna* for its struc-
ture and program is the tomb of Ulger,
bishop of Angers (d. 1148). Its wooden core
survives, as do eighteenth-century drawings
and antiquarian descriptions. Executed in
enamel on the roof were images of Christ in
Majesty flanked by prophets and evangelists.
On the front face the image was set, logically,
below the lid's figure of Christ, and on either
side of Ulger local church officials were de-
picted within arcades decorated in émail brun.

BDB

LITERATURE: Gómez-Moreno 1941; Lasko 1972,
pp. 230–31, figs. 264–66; Gauthier 1987, no. 81A–81B,
pp. 90–91, pl. LXIX (with previous literature and additional
documentation pp. 85–92); Gauthier 1990, pp. 383–85,
figs. 7, 8.

134b

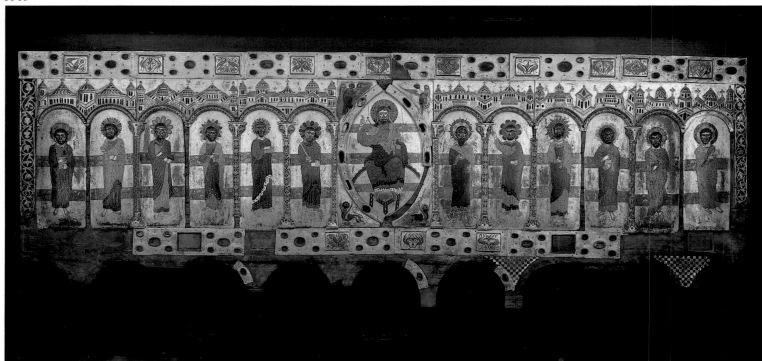

134: Detail

two plaques from a book cover

Castile or the Limousin, ca. 1170
Champlevé and cloisonné enamel on gilt copper
a. Christ in Majesty
9⁹⁄₁₀ x 5³⁄₈ x ¹⁄₈ in. (23.6 x 13.6 x 3 cm)
Musée National du Moyen Âge, Thermes de Cluny, Paris
(CL.13070)
b. Crucifixion
9⅛ x 5⅜ x ¹⁄₃₂ in. (24.5 x 13.8 x 4 cm)
Instituto de Valencia de Don Juan, Madrid

While neither the Cluny nor the Madrid plaque was known before the mid-nineteenth century, their close approximate dimensions, style, and palette indicate that they once formed part of the same ensemble. In addition, the plaque in Madrid is engraved with the Greek letter alpha on the reverse in a manner that closely resembles the alpha that appears next to Christ on the Cluny plaque.

The pairing of the Crucifixion and Christ in Majesty suggests that they constituted the upper and lower central plaques of a book cover, one of the chief uses for champlevé enamel from the mid-twelfth to the second quarter of the thirteenth century. More than 130 surviving plaques attributed to Limoges have been recorded.[1] A number of book covers from which only the central plaque survives are approximately the same size as these.[2] If these were book-cover plaques, however, it is surprising that neither piece is pierced to allow it to be nailed to an original underlying wooden support and that the metal is not worn at the edges from having been set into a band of framing metal.

While the iconographic details of book-cover plaques produced at Limoges quickly became standardized, these examples stand apart—if not by subject then by the accomplishment of the engraving and by the varied and distinctive palette and quality of the enameling. Walter L. Hildburgh compared the forms of the evangelist symbols on the Cluny plaque with decoration in Spanish manuscripts, but Marvin Ross's comparisons of the Christ with images in manuscripts from the abbey of Saint-Martial, Limoges, are equally compelling. The monumental effect of the Christ in Majesty and the forms of the evangelist symbols recall the Majesty image on the *urna* of Santo Domingo de Silos (cat. 134). It is presumably for this reason that Marie-Madeleine Gauthier attributed the pair of plaques without reservation to an enameler working at Silos. Yet the figural style and applied head on the Cluny

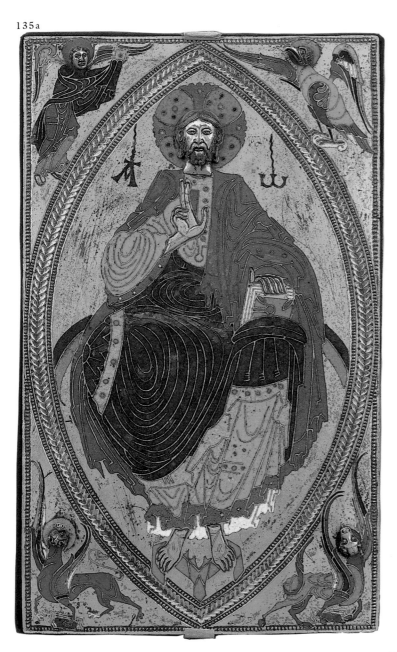

135a

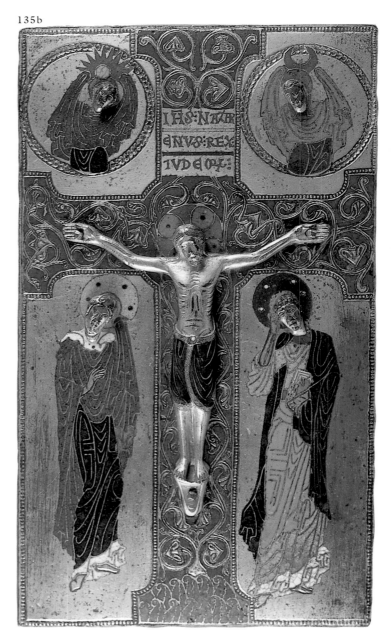

135b

plaque are more elegant than those of the *urna* and cannot represent the same hand.

BDB

1. Gauthier 1968, pp. 271–87.
2. Gauthier 1987, nos. 203, 213.

LITERATURE: Palustre and Molinier 1890, no. 3, pp. 96–97, pl. III (Paris plaque); Rupin 1890, p. 150 (Paris plaque); Hildburgh 1936, pp. 90–92, pl. XVII, figs. 23a, 23b; Ross 1939, pp. 472–73; Hoffmann 1970, no. 136, p. 132; Gauthier 1972, pp. 90–91, nos. 42, 43, figs. 86, 87; Gaborit-Chopin 1983, pp. 324–25; Gauthier 1987, nos. 133, 134, pp. 124–26.

136

CROSS

Northern Spain, ca. 1135–45
Gilt copper and champlevé enamel
8⅛ x 5⅝ in. (20.5 x 14.4 cm)
The Metropolitan Museum of Art, New York; Gift of
George Blumenthal, 1941 (41.100.154)

Made of a single sheet of copper, this cross bears the enameled image of Christ on the obverse and the engraved Lamb of God on the reverse. The figure of Christ fills the lower terminal and cross arms, the vibrant white enamel of his flesh and deep blue of his loincloth dramatically set against the gilt metal surface. The identifying inscription, IHS XPS (Jesus Christ), is set in the upper terminal. The Lamb of God, wearing the halo of Christ and emblematic of Jesus' sacrifice, as described in John (1:29), stands in the circular medallion at the center of the reverse. The letters alpha and omega are engraved on either side of its head, and it holds a book between its front hooves. Of relatively small size compared with surviving enamel crosses of the twelfth century, this example has slightly flared terminals, a circular medallion at the crossing, and a tapered stem, by means of which it would have been attached to a base or a staff.

The attribution of this cross, like that of many small objects, is complicated by its portability. The cross was first published as Spanish in 1955, though Metropolitan Museum archives indicate that as early as 1950 Paul Thoby proposed this attribution.

The style of the Christ, with such distinctive features as the massive neck, long, thick hanks of hair, large nose, and prominent thumbs, is close to that of crosses preserved in Paris, Baltimore, and Riggisberg. However, none of these can be traced earlier than nineteenth-century French private collections.

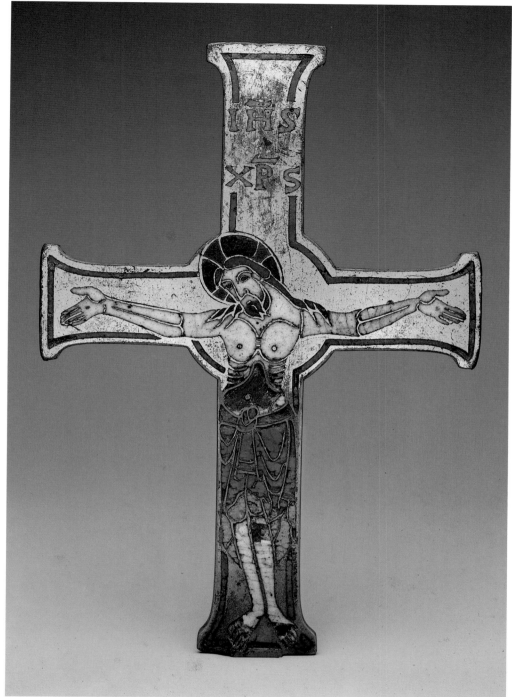

136

The clear, simple lines of the engraving on the reverse, consisting of trefoils set along a scrolling vine, recall the engraving that borders the émail brun figures on the *urna* of Santo Domingo de Silos (cat. 134). The design is likewise very close to one of the border patterns found on the Annunciation to the Shepherds ceiling fresco at the Pantheon of the Kings, León, painted during the reign of Ferdinand II (1157–88). While shared conventions are also to be seen in the realization of the pastoral animals—notably the use of paired lines to define haunches and musculature—the comparisons between the fresco and the enamel cannot be extended

to the figures. Nor does the enameling bear comparison with the Saint Dominic plaque on the casket from Cuenca (cat. 132) either in palette or in figural style.

A general trend in enameling toward virtuoso carving of the copperplate in imitation of the technique of cloisonné and more highly patterned surfaces found on such monuments as the Silos *urna* suggests that the cross must predate the mid-twelfth century.

BDB

LITERATURE: New York 1913, Introduction (p. 14), no. 21 (ill.); Rubinstein-Bloch 1926, pl. XV; New York 1954, no. 9; Gauthier 1987, no. 63, p. 76, pl. XXV, figs. 161, 162.

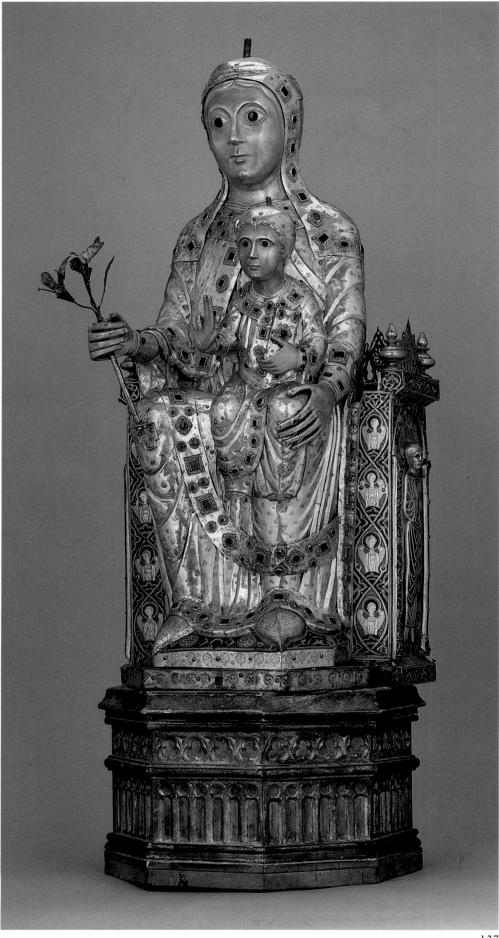

VIRGIN AND CHILD (LA VIRGEN DE LA VEGA)

Salamanca (Salamanca), ca. 1200
Gilt-copper alloy, champlevé enamel, and cabochons
on wood core
H. 28⅜ in. (72 cm)
Old Cathedral, Salamanca

Sheathed in a gilt-copper alloy, studded with jewels, the Virgin and Child sit on an enameled throne. Jesus holds a book in his left hand and raises his right hand in blessing. The Virgin holds him on her left knee; her right hand grasps a stalk that probably once supported a lily or an orb. The Child's feet are lost. A footstool rests before the polygonal throne, which is replete with busts of angels in enameled lozenges and appliquéd enamel figures of prophets or apostles standing under a Romanesque arcade with crenellated towers.

Posed together in this way, the Virgin and Child are presented as the Throne of Wisdom (*sedes sapientiae*). In this metaphor the Child symbolizes the word of God and Mary the throne of the biblical King Solomon.[1]

The distinctive physiognomies of the Salamanca Virgin and Child, with their moon-shaped faces and puffy almond eyes, are echoed in other, smaller images of the Virgin and Child, like the one in the Metropolitan Museum (cat. 138). The presence of goldsmiths in Salamanca is recorded beginning in the twelfth century, so it is reasonable to assume that the sculptures were made there.[2] Yet the artist responsible for this Virgin and Child borrowed features commonly found on Limoges enamels, especially the applied standing figures, the glass cabochons, and the half-length angels in medallions.

It has not been established whether relics were set into the core of this sculpture, as is known to have been the case with some images of the Virgin and Child.[3] Unlike the smaller Virgin and Child in the Metropolitan Museum, the Salamanca Virgin was not made with an opening in the throne.

The sculpture was once owned by a monastery near Salamanca that belonged to the canons of San Isidoro in León; when the monastery closed, the image was taken to the church of San Esteban and placed in a Baroque altarpiece. Since 1678 it has been the principal devotional image of the Old Cathedral in Salamanca.

BDB

1. See Forsyth 1972, pp. 22–30.
2. Hildburgh 1955, pp. 138–39.
3. Forsyth 1972, pp. 31–38.

LITERATURE: Hildburgh 1955, pp. 137–141, pls. LIV–LV, (with previous literature); Gauthier 1970, pp. 79–81, pl. III, fig. 1; Elorza 1992, pp. 90–93.

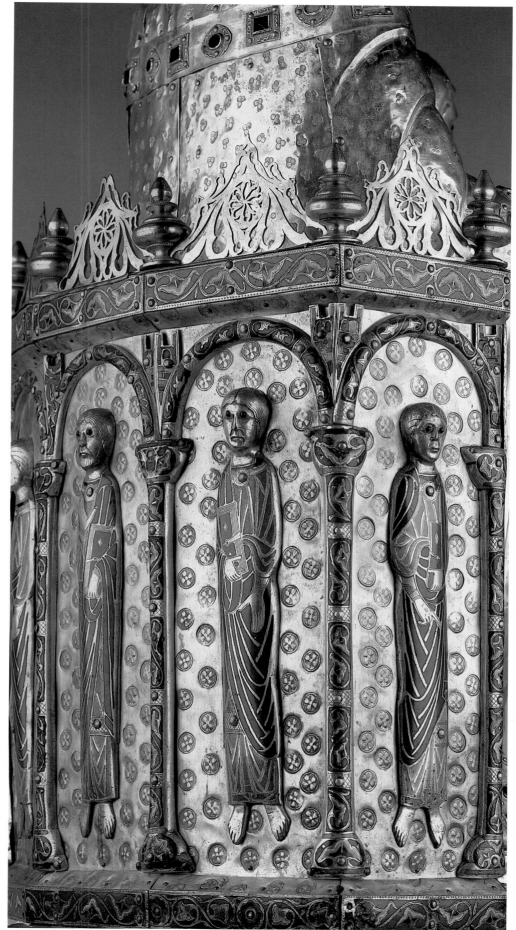

137: Detail

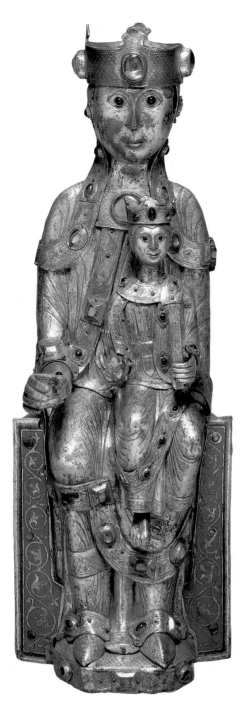

138

VIRGIN AND CHILD

Limousin artist active in Spain, ca. 1200
Gilt copper, champlevé enamel, and glass cabochons on
wood core
H. 14⅛ in. (36 cm)
The Metropolitan Museum of Art, New York; Gift of
J. Pierpont Morgan, 1917 (17.190.125)

The Virgin Mary, sitting erect on an enam-
eled and jeweled throne, balances the Christ
Child on her lap. He maintains a similarly
strict posture, holding an enameled book in
his left hand and raising his right hand in
blessing. The Virgin's left hand is now miss-

ing but once rested on her son's knee, and her right hand grasped an object, probably a lily or an orb. The Child's left foot has been lost. The Virgin's slippered feet rest on a footstool set with glass cabochons imitating gemstones. More cabochons, some backed with silk, decorate the robes of the Mother and Child, and crowns rest on their heads, proclaiming their regal nature. The crowns are ill fitting but appear to be original, as they are engraved with a pattern that appears elsewhere on the sculpture.

This Virgin and Child closely resembles the *Virgen de la Vega* of Salamanca (cat. 137), although it is only half as large. The similarity extends beyond the gilt-copper exterior, the bands decorated with glass "gems," and the poses of the figures, to the moon-shaped faces and puffy almond eyes. Though its throne is less elaborate, there can be little question that the Metropolitan Virgin derives from the celebrated monumental figure in Salamanca.

This kinship notwithstanding, the Metropolitan Virgin also belongs to a broader tradition of small-scale enameled figures of the enthroned Virgin and Child preserved into the nineteenth century largely in French and Spanish churches and now in museum collections as well. Many of these small sculptures, among them the Metropolitan example, have a hinged door at the back of the throne. While the openings may have contained relics, it is more likely that they were meant to contain the Host: since the consecrated bread of the Eucharist was believed to be the body of Christ, it was appropriately secured in an image of the Mother of God, whose body once nurtured the infant Jesus.[1]

The enameled decoration of this sculpture's copper surface follows the standard vocabulary of motifs employed in Limoges enamels of the late twelfth and early thirteenth centuries. The type of stylized enamel flower set in a lozenge and here fixed to the sides of the throne appears in Limousin work as early as the chasse of Saint Stephen of Muret of about 1182.[2] Glass cabochons also commonly decorate liturgical objects made in the Limousin, from knops of croziers to arms of crosses to reliquary coffrets.

The Metropolitan Museum sculpture differs from most surviving Limousin figures of the Virgin and Child in one important respect. The Limousin figures are made from a front and a back sheet of copper relief joined along the sides like two halves of a chocolate mold, while this work is made of a number of sheets of copper worked over a sculpted wood core, with the hands and head made separately and inserted. In this technique of its manufacture, the Metropolitan Museum Virgin and Child, like the Salamanca Virgin, follows another tradition, that of monumen-

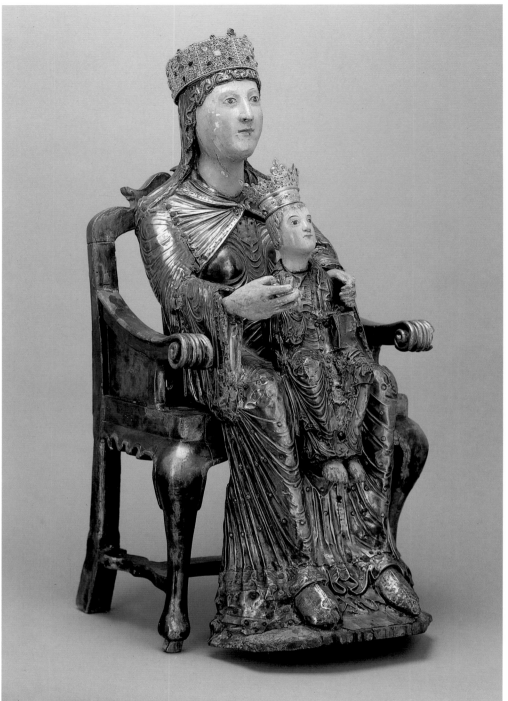

139

tal sculpture in precious metal, which was prevalent through the twelfth century and is exemplified, for instance, by the silver-gilt Virgin and Child at Toledo (cat. 139). Its type of construction suggests that the New York Virgin and Child is one of the earliest in the group of enameled images, as Marie-Madeleine Gauthier believes.　　B D B

1. See Gauthier 1968, pp. 87–88, pl. IV, no. 3, and Bynum 1987, p. 81.
2. Gauthier 1987, no. 159.

LITERATURE: Madrid 1892, no. 224, salle XVIII, pl. CVI; Hildburgh 1955, p. 139, pl. LVIIa–c; Gauthier 1970, pp. 72–81, pl. II.

139

VIRGIN AND CHILD

Navarre, second half of 12th century, with replaced crowns and throne
Silver gilt and cabochons on wood core
H. 31½ in. (80 cm)
Treasury of Toledo Cathedral

This Virgin, resplendent in a silver-gilt gown and mantle, balances the Christ Child on her lap. Likewise clad in silver, he holds a book in his left hand and raises his right hand in blessing. The folds of the Virgin's gown bind

139: Detail

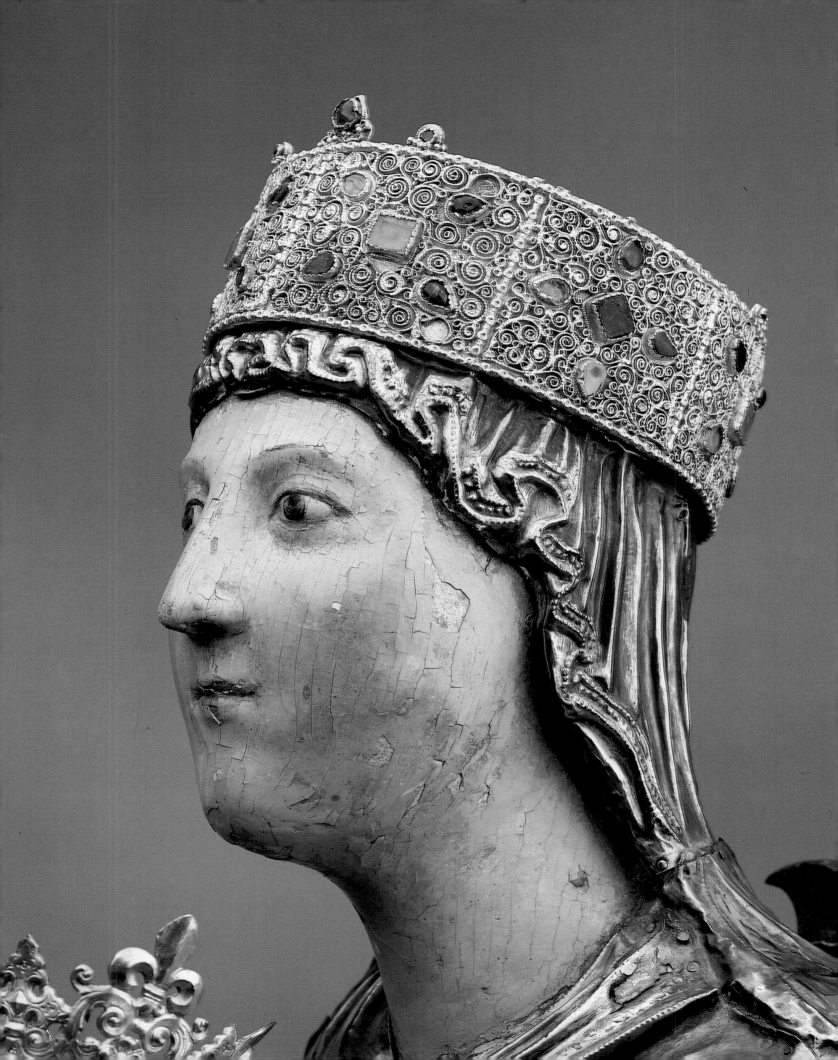

like wet fabric around her knees and fall in uniformly spaced loops. Her mantle, stretched taut over her full bosom, is clasped at the center. The veil under her crown is defined by a regular pattern of folds reminiscent of a pie crust. The faces and hands of both Mother and Child are painted. The Child wears a Baroque crown; the Virgin's, with its filigree decoration, may be contemporaneous with the figure.

Combining large size and precious materials, this kind of image became emblematic of the community for which it was made. The focus of devotion, such sculptures were placed at the altar, where they were continually embellished by gifts of the faithful, especially jewels. Images of the Virgin and Child were also carried in procession. With this kind of vital role in the church, such sculptures were easily damaged, resulting in losses like that of the original throne of the Toledo Virgin. Though the painted faces of the Virgin and Child are of a more recent date, they may well have been polychromed from the beginning. Like the enameled eyes of the Salamanca Virgin (cat. 137), this would have given a more human aspect to the heavenly image.

Though this type of hieratic image of the Virgin and Child was widespread in western Europe by the twelfth century, the Toledo example is distinctively north Spanish in style. The Virgin preserved at Irache has similarly rendered drapery, including the pie-crust pattern framing the face, as well as painted faces and hands. The present work likewise resembles an example at Pamplona, though the latter has undergone substantial restoration.[1]

<div style="text-align: right">B D B</div>

1. Fernandez-Ladreda 1988, esp. pp. 43–44.

LITERATURE: Gudiol 1950, fig. 441, no. 440, p. 389; Hildburgh 1955, p. 118, n. 8; Gauthier 1968, p. 81; Fernández-Ladreda 1988 (related material).

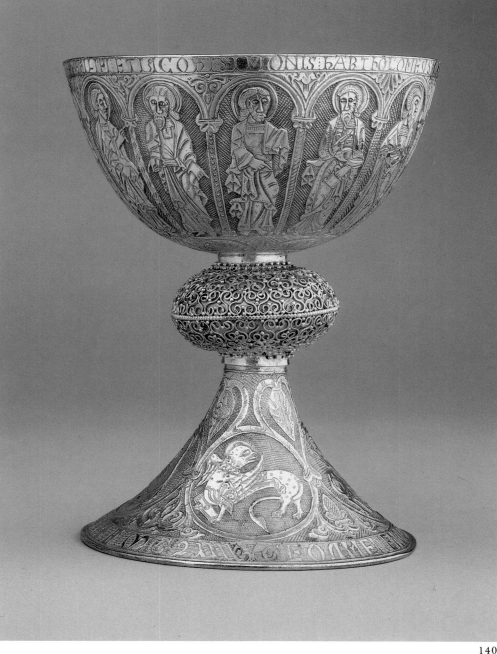

<div style="text-align: right">140</div>

140

chalice

Northern Portugal, perhaps Braga or Oporto, 1152
Silver gilt
H. 6¾ in. (17.3 cm)
Museu Nacional de Machado de Castro, Coimbra (6030)

This beautifully preserved chalice is richly decorated with engraving and filigree. Around the nearly hemispherical bowl are images of Christ and the apostles, set under the arches of an arcade and identified by an inscription that encircles the lip: IHESUS:REX:IOHANNES: PETRUS:PAVLVS:THOMAS:ANDREAS:FILIPI: ET IACOBI:SIMONIS:BARTHOMOMEVS:IACOBVS: MATEVS. The knop is richly encrusted with

filigree composed of simple and reverse S shapes and is encircled by a beaded band at its widest point, where the two sections join. The splayed base, which curves in counterpoint to the bowl, bears symbols of the evangelists in roundels from which springs stylized foliate decoration. On the base is the inscription: +G[U]EDA:MENENDIZ: ME:FECIT:IN: [H]ONOREM:S[AN]C[T]I: MICHAELIS:E:M:C: LXXXX (Gueda Mendes made me [had me made] in honor of Saint Michael 1190). Gueda Mendes, a member of the Portuguese nobility, donated the chalice to the Benedictine abbey of Refoios de Basto in the territory of Celorico de Basto, of which he served as governor from 1132. The gift was made in 1154, which was 1190 of

the Spanish era. The last document naming Mendes dates from 1140; thus it is not known whether the chalice was given during his lifetime or was a legacy to the monastery. It probably was taken to Coimbra in the fifteenth century, passed from San Bento de Coimbra to the cathedral after the abolition of the monastery in 1834, and subsequently transferred to the Museu Nacional.

The decoration of this chalice is accomplished. The variety of the apostles' poses, the lively portrayal of the evangelist symbols, and the textured engraving of the ground create a rich, highly reflective surface. There is no reason to think that the chalice was ever meant to be enameled, as António Gonçalves proposed in 1926: the metal surface is not

appropriately worked to receive champlevé, the enameling technique that would have been employed in the mid-twelfth century. Avelino Costa believes the chalice to be the work of the goldsmith Pedro Ourives, who worked for the archbishops of Braga, but the attribution is provoked largely by the desire to associate a work of such fine quality as this with a known artist. It is perhaps more prudent to recognize the chalice as the creation of an unidentified artist probably from Braga, an important center for goldsmith work, and as one of the principal European eucharistic vessels to survive from the twelfth century.

<div align="right">B D B</div>

LITERATURE: Gonçalves 1926, pp. 143–44; Costa 1990, pp. 659–78; Madrid 1992, no. 37, pp. 129–30 (with previous literature).

141

Relief with the Adoration of the Magi

Northern Spain, first half of 12th century
Whalebone
14⅛ x 6⁹/₁₆ in. (36.5 x 16 cm)
Trustees of the Victoria and Albert Museum, London
(142-1866)

This Adoration of the Magi relief is one of the most exotic images in Romanesque art —and the largest surviving medieval carving in bone (from the radius of a whale). Its function—it was perhaps a votive image— date, and place of origin have been widely debated. Among other suggestions, it has been proposed that the work originated in England, northern France, Belgium, and Spain, with dates ranging from 1100 to 1150.

The monumental Virgin and Child dwarf both the architectural setting and the approaching Magi. Compacted into a narrow vertical composition, the drama unfolds as if in an unreal world. The architectural framework, distorted to accommodate the tapered shape of the bone, is surmounted by a cross atop a pediment, on which there is an owl at the left and a half-length trumpeting man at the right. Along the very bottom of the relief is a frieze depicting a scene of zoomorphic combat, which heightens the overall drama and symbolism.

The argument for a Spanish origin is based, in part, upon stylistic parallels with a bone Virgin and Child that was found in Spain and is now in the Musée du Louvre, Paris. The quality of the carving—its sharply defined and abundant decorative elements creating a horror vacui effect—has more striking connections with Spanish art than with the art of

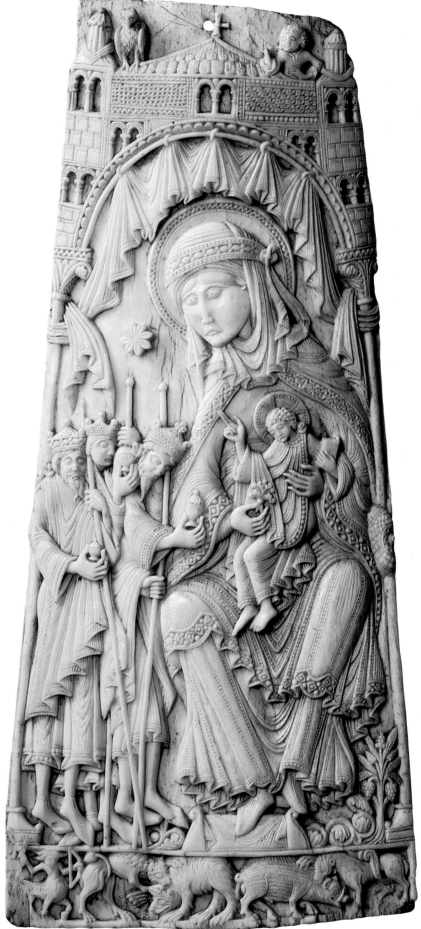

141

northern Europe. The tympanum of the church of Santa María at Uncastillo (Saragossa) presents a more expansive version of this iconography[1] and includes similar pictorial features not found in northern European art: the Magi are depicted as pilgrims with staffs, there is a draped curtain under the arch, and the Virgin wears a peculiar veil and pleated cap—a feature seemingly restricted to Spain and seen, for example, on the tomb of Doña Sancha (cat. 105).[2] The architectural setting, including the owl and the trumpeter, is also found in the Doubting Thomas relief in the cloister of Santo Domingo de Silos, and the Virgin's dress and type of headgear as well as the linear plasticity of the figures can be related to the cloister reliefs at Santillana del Mar (Santander). The theme of the Epiphany was one of the most popular among the sculpture along the Way of Saint James. Inherent in the subject, which gave rise to church portal and relief carvings in Aragon and León-Castile that were treated as independent images, is the idea of pilgrimage and the rewards of such a journey, which is as much physical as spiritual. Moreover, the subject is central to some of the earliest liturgical dramas based on the Adoration of the Magi (the *Officium Stellae*), and, indeed, the prominent star in the present relief and the animated gestures of the figures strengthen the theatrical character of the scene.

The refined and often highly decorative quality of Leonese ivories—for example, the prevalence of decorative knots in the draperies (see cats. 115a–c), which appear, as well, in the wall paintings of the Pantheon of the Kings at San Isidoro[3]—also has been linked to the Adoration relief. The sharp, radiating folds of the figures' draperies likewise have been related to the illuminations in the Codex Calixtinus, recently argued to be the work of a Norman painter. Thus, the stylistic complexities of the relief and the suggestion of a northern provenance take on added significance in the attempt to understand the international dimension of the Romanesque art found along the pilgrimage route.

CTL

1. Hunt 1954, fig. 13.
2. Anderson 1942, pp. 51–79.
3. See Viñayo 1972, pl. 17.

LITERATURE: Goldschmidt 1914–26, vol. 4, no. 14; Longhurst 1927, pp. 87–88; Hunt 1954, pp. 156–61; Bernis 1960; Beckwith 1966; Lasko 1972, p. 172; Gaborit-Chopin 1978; Avril, Barral, and Gaborit-Chopin 1983, pp. 313–14; Estella 1984; Williamson 1986, p. 126; Ayers 1992, p. 250.

PORTION OF A CROSIER SHAFT

Northern Spain, late 12th century
Ivory
H. 11¼ in. (28.6 cm), diam. 1⅜ in. (3.5 cm)
The Metropolitan Museum of Art, New York; The Cloisters Collection, 1981 (1981.1)

As one of the key symbols of ecclesiastical authority, the crosier was often lavishly decorated. The shaft of this crosier is one of the most elaborate, its surface ornamented with self-contained themes. The decoration is divided into four bands, depicting two principal realms—the celestial and the terrestrial—each heralded by angels. At the top of one side, Christ is seen enthroned within a mandorla composed of ten bust-length figures of the Elders of the Apocalypse supported by seraphim. This type of inhabited mandorla is exceptionally rare and is known only in Spain. Such an image is described in the Pilgrim's Guide, written about 1120–30, as on the no longer extant silver-gilt altar frontal at the shrine of Saint James at Santiago de Compostela, which might have been copied in the apsidal wall paintings in the church of San Justo in Segovia. The heavenly vision is amplified on the opposite side of the shaft by the enthroned Virgin and Child, who appear in a "mandorla of light" decorated with stars. Next to the throne is a dove—a direct allusion to the Incarnation.

The central registers are filled with angels dressed as deacons, who stand within arcades; each figure holds an orb and a long staff surmounted by a lantern—possibly a reference to Christ as the Light of the World. The bottom register features the installation of a bishop, who sits upon a high-backed episcopal chair and receives his miter from an angel who descends from the register above. Simultaneously, the bishop accepts a crosier from a secular donor, who kneels before him while other deacons and saints look on. Since the bishop has no nimbus, the image probably commemorates his actual installation in the presence of the donor of the crosier to which the present shaft belongs. Characteristic of the technical virtuosity of the carving are the figure style and the animated folds of the heavy drapery. This energized drapery style seems to be symptomatic of the Byzantine influence that prevailed toward the end of the twelfth century. The figures themselves are thickset, with fleshy faces and large hands. In painting, the closest parallel to this style is found in the Beatus from San Pedro de Cardeña (cat. 153) or in the image of Saint James in the Codex Calixtinus. In sculpture, the figures of the apostles that form supports

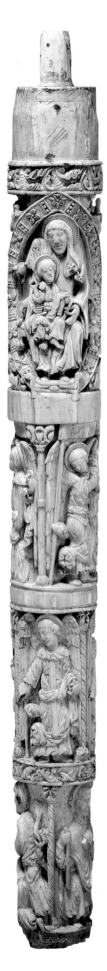
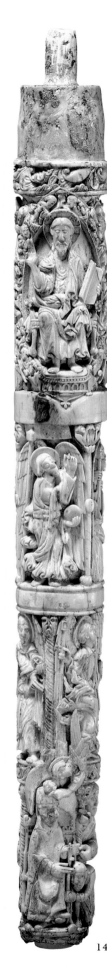

142

for the vaults in the Cámara Santa at Oviedo and the heavily draped figures on the great frieze in the church of Santiago in Carrión de los Condes (see p. 201) display the same "baroque" Romanesque quality in their treatment.

Two other cylindrical shafts are stylistically related: a crosier shaft in the British Museum, with registers of apostles in arcades, is similar in design to the column shafts of the Puerta de las Platerías at Santiago de Compostela. Another crosier, in the Museo Nazionale del Bargello, Florence, depicts the Labors of the Months, including an unusual representation of March as "Spinario," which is unknown in Spain of the time. This group of crosiers has traditionally been thought to have originated in northern France or England, although Spain now seems most certain. While these ivory carvings do reflect the often wide-ranging international influences occurring in northern Spain during the age of pilgrimage, the character of their workmanship, their design, and various iconographic idiosyncrasies point toward a Spanish provenance. CTL

LITERATURE: Vöge 1900, no. 75, pp. 42–43; Volbach 1923, J 614, p. 30, pl. 34; Goldschmidt 1914–26, vol. 4, no. 64, p. 21, pl. XVI; London 1984, no. 215, p. 229; Little 1981.

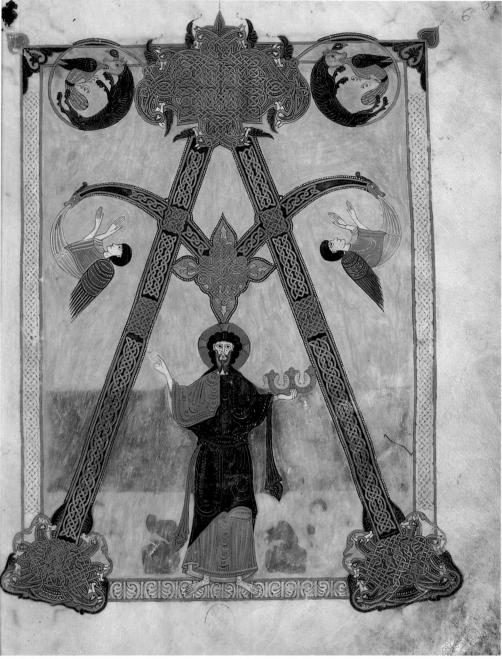

143: fol. 6. Alpha page

143

commentary on the apocalypse by beatus and commentary on daniel by jerome

León (León), 1047
Tempera on parchment
14⅛ x 11 in. (36 x 28 cm)
Biblioteca Nacional, Madrid (Vitrina 14–2)

An elegant acrostic on folio 7 and a colophon on folio 316 indicate that this sumptuous copy of the Beatus Commentary was commissioned by the rulers of the kingdom of León, Ferdinand and Sancha, in 1047 (fifteen years after their marriage), and carried out by Facundus. The only known Beatus Commentary not created for a monastery or convent, this copy remained at the palatine church of San Isidoro until the seventeenth century. It is the earliest object in the impressive history of Ferdinand and Sancha's patronage.[1] The gold and silver liberally employed in its opening illuminated pages and the richness of its decoration throughout accord with the royal nature of the commission.

The colophon mentions only a single scribe, Facundus. In a manuscript so sumptuously decorated that we would expect the painter to be named, it is a temptation to recognize him as the illuminator as well. However, both the writing and the illumination indicate that more than one hand was at work. The painting of the introductory pages, with the alpha, cross, acrostic, portraits of the evangelists, genealogical tables, and some display titles, exhibit an elegance and sureness of drawing that is not apparent in most of the material that follows. However, the depiction of the Seven Plague Angels (fol. 211v) is marked by the same high quality noted in the introductory pages and reinforces the conclusion that there were two illuminators. The format and content of this Beatus is based on the model first found, among surviving Beatus Commentaries, in the Morgan Beatus (cat. 78). Yet

the ornamental details of the Facundus Beatus, most particularly the interlace patterns in the initials, do not follow the schemes in such Leonese manuscripts as the Morgan Beatus but are based on those in Castilian manuscripts carried out at the Castilian monastery of Valeranica by Florentius or his disciple (cats. 84, 108). The Silos Beatus (cat. 145) also belongs to the same subfamily of the Commentaries as the Facundus Beatus, and there is reason to think that it was copied from a Valeranican model. It is possible that the Facundus Beatus also used such a model.[2] Before he was king of León, Ferdinand had ruled over Castile. It is likely that the Valeranican Bible of 960 (cat. 108) and perhaps other manuscripts as well came into his possession at that time.

Although the format and use of color of the Facundus Beatus are traditional, the figure style at times shows signs of the reform that will dominate in the Romanesque period. As the standing Christ of the Alpha page—a detail owed to the kind of anthropomorphism common in Romanesque art—best reveals, the Mozarabic mosaic of color patches began to give way to drapery patterns tied to the natural divisions of the body. The ovals of the right thigh and the left knee of the Christ, which indicate these divisions, exemplify this new rationalism. In the Osma Beatus (cat. 82) of 1086 still further progression in this direction is evident. J W W

1. See essay "León and the Beginnings of the Spanish Romanesque" by John W. Williams, this catalogue.
2. One element that may indicate such a link is the addition to the illustration of the Adoration of the Lamb in the Facundus Beatus (fol. 116v) of an enthroned Christ, a detail not justified by the text of the Apocalypse (4:6–5:14) found in any other copy except the Silos Beatus (fol. 86v).

LITERATURE: Werckmeister 1980, pp. 171ff; Díaz 1983, pp. 329–32; Perrier 1984, p. 73f.; New York 1985, pp. 75–76, no. 14; Williams 1993, vol. 3, no. 11.

144

prayer book of ferdinand and sancha

Monastery of Santos Facundo y Primitivo, Sahagún(?)
(León), 1055
Tempera on parchment
12¼ x 7⅞ in. (31 x 20 cm)
Biblioteca Universitaria de Santiago de Compostela
(Rs. 1)

A colophon on folio 208v tells us that this prayer book, made up of the Psalms and liturgical canticles from the Bible, was ordered by Queen Sancha in 1055, written by Petrus, and painted by Fructuosus. The painter's name is clearly peninsular. On folio 3 an acrostic of unusual form, a cross enclosed by a diamond, which falls within a Spanish tradition of acrostics for recording ownership, declares the book the property of King Ferdinand and Queen Sancha. How it arrived at its present home is not known. On the verso of folio 3 is a portrait of the king and queen. The king's gilt crown sits on a head of red hair, which, in fact, he had. Between them is a figure of a cleric,[1] presumably Petrus/Fructuosus, offering a gilt book to Ferdinand. However, Sancha's key role in its commissioning is acknowledged by the backward glance of the scribe/painter toward her and by her gesture, which advances the action. It was unprecedented on the penin-

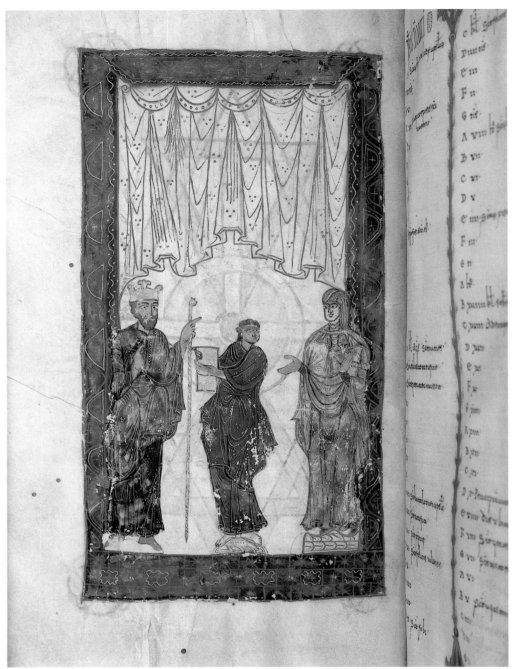

144: fol.3v. Ferdinand and Sancha and the scribe Fructuosus

sula to thus announce ownership pictorially; but Ottonian books of the eleventh century do include such images.[2] The Alpha frontispiece (fol. 1) placed before this unprecedented page combining patrons and scribe does, however, follow Spanish models. Eight years before our prayer book was made, this same royal couple had commissioned a Beatus Commentary (cat. 143), and its Alpha (fol. 1), like ours, included a standing figure of Christ. The full-page initial B of the Beatus Vir that opens the first Psalm of the prayer book (fol. 7v) relies for its basic structure on the kind of interlace patterns that Spanish artists had borrowed in the tenth century from Carolingian examples; however, the dogs' heads holding sprays of foliage in their mouths

that appear in this initial, and even more significantly in the Omega page's ornamental language, follow developments in northern illumination in the eleventh century.[3] In the design of draperies the figure style represents a marked departure from that associated with the manuscripts of the tenth century. These draperies have taken on a plasticity and rationality worthy of the denomination Romanesque. The colors of the manuscript, somber browns and blues against unpainted backgrounds, are a departure from the polychromatic brilliance of the Beatus Commentaries. Splendor is present, however, in the liberal use of gold and purple and in the extraordinarily high quality of the parchment. This was a book worthy of imperial patronage.

It is usually assumed that the prayer book of Ferdinand and Sancha was carried out in a scriptorium attached to the palace in León, but we have no confirmation of this. The northern vocabulary introduced in the prayer book was even more emphatically promoted in the Beatus of 1086 now in Burgo de Osma that was produced at Sahagún, a monastery favored by Ferdinand (cat. 82). Moreover, the prayer book's canine figures are found in the Osma Beatus, and its acrostic with a cross in a diamond resembles the unusual design of the Cross page of the Beatus (fol. 166). These parallels are not sufficient to establish Sahagún, the center in which the Osma Beatus was copied, as the scriptorium responsible for the prayer book; however, as a monastery with close ties to the Leonese monarchy and, at least by 1086, a scriptorium, Sahagún cannot be eliminated from consideration. The two manuscripts share a background from which also sprang the Beatus Commentary produced for Abbot Gregory of Saint-Sever in Gascony about 1070, which confirms the Gallic resources drawn on by Ferdinand's circle. Even closer to the prayer book, however, is the Privilegio de Nájera in the Real Academia de la Historia, Madrid, a charter written for García of Navarre, brother of Ferdinand, in 1054 at some unknown site.[4]

JWW

1. It is true that this individual is not tonsured, but his dress is decidedly not that employed for lay figures. In a line of figures labeled "clerics" in a conciliar codex copied in 976, several are not tonsured and, like our figure, are barefoot (Williams 1977a, pl. 31).
2. See the Pericopes produced for Henry III in about 1040 (Kupferstichkabinett, Berlin; HS. 78 A 2), where the frontispiece shows the enthroned ruler receiving a book from a cleric (Prochno 1929, p. 39).
3. See, for example, the canine initials in a lectionary from Saint-Martial, Limoges (fols. 23, 62v) (Gaborit-Chopin 1969, fig. 80).
4. Gómez-Moreno 1934a, pls. V, VI; Perrier 1984, pp. 45, 46.

LITERATURE: Férotin 1901, pp. 374–83; Robb 1945, pp. 169, 171; Janini 1977, no. 290, p. 246; Williams 1977a, p. 109, pl. 35; Sicart 1981, pp. 22–44, 225–29, pls. I–III, figs. 1–26; Perrier 1984, pp. 45f., 73–79, 88; Amalia Sarriá, in New York 1985, no. 8, p. 63; Yarza 1985b, pp. 372–73; Yarza 1990, p. 15.

145

COMMENTARY ON THE APOCALYPSE BY BEATUS AND COMMENTARY ON DANIEL BY JEROME

Monastery of Santo Domingo de Silos (León), 1091 (writing), 1109 (illumination)
Tempera on parchment
15 x 9¼ in. (38 x 23.5 cm)
The British Library, London (Add. MS. 11695)

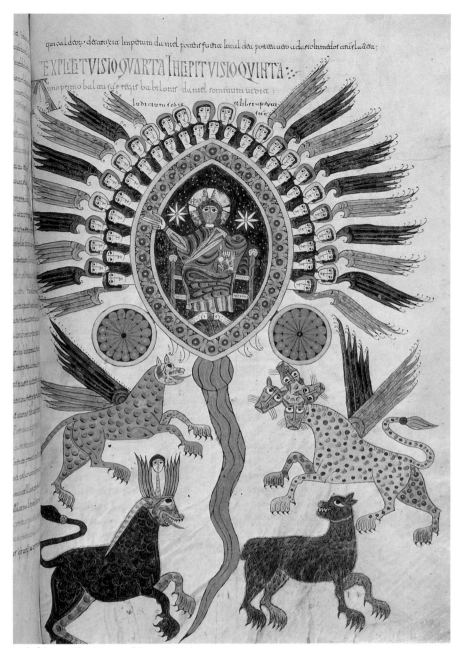

145: fol. 240. The Ancient of Days (Daniel 8:2–10)

Colophons (fols. 276, 277v, 278) of this copy of the Beatus Commentary made at the Castilian monastery of Santo Domingo de Silos reveal that the writing of the text, for which Munnio was chiefly responsible, was completed on April 18, 1091. The ornamental frames of these colophons fall below the artistic level of the rest of the manuscript, and, indeed, another colophon (fol. 275v) states that most of the illumination was not completed by Petrus until eighteen years later, on July 1, 1109. Despite this relatively late date and the Romanesque style associated with it, the Silos Beatus, with its flat figures assembled in a polychromatic mosaic that stresses the surface, presents itself as an outstanding example of the Mozarabic style.

Neo-Mozarabic is perhaps a more apt characterization than Mozarabic, for the style of most of the narrative illustrations reveals in such details as the hatchings of short parallel strokes along the contours of folds a desire for plasticity that is not found in true Mozarabic copies like the Morgan Beatus (cat. 78). However, some pages, especially the Hell of folio 2 with its pivoting figure of Saint Michael holding a spear and a pair of scales and the scenes of Lust and Avarice being punished, display both a style and an iconography that is decidedly Romanesque, in ways that Meyer Schapiro brilliantly exposed.[1] Schapiro went on to argue that the stylistic conservatism of this copy was a deliberate gesture of reaction against the

extrapeninsular currents that invaded Spain when León-Castile was ruled by Alfonso VI (d. 1109), especially the substitution of the Roman liturgy for the Hispanic after 1080. Whether or not style might have functioned in this ideological manner in the twelfth century is debatable, but clearly a nostalgic note is struck by the remnants of an eleventh-century Hispanic-rite antiphonary that are bound into the manuscript as folios 1, 2, and 4. Thus, the style of the Silos Beatus is not the only sign of conservatism here.

The colophons of the Silos Beatus match word for word those employed in the tenth century by Florentius, the great scribe of the Castilian monastery of Valeranica, about 25 miles (40 km) west of Silos (cat. 84). This coincidence and the existence of a page with Christ surrounded by symbols of the four evangelists (fol. 7v), a frontispiece not normally encountered in the Beatus tradition but present in the Bible carried out in 960 by Florentius's disciple, Sanctius, at Valeranica (cat. 108), raise in clear terms the distinct possibility that Petrus used as a model a Beatus illuminated in the tenth century by Florentius.[2] The influence of this model may help explain the conservative nature of the style of the Silos Commentary, as reflected in the Mozarabic character of its standard core of illustrations.　　　　　　　JWW

1. Schapiro 1939. Yarza (1981, p. 21) proposed that the Hell belonged to an antiphonary and was carried out after the rest of the illumination, perhaps as late as 1120. A Hell scene would be even more exceptional for an antiphonary than for a Beatus Commentary, which has as its end the preparation of the reader for the Final Judgment. There is nothing inconsistent in the design and color of this page with the campaign of 1109.
2. Boylan 1992, pp. 95–97.

LITERATURE: Schapiro 1939; Yarza 1977; Werckmeister 1980, pp. 180–92; Boylan 1992, pp. 43–123; Williams 1993, vol. 3, no. 16.

146

COPY OF DONATION OF PEDRO I

Monastery of San Juan de la Peña(?) (Huesca), 12th-century copy of 11th-century original
Parchment
12¾ x 16¾ in. (32.4 x 42.6 cm)
Cathedral Archive, Jaca

This parchment is a twelfth-century copy of a document dated 1136 of the Spanish era (i.e., A.D. 1098), the original of which, according to Antonio Ubieto, is in the Huesca Cathedral archives.[1] Of the seven extant examples, two—this one and a copy in Huesca, also from the late twelfth century—contain illustrations of Pedro I (r. 1094–1104) and the

bishop of Jaca-Huesca, identified within the document as Pedro, who reigned from 1087 to 1099. Also mentioned is Petro Sangiz (Pedro Sánchez), lord of Boltaña, one of the nobles who less than two years earlier had fought under Pedro I in the Christian reconquest of Huesca—an event that is relevant in understanding the historical importance of this document. The episcopal see, having been moved from Huesca when that city was occupied by invading Muslims, was subsequently set up in Jaca,[2] also the site of a royal palace. When Huesca was recaptured, the thorny problem of where to establish the bishopric was not long in surfacing as a major concern. Two competing camps were in clear opposition: a bishop was resident in Jaca and saw himself as heir to the throne once inhabited by the bishop of Huesca, while ecclesiastical authorities in Huesca were eager to put forward the historical and independent stature of that see. This document and at least one other, also signed in Calasanz in March 1098, would seem to have been an attempt by Pedro I to resolve some of these differences.[3] The document records the king's concession to the diocese of Jaca-Huesca of some of the tithes due him from the city of Huesca as a result of its reconquest from the Muslims—*sarracenorum* in the document. The concept of tithes, the donation of a tenth part—*decimam* in the document, and *décimas* or *diezmos* in Spanish—has its historical roots in the ancient tradition of tributes paid to conquerors, although by the Carolingian period tithes already had taken on their function as support for ecclesiastical authorities. Both aspects of tithing would seem to be referred to here.

The illustration in the Jaca document (below) shows a crowned Pedro I, seated on an elaborate throne, its feet in the form of animal paws and its arms decorated with beaked heads and with a foliate finial. Pedro hands the privileges, which are the subject of the document, to Bishop Pedro, who holds a crosier and sits in an X-shaped chair also decorated with animal terminals. The illustration of Pedro I appears in the traditional location of a signature—that is, following the word *facio*. The long vertical squiggle of the *f* of *facio* identifies that word, by virtue of its parallel shape, with the very representation of the enthroned king. Visible as well is the king's signature in Arabic, as was customary on his documents. That signature was at one time thought to indicate that Pedro was unable to write in Latin, but more recently Ubieto has claimed that Pedro's signature was calculated to prevent forgeries.[4] Even so, it is hard not to recognize that this is direct evidence of the role an Arabic education played within Christian court circles; many princes are recorded to have had Arab tutors, as was the case with Pedro's father.

Arthur Kingsley Porter, who mistakenly

146

accepted the document as an eleventh-century original, cited the illustration as evidence that by the end of the eleventh century Aragonese illumination, less insulated than it had previously been, was closely related to that of Catalonia and the rest of Spain.[5] While it is true that one might compare details of the drawing in general terms to a number of works, including examples from Catalonia[6] and León,[7] specific comparisons to establish provenance have been elusive. Porter stated, without citing evidence, that the document was written at the monastery of San Juan de la Peña, closely connected geographically and politically to Jaca, and while one might compare the floral finial of the king's throne with foliate decoration in manuscripts from that monastery,[8] the comparison is a general one. Certainly, given the historical nature of the document, it would seem likely that it was produced in an Aragonese scriptorium, and one close to Jaca. Less convincing was Porter's claim that the style is the same as that of the sarcophagus of Doña Sancha (cat. 105). If comparisons with sculpture can be made, a more effective one would be with the Passion capital from the cloister of Pamplona Cathedral, but this is based on corresponding details, not on organization or expressive content. It is perhaps not surprising that one looks to sculpture for parallels to this drawing, since the artist has forcefully suggested the mass of the figures and their drapery, even as he was able to employ linear pattern to animate the surface. DLS

1. Ubieto 1951, pp. 278–79. This copy dates to the reign of Alfonso II (1164–96).
2. Durán Gudiol 1962; Balaguer 1951, pp. 69–138.
3. Ubieto 1951, pp. 276–78; Durán Gudiol 1962, pp. 73, 144–47.
4. Ubieto 1951, pp. 18–19.
5. Porter 1924, p. 176; Porter 1926, p. 132; Porter 1928, vol. 1, pp. 53–54.
6. Domínguez 1930, pl. 44 A.
7. Pijoán 1966, pp. 105–6; Moralejo 1982, n. 79.
8. Domínguez and Ainaud 1962, fig. 66. Moralejo (1982) has convincingly compared manuscripts from San Juan de la Peña with sculpture from Jaca.

LITERATURE: Porter 1924; Porter 1926; Porter 1928; Domínguez 1930; Ubieto 1951; Durán Gudiol 1962; Domínguez and Ainaud 1962; Domínguez 1933; Pijoán 1966; Moralejo 1982.

147

commentary on the apocalypse by beatus and commentary on daniel by jerome

Castile, 1220
Tempera and gold on parchment
20⅞ x 13⅜ in. (53 x 34 cm)
Pierpont Morgan Library, New York (M. 429)

147: fol. 183. The tower and scriptorium of San Salvador de Tábara

This is the youngest of the dated copies of the Beatus Commentary, a tradition whose oldest witness[1] had been written more than three centuries earlier. A colophon on folio 184 reveals that it was copied for a woman but gives no clues to her identity or where she resided. In the eighteenth century this Beatus was seen at the Cistercian convent of Las Huelgas in the suburbs of the Castilian capital of Burgos. This convent, which had jurisdiction over the other Cistercian convents of the realm, had been founded in 1187 by Alfonso VIII and Eleanor, so it could have developed a scriptorium by 1220. However, the manuscripts still preserved at Las Huelgas[2]

offer no parallels for the style of this Beatus, and it was likely carried out at another site. One of the three painters responsible for the copy also helped produce a manuscript in Burgos Cathedral (Cod. 15). However, the two other illuminators had strong ties to another city within the kingdom of Castile, Toledo.[3] Moreover, when the Beatus was purchased by the Morgan Library, the seller claimed it was from San Clemente de Toledo, a Cistercian church dependent on Las Huelgas. A colophon that precedes the one noted above (fol. 182v), a verbatim copy of the colophon of the Tábara Beatus (cat. 79), is followed by a reproduction of the extraordi-

nary portrayal of the tower scriptorium of the Tábara Beatus. If it is not clear just where the Las Huelgas Beatus was written, without doubt its model was the Beatus of 970 from Tábara.

The iconographic tradition of the illustrated Beatus was, for the most part, respected in this late copy. In the Angels Restraining the Winds (fol. 77) or the Vision of God Enthroned (fol. 59v) cosmic schemes of a quadrangular shape were changed into circular ones, apparently to conform better to a thirteenth-century conception. However, most illustrations followed the compositional formulas employed in the Tábara Beatus. The style, on the other hand, is that of the thirteenth century and reflects, as so many other monuments of the period do, the penetration of currents from beyond the Pyrenees, more particularly the byzantinizing styles of Gallic origin. JWW

1. Biblioteca de la Abadia, Monasterio de Santo Domingo de Silos, fragm. 4; Williams 1993, vol. 2, no. 1.
2. Herrero González 1988.
3. They participated in the illumination of Bibl. Nac., Madrid; MSS 10087 and 21546. For this and other aspects of our Beatus, see Raizman 1980, 1987.

LITERATURE: Neuss 1931, pp. 54–55; Williams 1980, p. 205; Raizman 1980; Raizman 1987; Williams 1992b, p. 375.

148

sacramentary

Monastery of Santos Facundo y Primitivo, Sahagún (León), ca. 1080–86
Tempera on parchment
13⅞ x 7½ in. (35.1 x 19 cm)
Biblioteca Nacional, Madrid (MS. Vitr. 20–8)

This sacramentary or missal came to Madrid from Toledo Cathedral. A letter of 1086 copied into the final folios (134v–135) is from Abbot Hugh of Cluny and is addressed to Bernard, the Cluniac monk who became the head of the royally favored monastery of Sahagún in the spring of 1080.[1] It congratulates Bernard on his selection by Alfonso VI of León as archbishop of the ancient capital of Toledo, which Alfonso had liberated in May of 1085. The letter was written in the same year that saw the completion at Sahagún of the Beatus of Burgo de Osma (cat. 82). Although the Osma Beatus reflects a knowledge of artistic culture north of the peninsula, it was carried out by native monks in their national Visigothic script and represents one of the central manuscript traditions of Spain. However, the pure Caroline script of the sacramentary points to a Gallic scribe, for Caroline script would not finally supplant the

148: fol. 1. The initial P

Visigothic until well into the twelfth century. The illustration and initials are also Gallic in style and technique. The text of the sacramentary is one that normally is not illustrated in Spain, but within the text of the Canon of the Mass (on fol. 3) is a drawing of the Crucifixion executed in ink with an elegant spareness that recalls an initial with a depiction of an abbot in a manuscript from the Languedocian monastery of Moissac that was produced under Abbot Anquetil (1085–1115).[2] The sacramentary text is opened by the major decorated initial P, the stem of which is carried by a human figure (fol. 1). Both the design of the initial and its embellishment of interlace and vines issuing from the mouths

of birds and canines are paralleled in an initial in another manuscript illuminated at Moissac about 1100,[3] and yet another manuscript from Moissac initial employs a figure to carry a large initial P in a comparable way.[4] Indeed, Moissac was one of the sites from which Bernard recruited future Spanish prelates. That this sacramentary was executed at Sahagún is indicated by the presence in it of texts for the masses of Facundus and Primitivus, the saints to whom Sahagún is dedicated, and by the incorporation of their names in its litany, elements not found in a missal of the middle of the eleventh century imported from Limoges to San Millán.[5] The copy of the letter of 1086 from Hugh to

Bernard would seem to confirm that the manuscript was written at Sahagún at some time after Bernard's arrival in 1080 and before his occupation of the see, which took place in November 1086.

<div align="right">J W W</div>

1. Férotin 1900, pp. 339–45; Férotin 1902, pp. 682–86.
2. Dufour 1972, no. 43, pl. XLVI.
3. Dufour 1972, no. 103, pl. XXXVIII.
4. Dufour 1972, no. 59, pl. LII.
5. Gaborit-Chopin 1969, pp. 214–15, pl. 35 (Crucifixion).

LITERATURE: Janini 1969, no. 199, pp. 248–51; Yarza 1990, p. 21; Williams 1992c.

contrived to augment the authority of Oviedo. At that time Toledo, and Santiago de Compostela even more—the latter in the heyday of its popularity as a pilgrimage shrine reached by a highway passing to the south of Oviedo —overshadowed the venerable capital founded by Alfonso II.

There are no comparable illuminated manuscripts attributable to Oviedo extant, and it may be that Pelagius commissioned this important work from some established scriptorium elsewhere. One candidate is the great monastery of Sahagún, the home, earlier, of the Osma Beatus (cat. 82). Although far more modest in conception, a copy of about 1110 of a charter written at Sahagún employs the same kind of scheme that opens the Liber Testamentorum (fol. 1v)—the donor kneeling beneath an image of Christ in Majesty and reaching upward with outstretched hands

149: fol. 1v. Alfonso II, el Casto (the Chaste), kneeling before the enthroned Christ

149

LIBER TESTAMENTORUM

Monastery of Santos Facundo y Primitivo, Sahagún(?) (León), ca. 1118
Tempera on parchment
14⅛ x 9½ in. (36.4 x 24 cm)
Cathedral Archive, Oviedo (MS. 1)

This cartulary, or collection of deeds of gift, to Oviedo Cathedral, was composed by Bishop Pelagius, who occupied the episcopal throne from 1101 to his resignation in 1130. Pelagius was an extraordinary partisan for his diocese and on good terms with Alfonso VI of León (r. 1065–1109) and his successor, Urraca (r. 1109–26). In 1105 he received from Pope Paschal II the exemption of Oviedo from the jurisdiction of Toledo, a privilege reconfirmed by Pope Calixtus II in 1122. One of the miniatures (fol. 83) is of Paschal, but there is none of Calixtus. Although there is no colophonic date, the latest charter included is for a gift of 1118, and it is reasonable to assign the book to a date shortly after that.

Six of the seven full-page miniatures represent in artfully varied compositions the offering of privileges, or *testamenta*, by different Asturian rulers and their queens, with members of the court in elaborate arcaded frames that frequently employ a typical Romanesque vocabulary of animals and grotesque human figures. An exception is the frontispiece (fol. 1v), which shows Alfonso II kneeling before a composition of the enthroned Christ with symbols of the evangelists and flanked by the twelve apostles. It is the same subject that fills the front of the Arca Santa (cat. 124). The reliquary, central to Oviedo's claim to spiritual power, was provided with an elaborate history written by Bishop Pelagius in the opening pages of the Liber Testamentorum. The Arca Santa itself probably was largely the responsibility of Pelagius. Like the Arca Santa, the Liber Testamentorum, which registers gifts of highly suspect authenticity, was

—and its portrait of the abbot resembles the prelates in the Liber Testamentorum who receive gifts.[1] Moreover, Bishop Pelagius was a great admirer of Alfonso VI, whose favorite residence was at Sahagún. He would have been able to pay his respects at the tomb of the deceased ruler in Sahagún in 1116, when he was called to the Leonese monastery there to attend a meeting of the curia of the realm. This must have been about the time that the idea of the Liber Testamentorum began to take shape, and it is possible that arrangements were made for its composition then. A connection between Oviedo and Sahagún also is suggested by the Chronicon Silensis, the important history of the kingdom of León-Asturias that was written, it would seem, at Sahagún about the time the Liber Testamentorum was composed[2] and was extraordinarily well informed about Oviedo. This was also a moment in which the power of Bishop Diego Gelmírez of Santiago de Compostela, Oviedo's great rival as a pilgrimage center, was in decline, and an attempt to enhance the authority of Oviedo would have appeared especially opportune. The capital of the Leonese monarchs, León, also offers parallels for compositions in the Liber Testamentorum. The manner in which Alfonso II kneels with his swordbearer in the frontispiece cited above recalls the portrait of Ferdinand I kneeling before the painting of the Crucifixion in the Pantheon of the Kings at San Isidoro.[3] And on folio 26v Queen Teresa stands before an altar offering a *testamentum* with Ordoño II and is accompanied by a maidservant holding a bowl and plate, the same utensils held by a servant who stands behind Ferdinand's queen in the Pantheon's Crucifixion. In a mid-eleventh-century charter written for García of Navarre, brother of Ferdinand—a manuscript comparable to the Liber Testamentorum—royal portraits are combined with a religious subject and an architectonic structure.[4] Thus, even as Pelagius seems to have had Leonese roots,[5] artistic parallels with works at Sahagún and León suggest a Leonese background for the Liber Testamentorum.

J W W

1. Archivo Histórico Nacional, Madrid; Privilegios rodados no. 1, seccion clero. See Gutiérrez de Arroyo 1959; Moralejo 1985a, p. 68; see Gómez-Moreno 1934a, pl. X (mistakenly as 1060).
2. Canal 1980.
3. See essay "León and the Beginnings of the Spanish Romanesque" by John W. Williams, this catalogue.
4. Real Academia de la Historia, Madrid; Privilegio de Nájera. See Gómez-Moreno 1934a, p. 16, pls. V, VI.
5. Fernández Conde 1971, p. 36.

LITERATURE: Domínguez 1930, vol. 1, p. 26, pls. 69–76; Fernández Conde 1971; Moralejo 1985c, pp. 411–12; Yarza 1990, pp. 20–21.

149: fol. 26v. King Ordoño and Queen Teresa bestowing gifts on the Oviedo Cathedral

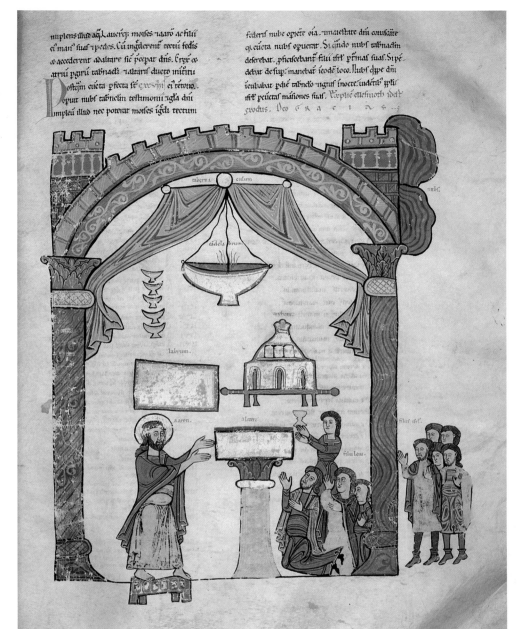

150: vol. 1, fol. 50. The Wilderness Tabernacle (Exodus 35:10–12)

150

BIBLE

Church of San Isidoro, León (Léon), 1161–62
Tempera on parchment
21¼ x 15 in. (55 x 38 cm)
Real Colegiata de San Isidoro, León (MS. 3 [3 volumes])

A colophon prominently displayed on the first page recounts in exceptionally complete terms the genesis of this Bible:

This book was undertaken in the time of King Ferdinand [II, r. 1157–88], son of Emperor Alfonso, and was concluded during his glorious reign. During the rule of the most reverend abbot Menendo, prudent rector of the monastery of San Isidoro, one of the canons with great effort on raging seas carried from France to our land the parchment for this marvelous work.

You may marvel at the completion of this book in the space of only six months for the writing and a seventh for its decoration in color. Sub era MCC. VII/Kal. Aprilis [March 25, 1162].[1]

Although scribes of the palatine church of San Isidoro may have carried out Abbot Menendo's commission, it is also possible that the whole enterprise was entrusted to a traveling team of professionals. At any rate, the task of illumination, which occupied a month, seems to have been realized by professional painters who traveled, as one of the two hands responsible for the more than a hundred illustrations worked on the frescoes in a far-distant Aragonese church in Navasa (now in the Museo Diocesano de Jaca), to judge by the identity of style in both enterprises.[2]

The team of miniaturists did not bring their model with them. Because of their extraordinary similarity and the fact that they belong to the same library, it is customarily assumed that the present Romanesque Bible was based upon the Bible of 960 at San Isidiro, León (cat. 108). However, the present manuscript contains Old Latin textual glosses —one of the distinguishing features of the Leonese Bibles—and an illustration in Exodus that were not included in the Bible of 960. There must have been a Bible that served as a model for both the surviving copies in San Isidoro.[3] One possible prototype is a fragment in Rome of a Bible written in 943 that is a twin of the Bible of 960 but not known to have been in León. Another candidate is a now lost Bible that was recorded to have been part of the library of San Isidoro in the eighteenth century.[4] J W W

1. My translation.
2. Yarza 1985b, pp. 385–86. Yarza hesitated to go beyond proposing that the same shop participated in both projects, but the same hand seems to have been at work. He perceptively identified the original frontispiece of the 1161–62 Bible as the Majesty page now in the library of the Museo Arqueológico Nacional, Madrid (ibid., p. 386).
3. Williams 1967.
4. McCluskey 1987, p. 238 n. 22.

LITERATURE: Pérez Llamazares 1923, pp. 19–24; Galindo 1960, pp. 51–62, 70–76; Williams 1965; Williams 1967; Cahn 1982, p. 290; Yarza 1985b, pp. 385–86; McCluskey 1987, pp. 238, 243–44; Burgos 1990, no. 16, pp. 66–67; Yarza 1992, p. 331.

151

BIBLE

Central Italy and Ávila (?), ca. 1150–60
Tempera on parchment
24¾ x 16¾ in. (63 x 42.5 cm)
Biblioteca Nacional, Madrid (Cod. Vit. 15–1)

This large Bible, known as the Ávila Bible, was begun and mostly completed in central Italy about the middle of the twelfth century in a format that has been associated with exported Bibles encountered notably in Germany as well as at sites in Italy. The copy also seems to have been intended for export, as the illustrations with which it was embellished in Spain are of a style that suggests it came to the peninsula soon after it was written. In fact, it left Italy even before it was completed: the texts of Esdras 3–5 (fols. 168–79) and the Psalms (fols. 204v–217v) were added in Spain, together with initials with author portraits.

Also incorporated were illustrations. Noah's Ark now appears as a frontispiece as part of a folio dedicated to genealogical tables of the type found in earlier Spanish Bibles and

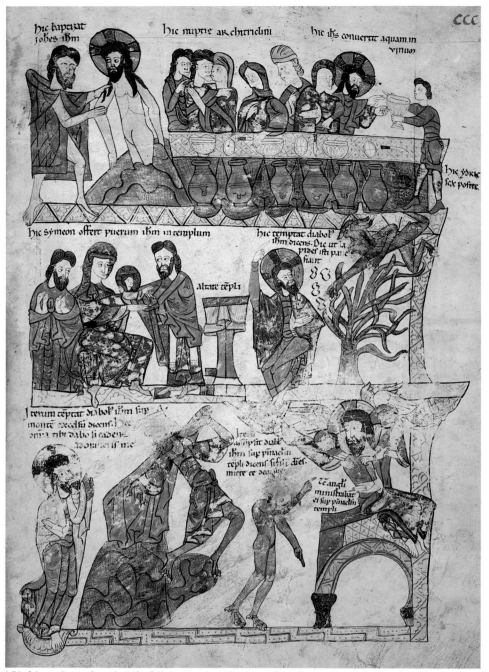

151: fol. 349. Scenes from the Life of Christ (Baptism, Marriage at Cana, Presentation in the Temple, and Temptation in the Wilderness)

Beatus Commentaries. The genealogical tables may be only a fragment of a complete set, since the biblical and Beatus versions begin with Adam and Eve and cover fourteen folios. The New Testament is prefaced by six pages of illustrations: the Baptism of Christ, the Wedding at Cana, the Presentation in the Temple, and the three Temptations of Christ (fol. 349r); the Entry into Jerusalem, the Last Supper, and the Washing of Feet (fol. 349v); the Arrest of Christ, the Crucifixion with the two thieves, and the Deposition of Christ along with Judas Hanged (fol. 350r); the Marys at the Tomb, the Descent into Hell, the Noli Me Tangere, and the Journey to Emmaus (fol. 350v); the Supper at Emmaus,

the Doubting Thomas, and the Ascension (fol. 351r); the Pentecost (fol. 351v). On folio 353v are symbols of the evangelists with human bodies and beast heads, a type favored on the peninsula.

These twenty-one illustrations constitute the largest set of New Testament scenes in a Spanish manuscript, with the exception of the Bible carried out at Ripoll in the eleventh century (cat. 157). Unlike that example, which was based on Italo-Byzantine sources, the Ávila Bible, as is most obvious in the illustrations of the Ascension and the Pentecost, does not reflect a Byzantine model. Cycles of New Testament subjects of this size are most commonly found in Romanesque psalters

like the Saint Albans Psalter of about 1125, which represent a text not popular as an independent illuminated unit in Spain.[1] The large Hell Mouth of the Descent into Hell especially recalls the English popularity of this theme.

Knowledge of English manuscript traditions in Spain is clearly revealed by one of the figure styles displayed in the Cardeña Beatus (cat. 153), but the figure style of the Ávila Bible has no obvious English counterpart. A note of the fourteenth century (fol. 305) indicates the presence of the Bible in Ávila at this time. Since there is no other illumination from that city, it cannot be confirmed that the Spanish elements were introduced there. However, the figure style of the frescoes of the not-too-distant church of San Justo in Segovia[2] has been related, with some justification, to that of the Bible of Ávila.[3] The absence of a strong component of Byzantine formulas suggests that the illustrations were carried out before the final third of the twelfth century when these began to appear to a marked degree in Spain. However, a terminus post quem depends on the date established for the Italian core, and 1150–60 has been proposed, although not unanimously.[4]

JWW

1. I am grateful to Leslie Blake DiNella for pointing this out to me.
2. Lozoya 1966; Bango 1992, pp. 300–302.
3. For the suggestion of a connection with San Justo, see Moralejo 1980, p. 207.
4. For arguments for a mid-twelfth-century date and Umbrian background for the Italian Ávila Bible Master, see Garrison 1953, pp. 109–12; Garrison 1960, pp. 59–72; Berg 1968, pp. 56–57. However, Nordenfalk (1980, pp. 325–26) proposed a north Italian setting and a career for the artist still continuing in 1200.

LITERATURE: Torre and Longás 1935, pp. 31–39; Miguel 1970, pls. 12–22; Yarza 1974, pp. 30–32; Cahn 1982, no. 125, pp. 208, 285; Sanchez Mariana, in Burgos 1990, no. 19, pp. 70–75; Yarza 1990, p. 22.

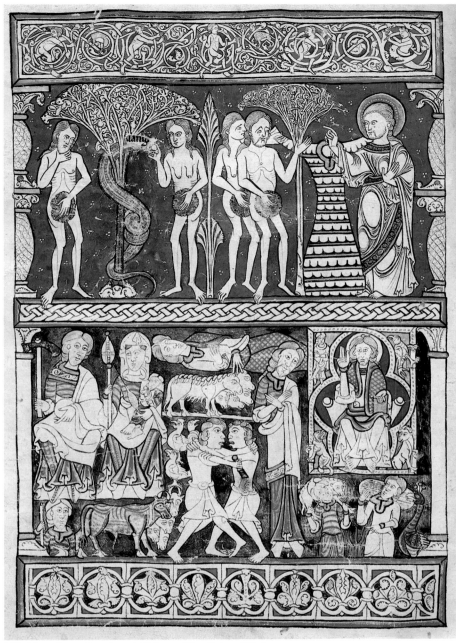

152: fol. 12v. Scenes from Genesis (Adam and Eve; Cain and Abel)

152

BIBLE

Monastery of San Pedro de Cardeña, Burgos (Burgos), ca. 1175
Tempera on parchment
20½ x 14 in. (52 x 37 cm)
Biblioteca Provincial de Burgos (MS. 846)

This is the surviving first volume of a two-volume Bible traditionally associated with San Pedro de Cardeña, a Benedictine monastery a short distance west of the Castilian capital of Burgos.[1] This venerable site had been founded in the tenth century. An illustrated Beatus Commentary (cat. 153) from about the same time was once at the same

monastery and is traditionally assigned to its scriptorium. That Commentary and this Bible seem to have shared an artist who included elements found in French and Insular Romanesque manuscripts. For example, the small, crosshatched ball or fruit forms on the bases of the columns flanking the upper register of the Genesis miniatures of folio 12v have counterparts in English and French manuscripts of the second quarter of the twelfth century.[2] More significantly, the peculiar manner of accenting parts of the body by circumscribing lozenge or tear-shaped patterns with tubular folds is so exactly followed in the delineation of the figure of God expelling Adam and Eve from Eden in the same sec-

tion of this page that it is probable that the painter was trained at Winchester or at a center imitating the Winchester manner.[3] These and other ornamental features are also found in a Book of Homilies of Smaragdus apparently carried out for Toledo Cathedral (cat. 155). The general distribution of the Winchester style is documented by initials in the Bible of Lleida Cathedral, which has been attributed to English artists about 1170.[4] However, in the case of the Burgos Bible an origin in or near Burgos is clearly indicated: initials in a lectionary in the library of the convent of Las Huelgas must have been painted by the illuminator responsible for the lower half of the Genesis page of our Bible.[5] This bottom

register, with Adam and Eve and Cain and Abel, employs a figure style of a more generic type, quite different from that of the upper register. Such a combination of styles within the same manuscript occurred also in the Cardeña Beatus, but there a different second artist was employed. In addition to illustrating numerous initials with figures of authors, the Bible's second painter rendered the Adoration of the Magi that concludes the genealogical tables of Christ's genealogy on folio 8v. These tables were an integral part of the Beatus Commentaries of the expanded, second family, represented by the Morgan Beatus (cat. 78).

Although there is no date within the manuscript, the elements it shares with northern manuscripts of the middle of the century and the presumed contemporaneity of the Cardeña Beatus suggest that it was carried out about 1175. J W W

1. According to Quentin (1922, p. 470), this Bible came to Burgos from the Cistercian convent of Vileña, to the north of Burgos, which was not founded until 1222. A page of the Epistles of Paul from the lost second volume is sewn into the "Antigua Biblia" in the library of the convent of Las Huelgas in the suburbs of Burgos (Herrero González 1988, pp. 81ff., fig. 71).
2. Kauffmann 1975, figs. 125, 220 (Winchester Psalter); Porcher 1960, pl. XXXIV (Gospels of Abbot Wedricus, Société Archéologique, Avesnes).
3. For Winchester see Kauffmann 1975, p. 25.
4. Yarza 1986b.
5. Herrero González 1988, fig. 11. See Yarza 1992, p. 322.

LITERATURE: Yarza 1969; Cahn 1982, pp. 289–90; E.S.G., in Burgos 1990, no. 18, pp. 68–70; Williams 1992b, pp. 374–75; Yarza 1992, pp. 319–22.

153

commentary on the apocalypse by beatus of liébana

Monastery of San Pedro de Cardeña, Burgos (Burgos), ca. 1180
Tempera on parchment
17½ x 11¾ in. (44.5 x 30 cm)
127 folios: Museo Arqueológico Nacional, Madrid (MS. 2)
15 folios: The Metropolitan Museum of Art, New York; Purchase, The Cloisters Collection, Rogers and Harris Brisbane Dick Funds, and Joseph Pulitzer Bequest, 1991 (1991.232.1–15)
2 folios: Collection Francisco de Zabálburu y Basabe, Madrid
1 folio: Museu d'Art de Girona (47)

This copy of the Beatus Commentary, the Cardeña Beatus, is one of four that have connections with Burgos, the capital of Castile. It was in the nineteenth century,

apparently, that this Romanesque copy was dismembered and that pieces found their way into various collections. Although the Cardeña Beatus belongs to the second branch of the family of Commentaries and therefore should end with Jerome's Commentary on the Book of Daniel, that entire section, as well as numerous other parts of the manuscript, is missing.

Fifteen folios entered the Parisian collection of Martin Le Roy and then passed to the J.-J. Marquet de Vasselot collection, also in Paris. These were purchased by The Metropolitan Museum of Art in 1991. The major part of the manuscript had entered the Museo Arqueológico Nacional by 1871, accompanied by a statement that it originally had been encountered in the monastery of San Pedro de Cardeña, a short distance from Burgos.[1] The Cardeña monastery was a tenth-century foundation that had enjoyed a prosperous history and was associated with the heroic warrior of the Reconquest, El Cid. A Cardeña provenance seems to be supported by the

153: Christ appearing to Saint John, who is shown at center and right in the lower register (Apoc. 1:1–6). MMA, 1991.232.3r

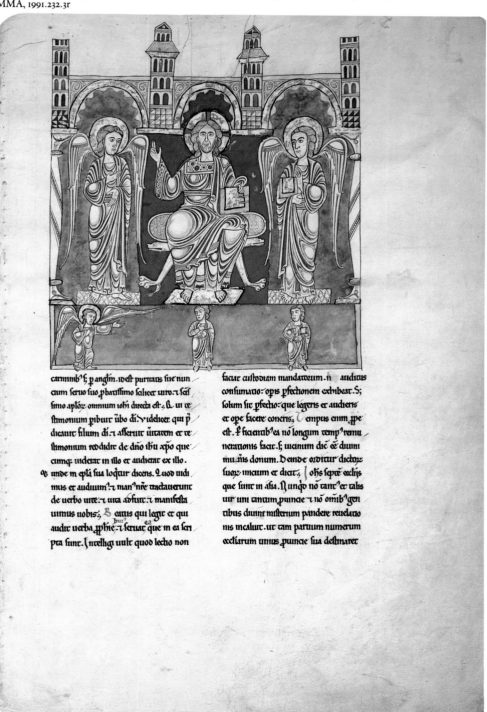

presence in a Bible now in the Biblioteca Provincial de Burgos (MS. 846) of a style of figure and ornament similar to that employed in our Beatus,[2] although that Bible has no documented ties to Cardeña. A later manuscript[3] produced at Cardeña offers stylistic similarities to our Beatus and provides some support for its Cardeña provenance; it should be pointed out, however, that one of the figure styles employed in the Beatus, which recalls illuminations from Winchester, and some of the ornamental details are also found in a manuscript written, apparently in Toledo, for the cathedral of Toledo (cat. 155).[4] Although they differ stylistically, in format, textual details, and the composition of illustrations, there is an extraordinary agreement between the Cardeña Beatus and the Beatus Commentary in Manchester (cat. 154). Although there is no documented origin for the Manchester Commentary, it is possible to conjecture, therefore, that it served as the model for the Cardeña Beatus.

Two sharply different figure styles are min-

153: fol. 92. The palm whose growth in the desert was used as an allegory of the spiritual life by Gregory the Great in his Moralia in Iob (parts of this treatise were included in the Cardeña Beatus). Museo Arqueológico Nacional, Madrid

153: The Seven Plague Angels and the Adoration of the Lamb (Apoc. 15:1–4). MMA, 1991.232.14r

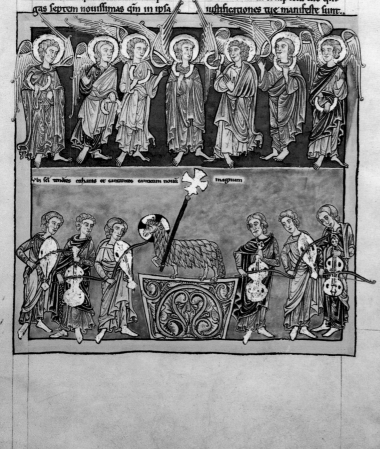

gled throughout the Cardeña Beatus, representing a lack of homogeneity that does not occur in manuscripts from previous centuries. One involves patterns of drapery that ultimately must be traced to the influence of Byzantine examples but also includes a particular formulation of teardrop or kidney-shaped folds defined by tubes of drapery that derives from formulas found in manuscripts of the middle of the twelfth century from Winchester in England. The other is more sculptural, building multiple folds out from the surface rather than disposing them across it. Both have analogues in sculpture and even appear together in the same monument, as they do in this manuscript: they are seen side by side in the apostles of the great frieze of the church of Santiago de Carrión de los Condes on the pilgrimage road to Santiago, west of Burgos,[5] an assemblage usually dated to about 1180. That date seems suitable for the Cardeña Beatus.

J W W

1. Dios de la Rada and Malibrán 1871, p. 26.
2. As noted first in Domínguez 1930, vol. 1, p. 22. For the Burgos Bible, see Yarza 1969.
3. Faulhaber 1983, vol. 1, no. 125.
4. Williams 1992b (imaginería), p. 375.
5. García Guinea 1961a, p. 126, pl. 90.

LITERATURE: Yarza 1986a; Yarza 1992, pp. 323–24; Williams 1992b, pp. 374–76; Williams 1993, vol. 5, no. 21.

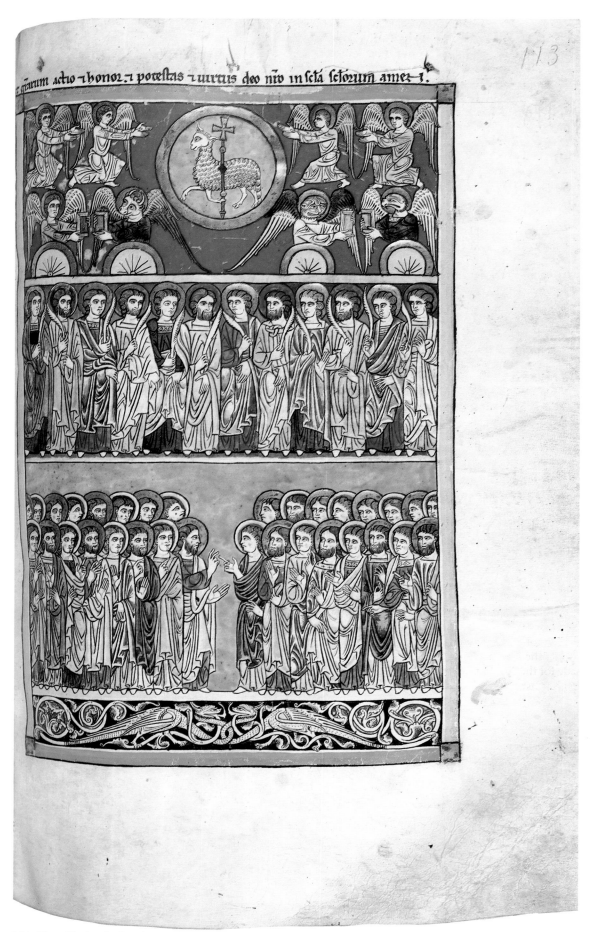

154: fol. 113. The Lamb of God presiding over the Sealing of the Elect (Apoc. 7:4–12)

commentary on the apocalypse by beatus and commentary on daniel by jerome

Burgos(?), ca. 1175
Tempera on parchment
17⅞ x 12⅞ in. (46 x 32.6 cm)
John Rylands University Library of Manchester
(Rylands Latin MS. 8)

This is one of the largest and most intact copies of the Commentary on the Apocalypse by Beatus of Liébana. The origin of the Rylands Beatus is not documented, but it almost certainly was copied in Castile, for it seems to have been the model for the Beatus of Cardeña (cat. 153). This conclusion is based not on the style but on relationships between the texts and the illustrations; it is confirmed by the apparent duplication in a frontispiece of the Cardeña Beatus (Metropolitan Museum, fol. 1) of an arcade that appears in a frontispiece in the Rylands Beatus (fol. 1). The arcade has no apparent function in the Cardeña Beatus, but in the Rylands manuscript it is part of series of linked medallions for what seems to have been a trial piece for Genealogical Table 2. Since the Cardeña Beatus is associated with the monastery of San Pedro de Cardeña, outside Burgos, the Rylands Beatus perhaps should be also. On the other hand, the extraordinarily close parallels between the Rylands illustrations and those of the Tábara Beatus (cat. 79), suggest that the Rylands manuscript was copied from that tenth-century Commentary. In any case, the affinities with the Tábara manuscript place the Rylands Beatus within a Castilian context, for the Tábara Commentary was the model for the Beatus (cat. 147) made for the convent of Las Huelgas just outside the Castilian capital, Burgos.

The fidelity of the copy to the Tábara Beatus also reveals the conservative nature of the Rylands scribe's approach to the iconographic formulas of his model. The style, however, is not conservative but employs a language ultimately based on Byzantine formulas that had migrated west. This is seen, for example, in the panels into which the drapery folds are divided. Generally, byzantinizing currents occur also in other works from areas near Burgos, notably in the enamel plaques from the shrine of Saint Dominic at his monastery in Silos (cat. 134). However, the particular byzantinizing style of the Rylands Beatus resembles that employed in sculpture in the Navarrese sites of San Miguel de Estella and the collegiate

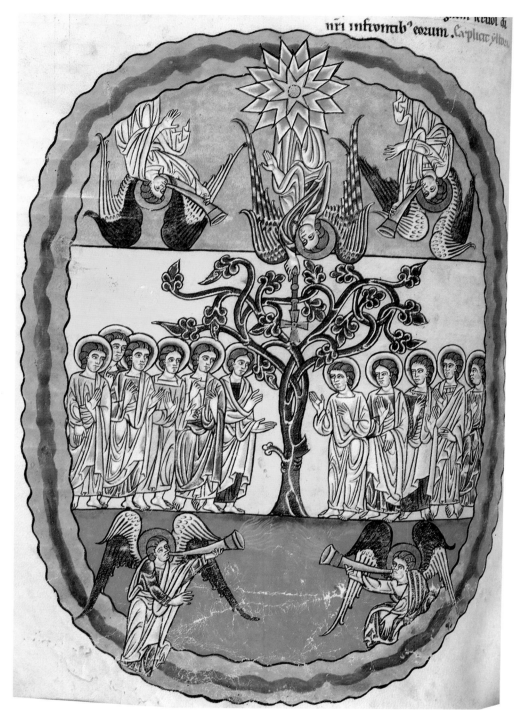

154: fol. 111v. Angels Restraining the Winds (Apoc. 7:1–3)

church of Tudela—as evidenced in the so-called Virgen Blanca of the latter.

JWW

LITERATURE: Klein 1990a; Yarza 1992, p. 329; Williams 1993, vol. 5, no. 20.

155

book of homilies of smaragdus

Toledo, ca. 1175
Tempera on parchment
21¼ x 14⅛ in. (54 x 36 cm)
Cathedral Archive, Toledo (MS. 44.9)

This is the first volume of a text bound in two volumes. The writings of Smaragdus, the Carolingian reformer and abbot of Saint-Mihiel in southern France, began to enter

303

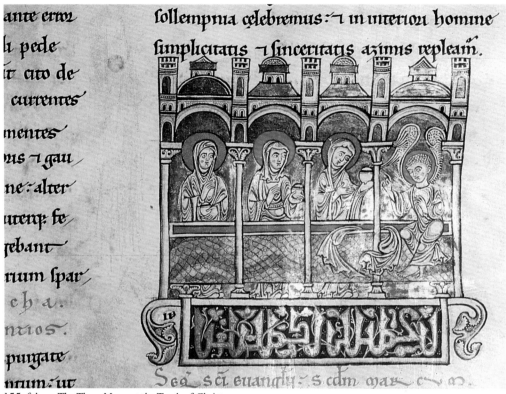

ante erou
li pede
it cuto de
currentes
mentes
ms i gau
ne alter
utenp fe
iebant
rium spar
ch a
ntios.
purgate
nium ut

sollempnia celebremus: i in interiori homine
simplicitatis i sinceritatis azimis repleam.

Sed sci euangly: s cdm mar c. v. m.

155: fol. 74. The Three Marys at the Tomb of Christ

commentary of peter lombard on the epistles of paul

*Monastery of Santos Facundo y Primitivo, Sahagún
(León), 1181
Tempera and gold on parchment
14⅛ x 9¾ in. (36.5 x 24.8 cm)
Pierpont Morgan Library, New York (M. 939)*

On three occasions fire ravaged the library of the great monastery of Sahagún,[1] and the losses that resulted must in part explain why Sahagún's role as a producer of illuminated manuscripts has been little appreciated until recently. Today it is clear, however, that the Beatus Commentary now at Burgo de Osma (cat. 82) and the copies that depended on it were produced there. The Liber Testamentorum of Oviedo (cat. 149) may also have been carried out at Sahagún, about 1118. In the case of the Pauline Epistles a colophon (fol. 275v) confirms the Sahagún origin, for it relates that the manuscript was completed in 1181 for Abbot Guterius.[2] Guterius, who ruled from 1164 to 1182, restored the spiritual life of Sahagún, which was favored with gifts from, among others, Alfonso VIII of Castile in whose territory it fell and Ferdinand II of León.[3] In the sixteenth century Ambrosio de Morales inspected at Sahagún a Peter Lombard Commentary on the Psalms, which had a colophon stating that it was made for Guterius in 1177.[4]

Peter Lombard, bishop of Paris until 1160, earned an exalted position as a theologian chiefly through his handbook on Christian doctrine, *The Book of Sentences*, and through his commentaries on books of the Bible. This copy of the Commentary on the Epistles of Saint Paul was prepared sumptuously, with the chief divisions of the text indicated by elegant, gold-embellished capitals. These capitals combine animals with vine scrolls and acanthus ornament and in the case of the major initials also incorporate scenes from the life of Paul (fols. 2v, 70, 143v, 181v, 194, 212, 217, 233v, 237). Although there was a longstanding tradition of Pauline illustration stemming from the Carolingian period, the illuminations of this Commentary are only loosely based on it.[5] This lack of reliance on Carolingian precedent was not, however, the result of provincial ignorance. On the contrary, the system of embellishment, as well as the text of the manuscript, appears to have been closely based on a Parisian model, and the colophon alone indicates that it was a peninsular product. It is likely that the illuminator was schooled in Paris. Stylistically the manuscript is part of a particular byzantinizing phase of European painting called the Chan-

Spain in the tenth century as progressive monastic culture became receptive to trans-Pyrenean culture. At that time a copy of his Book of Homilies, a collection of sermons arranged according to the ecclesiastical calendar for reading at the office of matins, was carried out at the monastery of Valeranica by Castile's leading scribe. That tenth-century manuscript is introduced by a full-page Cross frontispiece,[1] but the present copy of the homilies is the most luxuriously embellished of all the examples in the Smaragdan manuscript tradition. Gold is generously used, and there are eight large initials combining vine scrolls and interlace or employing precisely and elegantly shaped leaves with serrated edges (fols. 55, 129v). The initial I of the INCIPIT that opens the text (fol. 1) rises the full height of the page. Here, as in somewhat smaller initials (fols. 2v, 103), nude male figures clamber through the vines that curl within the ribbons of the borders. In addition, sirens and animals inhabit the vines of the I. In two instances narrative illustrations have been inserted above the appropriate text. In the illustration for Pentecost Sunday (fol. 109) Peter and the rest of the apostles, who flank him, occupy a towered building as a large hand emanating rays descends above their heads. The figures are drawn in sepia, but the background is gilt. Above the text of Mark's account of the visit of the Marys to the Tomb (fol. 74), an arcaded structure houses an empty sarcophagus covered with a reticulated pattern probably meant to suggest marble. Between the columns are figures of

three women holding jars and an angel who gestures toward them.

Two elements of this last miniature are significant but problematic clues to the origin of the manuscript. The manner in which the garments of the figures have been organized into circular patterns by means of tubular folds ultimately depends on formulas employed in the byzantinizing style associated with the monastery of Winchester and such continental scriptoria as that at Liesse. It is a formula notable in the Cardeña Beatus (cat. 153) and in the Cardeña Bible (cat. 152), which also employs an inhabited vine scroll almost identical to the one in our manuscript. These parallels point in the direction of an origin at the monastery of Cardeña outside the Castilian capital of Burgos. However, the columns that support the sarcophagus of Christ enframe a gold display text brilliantly set off by a deep blue background. This text employs pseudo-Kufic script possibly attempting to repeat an invocation to God similar to one frequently encountered on Islamic objects. The manuscript has been assigned to Toledo by text scholars. Nevertheless, there is no certain conclusion regarding Toledo, for the same kind of appropriation from non-Christian peninsular culture for Christian use had occurred earlier in the century in the Kufic frame provided for the Majesty and apostles of the Arca Santa in Oviedo Cathedral (cat. 124).

JWW

1. Williams 1972–74, p. 226, fig. 4.

LITERATURE: Janini and Gonzálvez 1977, no. 173, pls. 13, 14; Williams 1992b, p. 375, figs. 2–3.

regnum suum celeste idem tibi sparat
licet. cui est gla in scla sclorum amen.
Saluta priscam 7 aquilam. aquila
erat uir prisce. apud istos hospitabat
apls. 7 honesiphori domum idest familia
enastus remansit chorinti. Tro
phimum autem reliqui infirmum
mileti. Ideo hos nominat ut ueniens
p eos uisitet. Festina ante yeme
nenire. ppter ymbres 7 frigora. como
net ut autupno uenire. Salutat
te oebalus. 7 pudens. 7 linus. 7 clau
dia. 7 fratres omis. Post salutatione fror
ipse salutat. quasi subscribens hoc ri.
Dns ihs. sit cu spu tuo. 7 caue ne
amonic9 irascaris. sed pocius. Gra
sit uobcum. idest maneat nra dilectio.
am idest fiat. Vel uera sunt que
hac re hus dixi.

faciet: in regnu suum celeste.
cui gla in scla sclorum am. Salu
ta priscam. 7 aqla 7 honesiphori do
mum. Erast? remansit chorinti.
Trophimu aut: reliq infirmu
mileti. Festina: ante yeme ueni
re. Salutat te oebalus. 7 pudes.
7 linus. 7 claudia. 7 fratres omis.
Dns ihs: cum spu tuo. Ora
nobiscum a men

Paulus seruus
dei. 7 cetera. Hanc
epla scribit apls. tito.
quem creauit episcopu.
commonens eum fore
sollicitum in ecclastica
disciplina. Tito enim relicto
crete epo: ex humilitate. 7
ex simplicitate nimis pacien
ti. anchopoli scribit de epa
li officio. improse. 7 potestati
ue tractando. p scripta ei sua
auctoritate utili. debet enim
pontifex habere matiam pie
tatem. 7 patris seueritatem.
ut sic fortis: suplr. 7 suauis:
modestus. Vt non habens ti
mois angulum. nec elatiois
superbium. utrat 7 luceat.
Vnde: in ueste legali
pontificis erat cocc9
bistinctus. qui habet
speciem ignis. Ignis
aut: duo facit. urit:
7 lucet. tia 7 pontifex: gladio pdicatio
nis: scilicet igniro eloquio. urere debet
mordaci increpatione. 7 metuenda
comminatione. 7 lucere blandis foue
do. 7 delectabilia pmittendo. Ideo de
manna dicit. qd in durabat ad igneos:
7 liquescebat ad soleos. 7 baculus pon
tificalis. ab inferiori pungit. 7 in sumo

Paulus seruus dei

apostolus autem ihesu
xpisti. secundum fidem
electorum dei. 7 agniti
onem ueritatis. que se
cundum pietatem est
in spem uite eterne.
quam promisit qui
non mentitur deus.
ante tempora secularia.

nel Style. This explains the less-than-subtle emphasis on patterns of light and shade in flesh areas, and the soft patterns of the drapery. Manuscripts from other sites on the peninsula, particularly Burgos and its monastic scriptorium of Cardeña, are also witnesses to this current (cats. 152–54). More evolved versions of the style in the Leonese region may be seen in the Obras de Santo Martino, bound in two volumes in the library of San Isidoro, León (Cod. XI) and dated after 1185, and the still later Libro de las Estampas of León Cathedral.[6] It is possible that the three Leonese sites referred to, San Isidoro, León Cathedral, and Sahagún, shared scribes and illuminators or depended on a common scriptorium.

<div style="text-align: right">JWW</div>

1. García Muñoz 1920, p. 11.
2. Millar (1930, pp. 3–4) interpreted the colophon, which employs words rather than numerals, as giving the year as 1189 (1000 + 200 + 7 + 20–38), when it actually should be read as 1000 + 200 + 7 + 12–38, or 1181.
3. Escalona 1782, pp. 119–21.
4. Morales 1765, p. 38.
5. Eleen 1982, p. 77.
6. For these manuscripts, dated after 1185, see Fernández González 1987a; Yarza 1992, pp. 331–33.

LITERATURE: Millar 1930, pp. 1–4, pls. CI–CIV; London 1968, pp. 33–36, pls. 12, 13; Eleen 1982, p. 77, fig. 168; Avril, Barral, and Gaborit-Chopin 1983, p. 259, fig. 220.

157

BIBLE

Monastery of Santa Maria de Ripoll (Girona), second quarter of 11th century
Tempera on parchment
21⅞ x 14¼ in. (55.5 x 37.4 cm)
Biblioteca Apostolica Vaticana, Rome (MS. Vat. lat. 5729; 465 folios)

In earlier literature this Bible was falsely identified as the Farfa Bible, that is, attributed to the Italian monastery of Farfa, through an erroneous reading of one of its late glosses.[1] A number of indications assure us, however, that it originated in Catalonia in the monastery of Santa Maria de Ripoll and that it was probably one of three complete Bibles ("Bibliotecas III") listed in the inventory of the monastery library at Ripoll in 1047.[2]

The primary confirmation that this Bible comes from Ripoll is the obvious iconographic similarity between its illustrations for the books of Exodus and Kings and the corresponding reliefs on the west portal of the monastery church at Ripoll from the period

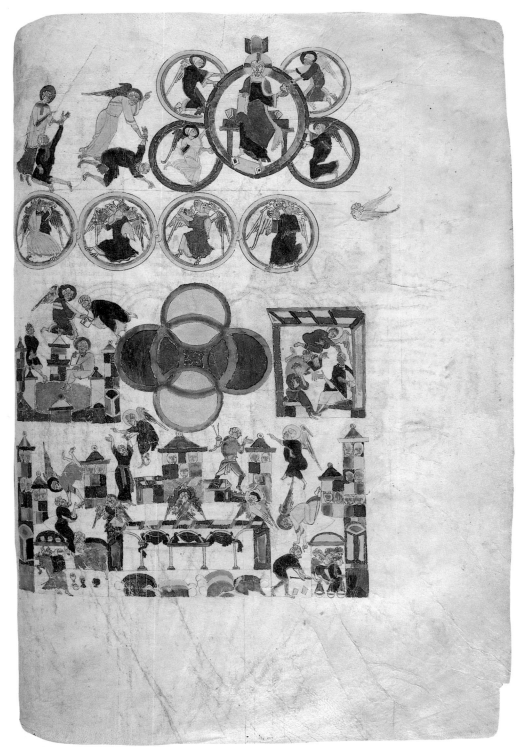

157: fol. 208v. The Prophecy of Ezekiel

1150–60 (see p. 191); those portions of the portal reliefs appear to have been directly patterned after the miniatures in the Bible.[3] Moreover, scholars have noted a number of paleographic and stylistic parallels between the Ripoll Bible and contemporaneous Catalonian manuscripts certain to have been produced in Ripoll, most convincingly the Ripoll Bede codex in Barcelona.[4] Compare, for example, the drapery of the enthroned Divine Judge in the Ripoll Bible (fol. 368v)[5] with

that of the enthroned Madonna in the Ripoll Bede codex (fol. 154r).[6] Finally, the presence in the Ripoll Bible of twelfth-century marginal glosses and trial strokes from southern France suggests that after serving as the model for the portal at Ripoll the manuscript found its way to France, presumably to Saint Victor in Marseilles,[7] of which Ripoll was then a dependency. In the sixteenth or seventeenth century, the manuscript must at last have come to rest in the Vatican Library in Rome.

The Ripoll Bible is a complete, large-format Bible; the text, written in three columns, is illustrated with over three hundred predominantly full-page miniatures. Like the somewhat later Roda Bible, also from Catalonia (cat. 158), it is one of the most richly illustrated Bibles of the early Middle Ages. Especially lavish are the illustrations for the books of Genesis, Kings, Ezekiel, Esther, Tobias, Judith, Maccabees, and the Gospels. The texts of both the Ripoll and Roda Bibles correspond generally with older Spanish versions of the so-called Peregrinus and Toledo type, although with certain Carolingian interpolations.[8] It is unusual that these scribes should have followed distinctly Spanish models, inasmuch as the traditions of central Europe were already making themselves felt in other aspects of local culture and society. The illustrations, however, are based on a wide variety of sources, some of them, despite the fundamental study by Wilhelm Neuss,[9] still largely unresearched.

A majority of the Ripoll Bible's Gospel illustrations must have derived from Byzantine prototypes, presumably by way of Italy.[10] The Creation scenes, virtually identical in the Ripoll and Roda Bibles, appear to combine western and Byzantine Genesis cycles,[11] thus representing a conflated Genesis type already seen in a different form in the Early Christian catacomb frescoes of the Via Latina in Rome[12] and further varied in the roughly contemporaneous Anglo-Saxon Caedmon codex[13] and the southern Italian ivories of the cathedral at Salerno.[14]

The pictorial sources for other illustrations in the Ripoll and Roda Bibles, however, are altogether unclear. The paintings for the book of Ezekiel are an example. The Ripoll and Roda Bibles contain not only the oldest but also the most extensive Ezekiel cycles from the early Middle Ages, yet oddly enough they differ considerably from each other.[15]

The page from the Ripoll Bible illustrated here begins directly with the prophet's great vision of God (Ezek. 1:4–2:1), followed by his being transported to Jerusalem to look upon the abomination there (Ezek. 8:1–3) and his return to Babylon to report to the congregation in captivity (Ezek. 11:24–25). At the very bottom is a detailed description of the abominations in the forecourts of the temple in Jerusalem (Ezek. 8:3–9:8): at the lower left the prophet digs through the wall into the image chamber, into which the idolatrous elders swing their censers (Ezek. 8:7–13); on the opposite side the angel sets the prophet down in the temple's north court, where women sit mourning the dying fertility god Tammus, or Adonis (Ezek. 8:14).[16] At the bottom center the men cower in the inner court of the temple, turning their backs to the shrine and worshiping the sun in the east (Ezek. 8:16). Inside the temple (columned arcade with curtains) hover three cherubim, while the glory of God—suggested by intersecting rings or "wheels"—has left the temple and hovers outside its threshold (Ezek. 9:3). On the left, above the temple, the angel speaks to the man with the writer's inkhorn, commanding him to mark the foreheads of the righteous (Ezek. 9:3–4). Some of these last scenes are depicted in the Roda Bible on a page separate from the one depicting the vision of God (vol. 3, fol. 45v).[17] Further analysis reveals how much the Ripoll and Roda Bibles diverge from each other in the arrangement and selection of the Ezekiel scenes.

The iconography of the two agrees in relatively few details, such as Ezekiel's transportation from his home to Jerusalem. The differences are especially striking in the prophet's vision of God, in which the two Bibles have almost no details in common. The depiction from the Ripoll Bible is further distinguished by the medallion frames around the Four Living Creatures (possibly representing the four wheels, although according to the text these appear next to the creatures), by the angels wearing the mandorla (they, too, framed by medallions), by the door above the head of the enthroned Christ (doubtless the "open door" of Apoc. 4:1), and by the two instances of an angel grasping the prophet by the hand. Most of these motifs may have been adapted from the iconography of the Apocalypse or the Christ in Majesty, which should come as no surprise, since the visions of God in Apocalypse 4 and Ezekiel 1 are closely related.

It remains unclear, however, how we are to explain that the Ezekiel iconography differs in the two Catalonian Bibles. Do both cycles derive from an older Spanish tradition, as we are left to assume but can scarcely prove? Yet the style of the miniatures and initials of the Ripoll Bible, which reveals the hands of various artists in addition to those of the chief painter,[18] is not traditionally Spanish. Derived from neither Visigothic nor Asturian nor Mozarabic art, these images represent instead a last offshoot of late Carolingian art.

P K K

1. The incorrect attribution to Farfa was made by Beissel (1893), pp. 29–34 (see p. 30). For criticism of Beissel, see Mundó 1976, p. 435.
2. See Neuss 1922, p. 21.
3. Already recognized by Pijoán 1911–12, pp. 479–88; Neuss 1922, pp. 22–25.
4. Now in the Archivo de la Corona de Aragón, Barcelona, MS. Riv. 151; see Neuss 1922, pp. 25–27. Mundó (1976, p. 435) speaks of codicological and paleographic parallels between the Ripoll Bible and other contemporary manuscripts from Ripoll (Archivo de la Corona de Aragón, Barcelona, MS. Riv. 52; and Montserrat, MS. 1104–IV). Unfortunately, he fails to identify them in any detail.
5. Neuss 1922, fig. 148; Cahn 1982, fig. 49.
6. Gudiol 1955, fig. 103; Delclaux 1973, color pl. p. 45.
7. Mundó 1976, p. 436.
8. Berger 1893, pp. 25–26, 184; Quentin 1922, pp. 399–400; Neuss 1922, p. 16; Fischer 1985, pp. 27, 51; Fischer 1986, p. 246.
9. Neuss 1922.
10. Ibid., pp. 128–30.
11. Sherman 1981.
12. Kötzsche-Breitenbruch 1976, pp. 103–9.
13. Now at the Bodleian Library, Oxford; MS. Junius 11, for which see Broderick 1978, pp. 371ff.
14. Bergman 1980, pp. 42–45.
15. For the Ezekiel cycles of the two Bibles, see Neuss 1912, pp. 203–27; Neuss 1922, pp. 87–90.
16. For this scene, see Neuss 1912, pp. 221–22.
17. Ibid., fig. 96.
18. Neuss (1922, p. 17) claims to identify the work of ten different painters, while Mundó (1976, p. 436) distinguishes only four.

LITERATURE: Pijoán 1911–12; Neuss 1922, pp. 16ff; Quentin 1922, pp. 399–400; Gudiol 1955, pp. 87–105; Bohigas 1960, pp. 68–77; Domínguez and Ainaud 1962, pp. 83–84; Dodwell 1971, pp. 115–17; Mundó 1976, pp. 435–36; Sherman 1981; Cahn 1982, pp. 70–80, 292–93, no. 150; Dalmases and José 1986, pp. 154–58, 261–67; Alcoy 1987, pp. 305–15; Barcelona 1992, no. 122, p. 60.

158

BIBLE

Monasteries of Santa Maria de Ripoll and Sant Pere de Rodes (Girona), mid- to late 11th century
Tempera on parchment
18⅞ x 12¼ in. (48 x 32.5 cm)
Bibliothèque Nationale, Paris (MS. lat. 6; 4 vols.; 110, 179, 164, and 113 folios)

This Bible comes from the monastery library at Sant Pere de Rodes (San Pedro de Roda), where it is documented beginning in the middle of the twelfth century.[1] It remains a matter of debate whether it was created in Rodes or, like the Ripoll Bible (cat. 157), in Ripoll. Most recent investigation has determined that the painter of the first two volumes of the Roda Bible was closely associated with the chief painter of the Ripoll Bible and certainly came from the same workshop in Ripoll.[2] Yet the painters of the last two volumes of the Roda Bible reveal stylistic parallels not only with manuscripts from Ripoll[3] but even more clearly with works from other Catalonian scriptoria, such as a Moralia codex from Vic, a homiliary in Girona, and a Gospel from Cuxa.[4] Still more striking is the fact that the last volume of the Roda Bible, containing the text of the New Testament, borrows from pictorial precedents different from those called upon for the Ripoll Bible. The Gospel illustrations of the Ripoll Bible are altogether lacking, replaced in the Roda Bible by an Apocalypse cycle not included in the Ripoll Bible. Moreover, in contrast to all the

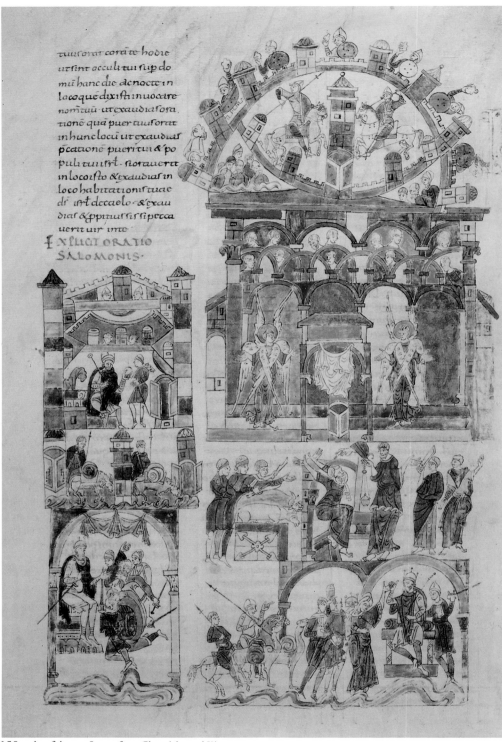

158: vol. 2, fol. 129v. Scenes from Chronicles and Kings

other illustrations in both Bibles, this Apocalypse cycle does not appear before the text but is interpolated between the relevant sections.[5]

All of this is best explained if we assume that the Roda Bible was written and illustrated for the most part in Ripoll and was from the very beginning destined for the library at Rodes—there would have been no reason to produce two so elaborately illustrated Bibles at the same time for Ripoll's own library.[6] Still unfinished, the Bible must then have gone to Rodes sometime in the second half of the eleventh century, where toward the end of that century the text was completed and the illustrations to the Apocalypse were interpolated. These paintings were based on patterns apparently unavailable in Ripoll, otherwise the Ripoll Bible would also have contained them. Although the Roda Bible was largely created in Ripoll, there is no point searching for it in the inventories of the Ripoll library; it would not have been one of the three complete Bibles included in the Ripoll inventory of 1047 for it was both incomplete as well as destined for another monastery.

The Roda Bible, like the Ripoll Bible, includes extensive pictorial cycles for the Old Testament, with especially rich illustrations for the books of the prophets. In the New Testament, however, there is only the one Apocalypse cycle, which remains unfinished. And, again like the Ripoll Bible, the Roda Bible contains picture cycles based on a variety of iconographic sources. Although some of these reflect native Spanish traditions, it is likely that central European iconography was also becoming increasingly influential. One senses it in the Genesis scenes, yet it becomes especially apparent in the illustrations for the books of the prophets and for the Apocalypse. The latter, for example, reveal particular parallels to Romanesque Apocalypse cycles in Italian wall painting, such as those at Castel Sant'Elia (Viterbo) and Anagni (Frosinone), and ultimately derive from an Italian archetype of the fifth or sixth century.[7] The uncommonly extensive Daniel cycle in the Roda Bible may also come from a late antique Italian archetype, other variants of which are preserved in the Spanish Daniel illustrations (in the Beatus manuscripts and Pamplona Bibles), in the English Lambeth Bible, and in an Ottonian Daniel commentary in Bamberg.[8] It has also been pointed out that there are Jewish elements in the Roda Bible's prophet cycles.[9]

Originally in a single volume, the Roda Bible was executed by at least five scribes, one of whom is close to the chief scribe of the Ripoll Bible.[10] The illustrations were essentially the work of two painters. The first of these illustrated the initial two volumes with

brightly colored pictures comparable in style to those of the primary illustrator of the Ripoll Bible (cat. 157). The painter of the third volume contented himself with uncolored pen drawings and was already wholly Romanesque in style. The same is true of the various painters of the fourth volume, the illustrations of which were probably not produced until near the end of the century.

The earlier chief painter of the Roda Bible also produced the frontispiece to the Psalms, which happens to contain a Solomon cycle for the First Book of Kings and the two books of Chronicles.[11] The narrative begins at the top of the left-hand column with David's last exhortation to his son Solomon to build a temple for the Lord (1 Chronicles 28:9–21).[12] Below follows the transport of materials for the construction of the temple (1 Kings 5:8; 2 Chronicles 2:16–17). At the bottom is the gathering of the elders before Solomon preceding the transfer of the ark of the covenant (1 Kings 8:1–2; 2 Chronicles 5:2–3). In the center of the illustration's main section we see Solomon's temple with the ark of the covenant and the two cherubim inside (1 Kings 8:6–7; 2 Chronicles 5:7–8). Below this is the consecration of the temple, with animal sacrifices and Solomon extending his arms toward heaven in prayer, just as in the text (1 Kings 8:54–64; 2 Chronicles 7:4–7). The bottom scene depicts the arrival before Solomon's throne of the queen of Sheba and her entourage (1 Kings 10:1–2; 2 Chronicles 9:1);[13] interestingly, the queen places one of her hands in Solomon's hand in a gesture suggestive of the *immixtio manuum* (joining of hands) in the feudal rite of homage, probably meant to show her subordinate rank.[14] While there are textual and pictorial precedents—from the *Dittochaeum* of the early Christian theologian Prudentius to a Romanesque fresco in the cathedral at Puy[15]—for combining the consecration of the temple with the visit from the queen of Sheba, the inclusion of the siege in the upper section of the picture remains unclear. Surely this is not meant to depict Solomon's building of the city and its fortifications (1 Kings 9:17–19; 2 Chronicles 8:2–6),[16] for there are no signs of construction. It does appear to be the siege and ultimate capture of a city, even though the attacking knights are illogically placed inside the walls, doubtless for lack of space. Perhaps this is meant to be the capture of Geser by the Egyptian king, who then bestowed it on his daughter, Solomon's wife, as a wedding gift (1 Kings 9:16–17).[17]

P K K

1. See the privilege of Pope Innocent II from December 5, 1130, on fol. 39r (Neuss 1922, p. 13). The Bible later found its way to France by way of the duke of Noailles, a marshal of King Louis XIV (1693), and subsequently into the Bibliothèque Royale (1740), which was absorbed into the present-day Bibliothèque Nationale.
2. Contrary to the almost unanimous opinion of most recent scholarship (Yolanda Zaluska, in Paris 1982, p. 37; Dalmases and José 1986, pp. 157–58), I do not believe that these two painters of the Ripoll and Roda Bibles are one and the same person.
3. Especially to the figural initials in the Archivo de la Corona de Aragón, Barcelona, MS. Riv. 52. See Neuss 1922, p. 27; Bohigas 1960, pp. 46–47; and Klein 1972, pp. 96–97.
4. Now in the Museu Episcopal, Vic, MS. 26; Museo Diocesano, Girona, MS. 44; and, for the Cuxa manuscript, Bibliothèque Municipale, Perpignan, MS. 1. See Klein 1972, pp. 97–99. Also see Neuss 1922, pp. 18, 27; Bohigas 1960, pp. 47, 80. For the Cuxa manuscript, see Gudiol 1955, pp. 122–26 and figs. 110–21, and Domínguez 1962, p. 93 and figs. 100, 101.
5. See Klein 1972–74, pp. 267–72, 298–301; Cahn 1982, pp. 70–72.
6. Regarding the latter, see Yolanda Zaluska, in Paris 1982, p. 42.
7. Klein 1972–74, pp. 290–96. See also Hoegger 1975, pp. 72–82.
8. For the Daniel illustrations of the Roda Bible, see Neuss 1922, pp. 89–94. A thorough investigation of the iconographic traditions and sources of medieval Daniel cycles has yet to be undertaken.
9. Nordström 1965, pp. 196–205. See also Nordström 1955–57, pp. 506–7.
10. Yolanda Zaluska, in Paris 1982, p. 31. See also Bohigas 1960, pp. 68–69.
11. For this illustration, see Neuss 1922, p. 79; Gudiol 1955, p. 90; Ferber 1976, pp. 21–43 (with many mistaken interpretations!); Moralejo 1981, pp. 79–88; Cahn 1982, pp. 72–74; Yolanda Zaluska, in Paris 1982, pp. 36–37; Dalmases and José 1986, p. 265.
12. Ferber (1976, p. 26), Yolanda Zaluska (Paris 1982, p. 36) and Dalmases and José (1986, pp. 261, 265) want to identify this image with the scene of Solomon sending a messenger to King Hiram of Tyre (1 Kings 5: 16; 2 Chronicles 2:2), which is unlikely, since in contrast to the other figures of Solomon on this side of the picture the king does not wear a beard.
13. For this scene in the Roda Bible, see Ostoia 1972, pp. 93–94; Moralejo 1981, pp. 80–88.
14. According to Moralejo 1981, pp. 85–86. It does appear that this is a misunderstood formulation of the gesture of the *immixtio manuum*, for Solomon appears to be lifting the queen by her hand (see Ostoia 1972, p. 93) instead of clasping the hand of his subordinate as in the feudal rite. Moreover, the queen is not depicted kneeling or even curtsying, as one would expect, but standing, although there are various pictorial precedents for the latter in the Catalonian manuscripts of the *Liber Feudorum Maior* and the *Liber Feudorum Ceritaniae* (see Gudiol 1955, fig. 169). For the ritual gesture of the *immixtio manuum*, see Le Goff 1976, pp. 687ff.).
15. See Moralejo 1981, p. 81.
16. As Neuss 1922, p. 79, and Cahn 1982, p. 74, suspect.
17. According to Yolanda Zaluska, in Paris 1982, p. 37.

LITERATURE: Neuss 1922, pp. 10ff; Quentin 1922, pp. 400–401; Gudiol 1955, pp. 87–91; Bohigas 1960, pp. 68–69, 72–74; Domínguez 1962, pp. 83–84; Nordström 1965, pp. 196–205; Dodwell 1971, pp. 116–17; Klein 1972–74; Delcor 1974, pp. 52–55; Mundó 1976, pp. 435–36; Moralejo 1981, pp. 80–88; Cahn 1982, pp. 70–80, 292, no. 148; Yolanda Zaluska, in Paris 1982, pp. 31–43, no. 36 (with extensive bibliography), 177–79 (Appendix); Dalmases and José 1986, pp. 154–58, 261–67; Alcoy 1987, pp. 292–305; Barcelona 1992, no. 1.21, p. 58.

CREATION TAPESTRY

Catalonia (?), ca. 1100
Wool and linen on wool twill
12 ft. x 17 ft. 2 in. (3.65 x 4.7 m)
Museu de la Catedral de Girona

With Christ at the center ordering the Creation of the Universe, this monumental embroidery, even in its fragmentary state, presents one of the most comprehensive images of the medieval cosmos. Within the Wheel of Creation five of the seven days of Creation are depicted in unequal segments arrayed around a young, beardless Christ. At the top of the Wheel, the nimbed Dove hovers between the Angels of Darkness and Light, who are flanked by the Creation of the Heavens at the left and the Separation of the Waters at the right. In the lower half of the circle, the Creation of the Animals appears in the center between the Creation of Eve at the left and Adam Naming the Animals at the right.

Ranged along three sides of the rectangular field enclosing the Creation is a border divided into square sections. Here, the figure of Annus (= Year) presides at the top center, flanked by two of the four seasons on each side. The personification of one of the rivers of paradise, Geon, is located in the upper left corner. To the right is the biblical figure of Samson with a mandible; Hercules(?) is in a corresponding position at the far right. The surviving months, beginning with February at the lower left corner, are depicted as Labors. These are interrupted, at left and right, by two medallions representing the summer and winter solstices as figures, one driving a quadriga and the other a biga (partly lost) and labeled *dies solis* and *dies (lunae* in all likelihood). The cardinal winds, which occupy the spandrels, are represented as nude men astride air bags blowing on horns. A few scenes from the Legend of the Cross appear on the friezelike fragment along the bottom edge. There is some question as to whether this piece formed part of the original embroidery. Despite certain stylistic similarities, some scholars have argued for a different provenance.[1]

Several proposals have been made regarding the missing portions of this textile. The simplest would merely add to the border the remaining rivers of paradise and a second biblical figure, in addition to completing the cycle of months. The most ambitious would almost triple the tapestry's height: in a mirror composition at the bottom, the Apocalyptic Christ would reign in majesty over the end of the world. Representations of the zodiac, the four elements, and three biblical or heroic figures (the Ages of Man?) would balance the

159

border figures above.[2] The Saint Cunibert embroidery in Cologne displays such a theme and arrangement.[3] The middle portion may have been plain as in the Cologne textile, or, as Palol favors, dominated by the figure of Constantine carrying the Cross amid narrative scenes.

Because of the scarcity of comparable works, it is difficult to assign a date or provenance to the Girona embroidery. A type of flat stitch known as figure stitch was used to fill in the outlines cast in stem or split stitches—a technique more typical of northern Europe than Spain in the Middle Ages.[4] The tapestry does not appear in the Girona Cathedral inventories or administrative documents between 1212 and 1686, although the inventory of 1212 does mention a great number of textiles.[5] The Turin Beatus, believed to have been copied from the Girona Beatus (cat. 80) in the cathedral scriptorium around 1100, provides a terminus ante quem because of the similar

and unusual representation of the cardinal winds in its Map of the World. The epigraphy of the Girona tapestry was identified as Spanish and dated to the second half of the eleventh century by A. M. Mundó.[6] So far this assertion provides the strongest argument for a date and provenance.

The personifications of the months of the year, the rivers, and the winds link the tapestry to classical imagery and, in particular, because of its subject matter and composition, to cosmological mosaics. But these traditions might well have been passed down through the intermediary of Carolingian works, since the depiction of the seasons and months as Labors stems from Carolingian sources. The tapestry's design is in line with schematic cosmological wheels, in particular the illustrations of Isidore of Seville's *Liber de natura rerum*, popular in Carolingian circles.[7] Girona, overrun by Islamic forces in 717, was taken by the Franks in 785 and became

part of the Spanish March, which placed it within the greater Carolingian orbit. Like the so-called Chair of Charlemagne and Tower of Charlemagne at Girona Cathedral, this work displays a strong attachment to the Carolingian tradition well into the Romanesque period. For stylistic reasons, such as the double lines and nested V's of the drapery folds and the clumps of hair of such figures as Christ and the sleeping Adam, a date shortly after 1100 is most likely. However, without comparative materials and a thorough analysis of the fibers, it is impossible to determine its place of origin.

This embroidery might have been used as an altarpiece or perhaps as a baldachin. It has been suggested that it was made for the altar of the Holy Cross in the Chapel of the Holy Sepulcher, known to have existed over the narthex of the Romanesque cathedral, an idea that would be very appealing if the fragment with scenes from the Legend of the

159: Detail

· LIGNŪ
POMIFERŪ

·D· X· ET· FACTAE· LVX·

S·C·S D·S
S·C·S

· VOLATILIA
CELI

MARE

VNCTA QVE FECER

CVORAS SETIVD
ERV

Cross was determined to have been a part of the original tapestry. EMM

1. Palol 1986, pp. 88–89.
2. Palol 1986, p. 65.
3. Cologne 1985, no. A8, pp. 62–63.
4. Dillmont n.d., pp. 146–47.
5. Palol 1986, pp. 79–80.
6. Palol 1986, p. 153.
7. Sears 1986, p. 17.

LITERATURE: Palol 1986 (with an extensive bibliography); Wilckens 1991, pp. 175–77; Bango 1992, pp. 94–95; Barcelona 1992, pp. 86–87.

160

SAINTS PHILIP, JUDE, AND BARTHOLOMEW

Church of Sant Pere, Vic (Barcelona), ca. 1140–70
Limestone
32 x 25 in. (81.4 x 63.4 cm)
Trustees of the Victoria and Albert Museum, London
(A.49-1932)

When the late twelfth-century church of Sant Pere in Vic was razed in 1791, most of its facade sculpture was discarded or cut down to be used as paving stones in the new Neoclassical church built in its place. A few important fragments, however, survived the destruction. The present piece, a relief representing Saints Philip, Jude, and Bartholomew, and a second similar relief depicting three prophets (Musée des Beaux-Arts, Lyons) were preserved in the church of La Guía just outside Vic. A third stone carved with Saints Paul, Andrew, and James (Nelson-Atkins Museum of Art, Kansas City) found a temporary home in the stairway of a private house.[1] These three reliefs had already left Spain by 1940, when Eduard Junyent discovered beneath the nave of the Neoclassical building the foundations, lower courses of the facade, and additional sculptural fragments, including two badly mutilated reliefs showing more apostles, from the twelfth-century cathedral.

Inscriptions on the books they carry identify the apostles on both the Kansas City and the London reliefs. While they share the same stocky proportions, oversize hands, bare feet, almond-shaped eyes with lead-filled pupils, and large halos, the apostles are individualized by differences in hair, beards, and gestures and especially by variations in their crisply pleated garments. Set in a shallow space in three-quarter poses, the apostles on both reliefs march boldly from right to left in opposition to their companion prophets on the Lyons relief, who move from left to right.

160

Opinions vary about the original use of the apostle reliefs and other sculptural fragments that were not demolished with the Romanesque cathedral of Vic. Judging by their unabraded condition, Arthur Kingsley Porter concluded that they had never been exposed to weather and thus it was most likely that they had been part of an altar rather than the facade of Sant Pere.[2] A text of 1318 cited by Juan Ainaud de Lasarte states that Bishop Ramón d'Anglesola (1265–98) had a stone retable made for the main altar of Sant Pere, parts of which were reused later in the choir stalls of the church. Although this fourteenth-century text provides no description of the retable's imagery, an eighteenth-century document refers to figures of apostles and prophets and scenes from the life of Saint Peter worked in stone that came

from the old main altar and were incorporated into the choir stalls built by Bishop Ramón in 1266.[3]

Josep Puig i Cadafalch, inspired by the mention of a figure of God above Sant Pere's portal in a will of 1244, contends that the reliefs were part of a monumental frieze over the church's west portal.[4] In his reconstruction an enthroned Christ, surrounded by a mandorla supported by angels above the evangelist symbols, decorated the central stone of the frieze. The twelve apostles arranged in two registers approached Christ from the right and prophets similarly placed advanced from the left. With the benefit of the additional fragments discovered in the excavations of the early 1940s Marilyn Stokstad, in general agreement with Puig, suggested that the apostle reliefs were part of a more elaborately

decorated facade similar to that added to the church of Ripoll in the twelfth century.[5]

J M

1. Porter 1928, vol. 1, p. 73.
2. Ibid.
3. Ainaud 1953, p. 208.
4. Puig 1933, pp. 332–33.
5. Stokstad 1970, pp. 9–17.

LITERATURE: Porter 1928, vol. 1, p. 73, pl. 57, figs. 56–58; Puig 1933, pp. 330–34; Jullian 1945, pp. 37–40; Ainaud 1953, pp. 202–9; Stokstad 1970, pp. 2–24; Stokstad 1977, p. 52; Barral 1979a, p. 124, pl. 74; Williamson 1983, p. 102; Goheen 1988, p. 32.

161

TWO SCULPTURES ATTRIBUTED TO THE MASTER OF CABESTANY

Church of Sant Pere de Rodes (Girona), second half of 12th century
Marble
a. Fragment of a Relief with the Calling of the Apostles Peter and Andrew
32¼ x 24 in. (82 x 61 cm)
Museu Frederic Marès, Ajuntament de Barcelona (654)
b. Head
H. 7⅞ in. (20 cm)
Museo del Castillo de Peralada (Girona) (6567)

This relief plaque and carved head attributed to the Master of Cabestany originally decorated the elaborate marble facade that was made for the west end of the church of Sant Pere de Rodes, apparently at the time that an atrium was added to the monastery complex. Today, the sculpture from the facade is scattered in museums and collections in Spain, France, the United States, and England, and all that survives at the monastery are fragments of a marble doorway. Evidence for the attribution of the present sculptures to Sant Pere de Rodes is provided by a number of comparable works that have been collected in and around Rodes,[1] as well as by a seventeenth-century account of marble sculpture on the main portal of the atrium—the Galilee Portal. Moreover, an inscription on a nineteenth-century drawing describes the present relief as having come from the ruins of the monastery, where it formed part of the decoration of the principal doorway, or "Galilea."[2]

The Master of Cabestany is named after a carved tympanum attributed to him at the church at Cabestany in Roussillon, although the origins of his style have most convincingly been sought in northern Italy, where he worked as well.[3] This style is sufficiently idiosyncratic to have made it possible to assign works to him, or to artists influenced by him, in a variety of locations, not only in Italy,

Roussillon, and Catalonia, but also in Navarre, Languedoc, and Aquitaine.[4] Although the general characteristics of his figure style—which is marked by the extensive use of the drill to achieve deep cutting at the corners of the eyes, flattened noses, and prominent cheekbones—are indeed specific enough to group various monuments together, issues of influence and quality await further resolution before it is possible to separate the works of the master from those of his assistants and copyists. Even so, the present head, from the Junyent collection, and the Barcelona plaque are extraordinary by any standards.

The distinctive style of the Master of Cabestany would seem to be in emulation of late antique or Early Christian monuments. Not only did the artist reuse an antique marble fragment from either a Roman or Early Christian sarcophagus for the relief plaque,[5] but also, as Marcel Durliat has suggested, the inscription on the relief is carved in a consciously archaizing manner.[6] Furthermore, other marble sculptures from the Rodes portal were spolia as well.[7]

The subject of the plaque is usually identified as the Calling of the Apostles, and it is assumed, not without justification, that, as is traditional, the two apostles depicted are Peter and Andrew. Oars in hand, they occupy a boat asail on a sea inhabited by fish whose scales establish a lively pattern as well as a textural contrast to the ribbony waters. Peter, the apostle closest to Christ, seems eager to climb from the boat, prepared to answer Christ's call "straightaway" (Matthew 4 : 18–20; Mark 1 : 16–18). However, the fact that

161a

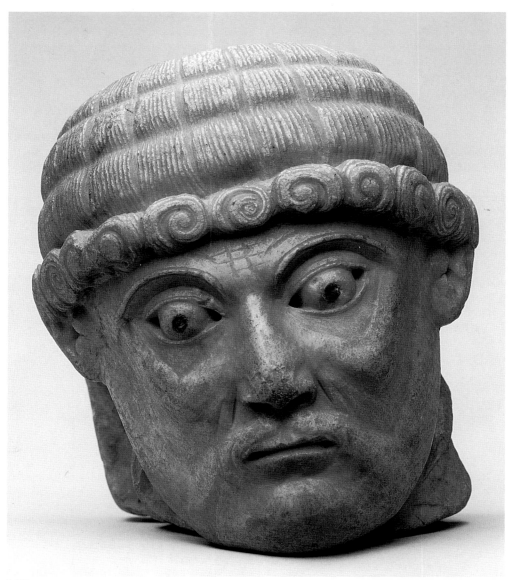

161b

Christ seems to be on the water rather than on land, together with the inscription, VBI D[OMI]N[V]SAPARVITDSC[V]P[V]LIS[I]NMAR[I] (Wherein Christ appears to the disciples on the sea), suggests that the scene represented here is Christ Walking on the Water. In Matthew 14:24–32, Peter is described as leaving the boat to walk on the water to reach Christ.[8] In a discussion of a problematic representation of Peter attempting to walk on the water, from the church of the Annunciation in Nazareth, Moshe Barasch cites a passage from *Contra symmachum*, an influential poem by the fourth-century Spanish writer Prudentius, in which Peter, asking for help during a storm, is encouraged by Christ to leave the boat. Prudentius describes Peter stretching out his hand toward Christ, who responds with a sign.[9] The framing of Christ's hand between Peter's raised hand and foot on the Rodes plaque has a visual resonance that is poetic indeed.

D L S

1. Durliat 1950–54, vol. 4, p. 22.
2. Bastardes 1982, p. 392.
3. Junyent 1962, pp. 169–78; Zarnecki 1964, pp. 536–39; Pressouyre 1969, pp. 30–55.
4. Pressouyre 1969, pp. 30–55; Durliat 1973, pp. 116–27; Durliat 1950–54, vol. 4, pp. 6–49; Simon 1979c; Gardelles 1976, pp. 231–37.
5. Durliat 1950–54, vol. 4, p. 16.
6. Bastardes 1982, p. 400.
7. Durliat 1952, p. 119.
8. Durliat 1972, p. 53; Bastardes 1982, p. 397.
9. Barasch 1971, pp. 118–37.

LITERATURE: Gudiol Ricart and Gaya 1948, p. 64; Durliat 1952, pp. 185–93, fig. 1; Durliat 1950–54, vol. 4, pp. 7–49; Barcelona 1961, no. 309, p. 211, pl. XX; Junyent 1962, pp. 169–78, pl. p. 173; Zarnecki 1964, pp. 536–39, figs. 69, 70; Palol and Hirmer 1967, pp. 160, 484, pls. 158, 159; Cahn 1968, pp. 60–61; Pressouyre 1969, pp. 30–55, pl. III.1; Providence 1969, pp. 111–13, fig. 40a; Crozet 1972; Durliat 1972, p. 53, pl. 5; Durliat 1973, pp. 116–27; Barral 1975, pp. 321–25; Gardelles 1976, pp. 231–37; Durliat 1979, pp. 153–74, fig. 6; Yarza 1979, p. 299; Bastardes 1982, p. 392; Simon 1984, pp. 152–55; Alcoy, Camps, and Lorés 1992, pp. 68–77; Loosveldt 1992, pp. 78–79.

CAPITAL WITH SCENES FROM THE LIFE OF ABRAHAM

Catalonia, last quarter of 12th century
Limestone
H. 13¼ in. (35 cm)
Musée National du Moyen Âge, Thermes de Cluny, Paris
(CL 19000)

This delicately carved cloister capital depicts four episodes from the life of Abraham. The story, reading counterclockwise, begins with Abraham kneeling in greeting before the three angels (Gen. 18:2–4) and continues with the angels in Abraham's tent and Sarah serving them bread, butter, and milk (Gen. 18:6–10). Proving his readiness to sacrifice his son Isaac, Abraham saddles an ass and departs with two young men (Gen. 22:3–6). The sequence culminates with the angel saving Isaac from the sword of Abraham (Gen. 22:9–13).

The compelling means by which the narrative unfolds within an architectural setting and the sympathetic rapport of the figures, often identified by labels above them, suggest that the capital may have been part of an ambitious program of historiated capitals for a cloister. In terms of the iconography, style, and technique, this capital corresponds closely to those in Girona Cathedral's cloister, where an elaborate series of biblical capitals survives intact, except for a few replacements from the Gothic period. Although the capital has traditionally been associated with Sant Pere de Rodes, it is more closely affiliated with the capitals in Girona Cathedral and perhaps with those from the same workshop made for Santa Maria de Manresa in the region of Bages. CTL

LITERATURE: Dalmases and José 1986, pp. 244–50.

CAPITAL ATTRIBUTED TO THE MASTER OF CABESTANY

Monastery of Sant Pere de Rodes (Girona), second half of 12th century
Marble
H. 18⅛ in. (46 cm)
Worcester Art Museum, Massachusetts; Gift of Arthur Byne (1934.33)

Arthur Byne, the American collector and art dealer who was influential in establishing a taste for Spanish medieval art in the United

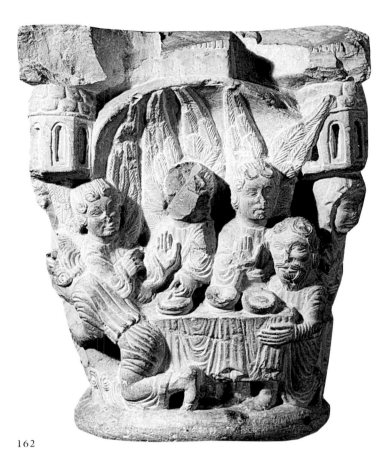

162

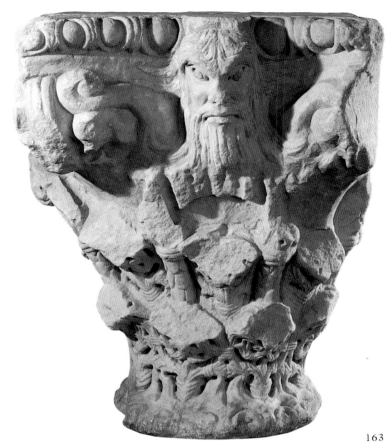

163

States, gave this capital to the Worcester Art Museum in 1934. He claimed to have bought the capital on site at the monastery of Sant Pere de Rodes.[1] Byne was not the only collector to take advantage of the ruinous state of the monastery; in fact, he would seem to have been a late arrival. Throughout most of the nineteenth century Sant Pere de Rodes was a virtual lapidary warehouse,[2] and sculpture from the monastery has been dispersed in public and private collections in the United States, France, England, and particularly in Catalonia. An analysis of the capital confirms the dealer's claim for a Rodes provenance, although it is less easy to be certain of the capital's original location within the monastery. On the basis of style the capital has been convincingly attributed to the Master of Cabestany, who worked at Rodes, principally on the Galilee Portal—the major doorway leading from the atrium.[3] The doorway is recorded to have been carved in marble, the master's preferred medium and the material of the present capital. Thus, it is to the doorway at Rodes that this capital is traditionally assigned—notwithstanding René Crozet's concerns that its relatively large size and the presence of carvings on all four sides preclude its placement there.[4]

Two rows of deeply carved acanthus, now mostly broken off, rise above and behind a framework of tendrils and scaly stalks that serves as a basket to contain the foliage.

Volutes unfurl at the top of the basket and, on one face, frame a large head or mask. The capital follows antique models in the arrangement of the foliage, the placement of the mask,[5] the beaded astragal at the bottom, and the egg-and-dart molding at the top, as well as the use of marble—a favored medium in antiquity. The mask has deeply drilled eyes, hair that falls low on the forehead, and cheekbones that emphasize the structure of the face.

The capital is convincingly related to work by the Master of Cabestany in its reliance on antique types, in the deep cutting, and in the details of the face, particularly the drill holes at the corners of the eyes. The flowing beard that merges with the background of the capital has parallels at Le Boulou (Le Voló)[6] and Saint-Papoul[7] in France, and in Villaveta[8] —all sites where the Master of Cabestany worked. He often employed beaded bands on astragals—as, for example, on the west-portal capitals at Rieux-Minervois, in France[9]—and beaded decoration appears on the base of the sculpted doorway fragments that survive in situ at Rodes.[10] The foliage itself can be compared to that carved on the doorway at Rieux-Minervois,[11] as well as on the abacus of a capital from the same church.[12]

Despite the severe damage to the capital, the density and richness of the carving are still apparent. The face appears at once to be part of the overall decoration of the capital and

yet to maintain its own identity—a result of a deeply plastic conception of form combined with an overriding sense of structural and compositional balance.

DLS

1. Cahn 1968, p. 60; Providence 1969, p. 113.
2. Barral 1975, p. 321.
3. Bastardes 1982, p. 392.
4. Crozet 1972, pp. 77–79.
5. Adhémar 1939, pp. 168–75.
6. Simon 1979b, figs. 63, 64.
7. Durliat 1950–54, vol. 4, fig. 36.
8. Simon 1979b, fig. 55.
9. Durliat 1950–54, vol. 4, figs. 25–26.
10. Ibid., vol. 3, fig. 36.
11. Ibid., vol. 4, figs. 27, 28.
12. Ibid., fig. 24.

LITERATURE: Durliat 1950–54, vol. 4, pp. 7–49; Cahn 1968; Providence 1969, pp. 111–13; Crozet 1972; Durliat 1973; Alcoy, Camps, and Lorés 1992, pp. 68–71.

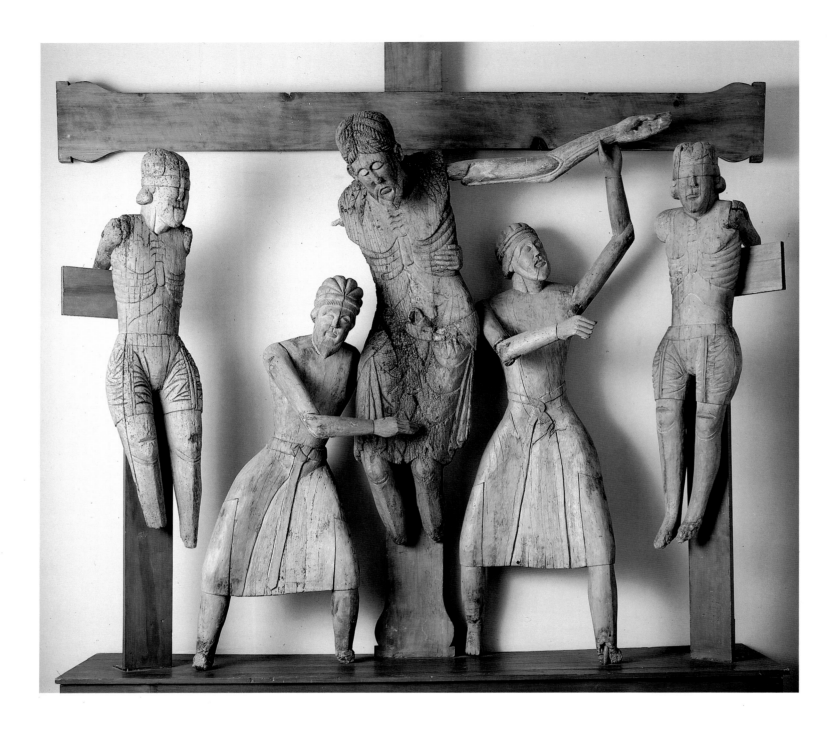

deposition group

Erill la Vall (Lleida), mid(?)-12th century
Wood, with traces of polychromy
a. Virgin
56¹¹/₁₆ x 15¼ in. (144 x 40 cm)
b. Saint John
56¹¹/₁₆ x 15¼ in. (144 x 40 cm)
a, b: Museu d'Art de Catalunya, Barcelona (3917–18)
c. Christ
57½ x 33⅞ in. (146 x 86 cm)
d. Nicodemus
67¹¹/₁₆ x 19⁹/₁₆ in. (172 x 49 cm)
e. Joseph
55¹⁵/₁₆ x 18½ in. (142 x 47 cm)

f. Dimas
53⁹/₁₆ x 12⅝ in. (136 x 32 cm)
g. Gestas
51⁹/₁₆ x 11¹³/₁₆ in. (131 x 30 cm)
c–g: Museu Arqueologic-Artistic Episcopal, Vic

This monumental Deposition ensemble of seven wooden figures is the most complete to survive from Romanesque Europe. Even without its original polychromy, and with some portions of the figures lost, the ensemble is evidence of the imposing large-scale sculpture groups that appear to have been common in medieval churches. The polychrome decoration would originally have been com-

parable to that of the Christ of Mig-Aran (cat. 166)—a work by the same atelier. Discovered in 1907 in the bell tower of the church at Erill la Vall (Lleida) by three members of the Institut d'Estudis Catalans (Institute for the Study of Catalonia), the sculpture group is owned by the museums in Vic and Barcelona, although the entire group has been exhibited in Barcelona.

The physical and emotional power of the group is determined by the composition of life-size figures and, despite the economy of the forms and the radically simplified drapery, by their grand gestures. The gravity of the figure of the dead Christ is especially poi-

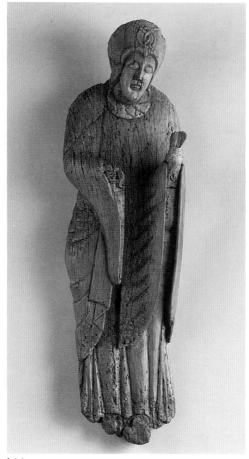

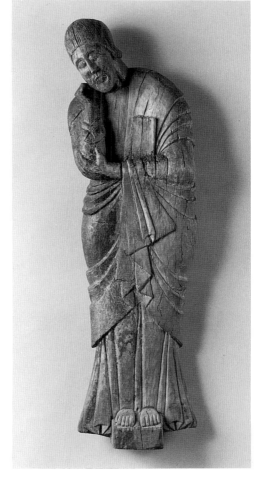

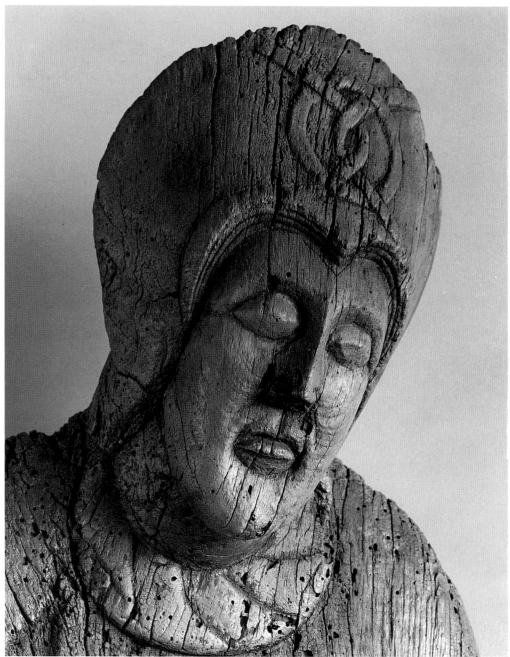

164a: Detail

gnant, and the emphatic curving volumetric forms of his body are echoed in the supporting figure of Joseph of Arimathea. In its original state, the striking figure of the Virgin —whose geometric shape is set off by her headdress, with its medallion-like ornament of interlaced lines—probably held the outstretched hand of Christ. The corresponding figure of Saint John, whose mantle is wrapped tightly around him, would have been on the opposite side of Christ and Nicodemus.

Only one other surviving Deposition group —that in the monastery of Sant Joan de les Abadeses (Girona), which may be dated to 1251—includes figures of the two thieves. The stylization of these figures is related to several

other twelfth-century sculpture groups, especially to the Virgin from Santa Maria in Taüll (cat. 165), which is not unlike the celebrated wall paintings originally from the church of Sant Climent, also of Taüll, which date to 1123 and are now in Barcelona. To judge from existing Catalan altar frontals that are painted, the loss of polychromy here has deprived the present Deposition group of its lifelike quality, yet at the same time its physical and emotional impact has become enhanced.

How these ensembles were originally displayed and how they served in the liturgy are not completely clear. The offering symbolism implied in the sacrificial theme of such groups immediately links them with the Easter lit-

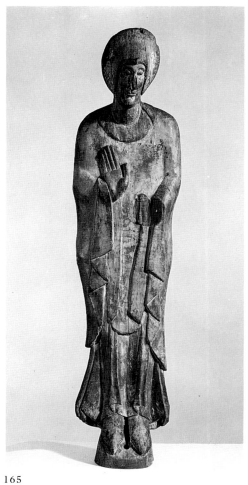

165

urgy, an association giving rise to the notion that these ensembles were integral to the development of the liturgical dramas of the *Depositio* performed on Good Friday. The meditative character of the sculptures and the fact that they are partly finished on the back suggest that they were intended to be seen from both sides. They may have been mounted atop a transenna, or choir screen, like the Gothic ensemble still in place at the monastery church of Las Huelgas (Burgos), or perhaps they were designed for an altar setting, as is the case with the group at Sant Joan de les Abadeses. Possibly also of significance is the evidence that the latter group served as a receptacle for relics, indicating still another function for the present figures.

CTL

LITERATURE: Schälicke 1975, pp. 19–21; Barcelona 1989, no. 99 (with previous literature).

VIRGIN FROM AN ANNUNCIATION

Church of Santa Maria, Taüll (Lleida), ca. 1125
Wood with traces of gesso and polychromy
61 x 15 in. (154.9 x 38.1 cm)
Fogg Art Museum, Harvard University Art Museum, Cambridge, Massachusetts; Gift of Friends of the Fogg Art Museum (1925.11)

In 1907 three members of the Institut d'Estudis Catalans, Josep Puig i Cadafalch, José Gudiol, and Josep Goday, embarked upon a mission to search for art treasures in the sparsely populated villages located in the high valleys of the Pyrenees. Their quest did not go unrewarded, for behind the retable of the small church of Santa Maria in Taüll they discovered six wooden sculptures, which they documented with a photograph.[1] Four of these—all about the same size—representing the crucified Christ, the Virgin Mary, Joseph of Arimathea, and the Good Thief, originally belonged to a Deposition group similar to that found a year later in the bell tower of the church in Erill la Vall (cat. 164). A fifth figure pictured in the photograph, similar in style but obviously not part of the Deposition group because of its larger scale, was the present Virgin Mary.

The narrow, attenuated figure of the Virgin almost seems to hover with an elegant weightlessness. When the Virgin is observed from the front, her solemn expression and direct gaze and the graceful fall of her drapery create a powerful sense of majesty that dissolves from a side view, in which the planklike nature of her body and her craning neck become all too apparent. Most likely, the work was meant to be seen only from the front. The large eyes, long face, curious oval headdress, and raised right palm are reminiscent of the Virgin Mary fresco, a contemporaneous work in the apse of Sant Climent, Taüll's other church. The shared features of these works, which were first pointed out by Arthur Kingsley Porter, laid to rest initial doubts about the authenticity of the Fogg Virgin.[2]

In 1931 Porter suggested, probably following Puig i Cadafalch, that the Fogg Virgin was one of a number of figures from a Deposition group made for Sant Climent in Taüll. Puig i Cadafalch had told Porter that a corresponding Saint John of the same dimensions had been found in that church.[3] Recently a Saint John of appropriate size and style in a private collection in the Netherlands was brought to the attention of Fogg curators by Hans Nieuwdorp, a museum official in Antwerp.[4]

The Fogg Virgin has the wide collar and distinctive high-crowned headdress also worn by Virgins of Catalan Deposition groups, such as those found at Durro and Erill la Vall. This similarity reinforces the theory that she too belonged with an ensemble showing mourners receiving the body of Christ as it was lowered from the cross. The Fogg piece, however, differs from the others in one significant aspect, her gesture. The other mourning Virgins reach forward with bent arms to receive the arm of Christ that has been freed from the cross. In contrast, the Fogg Virgin's arms are close to her body, and her right palm is raised against her chest and turned outward. Linda Seidel remarks that this is the typical gesture of Mary when she learns she will bear Christ, not when she mourns his death.[5] The Fogg Virgin then could just as easily be part of an Annunciation scene as a Deposition. Indeed, Porter once thought he saw the companion angel in a Barcelona museum.[6] The original context and role of the Fogg Virgin thus remain a mystery.

JM

1. Porter 1931, fig. 6.
2. Ibid., pp. 250–51.
3. Ibid., p. 261.
4. Mortimer 1985, no. 141, p. 124.
5. Seidel 1973, p. 134.
6. Ibid.

LITERATURE: Porter 1928, vol. 2, p. 13, pl. 71; Porter 1931, pp. 247–72; Duran Canyameres 1932, pp. 193–200; Folch 1932, p. 137; Porter 1932, pp. 129–36, figs. 1, 4; Cook and Gudiol 1950, pp. 322–28; Seidel 1973, pp. 133–34; Schälicke 1975, p. 48; Bergman 1978, pp. 375–76; Cahn and Seidel 1979, pp. 196–98; Bastardes 1980a, p. 44; Mortimer 1985, p. 124; further citations available in Cahn and Seidel 1979.

166

FRAGMENT OF CORPUS (CHRIST OF MIG-ARAN)

Church of Santa Maria de Mig-Aran (Lleida), 12th century
Wood
25⅝ x 15¾ in. (65 x 40 cm)
Church of Sant Miquel, Viella (Lleida)

This exceptional torso of Christ once belonged to a Deposition group possibly made for the early twelfth-century church of Santa Maria of Mig-Aran, where it was found.[1] The hand of Joseph of Arimathea visible on Christ's left side confirms that this fragment

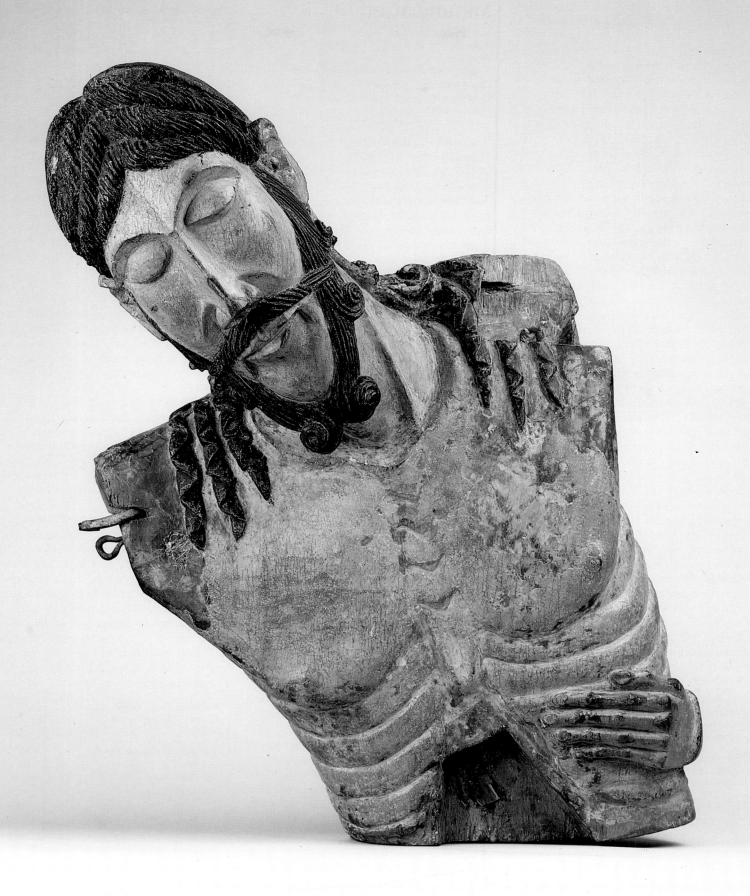

had been part of an ensemble of figures that constituted a tableau showing Christ's removal from the cross. This poignant bust-length remnant shows the recently dead Christ; his eyes are closed, his head has fallen to the right, and his calm expression conveys only the serenity of death. At the moment of physical sacrifice depicted in this work, Christ's humanity more than his divine nature has been emphasized by the artist.

The Mig-Aran Christ shares a number of stylistic and technical features with other Christ figures carved in the high valleys of the Catalan Pyrenees during the twelfth century. According to Bernd Schälicke, the method of fastening the now-missing arms to the Mig-Aran fragment duplicated that of the Christ in the Isabella Stewart Gardner Museum, Boston, and of the figures belonging to the Depositions from Santa Maria de Taüll and Erill la Vall.[2] Like the crucified Christ in the Museu Frederico Marès, Barcelona, the Mig-Aran figure's hair is parted down the middle and divided into three striated rolls covering the top of the skull. Three long tresses rest on each of his shoulders. The beard, similar to that of the Boston Christ, is divided into sections that swirl into elegant volutelike spirals at the ends. A regular and emphatic pattern of curved strips separated by bold incised lines creates the Mig-Aran torso's ribs, which connect to a prominent sternum articulated with four rounded incisions. This powerful abstract handling typifies most twelfth-century Catalan crucified Christs, which are perhaps best exemplified by the Christ from the Erill la Vall Deposition group (cat. 164). The strong similarity between the figures of that work and the Mig-Aran Christ have led a number of authors, including Rafael Bastardes, Pierre Ponsich, and Schälicke, to put forward the plausible suggestion that the Mig-Aran torso was carved by a sculptor from the atelier at Erill la Vall.[3]

JM

1. Delcor 1991, p. 184.
2. Schälicke 1975, p. 20.
3. According to Bastardes the following characteristics are shared by the Christs made by the Erill la Vall workshop: a triangular knee, a sharp tibia, a robust neck with a little break, hair parted down the middle and separated into parallel sections with three tresses falling on each shoulder, and a sternum decorated by incisions; also the arms are deformed (Bastardes 1980b, p. 63, cited in Delcor 1991, p. 183).

LITERATURE: Cook and Gudiol 1950, p. 317, fig. 318; Palol and Hirmer 1967, pp. 160–61, pl. XXXVII; Durliat and Allègre 1969, p. 172, figs. 89–91; Schälicke 1975, pp. 20–21; Bastardes 1980a, p. 44; Delcor 1991, pp. 185–86; Ponsich 1991, p. 176.

two statues of the virgin and child

Northern Spain, 12th century
a. Polychromed wood
H. 20⅛ in. (52.5 cm)
Museu Nacional d'Art de Catalunya, Barcelona (MNAC/ MAC 65503)
b. Wood
18⅞ in. (48 cm)
Cathedral Treasury, Girona (10)

The wistful little sculpture from Ger (a) is one of the most compelling of a large number of representations of the Virgin that are found throughout Europe and particularly in southern France and northern Spain. Like many sculptures of this type, this one comes from a remote mountain village in the Catalan Pyrenees, where it served as a cult object in a local parochial church.[1]

The Christ Child, seated in the Madonna's lap, raises his right hand in a gesture of benediction and with his left hand holds an open book, inscribed *Ego Sum* (I am), on his left knee. Both Madonna and Child are in fairly good condition, although they are missing either a foot, toes, or, in the case of the Madonna, some fingers. Most of the attrition has occurred in the lower half of the sculpture, the losses attributable to the portable nature of these objects, which were carried in processions during religious observances and in times of crisis.[2] It is almost certain that the present polychromy, while old, is not original. Arbitrary changes of color in the Child's garments and the clumsy lettering on his book are evidence of repainting; indeed, few if any such works survive with their original paint intact.[3]

The Madonna in the cathedral of Girona (b) is slightly smaller than the Ger Madonna and in somewhat worse condition. She has lost her nose, her forearms, and her feet; the Child is missing his right arm and leg, and the original throne on which they were seated has not survived. There is no trace of paint on the Girona group; rather, the presence of tiny nails and nail holes all over the surface indicates that this sculpture was covered with metal, probably silver,[4] in emulation of such splendid cult figures as the Throne of Wisdom statue, the golden Majesty, from Clermont-Ferrand, dating from 946.[5] The Girona group is made of boxwood, which is unusual because it is a very hard material and difficult to carve. There are small chip or chisel marks covering the surface that would have been hidden when the figures were sheathed in metal.

The enthroned Madonna reflects her role as the Queen of Heaven. She holds the Christ Child, Lord of the World, on her lap as if he were installed on the *sedes sapientiae*, or Seat of Wisdom.[6] Both Madonnas are shown frontally and convey an air of austere tranquillity, as if engaged in solemn religious thoughts. In many of these sculpture groups, the Madonna wears a crown, underscoring her aulic qualities; indeed, the Madonna from Ger did so originally,[7] and it may be assumed that her Girona counterpart did so as well.

The Madonna as Queen of Heaven and Seat of Wisdom has a venerable history. Deriving from Isaiah (6:1), the first representations appear in third-century Early Christian art in Rome. However, the concept of the *sedes sapientiae* as a cult image was solidified only in the Carolingian period, when church and state made a tremendous effort to convert large numbers of pagans to Christianity and to ensure their adherence to that faith. As the pagans had often adored statues, many of which represented a mother goddess, the usefulness of the sculpture type was admitted early on by the ecclesiastical establishment. It is known that Carolingian images of the *sedes sapientiae*—none of which survive or are clearly documented—were heavily enriched with precious metals and gems.[8] These glittering objects soon had miraculous powers attributed to them, and the population quickly began to venerate them as sources of hope and reward.

The earliest documented Throne of Wisdom sculpture was the aforementioned reliquary statue from Clermont-Ferrand.[9] It had an opening in the back to hold holy relics, which enhanced its religious power and that of the church that housed it. By the twelfth century, when the Madonnas from Ger and Girona were made, the majority of these statues were the sole cult objects in small, often provincial churches, where luxuries such as relics were not available. In the villages from which these and similar Madonna statues originate, the *sedes sapientiae* was often the only focus toward which an unsophisticated population directed its faith. These images are still the proudest possession of any church where they remain and are compelling witnesses to a belief that has continued for centuries and that even today both comforts and sustains its followers.

SCS

1. Barcelona 1961, p. 105; Cook and Gudiol 1950, p. 318, fig. 323; Palol and Hirmer 1967, pp. 173, 489, pl. XLIX; Durliat 1972, p. 65, fig. 89; Junyent 1970, vol. 2, pp. 270–71, fig. 98.
2. Forsyth 1972, p. 38.
3. Ibid.
4. Cook and Gudiol 1950, pp. 306–7, fig. 301; Barcelona 1961, p. 195, no. 261.
5. Forsyth 1972, p. 38.
6. Ibid., passim.
7. Barcelona 1961, p. 105.
8. Forsyth 1972, p. 91.
9. Ibid., p. 38; Cook and Gudiol 1950, p. 106.

LITERATURE: Cook and Gudiol 1950; Barcelona 1961, p. 105; Palol and Hirmer 1967; Junyent 1970, vol. 2, pp. 270–71; Durliat 1972; Forsyth 1972.

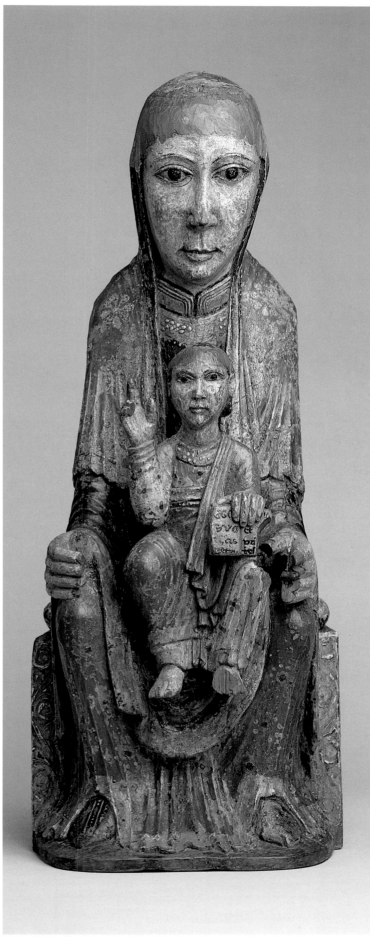

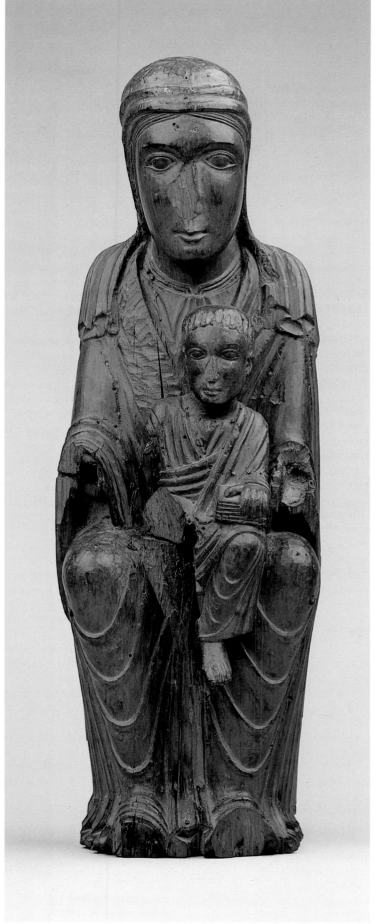

167a

167b

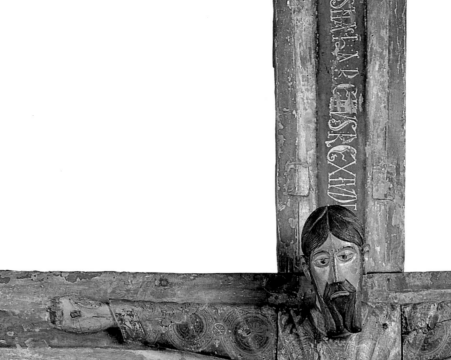

168

majestat batlló

Olot (Girona), mid-12th century
Polychromed wood
Christ: 37 x 37¼ in. (94 x 96 cm); cross: 61⅜ x 47¼ in.
(156 x 120 cm)
Museu Nacional d'Art de Catalunya, Barcelona (MNAC/
MAC 15937)

The image of the Crucifixion showing Christ
garbed in a long tunic called a colobium has
an extensive history in the Christian visual
tradition. It probably originated in the Mid-
east, as the earliest known example appears in
the Syriac Gospel Book written by a monk
named Rabbula in Mesopotamia in 586 and
now in the Biblioteca Medicea Laurenziana,
Florence. In medieval Catalonia sculptors
tended to represent Christ on the cross wear-
ing a long-sleeved colobium reaching to his
ankles. Over thirty examples of these large
wooden crucifixes, called *majestats*, survive.
They consistently depict Christ as still living
but indifferent to his human suffering; occa-
sionally, they show him crowned as king. The
Majestat Batlló, from the region of Olot near
Girona, is one of the finest and best-preserved
examples of these Catalan sculptures. Like
the majority of the others it dates from the
twelfth century.

Arresting in its strict frontality and immo-
bility, the Majestat Batlló presents Christ
bearing his suffering with noble stoicism.
Although the corners of his mouth turn
down slightly, Christ's open eyes and un-
furrowed brow create the impression of a
self-possessed impassivity that is as moving as
the vivid physical suffering portrayed in many
later Crucifixions. One striking feature of this
majestat is its well-conserved polychromy.
Christ's colobium, in imitation of rich orien-
tal silk, is decorated with blue floral designs
surrounded by circular red frames embellished
with dots and circles. A thin belt with an
elaborate interlace knot pulls the tunic in
above Christ's hips, making the fabric above
it swell out slightly and curving the path of
its flat, wide vertical folds.

So large a number of *majestats* still exist
from the Catalan districts of Girona, Barce-
lona, and Lleida, and the French province of
Roussillon, that some scholars believe these
monumental crosses once hung in almost
every First Romanesque church built in these
regions.[1] While this may be a slight exaggera-
tion, the *majestats* were the focus of an im-
portant and popular cult veneration in these
regions as early as the tenth century, accord-
ing to written sources.[2] They were normally
hung near the portals of the churches or
altars dedicated to the Savior. Often their

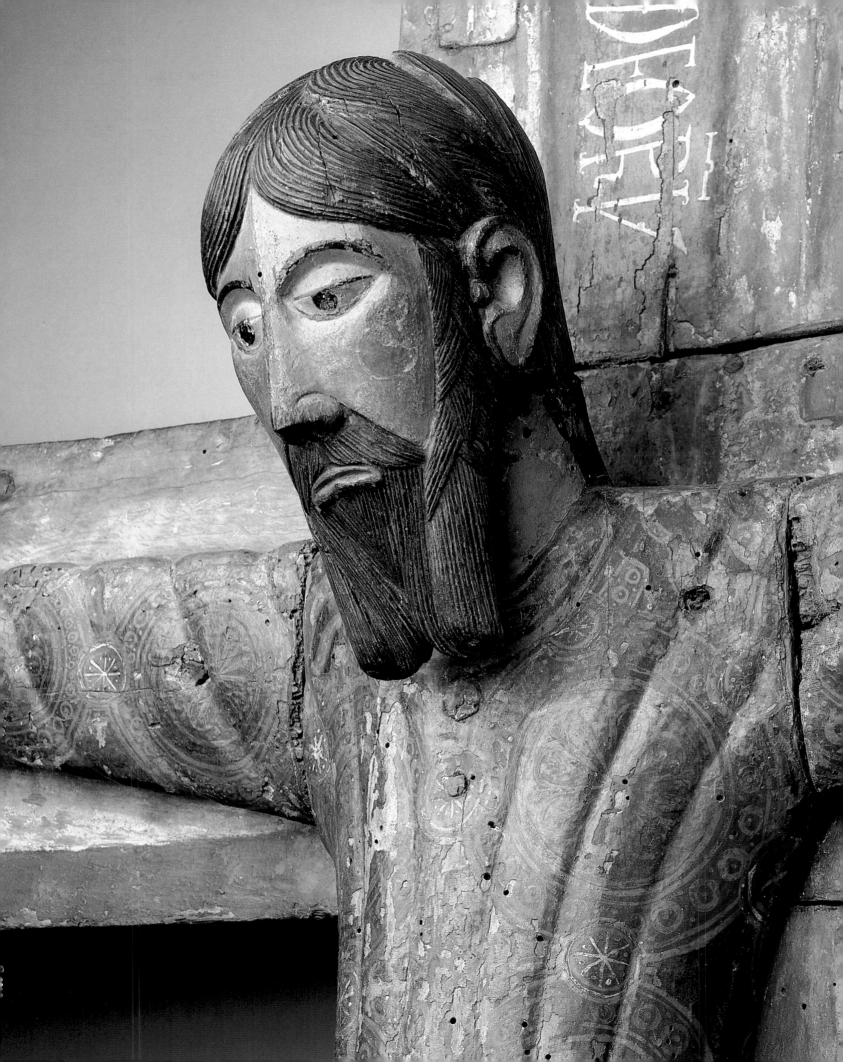

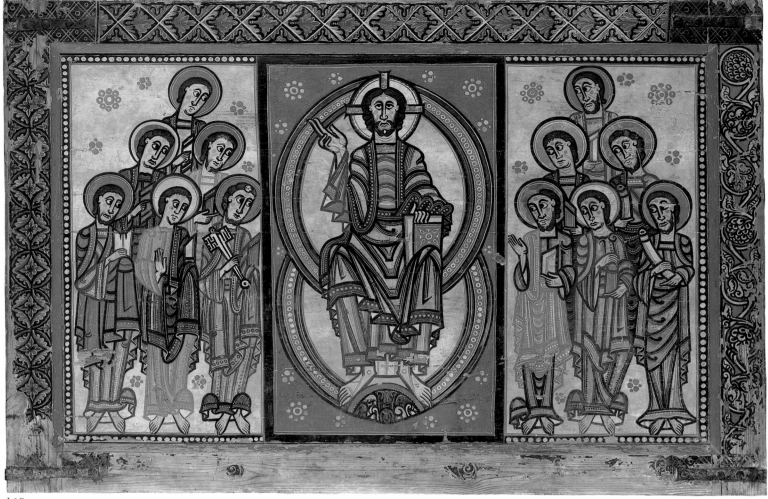

169

backs were painted with the Agnus Dei and the evangelist symbols, suggesting that these crosses were also carried in processions.[3] Perhaps, like the better-known Volto Santo in the church of San Martino, Lucca, to which they bear a notable similarity in appearance and date, these Catalan crucifixes were believed to have miraculous powers.

J M

1. Cook and Gudiol 1950, p. 295.
2. Delcor 1991, pp. 193–94.
3. Cook and Gudiol 1950, p. 295.

LITERATURE: Porter 1928, vol. 2, pp. 9–11; Cook and Gudiol 1950, p. 295, fig. 290; Junyent 1960–61, vol. 2 (plate), p. 269; Palol and Hirmer 1967, p. 160, pl. XXXVIII, fig. 161; Delcor 1991, pp. 193–94; Ponsich 1991, pp. 161–64.

169

antependium with christ in majesty

Urgell (Lleida), early 12th century
Polychromed wood
51 1/8 x 59 in. (130 x 150 cm)
Museu Nacional d'Art de Catalunya, Barcelona (15803)

An antependium, or frontal, was used to decorate the face of a medieval altar, with similar panels typically covering the altar's sides as well. Antependiums of wood, which were either carved or painted like the present example, were less expensive counterparts of the costly antependiums made of precious metals that adorned the more important churches and were similar in appearance to the Arca Santa at Oviedo Cathedral (cat. 124). Although they are rarely to be found throughout much of Europe, a great number of medieval wooden antependiums have survived from the mountain region of northern Spain, especially Catalonia. Among the three examples included here, this antependium—from an unidentified church in the diocese of Urgell—is the earliest in date and is most characteristic of the early type. The seated Christ in Majesty is shown within a mandorla in the central compartment flanked by the apostles in the lateral compartments. This is the theme most commonly encountered on antependiums, and it was often depicted as well in murals painted in the half dome of the apse, above the altar. The emphasis given Peter, singled out from the uniformly ren-

dered apostles by his tonsure and large keys, suggests that the antependium was made for a church dedicated to that saint. The brilliant, predominantly red-and-yellow color scheme, with a restricted range of secondary colors, is reminiscent of Mozarabic manuscript illumination, while the bold, flattened painting style displays a kinship with that of Catalan murals. Especially close in style are the apse murals from Sant Pere de La Seu d'Urgell, a small church adjacent to the cathedral at La Seu d'Urgell.[1] Closer still is another antependium from Saint-Martin in Hix, a village in the neighboring diocese of Cerdagne (Cerdanya in Spain), near Bourg-Madame—clearly the work of the same atelier if not the same artist.[2]

K F S

1. Museu Nacional d'Art de Catalunya, Barcelona, 15867; see Sureda 1981, no. 27.
2. Museu Nacional d'Art de Catalunya, Barcelona, 15802; see Sureda 1981, no. 20.

LITERATURE: Cook 1923; Gudiol 1929, pp. 85–86; Sureda 1981, pp. 229–31, 299 no. 28.

antependium with martyrdom of saints julita and quiricus

Hermitage of Santa Julita, Durro (Lleida), early 12th century(?)
Polychromed wood
39 ⅛ x 51 ⅛ in. (100 x 130 cm)
Museu Nacional d'Art de Catalunya, Barcelona (15809)

This unusual antependium is from the chapel of Saint Quiricus at the hermitage of Santa Julita near Durro, a village about 2 miles (3 km) southwest of Taüll, in the mountains of northern Lleida. In its mandorla-shaped central compartment is a representation of Saint Julita and her three-year-old son Saint Quiricus in a composition traditionally reserved for the Virgin and Child: only the adjacent inscriptions naming the saints prevent their erroneous identification. The four lateral com-

partments display various tortures inflicted on Julita: spikes are driven into the orifices of her head, she is lacerated with swords, her body is sawed into, and along with Saint Quiricus she is immersed in a cauldron of boiling pitch. The tortures are among many described in various versions of the apocryphal Acts of Quiricus and Julita that the saints miraculously survived, except the apocryphal accounts emphasize the torture of Quiricus rather than of his mother.[1] Although this is the only extant antependium depicting Julita and Quiricus, the veneration of these Early Christian martyrs was especially popular in Catalonia. Antependiums whose central as well as lateral compartments were devoted to the patron saints of a particular church or chapel became increasingly widespread over the course of the twelfth century. This antependium, usually assigned to the beginning or middle of the twelfth century, is often cited as the earliest known example of

the type. Its early date is based on the unsophisticated style of painting, which is similar to that of the murals in nearby Sant Joan d'Boí, dated sometime during the late eleventh or the early twelfth century.[2] The rendering of Julita's mantle and headdress in the central compartment, however, appears to emulate the voluminous triangular drapery folds characteristic of Gothic art beginning about the mid-thirteenth century, calling into question such an early attribution for the present work. Regardless of chronology, the appropriation of the mandorla and the composition of the Virgin and Child for an antependium dedicated to saints is without parallel. K F S

1. See *Acta Sanctorum* 1867, pp. 13–31.
2. Museu Nacional d'Art de Catalunya, Barcelona, 15951–15956; see Sureda 1981, pp. 290–91, no. 19.

LITERATURE: Gudiol 1929, pp. 293–96; Post 1930, pp. 236–38; Sureda 1981, pp. 242–43, 331–32, no. 73.

170

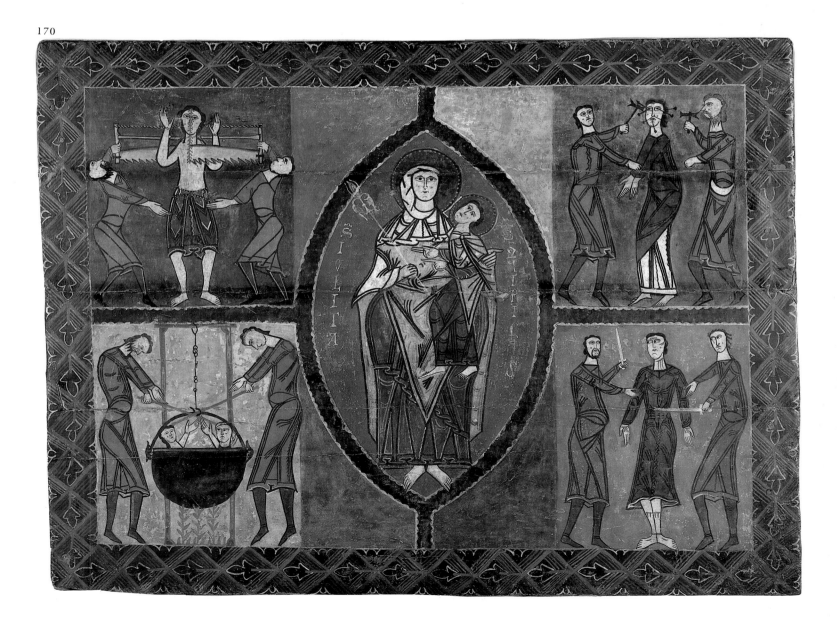

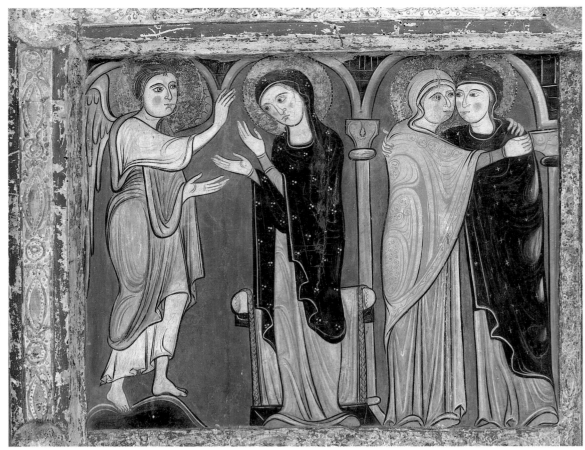

171 : Detail

171 : Detail

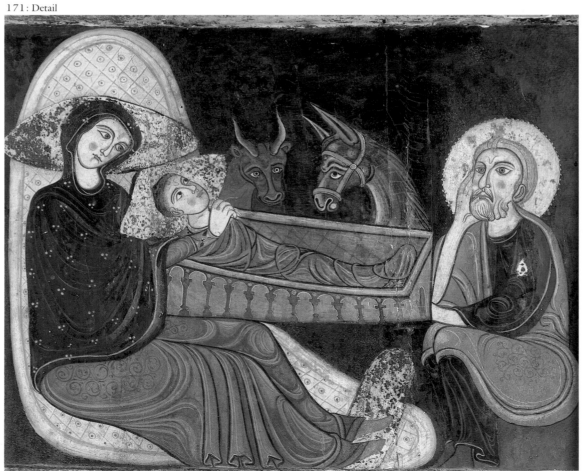

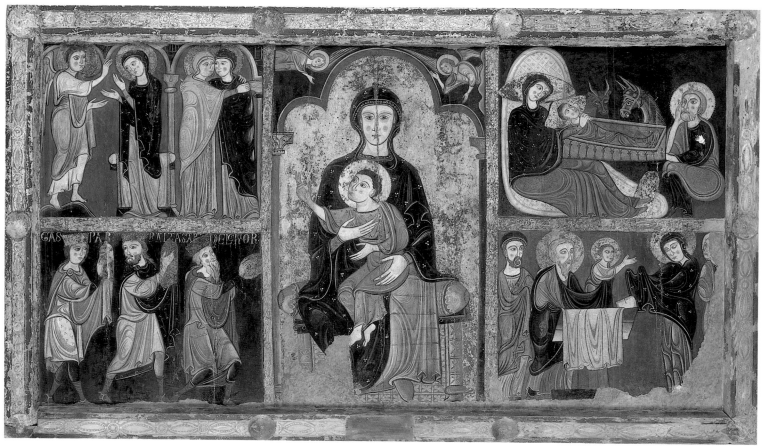

171

antependium with enthroned virgin and child

*Hermitage of Santa Maria, Avià (Barcelona), late 12th–
early 13th century
Polychromed wood and gilt stucco
41⅛ x 69¼ in. (105 x 176 cm)
Museu Nacional d'Art de Catalunya, Barcelona (15784)*

This exquisite antependium from the hermit-
age of Santa Maria in Avià, near Berga,
is appropriately dedicated to the Virgin Mary.
The Virgin and Child are depicted in the
center, surrounded, in the lateral compart-
ments, by scenes of the Annunciation and
Visitation, Nativity, Adoration of the Magi,
and Presentation in the Temple. The gilt-
stucco frame and borders between compart-
ments and the badly abraded gilt background
of the central compartment imitate the gold-
smiths' work of more sumptuous antependi-
ums. The incorporation of the Magi as a
composition subsidiary to that of the cen-
trally placed enthroned Virgin and Child is
typical of Catalan antependiums and apse
murals, but, curiously, here the Child raises
his hand in blessing toward the upper rather

than the lower compartment—perhaps the
result of employing a model with a different
arrangement of lateral scenes. The more vo-
luminous and refined style of painting here
displays marked Italo-Byzantine influence—a
pan-European phenomenon characteristic of
Catalan painting beginning in the later twelfth
century. Rather than a direct influence from
Italy, however, in the present case this Byzan-
tine style appears to have been at least partly
inspired by an English source. The flowing
treatment of the drapery, which is overlaid
with spiraling curvilinear patterns that are
especially prominent, for example, on Eliza-
beth's mantle in the Visitation, is typical of
English painting during the mid- to late
twelfth century—as in the murals in the
chapel of Saint Anselm at Canterbury Cathe-
dral, painted about 1160,[1] and the prefatory
miniatures in a psalter produced in northern
England about 1170.[2] The same anglicized
style recurs in an antependium from the altar
of Sant Sadurní de Rotgès, just 9 miles (15
km) northeast of Avià, which is clearly a
contemporary work by the same atelier.[3] The
type of bishop's miter depicted in the Sant
Sadurní antependium indicates that it was
painted after about 1175.[4] The stylistic parallels
to English art noted above suggest that both

the Sant Sadurní and Santa Maria de Avià
antependiums were produced no later than
the early thirteenth century.

KFS

1. See Demus 1970, pp. 121, 509.
2. Det Kongelige Bibliotek Copenhagen; MS. Thott 143
 2°; see Kauffmann 1975, pp. 188–99, no. 96.
3. Museu Arqueologic-Artistic Episcopal, Vic; see Sureda
 1981, pp. 364–65, no. 128.
4. See Braun 1907, p. 467.

LITERATURE: Gudiol 1929, pp. 168–74; Post 1930,
pp. 259–61; Sureda 1981, pp. 186–87, 252, 364, no. 127.

172

MARTYRDOM OF SAINT VINCENT OR SAINT LAWRENCE

Catalonia(?), ca. 1200
Pot-metal glass with vitreous paint
45⅛ x 8⅛ in. (116 x 22 cm)
Worcester Art Museum, Massachusetts (1961–17)

The legends of Saints Vincent and Lawrence —both Early Christian deacons and natives of Spain—tell a similar story of their torture upon a fiery gridiron. This animated portrayal in stained glass illustrates two henchmen vigorously wielding bellows to heat the coals under the grill, while two cohorts hover over the recumbent saint, "pressing him down with iron forks."[1] The upper panel depicts the heavenly reception of the martyr's soul, represented as a small head supported by two angels. Above, the hand of God appears in blessing. Perhaps once part of a larger glazing ensemble, the two scenes appear to have been joined prior to their first publication in 1908[2] to create a single lancet.[3] As such the present composition precludes any definitive identification of the saint depicted.

Overall, the glass survives in good condition, with replacements found in the face and feet of the saint; the fire; the skirt draperies of the fork-brandishing tormentors; the right angel's bodice drapery and left foot; the wings of the left angel; and portions of the red ground. Chantal Bouchon has noted the awkward alterations made to the angels' arms in a presumed effort to compress the upper panel's dimensions to match the lower panel's width. Most likely, the composition would originally have resembled the depiction of Saint Martin's soul on the altar frontal from Sant Martí de Puigbò (now in the Museu Arqueologic-Artistic Episcopal, Vic), where the angels' arms logically extend and the drapery cloth supporting the saint's soul is visible in its entirety.[4]

This spirited portrayal of martyrdom and heavenly reward is conveyed by a confident use of gesture emphasizing large pudgy hands that directs the eye to the saint at the center of each composition. This visual device is particularly striking as no groundline exists for any figures except the martyr—whether supine on the grill or supported by the drapery swag. Accordingly, he dominates both the narrative and compositional focal points. The vibrant palette of rich greens, orange-yellows, and pale blues set against a lustrous streaky red ground likewise enlivens the drama.

Despite the paucity of comparable stained glass, analogies exist between the window and Catalan wall and panel painting. The oval and pear-shaped heads have been likened to those of the seraphim in the apse painting from Santa Maria d'Àneu as well as the depiction of David slaying Goliath from Santa Maria de Taüll (both now in the Museu Nacional d'Art de Catalunya, Barcelona).[5] Intriguing correspondences can also be recognized between the Worcester glass and the Taüll painting in the method of abstracting body parts. Similarities have also been noted between the banded treatment of the bodice folds in the Worcester panel and those depicted in the wall paintings of Santa Maria d'Egara at Terrassa.[6] More recently, the sculpted apostle relief from the cathedral of Vic (now in the Victoria and Albert, London) and the Assumption of the Virgin from the tympanum of the church at Cabestany have been suggested as comparisons.[7] While these correspondences clearly situate the Worcester glass within the Catalan painting tradition, the combination of large, popping eyes emphasized by parallel diagonal lines, bulbous noses, and prominently dimpled chins appear unique to the window. Its bold juncture of color and assured application of paint demonstrate a discernible conversance with stained glass—despite the medium's rarity in Romanesque Catalonia.

M B S

1. *Golden Legend* 1969, p. 441.
2. Paris 1908, p. 59, no. 438.
3. Cambridge, Mass. 1978, p. 15; Bouchon 1992, pp. 129, 131.
4. Bouchon 1992, p. 131; for this scene from the Sant Martí altar frontal, see Durliat 1963, no. 125.
5. Bouchon 1992, pp. 131–32; Cambridge, Mass. 1978, p. 15.
6. Bouchon 1992, p. 131; Cambridge, Mass. 1978, p. 15.
7. Bouchon 1992, p. 132. For the Vic relief, see Williamson 1983, pp. 102–3. For the Cabestany tympanum, see Durliat 1963, no. 82 bis.

LITERATURE: Paris 1908, p. 59, no. 438; Ainaud 1952, pl. 374; Allyson E. Sheckler, in Cambridge, Mass. 1978, pp. 14–16; Caviness 1985, p. 63; Bouchon 1992, pp. 129–33; Vila-Grau 1993.

172

328

24bis

eagle fibulae

Jaén(?), 6th century
Gilt bronze, garnets or red glass, blue glass, yellow glass,
and meerschaum(?)
Left: H. 4¼ in. (10.97 cm); right: H. 4⅛ in. (10.51 cm)
Private Collection, Switzerland

Reminiscent of the ancient Egyptian artistic tradition, these birds are portrayed frontally, with their heads rendered in sharp profile. What appears to be the catch for the pin can be seen on the reverse of each head; the springs for the pins that would have been soldered to the reverse of the tails and the pins themselves are now missing. The raised oval central boss on the chest of each bird allies it to the majority of Visigothic cloisonné bird brooches and differentiates it from Ostrogothic examples. Although the design of the cells on the two birds varies considerably, both are based essentially on segmented wheels and semicircular patterns, which may indicate that they were made as a pair. However, there is a slight difference in size. Whereas red glass or almandines predominate, meerschaum and yellow glass are used to highlight the wings and may originally have done the same for the tails. These birds are close to the fibulae from Epinosa de Henares (Guadalajara; cat. 24a) and Talavera de la Reina (Toledo; cat. 24b) and an example in the Walters Art Gallery, Baltimore, found at Herrera de Pisuerga (Palencia).[1]

K R B

1. Baltimore 1979, no. 403.

BIBLIOGRAPHY

FURTHER READING

The following works provide an introduction to fundamental aspects of medieval Spanish art: *Beckwith 1960, *Demus 1970, *Dodds 1990, Domínguez 1930, Durliat 1990, Fontaine 1973 and 1977, Gaillard 1938a, Gauthier 1983, Gómez-Moreno 1919 and 1934a, Junyent 1960–61, *Moralejo 1985a, *New York 1992, Nieto 1989a, *Palol and Hirmer 1967 (comprehensive selection of plates of medieval Spanish works), *Palol 1968a, Palol and Ripoll 1988, *Porter 1928 (useful selection of plates), *Schapiro 1939, Schlunk and Hauschild 1978 (comprehensive selection of plates of Spanish works from early Christian and Visigothic periods), *Stokstad 1978, Sureda 1985, *Whitehill 1941, *Williams 1977a and 1993, and Yarza 1979. Although English-language studies make up only a small part of the bibliography on Spanish medieval art, they have been emphasized in this list and have been indicated by an asterisk. Complete publication information is found below in Works Cited in This Volume.

WORKS CITED IN THIS VOLUME

Abadal 1926–55
Ramón Abadal i de Vinyals. *Catalunya carolingia.* 5 vols. Barcelona, 1926–55.

Abadal 1948
Ramón Abadal i de Vinyals. *L'Abat Oliba, bisbe de Vic, i la seva època.* Barcelona, 1948. Reprinted in *Dels visigots als catalans,* vol. 2, pp. 141–277. Barcelona, 1970.

Abadal 1969–70
Ramón Abadal i de Vinyals. *Dels visigots als catalans.* 2 vols. Barcelona, 1969–70.

Aberg 1922
Nils Aberg. *Die Franken und Westgoten in der Völkerwanderungszeit.* Uppsala, 1922.

Abou-el-Haj 1975
Barbara Fay Abou-el-Haj. "The First Illustrated Life of Saint Amand: Valenciennes, Bibliothèque Municipale MS. 502." Ph.D. diss., University of California. Los Angeles, 1975.

Acta Sanctorum 1867
Acta Sanctorum, 24. Rome, 1867.

Adhémar 1939
Jean Adhémar. *Influences antiques dans l'art du Moyen Âge français.* London, 1939.

Ainaud 1952
Juan Ainaud de Lasarte. *Cerámica y vidrio.* Ars Hispaniae, 10. Madrid, 1952.

Ainaud 1953
Juan Ainaud de Lasarte. "Datos ineditos sobre la catedral románica de Vich." *Ausa* 5 (1953), pp. 202–9.

Ainaud 1957
Juan Ainaud de Lasarte. *Spain: Romanesque Paintings.* Unesco World Art Series. Paris, 1957.

Ainaud 1973
Juan Ainaud de Lasarte. *Arte románico: Guía.* Exh. cat., Museo de Arte de Cataluña. Barcelona, 1973.

Alcolea 1959
Santiago Alcolea. "Le Monastère de Sant Cugat del

Vallès." *Congrès archéologique de France* 117 (1959), pp. 177–88.

Alcolea 1975
Santiago Alcolea. *Artes decorativas en la España cristiana.* Ars Hispaniae, 20. Madrid, 1975.

Alcoy 1987
Rosa Alcoy i Pedrós. "Biblia de Ripoll." In *Catalunya romànica,* vol. 10, pp. 292–315. Barcelona, 1987.

Alcoy, Camps, and Lorés 1992
Rosa Alcoy i Pedrós, Jordi Camps i Sòria, and Imma Lorés i Otzet. *Cataluña medieval.* Barcelona, 1992.

Aldea, Marín, and Vives 1972–75
Quintín Aldea Vaquero, Tomás Marín Martínez, and José Vives Gatell. *Diccionario de historia eclesiástica de España.* 4 vols. Madrid, 1972–75.

Allan 1986
James W. Allan. *Metalwork of the Islamic World: The Aaron Collection.* London, 1986.

Almagro 1947
Martín Almagro Basch. "Materiales visigodos del Museo Arqueológico de Barcelona." *Memorias de los Museos Arqueológicos Provinciales* 8 (1947), pp. 56–75.

Almagro et al. 1975
Martín Almagro, L. Caballero, Juan Zozaya, and Antonio Almagro. *Qusayr 'Amra: Residencia baños omeyas en el desierto de Jordania.* Madrid, 1975.

Alonso 1988
P. A. Alonso Revenga. *Historia del descubrimiento del tesoro visigodo de Guarrazar.* Toledo, 1988.

Alvarez-Coca 1978
María Jesús Alvarez-Coca González. *Escultura románica en piedra en la Rioja Alta.* Logroño, 1978.

Alvarez de la Braña 1899
Ramón Alvarez de la Braña. "Crucifijos existentes en los Museos Arqueológicos de Madrid y León." *Revista de archivos, bibliotecas, y museos* 3, nos. 11–12 (1899), pp. 641–44.

Alvarez de la Braña 1905–6
Ramón Alvarez de la Braña. "Crucifijos románicos de Marfil." *Boletín de la Sociedad castellana de Excursiones* 2 (1905–6), pp. 147–52.

Alvarez Martínez 1988
María Soledad Alvarez Martínez. *Santa Cristina de Lena.* Oviedo, 1988.

Amador de los Ríos 1861
José Amador de los Ríos. *El Arte latino-bizantino en España y las coronas visigodas de Guarrazar: Ensayo histórico-crítico.* Memorias de la Real Academia de San Fernando. Madrid, 1861.

Amador de los Ríos 1877
José Amador de los Ríos. *Monumentos arquitectónicos de España: Principado de Asturias.* Madrid, 1877. Reprint, Oviedo, 1988.

Anderson 1942
Ruth M. Anderson. "Pleated Headdresses of Castilla and León (Twelfth and Thirteenth Centuries)." *Notes Hispanic* (1942), pp. 51–79.

Annual Report 1976
The Metropolitan Museum of Art. *Annual Report of the Trustees.* New York, 1976.

Antolín 1910
Guillermo Antolín. *Catálogo de los códices latinos de la Real Biblioteca de El Escorial,* vol. 1. Madrid, 1910.

Apocalipsis Beati Liebanensis 1992
Apocalipsis Beati Liebanensis. Burgi Oxomensis. Vol. 1: facsimile; vol. 2: *El Beato de Osma: Estudios.* Valencia, 1992.

Arbeiter 1990
Achim Arbeiter. "Die westgotenzeitliche Kirche von Quintanilla de las Viñas: Kommentar zur architektonischen Gestalt." *Madrider Mitteilungen* 31 (1990), pp. 393–427.

Arbeiter 1991
Achim Arbeiter. "Asturie." In *Enciclopedia dell'arte medievale,* vol. 2, pp. 672–81. Rome, 1991.

Arbeiter 1992
Achim Arbeiter. "Sobre los precedentes de la arquitectura eclesiástica en la época de Alfonso II." In *Congreso de Arqueología Medieval Española,* vol. 2, pp. 161–73. Oviedo, 1992.

Arco 1913
Ricardo del Arco y Garay. "El Monasterio de Santa Cruz de la Serós." *Linajes de Aragón* 4 (1913), pp. 431–55.

Arco 1919
Ricardo del Arco y Garay. *La Covadonga de Aragón: El Real monasterio de San Juan de la Peña.* Jaca, 1919.

Arco 1954
Ricardo del Arco. *Sepulcros de la Casa Real de Castilla.* Madrid, 1954.

Arias 1988a
Lorenzo Arias Páramo. "San Miguel de Liño: Arte prerromano asturiano." *Revista de arqueología* 9, no. 87 (1988), pp. 29–35.

Arias 1988b
Lorenzo Arias Páramo. "La pintura mural asturiana: Características generales." *Revista de arqueología* 9, no. 91 (1988), pp. 52–59.

Arias 1988c
Lorenzo Arias Páramo. "Santa María de Naranco y San Miguel de Liño." *Monumentos arquitectónicos de España.* Fundación Museo Evaristo Valle, boletín no. 19 (1988).

Arias 1990
Lorenzo Arias Páramo. *Palacio de Santa María de Naranco: Estudio planimétrico y de proporciones.* Candàs, 1990.

Arias 1991
Lorenzo Arias Páramo. *Iglesia de San Julián de los Prados: Dibujos del estudio planimétrico.* Somió, 1991.

Arias 1992a
Lorenzo Arias Páramo. "Avance al estudio sobre la geometría y proporción en la arquitectura prerrománica asturiana." In *III Congreso de Arqueología Medieval Española (Oviedo, 1989),* vol. 2, pp. 27–38. Oviedo, 1992.

Arias 1992b
Lorenzo Arias Páramo. "Geometría y proporción en la arquitectura prerrománica asturiana: La Iglesia de San Julián de los Prados." In *XXXIX Corso di cultura sull'arte ravennate e bizantine,* pp. 11–62. Ravenna, 1992.

Arias 1993
Lorenzo Arias Páramo. "Geometría y proporción en la arquitectura románica asturiana: El Palacio de Santa

María de Naranco." *Madrider Mitteilungen* 34 (1993), forthcoming.

Assas 1872
Manuel de Assas. "Crucifijo de marfil del rey Fernando I y su esposa doña Sancha." *Museo español de antigüedades*, vol. 1, pp. 193–210. Madrid, 1872.

Astorga 1990
María Jesús Astorga Redondo. *El Arca de San Isidoro: Historia de un relicario.* León, 1990.

Avril et al. 1983
François Avril et al. *Manuscrits de la péninsule ibérique.* Paris, 1983.

Avril, Barral, and Gaborit-Chopin 1983
François Avril, Xavier Barral i Altet, and Danielle Gaborit-Chopin. *Le Monde roman, 1060–1220: Les Royaumes d'occident.* Univers des formes, 30. Paris, 1983.

Ayers 1992
Larry Ayers. "The Illumination of the *Codex Calixtinus*: A Norman Dimension." In *The Codex Calixtinus and the Shrine of St. James*, edited by J. Williams and Alison Stones. Tübingen, 1992.

Ayuso 1956
Teófilo Ayuso Marazuela. *La Biblia visigótica de La Cava dei Tirreni.* Madrid, 1956.

Baer 1970–71
Eva Baer. "The 'Pila' of Játiva: A Document of Secular Urban Art in Western Islam." *Kunst des Orients* 7 (1970–71), pp. 142–66.

al-Bakri 1913
Abu Ubayd al-Bakri. *Al-Masalik wa-l-mamalik.* In *Description de l'Afrique septentrionale*, translated by M. de Siane. Algiers, 1913.

Balaguer 1951
Federico Balaguer. "Los Límites del obispado de Aragón y el Concilio de Jaca de 1063." *Estudios de Edad Media de la Corona de Aragón* 4 (1951), pp. 69–138.

Balmaseda, Zozaya, and Franco 1991
Luis Balmaseda Muncharaz, Juan Zozaya Stabel-Hansen, and María Angela Franco Mata. *Museo Arqueológico Nacional: Edad Media.* Madrid, 1991.

Balmelle et al. 1985
Catherine Balmelle et al. *Le Décor géometrique de la mosaïque romaine. Répertoire graphique et descriptif des compositions linéaires et isopropes.* Paris, 1985.

Baltimore 1947
The Walters Art Gallery. *Early Christian and Byzantine Art.* Baltimore, 1947.

Baltimore 1979
Anne Garside, ed. *Jewelry: Ancient to Modern.* Exh. cat., The Walters Art Gallery. Baltimore, 1979.

Baltimore 1990
Esin Atil, ed. *Islamic Art and Patronage: Treasures from Kuwait.* Exh. cat., The Walters Art Gallery. Baltimore, 1990.

Baltrusaitis 1931
Jurgis Baltrusaitis. *Les Chapiteaux de San Cugat del Vallès.* Paris, 1931.

Bango 1985
Isidro Gonzalo Bango Torviso. "L'Ordo Gothorum' et sa survivance dans l'Espagne du Haut Moyen Âge." *Revue de l'Art* 70 (1985), pp. 9–20.

Bango 1988
Isidro Gonzalo Bango Torviso. "El Arte asturiano y el imperio carolingio." In *Asturias, Villaviciosas 1984/II. Jornadas sobre arte prerrománico y románico en el norte de España*, pp. 31–88. Villaviciosa, 1988.

Bango 1992
Isidro Gonzalo Bango Torviso. *El Románico en España.* Madrid, 1992.

Barasche 1971
Moshe Barasche. *Crusader Figural Sculpture in the Holy Land: Twelfth Century Examples from Acra, Nazareth, and Belvoir Castle.* New Brunswick, N.J., 1971.

Barcelona 1961
Palacio Nacional. *El Arte románico.* Barcelona and Santiago de Compostela, 1961.

Barcelona 1989
Millenum: Història i Art de l'Església Catalana. Edifici de la Pia Almoina, Salo del Tinell, Capella de Santa Agata. Barcelona, 1989.

Barcelona 1992
Generalitat de Catalunya, Departament de Cultura. *Catalunya medieval.* Barcelona, 1992.

Barcelona 1992a
Prefiguración del Museu Nacional d'Art de Catalunya. Exh. cat., Museu Nacional d'Art de Catalunya. Barcelona, 1992.

Barcelona 1993
Milagros Guardia, Jordi Camps, and Immaculada Lorés, eds. *El Descubrimiento de la pintura mural románica catalana.* Exh. cat., Museu Nacional d'Art de Catalunya. Barcelona, 1993.

Barrachina 1980
Jaume Barrachina. "Dos Relleus fragmentaris de la portada de Sant Pere de Rodes del mestre de Cabestany." *Quaderns d'Estudis Medievals* 1 (1980), pp. 60–61.

Barral 1973
Xavier Barral i Altet. "Le Portail de Ripoll: État des questions." *Les Cahiers de Saint-Michel-de-Cuxa* 4 (1973), pp. 139–61.

Barral 1975
Xavier Barral i Altet. "Un Chapiteau roman de Saint Pierre de Rodes, au Musée de Cluny." *Bulletin monumental* 133 (1975), pp. 321–25.

Barral 1976
Xavier Barral i Altet. "La Representación del palacio en la pintura mural asturiana de la Alta Edad Media." In *España entre el Mediterráneo y el Atlántico: Actas del XXIII Congreso Internacional de Historia del Arte, Granada 1973*, vol. 1, pp. 293–301. Granada, 1976.

Barral 1979a
Xavier Barral i Altet. *La Catedral romànica de Vic.* Barcelona, 1979.

Barral 1979b
Xavier Barral i Altet. *Els Mosaics de paviment medievals a Catalunya.* Barcelona, 1979.

Barrau-Dihigo 1913
L. Barrau-Dihigo. *Chronique latine des rois de Castille.* Bordeaux, 1913.

Barrau-Dihigo 1921
L. Barrau-Dihigo. *Recherches sur l'histoire politique du royaume asturien (718–910).* Tours, 1921.

Basmachi 1975–76
Faraj Basmachi. *Treasures of the Iraq Museum.* Baghdad, 1975–76.

Bastardes 1980a
Rafael Bastardes i Parera. "Importació dels davallaments romànics catalans." *Quaderns d'estudis medievals* (1980), pp. 42–49.

Bastardes 1980b
Rafael Bastardes i Parera. *Els Davallaments romànics a Catalunya.* Barcelona, 1980.

Bastardes 1982
Rafael Bastardes i Parera. "La 'Vocació de Pere' i seu autor." *Quaderns d'estudis medievals* 1 (1982), p. 392.

Baum 1937
Julius Baum. *La Sculpture figurale en Europe à l'époque mérovingienne.* Paris, 1937.

***Beati in Apocalipsin* 1975**
Beati in Apocalipsin, Codex Gerundensis. 2 vols. Madrid, 1975.

Beckwith 1960
John Beckwith. *Caskets from Córdoba.* Victoria and Albert Museum. London, 1960. Reprinted in Beckwith 1989.

Beckwith 1966
John Beckwith. *The Adoration of the Magi in Whalebone.* London, 1966.

Beckwith 1971
John Beckwith. *Ivory Carving in Early Medieval England.* London, 1971.

Beckwith 1989
John Beckwith. *Studies in Byzantine and Medieval Art.* London, 1989.

Beenken 1925
Hermann Beenken. "Das romanische Tympanon des Städtischen Museums in Salzburg und die lombardische Plastik des zwölften Jahrhunderts." *Belvedere* 8 (1925), pp. 97–118.

Beer 1907
Rudolf Beer. "Die Handschriften des Klosters Santa Maria de Ripoll." *Sitzungsberichte der Kaiserlichen Akademie der Wissenschaften, Philosophisch-Historische Klasse* 155, no. 3 (1907), pp. 1–112.

Beeson 1913
Charles Henry Beeson. *Isidor Studien.* Quellen und Untersuchungen zur lateinischen Philologie des Mittelalters, 4, pt. 2. Munich, 1913.

Beissel 1893
Stephan Beissel. *Vatikanische Miniaturen.* Freiburg im Breisgau, 1893.

Beltrán 1960
Antonio Beltrán. *Estudio sobre el Santo Cáliz de la Catedral de Valencia.* Valencia, 1960.

Benito 1979
Eloy Benito Ruano. "La Época de la monarquia asturiana." In *Historia de Asturias*, vol. 4, pp. 1–129. Salinas, 1979.

Bercher 1922
L. Bercher. "Le Palais d'El Mansour à Bougie." *Revue Tunisienne* 29 (1922), pp. 53–54.

Berenguer 1956
Magín Berenguer. "Breves Notas sobre San Salvador de Val de Dios." *Boletín del Instituto de Estudios Asturianos* 10 (1956), pp. 35–49.

Berenguer 1972–73
Magín Berenguer. "Puntualizaciones sobre los edificios ramirenses del Naranco (Oviedo)." *Anuario de Estudios medievales* 8 (1972–73), pp. 395–403.

Berenguer 1984
Magín Berenguer. "El Templo de Santa Cristian de Lena (Asturias): Sus Posibilidades como construcción visigoda." *Boletín del Instituto de Estudios Asturianos* 38 (1984), pp. 733–53.

Berenguer 1991
Magín Berenguer. *Arte en Asturias*, vol. 2. Oviedo, 1991.

Berg 1968
Knut Berg. *Studies in Tuscan Twelfth-Century Illumination.* Oslo/Bergen/Tromsö, 1968.

Berger 1893
Samuel Berger. *Histoire de la Vulgate pendant les premiers siècles du Moyen Âge.* Paris, 1893.

Bergman 1978
Robert P. Bergman. "Varieties of Romanesque Sculpture." *Apollo* 107 (1978), pp. 370–76.

Bergman 1980
Robert P. Bergman. *The Salerno Ivories: Ars Sacra from Medieval Amalfi.* Cambridge, Mass., 1980.

Bernard 1894
Auguste Bernard. *Recueil des chartes de l'abbaye de Cluny.* Collection de documents inédits sur l'histoire de France, edited by Alexander Bruel, 2d ser., vol. 5. Paris, 1894.

Bernis 1956
Carmen Bernis. "Tapicería hispano-musulmana (siglos XIII–XIV)." *Archivo español de arte* 29 (1956), pp. 95–115.

Bernis 1960
Carmen Bernis. "La 'Adoración de los Reyes' del siglo XII, del Museo Victoria y Albert, es de escuela española." *Archivo español de arqueología* 33 (1960), pp. 82–84.

Bertrandus 1515
Nicolas Bertrandus. *De gestis tolosanorum*. Toulouse, 1515.

Bertraux 1906
Émile Bertraux. "Sculpture chrétienne en Espagne dès origines au XIVᵉ siècle." In *Histoire de l'art*, edited by A. Michel, vol. 2, pt. 1. Paris, 1906.

Besson 1987
François Marie Besson. "'À armes égales': Une Représentation de la violence en France et en Espagne au XIIᵉ siècle." *Gesta* 26, no. 2 (1987), pp. 113–26.

Bierbrauer 1975
Volker Bierbrauer. "Die ostgotischen Grab- und Schatzfunde in Italien." In *Biblioteca degli Studi Medievali*. Centro Italiano di Studi sull'Alto Medioevo, pp. 78–83, 363. Spoleto, 1975.

Bischoff 1963
Bernhard Bischoff. "Kreuz und Buch im Frühmittelalter und in den ersten Jahrhunderten der spanischen Reconquista." In *Bibliotheca docet: Festgabe für Carl Wehmer*, pp. 19–34. Amsterdam, 1963.

Bishko 1948
Charles Julian Bishko. "Salvul of Albelda and Frontier Monasticism in Tenth-Century Navarre." *Speculum* 23 (1948), pp. 559–90.

Bishko 1980
Charles Julian Bishko. "Fernando I and the Origins of the Leonese-Castillian Alliance with Cluny." In *Studies in Medieval Spanish Frontier History*. London, 1980. First published in Spanish in *Cuadernos de historia de España* 47–48 (1968), pp. 31–135, and 49–50 (1969), pp. 50–116.

Bishko 1984
Charles Julian Bishko. *Spanish and Portuguese Monastic History: 600–1300*. London, 1984.

Blanco 1987
Pilar Blanco Lozano. *Colección diplomática de Fernando I (1037–1065)*. Archivos Leoneses, no. 40. León, 1987.

Blázquez 1969
José María Blázquez. "The Possible African Origins of Iberian Christianity." *Classical Folia* 23 (1969), pp. 3–31.

Bleiberg 1981
Germán Bleiberg, ed. *Diccionario de historia de España*. 3 vols. 2d ed. Madrid, 1981.

Bohigas 1960
Pedro Bohigas. *La Ilustración y la decoración del libro manuscrito en Cataluña: Periodo románico*. Barcelona, 1960.

Bonassise 1975
Pierre Bonassise. *La Catalogne du milieu de Xᵉ à la fin du XIᵉ siècle*. 2 vols. Toulouse, 1975.

Bonet 1967
Antonio Bonet Correa. *Arte pre-románico asturiano*. Barcelona, 1967.

Bonnaz 1976
Yves Bonnaz. "Divers aspects de la continuité wisigothique dans la monarchie asturienne." *Mélanges de la Casa de Velázquez* 12 (1976), pp. 81–89.

Bonnaz 1987
Yves Bonnaz. *Chroniques asturiennes (fin IXᵉ siècle)*. Paris, 1987.

Borrás and García 1978
Gonzalo Borrás and M. García. *Le Pintura románica en Aragón*. Saragossa, 1978.

Boston 1940
Arts of the Middle Ages: 1000–1400. Exh. cat., Museum of Fine Arts. Boston, 1940.

Bouchon 1992
Chantal Bouchon. "Un Vitrail catalan oublié (Musée de Worcester, États-Unis)." *Narbonne Colloque* (1992), pp. 129–33.

Bousquet 1982
J. Bousquet. "Les Ivoires espagnoles du milieu du XIᵉ siècle: Leur Position historique et artistique." *Les Cahiers de Saint-Michel-de-Cuxa* 10 (1982), pp. 29–58.

Bovini 1954
Giuseppe Bovini. *Sarcophagi paleocristiani della Spagna*. Vatican City, 1954.

Boylan 1992
Ann Boylan. "Manuscript Illumination at Santo Domingo de Silos, Tenth to Twelfth Centuries." Ph.D. diss., University of Pittsburgh, 1990. Ann Arbor, 1992.

Braun 1907
Joseph Braun. *Die liturgische Gewandung im Occident und Orient nach Ursprung und Entwicklung*. Freiburg im Breisgau, 1907.

Braun 1924
Joseph Braun. *Der christliche Altar in seiner geschichtlichen Entwicklung*. 2 vols. Munich, 1924.

Braun 1932
Joseph Braun. *Das christliche Altargerät in seinem Sein und in seiner Entwicklung*. Munich, 1932.

Braun 1940
Joseph Braun. *Die Reliquiare des christlichen Kultes und ihre Entwicklung*. Freiburg im Breisgau, 1940.

Bravo and Matesanz 1986
María Isabel Bravo Juega and Pedro Matesanz Vera. *Los Capiteles del Monasterio de Santa María la Real de Aguilar de Campóo (Palencia) en el Museo Arqueológico Nacional*. Salamanca, 1986.

Breck 1920
James Breck. "Spanish Ivories of the Eleventh and Twelfth Centuries in the Pierpont Morgan Collection." *Journal of the Archaeological Institute of America* 24 (1920), pp. 217–25.

Breck 1929
James Breck. *The Pierpont Morgan Wing: A Handbook*. New York, 1929.

Bredekamp 1992
Horst Bredekamp. "Die romanische Skulptur als Experimentierfeld." In *Spanische Kunstgeschichte: Eine Einführung*, edited by H. Hänsel and H. Karge, pp. 101–12. Berlin, 1992.

Briesenick 1962
B. Briesenick. "Typologie und Chronologie des südwestgallischen Sarkophage." *Jahrbuch des Römisch-Germanischen Zentralmuseums Mainz* 9 (1962), pp. 76–182.

Brisch 1966
Klaus Brisch. "Die Fenstergitter und verwandte Ornamente der Hauptmoschee von Córdoba." *Madrider Forschungen* 4 (1966), pp. 10–12.

Brisch 1979–81
Klaus Brisch. "Sobre un grupo de capiteles y bases islámicas del siglo XI." *Cuadernos de la Alhambra* 15–17 (1979–81), pp. 156–64.

Broderick 1978
Herbert Broderick. "The Iconographic and Compositional Sources of the Drawings in Oxford, Bodleian Library MS. Junius 11." Ph.D. diss., Columbia University. New York, 1978.

Brown 1979
Katharine Brown. "The Mosaics of San Vitale: Evidence for the Attribution of Some Early Byzantine Jewelry to Court Workshops." *Gesta* 18 (1979), pp. 57–62.

Brown 1984
Katharine Brown. *The Gold Breast Chain from the Early Byzantine Period in the Römisch-Germanisches Zentralmuseum*. Mainz, 1984.

Brown 1989
Katharine R. Brown. "Buckle and Plate." In "The Metropolitan Museum of Art, Recent Acquisitions: A Selection, 1988–89." *The Metropolitan Museum of Art Bulletin* (1989), pp. 14–15.

Brown 1990
Katharine R. Brown. "Harness Pendant." In "The Metropolitan Museum of Art, Recent Acquisitions: A Selection, 1989–90." *The Metropolitan Museum of Art Bulletin* (1990), p. 17.

Brühl 1967
Carlrichard Brühl. "Remarques sur les notions de 'capitale' et de 'résidence' pendant le haut Moyen Âge." *Journal des savants* (1967), pp. 193–215.

Brussels and Cologne 1979
Hansgerd Hellenkemper, ed. *Trésors romains—trésors barbares: Industrie d'art à la fin de l'Antiquité et au début du Moyen Âge*. Exh. cat., Musées d'Histoire and Römisch-Germanisches Museum. Brussels and Cologne, 1979.

Bruyne 1927
Donatien de Bruyne. "Le Plus Ancien Catalogue des reliques d'Oviedo." *Analecta Bollandiana* 45 (1927), pp. 93–95.

Buero 1987
José Buero Rocha. "Restos de época visigoda en la iglesia de Santa Eulalia de Mérida." In *Actas del II Congreso de Arqueología Medieval Española*, vol. 2, pp. 322–30. Madrid, 1987.

Burgos 1990
Cathedral of Burgos. *Edades de Hombre*. Valladolid, 1990.

Buschbeck 1919
Ernst H. Buschbeck. *Der "Pórtico de la Gloria" von Santiago de Compostela*. Berlin, 1919.

Byne 1926
Mildred Stapley Byne. *The Sculptured Capital in Spain*. New York, 1926.

Bynum 1987
C. W. Bynum. *Holy Feast and Holy Fast: The Religious Significance of Food to Medieval Women*. Berkeley, 1987.

Caballero 1981
Luis Caballero Zoreda. "La Fíbula aquiliforme visigoda considerada de Calatayud (Zaragoza), pero procedente de Espinosa de Henares (Guadalajara)." *Papeles Bilbilitanos* (1981).

Caballero 1989
Luis Caballero Zoreda. "Una Nueva Iglesia visigoda: Sta. Lucía del Trampal." *Información cultural* 75 (1989), pp. 13–19.

Caballero and Mateos 1991
Luis Caballero Zoreda and Pedro Mateos Cruz. "Excavaciones en Santa Eulalia de Mérida." In *Extremadura arqueológica II: Primeras Jornadas de prehistoria y arqueología en Extremadura (1986–1990)*, pp. 525–46. Mérida and Cáceres, 1991.

Caballero and Mateos 1992
Luis Caballero Zoreda and Pedro Mateos Cruz. "Visigodo o asturiano? Nuevos hallazgos en Mérida y otros datos para un nuevo 'marco de referencia' de la arquitectura y la escultura altomedieval en el norte y oeste de la península Ibérica." In *XXXIX Corso di cultura sull'arte Ravennate e Bizantina (Ravenna, 1992)*, pp. 139–90. Ravenna, 1992.

Cabanot 1974
Abbot Jean Cabanot. "Le Décor sculpté de la Basilique de Saint-Sernin de Toulouse." *Bulletin monumental* 132, no. 2 (1974), pp. 99–146.

Caen 1990
Musée de Normandie, Attila. *Les Influences danubiennes dans l'ouest de l'Europe au Vième siècle*. Caen, 1990.

Cahn 1968
Walter Cahn. "Romanesque Sculpture in American Collections: II. Providence and Worcester." *Gesta* 7 (1968), pp. 51–61.

Cahn 1982
Walter Cahn. *Romanesque Bible Illustration*. Ithaca, N.Y., 1982.

Cahn and Seidel 1979
Walter Cahn and Linda Seidel. *Romanesque Sculpture in American Collections*, vol. 1. New York, 1979.

Caillet 1985
Jean-Pierre Caillet. *L'Antiquité classique: Le Haut Moyen Âge et Byzance au Musée de Cluny*. Paris, 1985.

Caldwell 1986
Susan Haven Caldwell. "Urraca of Zamora and San Isidoro in León: Fulfillment of a Legacy." *Woman's Art Journal* 7, no. 1 (1986), pp. 19–25.

Calleja and López 1990
Zolilo Calleja Ansotegui and J. J. López. "Un Altar mozárabe en Luca (Alava)." *Estudios de arqueología alavesa* 17 (1990), pp. 223–44.

Cambridge, Mass. 1978
Madeline H. Caviness, ed. *Medieval and Renaissance Stained Glass from New England Collections*. Exh. cat., Busch-Reisinger Museum, Harvard University Art Museums. Cambridge, Mass., 1978.

Camps 1933
Emilio Camps Cazorla. "Los Marfiles de San Millán de la Cogolla." *Museo Arqueológico Nacional: Adquisiciones en 1931*. Madrid, 1933.

Camps 1948
Emilio Camps Cazorla. "Revisión de algunos problemas de los monumentos ramirenses." *Boletín del Instituto de Estudios Asturianos* 2, no. 5 (1948), pp. 95–126.

Camps 1963
Emilio Camps Cazorla. "El Arte hispanovisigodo." In *La España visigoda (411–711 de J.C.)*, vol. 3 of *Historia de España*, edited by Ramón Menéndez Pidal, pp. 493–666. 2d ed. Madrid, 1963.

Canal 1980
José M. Canal Sánchez-Pagín. "¿Crónica Silense o crónica Domnis Sanctis?" *Cuadernos de historia de España* 63–64 (1980), pp. 94–103.

Canellas-López and San Vicente 1971
Angel Canellas-López and Angel San Vicente. *Aragón roman*. La Pierre-Qui-Vire, 1971.

Carbonnell-Lamothe 1974
Y. Carbonnell-Lamothe. "Les Devants d'autels peints de Catalogne: Bilan et problèmes." *Les Cahiers de Saint-Michel-de-Cuxa* 5 (1974), pp. 71–86.

Carderera 1855–64
Valentín Carderera y Solano. *Iconografía española: Colección de retratos, estatuas, mausoleos, y demás monumentos inéditos de reyes, reinas . . . etc., desde el siglo XI hasta el XCVII copiados de los originales. . . .* 2 vols. Madrid, 1855–64.

Carli 1960
Enzo Carli. *La Scultura lignea italiana dal XII al XVI secolo*. Milan, 1960.

Carro 1931
X. Carro García. "Os piares do altar do mosteiro de San-Pelayo de Sant-Yago." *Boletín de la Academia Gallega* (1931), pp. 8–9.

Carro 1944
Jesús Carro García. "Un nuevo relieve románico compostelano." *Cuadernos de estudios gallegos* 1 (1944), pp. 39–44.

Cassavoy 1988
Ken Cassavoy. "The 'Gaming Pieces.'" *INA Newsletter* [Institute of Nautical Archaeology, Texas A&M University] 15, no. 3 (1988), pp. 28–29.

Castejón 1961–62
R. Castejón y Calderón. "Madinat 'az-Zahra' en los autores árabes." *Al-Mulk (Cordova)* 2 (1961–62).

Castellanos 1988
E. Castellanos Martín. "Piezas hispano-visigodas halladas en Pozoantiguo (Zamora)." *Boletín del Museo Arqueológico Nacional* 6, no. 1.2 (1988), pp. 85–88.

Castillo, Elorza, and Negro 1988
Belén Castillo, Juan C. Elorza, and Marta Negro. *El Panteón Real de las Huelgas de Burgos: Los Enterramientos de los reyes de León y de Castilla*. León, 1988.

Castiñeiras 1993
M. A. Castiñeiras González. "La Iconografía de los meses en el arte medieval hispano (ss. XI–XIV)." Ph.D. diss. Santiago de Compostela, 1993.

Catel 1633
G. de Catel. *Mémoires de l'histoire du Languedoc*. Toulouse, 1633.

Cavanilles 1987
Ramón Cavanilles Navia Osorio. "Las Joyas asturianas de la Cámara Santa." In *I Semana del Patrimonio Artístico Asturiano (Oviedo 1987)*, pp. 17–31. Oviedo, 1987.

Caviness 1982
Madeline H. Caviness. *The Early Stained Glass of Canterbury Cathedral, Circa 1175–1220*. Princeton, 1982.

Caviness 1985
Madeline H. Caviness. *Stained Glass Before 1700 in American Collections: New England and New York (Corpus Vitrearum Checklist 1)*. Studies in the History of Art, 15; Monograph Series 1. Washington, D.C./Hanover, N.H./London, 1985.

Cazes and Durliat 1987
Daniel Cazes and Marcel Durliat. "Découverte de l'effigie de l'abbé Grégoire, créateur du cloître de Saint-Michel de Cuxa." *Bulletin monumental* 145 (1987), pp. 7–14.

Chamoso 1961
M. Chamoso Lamas. *Santiago de Compostela: Guías artísticas de España*. Barcelona, 1961.

Chamoso 1967
Manuel Chamoso Lamas. "Una Obra de Alfonso III el Magno: La Basilica del Apóstol Santiago." In *Symposium sobre Cultura Asturiana de la Alta Edad Media (Oviedo 1961)*, pp. 27–35. Oviedo, 1967.

"Chronique" 1977
"La Chronique des Arts. Principales acquisitions en 1975." *Gazette des Beaux-Arts* 89 (1977), p. 40.

Cid 1951
Carlos Cid Priego. "La Iconografía del claustro de la catedral de Gerona." *Anales del Instituto de Estudios Gerundenses* 6 (1951), pp. 5–118.

Cid 1978
Carlos Cid Priego. "Les Artes del prerrománico asturiano." In *Asturias*, pp. 148–94. Madrid and Barcelona, 1978. Reprint, 1989.

Cid 1988
Carlos Cid Priego. "Los Primeros Ángeles de la 'Cruz de los Ángeles' de Oviedo." *Sándalo* 3 (1988), pp. 20–21.

Cid 1990
Carlos Cid Priego. "Las Joyas prerrománicas de la Cámara Santa de Oviedo en la cultura medieval." *Liño* 9 (1990), pp. 7–43.

Cid 1992
Carlos Cid Priego. "Las Joyas prerrománicas de la Cámara Santa de Oviedo y el inicio de la arqueología medieval en época humanística." In *III Congreso de Arqueología Medieval Español (Oviedo, 1989)*, vol. 2, pp. 185–92. Oviedo, 1992.

Claude 1971
Dietrich Claude. *Adel, Kirche, und Königtum im Westgotenreich*. Sigmaringen, 1971.

Claude 1973
Dietrich Claude. "Beiträge zur Geschichte der frühmittelalterlichen Königsschätze. *Early Medieval Studies* 7 (1973), pp. 5–42.

Cobo, Cores, and Zarracina 1987
F. Cobo Arias, M. Cores Rambaud, and M. Zarracina Valcarce. *Guía básica de monumentos asturianos*. Oviedo, 1987.

Codoñer 1972
Carmen Codoñer Merino. *El "De viris illustribus" de Ildefonso de Toledo: Estudio y edición crítica*. Salamanca, 1972.

Colbert 1962
Edward P. Colbert. *The Martyrs of Córdoba (850–859): A Study of the Sources*. Studies in Medieval History, n.s. 17. Washington, D.C., 1962.

Collins 1977
Roger Collins. "Julian of Toledo and the Royal Succession in Late Seventh-Century Spain." In *Early Medieval Kingship*, edited by P. H. Sawyer and I. N. Wood, pp. 30–49. Leeds, 1977.

Collins 1983
Roger Collins. *Early Medieval Spain: Unity in Diversity, 400–1000*. New York, 1983.

Collins 1989
Roger Collins. "Doubts and Certainties on the Churches of Early Medieval Spain." In *God and Man in Medieval Spain: Essays in Honour of J. R. L. Highfield*, pp. 1–18. Warminster, 1989.

Cologne 1985
Schnütgen-Museum. *Ornamenta Ecclesiae: Kunst und Künstler der Romanik*. Cologne, 1985.

Colombás 1975
García M. Colombás. *El Monacato primitivo*. Vol. 25 of *La Espiritualidad*. Madrid, 1975.

Combe, Sauvaget, and Wiet 1936
Étienne Combe, J. Sauvaget, and G. Wiet. *Répertoire chronologique d'épigraphie arabe*, vol. 7. Cairo, 1936.

Conant 1978
John Kenneth Conant. *Carolingian and Romanesque Architecture, 800–1200*. The Pelican History of Art, 2d integrated ed. (revised). Harmondsworth, 1978.

Connoisseur 1955
"Early Spanish Treasures at the Cloisters." *Connoisseur* 136 (1955), pp. 17–18.

Cook 1923
Walter W. S. Cook. "The Earliest Painted Panels of Catalonia, II." *The Art Bulletin* 6 (1923), pp. 31–61.

Cook 1928
Walter W. S. Cook. "Review of A. Goldschmidt, *Die Elfenbeinskulpturen aus der romanischen Zeit*." *Art Bulletin* 10 (1928), pp. 279–88.

Cook 1960
Walter W. S. Cook. *La Pintura románica sobre tabla en Cataluña*. Madrid, 1960.

Cook and Gudiol 1950
Walter W. S. Cook and José Gudiol Ricart. *Pintura e imaginería románicas*. Ars Hispaniae, 6. Madrid, 1950.

Cook and Gudiol 1980
Walter W. S. Cook and José Gudiol Ricart. *Pintura e imaginería románicas*. Ars Hispaniae, 6. 2d rev. ed. Madrid, 1980.

Corzo 1986
Ramón Corzo Sánchez. *San Pedro de la Nave: Estudio histórico y arqueológico de la iglesia visigoda*. Zamora, 1986.

Cosmen 1989
María Concepción Cosmen Alonso. *El Arte románico en León. Diócesis de Astorga*. León, 1989.

Costa 1990
Avelino de Jesus da Costa. "Pedro Ourives grande artista e benemérito da cidade de Braga, injustamente esquecido." In *Actas do Congresso Internacional Comemorativo do IX Centenário da Dedicaçao da Sé de Braga*, vol. 1, pp. 659–78. Braga, 1990.

Cotarelo 1933
Armando Cotarelo Valledor. *Historia crítica y documentada de la vida y acciones de Alfonso III el Magno, último rey de Asturias*. Madrid, 1933.

Crespo 1978
Carmen Crespo. "Notas sobre el Beato de Tábara del Archivo Histórico Nacional." In *Actas del Simposio para el estudio de los códices del "Comentario al Apocalipsis" de Beato de Liébana*, vol. 1, pp. 251–57. Madrid, 1978.

Creswell 1932
K. A. C. Creswell, ed. *Early Muslim Architecture*. Vol. 1. Oxford, 1932.

Creswell 1940
K. A. C. Creswell, ed. *Early Muslim Architecture*. Vol. 2: *Early 'Abbasids, Umayyads of Cordova, Aghlabids, Tulunids, and Samanids, A.D. 751–905*. Oxford, 1940.

Crónica asturianas 1985
Crónica asturianas. Introduced and edited by Juan Gil Fernández, translation and notes by José L. Moralejo, preliminary studies by Juan I. Ruiz de la Peña. Oviedo, 1985.

Crozet 1972
René Crozet. "À propos du maître de Cabestany: Note sur un chapiteau de Saint Père de Roda au Musée de Worcester." *Annales du Midi* 134 (1972), pp. 77–79.

Cruz 1985
M. Cruz Villalón. *Mérida visigoda: La Escultura arquitectónica y litúrgica*. Badajoz, 1985.

Cruz and Cerrillo 1988
M. Cruz Villalón and E. Cerillo Martín de Cáceres. "La Iconografía arquitectónica desde la antigüedad a la época visigoda: Absides, nichos, veneras, y arcos." *Anas* 1 (1988), pp. 187–203.

Cuadrad 1992
Marta Cuadrad. *Arquitectura palatina del Naranco*. Cuadernos del arte español, 55. Madrid, 1992.

Cuesta 1947
José Cuesta Fernández. *Crónica del milenario de la Cámara Santa, 1942*. Oviedo, 1947.

Cuesta and Díaz 1961
José Cuesta Fernández and Moisés Díaz Caneja. "El Arca de los Ágatas." *Boletín del Instituto de Estudios Asturianos* 15 (1961), pp. 3–16.

Cutler 1985
Anthony Cutler. *The Craft of Ivory: Sources, Techniques, and Uses in the Mediterranean World, A.D. 200–1400*. Dumbarton Oaks Byzantine Collection Publications, 8. Washington, D.C., 1985.

Cutler 1987
Anthony Cutler. "Prolegomena to the Craft of Ivory Carving in Late Antiquity and the Early Middle Ages." In *Artistes, artisans, et production artistique au Moyen Âge*, edited by Xavier Barral i Altet. Vol. 2, *Commande et travail*, pp. 431–77. Paris, 1987.

Dallas and New York 1992
The Meadows Museum and Ariadne Galleries. *Spain: A Heritage Rediscovered, 3000 B.C.–A.D. 711*. Dallas and New York, 1992.

Dalmases and José 1986
Nuria de Dalmases and Antoni José i Pitarch. *Història de l'art català I: Els Inicis i l'art romànic, s. IX–XII*. Barcelona, 1986.

Darder and Ripoll 1989
Marta Darder and Gisela Ripoll. "Caballos en la Antigüedad Tardia hispanica." *Revista arqueología* 104 (1989), pp. 40–51.

Davillier 1879
Baron Ch. Davillier. *Recherches sur l'orfèvrerie en Espagne au Moyen Âge et à la Renaissance*. Paris, 1879.

Day 1954
Florence E. Day. "The Inscription of the Boston 'Baghdad' Silk: A Note on Method in Epigraphy." *Ars Orientalis* 1 (1954), pp. 191–94.

Daydé 1661
Raymond Daydé. *L'Histoire de Saint Sernin; ou, L'Incomparable Trésor de son église abbatiale de Tolose*. Toulouse, 1661.

Debenga 1916–17
Alvaro Debenga. "Los Marfiles de San Millán de la Cogolla." *Arte español* 3 (1916–17), no. 3, pp. 243–45, no. 4, 296–99, no. 3, pp. 328–39.

Deichmann 1969–89
Friedrich Wilhelm Deichmann. *Ravenna, Hauptstadt des spätantiken Abendlandes*. 3 vols. Wiesbaden, 1969–89.

Delclaux 1973
Federico Delclaux. *Imagenes de la Virgen en los codices medievales de España*. Madrid, 1973.

Delcor 1972
Mathias Delcor. "Les Origines de Saint-Martin du Canigou de la légende à l'histoire." *Les Cahiers de Saint-Michel-de-Cuxa* 3 (1972), pp. 103–14.

Delcor 1974
Mathias Delcor. "Le Scriptorium de Ripoll et son rayonnement culturel." *Les Cahiers de Saint-Michel-de-Cuxa* 5 (1974), pp. 45–64.

Delcor 1991
Mathias Delcor. "L'Iconographie des descentes de croix en Catalogne, à l'époque romane. Description, origine, et signification." *Les Cahiers de Saint-Michel-de-Cuxa* 22 (1991), pp. 179–202.

D'Emilio 1992a
James D'Emilio. "Tradición local y aportaciones foráneas en la escultura románica tardía: Compostela, Lugo, y Carrión." In *Actas del Simposio Internacional sobre "O Portico da Gloria e a Arte do seu Tempo" (Santiago de Compostela, 3–8 Octubre, 1988)*, pp. 83–94. La Coruña, 1992.

D'Emilio 1992b
James D'Emilio. "The Building and the Pilgrim's Guide." In *The Codex Calixtinus and the Shrine of St. James*, edited by J. Williams and A. Stones, pp. 185–201. Tübingen, 1992.

Demus 1968
Otto Demus. *Romanische Wandmalerei*. Munich, 1968.

Demus 1970
Otto Demus. *Romanesque Mural Painting*. New York, 1970.

Deschamps 1923
Paul Deschamps. "Notes sur la sculpture romane en Languedoc et dans le nord de l'Espagne." *Bulletin monumental* 82 (1923), pp. 305–51.

Díaz 1979
Manuel Díaz y Díaz. *Libros y librerías en la Rioja alto-medieval*. Logroño, 1979.

Díaz 1983
Manuel Díaz y Díaz. *Códices visigóticos en la monarquía leonesa*. León, 1983.

Dillmont n.d.
Thérèse Dillmont. *Encyclopedia of Needlework*. Mulhouse, n.d.

Dios de la Rada 1880
Juan de Dios de la Rada y Delgado. "La Cámara Santa, el Arca de las Reliquias, y las Cruces de la Victoria y de los Ángeles en la Catedral de Oviedo." In *Museo Español de Antigüedades* 10, pp. 527–40. Madrid, 1880.

Dios de la Rada and Malibrán 1871
Juan de Dios de la Rada y Delgado and J. de Malibrán. *Memoria que presentan al Excmo. Sr. Ministro de Fomento dando cuenta de los trabajos practicados y adquisiciones hechas para el Museo Arqueológico Nacional*. Madrid, 1871.

Dodds 1986
Jerrilynn D. Dodds. "Las Pinturas de San Julián de los Prados: Arte, diplomacia, y herejia." *Goya* 191 (1986), pp. 258–63.

Dodds 1990
Jerrilynn D. Dodds. *Architecture and Ideology in Early Medieval Spain*. University Park, Pa., and London, 1990.

Dodwell 1971
C. R. Dodwell. *Painting in Europe, 800–1200*. Harmondsworth, England, 1971.

Dodwell 1982
C. R. Dodwell. *Anglo-Saxon Art: A New Perspective*. Ithaca, N.Y., 1982.

Domínguez 1930
Jesús Domínguez Bordona. *Spanish Illumination*. 2 vols. New York, 1930.

Domínguez 1930a
Jesús Domínguez Bordona. *Die spanische Buchmalerei*. 2 vols. Florence and Munich, 1930.

Domínguez 1933
Jesús Domínguez Bordona. *Manuscritos con pinturas: Notas para un inventario de los conservados en colecciones públicas y particulares de España*. 2 vols. Madrid, 1933.

Domínguez and Ainaud 1962
Jesús Domínguez Bordona and Juan Ainaud. *Miniatura, Grabado, Encuadernación*. Ars Hispaniae, 18. Madrid, 1962.

Donnelly and Smith 1961
Marian C. Donnelly and Cyril S. Smith. "Notes on a Romanesque Reliquary." *Gazette des Beaux-Arts* 58 (1961), pp. 109–19.

Dresden 1975
M. Kryzhnovskaia and L. Faenson, eds. *Westeuropäische Elfenbeinarbeiten 11.–19. Jahrhundert aus des Staatlichen Ermitage Leningrad*. Exh. cat. Dresden, 1975.

Dshobadze 1954
Wachtang Dshobadze Zizichwili. "Antecedentes de la decoración visigoda y ramirense." *Archivo español de arte* 27 (1954), pp. 129–46.

Dufour 1972
Jean Dufour. *La Bibliothèque et le scriptorium de Moissac*. Geneva and Paris, 1972.

Du Mège 1828
Alexandre Du Mège. *Notice des monuments antiques et des objects de sculpture moderne conservés dans le Musée de Toulouse*. Toulouse, 1828.

Durán Canyameres 1932
F. Durán Canyameres. "Un Nota sobre els 'davallments' romanics catalans." *Butlletí dels Museus d'art de Barcelona* 2 (1932), pp. 193–200.

Durán Gudiol 1962
Antonio Durán Gudiol. *La Iglesia de Aragón durante los reinados de Sancho Ramírez y Pedro I (1062[?]–1104)*. Rome, 1962.

Durliat 1950–54
Marcel Durliat. *La Sculpture romane en Roussillon*. 4 vols. Perpignan, 1950–54.

Durliat 1952
Marcel Durliat. "L'Oeuvre de 'Maître de Cabestany.'" In *Congrès régional des Fédérations Historiques de Languedoc*, pp. 185–93. Montpellier, 1952.

Durliat 1961
Marcel Durliat. "La Peinture romane en Roussillon et en Cerdagne." *Cahiers de civilization médiévale* 4 (1961), pp. 1–14.

Durliat 1962
Marcel Durliat. *L'Art roman en Espagne*. Paris, 1962.

Durliat 1963
Marcel Durliat. *Art catalan*. Collection "Art et paysages," 21. Paris and Grenoble, 1963.

Durliat 1964
Marcel Durliat. *El Arte románico en España*. Barcelona, 1964.

Durliat 1965a
Marcel Durliat. "Les Données historiques relatives à la construction de Saint-Sernin de Toulouse." In *Homenaje a Jaime Vicens Vives*, vol. 1, pp. 235–41. Barcelona, 1965.

Durliat 1965b
Marcel Durliat. "Le Portail occidental de Saint-Sernin de Toulouse." *Annales du Midi* 67 (1965), pp. 215–23.

Durliat 1972
Marcel Durliat. *El Arte románico en España*. 2d ed. Barcelona, 1972.

Durliat 1973
Marcel Durliat. "Le Maître de Cabestany." *Les Cahiers de Saint-Michel-de-Cuxa* 4 (1973), pp. 116–27.

Durliat 1978
Marcel Durliat. *Haut-Languedoc roman*. La nuit des temps, 49. La Pierre-Qui-Vire, 1978.

Durliat 1979
Marcel Durliat. "Les Pyrénées et l'art roman." *Les Cahiers de Saint-Michel-de-Cuxa* 10 (1979), pp. 153–74.

Durliat 1982
Marcel Durliat. *L'Art roman*. Paris, 1982.

Durliat 1986
Marcel Durliat. *Roussillon roman*. La nuit des temps, 7. 4th rev. ed. St. Léger Vauban, 1986.

Durliat 1990
Marcel Durliat. *La Sculpture romane de la route de Saint-Jacques*. Mont-de-Marsan, 1990.

Durliat and Allègre 1969
Marcel Durliat and Victor Allègre. *Pyrénées romanes*. Zodiaque, La nuit des temps, 30. La Pierre-Qui-Vire, 1969.

Durliat and Rivère 1979
Marcel Durliat and Gérard Rivère. "Le Cloître de la Collégiale de Saint-Gaudens." *Revue de Comminges. Pyrénées centrales* 92 (1979), pp. 17–32.

Dutton 1967
B. Dutton. *La "Vida de San Millán de la Cogolla" de Gonzalo de Berceo*. London, 1967.

Dyggve 1952
E. Dyggve. "Le type architectural de la Cámara Santa d'Oviedo et l'architecture asturienne." *Cahiers archéologiques* 6 (1952), pp. 125–33.

Egbert 1967
V. W. Egbert. *The Medieval Artist at Work*. Princeton, 1967.

Elbern 1961
Victor H. Elbern. "Ein fränkisches Reliquiarfragment in Oviedo, die Engerer Burse in Berlin und ihr Umkreis." *Madrider Mitteilungen* 2 (1961), pp. 183–204.

Elbern 1963
Victor H. Elbern. "Der eucharistic Kelch im frühen Mittelalter." *Zeitschrift des deutschen Vereins für Kunstwissenschaft* 17 (1963), pp. 1–76, 117–88.

Eleen 1982
Luba Eleen. *The Illustration of the Pauline Epistles in French and English Bibles of the Twelfth and Thirteenth Centuries*. Oxford, 1982.

Elorza 1992
Juan Carlos Elorza Guinea. *Tesoros de Castilla y León: De la prehistoria a los reyes católicos*. Exh. cat., Exposición Universal de Sevilla de 1992. Madrid, 1992.

Elsberg and Guest 1934
Herman A. Elsberg and Rhuvon Guest. "Another Silk Fabric Woven at Baghdad." *Burlington Magazine* 64 (1934), pp. 270–72.

Engels 1980
Odilo Engels. "Die Anfänge des spanischen Jakobusgrabes in kirchenpolitischer Sicht." *Römische Quartalschrift für christliche Altertumskunde und Kirchengeschichte* 75 (1980), pp. 146–70.

Escalona 1782
R. Escalona. *Historia del real monasterio de Sahagún*. Madrid, 1782.

Escortell 1978
Matilde Escortell Ponsoda. *Catálogo de las salas de arte prerrománico del Museo Arqueológico, Oviedo*. Oviedo, 1978.

España Sagrada
Enrique Flórez. *España Sagrada. Theatro geográphico-histórico de la iglesia de España*. 52 vols. (vols. 30–42 written by M. Risco; vols. 43–44, by A. Merino and J. de la Canal; vols. 45–46, by J. de la Canal; vols. 47–48, by P. Sainz de Baranda; vols. 49–50, by V. de la Fuente; vol. 51, by C. R. Fort; vol. 52, by D. E. Jusué). Madrid, 1747–1918.

Estella 1982
Margarita-Mercedes Estella Marcos. "La talla de marfil." In *Marfiles*, vol. 8 of *La Historia de las artes aplicadas e industriales de España*, edited by Antonio Bonet Correa, pp. 435–62, figs. 308–327. Madrid, 1982.

Estella 1984
Margarita-Mercedes Estella Marcos. *La Escultura del marfil en España: Románica y gótica*. Madrid, 1984.

Ettinghausen 1943
Richard Ettinghausen. "The Bobrinski 'Kettle': Patron and Style of an Islamic Bronze." *Gazette des Beaux-Arts*, 6th ser., 24 (1943), pp. 193–208.

Ettinghausen 1954
Richard Ettinghausen. "Notes on the Lusterware of Spain." *Ars Orientalis* 1 (1954), pp. 135–36. Reprinted in Ettinghausen 1984, pp. 535–78.

Ettinghausen 1956
Richard Ettinghausen. "Early Realism in Islamic Art." In *Studi Orientalistice in onore di Giorgio Levi della Vida*, vol. 1, pp. 250–73. 1956. Reprinted in Ettinghausen 1984, pp. 158–81.

Ettinghausen 1984
Richard Ettinghausen. *Islamic Art and Archaeology: Collected Papers*, compiled and edited by Myriam Rosen-Ayalon. Berlin, 1984.

Ewig 1963
Eugen Ewig. "Résidence et capitale pendant le haut Moyen Âge." *Revue historique* 87 (1963), pp. 25–72.

Fábrega 1980
Angel Fábrega y Grau. "Barcelona, Bistum." In *Lexicon des Mittelalters*, vol. 1, pp. 1451–52. Munich, 1980.

Fagnan 1900
Edmond Fagnan, trans. *L'Afrique septentrionale au XIIᵉ siècle de notre ère*. Anonymous, *al-Istibsar*. Constantine, 1900.

Falke 1918
Otto von Falke. *Kunstgeschichte der Seidenweberei*. Berlin, 1918.

Falkenstein 1991
Ludwig Falkenstein. "Charlemagne et Aix-la-Chapelle." *Byzantion* 61 (1991), pp. 231–89.

Falque 1988
Emma Falque Rey, ed. *Historia Compostellana*. Corpus Christianorum, Continuatio Medievalis, vol. 70. Turnhout, 1988.

Faulhaber 1983
Charles B. Faulhaber. *Medieval Manuscripts in the Library of the Hispanic Society of America*. 2 vols. New York, 1983.

Féhérvari 1972
Géza Féhérvari. "Tombstone or Mihrab? A Speculation." In *Islamic Art in the Metropolitan Museum*, edited by R. Ettinghausen, pp. 241–54. New York, 1972.

Ferber 1976
Stanley Ferber. "The Temple of Solomon in Early Christian and Byzantine Art." In *The Temple of Solomon: Archaeological Fact and Medieval Tradition*, edited by Joseph Gutmann, pp. 21–43. Missoula, Mont., 1976.

Fernández Avello 1982
Manuel Fernández Avello. *La Cruz de la Victoria*. Oviedo, 1982.

Fernández Avello 1986
Manuel Fernández Avello. *La Cruz de los Ángeles y la Caja de las Ágatas*. Oviedo, 1986.

Fernández Buelta 1948
José Fernández Buelta. "Ruinas del Oviedo primitivo." *Boletín del Instituto de Estudios Asturianos* 2, no. 3 (1948), pp. 73–102. Reprinted in *Ruinas del Oviedo primitivo: Historia y secuencias de unas excavaciones*, pp. 13–36. Oviedo, 1984.

Fernández Buelta and Hevia 1949
José Fernández Buelta and Victor Hevia Granda. "La Cámara Santa de Oviedo, su primitiva construcción, su destrucción, y su reconstrucción." *Boletín del Instituto de Estudios Asturianos* 3, no. 6 (1949), pp. 51–119.

Fernández Conde 1971
Francisco Javier Fernández Conde. *El Libro de los testamentos de la catedral de Oviedo*. Rome, 1971.

Fernández Conde 1972
Francisco Javier Fernández Conde. *La Iglesia de Asturias en la Alta Edad Media*. Oviedo, 1972.

Fernández Conde 1982
Francisco Javier Fernández Conde. "La Iglesia en el reino astur-leonés." In *Historia de la iglesia en España*, vol. 2, pt. 1, pp. 64–83. Madrid, 1982.

Fernández Conde and Santos del Valle 1987
Francisco Javier Fernández Conde and M. C. Santos del Valle. "La Corte asturiana de Pravia: Influencias visigodas en los testimonios arqueológicos." *Boletín del Instituto de Estudios Asturianos* 41 (1987), pp. 315–44.

Fernández Conde and Santos del Valle 1987–88
Francisco Javier Fernández Conde and M. C. Santos del Valle. "La Corte de Pravia: Puentes documentales, cronisticas, y bibliográficas." *Boletín del Instituto de Estudios Asturianos* 41 (1987), pp. 866–932, and 42 (1988), pp. 59–84.

Fernández González 1987a
Etelvina Fernández González. "Miniaturas de los códices martinianos." In *Santo Martino de León* (Ponencias del I Congreso internacional sobre Santo Martino en el V centenario de su obra literaria 1185–1985), pp. 515–49. León, 1987.

Fernández González 1987b
Etelvina Fernández González. "Santo Martino de León, viajero culto y peregrino piadoso." *Annuario de estudios medievales* 17 (1987), pp. 49–65.

Fernández-Ladreda 1983
Clara Fernández-Ladreda Aguade. *La Arqueta de Leyre y otras esculturas medievales de Navarra*. Pamplona, 1983.

Fernández-Ladreda 1988
Clara Fernández-Ladreda. *Imagineria medieval mariana*. Pamplona, 1988.

Fernández Menéndez 1919
Jose Fernández Menéndez. "La Basílica de San Salvador de Val-de-Dios y su primitivo convento." *Boletín de la Sociedad Española de Excursiones* 27 (1919), pp. 77–89.

Fernández Ochoa, Encinas, and García 1989
C. Fernández Ochoa, M. Encinas Martínez, and Amanda García Carrillo. "Excavaciones en el interior del Palacio de Revillagigedo (Gijón)." *Boletín del Instituto de Estudios Asturianos* 43 (1989), pp. 677–79.

Fernández-Pajares 1969
José María Fernández-Pajares. "La Cruz de los Ángeles en la miniatura española." *Boletín del Instituto de Estudios Asturianos* 23 (1969), pp. 281–304.

Fernández-Pajares 1981
José María Fernández-Pajares. "Las Joyas de la Cámara Santa." In *Arte asturiano I: De la prehistoria al renacimiento*, pp. 189–204. Gijón, 1981.

Fernández Puertas 1979–81
Antonio Fernández Puertas. "La Decoración de las ventanas de la Bab al Uzara(*) según los dibujos de Don Félix Fernández Giménez." *Cuadernos de la Alhambra* 15–17 (1979–81), pp. 165–210.

Férotin 1897
D. Marius Férotin. *Recueil des chartes de l'abbaye de Silos.* Paris, 1897.

Férotin 1900
Marius Férotin. "Une Lettre inédite de Saint Hughes, Abbé de Cluny, à Bernard d'Agen, Archevêque de Tolède." *Bibliothèque de l'École de Chartres* 61 (1900), pp. 339–45.

Férotin 1901
Marius Férotin. "Deux Manuscrits wisigothiques de la bibliothèque de Ferdinand Ier, roi de Castille et de Léon." *Bibliothèque de l'École de Chartres* 62 (1901), pp. 374–87.

Férotin 1902
Marius Férotin. "Complément de la lettre de Saint Hughes, Abbé de Cluny, à Bernard d'Agen, Archevêque de Tolède." *Bibliothèque de l'École de Chartres* 63 (1902), pp. 682–86.

Ferrandis 1928
José Ferrandis. *Marfiles y azabaches españoles.* Barcelona, 1928.

Ferrandis 1935
José Ferrandis. *Marfiles árabes de Occidente.* Vol. 1. Madrid, 1935.

Ferrandis 1940
José Ferrandis. *Marfiles árabes de Occidente.* Vol. 2. Madrid, 1940.

Ferrandis 1940
José Ferrandis. "Artes decorativas visigodas." In *La España visigoda (414–711 de J.C.)*, vol. 3 of *Historia de España*, edited by Ramón Menéndez Pidal, pp. 611–66. Madrid, 1940.

Ferrandis 1963
José Ferrandis. "Arte decorativas visigodas." In vol. 3 of *Historia de España*, edited by Ramón Menéndez Pidal. Madrid, 1963.

Fischer 1963
Bonifatius Fischer. "Bibelausgaben des frühen Mittelalters." In *La Biblia nell'alto medioevo.* (Settimane di Studio del Centro italiano di Studi sull'alto medioevo, 10, 1962), pp. 519–60. Spoleto, 1963.

Fischer 1985
Bonifatius Fischer. *Lateinische Bibelhandschriften im frühen Mittelalter.* Freiburg im Breisgau, 1985.

Fischer 1986
Bonifatius Fischer. *Beitrage zur Geschichte der lateinischen Bibeltexte.* Freiburg im Breisgau, 1986.

Floriano 1949
Antonio C. Floriano Cumbreño, ed. *El Monasterio de Cornellana.* Oviedo, 1949.

Floriano 1949–51
Antonio C. Floriano Cumbreño. *Diplomática española del periodo astur. . . (718–910).* 2 vols. Oviedo, 1949, 1951.

Folch 1932
Joachim Folch y Torres. "Nota al Treball del Professor Kingsley Porter, sobre 'La Verge de Tahull.'" *Butlletí dels Museus d'Art de Barcelona* 2 (1932), pp. 136–37.

Folch 1956
Joachim Folch y Torres. *La Pintura románica sobre fusta.* Monumenta Cataloniae, 9. Barcelona, 1956.

Foltiny 1977
Stephen Foltiny. "Visigothic Jewelry in the Virginia Museum." *Arts in Virginia* 17 (1977), pp. 12–17.

Fontaine 1973
Jacques Fontaine. *L'Art préroman hispanique.* Vol. 1. Zodiaque. La Pierre-Qui-Vire, 1973.

Fontaine 1977
Jacques Fontaine. *L'Art préroman hispanique.* Vol. 2. Zodiaque. La Pierre-Qui-Vire, 1977.

Fontaine 1983
Jacques Fontaine. *Isidore de Séville et la culture classique dans l'Espagne wisigothique.* 2 vols. 2d ed. Paris, 1983.

Forsyth 1972
Ilene H. Forsyth. *The Throne of Wisdom.* Princeton, 1972.

Franco 1988
Angela Franco Mata. "Arte medieval cristiano leonés en el Museo Arqueológico Nacional." *Tierras de León* 27 (1988), pp. 29–59.

Franco 1991a
Angela Franco Mata. "El Tesoro de San Isidoro y la monarquía leonesa." *Boletín del Museo Arqueológico Nacional* 9 (1991), pp. 34–68.

Franco 1991b
Angela Franco Mata. "Antigüedades cristianas de los siglos VIII al XV." In *Museo Arqueológico Nacional: Edad media*, pp. 77–111. Madrid, 1991.

Francovich 1940
Géza de Francovich. "Wiligelmo da Modena e gli inizii della scultura romanica in Francia e in Spagna." *Rivista del Reale Istituto d'Archeologia e Storia dell'Arte* 7 (1940), pp. 225–94.

Francovich and Maffei 1957
Géza de Francovich and Fernanda de' Maffei, eds. *Mostra di sculture lignee medioevali.* Milan, 1957.

Franz 1981
Philipp Franz. "El Greco's *Entombment of the Count of Orgaz* and Spanish Medieval Tomb Art." *Journal of the Warburg and Courtauld Institutes* 44 (1981), pp. 76–89.

Frazer 1985–86
M. E. Frazer. "Medieval Church Treasures." *Bulletin of the Metropolitan Museum of Art* (1985–86), pp. 18–19.

Frinta 1964
M. S. Frinta. "The Frescoes from San Baudelio de Berlanga." *Gesta* 1 (1964), pp. 9–13.

Frolow 1961
A. Frolow. *La Relique de la Vraie Croix: Recherches sur le développement d'un culte.* Paris, 1961.

Gaborit-Chopin 1969
Danielle Gaborit-Chopin. *La Décoration des manuscrits à Saint-Martial-de-Limoges et en Limousin du IX^e au XII^e siècle.* Paris and Geneva, 1969.

Gaborit-Chopin 1978
Danielle Gaborit-Chopin. *Ivoires du Moyen Âge.* Fribourg, 1978.

Gaborit-Chopin 1983
Danielle Gaborit-Chopin. *Les Royaumes d'occident.* Paris, 1983.

Gabrieli and Scerrato 1979
Francesco Gabrieli and Umberto Scerrato. *Gli Arabi in Italia: Cultura, contati, e tradizioni.* Milan, 1979.

Gaiffier 1967
Baudouin de Gaiffier. "Les Sources de la Translatio Sancti Aemiliani." In *Études critiques d'hagiographie et d'iconologie*, pp. 140–49. Brussels, 1967.

Gaiffier 1968
Baudouin de Gaiffier. "Saint Ide de Boulogne et l'Espagne à propos de reliques mariales." *Analecta bollandiana* 86 (1968), pp. 67–81.

Gaiffier 1971
Baudouin de Gaiffier. "Relations religieuses de l'Espagne avec le Nord de la France, transferts de reliques (VIII–XII siècle)." In *Recherches d'hagiographie latine*, pp. 7–30. Brussels, 1971.

Gaillard 1929
Georges Gaillard. "La Date des sculptures de Compostelle et de León." *Gazette des Beaux-Arts*, 6th ser., no. 1 (1929), pp. 341–78.

Gaillard 1938a
Georges Gaillard. *Les Débuts de la sculpture romane espagnole.* Paris, 1938.

Gaillard 1938b
Georges Gaillard. *Premiers Essais de sculpture monumentale en Catalogne au X^e et XI^e siècles.* Paris, 1938.

Gaillard 1957
Georges Gaillard. "Les Statues-colonnes d'Antéaltares à Saint-Jacques-de-Compostelle." *Bulletin de la Société Nationale des Antiquaires de France* (1957), pp. 171–79.

Gaillard 1959
Georges Gaillard. "Ripoll." *Congrès archéologique de France* 117 (1959), pp. 144–59.

Gaillard 1960a
Georges Gaillard. "Le Chapiteau de Job aux Musées de Toulouse et de Pampelune." *Revue des arts* 10 (1960), pp. 146–56.

Gaillard 1960b
Georges Gaillard. "El Capitel de Job en los museos de Toulouse y de Pamplona." *Príncipe de Viana* 21 (1960), pp. 237–40.

Gaillard 1963
Georges Gaillard. "Sculptures espagnoles de la seconde moitié du douzième siècle." In *Acts of the Twentieth International Congress of the History of Art: Studies in Western Art.* Vol. 1, *Romanesque and Gothic Art*, pp. 142–49. Princeton, 1963.

Gaillard 1967
Luís-María de Lojendio. *Navarre romane.* Introduction by Georges Gaillard. La Pierre-Qui-Vire, 1967.

Galindo 1960
Pascual Galindo. "La 'Biblia de León' del 960." *Gesammelte Aufsätze zur Kulturgeschichte Spaniens* 16 (1960), pp. 37–76.

Galtier 1988
Fernando Galtier Martí. "O Turre Tabarense Alta et Lapidea: Un Saggio d'iconografia castellologica sulla miniatura della Spagna cristiana del secolo X." In *XXXIV Corso di Cultura sull'arte ravennate e bizantina (Ravenna, 4–11 April 1987)*, pp. 253–89. Ravenna, 1988.

García Calles 1972
Luisa García Calles. *Doña Sancha, hermana del emperador.* León and Barcelona, 1972.

García Díaz 1988
Paloma García Díaz. "Fragmentos de dos piezas con decoración visigoda de Santianes de Pravia (Asturias)." *Trabalhos de Antropología e Etnología* 28 (1988), pp. 257–68.

García García 1986
Manuel García García. "Palacio del Naranco, 1885–1985." In *Acciones para hacer eficaz una protección monumental que ya cumplió 100 años*, no. 3 (1986), pp. 33–44.

García Guinea 1961a
Miguel Angel García Guinea. *El Arte románico en Palencia.* Palencia, 1961.

García Guinea 1961b
Miguel Angel García Guinea. "Las Huellas de Fruchel en Palencia y los capiteles de Aguilar de Campóo." *Goya* 43–45 (1961), pp. 158–67.

García Guinea 1975
Miguel Angel García Guinea. *El Arte románico en la provincia de Palencia.* 2d ed. Palencia, 1975.

García Larragueta 1962
S. García Larragueta. *Colección de documentos de la catedral de Oviedo.* Oviedo, 1962.

García Lobo 1982
Vicente García Lobo. *Las Inscripciones de San Miguel de Escalada.* Barcelona, 1982.

García Lobo 1987
Vicente García Lobo. "Las Inscripciones medievales de San Isidoro de León." In *Santo Martino de León* (Ponencias del I Congreso internacional sobre Santo Martino en el V centenario de su obra literaria, 1185–1985), pp. 371–98. León, 1987.

García Moreno 1981
Luis A. García Moreno. "Las Invasiones y la época visigoda, reinos, y condados cristianos." In *Historia de España.* Vol. 2, *Romanismo y germanisco, el despertar de los pueblos hispánicos (siglos IV al X)*, pp. 243–478, 490–505. Barcelona, 1981.

García Muñoz 1920
German García Muñoz. *La Biblioteca del monasterio de San Benito el Real de Sahagún.* Moratalla, 1920.

García Rodríguez 1966
C. García Rodríguez. *El Culto de los santos en la España romana y visigoda.* Madrid, 1966.

García Toraño 1981
Paulino García Toraño. "Los Dípticos consulares y el ramirense." *Boletín del Instituto de Estudios Asturianos* 35 (1981), pp. 837–48.

García Toraño 1986
Paulino García Toraño. *Historia de el reino de Asturias (718–910).* Oviedo, 1986.

García Villada 1919
Zacarias García Villada. *Catálogo de los códices y documentos de la Catedral de León.* Madrid, 1919.

Gardelles 1976
Jacques Gardelles. "L'Oeuvre du Maître de Cabestany et les reliefs du château de la Réole." *Bulletin monumental* 134 (1976), pp. 231–37.

Garrison 1953
E. B. Garrison. *Studies in the History of Medieval Italian Painting.* Vol. 1. Florence, 1953.

Garrison 1960
E. B. Garrison. *Studies in the History of Medieval Italian Painting.* Vol. 2. Florence, 1960.

Garvin 1946
Joseph N. Garvin, ed. and trans. *The Vitas Sanctorum Patrum Emeretensium.* Washington, D.C., 1946.

Gauthier 1962
Marie-Madeleine Gauthier. "Los Esmaltes meridionales en la Exposición Internacional de arte románico en Barcelona y Santiago de Compostela." *Goya* 48 (1962), pp. 400–407.

Gauthier 1968
Marie-Madeleine Gauthier. "Les Reliures en émail de Limoges conservées en France, recensement raisonné." In *Humanisme actif: Mélanges d'art et de littérature offerts à Julien Cain*, pp. 271–87. Paris, 1968.

Gauthier 1970
Marie-Madeleine Gauthier. "Les Majestés de la Vierge 'limousines' et méridionales du XIIIᵉ siècle au Metropolitan Museum of Art de New York." *Bulletin de la société nationale des antiquaires de France* (1970), pp. 72–81.

Gauthier 1972
Marie-Madeleine Gauthier. *Émaux du Moyen Âge occidental.* 2d ed. Fribourg, 1972.

Gauthier 1983
Marie-Madeleine Gauthier. *Les Routes de la Foi: Reliques et reliquaires de Jérusalem à Compostelle.* Fribourg, 1983.

Gauthier 1987
Marie-Madeleine Gauthier. *Émaux méridionaux: Catalogue international de l'oeuvre de Limoges.* With a documentary contribution by Geneviève François. Vol. 1, *L'Époque romane.* Paris, 1987.

Gauthier 1990
Marie-Madeleine Gauthier. "L'Atelier d'orfèvrerie de Silos à l'époque romane." In *El Románico en Silos: IX centenario de la consagración de la iglesia y claustro*, pp. 377–95. Silos, 1990.

Geneva 1985
Musée Rath, Geneva. *Treasures of Islam.* Exh. cat. London, 1985.

Gent 1985
Centrum voor Kunst en Cultuur, Abbaye Saint-Pierre. *Santiago de Compostela: 1,000 Ans de pèlerinage européen.* Gent, 1985.

George 1988
Philippe George. "Un Reliquaire, 'souvenir' du pèlerinage des liégeois à Compostelle en 1056?" *Revue Belge d'Archéologie et d'Histoire de l'Art* 57 (1988), pp. 5–21.

Gil 1978
Juan Gil. "Epigráfica III." *Cuadernos de filología clásica* 14 (1978), pp. 83–120.

Gil Fernández, Moralejo, and Ruiz 1985
Juan Gil Fernández, José L. Moralejo, and Juan I. Ruiz de la Peña. *Crónicas asturianas: Crónica de Alfonso III, Crónica Albeldense.* Universidad de Oviedo, Publicaciones del Departamento de Historia Medieval, 11. Oviedo, 1985.

Gil López and Marín 1988
Juana María Gil López and Fernando A. Marín Valdés. *Santa María del Naranco, San Miguel de Lillo.* Oviedo, 1988.

Glass 1970
Dorothy Glass. "Romanesque Sculpture in American Collections. V: Washington and Baltimore." *Gesta* 9 (1970), pp. 46–59.

Glick 1979
Thomas F. Glick. *Islamic and Christian Spain in the Early Middle Ages.* Princeton, 1979.

Goheen 1988
Ellen R. Goheen. *The Collections of the Nelson-Atkins Museum of Art.* New York and Kansas City, 1988.

Goitein 1967
S. D. Goitein. *A Mediterranean Society: The Jewish Communities of the Arab World As Portrayed in the Documents of the Cairo Geniza.* Vol. 1, *Economic Foundations.* Berkeley and Los Angeles, 1967.

Golden Legend 1969
Granger Ryan and Helmut Ripperger, trans. *The Golden Legend of Jacobus de Voragine.* New York, 1969.

Goldschmidt 1914–26
Adolph Goldschmidt. *Die Elfenbeinskulpturen aus der Zeit der karolingischen und sächsischen und der romanischen Zeit.* 4 vols. Berlin, 1914–26.

Goldschmidt 1936
Werner Goldschmidt. "El Sepulcro de San Vicente, en Ávila." *Archivo español de arte y arqueología* 35 (1936), pp. 215–21.

Goldschmidt 1939
Werner Goldschmidt. "Toulouse and Ripoll: The Origin of the Style of Gilabertus." *The Burlington Magazine* 74 (1939), pp. 104–10.

Goldschmidt and Weitzmann 1930–34
Adolph Goldschmidt and Kurt Weitzmann. *Die byzantinischen Elfenbeinskulpturen des X.–XIII. Jahrhunderts.* 2 vols. Berlin, 1930–34.

Golvin 1965
Lucien Golvin. *Recherches archéologiques e la Qal'a des Banû Hammâd.* Paris, 1965.

Gómez 1988
María Jesús Gómez Barcena. "La Liturgia de los funerales y su repercusión en la escultura gótica funeraria." In *La Idea y el sentimiento de la muerte en la historia y en el arte de la edad media*, edited by Manuel Núñez Rodríguez and Ermelindo Portela Silva, pp. 31–50. Santiago de Compostela, 1988.

Gómez-Moreno 1919
Manuel Gómez-Moreno. *Iglesias mozárabes: Arte español de los siglos IX a XI.* Madrid, 1919. Reprint, Granada, 1975.

Gómez-Moreno 1925–26
Manuel Gómez-Moreno. *Catálogo monumental de España: Provincia de León.* 2 vols. Madrid 1925–26.

Gómez-Moreno 1929
Manuel Gómez-Moreno. *Catálogo monumental de España: Provincia de León (1906–1908).* Madrid, 1929.

Gómez-Moreno 1932
Manuel Gómez-Moreno. "El Arca de las reliquias de San Isidoro." *Archivo Español de Arte y Arqueología* 8 (1932), pp. 205–12.

Gómez-Moreno 1934a
Manuel Gómez-Moreno. *El Arte románico español: Esquema de un libro.* Madrid, 1934.

Gómez-Moreno 1934b
Manuel Gómez-Moreno. "La Destrucción de la Cámara Santa de Oviedo." *Boletín de la Real Academia de la Historia* 105 (1934), pp. 605–10.

Gómez-Moreno 1941
Manuel Gómez-Moreno. "La Urna de Santo Domingo de Silos." *Archivo español de arte* 48 (1941), pp. 493–502.

Gómez-Moreno 1945
Manuel Gómez-Moreno. "El Arca Santa de Oviedo documentada." *Archivo español de arte y arqueología* 18 (1945), pp. 125–36.

Gómez-Moreno 1946
Manuel Gómez-Moreno. *El Panteón Real de las Huelgas de Burgos.* Madrid, 1946.

Gómez-Moreno 1947
María Elena Gómez-Moreno. *Mil Joyas del arte español.* Vol. 1: *Antigüedad y edad media.* Barcelona, 1947.

Gómez-Moreno 1949
Manuel Gómez-Moreno. *Arte Almohade, Arte Nazari, Arte Mudejar.* Ars Hispaniae, 4. Madrid, 1949.

Gómez-Moreno 1951
Manuel Gómez-Moreno. *El Arte árabe español hasta los Almohades. Arte mozárabe.* Ars Hispaniae, 3. Madrid, 1951.

Gómez-Moreno 1964
Manuel Gómez-Moreno. "Prémices de l'art chrétien en Espagne." *Information d'histoire de l'art* 5 (1964), pp. 185–212. Also published as "Primicias del arte cristiano español," *Archivo español de arte* 39 (1966), pp. 101–39.

Gómez-Moreno and Vázquez de Parga 1965
Manuel Gómez-Moreno and L. Vázquez de Parga. *En torno al crucifijo de los reyes Fernando y Sancha.* Informes y Trabajos del Instituto de Conservación y Restauración de Obras de Arte, Arqueología y Etnología, 3. Valencia, 1965.

Gómez Tabanera 1976
J. M. Gómez Tabanera. *La Iglesia ramirense de San Miguel de Lillo (monte Naranco, Oviedo) y el simbolismo de la acrobacia antigua en le prerrománico asturiano.* Valdediós, 1976.

Gonçalves 1926
António Augusto Gonçalves. "O Museu de Ourivesaria, Tecidos e Bordados: Annexo ao Museu Machado de Castro em Coimbra." *Ilustração Moderna* 1, no. 6 (1926), pp. 143–44.

Goñi 1953
José Goñi Gaztambide. "Nuevos Documentos sobre la Catedral de Pamplona." *Príncipe de Viana* 14 (1953), pp. 311–27.

Goñi 1964
José Goñi Gaztambide. "La Fecha de la terminación del claustro románico de la Catedral de Pamplona." *Príncipe de Viana* 25 (1964), pp. 281–83.

González García 1974
Vicente José González García. *La Iglesia de San Miguel de Lillo (apuntes para su reconstrucción)*. Oviedo, 1974.

González García and Suárez 1979
Vicente José González García and G. Suárez Suárez. *La Cámara Santa y su tesoro*. Oviedo, 1979.

González Miranda 1956
Marina González Miranda. "La Condesa doña Sancha y el monasterio de Santa Cruz de la Serós." *Estudios de Edad Media de la Corona de Aragón* 6 (1956), pp. 185–202.

Grabar 1945
André Grabar. "Une Fresque visigothique et l'iconographie du silence." *Cahiers archéologiques* 1 (1945), pp. 124–28.

Grabar 1968
André Grabar. *Christian Iconography: A Study of Its Origins*. Princeton, 1968.

Grabar 1972
André Grabar. *Les Manuscrits grecs enluminés de provenance italienne*. Paris, 1972.

Grabar and Nordenfalk 1957
André Grabar and Carl Nordenfalk. *Early Medieval Painting from the Fourth to the Eleventh Century*. New York, 1957.

Grodecki 1973
Louis Grodecki. "Architecture et décor monumental." In *Le Siècle de l'an mil*, edited by L. Grodecki et al., pp. 3–84. Paris, 1973.

Grodecki, Mütherich, and Taralon 1973
Louis Grodecki, Florentine Mütherich, and Jean Taralon. *Die Zeit der Ottonen und Salier*. Munich, 1973.

Gros 1989
Miquel S. Gros i Pujol. "L'Antic retaule romànic de la catedral de Vic: Assaig de reconstrucció." *Studia vicensia* 1 (1989), pp. 99–126.

Gros 1991
Miquel S. Gros i Pujol. *Museu Episcopal de Vic: Romànic*. Sabaell, 1991.

Growden 1976
Marcia Growden. "The Narrative Sequence in the Preface to the Gerona Commentaries of Beatus on the Apocalypse." Ph.D. diss., Stanford University, 1976.

Grube 1965
E. J. Grube. "A Bronze Bowl from Egypt." *Journal of the American Research Center in Egypt* 4 (1965), pp. 141–43.

Guardia 1984
Milagros Guardia Pons. *Las Pinturas bajas de la Ermita de San Baudelio de Berlanga (Soria)*. Soria, 1984.

Gudiol 1909
Josep Gudiol i Cunill. *Iconografía de la Portada de Ripoll*. Barcelona, 1909.

Gudiol 1929
Josep Gudiol i Cunill. *Els Primitius II: La Pintura sobre fusta*. Barcelona, 1929.

Gudiol 1950
Josep Gudiol i Cunill. *Pintura e imaginería románicas*. Ars Hispaniae, 4. Madrid, 1950.

Gudiol 1955
Josep Gudiol i Cunill. *Els Primitius III: Els Llibres il·luminats*. Barcelona, 1955.

Gudiol Ricart and Gaya 1948
José Gudiol Ricart and Juan Antonio Gaya Nuño. *Arquitectura y escultura románicas*. Ars Hispaniae, 5. Madrid, 1948.

Guerra 1962
José Guerra Campos. "La Exposición de arte románico en Santiago de Compostela." *Cuadernos de estudios gallegos* 17 (1962), pp. 293–96.

Guerra 1982
José Guerra Campos. *Exploraciones arqueológicas en torno al sepulcro de apóstol Santiago*. Santiago de Compostela, 1982.

Guilmain 1981
Jacques Guilmain. "On the Chronological Development and Classification of Decorated Initials in Latin Manuscripts of Tenth-Century Spain." *Bulletin of the John Rylands University Library of Manchester* 63 (1981), pp. 369–401.

Gutiérrez de Arroyo 1959
Consuelo Gutiérrez de Arroyo. "Sobre un documento notable del monasterio de San Salvador de Villacete." *Revista de archivos, bibliotecas, y museos* 67 (1959), pp. 7–19.

Hacker-Suck 1962
Inge Hacker-Sück. "La Sainte-Chapelle de Paris et les chapelles palatines du Moyen Âge." *Cahiers archéologiques* 13 (1962), pp. 217–57.

al-Hamdani 1974
Betty al-Hamdani. "The Genesis Scenes in the Romanesque Frescoes of Bagües." *Cahiers archéologiques* 23 (1974), pp. 169–94.

Hamilton 1959
R. W. Hamilton. *Khirbat al-Mafjar: An Arabian Mansion in the Jordan Valley*. Oxford, 1959.

Hanfmann 1951
George M. A. Hanfmann. *The Seasons Sarcophagus in Dumbarton Oaks*. 2 vols. Dumbarton Oaks Studies, 2. Cambridge, Mass., 1951.

Harris 1989
Julie Harris. "The Arca of San Millán de la Cogolla and Its Ivories." Ph.D. diss., University of Pittsburgh, 1989.

Harris 1990
Julie Harris. "The Beatitudes Casket in Madrid's Museo Arqueológico: Its Iconography in Context." *Zeitschrift für Kunstgeschichte* 53 (1990), pp. 134–39.

Harris 1991
Julie Harris. "Culto y narrativa en los marfiles de San Millán de la Cogolla." *Boletín del Museo Arqueológico Nacional* 9 (1991), pp. 69–86.

Harrison 1989
Martin Harrison. *A Temple for Byzantium: The Discovery and Excavation of Anicia Juliana's Palace-Church in Istanbul*. Austin, 1989.

Hasan 1937
Z. M. Hasan. *Kunuz al-fatimiyyin* [Fatimid Art Treasures]. Cairo, 1937.

Hassig 1991
Debra Hassig. "He Will Make Alive Your Mortal Bodies: Cluniac Spirituality and the Tomb of Alfonso Ansúrez." *Gesta* 30, no. 2 (1991), pp. 140–53.

Haupt 1916
Albrecht Haupt. "Die spanisch-westgotische Halle zu Naranco und die nordischen Königshallen." *Monatshefte für Kunstwissenschaft* 9 (1916), pp. 242–63.

Haupt 1935
Albrecht Haupt. *Die älteste Kunst: Insbesondere die Baukunst der Germanen von der Völkerwanderung bis zu Karl dem Grossen*. 3d ed. Berlin, 1935.

Hauschild 1972
Theodor Hauschild. "Westgotische Quaderbauten des 7. Jahrhunderts auf der iberischen Halbinsel." *Madrider Mitteilungen* 13 (1972), pp. 270–85.

Hauschild 1992a
Theodor Hauschild. "Informe preliminar sobre las excavaciones en la iglesia de San Miguel de Liño." In *Excavaciones arqueológicas en Asturias 1987–90*, pp. 171–77. Oviedo, 1992.

Hauschild 1992b
Theodor Hauschild. "Archeology and the Tomb of St. James." In *The "Codex Calixtinus" and the Shrine of St. James*, edited by John Williams and Alison Stones, pp. 89–103. Tübingen, 1992.

Hearn 1981
Millard Fillmore Hearn. *Romanesque Sculpture: The Revival of Monumental Stone Sculpture in the 11th and 12th Centuries*. First published Ithaca, 1980. Oxford, 1981.

Hermosilla 1983
V. Hermosilla. *Monasterio de San Millán de la Cogolla: Un Siglo de historia agustiniana, 1878–1978*. Rome, 1983.

Hernando 1987
Mercedes Jover Hernando. "Los Ciclos de Pasión y Pascua en la escultura monumental románica en Navarra." *Príncipe de Viana* 48 (1987), pp. 7–40.

Hernández 1930
Félix Hernández. "Un Aspecto de la influencia del arte califal en Cataluña." *Archivo español de arte y arqueología* 6 (1930), pp. 21–49.

Hernández 1961
Jesús Hernández Perrera. "Los Artes industriales españolas de la época románica." *Goya* 43–45 (1961), pp. 98–112.

Herrero-Carretero 1988
Concha Herrero-Carretero. *Museo de telas medievales: Monasterio de Santa María la Real de Huelgas*. Madrid, 1988.

Herrero González 1988
Sonsoles Herrero González. *Códices miniados en el real monasterio de Las Huelgas*. Barcelona and Madrid, 1988.

Herrin 1987
Judith Herrin. *The Formation of Christendom*. Princeton, 1987.

Hildburgh 1936
Walter Leo Hildburgh. *Medieval Spanish Enamels and Their Relation to the Origin and the Development of Copper Champlevé Enamels of the Twelfth and Thirteenth Centuries*. Oxford, 1936.

Hildburgh 1955
Walter Leo Hildburgh. "Medieval Copper Champlevé Enamelled Images of the Virgin and Child." *Archeologia* 96 (1955), pp. 116–58.

Hill 1953
Dorothy Kent Hill. "Animals from Ancient Spain." *The Bulletin of the Walters Art Gallery* 5 (1953).

Hoegger 1975
Peter Hoegger. *Die Fresken in der ehemaligen Abteilkirche S. Elia bei Nepi*. Frauenfeld and Stuttgart, 1975.

Hoffmann 1970
Konrad Hoffmann. *The Year 1200: A Centennial Exhibition at The Metropolitan Museum of Art*. The Cloisters Studies in Medieval Art, 1. New York, 1970.

Holmquist 1968
Wilhelm Holmquist. "Christliche Kunst und germanische Ornamentik." In *Atti del Convegno internazionale sul tema: Tardo Antico e Alto Medioevo* (Rome, 1967), pp. 349–74. Rome, 1968.

Horste 1982
Kathryn Horste. "The Passion Series from La Daurade and Problems of Narrative Composition in the Cloister Capital." *Gesta* 21 (1982), pp. 51–52.

Hubert 1967
Jean Hubert. "Le Décor du palais de Naranco et l'art de l'Europe barbare." In *Symposium sobre cultura asturiana de la alta edad media (Oviedo 1961)*, pp. 151–60. Oviedo, 1967.

Hubert 1977
Jean Hubert. *Arts et vie sociale de la fin du monde antique au Moyen Âge*. Geneva, 1977.

Hübner 1871
Emil Hübner. *Inscriptiones hispaniae christianae*. Berlin, 1871.

Hunt 1954
John Hunt. "The Adoration of the Magi." *Connoisseur* 133 (1954), pp. 156–61.

Ibn Hawqual 1842
Ibn Hawqual. *Kitab al-masalik wa al-mamalik*, trans. M. de Slane, "Description de l'Afrique," *Journal asiatique*, 3d series, 13 (1842).

Idris 1962
H. R. Idris. *La Berberie orientale sous les Zirides, X^e–XII^e siècles*. Paris 1962.

al-Idrisi 1968
al-Idrisi. *Kitab Nuzhlah al-mustaq fi ihtiraq al-afaz*. In *Description de l'Afrique et de l'Espagne*. Translated by R. Dozy and M. J. de Goeje. Leiden, 1968.

al-Imad 1990
Laila S. al-Imad. *The Fatimid Vizierate: 969–1172*. Islam-kundliche Untersuchungen, 133. Berlin, 1990.

Iñiguez Almech 1968
Francisco Iñiguez Almech. "Sobre tallas románicas del siglo XII." *Príncipe de Viana* 29, nos. 112, 113 (1968), pp. 181–236.

Iñiguez Herrero 1978
José Antonio Iñiguez Herrero. *El Altar cristiano: De los orígenes a Carlomagno (s. II–año 800)*. Vol. 1. Pamplona, 1978.

Jacob 1954
Henriette s'Jacob. *Idealism and Realism: A Study of Sepulchral Symbolism*. Leiden, 1954.

James 1977
E. James. *The Merovingian Archaeology of South-West Gaul*. 2 vols. BAR suppl. series 25 (1977).

Janini 1969
José Janini. *Manuscritos litúrgicos de la Biblioteca Nacional*. Madrid, 1969.

Janini 1977
José Janini. *Manuscritos litúrgicos de las bibliotecas de España*. Vol. 1: *Castilla y Navarra*. Burgos, 1977.

Janini and Gonzálvez 1977
José Janini and Ramón Gonzálvez. *Manuscritos litúrgicos de la catedral de Toledo*. Toledo, 1977.

Jenkins 1975
Marilyn Jenkins. "Western Islamic Influences on Fatimid Egyptian Iconography." *Kunst des Orients* 10, nos. 1, 2 (1975), pp. 91–107.

Jenkins 1978
Marilyn Jenkins. "Medieval Maghribi Ceramics: A Reappraisal of the Pottery Production of the Western Regions of the Muslim World." Ph.D. diss., New York University, 1978.

Jenkins 1980
Marilyn Jenkins. "Medieval Maghribi Luster-Painted Pottery." In *La Céramique médievale en Méditerranée occidentale, X^e–XV^e siècles: Actes du colloque international C.N.R.S., Valbonne, 1978*, pp. 335–42. Paris, 1980.

Jenkins 1982
Marilyn Jenkins. "New Evidence for the Possible Provenance and Fate of the So-Called Pisa Griffin." *Islamic Archaeological Studies* 1 (1978), pp. 79–85. Cairo, 1982.

Jenkins 1983
Marilyn Jenkins, ed. *Islamic Art in the Kuwait National Museum: The al-Sabah Collection*. London, 1983.

Jenkins 1988a
Marilyn Jenkins. "Fatimid Jewelry: Its Subtypes and Influences." *Ars Orientalis* 18 (1988), pp. 39–57.

Jenkins 1988b
Marilyn Jenkins. "Mamluk Jewelry: Influences and Echoes." *Muqarnas* 5 (1988), pp. 29–42.

Jerusalem 1987
The Israel Museum. *Islamic Jewelry*. Jerusalem, 1987.

Jorge 1957
Manuel Jorge Aragoneses. "El Grifo de San Miguel de Liño y su filiación visigoda." *Boletín del Instituto de Estudios Asturianos* 11 (1957), pp. 259–68.

Joris 1988
A. Joris. "Espagne et Lotharingie autour de l'an mil: Aux origines des franchises urbaines?" *Le Moyen Âge: Revue d'histoire et de philologie* 94 (1988), pp. 5–19.

Jover 1987
Mercedes Jover Hernando. "Los Ciclos de Pasión y Pascua en la escultura monumental románica en Navarra." *Príncipe de Viana* 48 (1987), pp. 7–40.

Juaristi 1933
Victoriano Juaristi. *Esmaltes, con especial mención de los españoles*. Barcelona, 1933.

Jullian 1945
R. Jullian. "La Sculpture du Moyen-Âge et de la Renaissance." *Catalogue du Musée de Lyon* 3 (1945), pp. 37–40.

Junyent 1960–61
Eduard Junyent. *Catalogne Romane*. 2 vols. Zodiaque. La Pierre-Qui-Vire, 1960–61.

Junyent 1962
Eduard Junyent. "L'Oeuvre du maître de Cabestany." In *Actes du quatre-vingt-sixième Congrès des Sociétés Savantes (Montpellier, 1961): Bulletin archéologique du Comité travaux historiques et scientifiques* (1962), pp. 169–78.

Junyent 1966
Eduard Junyent. "La Cripta románica de la catedral de Vich." *Anuario de estudios medievales* 3 (1966), pp. 91–109.

Junyent 1970
Eduard Junyent. *Catalogne romane*. 2 vols. 2d ed. La Pierre-Qui-Vire, 1970.

Junyent 1971
Eduard Junyent. *Diplomatari d'Oliba, comte abat i bisbe*. Barcelona, 1971.

Junyent 1976
Eduard Junyent. *Sant Joan de les Abadesses*. Barcelona, 1976.

Kahle 1935
Paul Kahle. "Die Schätze der Fatimiden." *Zeitschrift der Deutschen Morgenländischer Gesellschaft* 89, n.s. 14 (1935), pp. 329–62.

Kantorowicz 1957
Ernst H. Kantorowicz. *The King's Two Bodies: A Study in Mediaeval Political Theology*. Princeton, 1957.

Karge 1989
Henrik Karge. *Die Katedrale von Burgos und die spanische Architektur des 13. Jahrhunderts Französische Hochgotik in Kastilien und León*. Berlin, 1989.

Kauffmann 1975
Claus Michael Kauffmann. *Romanesque Manuscripts, 1066–1190*. A Survey of Manuscripts Illuminated in the British Isles, 3. London, 1975.

Keene 1981
M. Keene. "The Lapidary Arts in Islam." *Expedition* 24, no. 1 (1981), p. 38.

Kehr 1907
Paul Kehr. *Das Papsttum und der katalanische Prinzipat bis zur Vereinigung mit Aragon*. Abhandlungen der Preussischen Akademie der Wissenschaften, Phil.-Hist. Klasse, no. 1. Berlin, 1926.

Kendrick 1927
A. F. Kendrick. "Textiles." In *Spanish Art* (Burlington Magazine Monograph II), edited by Tatlock et al., pp. 59–70. London, 1927.

Kirschbaum 1961
E. Kirschbaum. "Die Grabungen unter der Kathedrale von Santiago de Compostela." *Römische Quartalschrift für christliche Altertumskunde und Kirchengeschichte* 56 (1961), pp. 234–54.

Klein 1972
Peter K. Klein. "Date et scriptorium de la Bible de Roda." *Les Cahiers de Saint-Michel-de-Cuxa* 3 (1972), pp. 91–102.

Klein 1972–74
Peter K. Klein. "Der Apokalypse-Zyklus der Roda-Bibel und seine Stellung in der ikonographischen Tradition." *Archivo Español de Arqueología* 45–47 (1972–74), pp. 267–333.

Klein 1976
Peter K. Klein. *Der ältere Beatus-Kodex Vitr. 14–1 der Biblioteca Nacional zu Madrid*. Hildesheim, 1976.

Klein 1979
Peter K. Klein. "Les Cycles de l'Apocalypse du haut Moyen Âge." In *L'Apocalypse de Jean: Traditions exégétiques et iconographiques*, edited by Yves Christe, pp. 135–86. Geneva, 1979.

Klein 1989
Peter K. Klein. "Les Portails de Saint-Genis-des-Fontaines et de Saint-André-de-Sorède. I: Le Linteau de Saint-Genis." *Les Cahiers de Saint-Michel-de-Cuxa* 20 (1989), pp. 121–59.

Klein 1990a
Peter K. Klein. *Beatus a Liébana In Apocalypsin commentarius: Manchester, The John Rylands University Library, Latin MS. 8* (Codices illuminati medii aevi, 16). Munich, 1990.

Klein 1990b
Peter K. Klein. "La Puerta de la Virgenes: su datación y su relación con el transepto y el claustro." In *El Románico en Silos: IX centenario de la consegración de la iglesia y claustro* (Studia Silensia Series Maior 1), pp. 297–315. Abadía de Silos, 1990.

Koenig 1979
G. G. Koenig. "No. 57a." In *Propylaen Kunstgeschichte*, supplementband 4, *Kunst der Völkerwanderungszeit*, pp. 146–47. Berlin, 1979.

Köhler-Schommer 1992
Isolde Köhler-Schommer. "Romanische Architektur. Katalonien und die Tonnenhallen des 'primer art romànic.'" In *Spanische Kunstgeschichte: Eine Einführung*, edited by S. Hänsel and H. Karge. Vol. 1, pp. 87–100. Berlin, 1992.

Koningsveld 1977
P. S. van Koningsveld. *The Latin-Arabic Glossary of the Leiden University Library: A Contribution to the Study of Mozarabic Manuscripts and Literature*. Leiden, 1977.

Kötzsche 1973
Dietrich Kötzsche. *Der Welfenschatz im Berliner Kunstgewerbemuseum*. Bilderhefte der Staatlichen Museen Preussischer Kulturbesitz, 20–21. Berlin, 1973.

Kötzsche-Breitenbruch 1976
Lieselotte Kötzsche-Breitenbruch. "Die neue Katakombe an der Via Latina in Rom: Untersuchungen zur Ikonographie der alttestamentlichen Wandmalereien." *Jahrbuch für Antike und Christentum* 4 (1976), pp. 103–9.

Kubach 1964
Erich Kubach. "Baukunst der Romanik." In *Früh- und*

Hochromanik, edited by Erich Kubach and Peter Bloch, pp. 1–134. Baden-Baden, 1964.

Kubach 1968
Erich Kubach. "Die Architektur zur Zeit der Karolinger und Ottonen." In *Catalunya romànica*, vol. 18: *El Vallès occidental—El Vallès oriental*, edited by Erich Kubach and Victor H. Elbern, pp. 5–106. Baden-Baden, 1968.

Kühnel 1971
Ernst Kühnel. *Die islamischen Elfenbeinskulpturen, VII.– XIII. Jahrhundert.* Berlin 1971.

Küpers and Mikat 1966
Leonhard Küpers and Paul Mikat. *Der Essener Münster-schatz.* Essen, 1966.

Kurz 1990
Herbert Kurz. "Der Volto Santo von Lucca." M.A. thesis, University of Regensburg, 1990.

Lacarra 1972
José María Lacarra. *Historia política del reino de Navarra desde sus orígenes hasta su incorporación a Castilla.* 3 vols. Pamplona, 1972.

Lacoste 1973
Jacques Lacoste. "La Sculpture à Silos autour de 1200." *Bulletin Monumental* 131–32 (1973), pp. 109–14.

Lacoste 1979
Jacques Lacoste. "Le maître de San Juan de la Peña (XII siècle)." *Les Cahiers de Saint-Michel-de-Cuxa* 10 (1979), pp. 175–89.

Lahondès 1903–6
Jules de Lahondès. "Les Statues des deux femmes portant un lion et un bélier." *Bulletin de la Société Archéologique du Midi de la France* 7 (1903–6), pp. 452–55.

Lampérez 1908a
Vicente Lampérez y Romea. "El Monasterio de Aguilar de Campóo (Palencia)." *Boletín de la sociedad española de excursiones* 16 (1908), pp. 215–21.

Lampérez 1930
Vicente Lampérez y Romea. *Historia de la arquitectura cristiana española en la Edad Media según el estudio de los elementos y los monumentos.* Bilbao/Madrid/Barcelona, 1930. 1st ed., 1908.

Lapeña 1989
Paul A. I. Lapeña. *El Monasterio de San Juan de la Peña en la alta Edad Media.* Saragossa, 1989.

Larrén 1985
Hortensia Larrén Izquierdo. "Aspectos visigodos de San Miguel de Escalada." In *Antigüedad y cristianismo: Monografías históricas sobre la antigüedad tardía*, edited by A. González Blanco. Vol. 3: *Los Visigodos*, pp. 501–12. Murcia, 1986.

Lasko 1972
Peter Lasko. *Ars Sacra: 800–1200.* Harmondsworth, 1972.

Lasteyrie 1861
Ferdinand de Lasteyrie. *Description du trésor de Guarrazar.* Paris, 1861.

Lasteyrie 1901
Charles de Lasteyrie. *L'Abbaye de Saint-Martial de Limoges.* Paris, 1901.

Lázaro 1894
Juan Bautista Lázaro Galdiano. *Ermita de Santa Cristina de Lena (Oviedo): Reseña de las obras hechas para su restauración.* Madrid, 1894.

Lázaro 1925
Juan Bautista Lázaro Galdiano. *El Robo de la Real Armería y las coronas de Guarrazar.* Madrid, 1925.

Leclerq 1921
Henri Leclerq. *Dictionnaire d'archéologie chrétienne et liturgie.* Vol. 4, pt. 2. Paris, 1921.

Le Goff 1976
Jacques Le Goff. "Les Gestes symboliques dans la vie

sociale: Les Gestes de vassalité." In *Simboli e simbologia nell'alto medioevo*, Settimane di Studio del Centro Italiano di Studi sull'Alto Medioevo, 23, pp. 679–779. Spoleto, 1976.

Lejeune and Stiennon 1971
Rita Lejeune and Jacques Stiennon. *The Legend of Roland in the Middle Ages.* 2 vols. London, 1971.

Leningrad 1986
The Hermitage Museum. *The Basilewsky Collection.* Exh. cat. Leningrad, 1986.

Leningrad 1990
The Hermitage Museum. *Medieval Art from Late Antique through Late Gothic from The Metropolitan Museum of Art and The Art Institute of Chicago.* Exh. cat. Leningrad, 1990.

Lévi-Provençal 1931
E. Lévi-Provençal. *Inscriptions arabes d'Espagne.* Leiden and Paris, 1931.

Little 1979
Charles T. Little. "Head of a Youth." *Metropolitan Museum of Art. Notable Acquisitions 1975–1979.* New York, 1979.

Little 1981
Charles T. Little. "Portion of a Crozier Shaft." *The Metropolitan Museum of Art: Notable Acquisitions, 1980–1981*, pp. 21–22. New York, 1981.

Little 1987
Charles T. Little. "Acquisition Announcement." *The Metropolitan Museum of Art. Recent Acquisitions: A Selection 1986–87*, p. 15. New York, 1987.

Little and Husband 1987
Charles T. Little and Timothy Husband. *The Metropolitan Museum of Art: Europe in the Middle Ages.* New York, 1987.

Little, Simon, and Bussis 1987
Charles T. Little, David L. Simon, and Leslie Bussis. "Romanesque Sculpture in North American Collections. XXV: The Metropolitan Museum of Art. Part V: Southwestern France." *Gesta* 25 (1987), pp. 61–76.

Llamazares 1925
Julio Pérez Llamazares. *El Tesoro de la Real Colegiata de San Isidoro: Reliquias, relicarios, y joyas artísticas.* León, 1925.

Llamazares 1927
Julio Pérez Llamazares. *Historia de la Real Colegiata de San Isidoro.* León, 1927.

Llano 1917a
Aurelio de Llano Roza de Ampudia. "La Iglesia de San Miguel de Liño en Asturias." *Boletín de la Real Academia de la Historia* 70 (1917), pp. 109–13.

Llano 1917b
Aurelio de Llano Roza de Ampudia. *La Iglesia de San Miguel de Lillo.* Oviedo, 1917. Reprint, 1982.

Llano 1928
Aurelio de Llano Roza de Ampudia. *Bellezas de Asturias de oriente a occidente.* Oviedo, 1928. Reprint, 1977.

Lojendio 1967
Luis-María de Lojendio. *Navarre romane.* La nuit des temps, 21. La Pierre-Qui-Vire, 1967.

London 1968
Sotheby and Company. *The Chester Beatty Western Manuscripts* (pt. 1, 3 December 1968). Sale cat. London, 1968.

London 1976
Hayward Gallery. *The Arts of Islam.* Exh. cat. London, 1976.

London 1984
Hayward Gallery. *English Romanesque Art: 1066–1200.* London, 1984.

Longhurst 1927
Margaret H. Longhurst. *Catalogue of Carvings in Ivory.* Pt. 1: *Up to the Thirteenth Century.* London, 1927.

Loosveldt 1992
Manuel Loosveldt. "Dibujo de la Vocación de San Pedro." *Cataluña medieval* (1992), pp. 78–79.

López 1898
Antonio López Ferreiro. *Historia de la S. M. Iglesia de Santiago de Compostela*, vol. 1. Santiago de Compostela, 1898.

López 1900
Antonio López Ferreiro. *Historia de la S. M. Iglesia de Santiago de Compostela*, vol. 3. Santiago de Compostela, 1900.

López 1905
Antonio López Ferreiro. *Historia de la S. M. Iglesia de Santiago de Compostela*, vol. 8. Santiago de Compostela, 1905.

López Alsina 1988
Fernando López Alsina. *La Ciudad de Santiago de Compostela en la alta edad media.* Santiago de Compostela, 1988.

Lowe 1937
E. A. Lowe. "The Codex Cavensis: New Light on Its Later History." In *Quantulumcumque: Studies Presented to Kirsopp Lake*, edited by R. Casey, S. Lake, and A. Lake, pp. 325–31. London, 1937.

Lowe 1947
E. A. Lowe. *Codices Latini Antiquores.* Pt. 4. Oxford, 1947.

Lowe 1954
E. A. Lowe. "The Morgan Golden Gospels: The Date and Origin of the Manuscript." In *Studies in Art and Literature for Belle Da Costa Greene*, edited by D. Miner, pp. 266–79. Princeton, 1954.

Lozinski and Lozinski 1976
Jean Lozinski and Philip Lozinski. "The Treasure of Guarrazar." In *España entre el Mediterráneo y el Atlántico: Actas del XXIII Congreso Internacional de Historia del Arte, Granada, 1973*, vol. 1, pp. 379–92. Granada, 1976.

Lozoya 1966
Marqués de Lozoya. *Las Pinturas románicas en la iglesia de San Justo de Segovia.* Madrid, 1966.

Luis 1961
Carlos María de Luis. *Catálogo de las salas de arte asturiano prerrománico del Museo Arqueológico Provincial.* Oviedo, 1961.

Lyman 1978
Thomas Lyman. "Arts somptuaires et art monumental: Bilan des influences auliques pré-romanes sur la sculpture romane dans le sud-ouest de la France et en Espagne." *Les Cahiers de Saint-Michel-de-Cuxa* 9 (1978), pp. 115–27.

McCann 1978
Anna Marguerite McCann. *Roman Sarcophagi in the Metropolitan Museum of Art.* New York, 1978.

McCluskey 1987
Raymond McCluskey. "The Librarie and Scriptorium of San Isidoro de León." In *Santo Martino de León: Ponencias del I Congreso internacional sobre Santo Martino en el VIII Centenario de su obra literaria 1185–1985*, pp. 231–48. León, 1987.

McCormick 1986
Michael McCormick. *Eternal Victory: Triumphant Rulership in Late Antiquity, Byzantium, and the Early Medieval West.* Cambridge, Mass., 1986.

Madrazo 1879
Pedro de Madrazo y Kunz. *Coronas y cruces del tesoro de Guarrazar.* Monumentos arquitectónicos de España. Madrid, 1879.

Madrazo 1886
Pedro de Madrazo y Kunz. *España: Sus Monumentos y artes, su naturaleza e historia.* Vol. 18: *Navarra y Logroño*, 3 vols. Barcelona, 1886.

Madrid 1892
Exposición historico-europea, Catálogo. Madrid, 1892.

Madrid 1919
Sociedad Española de Amigos del Arte. *Exposición de hierros antiguos españoles.* Madrid, 1919.

Madrid 1925
Pedro M. de Artiñano y Galdacano. *Catálogo de la exposición de Tejidos Españoles.* Madrid, 1925.

Madrid 1992
Portugal en el medievo: De los monasterios a la monarquía. Madrid, 1992.

Mainz 1992
Römisch-Germanisches Zentralmuseum Mainz. *Das Reich der Salier: 1024–1125.* Mainz, 1992.

Mansilla 1955
Demetrio Mansilla, ed. *La Documentación pontificia hasta Inocencio III: 965–1216.* Rome, 1955.

Manzanares 1957
Joaquín Manzanares Rodríguez. "Santa María de Bendones: An Unknown Pre-Romanesque Church." *Journal of the Society of Architectural Historians* 16, no. 4 (1957), pp. 2–7.

Manzanares 1964
Joaquín Manzanares Rodríguez. *Arte prerrománico asturiano: Síntesis de su arquitectura.* 2d ed. Oviedo, 1964.

Manzanares 1972
Joaquín Manzanares Rodríguez. *Las Joyas de la Cámara Santa: Valores permanentes de Oviedo.* Oviedo, 1972.

Manzano 1732
Joseph Manzano. *Vida y portentos milagros de el glorioso San Isidoro, arzobispo de Sevilla.* Salamanca, 1732.

Maravall 1954
José Antonio Maravall. *El Concepto de España en la Edad Media.* Madrid, 1954.

Maravall 1964
José Antonio Maravall. *El Concepto de España en la Edad Media.* 2d ed. Madrid, 1964.

Marçais 1928
Georges Marçais. *Les Faïences à reflets métalliques de la Grande Mosquée de Kairowan.* Paris, 1928.

Marçais 1936
Georges Marçais. "L'Art musulmane d'Espagne." *Hesperis* 22 (1936).

Marín 1990
Fernando A. Marín Valdés. "Santa María del Naranco: Bestiaro y paraíso." *Boletín del Instituto de Estudios Asturianos* 44 (1990), pp. 413–26.

Marín and Gil 1989
Fernando A. Marín Valdés and Juana María Gil López. *San Julian de los Prados o el discurso de las dos ciudades.* Oviedo, 1989.

Mariné and Terés n.d.
Maria Mariné and Elias Terés, eds. *Museo de Ávila: Documentación Gráfica.* Ávila, n.d.

Marinetto 1986
P. Marinetto Sánchez. *El Capitel en el Palacio de los Leones: Genesis, evolución, estudio, y catálogo.* Granada, 1984. Microfiche.

Mariño 1986
Beatriz Mariño. "'In Palencia non ha batalla pro nulla re.' El duelo de villanos en la iconografía románica del Camino de Santiago." *Compostellanum* 31 (1986), pp. 349–64.

Marqués 1963
Jaime Marqués Casanovas. *Le Cloître de la cathédrale de Gerona.* Girona, 1963.

Martínez 1931
Julio Martínez Santa-Olalla. "Sobre algunas Hallazgos de Brances Visigóticos en España." *Ipek* (1931), pp. 57–60.

Martínez 1934
Julio Martínez Santa-Olalla. "Notas para un ensayo de sistematización de la arqueología visigoda en España: Periodos godo y visigodo." *Archivo español de arte y arqueología* 10 (1934), pp. 139–76.

Martínez 1936
Julio Martínez Santa-Olalla. "Westgotische Adlerfibeln aus Spanien." *Germania* 20 (1936), pp. 47–52.

Martínez 1940–41
Julio Martínez Santa-Olalla. "Nuevas Fíbulas aquiliformes hispanovisigodas." *Archivo español de arqueología* 14 (1940–41), pp. 33–54.

May 1957
Florence Lewis May. *Silk Textiles of Spain: Eighth to Fifteenth Century.* New York, 1957.

Mecolaeta 1724
Fr. Diego Mecolaeta. *Desagravio de la verdad en la historia de San Millán.* Madrid, 1724.

Melero 1992
Marie Luisa Melero Moneo. "La Sculpture du cloître de la cathédrale de Pampelune et sa répercussion sur l'art roman navarrais." *Cahiers de civilisation médiévale* 35 (1992), pp. 241–46.

Mélida 1908
José Ramón Mélida. *La Escultura hispanocristiana de los primeros siglos de la era.* Madrid, 1908.

Mélida 1912
José Ramón Mélida. "La Iglesia parroquial de San Salvador de Priesca." *Boletín de la Real Academia de la Historia* 61 (1912), pp. 125–29.

Mély 1922
F. de Mély. "Les Deux 'Vierges' de Toulouse et leur légende." *Gazette des Beaux-Arts* (1922), pp. 88–96.

Memorias 1947
Memorias de los museos arqueológicos provinciales. Vol. 8, 1947.

Menéndez Pidal 1941a
Luis Menéndez Pidal. "Asturias: Destrucciones habidas en sus monumentos durante el dominio marxista, trabajos de protección y restauración efectuados o en proyecto." *Revista nacional de arquitectura* 1, no. 3 (1941), pp. 9–17.

Menéndez Pidal 1941b
Luis Menéndez Pidal. "Proyecto de ficha para monumentos: San Julián de los Prados (Oviedo)." *Revista nacional de arquitectura* 1, no. 3 (1941), pp. 18–48.

Menéndez Pidal 1950
Ramón Menéndez Pidal. *El Imperio hispánico y los cinco reinos.* Madrid, 1950.

Menéndez Pidal 1954
Luis Menéndez Pidal. *Los Monumentos de Asturias: Su aprecio y restauración desde el pasado siglo.* Madrid, 1954.

Menéndez Pidal 1955
Gonzalo Menéndez Pidal. "El Labaro primitivo de la Reconquista: Cruces asturianas y cruces visigodas." *Boletín de la Real Academia de la Historia* 136 (1955), pp. 275–96.

Menéndez Pidal 1958
Gonzalo Menéndez Pidal. "Sobre el escritorio emilianense en los siglos X a XI." *Boletín de la Real Academia de la Historia* 143 (1958), pp. 7–19.

Menéndez Pidal 1960
Luis Menéndez Pidal. "La Cámara Santa de Oviedo, su destrucción y reconstrucción." *Boletín del Instituto de Estudios Asturianos* 14 (1960), pp. 3–34.

Menéndez Pidal 1974
Luis Menéndez Pidal. "Santa María de Bendones: Reconstrucción, Oviedo 1974; Adición al libro de Santa María de Bendones." *Boletín del Instituto de Estudios Asturianos* 28 (1974), pp. 861–62.

Menéndez Pidal 1980a
Ramón Menéndez Pidal. *España visigoda, 414–711 de J.C.* Historia de España, 3. Madrid, 1980.

Menéndez Pidal 1980b
José Menéndez Pidal. "La Basílica de Santianes de Pravia." In *Actas del simposio para el estudio de los códices del "Comentario al Apocalipsis" de Beato de Liébana (Madrid, 1976).* Vol. 2, pp. 279–97; vol. 3, pp. 169–75. Madrid, 1980.

Menéndez Pidal 1991
Ramón Menéndez Pidal. *Historia de España.* Vol. 2: *España visigoda.* Madrid, 1991.

Mentré 1986
Mireille Mentré. "L'Enlumineur et son travail selon les manuscrits hispaniques du haut Moyen Âge." In *Artistes, artisans, et production artistique au Moyen Âge,* edited by X. Barral i Altet, vol. 1, pp. 295–309. Paris, 1986.

Mesplé 1961
Paul Mesplé. *Toulouse, Musée des Augustins: Les Sculptures romanes.* Inventaire des collections publiques françaises, 5. Paris, 1961.

Mesplé 1963
Paul Mesplé. "Chapiteaux de la Passion aux Musées de Toulouse et de Pampelune." *Revue des arts* 13 (1963), pp. 255–62.

Metz 1932
Peter Metz. "Das Kunstgewerbe von der Karolingerzeit bis zum Beginn der Gotik." In *Geschichte des Kunstgewerbes aller Zeiten und Völker,* edited by H. T. Bossert, vol. 5, pp. 197–336. Berlin, 1932.

Miguel 1970
Pilar de Miguel. *La Biblia en los códices de España.* Madrid, 1970.

Miguel Vigil 1887
Ciriaco Miguel Vigil. *Asturias monumental, epigráfica y diplomática: Datos para la historia de la provincia.* 2 vols. Oviedo, 1887. Reprint, 1987.

Miguel Vigil 1980
Ciriaco Miguel Vigil. *La Iglesia de San Martín de Salas.* Consejo Regional de Asturias, Consejería de Cultura y Deportes. Reprint, Oviedo, 1980.

Milhau 1971
Denis Milhau. *Les Grandes Étapes de la sculpture romane toulousaine: Des monuments aux collections.* Toulouse, 1971.

Millar 1930
Eric G. Millar. *The Library of A. Chester Beatty.* Vol. 2, 1930.

Millares 1931
Agustín Millares Carlo. "A propósito del Códex Hispalensis de la Biblia." In *Contribución al "corpus" de códices visigóticos,* pp. 97–130. Madrid, 1931.

Molinero 1971
Antonio Molinero Pérez. "Aportaciones de las excavaciones y hallazgos casuales (1941–1959) al Museo Arqueológico de Segovia." *Excavaciones Arqueológicas en España* 72 (1971).

Molinier 1891
Émile Molinier. *L'Émaillerie.* Paris, 1891.

Mora 1991
Bernadette Mora. "*Signum Leonis, Signum Arietis*: Signes Zodiacaux? À propos du bas-relief toulousain de 'deux vierges.'" *Annales du Midi* 103, no. 196 (1991), pp. 483–89.

Moralejo 1969
Serafín Moralejo Álvarez. "Primitiva Fachada norte de la Catedral de Santiago." *Compostellum* 15 (1969), pp. 623–68.

Moralejo 1973a
Serafín Moralejo Álvarez. "Une Sculpture du style de Bernard Gilduin à Jaca." *Bulletin Monumental* 131 (1973), pp. 7–16.

Moralejo 1973b
Serafín Moralejo Álvarez. "Esculturas compostelanas del último tercio del siglo XII." *Cuadernos de estudios gallegos* 28 (1973), pp. 294–310.

Moralejo 1976
Serafín Moralejo Álvarez. "Sobre la formación del estilo escultórico de Frómista y Jaca." In *XXIII Congreso Internacional de Historia de Arte, Granada 1973*, vol. 1, pp. 427–34. Granada, 1976.

Moralejo 1977
Serafín Moralejo Álvarez. "Saint Jacques de Compostelle: Les Portails retrouvés de la cathédrale romane." *Dossiers d'archéologie* 20 (1977), pp. 87–103.

Moralejo 1979
Serafín Moralejo Álvarez. "La Sculpture romane de la cathédrale de Jaca: État des questions." *Les Cahiers de Saint-Michel-de-Cuxa* 10 (1979), pp. 85–87.

Moralejo 1980
Serafín Moralejo Álvarez. "'Ars Sacra' et sculpture romane monumentale: Le Trésor et le chantier de Compostelle." *Les Cahiers de Saint-Michel-de-Cuxa* 11 (1980), pp. 189–238.

Moralejo 1981
Serafín Moralejo Álvarez. "La Rencontre de Salomon et de la Reine de Saba: De la Bible de Roda aux portails gothiques." *Les Cahiers de Saint-Michel-de-Cuxa* 12 (1981), pp. 79–109.

Moralejo 1982
Serafín Moralejo Álvarez. "Les Arts somptuaires hispaniques aux environs de 1100." *Les Cahiers de Saint-Michel-de-Cuxa* 13 (1982), pp. 285–310.

Moralejo 1984
Serafín Moralejo Álvarez. "Reutilización e influencia de los sarcófagos antiguos en la España medieval." In *Colloquio sul reimpiego dei sarcófagi romani del medioevo (Pisa, 5–12 settembre 1982)*, edited by B. Andrea and S. Settis, pp. 187–203. Marburg, 1984.

Moralejo 1985a
Serafín Moralejo Álvarez. "The Tomb of Alfonso Ansúrez (+1093): Its Place and the Role of Sahagún in the Beginnings of Spanish Romanesque Sculpture." In *Santiago, Saint-Denis, and Saint Peter: The Reception of the Roman Liturgy in León–Castille in 1080*, edited by Bernard Reilly, pp. 63–100. New York, 1985.

Moralejo 1985b
Serafín Moralejo Álvarez. "Imagen arquitectónica de la catedral de Santiago de Compostela." In *Il Pellegrinaggio a Santiago de Compostela e la letteratura jacopea* (Atti del Convegno internazionale di studi, Perugia, 23–25 settembre 1983), pp. 35–59. Perugia, 1985.

Moralejo 1985c
Serafín Moralejo Álvarez. "Artistas, patronos, y público en el arte del Camino de Santiago." *Compostellanum* 30 (1985), pp. 395–430.

Moralejo 1985d
Serafín Moralejo Álvarez. "Artes figurativas y artes literárias en la España medieval: románico, romance, y *roman*." *Boletín de la Asociación Europea de Profesores de Español* 32–33 (1985), pp. 61–70.

Moralejo 1986
Serafín Moralejo Álvarez. "San Martín de Frómista en los orígines de la escultura románica europea." In *Jornadas sobre el románico en la provincia de Palencia* (August 5–10, 1985), pp. 27–37. Palencia, 1986.

Moralejo 1987
Serafín Moralejo Álvarez. "El Patronazgo artístico del arzobispo Gemírez (1100–1140): Su Reflejo en la obra e imagen de Santiago." In *Atti del Convegno internazionale di studi, Pistoia e il Cammino di Santiago (Pistoia 1984)*, pp. 268–69. Perugia, 1987.

Moralejo 1988a
Serafín Moralejo Álvarez. "De Sant Esteve de Tolosa a la Daurade: Notes sobre l'escultura del claustre romànic de Santa María de Solsona." *Quaderns d'estudis medievals* 7 (1988), pp. 104–19.

Moralejo 1988b
Serafín Moralejo Álvarez. "*Da Marie Tympanum* de Pedro Abelardo, al claustro de Silos." In *Actas del I Congreso de la Asociación Hispánica de Literatura Medieval (Santiago de Compostela, 1985)*, pp. 453–56. Santiago de Compostela, 1988.

Moralejo 1989a
Serafín Moralejo Álvarez. "Origini del programma iconografico dei portali nel romanico spagnolo." In *Wiligelmo e Lanfranco nell'Europa romanica*, pp. 35–51. Modena, 1989.

Moralejo 1989b
Serafín Moralejo Álvarez. "Placa de marfil del arca de San Felices." *Boletín del Museo Arqueológico Nacional* 7 (1989), pp. 97–99.

Moralejo 1990a
Serafín Moralejo Álvarez. "Claustro de Silos y el arte de los caminos de peregrinación." In *El románico en Silos: IX centenario de la consegración de la iglesia y claustro, 1088–1988*, pp. 203–15. Abadía de Silos, 1990.

Moralejo 1990b
Serafín Moralejo Álvarez. "Cluny et les débuts de la sculpture romane en Espagne." In *Le Gouvernement d'Hugues de Semur à Cluny* (Actes du Colloque scientifique international, 1988), pp. 405–34. Cluny, 1990.

Moralejo 1990c
Serafín Moralejo Álvarez. "Cluny y los origines del románico palentino: El Contexto de San Martín de Frómista." In *Jornadas sobre el arte de las órdenes religiosas*, pp. 9–27. Palencia, 1990.

Moralejo 1990d
Serafín Moralejo Álvarez. "Raimundo de Borgoña (+1107) o Fernando Alfonso (+1214): Un Episodio olvidado en la historia del panteón real compostelano." In *Galicia en la Edad Media*, pp. 161–74. Santiago de Compostela, 1990.

Moralejo 1992a
Serafín Moralejo Álvarez. "The Codex Calixtinus as an Art-Historical Source." In *The Codex Calixtinus and the Shrine of St. James*, edited by John Williams and Alison Stones, pp. 207–30. Tübingen, 1992.

Moralejo 1992b
Serafín Moralejo Álvarez. "El Mundo y el tiempo en el mapa del Beato de Osma." In *Apocalipsis Beati Liebaensis. Burgi Oxomensis*. Vol. 2: *El Beato de Osma, Estudios*, pp. 151–79. Valencia, 1992.

Moralejo, Torres, and Feo 1951
Serafín Moralejo Álvarez, C. Torres, and J. Feo. *Liber Sancti Jacobi: Codex Calistinus*. Santiago de Compostela, 1951.

Morales 1765
Ambrosio de Morales. *Viage de Ambrosio de Morales por orden del rey D. Phelipe II*. Madrid, 1765.

Morgan 1982
Nigel Morgan. *Early Gothic Manuscripts: I. 1190–1250. A Survey of Manuscripts Illuminated in the British Isles*, 4. London, 1982.

Mortimer 1985
Kristin A. Mortimer with contributions by William G. Klingelhofer. *Harvard University Art Museums: A Guide to the Collections*. Cambridge, Mass., and New York, 1985.

Müller-Wiener 1977
Wolfgang Müller-Wiener. *Bildlexikon zur Topographie Istanbuls*. Tübingen, 1977.

Mundó 1976
A. M. Mundó. "Las Biblias románicas de Ripoll." In *Actas del XXIII Congreso de Historia del Arte*, vol. 1. Granada, 1976.

Munteau 1977
Voichita Munteau. "A Romanesque Copy of the Anastasis: The Chapel of St. Jean of Le Liget." *Gesta* 16 (1977), pp. 27–40.

Museu Solsona 1990
Joaquim Calderer i Serra, ed. *Museu Diocesà i Comarcal de Solsona: Catàleg d'art romànic i gòtic*. Barcelona, 1990.

Mütherich 1955
Florentine Mütherich. "An Illustration of the Five Senses in Medieval Art." *Journal of the Warburg and Courtauld Institutes* 18 (1955), pp. 140–41.

Mütherich and Gaehde 1976
Florentine Mütherich and Joachim E. Gaehde. *Carolingian Painting*. New York, 1976.

Naval 1991
A. Naval Mas. "Evangeliario de Jaca, en Nueva York." *Diario del Altoaragón* (Cuadernos Altoaragonese) (1991), p. 5.

Navarro 1939
Rafael Navarro García. *Catálogo monumental de Palencia*. Vol. 3. Palencia, 1939.

Nees 1987
Lawrence Nees. *The Gundohinus Gospels*. Cambridge, Mass., 1987.

Neuss 1912
Wilhelm Neuss. *Das Buch Ezechiel in Theologie und Kunst bis um Ende des XII. Jahrhunderts*. (Beiträge zur Geschichte des alten Mönchtums und des Benediktinerordens, 1–2). Münster, 1912.

Neuss 1922
Wilhelm Neuss. *Die katalanische Bibelillustration um die Wende des ersten Jahrtausends und die altspanische Buchmalerei*. Bonn and Leipzig, 1922.

Neuss 1931
Wilhelm Neuss. *Die Apokalypse des hl. Johannes in der altspanischen und altchristlichen Bibel-Illustration*. 3 vols. Münster, 1931.

New York 1913
The Rita Lydig Collection. Sale cat., The American Art Association. Introduction by Wilhelm R. Valentiner and Durr Friedley. New York, 1913.

New York 1954
The Metropolitan Museum of Art. *Spanish Medieval Art: Loan Exhibition in Honor of Walter W. W. Cook*. New York, 1954.

New York 1968–69
The Metropolitan Museum of Art, The Cloisters. *Medieval Art from Private Collections: A Special Exhibition at The Cloisters*. New York, 1968–69.

New York 1982
Jane Hayward and Walter Cahn. *Radiance and Reflection: Medieval Art from the Raymond Pitcairn Collection*. Exh. cat., The Metropolitan Museum of Art, The Cloisters. New York, 1982.

New York 1984
The Metropolitan Museum of Art. *Treasury of San Marco, Venice*. Exh. cat. New York, 1984.

New York 1985
The New York Public Library. *Tesoros de España: Ten Centuries of Spanish Books*. New York, 1985.

New York 1987
Michael Ward Gallery. *Masterpieces of Medieval Art*. New York, 1987.

New York 1990
Dietrich von Bothmer, ed. *Glories of the Past: Ancient Art from the Shelby White and Leon Levy Collection*. Exh. cat., The Metropolitan Museum of Art. New York, 1990.

New York 1991
Ariadne Galleries. *Treasures of the Dark Ages in Europe*. New York, 1991.

New York 1992a
Jerrilynn D. Dodds, ed. *Al-Andalus: The Art of Islamic Spain*. Exh. cat., The Metropolitan Museum of Art. New York, 1992.

New York 1992b
Vivian B. Mann, Thomas G. Glick, and Jerrilynn D. Dodds, eds. *Convivencia: Jews, Muslims, and Christians in Medieval Spain*. Exh. cat., The Jewish Museum. New York, 1992.

Nieto 1966
Victor Nieto Alcaide. "El Arco románica de las reliquias de San Eugenio." *Art et archéologie* 39 (1966), pp. 167–77.

Nieto 1989a
Victor Nieto Alcaide. *Arte prerrománico asturiano*. Salinas, 1989.

Nieto 1989b
Victor Nieto Alcaide. "La Imagen de la arquitectura asturiana de los siglos VIII y IX en las crónicas de Alfonso III." *Espacio, Tiempo, y Forma* 2 (1989), pp. 11–34.

Noack 1977
Detlef M. Noack. "Parallelen zur figuralen Dekoration von San Miguel de Lillo (Liño) am Monte Naranco bei Oviedo." In *Kaleidoskop: Eine Festschrift für Fritz Baumgart zum 75. Geburtstag*, pp. 10–23. Berlin, 1977.

Noack 1986a
Sabine Noack. "Un Capitel visigodo en Marrakech." In *Actas del Iº Congreso de Arqueología Medieval Española (Huesca, 1985)*, vol. 2, pp. 153–64. Saragossa, 1986.

Noack 1986b
Sabine Noack. "Westgotenzeitliche Kapitelle im Duero-Gebiet und in Asturien." *Madrider Mitteilungen* 27 (1986), pp. 389–409.

Noack 1987
Sabine Noack. "En torno al 'arte mozárabe.'" In *Congreso de arqueología medieval española* (Madrid, Jan. 19–24, 1987), vol. 3, pp. 581–88. Madrid, 1987.

Noack-Haley 1991
Sabine Noack-Haley. *Mozarabischer Baudekor*. Vol. 1: *Die Kapitelle*. Mainz, 1991.

Noack-Haley 1992
Sabine Noack-Haley. "Tradición e innovación en la decoración plástica de los edificios reales asturianos." In *IIIº Congreso de arqueología medieval española (Oviedo 1989)*, vol. 2, pp. 174–84. Oviedo, 1992.

Noack-Haley and Arbeiter, in press
Sabine Noack-Haley and Achim Arbeiter. *Asturische Königsbauten des 9. Jahrhunderts: San Miguel de Liño, Belvedere am Naranco, Santa Cristina de Lena, San Salvador de Valdediós*. Aufnahmen und Untersuchungen des Deutschen Archäologischen Instituts, Madrid. 2 vols. (in press).

Noguier 1556
Antoine Noguier. *Histoire tolosaine*. Toulouse, 1556.

Nordenfalk 1980
Carl Nordenfalk. "Review of A. Melnikas, *The Corpus of the Miniatures in the Manuscripts of the Decretum Gratiani*." *Zeitschrift für Kunstgeschichte* 43 (1980), pp. 318–37.

Nordenfalk 1985
Carl Nordenfalk. "The Five Senses in Late Medieval and Renaissance Art." *Journal of the Warburg and Courtauld Institutes* 48 (1985), pp. 1–22.

Nordström 1955–57
Carl-Otto Nordström. "Some Jewish Legends in Byzantine Art." *Byzantion* 25–27 (1955–57), pp. 487–508.

Nordström 1965
Carl-Otto Nordström. "Rabbinic Features in Byzantine and Catalan Art." *Cahiers archéologiques* 15 (1965), pp. 179–205.

Nuñez 1978
Manuel Nuñez Rodríguez. *Arquitectura prerrománica*. Madrid, 1978.

Nuñez 1991
Manuel Nuñez Rodríguez. *San Salvador de Valdediós, o la fábrica sencilla de una arquitectura admirabile*. Oviedo, 1991.

Nuremberg 1987
Wilfried Menghin, ed. *Germanen, Hunnen, und Avaren*. Exh. cat., Germanisches Nationalmuseum. Nuremberg, 1987.

Al-Nuwayri 1917–19
Al-Nuwayri. *Historia de los musulmánes de España y Africa*. Edited and translated by M. Gaspar Remiro. Granada, 1917–19.

Oakeshott 1972
Walter Oakeshott. *Sigena: Romanesque Paintings in Spain and the Artists of the Winchester Bible*. London, 1972.

O'Callaghan 1975
Joseph F. O'Callaghan. *A History of Medieval Spain*. Ithaca and London, 1975.

Oklahoma City 1985
Songs of Glory: Medieval Art from 900 to 1500. Oklahoma City, 1985.

Olávarri and Arias 1987
Emilio Olávarri and Lorenzo Arias Páramo. "La Proporción áurea en arte asturiano: Santa María del Naranco." *Revista de arqueología* 8, no. 73 (1987), pp. 44–57.

Oliván 1969
Francisco Oliván Baile. *Los Monasterios de San Juan de la Peña y Santa Cruz de los Serós*. Saragossa, 1969.

Ostoia 1972
Vera K. Ostoia. "More about Solomon and Sheba." *Metropolitan Museum Journal* 6 (1972), pp. 92–96.

Otero 1965
Ramón Otero Nuñez. "Problemas de la catedral románica de Santiago." *Compostellanum* 10 (1965), pp. 961–80.

Pächt 1961
Otto Pächt. "A Cycle of English Paintings in Spain." *The Burlington Magazine* 103 (1961), pp. 166–75.

Palma de Mallorca 1991
El tresor d'època almohade. Exh. cat. Palma de Mallorca, 1991.

Palol 1950a
Pedro de Palol Salellas. *Bronces hispanovisigodos de origen mediterráneo*. Vol. 1: *Jarritos y patenas liturgicos*. Barcelona, 1950.

Palol 1950b
Pedro de Palol Salellas. "Fibulas y broches de cinturón de la época visigoda en Cataluña." *Archivo español de arqueología* 23 (1950), pp. 73–98.

Palol 1952
Pedro de Palol Salellas. "Algunas piezas de adorno de arnés de época tardo-romana y hispano-visigoda." *Archivo español de arqueología* 25 (1952), pp. 297–319.

Palol 1953
Pedro de Palol Salellas. *Tarraco hispano-visigoda*. Tarragona, 1953.

Palol 1953–54
Pedro de Palol Salellas. "Bronces de arnés con representaciones zoomorficas." *Ampurias* 15–16 (1953–54), pp. 279–92.

Palol 1956a
Pedro de Palol Salellas. "Une Broderie catalane d'époque romane: La Genèse de Gérone." *Cahiers archéologiques* 8 (1956), pp. 205–14.

Palol 1956b
Pedro de Palol Salellas. "Esencia del arte hispánico de época visigoda: Romanismo y germanismo." In *Settimane di studio sull'Alto Medioevo*, pp. 3–64. Spoleto, 1956.

Palol 1961–62
Pedro de Palol Salellas. "Los Bronces liturgicos y sus perduraciones." In *Homenaje al Profesor Cayetano de Mergelina*, pp. 699–710. Murcia, 1961–62.

Palol 1967a
Pedro de Palol Salellas. *Arqueología cristiana de la España romana: Siglos IV–VI*. España cristiana, serie monográfica: monumentos, 1. Madrid and Valladolid, 1967.

Palol 1967b
Pedro de Palol Salellas. *Early Medieval Art in Spain*. London, 1967.

Palol 1968a
Pedro de Palol Salellas. *Hispanic Art of the Visigothic Period*. New York, 1968.

Palol 1968b
Pedro de Palol Salellas. *Arte paleocristiano en España*. Barcelona, 1968. English edition, New York, 1969.

Palol 1969
Pedro de Palol Salellas. "Demography and Archaeology in Roman Christian and Visigothic Hispania." *Classical Folia* 23 (1969), pp. 32–114.

Palol 1972
Pedro de Palol Salellas. "Los Monuments de Hispania en la arqueología paleocristiana." In *Actas del Congreso Internacional de Arqueología Cristiana (Barcelona, 1969)*, pp. 167–85. Barcelona and Vatican City, 1972.

Palol 1986
Pedro de Palol Salellas. *El Tapis de la creacio de la catedral de Girona*. Barcelona, 1986.

Palol 1990
Pedro de Palol Salellas. "Bronces cristianos de época romana y visigoda en España." In *Los Bronces romanos en España*. Exh. cat., Ministerio de Cultura, pp. 137–52. Madrid, 1990.

Palol and Hirmer 1965
Pedro de Palol Salellas and Max Hirmer. *Spanien: Kunst des frühen Mittelalters*. Munich, 1965.

Palol and Hirmer 1967
Pedro de Palol Salellas and Max Hirmer. *Early Medieval Art in Spain*. New York, 1967.

Palol and Ripoll 1988
Pedro de Palol Salellas and Gisela Ripoll. *Los Godos en el occidente europeo: Ostrogodos y Visigodos en los siglos V–VIII*. Madrid, 1988.

Palol and Ripoll 1990
Pedro de Palol Salellas and Gisela Ripoll. *Les Goths: Ostrogoths et Wisigoths en Occident Vᵉ–VIIIᵉ siècle*. Madrid, 1990.

Palustre and Molinier 1890
Léon Palustre and Émile Molinier. *La Collection Spitzer*. Vol. 1: *L'Orfèvrerie religieuse*. Paris and London, 1890.

Panofsky 1962
Erwin Panofsky. *Studies in Iconology: Humanistic Themes in the Art of the Renaissance*. New York, 1962.

Panofsky 1964
Erwin Panofsky. *Tomb Sculpture*. New York, 1964.

Panofsky and Saxl 1933
Erwin Panofsky and Fritz Saxl. "Classical Mythology in Medieval Art." *Metropolitan Museum Studies* 4, pt. 2 (1933), pp. 228–80.

Paris 1900
Catalogue officiel illustré de l'exposition rétrospective de l'art français dès origines à 1800. Paris, 1900.

Paris 1908
Galerie Georges Petit. *Catalogue des objects d'art de haute curiosité composant la collection de feu M. O. Hombert*. Sale cat. Paris, 1908.

Paris 1982
Bibliothèque Nationale. *Manuscrits enluminés de la peninsule ibérique*. Exh. cat. Paris, 1982.

Paris 1988
Musée du Luxembourg. *Trésors sacrés, trésors cachés: Patrimoine des églises de Seine-et-Marne.* Exh. cat. Paris, 1988.

Paris 1990
Musée du Petit Palais. *De l'empire romain aux villes impériales: 6,000 ans d'art au Maroc.* Exh. cat. Paris, 1990.

Paris 1992
Les Vikings: Les Scandinaves et l'Europe, 800–1200. Paris, 1992.

Park 1965
Marlene Park. "The Crucifix of Fernando I and Sancha." Ph.D. diss., Columbia University. Ann Arbor, 1965.

Park 1973
Marlene Park. "The Crucifix of Fernando and Sancha in Its Relationship to North French Manuscripts." *Journal of the Warburg and Courtauld Institutes* 36 (1973), pp. 77–91.

Partearroyo 1991
Cristina Partearroyo Lacaba. *La Seda en España: Leyenda, poder, y realidad.* Exh. cat., Museo Textil de Tarrasa. Tarrasa, 1991.

Patrologia latina
J.-P. Migne, ed. *Patrologia cursus completus: Series latina.* 221 vols. Paris, 1844–64.

Pavón 1973
Basilio Pavón Maldonado. *Arte toledano: Islámico y mudejar.* Madrid, 1973.

Pavón 1981
Basilio Pavón Maldonado. *El Arte hispano-musulmán en su decoración floral.* Madrid, 1981.

Peirce and Tyler 1932–34
Hayford Peirce and Royall Tyler. *L'Art byzantin.* 2 vols. Paris, 1932–34.

Peña 1978
J. Peña. *Los Marfiles de San Millán de la Cogolla.* Logroño, 1978.

Pérez Carmona 1975
José Pérez Carmona. *Arquitectura y escultura románicas en la provincia de Burgos.* Burgos, 1975.

Pérez Llamazares 1923
Julio Pérez Llamazares. *Catálogo de los códices y documentos de la Real Colegiata de San Isidoro de León.* León, 1923.

Pérez Llamazares 1925
Julio Pérez Llamazares. *El Tesoro de la R. Colegiata de San Isidoro: Reliquias, relicarios, y joyas artísticas.* León, 1925.

Pérez Pastor 1908
C. Pérez Pastor. *Índices de los códices de San Millán de la Cogolla y San Pedro de Cardeña, existentes en la Biblioteca de la Real Academia de la Historia.* Madrid, 1908.

Pérez de Urbel 1940
Justo Pérez de Urbel. *San Isidoro de Sevilla.* Barcelona, 1940.

Pérez de Urbel and González 1959
Justo Pérez de Urbel and Atilano González Ruíz-Zorrilla, eds. *Historia Silense.* Madrid, 1959.

Perin 1991
Patrick Perin, ed. *Actes des VIIᵉ journées internationales d'archéologie mérovingienne, Toulouse 1985: Gallo-romains, wisigoths, et francs en Aquitaine, Septimanie, et Espagne.* Rouen, 1991.

Perrier 1982
Danielle Perrier. "Das Verhältnis von Monumentalskulptur zur spanischen Kleinkunst des 11. Jahrhunderts." In *Romanico padano, romanico europeo,* pp. 193–202. Parma, 1982.

Perrier 1984
Danielle Perrier. "Die spanische Kleinkunst des 11. Jahrhunderts: Zur Klärung ihrer stilistischen Zusammenhänge im Hinblick auf die Frage ihrer Beziehungen zur Monumentalskulptur." *Aachener Kunstblätter* 52 (1984), pp. 30–150.

Petrassi 1982
Mario Petrassi. *Gli Smalti in Italia.* Rome, 1982.

Petrucci 1976
Armando Petrucci. "Aspetti simbolici delle testimonianze scritte." In *Simboli e simbologia nell'alto medioevo* (Settimane di Studi del Centro italiano di studi sull'alto medioevo, 23, 1975), pp. 813–44. Spoleto, 1976.

Petrusi Pucci 1985–86
Francesca Petrusi Pucci. "I Crocifissi tunicati de Force e di Amandola nell'ascolano." *Rivista dell'Istituto Nazionale d'Archeologia e Storia dell'Arte* 8–9 (1985–86), pp. 365–98.

Pijoán 1911–12
Josep Pijoán. "Les Miniatures de l'Octateuch a les Biblies romàniques catalanes." *Anuari de l'Institut d'Estudis Catalans* 4 (1911–12), pp. 475–508.

Pijoán 1924
Josep Pijoán. "De com es varen descobrir i publicar les pintures murals catalanes." *Gaseta de les Arts* 1, no. 11 (1924), pp. 5–6.

Pijoán 1942
José Pijoán. *Arte bárbaro y prerrománico desde el siglo IV hasta el año 1000.* Summa Artis, 14. Madrid, 1942.

Pijoán 1944
José Pijoán. *El Arte románico.* Summa Artis, 9. Madrid, 1944.

Pijoán 1966
José Pijoán. *El Arte románico.* 5th ed. Madrid, 1966.

Pita 1952
José Manuel Pita Andrade. "Un Capítulo para el estudio de la formación artística del maestro Mateo: La Huella de Saint-Denis." *Cuadernos de estudios gallegos* 7 (1952), pp. 371–83.

Pita 1953
José Manuel Pita Andrade. "El Arte de Mateo en las tierras de Zamora y Salamanca." *Cuadernos de estudios gallegos* 8 (1953).

Pita 1955
José Manuel Pita Andrade. *Los Maestros de Oviedo y Ávila.* Madrid, 1955.

Pita 1963
José Manuel Pita Andrade. *Arte asturiano.* Madrid, 1963.

Pita and Palol 1972
R. Pita and Pedro de Palol Salellas. "La Basilica de Bobala y su mobiliario liturgico." In *Actas del VIIIᵒ Congreso Internacional de Arqueología Cristiana, Barcelona 1969,* pp. 383–401. Barcelona and Vatican City, 1972.

Ponsich 1977
Pierre Ponsich. "L'Évolution du portail d'église en Roussillon du IXᵉ au XIVᵉ siècle." *Les Cahiers de Saint-Michel-de-Cuxa* 8 (1977), pp. 175–99.

Ponsich 1980
Pierre Ponsich. "Les Plus Anciennes Sculptures médiévales du Roussillon (Vᵉ–XIᵉ siècles)." *Les Cahiers de Saint-Michel-de-Cuxa* 11 (1980), pp. 293–331.

Ponsich 1984
Pierre Ponsich. "Les Derniers Cloîtres romans du Roussillon." *Les Cahiers de Saint-Michel-de-Cuxa* 15 (1984), pp. 5–23.

Ponsich 1985–87
Pierre Ponsich. "Le Problème des tribunes de Cuxa et de Serrabona, I, II." *Les Cahiers de Saint-Michel-de-Cuxa* 16 (1985), pp. 9–24, and 18 (1987), pp. 265–72.

Ponsich 1991
Pierre Ponsich. "Les Crucifix romans du Roussillon de Cerdagne et de Capcir: Dernières Découvertes." *Les Cahiers de Saint-Michel-de-Cuxa* 22 (1991), pp. 159–77.

Pope 1938
Arthur Upham Pope, ed. *A Survey of Persian Art from Prehistoric Times to the Present.* 6 vols. Oxford, 1938.

Porcher 1960
Jean Porcher. *French Miniatures from Illuminated Manuscripts.* London, 1960.

Porcher 1965
Jean Porcher. "La Peinture provinciale." In *Karl der Grosse: Lebenswerk und Nachleben,* edited by W. Braunfels. Vol. 3, pp. 54–73. Düsseldorf, 1965.

Porter 1923
Arthur Kingsley Porter. *Romanesque Sculpture of the Pilgrimage Roads.* 10 vols. Boston, 1923.

Porter 1924
Arthur Kingsley Porter. "The Tomb of Doña Sancha and the Romanesque Art of Aragón." *Burlington Magazine* 45 (1924), pp. 165–79.

Porter 1926
Arthur Kingsley Porter. "La tumba de Doña Sancha en el arte románico en Aragón." *Boletín de la Real Academia de la Historia* 89 (1926), pp. 119–33.

Porter 1926a
Arthur Kingsley Porter. "Leonesque Romanesque and Southern France." *The Art Bulletin* 8 (1926), pp. 235–50.

Porter 1927a
Arthur Kingsley Porter. "The Alabanza Capitals." *Fogg Museum Notes* 2 (1927), pp. 91–96.

Porter 1927b
Arthur Kingsley Porter. "Santiago Again." *Art in America* 15 (1927), pp. 96–113.

Porter 1928
Arthur Kingsley Porter. *Spanish Romanesque Sculpture.* 2 vols. Florence and Paris, 1928.

Porter 1931
Arthur Kingsley Porter. "The Tahul Virgin." *Fogg Art Museum Notes* 2, no. 6 (1931), pp. 246–72.

Porter 1932
Arthur Kingsley Porter. "La Verge de Tahull." *Butlletí dels Museus d'Art de Barcelona* 2 (1932), pp. 120–36.

Post 1930
C. R. Post. *A History of Spanish Painting.* Vol. 1. Cambridge, 1930.

Prelog 1980
Jan Prelog. *Die Chronik Alfons III: Untersuchung und kritische Edition der vier Redaktionen.* Frankfurt/Bern/Cirencester, 1980.

Pressouyre 1969
Léon Pressouyre. "Une Nouvelle Oeuvre du 'Maître de Cabestany' en Toscane: Le Pilier sculpté de San Giovanni in Sugana." *Bulletin de la Société nationale des antiquaires de France* (1969), pp. 30–55.

Prieto Bances 1956
Ramón Prieto Bances. *El Mensaje de la Cruz de los Ángeles.* Oviedo, 1956.

Prieto y Vives 1926
Antonio Prieto y Vives. *Los Reyes de Taifas: Estudio histórico-numismático de los musulmánes españoles en el siglo V de la Hégira (XI de J.C.).* Madrid, 1926.

Prochno 1929
J. Prochno. *Das Schreiber-und-Dedikationsbild in der deutschen Buchmalerei.* Leipzig, 1929.

Providence 1969
Stephen K. Scher, ed. *The Renaissance of the Twelfth Century.* Exh. cat., Rhode Island School of Design. Providence, 1969.

Puertas 1975
Rafael Puertas Tricas. *Iglesias hispánicas (siglos IV al VIII): Testimonios literarios.* Madrid, 1975.

Puig 1909–18
Josep Puig i Cadafalch. *L'Arquitectura romànica a Catalunya*. 3 vols. Barcelona, 1909–18.

Puig 1928
Josep Puig i Cadafalch. *Le Premier Art roman: L'Architecture en Catalogne et dans l'occident méditerranéen aux X^e et XI^e siècles*. Paris, 1928.

Puig 1933
José Puig y Cadafalch. "Un Relleu románic de Vic emignat a Londres." *Butlletí dels Museus d'Art de Barcelona* 3 (1933), pp. 330–34.

Puig 1935
Josep Puig i Cadafalch. *La Géographie et les origines du premier art roman*. Paris, 1935.

Puyol 1926
Julio Puyol Alonso, ed. *Crónica de España, por Lucas, obispo de Túy*. Madrid, 1926.

Qaddumi 1990
Ghada Hijjawi Qaddumi. "A Medieval Islamic Book of Gifts and Treasures: Translation, Annotation, and Commentary on the Kitab al-Hadaya wa al-Tuhaf." Ph.D. diss., Harvard University, 1990.

Quadrado 1855
José María Quadrado. *Recuerdos y bellezas de España: Asturias y León*. Madrid, 1855. Reprint, Salinas, 1977.

Quentin 1922
Henri Quentin. *Mémoire sur l'établissement du texte de la Vulgate*. Collectanea Biblica Latina, vol. 6. Rome, 1922.

Raizman 1980
David Raizman. "The Later Morgan Beatus (M. 429) and Late Romanesque Illumination in Spain." Ph.D. diss., University of Pittsburgh, 1980.

Raizman 1987
David Raizman. "A Rediscovered Illuminated Manuscript of St. Ildefonsus's *De Virginitate Beatae Mariae* in the Biblioteca Nacional in Madrid." *Gesta* 26, no. 1 (1987), pp. 37–45.

Redondo 1974–77
Feliciano Redondo Cadenas. "La Iglesia de San Tirso el Real de Oviedo." *Boletín del Instituto de Estudios Asturianos* 28 (1974), pp. 171–83; 30 (1976), pp. 607–26; and 31 (1977), pp. 343–62.

Reguerras 1990
Fernando Reguerras. *La Arquitectura mozárabe en León y Castilla*. Valladolid, 1990.

Reilly 1985
Bernard F. Reilly. "The Chancery of Alfonso VI." In *Santiago, St. Denis, and St. Peter*, edited by B. Reilly, pp. 1–40. New York, 1985.

Reilly 1988
Bernard F. Reilly. *The Kingdom of León-Castilla under King Alfonso VI (1065–1109)*. Princeton, 1988.

Reilly 1992
Bernard F. Reilly. *The Contest of Christian and Muslim Spain, 1031–1157*. Cambridge, Mass., and Oxford, 1992.

Revuelta 1979
Matilde Revuelta Tubino. *Museo Taller del Moro, Toledo*. 2d ed. Toledo, 1979.

Ripoll 1985
Gisela Ripoll. "La Necrópolis visigoda de El Carpio de Tajo (Toledo)." *Excavaciones Arqueológicas en España* 142 (1985).

Ripoll 1986a
Gisela Ripoll López. "Archéologie des Wisigoths." *Dossiers Histoire et archéologie* 108 (1986), pp. 54–67.

Ripoll 1986b
Gisela Ripoll López. "Bronces romanos, visigodos, y medievales en el M.A.N." *Boletín del Museo Arqueológico Nacional* 4 (1986), pp. 55–82.

Ripoll 1987
Gisela Ripoll López. "Reflexiones sobre arqueología funeraria, artesanos, y producción artística de la Hispania visigoda." In *XXXIV° Corso di Cultura sull'arte Ravennate e Bizantine, Ravenna 1987: Seminario Internazionale di Studi su "Archeologia e Arte nella Spagna tardoromana, visigota, e mozarabica,"* pp. 343–73. Ravenna, 1987.

Ripoll 1991a
Gisela Ripoll López. *La Ocupación visigoda en época romana a través de sus necrópolis (Hispania)*. Collecció de Tesis Microfixtadas, no. 912. Servei de Publicacions de l'Universitat de Barcelona. Barcelona, 1991.

Ripoll 1991b
Gisela Ripoll López. "Materiales funerarios de la Hispania visigoda: Problemas de cronología." In *Gallo-Romains, Wisigoths, et Francs en Aquitaine, Septimanie, et Espagne* (Actes des VII^e Journées internationales d'Archéologie mérovingienne, Toulouse 1985), edited by Patrick Perin, pp. 111–31. Rouen, 1991.

Risco 1792
Manuel Risco. *Historia de la ciudad y corte de León y de sus reyes*. 2 vols. Madrid, 1792.

Rivère 1978
Gérard Rivère. "Le Cloître de la Collégiale de Saint-Gaudens." *Revue des Comminges, Pyrénées centrales* 91 (1978), pp. 161–79, 329–40, 459–77.

Rivère 1979
Gérard Rivère. "Le Cloître de la Collégiale de Saint-Gaudens." *Revue des Comminges, Pyrénées centrales* 92 (1979), pp. 165–74.

Robb 1945
David M. Robb. "The Capitals of the Panteón de los Reyes, San Isidoro de León." *The Art Bulletin* 37 (1945), pp. 165–74.

Rodríguez Alonso 1975
Cristóbal Rodríguez Alonso, ed. and trans. *Las Historias de los godos, vándalos, y suevos de Isidoro de Sevilla*. León, 1975.

Rodríguez Balbín 1977
Herminia Rodríguez Balbín. *De un monte despoblado a un fuero real, 700 a 1145: Estudio sobre los primeros siglos del desarrollo urbano de Oviedo*. Oviedo, 1977.

Rohault de Fleury 1883–89
Charles Rohault de Fleury. *La Messe—Études archéologiques sur ses monuments*. Paris, 1883–89.

Rojo 1931
Timoteo Rojo Orcajo. "El 'Beato' de la catedral de Osma." *Art Studies* 8 (1931), pp. 103–56.

Rollán Ortiz 1983
Jaime-Federico Rollán Ortiz. *Iglesias mozárabes leonesas*. 2d ed. Madrid, 1976.

Roosen-Runge 1967
Heinz Roosen-Runge. *Farbgebung und Technik frühmittelalterlicher Buchmalerei*. 2 vols. Munich and Berlin, 1967.

Rorimer 1935
James J. Rorimer. "A Twelfth-Century Crucifix." *The Bulletin of the Metropolitan Museum of Art* 30 (1935), pp. 236–39.

Rorimer 1938
James J. Rorimer. *The Cloisters*. New York, 1938.

Rorimer 1963
James J. Rorimer. *The Cloisters: The Building and the Collection of Medieval Art in Fort Tryon Park*. 3d edition. New York, 1963.

Ross 1939
Marvin Chauncey Ross. "An Enameled Reliquary from Champagnat." In *Medieval Studies in Memory of A. Kingsley Porter*, edited by Wilhelm R. W. Koehler, pp. 467–77. Harvard-Radcliffe Fine Art Series. Cambridge, Mass., 1939.

Ross 1961
Marvin Chauncey Ross. *Arts of the Migration Period in The Walters Art Gallery*. Baltimore, 1961.

Roth 1979
H. Roth. *Kunst der Völkerwanderungzeit, Propylaen Kunstgeschichte*. Suppl. vol. 4. Frankfurt, 1979.

Rotili 1978
M. Rotili. *La Miniatura nella Badia di Cava*. 2 vols. Cava dei Tirreni, 1978.

Roulin 1899
Eugène Roulin. "Une plaque émaillée d'un coffret de Burgos." *Bulletin de la Société scientifique, historique, et archéologique de la Corrèze* 21 (1899), pp. 252–55.

Rubinstein-Bloch 1926
Stella Rubinstein-Bloch. *Catalogue of the Collection of George and Florence Blumenthal*. Vol. 3: *Works of Art: Medieval and Renaissance*. Paris, 1926.

Rueda 1991
Mercedes Rueda. *Primeras acuñaciones de Castilla y León*. Monografías de arqueología medieval, 1. Salamanca, 1991.

Ruiz 1978
Margarita Ruiz Maldonado. "La Contraposición 'superbia-humilitas': El Sepulcro de Doña Sancha y otras obras." *Goya* (1978), pp. 75–81.

Rupin 1890
Ernest Rupin. *L'Oeuvre de Limoges*. Paris and Brive, 1890.

Safadi 1978
Yasin Hamid Safadi. *Islamic Calligraphy*. Boulder, Colo., 1978.

Saint-Paul 1897
Anthyme Saint-Paul. "Addition au mémoire sur Saint-Sernin." In *Album des monuments et de l'art ancien du Midi de la France*, vol. 1. Toulouse, 1897.

Salas 1935
Xavier de Salas. "La Carta sobre recientes descubrimientos en Santa María de Naranco de Parcerisa a Quadrado." *Anuario del Cuerop Facultativo de Archiveros, Bibliotecarios, y Arqueólogos* 3 (1935), pp. 119–28.

Salcedo 1987
Fabiola Salcedo Garcés. "Los Entalles romanos de la Cruz de los Ángeles." *Boletín del Instituto de Estudios Asturianos* 41 (1987), pp. 73–101.

Salin 1935
Bernhard Salin. *Die Altgermanische Thierornamentik*. Stockholm, 1935. 1st ed., 1904.

Salrach 1987
Josep M. Salrach. *El Procés de feudalització (segles III–XII)*. Història de Catalunya, edited by Pierre Vilar, vol. 2. Barcelona, 1987.

Salvador-Daniel 1915
Francisco Salvador-Daniel. *The Music and Musical Instruments of the Arab: With an Introduction on How to Appreciate Arab Music*. New York, 1915. Reprint, Portland, Maine, 1976.

Salvini 1956
Roberto Salvini. *Wiligelmo e le origini della scultura romanica*. Milan, 1956.

Samaran 1955
Charles Samaran. "La Stèle récemment découverte à Nogaro." *Bulletin de la Société Archéologique, Historique, Littéraire, et Scientifique du Gers, Auch* (1955), pp. 253–60.

Sánchez-Albornoz 1972–75
Claudio Sánchez-Albornoz. *Orígenes de la nación española: Estudios críticos sobre la historia del reino de Asturias*. 3 vols. Oviedo, 1972–75.

Sánchez-Albornoz 1986
Claudio Sánchez-Albornoz. *La España musulmána, según los autores islamitas y cristianos medievales*. 2 vols. 7th ed. Madrid, 1986.

Sancti Beati a Liébana 1962
Sancti Beati a Liébana in Apocalipsin Codex Gerundensis, Prolegomena. Olten–Lausanne, 1962.

Sandoval 1601
Prudencio de Sandoval [Bp. of Pamplona]. *Primera Parte de las fundaciones de los monasterios del glorioso Padre San Benito.* Madrid, 1601.

Sandoval 1634
Prudencio de Sandoval [Bp. of Pamplona]. *Historia de los reyes de Castilla y de León, Don Fernando el Magno, primero deste nombre, Infante de Navarra, Don Sancho....* Pamplona, 1634.

Santiago de Compostela 1988
El Pórtico de la Gloria e o seu tempo. Santiago de Compostela, 1988.

Santiago de Compostela 1990
San Martiño Pinario. *Galicia no tempo.* Santiago de Compostela, 1990.

Santos 1951
Samuel de los Santos Jener. *Guía del Museo Arqueológico Provincial de Córdoba.* Madrid, 1951.

Sarthou 1947
Carlos Sarthou Carreras. *El Museo Municipal de Játiva.* 1947. Reprint, Valencia 1987.

Saxl 1938–39
Fritz Saxl. "The Literary Sources of the 'Finiguerra Planets.'" *Journal of the Warburg Institute* 2 (1938–39), pp. 72–74.

Saxl 1957
Fritz Saxl. "The Revival of Late Antique Astrology." In *Lectures,* vol. 1, pp. 73–84; vol. 2, pls. 43–48. London, 1957.

Scerrato 1966
Umberto Scerrato. *Metalli islamici.* Milan, 1966.

Schälicke 1975
Bernd Schälicke. "Die Ikonographie der monumentalen Kreuzabnahmegruppen des Mittelalters in Spanien." Ph.D. diss., Berlin University, 1975.

Schapiro 1939
Meyer Schapiro. "From Mozarabic to Romanesque at Silos." *The Art Bulletin* 21 (1939), pp. 312–74. Reprinted in *Romanesque Art. Selected Papers,* pp. 28–101. New York, 1977.

Schiller 1972
Gertrude Schiller. *Iconography of Christian Art.* Translated by Janet Seligman. 2 vols. London, 1972.

Schlink 1978
Wilhelm Schlink. *Saint-Bénigne in Dijon: Untersuchungen zur Abteilkirche Wilhelms von Volpiano (962–1031).* Berlin, 1978.

Schlunk 1936
Helmut Schlunk. "Die Ornamentik in Spanien zur Zeit der Herrschaft der Westgoten." Ph.D. diss., Friedrich-Wilhelms-Universität. Berlin, 1936.

Schlunk 1944
Helmut Schlunk. "El Arte decorativo visigodo." *Boletín bibliográfico* 12 (1944), pp. 14–34.

Schlunk 1945a
Helmut Schlunk. "Esculturas visigodas de Segóbriga (Cabeza de Griego)." *Archivo español de arqueología* 18 (1945), pp. 305–19.

Schlunk 1945b
Helmut Schlunk. "Observaciones en torno al problema de la miniatura visigoda." *Archivo español de arte* 17 (1945), pp. 241–65.

Schlunk 1945c
Helmut Schlunk. "Relaciones entre la península ibérica y Bizancio durante la época visigoda." *Archivo español de arqueología* 18 (1945), pp. 177–204.

Schlunk 1947a
Helmut Schlunk. "Arte visigodo." In *Ars Hispaniae: Historia universal del arte hispánico,* vol. 2, pp. 225–323. Madrid, 1947.

Schlunk 1947b
Helmut Schlunk. "Arte asturiano." In *Ars Hispaniae: Historia universal del arte hispánico,* vol. 2, pp. 325–416. Madrid, 1947.

Schlunk 1948
Helmut Schlunk. "La Decoración de los monumentos ramirenses." *Boletín del Instituto de Estudios Asturianos* 2, no. 5 (1948), pp. 55–94.

Schlunk 1949
Helmut Schlunk. "La Iglesia de San Julián de los Prados (Oviedo) y la arquitectura de Alfonso el Casto." In *Estudios sobre la monarquía asturiana: Colección de trabajos realizados con motivo del XI centenario de Alfonso II el Casto, celebrado en 1942,* pp. 417–97. Oviedo, 1949. 2d ed., 1971, pp. 405–65.

Schlunk 1950
Helmut Schlunk. "The Crosses of Oviedo: A Contribution to the History of Jewelry in Northern Spain in the Ninth and Tenth Centuries." *The Art Bulletin* 32 (1950), pp. 91–114.

Schlunk 1962
Helmut Schlunk. "Die Sarkophage von Écija und Alcaudete." *Madrider Mitteilungen* 3 (1962), pp. 119–51.

Schlunk 1964
Helmut Schlunk. "Byzantinische Bauplastik aus Spanien." *Madrider Mitteilungen* 5 (1964), pp. 234–54.

Schlunk 1965
Helmut Schlunk. "Die Auseinandersetzung der christlichen und der islamischen Kunst auf dem Gebiete der iberischen Halbinsel bis zum Jahre 1000." In *L'Occidente e l'Islam nell'Alto Medioevo,* vol. 2, pp. 903–31, 969–73. Spoleto, 1965.

Schlunk 1968
Helmut Schlunk. "Ein Sarkophag aus Dume im Museum zu Braga (Portugal)." *Madrider Mitteilungen* 9 (1968), pp. 424–58.

Schlunk 1970a
Helmut Schlunk. "Beiträge zur Kunstgeschichtlichen Stellung Toledos im 7. Jahrhundert." *Madrider Mitteilungen* 11 (1970), pp. 161–86.

Schlunk 1970b
Helmut Schlunk. "Estudios iconográficos en la iglesia de San Pedro de la Nave." *Archivo español de arte* 43 (1970), pp. 245–68.

Schlunk 1970c
Helmut Schlunk. "Die frühchristlichen Denkmäler aus dem Nord-Westen der iberischen Halbinsel." In *Legio VII Gemina,* pp. 475–509. León, 1970.

Schlunk 1971
Helmut Schlunk. "Die Kirche von S. Gião bei Nazaré (Portugal): Ein Beitrag zur Bedeutung der Liturgie für die Gestaltung des Kirchengebäudes." *Madrider Mitteilungen* 12 (1971), pp. 205–40.

Schlunk 1972
Helmut Schlunk. "Sarcófagos paleocristianos labrados en Hispania." In *Actas del VIIIº Congreso Internacional de Arqueología Cristiana, Barcelona, 1969,* pp. 187–218. Barcelona, 1972.

Schlunk 1974
Helmut Schlunk. "Entwicklungsläufe der Skulptur auf der iberischen Halbinsel vom 8. bis 11. Jahrhundert." In *Kolloquium über spätantike und frühmittelalterliche Skulptur: Vortragstexte 1972,* vol. 3, pp. 121–38. Mainz, 1974.

Schlunk 1977
Helmut Schlunk. "Las Iglesias palatinas de la capital del reino asturiano." *Discurso del Dr. Helmut Schlunk en el acto de su investidura como Doctor Honoris Causa por la Universidad de Oviedo (14 de abril de 1977).* Oviedo, 1977.

Schlunk 1980a
Helmut Schlunk. "El Arte asturiano en torno al 800." In *Actas del simposio para el estudio de los códices del "Comentario al Apocalipsis" de Beato de Liébana (Madrid, 1976),* vol. 2, pp. 135–64, and vol. 4, pp. 87–120. Madrid, 1980.

Schlunk 1980b
Helmut Schlunk. "Asturianische Kunst." In *Lexikon des Mittelalters,* vol. 1. Munich and Zurich, 1980.

Schlunk 1980c
Helmut Schlunk. "Spanien." In *Spätantike und frühes Christentum,* edited by Beat Brenk. Propyläen Kunstgeschichte, Supplementband, 1., pp. 272–88. Frankfurt/Berlin/Vienna, 1980.

Schlunk 1985
Helmut Schlunk. *Las Cruces de Oviedo: El Culto de la Vera Cruz en el reino asturiano.* Oviedo, 1985.

Schlunk and Berenguer 1957
Helmut Schlunk and Magín Berenguer. *La Pintura mural asturiana de los siglos IX y X.* Translated by María de los Angeles Vázquez de Parga. Madrid, 1957. Reprint, Oviedo, 1991.

Schlunk and Hauschild 1978
Helmut Schlunk and Theodor Hauschild. *Hispania Antiqua: Die Denkmäler der frühchristlichen und westgotischen Zeit.* Mainz, 1978.

Schmiddunser 1990
Agathe Schmiddunser. *Die Wandmalereien von St. Quirze de Pedret.* Schriften aus dem Institut für Kunstgeschichte der Universität München, 50. Munich, 1990.

Scott 1964
David W. Scott. "A Restoration of the West Portal Relief of Saint-Sernin, Toulouse." *Art Bulletin* 46 (1964), pp. 271–82.

Sears 1986
Elizabeth Sears. *The Ages of Man.* Princeton, 1986.

Seidel 1973
Linda Seidel. "Romanesque Sculpture in American Collections: The Fogg Art Museum, III." *Gesta* 12 (1973), pp. 133–50.

Seidel 1981
Linda Seidel. *Songs of Glory: The Romanesque Facades of Aquitaine.* Chicago and London, 1981.

Selgas 1902
Fortunato de Selgas. "La Primitiva Basílica de Santianes de Pravia (Oviedo) y su panteón regio." *Boletín de la sociedad española de excursiones* 10 (1902), pp. 5–14, 28–34, 52–57.

Selgas 1908
Fortunato de Selgas. *Monumentos ovetenses del siglo IX.* Madrid, 1908.

Selgas 1909
Fortunato de Selgas. "Las Iglesias de Naranco." *Boletín de la sociedad española de excursiones* 17 (1909), pp. 17–40.

Selgas 1916
Fortunato de Selgas. *La basílica de San Julián de los Prados (Santullano) en Oviedo: Estudio de las restauraciones efectuadas en 1912-1915.* Madrid, 1916. Reprint, Oviedo, 1990.

Sepúlveda 1989
María de los Angeles Sepúlveda González. "El Programa iconográfico de las cajas de Astorga y de las Agatas." In *Cuadernos de arte y iconografía: Actas del primer coloquio de iconografía (26–28 mayo 1988)* 1 (1989), pp. 148–58.

Serjeant 1972
R. B. Serjeant. *Islamic Textiles: Materials for a History up to the Mongol Conquest.* Beirut, 1972.

Serrano 1926
Luciano Serrano. *El Real Monasterio de Santo Domingo de Silos (Burgos): Su Historia y tesoro artístico.* Burgos, 1926.

Serrano Fatigati 1901
Enrique Serrano Fatigati. "Esculturas de los siglos IX a XIII." *Boletín de la Sociedad española de excursiones* 9–10 (1901), pp. 35–45.

Seville 1992
Juan Carlos Eleorza Guinea. *Tesoros de Castilla y León: De la prehistoria a los Reyes Católicos.* Exh. cat., Seville, 1992. Madrid, 1992.

Shailor 1992
Barbara A. Shailor. "The Beatus of Burgo de Osma: A Paleographical and Codicological Study." In *Apocalipsis Beati Liebanensis. Burgi Oxomensis.* Vol. 2: *El Beato de Osma, Estudios*, pp. 29–52. Valencia, 1992.

Shepherd 1957
Dorothy G. Shepherd. "A Dated Hispano-Islamic Silk." *Ars Orientalis* 2 (1957), pp. 373–82.

Shepherd 1958
Dorothy G. Shepherd. "Two Medieval Silks from Spain." *The Bulletin of the Cleveland Museum of Art* 45 (1958), pp. 3–7.

Shepherd 1978
Dorothy G. Shepherd. "A Treasure from a Thirteenth-Century Spanish Tomb." *The Bulletin of the Cleveland Museum of Art* 65 (1978), pp. 111–34.

Sherman 1981
Randi E. Sherman. "Observations on the Genesis Iconography of the Ripoll Bible." *Rutgers Art Review* 2 (1981), pp. 1–12.

Sicart 1981
Angel Sicart. *Pintura medieval: La Miniatura.* Santiago de Compostela, 1981.

Silos 1973
Monasterio de Silos. *Silos y su época.* Barcelona, 1973.

Silva 1984
Soledad de Silva y Verástegui. *Iconografía del siglo X en el reino de Pamplona-Nájera.* Pamplona, 1984.

Silva 1985
Soledad de Silva y Verástegui. "El Papel de la Rioja en los orígenes hispánicos del retrato del artista." In *Segundo Coloquio sobre Historia de la Rioja, Logroño, 2–4 oct. 1985*, vol. 3, pp. 27–38. Logroño, 1987.

Silva 1988
Soledad de Silva y Verástegui. "Iconografía del donante en el arte navarro medieval." *Príncipe de Viana* 49 (1988), pp. 445–56.

Simon 1975
David L. Simon. "Roland, the Moor, the Pilgrim, and Spanish Romanesque Sculpture." *Acta* 2 (1975), pp. 104–18.

Simon 1979a
David L. Simon. "Le Sarcophage de Doña Sancha à Jaca." *Les Cahiers de Saint-Michel-de-Cuxa* 10 (1979), pp. 107–24.

Simon 1979b
David L. Simon. "Still More by the Cabestany Master." *The Burlington Magazine* 121 (1979), pp. 108–11.

Simon 1979c
Sonia C. Simon. "Le Christ victorieux: Iconographie d'un chapiteau de Jaca." *Les Cahiers de Saint-Michel-de-Cuxa* 10 (1979), pp. 125–29.

Simon 1980a
David L. Simon. "L'Art roman, source de l'art roman." *Les Cahiers de Saint-Michel-de-Cuxa* 11 (1980), pp. 249–67.

Simon 1980b
Sonia C. Simon. "David et ses musiciennes: Iconographie d'un chapiteau de Jaca." *Les Cahiers de Saint-Michel-de-Cuxa* 11 (1980), pp. 239–48.

Simon 1981a
David L. Simon. "Ateliers roman et style roman." *Les Cahiers de Saint-Michel-de-Cuxa* 12 (1981), pp. 159–60.

Simon 1981b
Sonia C. Simon. "Un Chapiteau du cloître de la cathédrale de Jaca, représentent la psychomachie." *Les Cahiers de Saint-Michel-de-Cuxa* 12 (1981), pp. 151–57.

Simon 1984
David L. Simon. "Romanesque Art in American Collections XXI, The Metropolitan Museum of Art: Part I, Spain." *Gesta* 23 (1984), pp. 145–59.

Simonet 1903
Francisco Javier Simonet. *Historia de los mozárabes de España.* Madrid, 1903.

Sommerard 1883
E. du Sommerard. *Catalogue et description des objets d'art, Musée des Thermes et de l'Hôtel de Cluny.* Paris, 1883.

Sourdel-Thomine and Spuler 1973
Janine Sourdel-Thomine and Bertold Spuler. *Die Kunst des Islam.* With contributions by Klaus Brisch et al. Propyläen Kunstgeschichte, 4. Berlin, 1973.

Soustiel 1985
Jean Soustiel. *La Céramique islamique.* Paris and Fribourg, 1985.

Southern 1962
Richard W. Southern. *Western Views of Islam in the Middle Ages.* Cambridge, Mass., 1962.

Steenbock 1965
F. Steenbock. *Die kirchliche Prachteinband im frühen Mittelalter.* Berlin, 1965.

Stern 1953
Henri Stern. *Le Calendrier de 354: Étude sur son texte et ses illustrations.* Paris, 1953.

Stiennon 1958
J. Stiennon. "Le Voyage de Liégeois à Saint-Jacques de Compostelle en 1506." In *Mélanges Félix Rousseau: Études sur l'histoire du Pays Mosan au Moyen Âge*, pp. 553–81. Brussels, 1958.

Stokstad 1970
Marilyn Stokstad. "Three Apostles from Vich." *The Nelson Gallery and Atkins Museum Bulletin* 4, no. 11 (1970), pp. 2–24.

Stokstad 1977
Marilyn Stokstad. "Romanesque Sculpture in American Collections XV: Kansas City, Missouri, and Lawrence, Kansas." *Gesta* 16 (1977), pp. 49–61.

Stokstad 1978
Marilyn Stokstad. *Santiago de Compostela in the Age of the Great Pilgrimage.* Norman, Okla., 1978.

Stones 1991
A. Stones. "Arthurian Art since Loomis." In *Arturus rex, II, Acta Conventul Lovaniensis 1987*, pp. 32–34. Louvain, 1991.

Storch 1986
José Jacobo Storch de Gracia y Asensio. "Las Artes decorativas visigodas en Toledo." Master's thesis [Tesis de Licenciatura], Universidad Complutense de Madrid, 1983. Madrid, 1986.

Stothart 1975
Herbert Stothart. "Studies Relating to the Influence of Lombard Artists in Catalan Spain During the Eleventh Century." In *Il Romanico: Atti del Seminario di Studi, Villa Monastero di Varenna 1973*, edited by Piero Sanpaolesi, pp. 212–24. Milan, 1975.

Stratford 1992
Neil Stratford. "'Compostela and Burgundy?' Thoughts on the Western Crypt of the Cathedral of Santiago." In *Actas del Simposio Internacional sobre "O Portico da la Gloria e a Arte do seu Tempo"* (Santiago de Compostela, 3–8 octubre, 1988), pp. 53–68. La Coruña, 1992.

Stroheker 1965
Karl Stroheker. *Germanentum und Spätantike.* Zurich and Stuttgart, 1965.

Sureda 1981
Joan Sureda. *La Pintura románica en Cataluña.* Madrid, 1981.

Sureda 1985
Joan Sureda. *La Pintura románica en España.* Madrid, 1985.

Svoboda 1983
R. Svoboda. "The Illustrations of the Life of St. Omer (St. Omer, Bibliothèque Municipale, MS. 698)." Ph.D. diss., University of Minnesota, 1983.

Swarzenski 1954
Hanns Swarzenski. *Monuments of Romanesque Art: The Art of Church Treasures in Northwestern Europe.* Chicago, 1954.

Teillet 1984
Suzanne Teillet. *Dès Goths à la nation gothique: Les Origines de l'idée de nation en Occident du Ve au VIIe siècle.* Paris, 1984.

Thirion 1977
Jacques Thirion. "Le Décor sculpté du cloître de la cathédrale d'Avignon." *Académie des inscriptions et belles-lettres* 61 (1977), pp. 84–164.

Toledo 1975
Museo Palacio de Fuensalida. *Arte mozárabe.* Toledo, 1975.

Torre and Longás 1935
Martín de la Torre and P. Longás. *Catálogo de los códices latinos de la Biblioteca Nacional de Madrid.* Vol. 1: *Biblicos.* Madrid, 1935.

Torres 1934
Leopoldo Torres Balbás. "Arte de la alta edad media y del periodo románico en España." In *Arte de la alta edad media*, edited by M. Hauttmann, translated by J. Rovira y Ermengol. Barcelona/Madrid/Buenos Aires, 1934.

Torres 1936
Leopoldo Torres Balbás. "Los Modillones de lóbulos: Ensayo de análisis de la evolución de una forma arquitectónica a través de dieciseis siglos." *Archivo español de arte y arqueología* 12 (1936), pp. 1–63, 113–50.

Torres 1957
Leopoldo Torres Balbás. "Arte hispano-musulmán." In *Historia de España*, dir. R. Menéndez Pidal, vol. 5. Madrid, 1957.

Toubert 1969
Hélène Toubert. "Une Fresque de San Pedro de Sorpe (Catalogne) et le thème iconographique de *l'arbor bona–ecclesia, arbor mala–synagoga*." *Cahiers archéologiques* 19 (1969), pp. 167–89.

Trens 1923
Manuel Trens. *Las "Majestades" catalanas y su filiación iconográfica.* Barcelona, 1923.

Trens 1966
Manuel Trens. *Les Majestats catalanes.* Monumenta Cataloniae, 13. Barcelona, 1966.

Tucoo-Chala 1976
P. Tucoo-Chala. *Lacommande.* Juracon, 1976.

Tyler 1941
W. R. Tyler. "A Spanish Romanesque Column in the Fogg Art Museum." *The Art Bulletin* 23 (1941), pp. 45–52.

Ubieto 1950
Antonio Ubieto Arteta. "La Fecha de la construcción del claustro románico de la Catedral de Pamplona." *Príncipe de Viana* 11 (1950), pp. 77–83.

Ubieto 1951
Antonio Ubieto Arteta. *Colección diplomático de Pedro I de Aragón y Navarra.* Saragossa, 1951.

Ubieto 1976
Antonio Ubieto Arteta. *Cartulario de San Millán de la Cogolla (759–1076).* Valencia, 1976.

Ubieto 1987
Antonio Ubieto Arteta, ed. *Crónicas anónimas de Sahagún.* Saragossa, 1987.

Ulbert 1971
Thilo Ulbert. "Skulptur in Spanien (6.–8. Jahrhundert)." In *Kolloquium über spätantike und frühmittelalterliche Skulptur, II: Vortragstexte, Heidelberg, 1970,* pp. 25–34. Mainz, 1971.

Ulbert 1978
Thilo Ulbert. *Frühchristliche Basiliken mit Doppelapsiden auf der iberischen Halbinsel.* Berlin, 1978.

Uranga and Iñiguez 1971–73
José Esteban Uranga Galdiano and Francisco Iñiguez Almech. *Arte medieval navarro.* 5 vols. Pamplona, 1973.

Uría 1967
Juan Uría Ríu. "Cuestiones histórico-arqueológicas relativas a la ciudad de Oviedo de los siglos VIII al X." In *Symposium sobre Cultura Asturiana de la Alta Edad Media (Oviedo, 1961),* pp. 261–328. Oviedo, 1967.

Valdeavellano 1963
Luis G. de Valdeavellano. "Las Instituciones feudales en España." In *El Feudalismo,* edited by F. L. Ganshof, pp. 227–305. Barcelona, 1963.

Valdez del Alamo 1979
Elizabeth Valdez del Alamo Moore. "A New Interpretation of the Signs Relief from Saint-Sernin in Toulouse." Unpublished talk, Fourteenth International Congress of Medieval Studies, May 3–6, 1979, Western Michigan University, Kalamazoo.

Valdez del Alamo 1986
Elizabeth Valdez del Alamo. "Nova et Vetera in Santo Domingo de Silos: The Second Cloister Campaign." Ph.D. diss., Columbia University. New York, 1986.

Valencia de Don Juan 1898
Conde Viudo de Valencia de Don Juan. *Catálogo histórico-descriptivo de la Real Armería de Madrid.* Madrid, 1898.

Valero 1987
Clara Delgado Valero. *Materiales para el estudio morfológico y ornamental del arte Islamico en Toledo.* Toledo, 1987.

Valladolid 1988
Cathedral of Valladolid. *Edades de Hombre.* Exh. cat. Salamanca, 1988.

Vázquez de Parga 1941
Luis Vázquez de Parga. "La Historia de Job en un capitel románico de la Catedral de Pamplona." *Archivo español de arte y arqueología* 14 (1941), pp. 410–11.

Vázquez de Parga 1943
Luis Vázquez de Parga. *Sancti Braulionis Caesaraugustani Episcopi Vita S. Emiliani.* Madrid, 1943.

Vázquez de Parga 1947
Luis Vázquez de Parga. "Los Capiteles historiados del claustro románico de la Catedral de Pamplona." *Príncipe de Viana* 8 (1947), pp. 3–11.

Vázquez de Parga 1958
Luis Vázquez de Parga. "Joyas visigodas." *Memorias de los Museos Arqueológicos Provinciales* 15 (1958).

Vázquez de Parga 1967
Luis Vázquez de Parga. "Studien zu Reccopolis 3: Die archäologischen Funde." *Madrider Mitteilungen* 8 (1967), pp. 259–80.

Vázquez de Parga 1978
Luis Vázquez de Parga. "Beato y el ambiente cultural de su época." In *Actas del Simposio para el Estudio de los Códices del "Comentario al Apocalipsis" de Beato de Liébana (Madrid, 1976),* vol. 1, pp. 33–45. Madrid, 1978.

Vázquez de Parga, Lacarra, and Uría 1948–49
Luis Vázquez de Parga, J. M. Lacarra, and J. Uría Ríu. *Las Peregrinaciones a Santiago de Compostela.* 3 vols. Madrid, 1948–49. Reprint, 1981.

Velado 1991
Bernardo Velado Graña. *La Catedral de Astorga y su Museo.* Astorga, 1991.

Verzar 1983
C. Verzar Bornstein. *Romanico mediopadano: Strada, Città, Ecclesia.* Parma, 1983.

Vicens 1972
J. Vicens Vives, ed. *Historia social y económica de España y América.* 5 vols. 2d rev. ed. Barcelona, 1972.

Vieillard-Troiekouroff 1968
Vieillard-Troiekouroff. "Les Bibles de Theodulphe et la bible wisigothique de La Cava di tirreni." In *Synthronon* (Bibliothèque des Cahiers Archéologiques, 2), pp. 153–66. Paris, 1968.

Vila-Grau 1993
J. Vila-Grau. "L'Incert Origen del vitrall de Worcester." *Butlletí del Museu Nacional d'Art de Catalunya* 2 (1993) (in print).

Villanueva 1803–52
Jaime Villanueva. *Viaje literario a las iglesias de España.* 22 vols. Madrid, 1803–52.

Viñayo 1967
Antonio Viñayo. "La Real Colegiata de San Isidoro y la expansión del arte prerrománico asturiano." In *Symposium sobre Cultura Asturiana de la Alta Edad Media (Oviedo, 1961),* pp. 105–17. Oviedo, 1967.

Viñayo 1971a
Antonio Viñayo González. *La Colegiata de San Isidoro, León.* León, 1971.

Viñayo 1971b
Antonio Viñayo González. *Pintura románica: Panteón real de San Isidoro, León.* León, 1971.

Viñayo 1972
Antonio Viñayo González. *L'Ancien royaume de León roman.* La Pierre-Qui-Vire, 1972.

Viñayo 1982
Antonio Viñayo González. "Reinas e infantas de León, abadesas y monjas del monasterio de San Pelayo y San Isidoro." In *Semana de historia del monacato Cántabro–Astur–Leonés,* pp. 123–35. Oviedo, 1982.

Vives 1963
José Vives, ed. *Concilios visigóticos e hispano-romanos.* Barcelona and Madrid, 1963.

Vives and Fábrega 1949
José Vives and A. Fábrega. "Calendarios hispánicos anteriores al siglo XII." *Hispania Sacra* 2 (1949), pp. 119–46.

Vöge 1900
Wilhelm Vöge. *Die Elfenbeinbildwerke.* Beschreibung der Bildwerke der christlichen Epochen, 1. 2d ed. Berlin, 1900.

Vogüé 1971
A. de Vogüé. *La Règle de Saint Benoît.* Vol. 4: *Commentaire historique et critique.* Paris, 1971.

Volbach 1923
Wolfgang F. Volbach. *Die Elfenbeinbildwerke.* Die Bildwerke des Deutschen Museen zu Berlin, 1. Berlin and Leipzig, 1923.

Volbach 1958
Wolfgang F. Volbach. *Frühchristliche Kunst.* Munich, 1958.

Wagner-Rieger 1971
Renate Wagner-Rieger. "Premier Art roman." *Aachener Kunstblätter* 41 (1971), pp. 27–36.

Ward 1992
Michael Ward. "El Pórtico de la Gloria y la conclusión de la catedral de Santiago de Compostela." In *Actas del Simposio Internacional sobre "O Portico da Gloria e a Arte do seu Tempo" (Santiago de Compostela, 3–8 de octubre, 1988),* pp. 43–47. La Coruña, 1992.

Watson 1989
Katherine Watson. *French Romanesque and Islam: Andalusian Elements in French Architectural Decoration, c. 1030–1180.* BAR series. 2 vols. Oxford, 1989.

Weisbach 1945
Werner Weisbach. *Religiöse Reform und mittelalterliche Kunst.* Zurich, 1945.

Weise 1927
Georg Weise. *Spanische Plastik aus sieben Jahrhunderten.* 4 vols. Reutlingen, 1927.

Weitzmann 1972
Kurt Weitzmann. *Catalogue of the Byzantine and Early Medieval Antiquities in the Dumbarton Oaks Collection.* Vol. 3: *Ivories and Steatites.* Washington, D.C., 1972.

Weitzmann 1979
Kurt Weitzmann. *Age of Spirituality: Late Antique and Early Christian Art, Third to Seventh Century.* Exh. cat., The Metropolitan Museum of Art. New York, 1979.

Werckmeister 1963a
Otto Karl Werckmeister. "Die Bilder der drei Propheten in der *Biblia Hispalense.*" *Madrider Mitteilungen* 4 (1963), pp. 141–88.

Werckmeister 1963b
Otto Karl Werckmeister. "Three Problems of Tradition in Pre-Carolingian Figure Style." *Proceedings of the Royal Irish Academy,* section C, 63, no. 5 (1963), pp. 167–89.

Werckmeister 1965
Otto Karl Werckmeister. "Islamische Formen in spanischen Miniaturen des 10. Jahrhunderts und das Problem der mozarabischen Buchmalerei." *Settimane di Studi del Centro Italiano di Studi sull'Alto Medioevo, XII,* pp. 933–67. Spoleto, 1965.

Werckmeister 1968
Otto Karl Werckmeister. "Das Bild zur Liste der Bistümer Spaniens im *Codex Aemilianensis.*" *Madrider Mitteilungen* 9 (1968), pp. 399–423.

Werckmeister 1979
Otto Karl Werckmeister. "Review of *Romanesque Art (Selected Papers, I),* by Meyer Schapiro." *The Art Quarterly,* n.s., 2, no. 2 (1979), pp. 211–18.

Werckmeister 1980
Otto Karl Werckmeister. "The First Romanesque Beatus Manuscripts and the Liturgy of Death." In *Actas del simposio para el estudio de los codices del "Comentario al Apocalipsis de Beato de Liébana,"* vol. 1, pp. 167–92. Madrid, 1980.

Wesenberg 1972
Rudolf Wesenberg. *Frühe mittelalterliche Bildwerke: Die Schulen rheinischer Skulptur und ihre Ausstrahlung.* Düsseldorf, 1972.

Wettstein 1971
Janine Wettstein. *La Fresque romane: Italie, France, Espagne.* Geneva, 1971.

Whitaker 1990
M. Whitaker. *The Legends of King Arthur in Art.* Woodbridge, 1990.

Whitehill 1941
Walter M. Whitehill. *Spanish Romanesque Architecture of the Eleventh Century.* London, 1941.

Wilckens 1991
Leonie von Wilckens. *Die textilen Künste: Von der Spätantike bis um 1500.* Munich, 1991.

Williams 1965
John Williams. "A Castilian Tradition of Bible Illustration." *Journal of the Warburg and Courtauld Institutes* 28 (1965), pp. 66–85.

Williams 1967
John Williams. "A Model for the León Bibles." *Madrider Mitteilungen* 8 (1967), pp. 281–86.

Williams 1970
John Williams. "A Contribution to the History of the Castilian Monastery of Valeránica and the Scribe Florentius." *Madrider Mitteilungen* 11 (1970), pp. 231–48.

Williams 1972–74
John Williams. "The 'Moralia in Iob' of 945: Some Iconographic Sources." *Archivo español de arqueología* 45–47 (1972–74), pp. 223–35.

Williams 1973
John Williams. "San Isidoro in León: Evidence for a New History." *Art Bulletin* 55 (1973), pp. 171–84.

Williams 1974
John Williams. "*Marcialis Pincerna* and the Provincial in Spanish Medieval Art." In *Hortus Imaginum: Essays in Western Art*, edited by Robert Enggass and Marilyn Stokstad, pp. 31–36. University of Kansas Publications, Humanistic Studies, 45. Lawrence, 1974.

Williams 1977a
John Williams. *Early Spanish Manuscript Illumination.* New York, 1977.

Williams 1977b
John Williams. "Generationes Abrahae: Reconquest Iconography in León." *Gesta* 16, no. 2 (1977), pp. 3–15.

Williams 1980
John Williams. "The Beatus Commentaries and Spanish Bible Illustration." In *Actas del simposio para el estudio de los códices del "Comentario al Apocalipsis" de Beato de Liébana*, vol. 1, pp. 212–27. Madrid, 1980.

Williams 1984
John Williams. "Arquitectura del Camino de Santiago." *Compostellanum* 29 (1984), pp. 267–90.

Williams 1987
John Williams. "Tours and the Early Medieval Art in Spain." In *Florilegium in Honorem Carl Nordenfalk Octogenarium Contextum*, pp. 197–208. Stockholm, 1987.

Williams 1988
John Williams. "Cluny and Spain." *Gesta* 27 (1988), pp. 93–101.

Williams 1992a
John Williams. "Purpose and Imagery in the Apocalypse Commentary of Beatus of Liébana." In *The Apocalypse in the Middle Ages*, edited by Richard K. Emmerson and Bernard McGinn, pp. 217–33. Ithaca and London, 1992.

Williams 1992b
John Williams. "Imaginería apocalíptica en el románico tardío español." In *Actas del Simposio Internacional sobre "O Portico da la Gloria e a Arte do seu Tempo" (Santiago de Compostela, 3–8 de octubre, 1988)*, pp. 371–82. La Coruña, 1992.

Williams 1992c
John Williams. "Introduction." In *Apocalipsis Beati Liebanensis. Burgi Oxomensis.* Vol. 2: *El Beato de Osma, Estudios*, pp. 9–28. Valencia, 1992.

Williams 1993
John Williams. *The Illustrated Beatus: A Corpus of the Illustrations in the Commentary on the Apocalypse.* 5 vols. London, 1993 (forthcoming).

Williams, forthcoming.
John Williams. "León." In *Dictionary of Art.* London (forthcoming).

Williams and Shailor 1991
John Williams and Barbara Shailor. *A Spanish Apocalypse: The Morgan Beatus Manuscript.* New York, 1991.

Williams et al. 1992
John Williams, Barbara Shailor, E. Romero Pose, and Serafín Moralejo Álvarez. *Apocalipsis Beati Liebanensis Burgi Oxomensis* (Facsimile and Commentary Volume). Valencia, 1992.

Williamson 1983
Paul Williamson. *Catalogue of Romanesque Sculpture* [Victoria and Albert Museum]. London, 1983.

Williamson 1986
Paul Williamson, ed. *The Medieval Treasury: The Art of the Middle Ages in the Victoria and Albert Museum.* London, 1986.

Wixom 1967
William D. Wixom. *Treasures from Medieval France.* Exh. cat., The Cleveland Museum of Art. 1967.

Wolf 1988
Kenneth Baxter Wolf. *Christian Martyrs in Muslim Spain.* Cambridge Iberian and Latin American Studies. New York, 1988.

Wolf 1990
Kenneth Baxter Wolf. *Conquerors and Chroniclers of Early Medieval Spain.* Oxford, 1990.

Yarza 1969
Joaquín Yarza Luaces. "Las Miniaturas de la Biblia de Burgos." *Archivo español de arte* 42 (1969), pp. 185–203.

Yarza 1970
Joaquín Yarza Luaces. "Nuevos Hallazgos románicos en el monasterio de Silos." *Goya* 46 (1970), pp. 342–45.

Yarza 1974
Joaquín Yarza Luaces. "Iconografía de la Crucifixión en la miniatura española, siglos X al XIII." *Archivo español de arte* 47 (1974), pp. 13–37.

Yarza 1977
Joaquín Yarza Luaces. "El Infierno del Beato de Silos." *Pro arte* 12 (1977), pp. 26–39.

Yarza 1979
Joaquín Yarza Luaces. *Arte y arquitectura en España, 500–1250.* Madrid, 1979.

Yarza 1980
Joaquín Yarza Luaces. *La Edad Media: Historia del Arte Hispánico.* Vol. 2. Madrid, 1980. 2d ed., 1982.

Yarza 1981
Joaquín Yarza Luaces. "San Miguel y la balanza. Notas iconográficas acerca de la psicostasis y el pesaje de las acciones morales." *Boletín del Museo e Instituto "Camón Aznar"* 6–7 (1981), pp. 5–36.

Yarza 1985a
Joaquín Yarza Luaces. "Arte asturiano, arte 'mozárabe.'" *Cuadernos de historia del arte* 5 (1985), pp. 7–38.

Yarza 1985b
Joaquín Yarza Luaces. "Peregrinación a Santiago y la pintura y miniatura románicas." *Compostellanum* 30 (1985), pp. 369–93.

Yarza 1985c
Joaquín Yarza Luaces. "Sant Quirze de Pedret." In *Catalunya románica.* Vol. 12: *El Berguedà*, pp. 218–34. Barcelona, 1985.

Yarza 1985d
Joaquín Yarza Luaces. *Arte y arquitectura en España, 500–1250.* 4th ed. Madrid, 1985.

Yarza 1986a
Joaquín Yarza Luaces. "Beatus de Girona." In *Thesaurus Estudis: L'Art als Bisbats de Catalunya, 1000–1800*, pp. 29–30. Barcelona, 1986.

Yarza 1986b
Joaquín Yarza Luaces. "La Biblia de Lérida, manuscrito de procedencia aragonesa, muestra de la internacionalidad del románico." In *Actas del IV Coloquio de arte aragonés (Benasque, 1985)*, pp. 357–74. Saragossa, 1986.

Yarza 1990
Joaquín Yarza Luaces. "La Miniatura románica en España: Estado de la cuestión." In *Anuario del Departamento de Historia y Teoría del Arte* (Universidad Autónama de Madrid), vol. 2 (1990), pp. 9–25.

Yarza 1992
Joaquín Yarza Luaces. "La Miniatura en Galicia, León, y Castilla en tiempos de Maestro Mateo." In *Actas del Simposio Internacional sobre "O Portico da la Gloria e a Arte do seu Tempo"* (Santiago de Compostela, 3–8 October 1988), pp. 319–40. La Coruña, 1992.

Yepes 1609
Fray Antonio de Yepes. *Crónica general de la orden de San Benito.* Vol. 1. Navarre and Valladolid, 1609.

Yepes 1617
Fray Antonio de Yepes. *Crónica general de la orden de San Benito, patriarca de religiosos.* Vol. 6: *Centuria VI.* Valladolid, 1617.

Yepes 1959–60
Antonio de Yepes. *Crónica general de la orden de San Benito.* Ed. J. Pérez de Urbel. Biblioteca de autores españoles. 2 vols. Madrid, 1959–60.

Young 1979
Bonnie Young. *A Walk Through The Cloisters.* New York, 1979.

Zahn 1976
Leopold Zahn. "Die Klosterkirche Sant Pere de Roda: Studien zur Baugeschichte und kunstgeschichtlichen Stellung." Ph.D. diss., Freiburg in Bresgau University. Berlin, 1976.

Zamorano 1974
Isabel Zamorano Herrera. "Caracteres del arte visigodo en Toledo." *Anales toledanos* 10 (1974), pp. 3–149.

Zarnecki 1964
George Zarnecki. "A Sculptured Head Attributed to the Maître de Cabestany." *Burlington Magazine* 106 (1964), pp. 536–59.

Zarnecki 1975
George Zarnecki. *Art of the Medieval World.* New York, 1975.

Zeiss 1934
Hans Zeiss. *Die Grabfunde aus dem spanischen Westgotenreich.* Berlin and Leipzig, 1934.

Zimmermann 1916
Ernst Heinrich Zimmermann. *Volkarolingische Miniaturen* (Denkmäler deutscher Kunst, 3). 4 vols. Berlin, 1916.

Zozaya 1977
Juan Zozaya. "Algunas observaciones en torno a la ermita de San Baudelio de Casillas de Berlanga." *Cuadernos de la Alhambra* 12 (1976), pp. 307–38.

index

Compiled by Susan Bradford

photograph credits

Photographs of catalogue works in Spain commissioned by the Metropolitan Museum

Bruce White: cats. 1–7, 10, 11, 24a, 24b, 26, 27, 34–38, 41, 44–47, 50, 52, 56a–d, 61, 62, 63a, 63b, 65–68, 70–72, 73a–c, 79, 80, 82, 88–92, 94, 95, 96a–d, 100, 101, 103f–h, 104–106, 108, 109, 110 (exterior and lining of lid), 113, 114, 115a, 118–121, 123, 124, 125a, 125g, 127, 129, 132, 134, 137, 139, 140, 144, 146, 149, 150, 153, 161, 164a–g, 166–171

Other photographs of catalogue works

The Photograph Studio, The Metropolitan Museum of Art: cats. 17, 25, 28, 29, 49, 87, 102, 103a–c, 115c, 125c, 128, 130, 131, 133, 136, 138, 142, 153 (two folios); Archivo Fotográfico Oronoz, Madrid: cats. 8, 12a, 74c, 107, 111, 159; Sheldan Collins, New York: cats. 31–33, 38a, 59; Deutsches Archäologisches Institut, Madrid: cats. 64, 76, 77; Patrick Goetelen, Geneva: cat. 24bis; Barry Halkin, Philadelphia: cats. 69, 116b, 116c; Marilyn Jenkins, New York: cat. 54; Charles T. Little, New York: cats. 110 (interior), 125b, 125e, 125g, 126; Lumen, Burgos:

cat. 152; Joseph Martin, LARA, Madrid: cats. 12e, 13; Gordon H. Roberton, London: cats. 30, 55; John W. Williams, Pittsburgh: cat. 155; Juan Antonio Yeves Andrés, Madrid: cats. 9a, 9b, 48, 135b. All other photographs of objects in the exhibition were supplied by the lenders.

Illustrations in the essays

These photographs were provided by: Achim Arbeiter, Madrid; Archivo Fotográfico Oronoz, Madrid; Mario Carrieri, Milan; Sheldan Collins, New York; Jerrilyn D. Dodds, New York; Foto Peñarroya, Jaca; Hirmer Fotoarchiv, Munich; Marilyn Jenkins, New York; Joseph Martin, LARA, Madrid; MAS, Madrid; Detlev M. Noack, Deutsches Archäologisches Institut, Madrid; Lorenzo Arias Páramo, Oviedo; John Patterson, Deutsches Archäologisches Institut, Madrid; Photo Zodiaque, La Pierre-Qui-Vire; Raghubir Singh, London; O. K. Werkmeister, Evanston, Illinois; Bruce White, New York; and the institutions noted in the captions.

The text of this book is set in Galliard, a face designed for photocomposition by the English type-designer Matthew Carter in 1979; it is based on the sixteenth-century face Granjon, which was designed by Robert Granjon (1513–1589), a French type-founder who worked in Paris and Lyons. The display type is Libra, a face created by the Dutch type-designer Sjorrd Hendrick De Roos in 1938; it is based on early medieval uncials.

LIBRARY OF CONGRESS CATALOGING-IN-PUBLICATION DATA

The Art of medieval Spain, A.D. 500–1200.
 p. cm.
 An Exhibition catalog.
 Includes bibliographical references and index.
 ISBN 0–87099–685–1. —ISBN 0–87099–687–8 (pbk.). —
 ISBN 0–8109–6433–3 (Abrams)
 1. Art, Medieval—Spain. 2. Art, Spanish. I. Metropolitan
Museum of Art (New York, N.Y.)
N7103.A78 1993
709'.46'0747471—dc20 93–28791
 CIP